Complete
Digital Photography
Sixth Edition

Ben Long

COURSE TECHNOLOGY
CENGAGE Learning

Australia, Brazil, Japan, Korea, Mexico, Singapore, Spain, United Kingdom, United States

COURSE TECHNOLOGY
CENGAGE Learning™

Complete Digital Photography
Sixth Edition
Ben Long

Publisher and General Manager,
Course Technology PTR:
Stacy L. Hiquet

Associate Director of Marketing:
Sarah Panella

Manager of Editorial Services:
Heather Talbot

Marketing Manager: Jordan Castellani

Project and Copy Editor: Marta Justak

Technical Reviewer: Jim Long

Interior Layout: Jill Flores

Cover Designer: Mike Tanamachi

Indexer: Larry Sweazy

Proofreader: Sue Boshers

For product information and technology assistance, contact us at
Cengage Learning Customer & Sales Support, 1-800-354-9706.

For permission to use material from this text or product,
submit all requests online at **cengage.com/permissions.**
Further permissions questions can be emailed to
permissionrequest@cengage.com.

Adobe® Photoshop® and Adobe Photoshop Lightroom® are registered trademarks of Adobe Systems, Inc. in the U.S. and other countries. Apple Aperture™ and iPhoto® are trademarks of Apple Inc., registered in the U.S. and other countries. All other trademarks are the property of their respective owners.

All images © Ben Long.

Library of Congress Control Number: 2011920245

ISBN-13: 978-1-4354-5920-5

ISBN-10: 1-4354-5920-2

Course Technology, a part of Cengage Learning
20 Channel Center Street
Boston, MA 02210
USA

Cengage Learning is a leading provider of customized learning solutions with office locations around the globe, including Singapore, the United Kingdom, Australia, Mexico, Brazil, and Japan. Locate your local office at: **international.cengage.com/region.**

Cengage Learning products are represented in Canada by Nelson Education, Ltd.

For your lifelong learning solutions, visit **courseptr.com**

Visit our corporate Web site at **cengage.com.**

Printed in the United States of America
1 2 3 4 5 6 7 13 12 11

ACKNOWLEDGMENTS

There are a lot of changes and additions in this revision of *Complete Digital Photography, Sixth Edition* and many of them are there because, once again, my dad, Jim Long, did such a thorough job of technical editing.

I was also thrilled to again have the production team of Marta Justak and Jill Flores, who applied their considerable talent and care to making this such a nice book. Finally, thanks to Stacy Hiquet for giving us the go-ahead to move this book forward ahead of schedule.

ABOUT THE AUTHOR

Ben Long is a San Francisco-based photographer and writer. The author of over a dozen books on digital photography and digital video, he has been a longtime contributor to many magazines including *MacWeek*, *MacUser*, *Macworld UK*, and more. He is currently a senior contributing editor for *Macworld* magazine, a senior editor at CreativePro.com, and has created several photography instruction courses for Lynda.com. His photography clients include 20th Century Fox, Blue Note Records, Global Business Network, the San Francisco Jazz Festival, the Pickle Family Circus, and Grammy-nominated jazz musicians Don Byron and Dafnis Prieto. Long has taught and lectured on photography around the world. He also dabbles in computer programming, and has written image editing utilities that are in use in the Smithsonian, the British Museum, and the White House.

CONTENTS

INTRODUCTION .**xix**

1 EYES, BRAINS, LIGHTS, AND IMAGES **2**

Understanding How You See

How Your Eyes See . 4
 Transmitting Color to the Brain 5
 Light and Dark . 7
 Summing Up . 9
How to Learn Photography . 9

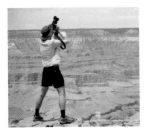

2 GETTING TO KNOW YOUR CAMERA**10**

Using Auto Mode for Snapshot Shooting

Camera Basics . 11
 Point-and-Shoot or SLR . 11
 Compact Interchangeable Lens Cameras. 14
 Battery, Media Card, Power Switch. 15
Shooting in Auto Mode . 15
 Setting Your Camera to Auto Mode. 15
 Framing Your Shot . 16
 Focal Length . 17
 How to Press the Shutter Button 17
 Adjusting the Focus of the Viewfinder 19
 Practice Shots . 20
Shutter Speed and Status . 20
 Reading Shutter Speed. 21
 When Shutter Speed Can't Go Low Enough. 23
Playing Back Your Images . 23
Using Scene Modes . 24
Snapshot Tips. 27
 Pay Attention to Headroom—Fill the Frame 27
 Don't Be Afraid to Get in Close 28
 Lead Your Subject . 28
 Remember: Your Knees Can Bend 29
 Watch the Background . 29
 Watch Out for Backlighting 30

Watch Those Joints . 31
Understand Flash Range. 31
Coverage . 31

3 CAMERA ANATOMY . 32

Holding and Controlling Your Camera

Point-and-Shoots and SLRs Revisited 33
A Very Fancy Box . 33
What an Image Sensor Does . 34
Point-and-Shoot Design . 34
SLR Design . 36
Camera Parts . 38
The Lens . 38
Basic Controls . 43
Mode Selection . 43
Status Display . 44
Shooting Controls. 45
Menu Activation and Navigation 46
Flash System. 46
Playback Controls. 46
Configuring Your Camera . 48
Date and Time . 48
Image Size and Compression. 48
File Format . 50
Image Processing Parameters 50
Other Features. 51
Holding the Camera . 53
The Grip . 53
Feet, Elbows, and Neck . 54
More Practice with Auto . 56
Shoot with a Fixed Focal Length 56
Camera Care and Maintenance. 57
Batteries and Power . 57
Lens Cleaning . 58
UV Filters . 59
Sensor Cleaning. 59
Cleaning Your Sensor . 60
Water and Digital Cameras . 61
Cold Weather. 63
Hot Weather and Digital Cameras. 63

Media Cards. 64
 Laptop Computers . 65
 Portable Battery-Powered Hard Drives 65
 Netbook Computers . 66
 Tablet Computers. 66
 Blank Discs, Cables, and PC Adapters 66

4 IMAGE TRANSFER . 68

Building a Workstation and Transferring from Your Camera

Choosing a Computer . 69
Storage . 70
 Backup. 71
 Backup Software . 72
Monitors . 73
 Preparing Your Monitor. 73
 A Little More Color Theory. 74
 Profiling and Calibrating Your Monitor 75
Software . 76
 Two Approaches to Workflow . 77
 Browsing and Cataloging Applications 77
 Image Editing Applications . 79
 Workflow Applications. 82
 Raw Converter Compatibility . 86
 Other Software. 86
Importing Images . 86
 Card Readers. 86
 Transferring Images to a Windows XP or Vista Computer. . . 87
 Transferring Images to a Windows 7 Computer 89
 Using Adobe Photo Downloader. 90
 Transferring Images to a Macintosh Computer. 90
 Configuring Your Mac for Image Transfer. 91
 Transferring Images Manually Using Windows or a Mac . . . 92
 Renaming and Organizing. 92
Moving On . 93

5 IMAGE SENSORS . 94

How a Silicon Chip Captures an Image

How an Image Sensor Works . 97
 Counting Photons. 98
 A Little Color Theory. 99
 Interpolating Color . 101

Turning Data into an Image . 103
Colorimetric Adjustment . 103
Color Space Conversion. 103
Gamma Correction . 103
White Balance and Image Processing. 105
Sharpening and Noise Reduction. 105
JPEG Compression and Saving . 105
How JPEG Compression Works. 105
Meanwhile, Back in the Real World 107

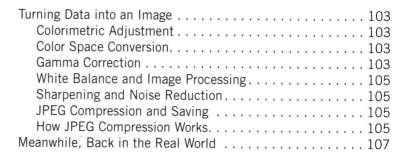

6 EXPOSURE BASICS .108

The Fundamental Theory of Exposure

Stops. 109
Over- and Underexposure Defined. 109
Exposure Control Mechanisms . 111
Shutter Speed . 112
Aperture . 113
Less Is More . 113
Why There Are Two Ways to Control Light 114
How Shutter Speed Choice Affects Your Image 115
Depth of Field—How Aperture Choice Affects Your Image . . 116
Shutter Speed/Aperture Balance 117
Reciprocity . 118
ISO—The Third Exposure Parameter 119
Reciprocal ISOs. 119
ISO and Noise . 120
Fractional Stops. 120
Summing Up . 120
Returning to Auto Mode . 121

7 PROGRAM MODE .122

Taking Control of Exposure, Focus, and More

Switching to Program Mode. 123
Focusing Revisited . 124
How Autofocus Works . 124
Autofocus Modes . 126
Evaluating Focus . 135
The Golden Rule of Focus. 136
White Balance . 136
Auto and Preset White Balance 138
Manual White Balance . 139
Assessing White Balance. 140

White Balance Shift . 140
White Balance Bracketing . 141
Avoid White Balance Concerns Altogether 141
White Balance Aids . 141
Drive Mode . 145
Shooting in Drive Mode . 146
Self-Timer . 147
Remote Controls . 149
Manual Override with Program Shift (Flexible Program) 152
Calculating a Safe Shutter Speed for Handheld Shooting . . . 154
Stabilization and Shutter Speed 154
Do You Really Need to Calculate Handheld Shutter Speed 155
Changing ISO . 155
Fractional ISO Numbers . 159
Putting It All Together . 159

8 ADVANCED EXPOSURE 160

*Learning More About Your Light Meter
and Exposure Controls*

The Light Meter Revisited . 161
Locking Exposure . 163
What Your Light Meter Meters 164
The Risks of Over- and Underexposure 166
Adjusting Exposure . 169
Exposure Compensation . 169
Exposure Compensation and Program Shift 170
Controlling Exposure with Your Light Meter 171
Priority Modes . 173
Manual Mode . 174
Which Method Should You Use 176
In-Camera Histograms . 176
Histograms Defined . 177
Assessing Contrast . 179
The Three-Channel Histogram 182
Bracketing . 183
Auto Bracketing . 184
Scene Modes Revisited . 187
Image Processing Parameters Revisited 187
Exposure Strategy . 189
Enough with the Button Pushing 189

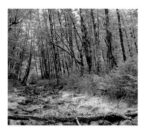

9 FINDING AND COMPOSING A PHOTO190

Learning the Art of Photography

Looking Versus Seeing. 191
Seeing Exercises. 192
 Warming Up . 193
 Make an Assignment . 193
 Look at Other Photos . 194
 Sketch and Draw . 195
 Pay Attention and Do What Works for You 195
Finding a Subject . 196
 Photography as Abstraction. 200
 Know Your Audience. 203
Building a Shot . 203
 Choosing a Camera Position and Focal Length 204
 Shooting Shallow Depth of Field 208
Composition. 212
 Balance. 212
 The Rule of Thirds . 215
 Repetition . 216
 Geometry. 216
 Lines . 217
 Mixing and Matching . 219
 Foreground/Background . 219
Composing with Light and Dark . 221
 Less Is More . 222
Mixing, Matching, and Ignoring . 223
Six Practices for Better Shooting 224
 Seeing *in* the Camera, not *Through* the Camera. 224
 Work the Subject . 225
 Narrative. 227
 Simplify . 229
 Don't Be Afraid . 229
Equipment Doesn't Matter (Usually). 230
Combining Art and Craft . 230

10 LIGHTING . 232

The Process of Controlling Light

Controlling Available Light. 233
Broad and Narrow Lighting . 237
Flash Photography . 237
 Flash Modes . 238
 Flash White Balance. 240

Using Flash in Low Light. 240
 High ISO Low-Light Shooting 240
 Slow Sync Flash Mode . 241
Using Fill Flash in Bright Light 243
External Flash . 244
 What to Look for in an External Flash. 244
 Shooting with External Flash. 245
 Getting Your Flash off the Camera 247
 Slow Sync Flash. 248
Further Lighting Study . 249

11 RAW SHOOTING 250

Gaining More Editing Power Through Raw Format

What Raw Is. 251
Why Use Raw. 252
 Editable White Balance . 252
 Highlight Recovery. 253
 More Editing Latitude. 254
 Digital "Negative" . 255
 Batch Processing. 257
 Nondestructive Editing. 257
The Downsides of Raw . 257
 Raw Files Use More Storage 257
 Other People May Not Be Able to Read Your Files 257
 Your Software of Choice May Not Support Your Camera. . . . 258
 Workflow Can Be a Bit More Complicated 258
Configuring Your Camera to Shoot Raw 258

12 SPECIAL SHOOTING 260

Camera Features and Techniques for Specific Situations

Black and White. 261
 You Say Red, I Say Gray . 263
 Seeing in Color, Shooting in Black and White 264
 Black-and-White Exposure 265
Infrared Photography. 265
 Focusing. 267
 Choosing an IR Exposure 268
Stable Shooting . 269
Landscape Photography. 271
 Keep an Eye out for Flare 272
 Exposing for Extreme Depth of Field 273
 Tilt-and-Shift Lenses and Depth of Field. 275

Shooting Panoramas . 276
 Preparing Your Camera . 278
 Proper Panoramic Panning 279
 Panoramic Exposure . 281
 Shoot with Care . 282
 Collaging . 285
Macro Photography . 286
 Finding the Optimal Macro Focal Length 287
 Macro Focusing . 287
 Poor Depth of Field . 288
 Improving Macro Depth of Field 289
High-Dynamic Range (HDR) Imaging 289
 Shooting HDR . 290
Shooting Concerts and Performances 291
 Setup . 292
 Exposure Strategy . 293
 Performance Composition 295
Shooting Events . 296
 Exposure Strategy . 297
Shooting Sports . 297
 Exposure Strategy . 298
Street Shooting . 299
 Offering Something in Return 300
 Using Street Shots . 301
 Exposure Strategy . 302
Shooting at Night . 302
 Low Light Focus . 303
 Real-World Low Light Shooting 303
Underwater Photography . 305
Vacation Shooting . 306
Product Shots . 307
Using Filters . 308
 Types of Filters . 308
Lens Extensions for Point-and-Shoot Cameras 311
Exploring on Your Own . 311

13 WORKFLOW . 312

Managing Your Images and Starting Postproduction

Postproduction Workflow . 313
 Importing and Organizing 316
 Metadata Tagging and Keywording 316
 Selecting Your Pick Images 317
 Correcting and Editing . 318

Outputting. 318
Archiving and Backup. 318
Cataloging. 319
No Right or Wrong Approach to Workflow 319
Tutorial: Getting Started with Bridge 320
Tutorial: Making Selects and Rating Images
with Bridge. 326
Tutorial: Filtering Images 329
Tutorial: Stacking Images. 330
Sorting Images . 332
IPTC Metadata . 332
Tutorial: Create and Use a Metadata Template 332
Keywords. 334
Creating Keywords . 334
Applying Keywords. 335
Filtering by Keywords . 335
Collections. 335
Tutorial: Creating a Collection. 336
Smart Collections. 337
Tutorial: Creating a Smart Collection 337
One Approach to Applying Collections 338
Batch Rename . 338
String Substitution. 339
Opening Images in Photoshop 340
Other Bridge Commands . 340
Mini Bridge . 341
Image Forensics . 342
It's Not Which Software, It's What You Do with It. 343

14 EDITING WORKFLOW AND FIRST STEPS 344

*Understanding the Order of Edits and
Making Your First Adjustments*

Editing Order . 345
Histograms Revisited . 347
Cropping . 348
Tutorial: Cropping an Image 349
Straightening . 353
Tutorial: Straightening an Image 353
Correcting Geometric Distortion 355
Tutorial: Correcting Barrel and Pincushion Distortion
in Photoshop CS2 or Later 356
Auto Lens Correction . 358

Correcting Perspective. 359
 Tutorial: Correcting Perspective in Photoshop CS2
 and Later . 359
Correcting Chromatic Aberrations 361
 Tutorial: Correcting Chromatic Aberration with
 Photoshop CS2 or Later 361
Dust and Spot Removal. 363
 Tutorial: Correcting Dust Problems 364
Red Eye. 365
Undo and History . 366
Saving Your Image . 367
 Understanding Save and Save As. 367

15 CORRECTING TONE . 370

Ensuring That White, Black,
and Overall Contrast Are Correct

Correcting Tone . 372
Levels . 372
 Tutorial: Using Levels Input Sliders. 373
 Tutorial: Adjusting a Real-World Image 376
Should You Worry About Data Loss? 381
Auto Levels . 382
Curves. 383
 Tutorial: Correcting Tone with Curves 386
 An Easier Way to Edit Curves. 390
Learning to See Black as Black 391

16 CORRECTING COLOR . 394

Repairing, Improving, and Changing Color

Levels and Curves and Color . 395
 Tutorial: Correcting a Color Cast 397
 Tutorial: Correcting Color with Curves 401
Hue/Saturation. 405
 Tutorial: Adjusting Saturation 406
Vibrance . 408
The Story So Far. 409

17 IMAGE EDITING IN RAW410

Correcting the Tone and Color of Raw Files

Getting Started with Raw............................411
 Nondestructive Editing..........................411
 Basic Raw Adjustments412
 Navigation and Zooming........................412
 Initial Settings...............................412
 Tutorial: Performing Basic Edits in Camera Raw412
Nondestructive Editing Revisited416
 A Simple Experiment416
 Keeping Track of XMPs.........................417
Raw Workflow...................................417
 Reviewing Raw Images in Your File Manager.........418
Raw Conversion Software............................418
Workflow with Bridge/Camera Raw/Photoshop420
 Choosing a File Format for Saving Raw Files.........421
More About White Balance422
 Manual White Balance422
 Correcting White Balance When There's No
 Gray to Sample423
 White Balance and Posterizing425
 When "Correct" White Balance Isn't the Best Choice....426
More About Highlight Recovery426
 The Recovery Slider426
 Tutorial: Recovering Overexposed Highlights........427
 Highlight Recovery and Color.....................429
 Tutorial: Recovering Overexposed Highlights430
More About Fill Light431
 Highlights and Shadows in Aperture................433
 D-Lighting in Capture NX433
Additional Adjustments in Photoshop Camera Raw........433
Additional Tabs.................................433
 Tone Curve434
 Detail434
 HSL/Grayscale...............................435
 Split Toning.................................435
 Lens Corrections435
 Effects435
 Camera Calibration............................436
 Presets436
 Workflow Options436
Copying Your Edits from One Image to Another438
 Copying Raw Edits in Photoshop Camera Raw........438
 Copying Edits in Aperture439

Copying Edits in Lightroom . 439
Copying Edits in Nikon Capture NX 439
Batch Processing in Camera Raw . 439
Choosing Where to Host a Batch 440
Adjust in Camera Raw? Or Photoshop? 441
What More Do You Need? . 441

18 MASKING . 442

Using Masks to Constrain Your Adjustments

Mask Tools . 444
Selection Tools . 444
Altering the Edge of a Selection 449
Tutorial: Using Refine Edge and Smart Radius 450
Tutorial: Masking Hair with Refine Edge 455
Saving Masks . 455
The Limits of Selection Tools . 457
Tutorial: Creating Complex Masks 457
Adjustment Layers . 462
Tutorial: Adjustment Layers . 463
Tutorial: More Layer Masking 469
Targeted Hue/Saturation . 473
Tutorial: Targeted Saturation Adjustment 473
Selective Edits in Camera Raw . 476
Tutorial: Selective Editing in Camera Raw 477
Tutorial: Gradient Adjustments in Camera Raw 480
Targeted Adjustment . 481
The Masks Palette . 482
One-Click Layer Masking . 483
Advanced Masking . 484
Tutorial: Advanced Masking in Photoshop 485
Saving Revisited . 489

19 BLACK-AND-WHITE CONVERSION 490

Turning Your Color Images into Black-and-White Images

Simple Grayscale Conversion . 491
Photoshop's Black-and-White Command 492
Tutorial: Using the Black-and-White Adjustment 492
Black-and-White Adjustment Layers 495
Sepia Toning . 497
Other Black-and-White Conversion Techniques 498
Channel Mixing . 498
Converting to Luminance . 499
Desaturating an Image . 499

Black-and-White Conversion in Camera Raw. 500
 Split Toning . 501
Black-and-White Plug-ins . 501
Refining a Grayscale Image. 502
Low Contrast Images . 503

20 LAYERS, RETOUCHING, AND SPECIAL EFFECTS. . 506

Additional Editing Tools and Concepts
for Improving Your Images

Layers. 507
 Some Layer Basics . 508
 Tutorial: Compositing . 509
 Opacity and Transfer Modes . 513
 To Flatten or Not to Flatten . 515
Brushes and Stamps . 516
 Brushes . 516
 Rubber Stamp or Clone . 517
 Video Tutorial: Cloning Video 518
 Patch and Heal. 518
 Video Tutorial: Painting Light and Shadow. 519
Applied Editing Techniques. 520
 Adaptive Shadow/Highlight Correction 520
 Tutorial: Correcting a Bad White Balance
 in a JPEG File . 523
 Tutorial: Retouching with Content-Aware Fill 526
 Cleaning Portraits . 529
Noise . 531
Vignetting . 531
Photoshop Smart Objects . 533
Where to Go from Here. 534

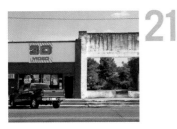

21 PANORAMIC STITCHING AND HDR MERGING . . . 536

How to Process These Multi-Shot Effects

Stitching Panoramas . 537
 Stitching Workflow . 538
 Launching a Stitch from Within Bridge 538
 Launching a Stitch from Within Photoshop 539
 Configuring Photomerge. 539
 Other Photomerge Options 540
Correcting Stitched Panoramas 541
 Cropping and Filling . 541
 Retouching. 543

Stitching Raw Images. 543
Speeding Up Stitching . 544
Stitching Vertical Panoramas. 544
Merging High-Dynamic Range (HDR) Images. 545
What HDR Merging Does. 545
Launching HDR Merge from Bridge 546
Launching HDR Merge from Photoshop 546
Configuring Merge to HDR Pro. 546
Aesthetic Considerations. 548
HDR Panoramas . 550

22 OUTPUT . 552

Taking Your Images to Print or Electronic Output

Resizing. 553
Resolution. 553
Resizing an Image . 554
Tutorial: Understanding Resolution 556
When Should You Resample? 558
Sharpening . 560
How Sharpening Works. 560
Not All Sharpness Is Created Equal 562
Selective Sharpening . 563
Web and Email Output . 564
Outputting Electronic Files . 567
Bridge CS5 Export Tab . 568
Choosing a Printer . 569
Ink-Jet Printers . 570
Media Selection. 571
Ink Choice. 572
Printing . 572
Choosing a Resolution . 572
Tutorial: Printing from Photoshop 575
Improving Your Print. 578
Web-Based Printing . 581
Conclusion. 582

INDEX . 584

INTRODUCTION

For the bulk of photography history, change and innovation have come in the form of new types of hardware. Look back over the history of the development of photography and you'll see breakthrough moments of all kinds: roll film, the SLR, the light meter, the electronic flash, the zoom lens, image stabilization, and on and on. I would also include in that list the advancement of film and paper technology: color film, more sensitive film, and film stocks with unique contrast and color qualities. Still, all of these changes represent advances in the physical hardware realm.

Those advances are still occurring, of course. The shift to digital imaging was one of the most significant events in all of photographic history, and digital image sensors continue to improve, as does lens technology. Camera vendors also find all sorts of new features to pack into their hardware from face recognition autofocus to the ability to capture video.

But these days, the dramatic breakthroughs that open up new photographic possibilities are software-based as often as they are hardware-based. For example, the development of panoramic stitching software in the early 2000s made it possible to shoot wide angle vistas that were previously unobtainable. Software advances allow us to now capture scenes with very high dynamic range, to shoot in low light, and to correct perspective and lens distortion. These advances not only allow us to repair what would previously have been unusable images, but they also let us visualize and capture scenes that were simply impossible to photograph before.

This sixth edition of *Complete Digital Photography* has seen a lot of changes from start to finish, but the most profound changes occur in the postproduction chapters of the book because, right now, the most profound changes in photography are happening in software.

But while software advances mean there are new tools to learn, ultimately, learning photography has not changed from the earliest days. Technically, the most critical concepts to understand are *still* the fundamental concepts of exposure. And while new technologies open up new avenues of visual expression, these possibilities are irrelevant if you don't understand the fundamentals of composition and how to see photographically. These fundamentals come into play both when shooting and editing, which is why fully half this book is devoted to the essential foundations of the photographic process.

With each new edition, I get more feedback about what does and doesn't work, in terms of instruction. Alongside this, my workshops and classroom instruction have continually helped me refine and revise my teaching concepts. Consequently, there are changes and, what I hope are improvements, to explanations and discussions throughout this book.

So, no matter what your skill level, you will most likely find something in these pages that will help you advance your shooting to a new level.

How This Book Is Organized

If you're familiar with one of the first five editions of *Complete Digital Photography*, then you'll notice some huge changes with this latest revision. In addition to lots of new material, the book has a radically altered structure, borne of my teaching experience over the past few years.

Photographic technology, whether digital or film, sees the world very differently from your eyes, and it's important to understand how your camera's results will differ from your visual experience at the scene. Therefore, Chapter 1, "Eyes, Brains, Lights, and Images," leads you through an exploration of your visual sense and how it differs from your camera. Many of the concepts in this chapter will become critical when you learn more about exposure.

Chapters 2 and 3, "Getting to Know Your Camera" and "Camera Anatomy," serve to familiarize you with your camera. Like any tool, you'll get better results from your camera if you know how to use it well, and these chapters should get you up to speed with all those buttons and dials.

To assess the results of the exercises in Chapters 2 and 3, you'll need to move your images into your computer. Chapter 4, "Image Transfer," will walk you through the process of importing images from your camera.

The great film photographers of the past didn't just understand composition and exposure theory, they also had detailed understanding of the chemistry of their film and darkroom technologies. It was this understanding that provided them with such fine control over their final result. Digital photographers similarly benefit from an understanding of digital image capture, so Chapter 5, "Image Sensors," walks you through the basics of how the guts of your digital camera work.

Chapters 6, 7, and 8—"Exposure Basics," "Program Mode," and "Advanced Exposure"— provide a thorough, detailed series of lessons in exposure theory. Starting with the most basic concerns and controls, you'll progress steadily up to the most advanced exposure features of your camera and learn how these tools can be used to broaden your expressive palette.

Chapter 9, "Finding and Composing a Photo," gives you a break from the technical concerns of shooting, and offers a lengthy discussion of how you go about finding a potential subject, and how to craft that subject into a final image. Photography is a discipline that rewards constant practice and experimentation, and this chapter will provide you with an understanding of the nontechnical subjects that you will explore for the rest of your photographic life.

Just about any digital camera you buy these days will have a built-in flash unit, and learning to use it can be tricky. Chapter 10, "Lighting," will walk you through the process of modifying light using flashes and reflectors.

All SLRs and many point-and-shoot cameras offer the ability to shoot in raw format, which provides several advantages over the JPEG shooting that your camera defaults to. Chapter 11, "Raw Shooting," discusses the particular advantages of raw shooting and addresses specific concerns that you'll face when shooting in raw mode.

Chapter 12, "Special Shooting," takes the detailed understanding of shooting that you glean from the first 11 chapters, and applies it to specific situations. In this chapter, you'll learn to shoot sporting events, theatrical events, how to shoot in low light, and much more.

With Chapters 13 and 14, "Workflow" and "Editing Workflow and First Steps," your post-production education will begin, starting with a discussion of what workflow is and why it matters.

As you'll learn in the workflow chapters, one of your first image editing tasks is to correct tone, so Chapter 15, "Correcting Tone," will walk you through basic tonal adjustments. This is followed by Chapter 16, "Correcting Color."

While raw editing is very similar to the editing tools you'll learn in Chapters 15 and 16, there are some important differences, and you'll learn about these in Chapter 17, "Image Editing in Raw." Here, you'll also learn about raw workflow and where raw editing fits into your overall postproduction pipeline.

Chapter 18, "Masking," presents some of the most important tools that you'll add to your editing arsenal. With masks, you can make localized edits and adjustments, and good masking skills can be crucial to getting the results you want.

Black-and-white processing is given a detailed discussion in Chapter 19, "Black-and-White Conversion," while layers and other special effects and retouching tools are covered in Chapter 20, "Layers, Retouching, and Special Effects."

Panoramic stitching and HDR (high dynamic range) merging are covered in Chapter 21, "Panoramic Stitching and HDR Merging." These lessons build on the panoramic and HDR shooting discussions that are introduced in Chapter 12.

Finally, the last stage of your workflow is covered in Chapter 22, "Output," where you'll learn how to turn your finished images into files for email, Web pages, or archival prints.

However, this book offers you much more than what's printed on these pages. Throughout the book, you'll find Web links to movies and additional PDF documents that you can download. These resources will provide you with further discussions, examples, and tutorials on a wide variety of topics.

What You Need

Obviously, to take pictures you need a camera, and this book assumes that you already have one. However, if you don't, the companion Web site offers an additional chapter, Chapter 23, Choosing a Digital Camera." This chapter offers a comprehensive, exhaustive discussion that provides a detailed methodology for assessing and choosing a camera. You can download it from *www.completedigitalphotography.com/CDP6*.

The postproduction chapters of this book are built around Adobe Photoshop, and you can download a 30-day demo of Photoshop from *www.adobe.com/downloads*. However, most image editing programs use similar interfaces, so you should find that the editing lessons herein translate very easily to many other image editing programs.

The Photoshop tutorials are built around the latest version of Photoshop (as of this writing), which is Photoshop CS5. Most of the tutorials will work on earlier versions, and Photoshop Elements can easily be used for the book's tutorial sections. I've noted places where discussed features are CS5-only.

Finally, you need to have some curiosity about photography and the world in general. As with any art form, photography is a process of exploration. There's no recipe for a good photo, and while I recommend some specific ways of doing things, it's very rare that my recommendations are the best for everybody. Don't ever stop exploring on your own and trying to find the methods that work best for you.

1

EYES, BRAINS, LIGHTS, AND IMAGES

Understanding How You See

C

onsider, for a moment, a piece of film.

To make a piece of film, a thin strip of translucent celluloid is covered with a gelatin emulsion that includes crystals of silver halide. Silver halide is light sensitive, and when photons strike silver halide crystals, the crystals undergo a chemical change. As more light strikes a particular area, that area goes through more changes. When the film is developed, those chemically changed silver halide crystals turn into a grain of silver. Where more silver halide was exposed, more metallic silver grains appear. The silver crystals, though, are dark, so areas that were exposed to more light get darker and darker—in other words, lighter areas of the original scene are represented as darker. Thus, a negative image is created, as shown in Figure 1.1.

Figure 1.1 After a piece of film is developed, it contains a negative image.

If you project that negative image onto a photographic paper that is coated with silver halide crystals, the same chemical process occurs. A latent image is captured by the silver halide crystals, and when developed, the photon-activated crystals are turned into black metallic silver. But because the image is a negative, this time the original lighter areas collect fewer silver halide crystals. The practical upshot is that a positive image is produced.

One of the things that is amazing about film is that it's both an imaging medium and a storage device. What's more, the negative and prints that are produced can be very durable.

The image sensor that you'll find inside a digital camera also exploits the light sensitivity of certain elements. Instead of silver, though, a digital image sensor uses a special type of electronic circuit consisting of a capacitor and a photodiode. Before capturing an image, the capacitor must be given an electrical charge. When the photodiode is struck by light, the photodiode drains some of the charge from the capacitor. Just as silver halide crystals clump together in proportion to the amount of light that strikes them, a photodiode will reduce the charge on the capacitor in direct proportion to the number of photons that it was exposed to. Your image sensor is covered with these circuits—one for each pixel in your final image. By measuring the voltages across the surface of the image sensor, you can find out how much light struck each part.

This information is passed to a computer, which analyzes it and interprets it to yield a full-color digital image, which is then stored on a memory card. All of this (and more) happens so quickly that your camera can capture multiple images in a single second.

Digital image sensors are incredibly sensitive to light. To understand how sensitive they are, just look at images from the Hubble telescope. This giant, orbiting telescope can yield images by capturing photons that have traveled for billions of years.

Both film and digital image sensors are amazing technologies, and they have improved dramatically over the years, thanks to the work of untold numbers of brilliant engineers. Both allow for the capture and creation of striking, finely detailed, color-rich images.

And both pale in comparison to the imaging properties of the human eye.

The fact is, as amazing as our current imaging technologies are, there are many things that the human eye does much better, and a few things the eye does that analog and digital imaging technology can't do at all.

How Your Eyes See

Like a piece of film, or a digital image sensor, your eye has a light-sensitive area called the *retina* (see Figure 1.2).

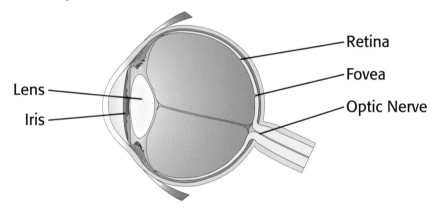

Figure 1.2

The eye is a lot like a camera: it focuses light with a lens, controls exposure with an iris, and has an imaging medium, the retina.

Image courtesy of
©iStockphoto.com/djgunner

Located at the back of the eye, the retina contains four different kinds of light-sensitive cells: rods and three different types of cones. Cones are the color-sensitive cells, and most of them are found in a tiny region called the *fovea*. Less than one millimeter in diameter, the fovea is responsible not only for color, but also for sharpness and almost all your spatial sensitivity. Cones can only detect light that strikes them straight on, which means that only well-focused light will activate them.

Because the fovea is very small, only a tiny bit of your field of view is in focus. This may come as a bit of a surprise, but of your whole field of view, only an area about the size of your thumbnail is actually in focus.

To test this, try an experiment. With this book held at arm's length, place your thumb on the page in the middle of a paragraph. Without moving your eyes, pay attention to the text around your thumb. While the area right next to your thumb might be in focus, (it might not, depending on the size of your thumb), you probably can't read the text that's just a little farther away. Without moving your eyes, take your thumb off the page and note that the text underneath it is now in focus.

This area that is in focus is the extent of your foveal vision. However, you perceive a full field of view of focused, color vision because you subconsciously move your eyes around to sample your entire field of view. Your brain then assembles this into a fully focused, full-color visual sense.

Because they only respond to light coming from a single angle, cones (the light sensitive cells in the fovea) are not very light-sensitive, and as light levels decrease, colors become muted, and the rods in your eyes take over.

Rods cover the rest of the retina—about 98 to 99 percent of it—and they see only in monochrome. However, they can be triggered by light coming from just about any direction, which makes them incredibly sensitive to light. A rod that has been given time to adapt to the dark can detect a single photon of light—this means that, in good conditions, you could see the light of a candle from seventeen miles away. But because rods are not located in the fovea, they don't yield as focused an image as what you see when your foveal vision is active.

Your rods are what we consider *peripheral vision*, and while your peripheral vision is not super sharp, it is great for seeing dim objects in low light. If you've ever spent any time making astronomical observations through a telescope, then you might already know that, often, the only way to see a very dim object is to avert your eyes from it. When you point your peripheral, rod-based vision at a very dim subject, you often see the object better—not necessarily sharper, but brighter. In fact, you may not be able to see the object at all unless you look away from it.

Your rod vision can also come in handy when walking in the dark. Next time you're out in the country, away from bright lights, take a walk outside. If possible, get off the pavement and put your feet on some less even terrain. If you keep your eyes focused directly ahead of you and don't move them while you walk, you'll probably find that your peripheral vision reveals a tremendous amount of detail on the path in front of you. Some of the things you see might disappear if you look directly at them, because your rod vision does a much better job in the dark than your foveal vision. If you practice this technique, you'll probably find it's easier to walk in the dark using your peripheral vision than it is to use a flashlight, which completely wipes out your low-light vision and confines what you see to only the area lit up by the light.

Of course, these days we spend most of our time in well-lit areas, moving through a full-color world.

Transmitting Color to the Brain

Earlier, I mentioned that there are three types of cones. Each type is sensitive to a different wavelength of color. One type is sensitive to red, another to green, and the third to blue. These colors are the additive primaries of light. As they are mixed together, they create other colors (see Figure 1.3).

If you mix equal amounts of red, green, and blue, the result is white. Varying amounts of each of these primaries allow you to create all of the other colors that the human eye can perceive.

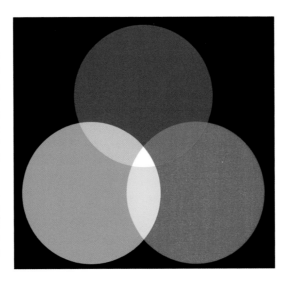

Figure 1.3

Red, green, and blue—the three additive primary colors of light—can be mixed together to create other colors. As you combine them, the resulting color gets lighter, eventually becoming white. Note also that where the colors overlap they create the secondary primary colors—cyan, magenta, and yellow. These are the primary colors of ink.

The Different Primary Sets

In grade school, you might have learned some different primary colors, such as yellow. Yellow, cyan, and magenta are the primary colors of pigment, which are different from the light primaries. If you mix equal amounts of the primary colors of pigment, you get black.

The total number of colors that the eye can perceive is not known for certain. Current research suggests a number from 2.3 million to 10 million different colors.

Like a digital camera, rods and cones generate electrical impulses when exposed to light. These signals are transmitted to the brain along the optic nerve, and the eye separates the data into two channels, a brightness channel and a color channel. The brightness channel contains far more information than the color channel, which might be one reason that black-and-white images are so compelling—they contain most of the information used by the human visual system.

Once these visual signals get to the visual cortex in the brain, they get processed in many different ways.

If you've replaced any of the old-fashioned light bulbs in your house with new compact fluorescents, you might have noticed how the compact fluorescents have a different color. They are what we call a "cooler" light, and they cast a light that's bluer than the warmer red light created by a tungsten bulb. Different types of light have different inherent colors, but your brain is able to compensate for this by automatically adapting so that color looks correct in any type of light.

For example, you might read this book under tungsten lighting and see the pages as white. However, if you carry it into your fluorescently lit kitchen, it will still look white. It will continue to appear white if you take it out into bright sun, into shade, or look at it under sodium vapor lights at night.

The brain is able to correct color in this way because it understands that a piece of paper is supposed to be white. While your eyes are incredibly sensitive to light and collect a good amount of visual data, a full 80 percent of what you perceive with your eyes is generated by your brain!

Based on your experience, memory, and expectations, your brain imposes a model of the world onto the visual signals that it receives from your eyes. At the simplest level, this model allows your brain to correct color, but it can also dramatically change your perception of objects in the world.

The best examples of how much the brain is involved in visual processing are optical illusions. An optical illusion occurs when your brain's model, or expectation, doesn't quite match the data coming from your eyes. The brain gets confused, and your sense of what you're seeing becomes more ambiguous.

One of the simplest examples is shown in Figure 1.4.

Figure 1.4

Your brain knows enough about the overall shape of these two-dimensional lines to assume they represent a three-dimensional object—a cube. Of course, the brain is wrong about this being a 3D object, and there isn't enough information in the image for your brain to correctly render a fully realized cube, so the cube appears to flip back and forth as your visual system tries to reconcile the lines to its expectation of the shape the lines represent.

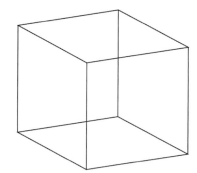

Your brain recognizes some lines that seem to indicate a particular thing, a cube, and so it tells you "oh yeah, I know what that is, that's a cube." Except that it's not a cube, it's merely some lines on the page, even though those lines are describing a shape very similar to a cube. So, at some point in the process of trying to reconcile "cube" with that set of lines, the brain gets tripped up, and your perception of the object becomes less certain. The cube appears to change orientation as the brain tries to sort out what it's seeing. Ultimately, of course, your brain is simply wrong—the image is merely flat lines on paper.

Here's another example in Figure 1.5, an optical illusion created by MIT researcher Edward H. Adelson.

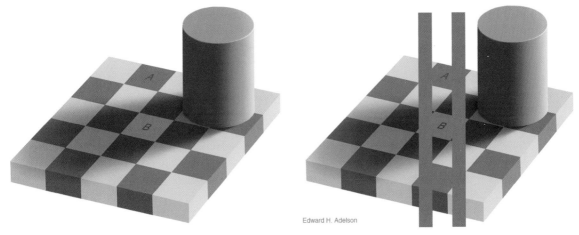

Edward H. Adelson

Figure 1.5 While the checkered squares appear to be alternating colors, squares A and B are actually the same color. In fact, your brain "corrects" the B square to make it fit an expectation that isn't true. The right figure shows that the two squares are actually the same color.

Light and Dark

We have yet to devise any kind of technology that can perform the type of sophisticated color adaptation that your eyes pull off. When you throw in the fact that the eye also provides extremely fast, silent autofocus with a range from a couple of dozen centimeters all the way to infinity, it becomes obvious that current camera technology lags far behind the capability of the human eye.

The good news is that none of these facts mean that you can't take beautiful, compelling images. However, it is important to understand that your eyes see a world that your camera can't necessarily capture. Understanding the differences between what your eyes can see and what your camera can capture is an essential step for taking better pictures.

The most significant difference between the eye and any camera is the range of brightness that your eye can perceive. Your eye controls brightness, or exposure, by opening and closing its iris, or pupil, to limit the amount of light that strikes the retina. It does this automatically as you look at brighter and darker things, and as the light in a scene changes.

Dynamic range is the measure of the darkest to lightest tones that can be captured by a device. Your eye can manage very dark, moonless nights guided only by starlight, as well as harsh glaring sunlight. If you express this difference as a ratio, then the total dynamic range of the human eye is about a billion to one—the brightest thing you can perceive is about a billion times brighter than the darkest thing.

Photographers use a different way to measure light, though. Every time the amount of light in a scene doubles, photographers say that the scene has brightened by *one stop*, or *f-stop*. Conversely, if you cut the amount of light in a scene in half, then the scene has darkened by one stop. *Every doubling or halving of light is measured as one stop.*

Using this measure, the human eye can perceive a total dynamic range of about 30 stops.

While the entire dynamic range of the eye is around 30 stops, when looking at a single scene, the eye can discern a dynamic range of about 15 stops. That is, the darkest thing and brightest thing in the scene can be about 15 stops apart. By comparison, a digital camera has a total dynamic range of 10 to 12 f-stops, and in any particular scene, you can expect to capture a range of about 5 to 9 stops.

Because the eye can see so much more dynamic range than your camera can, you will often have to make decisions about what part of the range you want to capture in a scene.

For example, consider Figure 1.6. In real life, the bottom of the canyon and the blue of the sky were visible to the eye. However, because the camera has a smaller dynamic range than the eye, it could capture only some of the range of light. It was not possible to shoot a single exposure that would properly expose both the depths of the canyon and the bright sky above. Although we can see detail in the sky in the first image, we see no detail in the canyon. In the second image, we have the exact opposite problem.

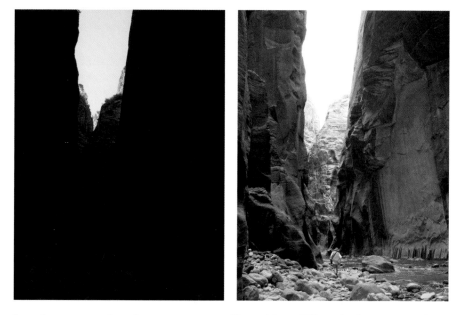

Figure 1.6

Because of the huge range of light to dark in this canyon, it was not possible to take a single exposure that captured both the bottom of the canyon and the sky above.

Learning to recognize when your camera will see things differently than your eye is an essential skill that will come with practice. In this book, you'll also learn how to compensate for your camera's deficiencies, so that you can get images that are closer to how you actually see a scene.

Summing Up

Offering continuous autofocus from a few centimeters to infinity, real-time color adaptation for different types of lights, a tremendous dynamic range, silent operation, and easy portability, your eyes trump modern camera technology in a number of ways. By understanding what we've discussed here, you'll be better able to work around the limitations of your camera.

However, there are a few ways that your camera outperforms the human eye. First, you can change the lens on it. Sure, modern surgical technique allows lens replacement in the eye, but it's not the sort of thing you want to do every day, and you can't swap your eye's lens out for one with more magnification or a wider field of view.

Your eyes are used for more than just creating pretty pictures, of course. They serve a valuable role in balance, locomotion, and general survival. As such, they need to work quickly to provide you with a constantly updated stream of visual information. With a camera, though, you can choose to spend more time gathering light to create a single image. If you take, for example, 15 seconds for an exposure, then you'll produce an image with a tremendous amount of detail that you can't see in the scene with your naked eye.

How to Learn Photography

A title "How to Learn Photography" might be a little presumptuous, so I'll qualify it here by saying that the method used in this book is a way to learn photography, but it's one that, after years of teaching and writing, I have found works very well.

The study of photography covers two major domains: craft, which is the study of the mechanics of making a good image (or to put it in simpler terms: the button pushing) and artistry, which encompasses the study of recognizing and understanding what makes a good image. In this book, we're going to cover both domains.

As in any discipline, craft and art inform each other. When you have more sophisticated craft skills, your artistic eye will change, and you will begin to recognize more potential images. Similarly, as your artistic side becomes more developed, you will come to understand the relevance and importance of more areas of photographic craft.

While some people have a predisposition to both the art and craft side of photography, both domains are simply skills that can be learned by anybody. Some people resist the idea that "art" is simply a skill that can be learned, but I believe it is. Some people seem more "artistic" because they simply have an innate understanding of certain processes, which the rest of us have to learn. The most important thing to understand is that both domains require practice. Lots of practice. This is a theme that I will harp on throughout this book, and at various places I will encourage you to go out and practice particular things.

Because this book is intended for shooters of many skill levels, the next chapter is going to begin with a very basic study of craft. If you're already beyond this level, give it a quick skim and feel free to move on. The goal in the next couple of chapters is to get the basic skills down that will be required for more advanced work in the rest of the book.

2

GETTING TO KNOW YOUR CAMERA

Using Auto Mode for Snapshot Shooting

Twenty or so years ago, if you had gone camera shopping, you would have been able to buy an all-manual camera for a fairly reasonable amount of money. If you wanted to add a bunch of automatic features, though, you would have expected to pay a lot more.

Things are very different today. Now, for a very reasonable amount of money, you can get an all-automatic camera with far more automation than any camera of 20 years ago. But if you want to start adding manual features, you'll have to pay a lot more.

Whether you work with an inexpensive point-and-shoot or an expensive SLR, your camera will have a fully automatic mode. In this mode it will make all of the critical decisions required to take a good photo. It will focus, select exposure settings, calculate correct color, and make many other important decisions.

Auto mode can't compose your shot for you, of course, and there's no guarantee that it will always make the best decision, creatively, but in general, auto modes on cameras today are *extremely* capable, and will almost always make very good—if not the outright best—decisions.

Because auto modes do such a good job, they provide an excellent way to practice some fundamental skills. With them, you can start shooting right away and then activate more advanced features later. In this chapter, we're going to take advantage of Auto mode, so that you can begin practicing shooting right now. Along the way, you're going to get an introduction to some fundamental photographic concepts. We'll build on these skills throughout the rest of the book.

If you're a more advanced user, there may not be anything new for you in this chapter, but give it a skim anyway. If it seems way below your skill level, don't worry, we'll soon be moving on to more advanced topics.

Camera Basics

Before we get shooting, it's important that you know some very basic things about your camera. You've probably dealt with all of these already, but just to be sure we're on the same page, let's work through some basic camera anatomy.

All cameras are different, so I can't speak to the specifics of your particular model, but if you have your camera manual in-hand, you should be able to follow along with this section and figure out the equivalent controls on your camera. You'll also learn some terms here that we'll be using throughout the rest of this book.

Point-and-Shoot or SLR

The digital camera market is divided into two major categories: point-and-shoot cameras and single lens reflex, or SLR cameras. While both types share many features, and both are capable of producing great images, they vary significantly in their capabilities and the way you use them.

Point-and-Shoots

The term *point-and-shoot* covers a huge range of sizes, body designs, and capabilities. While some people think point-and-shoot implies "lower quality" or "underfeatured," this isn't necessarily true, so don't be prejudiced by this term. These days, point-and-shoot digital cameras can have pro-quality lenses, possess extensive feature sets, and produce excellent images.

Point-and-shoot cameras come in a huge range of sizes and designs, but if you have one it probably looks something like one of the cameras shown in Figure 2.1.

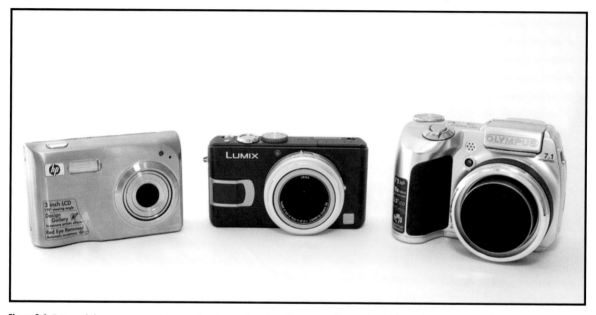

Figure 2.1 Point-and-shoot cameras run the gamut from tiny, easily pocketable cameras to larger units with longer lenses, more controls, and advanced features.

With a point-and-shoot camera, you usually use the LCD screen on the back of the camera as your viewfinder. With it, you can frame your shot and check the camera's current status. Menu settings and other control readouts are also displayed on the LCD. Some point-and-shoot cameras also include an *optical viewfinder*, which is a small window you can look through to frame your shot.

Your point-and-shoot probably also has a built-in flash, and depending on how sophisticated it is, it might have any number of additional buttons and controls. We'll discuss these in more detail later.

Point-and-shoot cameras with optical viewfinders have *two* lenses. Your viewfinder looks through one, while the other is used to focus light onto the image sensor (Figure 2.2).

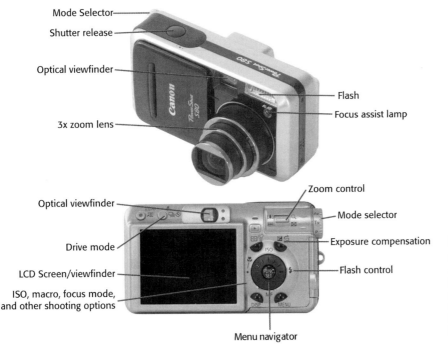

Mode Selector

Shutter release

Optical viewfinder

3x zoom lens

Flash

Focus assist lamp

Zoom control

Optical viewfinder

Mode selector

Drive mode

Exposure compensation

LCD Screen/viewfinder

Flash control

ISO, macro, focus mode,
and other shooting options

Menu navigator

Figure 2.2

On a point-and-shoot camera
with an optical viewfinder, you
look through one lens, but the
camera's image sensor looks
through a second lens. On an
SLR, you look through the same
lens that the image sensor uses.

SLR

SLR, or *single lens reflex*, means that your camera's viewfinder looks through the same lens that is used to focus light onto the image sensor inside the camera body (see Figure 2.3). You'll learn more about these differences in Chapter 3, "Camera Anatomy." The advantage of an SLR viewfinder is that it shows a much more accurate framing than the viewfinder on a typical point-and-shoot camera, and it shows the effects of any filters or lens attachments that you might have added.

Of course, on a point-and-shoot, you can use the LCD screen as a viewfinder, but the viewfinder on an SLR will always be much brighter and clearer than what you'll see on an LCD screen. There are other important viewfinder differences, which we'll discuss later.

Almost all digital SLRs use removable lenses, meaning you can change to different types of lens at any time. In addition, you can add specialty lenses such as tilt-and-shift lenses for architectural photography or telescope mounts for astronomical photography. The capability to change lenses also means that you can improve image quality by investing in better (although more expensive) lenses.

SLRs also offer other more professional features than their point-and-shoot counterparts, such as more sophisticated focus mechanisms, faster performance, the ability to shoot raw format, advanced external flash systems, body designs tailored to rugged environments, and more (see Figure 2.3).

Both camera types have their advantages and disadvantages, and I'm not trying to argue that you should use one over another. Rather, at this point you should simply identify which type of camera you have, and understand the terms that we've mentioned here.

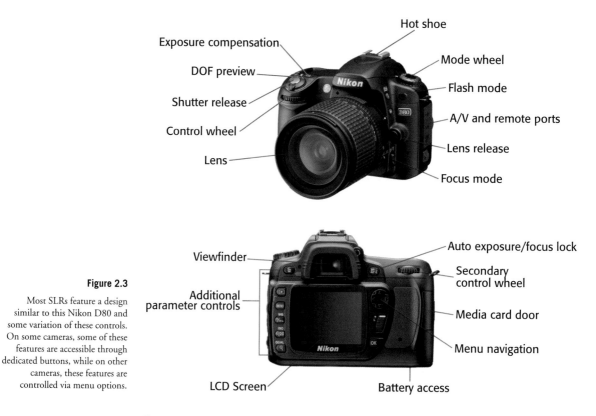

Hot shoe

Exposure compensation

DOF preview

Shutter release

Control wheel

Lens

Mode wheel

Flash mode

A/V and remote ports

Lens release

Focus mode

Viewfinder

Additional parameter controls

LCD Screen

Auto exposure/focus lock

Secondary control wheel

Media card door

Menu navigation

Battery access

Figure 2.3

Most SLRs feature a design similar to this Nikon D80 and some variation of these controls. On some cameras, some of these features are accessible through dedicated buttons, while on other cameras, these features are controlled via menu options.

Compact Interchangeable Lens Cameras

Sitting between SLRs and point-and-shoots is a new category of camera that has many of the quality and usability advantages of an SLR, but that is closer to the size of a point-and-shoot. Similar to an SLR, *compact interchangeable lens cameras (CILC)* have removable lenses and larger image sensors, as well as high-end features such as full manual controls. But CILC cameras are smaller than even the tiniest SLR, making them much easier to tote around (see Figure 2.4).

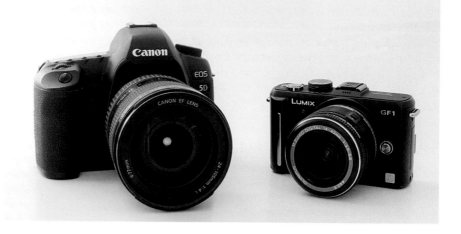

Figure 2.4

Micro Four Thirds cameras, such as the Panasonic GF-1 on the right, are just one type of a new category of camera that offers removable lenses and excellent image quality in a far smaller package than a typical SLR.

The dominant CILC cameras at the time of this writing conform to the Micro Four Thirds specification. Olympus and Panasonic both make Micro Four Thirds cameras.

Compared to a point-and-shoot, a CILC camera offers better image quality and more control. However, note that unlike an SLR, they don't offer optical viewfinders—only electronic LCD viewfinders.

You'll find extensive coverage of this new type of camera in Chapter 23, "Choosing a Digital Camera," which you can download from the companion Web site at *www.complete digitalphotography.com/CDP6*.

Battery, Media Card, Power Switch

Your camera requires a battery to operate, and you should know how to install and remove the battery, as well as how to charge it.

A media card is also required by your camera. This is a small memory chip that your camera uses to store images while you're shooting. You need to know how to insert and remove the media card.

Finally, your camera should have a power switch on it somewhere, which you use—obviously —to turn the camera on and off.

These are all covered in your camera's owner's manual, and if you have any doubt or confusion about any of these, check out your manual now.

Don't Drop That Camera!

Your camera probably also came with a shoulder or wrist strap, along with instructions on how to attach it to your camera. Take my advice and install the strap! Dropping is not good for any camera (and hitting the ground is even worse), and a strap is the easiest way to prevent a potentially damaging camera drop.

Shooting in Auto Mode

Unless it's an older, extremely simple model, your camera will have a mechanism for choosing a *shooting mode*, and will provide a selection of different mode choices. The shooting mode you choose determines which decisions the camera will make and which decisions will be left to you.

In Auto mode, the camera will make most, if not all, decisions. On all cameras, Auto mode will determine all essential exposure settings, as well as many other important parameters, such as whether the flash should fire. Some cameras will even automatically detect if you need to be in a different mode, for example, if your subject is smiling, if the camera is shaking, and more.

To shoot in Auto mode, follow these steps.

Setting Your Camera to Auto Mode

If you don't already know how to change the shooting mode on your camera, find the control now. On some cameras it will be a physical dial on the camera body. On other cameras, particularly small cameras that don't have room for a lot of physical controls, it might be an option that you configure using a menu (see Figure 2.5)

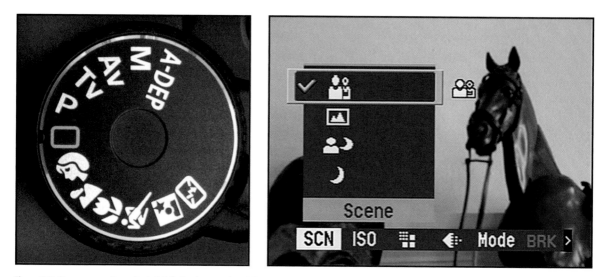

Figure 2.5 Some cameras have physical dials that let you select different shooting modes; others require a trip into the camera's menu system to change modes.

Consult your camera's manual if you can't find the mode control. Look for "shooting mode," "mode," "Auto mode," or a similar term. If you still can't find it, and you're working with an inexpensive point-and-shoot camera, then your camera may not have a shooting mode control. Rather, it might simply be in Auto mode all the time. Most automatic modes are named some variation of *Auto*.

Canon Auto Mode

Most Canon SLRs use an icon of a green box to indicate Auto mode.

Figure 2.6

If you're using an SLR, your lens should have a switch on it somewhere that lets you change the lens from autofocus to manual focus. Make sure that it's set to autofocus, which is usually designated "A" or "AF."

If you're working with an SLR, then you'll need to check one more setting. SLR lenses can be set to either auto or manual focus, usually using a switch on the lens. If your lens has such a switch, make sure it's set to autofocus, which is usually designated AF (see Figure 2.6).

Framing Your Shot

You probably already know this step: look through the viewfinder and frame your shot. If your camera has a zoom lens, then you can zoom to frame tighter or wider. Don't worry too much right now about composition, as we'll discuss composition in detail in Chapter 9, "Finding and Composing a Photo."

Focal Length

If you wear glasses, then you already know that as your eyes get worse, you have to get thicker glasses, simply because a thicker lens provides more magnification. Camera lenses work the same way. The longer the lens, the more magnification it provides.

With camera lenses, the length of the lens is measured in millimeters, and is referred to as the *focal length* of the lens. A longer focal length means a more telephoto lens, which means more magnification and less field of view. So a 200mm lens provides a greater telephoto capacity than a 50mm lens (see Figure 2.7).

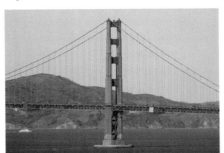

Figure 2.7

These three images were shot from the same location. The only thing that changed was the focal length of the lens. First, at 300mm, then at 75mm, then at 24mm. As you can see, as focal length increases, so does magnification.

Magnification also affects the field of view of a lens. A lens with more magnification yields an image with a narrower field of view. You can see this in Figure 2.7. At 300mm, we see a fairly narrow field of view, encompassing just one tower of the bridge. At the much shorter 24mm focal length, we see a tremendously wide field of view, which encompasses the entire bridge and much of the surrounding countryside and water.

How to Press the Shutter Button

After you frame your shot, you're ready to take the picture. Pressing the shutter button may seem very simple, but there are certain things to understand about it, because proper use of the shutter button is how you control your camera's autofocus and metering features.

With your shot framed, press the shutter button down *halfway*. You should feel a halfway point, where the shutter button kind of stops. When you do this, the camera's autofocus mechanism will analyze your scene to try to determine what the subject is. It will then lock focus on that subject.

Once it locks focus, a few things may happen, depending on your camera. Autofocus systems typically have different points in the frame that they can focus on, and many viewfinders show you the actual points. Once the camera has picked a point, a lot of cameras will highlight the chosen focus point. In an SLR, you'll see this in the viewfinder, while with a point-and-shoot

camera, you'll usually only see this in the LCD viewfinder (as opposed to the optical viewfinder, if your camera has one).

Some cameras only have one focus point, usually in the center of the frame. But these days, most cameras have multiple focus points. This allows the autofocus system to accommodate more complex compositions, such as a person standing to the side of the frame.

Your scene might include several potential subjects that are all positioned at the same distance. If this is the case, then the camera will light up all of the focus points that cover where the camera will focus. As long as one of these points is on the subject you want, then your camera has focused correctly (see Figure 2.8).

Figure 2.8

When you half-press the shutter button to autofocus, your camera will let you know when it has locked focus. Here, focus points are lighting up in the viewfinder to indicate where the camera has decided to focus.

After the camera has focused, it will probably also beep, and will possibly show a "go" indicator of some kind, which is usually a green light in the viewfinder or on the LCD display. At this point, you can press the shutter button the rest of the way to take the shot.

It is *crucial* that you use this "half-press, wait, full-press" process when using an autofocus camera. If you wait until the precise moment when you want to take the shot, and then mash the button down all the way, you'll most likely miss the moment you were hoping to capture, because the camera will have to focus, meter, and perform a bunch of other calculations before it can fire. All of these processes take time, so it's essential that you engage in the pre-focus step of pushing the shutter button down halfway to give the camera time to take its measurements.

Easy Does It with the Shutter Button

When the camera has indicated that it has locked focus, and you're ready to press the shutter button all the way, gently squeeze the button. If you jab at it, you might jar the camera and end up shaking it enough to soften the image.

After you take the shot, your camera will display the resulting image on its LCD screen, allowing you to review it. Many cameras also give you the option of deleting the image during this review, by simply pressing the delete button. Once you're done, you can start the whole process over.

As mentioned earlier, in Auto mode your camera will most likely automatically decide when to fire the flash. If you don't want the flash to fire, you're out of luck. Don't worry, though, in later sections we'll learn how to deactivate it.

In a low-light situation, you might see some strange flashes coming from built-in flash or even a bright light being shined into your scene from a lamp on the front of the camera. Because autofocus mechanisms can be stumped in low light, many cameras employ their built-in flash or a built-in "focus-assist light" to brighten up the scene so that the autofocus mechanism can work.

If, after you half-press the shutter button, your camera *doesn't* beep or indicate that focus has been locked, then it might be that the scene is too dark for the camera to achieve focus, or it might be that it is confused by the composition. Release the shutter button, try a slight reframing, and then half-press again.

Reset Your Camera

If you don't hear a beep when the camera autofocuses, or if you don't see an image review after you take a shot, there's a chance that these features on your camera have been disabled or altered. Consult your manual for how to re-enable them. Your camera might also have a reset feature, which will restore all settings to their factory defaults. After a reset, you can slowly customize the camera as you learn about different features.

Adjusting the Focus of the Viewfinder

If you have an SLR, or a point-and-shoot camera with an optical viewfinder, and you find that the image still looks fuzzy after the camera has locked focus, then there's a chance that the *diopter* control on your viewfinder needs adjustment. The diopter is usually a small knob next to the viewfinder (see Figure 2.9). As you turn it, you should see the image get sharper or softer. If you wear glasses, you can remove your glasses and adjust the diopter to compensate, providing you with a way of shooting, glasses-free. Note that if your eyes are bad enough, the diopter may not be able to compensate.

Figure 2.9

A diopter wheel lets you adjust your optical viewfinder to compensate for your own vision.

Practice Shots

What we've covered here are the basics of shooting: compose, half-press the shutter to focus, and then squeeze to shoot. This is the process that you'll use no matter what shooting mode you're working in.

Spend some time shooting in Auto mode to get a feel for the shutter and basic camera controls.

Shutter Speed and Status

Exposure is a topic we'll be covering and discussing in great detail throughout this book. At the simplest level, exposure is simply a measure of how much light the image sensor in your camera is exposed to during the shot. If there's too much light, then your image will be too bright, and many details will be washed out to complete white. If there's not enough light, then your image will be too dark, and many details will be lost in dark shadows (see Figure 2.10). Your camera provides three different mechanisms for controlling exposure: shutter speed, aperture, and ISO. In addition to controlling how bright or dark your image is, these mechanisms also provide you with some creative options. Throughout the rest of this book, you'll learn the details of these mechanisms and creative options, but for right now, your goal is to develop an important habit.

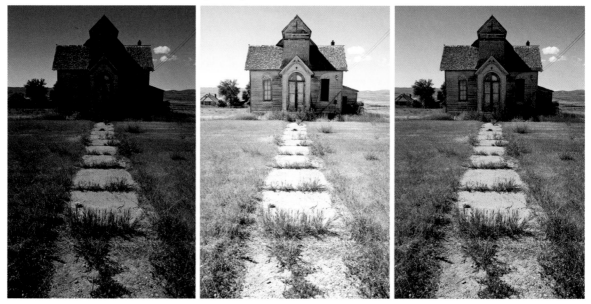

Figure 2.10 The first image is underexposed. It's too dark, and details in the shadow areas have gone to black. The second image has the opposite problem. It's overexposed, and it is so bright that the highlight areas have gone to white. The third image has a good, overall brightness level—both the shadows and highlights are preserved.

The shutter in your camera is a little curtain that sits in front of the image sensor. It opens and closes very quickly to control how much light passes through to the sensor. *Shutter speed* is a measure of how many seconds the shutter stays open. When the shutter is open longer, moving objects in your image will get blurrier. In addition, with a longer shutter speed, any motion of the camera will result in a soft or outright blurry image. In other words, if your hands are a little shaky, your image could end up soft if your shutter speed is slow (see Figure 2.11).

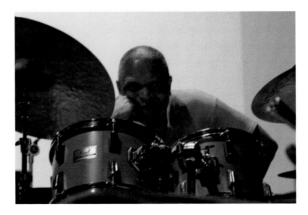

Figure 2.11

This image is a little soft because this venue was dark enough that the camera selected a slower shutter speed. The shutter speed was slow enough that the natural shakiness of my hands blurred the image.

Typically, a scene in bright sunlight, shot with a fairly typical lens, will require a shutter speed around 1/60th of a second. Shutter speeds can range tremendously, from 1/8000th of a second to whole minutes or even hours.

Reading Shutter Speed

As you learned in the last section, when you half-press the shutter button, your camera uses its autofocus mechanism to choose and focus on a subject in your scene. It also selects exposure settings—shutter speed, aperture, and ISO. When it beeps to indicate focus lock, it will also probably display its chosen shutter speed and aperture, either in the viewfinder or on the camera's LCD screen.

Shutter Speed Display

Some older, very simple point-and-shoots won't display shutter speed and aperture. These days, though, most cameras do.

Some cameras have two LCD screens, the large screen used for image playback and composition, and a smaller screen that is dedicated to showing camera status. SLRs typically show chosen exposure settings both in the viewfinder and on one of these LCD screens. Point-and-shoot cameras normally only show exposure settings on the LCD viewfinder screen.

Shutter speed and aperture are usually listed side-by-side with shutter speed appearing first. Because shutter speeds are almost always fractional—1/100th of a second, for example—some shutter speed displays only show the denominator of the fraction. So, if your camera has chosen a shutter speed of 1/100th of a second, your camera might show a shutter speed readout of 100 (see Figure 2.12).

Find the shutter speed display on your camera:

1. Point the camera at a window or bright light and press the shutter button halfway down to lock focus and calculate an exposure. The camera should display its chosen shutter speed and aperture on one of its displays.

2. Now release the shutter and point the camera at a darker subject—a shadow under a table, for example. Then press the shutter button halfway down. You should now see a slower shutter speed. Because the darker scene requires more light, the camera has chosen a longer shutter speed. Remember, a longer shutter speed allows more light.

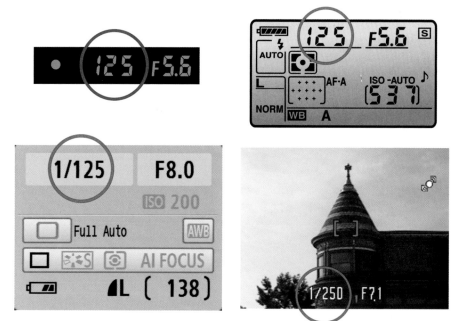

Figure 2.12

Your camera might display exposure information in one or more different ways. Clockwise from upper left, you can see the readout in a typical SLR viewfinder, the readout on a dedicated status screen, the readout from the status presented on a rear LCD screen, and the status shown on a typical point-and-shoot LCD viewfinder. Note that sometimes shutter speed is shown as a denominator only.

The habit that you need to develop right now is to always pay attention to that shutter speed number when you're shooting, because if the number goes too low, there's a chance your image will be soft or blurry.

So every time you half-press the shutter button, take note of the shutter speed that the camera has chosen. In Chapter 7, "Program Mode," we'll learn how to calculate the lowest shutter speed that you can use in a given situation. For now, just assume that if the shutter speed drops below 1/60th of a second, there's a chance that your image will be soft due to camera shake.

I've often had beginning students say "This picture is out of focus, why isn't my camera working?" when in fact the image was properly focused, but the shutter speed was slow enough that handheld shaking rendered the image soft. There are things you can do when shutter speed goes too slow for sharp shooting. For now, your goal is to get in the habit of always knowing what shutter speed you're shooting at.

Check Once in Non-Changing Light

In general, if the light in your scene stays the same, your shutter speed probably won't change from shot to shot. So, if you're trying to shoot quickly in a situation where the light's not changing—a sporting event, for example—then you probably only need to check shutter speed when you start shooting. After you've determined it's acceptable, you can simply keep shooting with only an occasional check-in.

When Shutter Speed Can't Go Low Enough

If the light is such that your camera can't get a shutter speed that it thinks is fast enough to ensure a good hand-held shot, then it might flash some kind of "shaky camera" indicator in the viewfinder (see Figure 2.13). Or it might flash the shutter speed or aperture readout to indicate that the current image will be over- or underexposed.

Figure 2.13

On some cameras, when the camera is forced to a shutter speed that's not fast enough for stable handheld shooting, a shake warning of some kind will appear on the LCD screen.

Playing Back Your Images

As you've already seen, your camera gives you a brief review after you shoot an image. Your camera might even provide settings that allow you to shorten or extend this review time. But when you're ready for a serious review of your images, you'll want to use your camera's playback function.

Your camera should have a play control that switches into Playback mode, for reviewing your images. On some cameras, Playback is a mode, just like Auto mode, and is selected using the same mode control that you use to select Auto mode.

Once you're in Playback mode, you should be able to navigate through your images. You might also be able to zoom into your images and pan about them or zoom out to view multiple images as thumbnails (see Figure 2.14). Finally, you should also be able to delete images that you don't want. Some cameras also let you lock images to prevent accidental deleting. Consult your camera manual to learn more about these features.

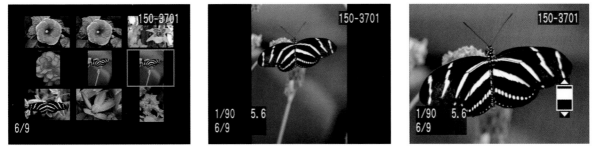

Figure 2.14 The Playback modes on many cameras let you zoom out to see thumbnail views of all of the images on a card or zoom in and pan to see a close-up view of an individual image.

Your camera might also display data about the images you've shot (Figure 2.15). In addition to the image number, your camera might display other parameters about the image, such as the image quality setting and the shutter speed and aperture. If you see that an image looks kind of soft, you can check the shutter speed to see if that might have been the problem.

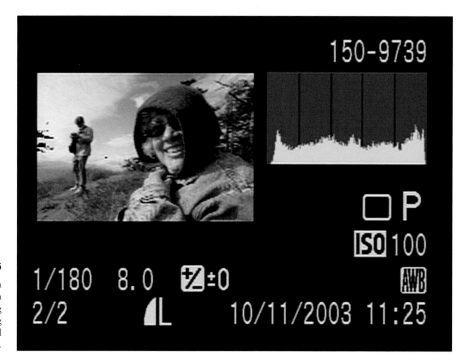

Leaving Playback Mode

On many cameras, you can leave Playback mode and return to shooting mode simply by giving the shutter button a half-press. This means that you can switch back to shooting quickly after reviewing shots. If your camera requires you to change a mode dial or other control to return to shooting, it will be harder to switch quickly between playback and shooting. This is something to consider when shopping for a camera.

Using Scene Modes

As you've probably already determined, Auto mode can do a very good job of making critical decisions for you. In fact, for 80–90% of the images you take, Auto mode will probably be all that you need.

However, Auto mode knows nothing about the subject matter in your scene. Consequently, it's incapable of making any kind of creative decisions or even of knowing when it might need to bias its decision-making to be able to capture, say, a fast-moving object.

Many cameras, therefore, have additional Auto modes called *Scene modes.* These special shooting modes automatically bias certain decisions to be more appropriate to specific types of subject matter.

For example, a Sports mode will err on the side of faster shutter speeds, to better freeze fast-moving action.

Scene modes are typically accessed using the same control that you used to select Auto (see Figure 2.16). Different cameras provide different assortments of Scene modes, but most cameras typically have at least these modes:

■ **Portrait mode.** Very often, when shooting a portrait, you want to blur out the background, to bring more attention to the foreground. In Portrait mode, the camera will choose exposure settings that will help soften the background (refer to Figure 2.17).

■ **Landscape mode.** This is typically the opposite of portrait. When shooting a landscape, you want to ensure that everything in the scene is in focus. This mode will choose settings that will ensure that objects both near and far are in focus.

■ **Close-up mode.** This mode is used for shooting small objects, flowers, or close-ups of products. Close-up mode selects specific focusing modes and exposure options.

■ **Sand and Snow mode.** If you're shooting a scene that includes lots of white, such as a beach or snow-covered field, then this mode can help ensure that the whites in the scene actually appear white.

■ **Sports mode.** As mentioned earlier, Sports mode will bias toward fast, motion-stopping shutter speeds. On some cameras, Sports mode will also engage a *servo autofocus*, which can track a moving subject to ensure that it's always in focus, and Burst mode so that you can simply hold down the button to shoot multiple shots.

■ **Night Portrait mode.** The flash on your camera has a limited range—and on a small camera, a *very* limited range. If you're shooting in very low light with your flash, the flash will *only* illuminate subjects within its range. Everything else in the frame will be dark. Night Portrait mode causes the camera to fire the flash but also use a slow shutter speed to expose elements properly that are outside of the flash range (see Figures 2.18 and 2.19).

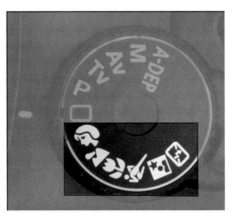

Figure 2.16

If your camera has a mode dial, then it might have options for Scene modes, which bias the camera's decisions so that it calculates more appropriate exposures for specific shooting situations.

Figure 2.17

In the upper image, everything in the scene is in focus. In the lower image, the camera was switched to Portrait mode, which chose exposure settings that caused the background to blur out. The result is a subject who commands more attention.

Figure 2.18

If you take a flash picture at night, you'll usually end up with a well-exposed subject on a background that is completely black. On most cameras, the range of the flash is only around 10 feet. Objects beyond that distance will not be illuminated by the flash.

Figure 2.19

Night Portrait mode combines the flash with a longer shutter speed so that both your subject and background are well exposed.

Tell Your Night Portrait Subjects to Hold Still!

Because Night Portrait modes use a slow shutter speed, it's important to tell your subjects to stay still after the flash has fired. Ask them not to move until you say it's okay.

Learn This Feature!

If your camera has a Night Portrait mode (or an equivalent), you'll probably find it to be one of the most useful features on your camera. If your camera doesn't have a specific Night Portrait mode, don't worry, because you can probably achieve the same result through manual control.

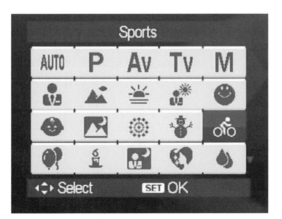

Figure 2.20

Many point-and-shoot cameras are loaded with Scene modes, tailored to very specific situations. On smaller cameras, this is often the only manual control that you have. Note that some cameras lump Scene modes and shooting modes together, as in this case, where program and priority modes are alongside specialized Scene modes.

Your camera might have all, some, or none of these Scene modes, or additional modes not mentioned here. Since most smaller point-and-shoot cameras lack manual features, they often come with a *huge* assortment of Scene modes, usually accessed from a menu of some kind (see Figure 2.20). These modes will cover everything from low light to different lighting types, and on and on. Consult your camera manual for details on how to access Scene modes and what they do.

Not All Features Will Be Available

When you shoot in Auto mode or a Scene mode, some features of your camera will be locked out. For example, in Auto mode, you probably won't be allowed to change white balance or ISO. If you find a feature you can't use, this means that you'll need to change to a different mode. For now, though, stick with Auto and Scene modes. We'll cover all of the other modes and controls as we work forward.

Snapshot Tips

One of the best things about Auto mode is that since it takes care of the technical burden of shooting, you can focus on handling the camera and composing shots. Here are some quick tips for improving your shots.

Pay Attention to Headroom—Fill the Frame

When shooting a portrait or a candid snapshot of someone, you usually don't need a lot of headroom, unless you want to show something specific above your subject's head.

For example, in this image, the extra headroom doesn't add anything to the picture. In fact, it's kind of distracting, and takes up space that could be used to show a larger image of the person (see Figure 2.21).

A better approach is to fill the frame with more of the person. We can see a better view of them, but still have enough background to get an idea of their environment. Most importantly, we have no trouble identifying the subject of the image. By getting in tighter, we're focusing the viewer's attention.

"Fill the frame" is one of the most important compositional rules you can learn. Don't waste space in the frame. Empty space in your image is space that could be used to get a better view of your subject.

Figure 2.21

Don't waste space in the frame! Try to put only the things that matter in your shot. This image works much better without all that extra, empty headroom.

Watch Out for Backlighting

This tip is loosely related to the previous tip. Be careful about shooting your subject in front of a brightly lit background, such as a window or shooting into the sun. While there are times when you can use such an approach to great effect for simple snapshots, you'll get better results by keeping a close eye on the backlight in your shots.

If you find yourself shooting someone in front of a window or bright light, try to move them or yourself so that the light is not directly behind them, or try using your camera's fill flash (see Figure 2.26).

Figure 2.26

This image has a problem with backlighting, which can be corrected with the use of a flash.

The problem with bright lights in the background of a shot is that they confuse the camera's light meter. When there's a bright light in the background, the camera meters to expose that bright light properly, which usually means that the foreground is left underexposed and appears too dark.

In Auto mode, your camera might recognize such a situation and fire the flash automatically. The flash will serve to light up the foreground, creating a more even exposure with the background.

Later, you'll learn more about metering, as well as other strategies for handling backlighting. For now, even if you aren't sure exactly how to handle such a situation, at least start learning to recognize when you're shooting in this type of difficult lighting condition.

Watch Those Joints

Whether shooting events, performances, candid street shots, or any other type of shot that includes people, be careful about how you crop joints. Don't let the edge of the frame crop a person at an elbow, knee, wrist, neck, or any other joint. It's better to crop someone in between the joints of a limb, rather than hack them off right at the joint.

Understand Flash Range

Remember that the flash on your camera has a limited range. Anything beyond the range of the flash will not be illuminated at all. So, if you're standing at night across the street from a person or building and you shoot a picture with the flash popped up, you'll probably get a shot that's completely black.

For that situation, flash is not the answer. Instead, you'll need to employ some low-light shooting strategies, which we'll discuss in Chapter 12, "Special Shooting."

Coverage

Many people think that an expert photographer sees a scene or subject, thinks about how to best frame and expose it, and then takes a picture of it. Describe this to any "experts" or "professional" photographers, and they'll probably laugh at you.

The fact is, even the most accomplished photographer rarely shoots only one exposure of a subject. Instead, photographers *work* their subject—something we'll be discussing a lot in this book.

Very often, the only way to find the best composition of a scene is to move around. Get closer and farther, stand on your tiptoes, squat down low, and circle the scene. Look through the viewfinder the whole time and shoot the whole time.

It's okay to review your shots and try again during this process. Photography is like sculpture: you can't always visualize the finished shot right away. Instead, you have to "sculpt" the scene and try different vantage points until you find an angle that makes the most interesting composition and that has the nicest play of shadow, light, and color.

It is very rare that, when a subject catches your eye, you just happen to be standing in the very best spot in the world (and that you also happen to be exactly the right height) to shoot the image.

So, as you continue your practice, be sure to shoot broad coverage of your scene. Stay moving, play with distance and angle, and notice the differences that you see in the viewfinder and what catches your eye as you move around.

You may be surprised to find that the final images that you like best are very different from what you originally envisioned.

CAMERA ANATOMY

Holding and Controlling Your Camera

Photography is a physical act. In addition to the physical act of seeing, you have to manipulate your camera to get the framing and settings that you want. If you're in a rapidly changing situation, or if you've spotted a scene that's soon going to change, then you have to be able to make changes to your camera's settings very quickly. For these reasons, it's essential that you have a thorough familiarity and understanding of your cameras controls.

So just as artisans need to know how to coax the behavior they want from their tools, you need to understand what the different settings on your camera do and why you might want to configure them in a particular way. Just as importantly, you need to be able to make these adjustments quickly and efficiently without breaking the "flow" of your shooting.

In this chapter, we're going to build on what you learned in Chapter 2 and explore the handling of your camera a little deeper. Along the way, you'll learn a little more about its inner workings.

Point-and-Shoots and SLRs Revisited

In the last chapter, you learned some of the very high-level differences between a point-and-shoot camera and an SLR. However, for a more useful understanding of the strengths and weaknesses of both types of cameras, we need to go a little deeper into the fundamental characteristics of both types of cameras.

A Very Fancy Box

When you strip it down to its most basic construction, a digital camera is no different than a film camera from 150 years ago, because all cameras have certain things in common. Whether it's a digital or film camera, has fully automatic controls or is completely manual, all camera designs start with a lightproof box. On one side of this box sits a lens for focusing light, and on the opposite side of the box sits the *focal plane*—the area that the lens focuses onto. The focal plane holds a light-sensitive recording medium of some kind. In a film camera, this would be a piece of film of any type. In an 18th-century camera obscura, this might have been a big piece of paper—the "photographer" would trace over the projected image to create a drawing or painting. In a digital camera, the focal plane houses a digital image sensor. Everything else on a camera is simply there to add convenience to the photographer. Film cameras, for example, add the capability to hold rolls of film and have a mechanism to advance the film roll to a new, unexposed area of film. This saves the photographer the trouble of hassling with changing the film every time he wants to take an image. Light meters, autofocus systems, and LCD screens—all of these serve to make things easier for the photographer. As far as actual image capture goes, though, all you really need is a lightproof box, a recording medium, and a lens.

One Camera, Hold the Lens

Actually, you don't necessarily even need a lens. A pinhole camera simply uses a pinhole in the camera body in place of the lens. Thanks to the physics of light, this pinhole projects an inverted image onto the focal plane.

What an Image Sensor Does

An image sensor is a special type of light-sensitive silicon chip. Currently, there are two major types of image sensors available: the *charge-coupled device (CCD)* and the *Complementary Metal Oxide Semiconductor (CMOS)*. When you take a picture, the light falling on the image sensor is sampled and converted into electrical signals. (For those of you who keep track of such things, the *sampling rate* of a sensor is basically the number of pixels on the sensor.) After the image sensor is exposed, these signals are boosted by an amplifier and sent to an analog-to-digital converter that turns the signals into digits. These digits are then sent to an onboard computer for processing. Once the computer has calculated the final image, the new image data is stored on a memory card (see Figure 3.1).

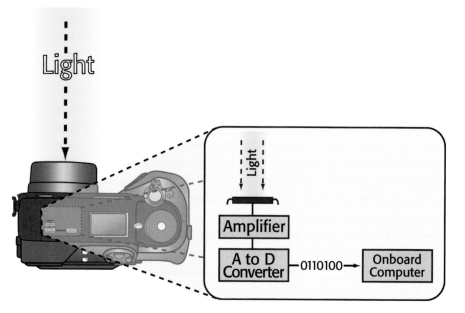

Figure 3.1

Light passes into a digital camera, just as it would in a film camera. However, instead of hitting a piece of film, it is digitized by a computer chip and passed to an onboard computer to create an image.

Later, we'll look at exactly what the onboard computer does with the image data that it gets off the sensor.

Figure 3.2

Most image sensors are very small, particularly when compared to the size of 35mm film.

Point-and-Shoot Design

From a camera design perspective, one of the great advantages that digital cameras have over film cameras is that digital image sensors can be made extremely small. Whereas a piece of 35mm film is 36mm wide, the image sensor in a typical point-and-shoot camera is only 5mm wide (see Figure 3.2). Thanks to this small sensor size and the fact that a digital camera doesn't need a mechanism for holding and moving film, digital cameras can be made extremely small.

No matter what their size and shape, a digital point-and-shoot camera is still built around a lightproof box with a digital image sensor on one side and a lens on the other.

As light falls on the image sensor, the camera turns it into an image and passes that image onto the LCD screen, which is why you can use the LCD screen as a viewfinder. Because it's a purely digital process to get the image to the screen—rather than having to bounce light around inside the camera body—point-and-shoot cameras can have fairly radical designs.

A point-and-shoot camera with an optical viewfinder uses an entirely separate lens for the viewfinder. So the main camera lens is used to expose the sensor, while the optical viewfinder looks through a second lens (see Figure 3.3).

One downside to this scheme is that, because you're not looking through the same lens that the image sensor is looking through, you're not necessarily seeing the exact image that will be recorded. If you're using lens filters or extensions—such as a telephoto or wide-angle extension—you won't be able to see the effects of these lens add-ons through your viewfinder.

Also, note that the optical view-finders on most point-and-shoot cameras typically only show you around 80–85 percent of what will be in your final image. By contrast, the LCD screen shows you 98–100 percent of your composition. What's more, the crop in the optical viewfinder might not be uniform. In other words, it won't necessarily crop out of the center of the frame (see Figure 3.4).

Small size is obviously a great advantage to a point-and-shoot camera. After all, it doesn't matter how good your camera is if it's so big that you never carry it with you. A small point-and-shoot can be stuck in a pocket easily anytime you head out the door, and many point-and-shoots these days yield excellent image quality and pack great lenses and features.

Figure 3.3

In most point-and-shoot cameras, the light passing through the camera's lens falls onto the focal plane. The viewfinder uses a completely different light path, meaning that what you're seeing in your viewfinder is not exactly what's landing on the image sensor.

85% Coverage
(Typical optical viewfinder)

95% Coverage
(Typical LCD viewfinder)

Figure 3.4

The LCD viewfinders on most digital cameras offer an almost complete view of the image that will be captured. The optical viewfinders on most point-and-shoot cameras offer much less coverage.

Buying a Camera

If you've been looking to buy a new camera, (either because you're new to photography, or because you're upgrading from an older camera), then the information in this chapter and the last should help. For an in-depth guide to buying a digital camera, check out Chapter 23, "Buying a Camera," available for download at *www.completedigitalphotography.com/CDP6*.

Camera Parts

Whether you're rushing to get a shot in a rapidly changing situation or concentrating hard on composition and light, you don't want to be struggling with unfamiliar camera controls. Spending some time at home learning exactly what each button and dial does and where to access specific controls will help you shoot quickly and efficiently in the field.

Throughout the shooting chapters of this book, I'll be referring to specific controls that you might need to activate or modify to get particular results. Since this book can't address the interface specifics of every camera in the world, this section will teach you some broad concepts and help you find out for yourself how your camera's interface is set up. As you read the following sections, identify each of the parts and controls on your camera. It's a good idea to have your camera's manual with you through this section, and it doesn't matter if your camera is an SLR or point-and-shoot.

The Lens

It may sound a little patronizing to ask you to identify the lens on your camera, but bear with me for a moment, as there are some less obvious things that you might not know. On most cameras, the lens is fairly conspicuous—it's the big round thing that sticks off the front of the camera body.

On small point-and-shoot cameras, the lens may retract into the camera body and not be visible until you activate the camera. If your camera has such an automatic mechanism, then it might have a built-in lens covering that opens and closes as the lens extends (see Figure 3.7).

It's important to understand that these automatic lens coverings can be somewhat fragile. If they get jabbed with something, such as a ball point pen that's floating loose in your camera bag, they can be damaged in a way that will prevent them from opening or closing, and possibly in a way that will even keep the lens from extending and retracting. If this happens, then you'll have to send the camera to a service center for repairs.

You need to be careful with all lenses, but be especially cautious with mechanized, extensible lenses, as they can be fragile.

Some advanced point-and-shoot cameras allow you to attach optional lens accessories, such as filter holders, or wide-angle and telephoto add-ons. Consult your manual for details.

Figure 3.7

This camera has a lens that automatically retracts into the camera body when the camera is powered down. It also has a lens cap that automatically opens and closes when the lens extends and retracts.

Hidden Lenses

If your camera doesn't have any kind of visible lens—just an opening on the front of the camera—but it still offers a zoom feature, then most likely the lens is mounted vertically inside the camera body (see Figure 3.8). A prism or mirror is used to bounce the light that enters the lens opening down into the vertically positioned lens.

Figure 3.8

If your camera looks something like this, with no visible lens on the outside of the camera, then most likely the lens is positioned vertically within the camera body.

Stabilization

Many lenses include image stabilization hardware. These mechanisms track the jitter you produce with your hands and automatically alter certain optical properties of the lens to counteract the effects of that jitter. Therefore, if you jitter to the left, the lens alters itself to bend the light passing through the lens back to the right to counteract the jitter. Image stabilization is not meant to be a substitute for a tripod. Instead, it provides enough stability to make it easier to frame a shot when using an extreme telephoto lens, and can allow you to shoot in much lower light, with slower shutter speeds, without worrying about hand shake.

If your camera has this feature, it might provide a switch on the lens for turning it on and off. (Later, we'll discuss why you might want to turn it off.) Some point-and-shoot cameras also have a stabilization feature and offer a menu control for activating and deactivating stabilization.

Note that a stabilization feature on a lens will drain your battery faster. Stabilization doesn't kick in until you half-press the shutter button, so if your battery is running low, you'll want to minimize the time you spend with the shutter button held down or turn off stabilization altogether.

Some higher-end lenses include two modes of stabilization. One stabilizes the lens as described here, while the second mode stabilizes only the vertical axis, enabling you to pan the camera smoothly. If you're panning with the idea of blurring out the background of a moving subject, such as a racecar, single-axis stabilization can be very handy.

With some older stabilization systems, it is recommended that you deactivate the stabilizer when your camera is mounted on a tripod, as the system can be confused when you pan or tilt. Most new systems don't have this trouble, but if you're tripod-mounted, you might want to deactivate stabilization simply to save battery power. If you're shooting extremely close (macro shooting), then stabilization offers no advantage, so you might as well turn it off to save power.

Some curious stabilization trivia: when you half-press the shutter button to focus, you'll probably hear the stabilization system kick in, and you should see its effects in the viewfinder. However, what you're seeing is possibly not the full stabilization effect that your camera can muster. That doesn't kick in until you press the shutter completely, the reason being that your camera maker doesn't want you to get motion sick.

Motion sickness occurs when the information that your eyes send to your brain conflicts with the information that your inner ear sends to your brain. So, if your ear is saying that you're moving, but your eyes are saying "no, everything's perfectly stable," then you can end up motion sick. Apparently, with early stabilization systems, people were getting queasy when looking through a stabilized viewfinder for a length of time.

Newer stabilization systems should be free of any nausea-inducing traits.

Stabilized Sensors

While some vendors, such as Canon and Nikon, make lenses that have built-in stabilizing mechanisms, a few vendors, such as Sony and Pentax, have opted to stabilize the image sensor itself. In these cameras, the sensor sits on a movable plate that can be shifted from side-to-side and up and down to compensate for any jitter introduced by your hand.

The advantage of a stabilized sensor is that it will work with any lens you attach to the camera. The disadvantage is that stabilization mechanisms usually need to be tweaked to work optimally with a particular lens. Consequently, you'll typically find that sensor stabilization methods don't yield as much of a stabilizing effect as stabilized lenses. In addition, with a stabilized sensor, the stabilization occurs *after* you've looked at the image, which means that a stabilized sensor offers no advantage when trying to shoot with a very long telephoto lens. A stabilized lens, on the other hand, provides a steady view while framing, which can make telephoto shooting much easier.

Digital Zoom

Most point-and-shoot cameras also include a digital zoom feature. Before we get into how a digital zoom works, you'll want to follow this simple procedure.

Step 1: Turn off the digital zoom feature.

Step 2: Don't ever turn it on again.

That's it! You're done and can now go on to the next section.

However, if you're curious about the digital zoom feature on your camera (which you're never going to use, right?), here's how it works.

Obviously, the camera cannot digitally increase its focal length, so a digital zoom feature works by cropping the image and then scaling that cropped area up to the full size of the frame. The problem with most digital zooms is that they use bad interpolation algorithms when they scale up, so they tend to produce jagged, blocky images. Consequently, rather than using a digital zoom, it's much better to shoot the image with your camera's maximum optical zoom and then crop and enlarge it yourself using an image editor. Most image editors provide more sophisticated interpolation options, and since most cameras today pack huge pixel counts, you can do a lot of cropping and enlarging.

There are four occasions when a digital zoom can prove useful:

- If you don't have any image editing software that is capable of cropping and upsampling.

- If you don't want to magnify the JPEG artifacts in your image. Because the camera enlarges your image *before* compressing, digital zooms don't worsen any JPEG artifacts. Enlarging the image in an image editor will do so.

- If you're shooting at one of the camera's lower resolutions, digital zoom may not degrade your image. Most of the time, when you shoot at a lower resolution, the camera simply shoots at full resolution and then downsamples. Because there's more resolution to start with, using a digital zoom on a lower-resolution image often produces fine results.

- If you absolutely need a close-up of something that is beyond the range of your camera's optical zoom, and you don't care about image quality.

If you must use a digital zoom feature, you ideally want to have one that offers good interpolation and provides a continuous range of zooming rather than fixed zoom ratios.

When digital zoom is active, the zoom indicator on the camera's LCD screen will be divided into separate optical and digital parts, and the camera might even pause before going into digital zoom, so you don't have to worry about accidentally using digital zoom. Still, it's best to just turn it off and forget about it.

SLR Lenses

If you're using an SLR, then your lens is most likely removable, usually by pressing and holding a lens release button while you twist the lens. Changing lenses in the field can require a bit of coordination as you try to hold two lenses and your camera, but a neck strap can make this much easier, because you don't have to worry about the camera falling.

Your SLR lens probably also has a focus ring, which allows you to focus the lens manually by simply turning the ring. Some cameras require you to put the lens into manual focus mode by flipping a manual focus switch. Others offer a manual focus override that automatically activates when you turn the focus ring.

These days, most digital SLRs come with some kind of starter lens as part of a kit. These "kit" lenses are often very capable, decent lenses that offer a good zoom range. But as your photography skills improve, you might find that you want something more. One of the great advantages of an SLR is that you can choose lenses tailored to the type of shooting you like to do and to the image quality level you want. For example, if you mostly shoot sports or wildlife, you might want to get longer, more telephoto lenses, while landscape shooters might

invest in lenses on the other end of the spectrum. If you plan on printing your images very large, then you might need lenses that yield excellent sharpness, because large printing often reveals image flaws caused by weak optics.

Lenses fall into two categories: zoom lenses, which allow you to vary focal length, to go from wide angle to telephoto, and prime lenses, which have a fixed focal length.

Prime lenses are sometimes sharper than the same focal length in a zoom lens, but zoom lenses let you carry the equivalent of a huge number of prime lenses.

Focal Length Multipliers—35mm Equivalency

All lenses project a circular image onto the focal plane. The film or image sensor that's sitting on the focal plane records a rectangular crop from the middle of that circle. Obviously, a larger sensor records a larger crop (see Figure 3.9).

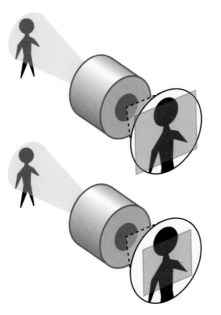

Figure 3.9

Your lens projects a circular image, but your camera's image sensor crops a rectangular portion out of that image. The amount that is cropped depends on the size of the sensor. This is why different sensor sizes yield different fields of view for any given focal length.

Because of this, the same lens placed on a camera with a different sensor size will yield a different field of view.

The 35mm frame size has been the standard for so long that experienced photographers tend to think in terms of 35mm when they consider a particular focal length. On a 35mm film camera, a 50mm lens is considered a "normal" lens (that is, one with a field of view that's roughly equivalent to what the naked eye sees), while a 200mm is considered telephoto and 28mm is considered wide angle. When you attach those same lenses to cameras with smaller sensors, they have a field of view that is more telephoto than what they'd have on a 35mm film camera. In other words, when you place a 50mm lens on a camera with a sensor that is smaller than a piece of 35mm film, it might end up having the equivalent field of view of a 70mm lens on a 35mm camera.

The sensor in a point-and-shoot camera is so small that camera makers can get away with using lenses that have very short focal lengths—usually in the 8–15mm range. In 35mm terms, 8–15mm is insanely wide-angle, but on a small point-and-shoot, it might be the equivalent of a fairly normal zoom range.

If you want to know the 35mm field-of-view equivalency on a camera that uses a smaller sensor, then you must multiply the actual focal length of the lens by a *multiplication factor*.

Fortunately, with point-and-shoot cameras, if your manual doesn't list the multiplication factor, it will probably list the equivalent 35mm focal length range.

This cropping factor can be very handy for shooters who like using very long telephoto lenses. For example, if you stick a 300mm lens on a Canon EOS Digital Rebel series camera, which has a 1.6x focal length multiplier, you'll have the same field of view as a 480mm lens. If you like shooting with wide-angle lenses, though, things are a different story. A 24mm lens—a very wide lens on a full-frame camera—will have a full-frame equivalent field of view of 36mm, which is not very wide.

Cropped Versus Full-Frame Sensors

Most digital SLRs have an image sensor that's smaller than a piece of 35mm film; these are known as *cropped sensors*. Canon, Nikon, and Sony also make cameras with a *full-frame* sensor, which is the size of a piece of 35mm film. When you put a lens on a camera with a full-frame sensor, you don't have to apply any kind of 35mm equivalency. Full-frame sensors allow for higher pixel counts. At the time of this writing, you can get 24 megapixel full-frame SLRs. Because of their bigger mirrors and viewfinders, full-frame cameras also tend to have larger, brighter viewfinders than SLRs equipped with cropped sensors. As you'll learn later, cameras with full-frame sensors also have some properties that give you some different creative choices.

Lenses that work on full-frame cameras will also work on cropped-sensor cameras. Both Canon and Nikon, as well as third-party lens manufacturers like Tamron and Sigma, also make lenses that are designed specifically for their cropped-sensor cameras. These lenses are smaller and lighter than equivalent full-frame lenses, and they will not work on a full-frame camera. Canon denotes their cropped-sensor lenses with an S moniker, while Nikon tags theirs with DX.

Basic Controls

You should already know where the most basic controls on your camera are: power switch, shutter button, and zoom control.

- **Power switch.** This might be a button, a sliding switch, or a rocker switch of some kind. Some power switches also do double duty. For example, on Nikon SLRs, the power switch also lets you turn on the light for the top-mounted LCD screen.

- **Shutter button.** We discussed the shutter button in detail in Chapter 2, "Getting to Know Your Camera," so you should already be comfortable with where it is and how to use it to control autofocus.

- **Zoom control.** If you're using a point-and-shoot camera, there will be an electronic zoom control somewhere on the camera's body. Often, it is a rocker switch that surrounds the shutter button. Other cameras have simple press buttons on the back of the camera body. Typically, to zoom in, you'll rotate a rocker switch to the right, or if your camera has buttons, press the right-hand button. These days, most vendors are using the icons shown in Figure 3.10 to indicate zoom.

If you're using an SLR, then you'll control zooming by turning a ring on the camera's lens. You'll learn more about this below.

Zoom Out Zoom In

Figure 3.10

Most cameras use icons like these to indicate zooming out and in.

Mode Selection

If you worked through Chapter 2, you should already be familiar with your camera's mode selection control. This is the dial or menu option that you'll use to choose the camera's shooting mode. As explained earlier, the mode you choose determines what the camera will control automatically and what will be left up to you. We'll be exploring modes in more detail in the shooting chapters later in this book.

Some cameras use their mode selection controls to activate video features, specialized functions like panoramic shooting, or even image playback.

Status Display

This is another one that you probably already know, but I'm calling it out here to make certain that you understand what I mean when I refer to your camera's status display. There are a *lot* of settings to keep track of on your camera, from shutter speed and aperture to image size and format and white balance settings. On all cameras, these settings are shown in a status display of some kind. You saw examples of different status displays in Chapter 2 when you learned how to read the camera's shutter speed choice.

Most cameras also provide a control that lets you deactivate the status display or cycle through different configurations of status information (see Figure 3.11). This control is usually a button called *Display* or *DISP*. Pressing the button repeatedly will show different status screens and probably offer the option of turning the screen off altogether, which can be important when shooting in low-light venues such as concerts and performances.

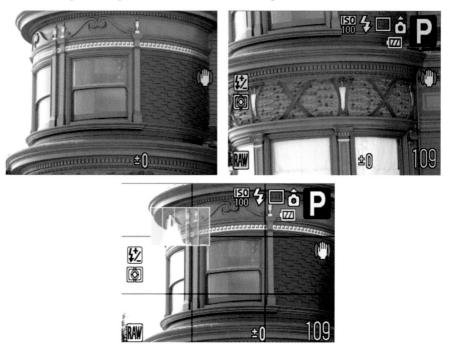

Figure 3.11

Some cameras allow you to display different amounts of status information while shooting. Some cameras include a very bare screen, a screen with basic exposure information, and additional screens with more advanced features such as a grid and Live Histogram.

More advanced SLRs will usually have a second LCD screen mounted on the top of the camera or above the main LCD.

On your camera's status display, make sure that you know where shutter speed and aperture are displayed. You'll learn what the rest of the status readouts mean as we work through more features.

LCD Screens

One of the decisions you'll need to make when shopping for an SLR is whether you want a dedicated status display. A dedicated status display is an additional LCD screen mounted on top of the camera, and it is usually easier to read in bright daylight. Cameras that use their main LCD for a status display are often smaller and lighter. If you opt for one of these models, look for a camera that has a sensor that automatically detects when you are looking through the viewfinder. These cameras will automatically shut off the camera's rear LCD, so that it doesn't shine in your eyes while looking through the viewfinder.

Shooting Controls

Autofocus and zooming will be the shooting controls that you'll use most often, but your camera probably also has some other very important shooting features, multiple light meters, different autofocus, flash, and burst modes, and many more options and controls.

Usually, these sorts of primary shooting controls and others like them are grouped together (see Figure 3.12).

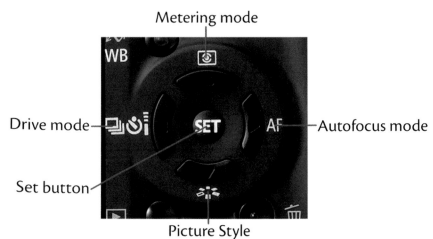

Metering mode

Drive mode

Set button

Autofocus mode

Picture Style

Figure 3.12

Most cameras group essential shooting configuration controls together, either in a collection of buttons or in a menu.

On smaller point-and-shoot cameras, there's not always enough room for external buttons for these controls. Instead, these cameras usually offer a button you can press to bring up a simple menu for configuring these critical features (see Figure 3.13). On some cameras, this is listed as a *Function*, or *Func* button. On other cameras, the menu is always visible on-screen, and you simply use a navigation control to select and configure parameters.

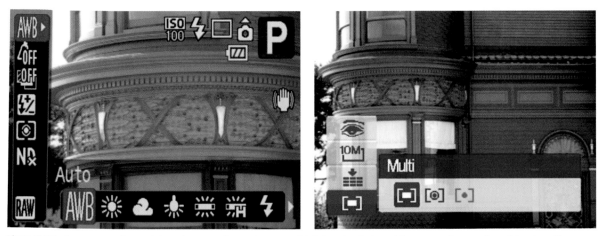

Figure 3.13 Some cameras have a dedicated Function button (sometimes labeled *Func*), which provides a menu of commonly used functions, like meter selection. Function menus provide quick access and keep you from having to tunnel into the full menu system.

The controls on most SLRs are operated by a combination of buttons and control wheels—usually a wheel near the shutter button and another on the back of the camera. Consult your camera manual for details on how these controls are used.

Feet, Elbows, and Neck

No matter what your shooting conditions, from simple street or event shooting to more complex shooting in harsh environments, keeping your camera stable is an essential part of shooting sharp images and having maximum creative control.

Many people believe that if you're shooting with a fast shutter speed, you don't have to worry about camera stability, but camera shake can impact your images even at very fast shutter speeds. What's more, camera stability becomes more important if you're shooting with a camera that has a very high pixel count. A camera with 10 or 12 megapixels is capable of revealing the softness that can be caused by very fine camera shake and vibration.

While tripods and monopods are the obvious solutions for stabilizing your camera (and we'll talk about shooting with these devices later in this section), there are also tricks you can employ when shooting handheld to achieve better stability. As you practice your handheld shooting, you'll get more adept at keeping your camera steady. Here are some tips you can use to improve your camera stability when holding by hand.

Keep your elbows in. Holding your elbows against your sides provides much better stability than holding them out and away from your body (see Figure 3.19). Practice this enough, and you'll get so used to feeling your elbows tucked into your body while shooting (as if you're being hugged) that it should feel weird when you don't shoot this way.

This is especially true when shooting with the camera in portrait orientation. When shooting vertically, many people use the position shown in Figure 3.20. If you turn the camera the other way, though, you can keep your elbows against your body for greater stability. It's also more comfortable, albeit it doesn't give you that cool "gotta get the shot" look.

Figure 3.19

You'll get a much more stable hold on the camera if you keep your elbows at your side to stabilize your arms.

Figure 3.20

The "elbows in" rule also applies to shooting in portrait mode. In the right-hand image, the photographer has a much more stable position than she does in the left, with her elbows akimbo.

When using a camera with an optical viewfinder, always lift the camera all the way to your face (see Figure 3.21). You may think that you're doing this, but many people lift the camera partway to their face and then push their neck forward to close the gap. In addition to giving you bad posture and possibly contributing as much to back pain as a heavy camera bag on your shoulder, jutting your neck forward is a less stable position.

Figure 3.21

You'll get a more stable shot, and have less neck pain, if you bring the camera all the way to your eye, rather than pushing your neck forward.

Netbook Computers

The latest generation of *netbook* computers are ideal photo accessories. Small, light, inexpensive (around $350–$500), and often packing built-in card readers, these computers are not significantly bigger or heavier than a device like the Epson P-6000, but they are significantly cheaper, *and* they're a full-fledged computer. They may not pack a screen that's big enough for serious image editing, but they come with lots of storage, and you can also use them for email and Web browsing, media playback, and all your usual laptop computer chores. Like a laptop, with a netbook, you have the option of starting (and possibly finishing) your postproduction while you're still on the road.

Tablet Computers

At the time of this writing, the iPad is generating quite a stir, as it ushers in what will surely be a popular new computing paradigm. Currently, neither the iPad nor any other tablet device is a great option for offloading images, if for no other reason than price/gigabyte. These devices are expensive, and don't offer the features that you'll get on a netbook or a laptop.

If you tend to shoot low volume and carry an iPad with you anyway, then this might be an ideal choice. For the heavy shooter, lack of storage capacity on current tablets will probably be a deal-breaker.

Also, you won't be able to run your normal postproduction software, so inserting a tablet into your workflow might complicate things a bit.

Blank Discs, Cables, and PC Adapters

Finally, you can simply carry around some blank CDs or DVDs and all of your camera's connectivity options. Then you need only find a service bureau, an Internet café, or a friend with a computer to burn your camera's images to your blanks. Obviously, your service bureau or friend will need a burner and the appropriate port. If they're running an older operating system that doesn't automatically download images, you'll need to bring the transfer software provided with your camera.

Hedge Your Bets by Offloading

Even if you have a very large storage card—one that can hold all the pictures you might conceivably need to shoot—it's still a good idea to offload some images from time to time. Media cards can crash, and backing up to another form of media is a good way to ensure that you won't lose all your images in the event of a storage crash. If you have the space, consider making more than one backup.

For Those Times When You're "Not Seeing Any Images"

On field trips, I'll occasionally have a student come up and say that they're "just not seeing anything." I'll follow them around for a while and find out that they're walking around and looking at a lot of things, but they're *never* raising the camera to their eye. Great photographers often don't recognize an image until they look through the camera, so don't expect shots to just leap out at you while you're walking around. Don't be shy about constantly raising the camera to your eye to check things out. You might be surprised by what you find.

Camera Care and Maintenance

One great advantage of film cameras over digital cameras is that they can be incredibly simple machines and thus very durable. Because all the imaging and storage technology in a film camera is contained in the film, the camera itself can be little more than a box. This is not true with a digital camera, which requires batteries, silicon chips, LCD screens, and many more potentially fragile components.

Fortunately, most of the cameras you can buy today are very durable, provided you handle them with a little care. Basic camera care is pretty simple, and is just what you'd expect for any electronic or optical device: Don't drop it, don't smash it into things, keep it dry, and keep it clean.

In this section, we'll look at some specific maintenance issues and care concerns.

Batteries and Power

Batteries made using old NiCad technology had an annoying tendency to develop a performance-limiting "memory" if they weren't completely drained before being recharged. The newer technology used in the batteries in today's digital cameras doesn't have this problem, and you can feel free to "top off" your batteries any time you want—there's no need to completely drain them before you put them on the charger. That said, for the first couple of charges, it's good to drain the battery completely before you charge it up. Doing this every so often will "condition" the battery.

Rechargeable batteries eventually wear out, so if you notice that your battery is not holding a charge for very long, you might need to replace it.

If you're planning a long trip and won't have access to power, then you might want to carry multiple batteries. You can buy additional batteries for your camera from most major camera vendors. You might also find that there are third-party battery options for your camera. While your camera manufacturer will likely warn you that using such batteries can damage your camera, I've never had any trouble using third-party batteries, and they're often much cheaper than the batteries sold by camera manufacturers.

You might also be able to find a third-party charging solution for your batteries. Third-party chargers are often cheaper than the battery chargers sold by your camera maker, and they are also often smaller, lighter, and sometimes come with additional options such as car cigarette lighter adapters.

Other remote power options include solar chargers, such as those made by Solio (*www.solio.com*). I've used their solar chargers extensively for powering my digital SLR in remote locations, and they can also be used to charge your cell phone, iPod, and more (see Figure 3.22).

Figure 3.22

If you have a car charger for your camera battery, you can easily charge it while driving or connect it to a Solio portable solar charger.

Obviously, when you travel abroad, you'll need to buy the appropriate adapters and converters to power your charger and any other equipment you might choose to bring along. Most camera chargers will work on any voltage from 100 to 240 volts, so all you'll need to bring is an adapter for the particular plug style that's used at your destination. The back of your camera's charger should indicate the voltage range that it can use.

Finally, be aware that cold temperatures will noticeably shorten battery life. If you're shooting outside in below-freezing temperatures, your batteries will probably die quickly. You can often squeeze a little more power out of them by taking them out of the camera and warming them up inside your pocket. This might sound hard to believe, but it's true. A few minutes inside your coat can often get you an additional dozen pictures. Don't put the whole camera in your pocket because the temperature change might fog your lens.

Lens Cleaning

Given how critical your camera's lens is to the photographic process, it's obviously important to keep it clean. The good news is that tiny specks and splotches on your lens are often not visible to the camera, since it might focus *past* the debris on the end of the lens. Still, there's nothing wrong with erring on the side of caution and keeping your lens as clean as possible.

Any camera or eyeglasses store will sell lens papers or lens cloths. These are the best way to keep your lens clean. Disposable lens papers are a better alternative than lens cloths, because it's difficult to keep a lens cloth clean while carrying it around.

You will rarely, if ever, need to use any kind of liquid lens cleaner, but if you do—perhaps there's a spot that won't come off easily—be sure to use one designed for cleaning fine optics. Don't just grab a bottle of Windex and start squirting, as this can damage the anti-glare coatings on the end of your lens.

Also, don't clean your lens with your shirt or any other article of clothing that you might be wearing. While it may look clean, the cloth might be hiding abrasive particles or dirt that could scratch your lens.

Don't use cans of compressed air to clean your lens because the liquid propellant used in the can could spray onto your lens. A blower brush, available at any camera store, is a good tool for lens and camera cleaning (see Figure 3.23).

If you're an SLR user, remember to clean both ends of the lens. Again, a blower brush is the best way to deal with the camera end of the lens.

Figure 3.23

Use a blower brush for cleaning dust off the ends of your lenses.

UV Filters

One of the best ways to protect your lens investment is to attach a UV or skylight filter to the end of your lens. These filters don't alter the appearance of your image at all, and they provide valuable protection to the end of your lens. In addition to safeguarding against scratches and dirt, a filter can even protect the lens in the event you fall or drop it.

When shopping for a filter, be sure to spend a little extra for a multicoated filter. This will ensure that you're getting a filter with optical properties that won't degrade your lens.

Sensor Cleaning

If you have a digital SLR with removable lenses, then you might one day encounter the problem of sensor dust. When you take the lens off your camera, the sensor chamber is exposed to the elements in a way that it never is with a point-and-shoot camera. With the lens off, it's possible for dust and other debris to get on the image sensor, and this dust can be visible in your final image.

The pixels on a digital image sensor are very, very small. On a 10-megapixel point-and-shoot camera, 10 million of them are crammed into an area smaller than your fingernail. Because they're so small, it doesn't take a very big piece of dust to obscure thousands of them, leaving a dark smudge or spot in your final image (see Figure 3.24).

Figure 3.24

If you see spots or smudges in the same place on multiple images, you could be facing a sensor dust problem.

The sensor itself is not actually directly exposed to the outside world, since it sits behind a clear glass filter. In many newer SLRs, a built-in cleaning mechanism automatically vibrates this filter every time you turn the camera on or off, in an attempt to remove dust. A piece of sticky material below the filter traps any fallen dust so that it doesn't float around the sensor chamber.

Whether or not your camera includes built-in sensor cleaning, you should take precautions to keep your sensor clean. Where sensor dust is concerned, prevention can be very effective.

Most of the dust that lands on your sensor is delivered by the end of the lens—the end that attaches to your camera. So keeping your lenses clean is a good way to keep your sensor clean. Before you go out on a shoot, use a blower bulb or blower brush (but never compressed air) to blow out the camera end of your lens.

When changing lenses, try to use gravity in your favor. Keep the camera pointed down and don't remove one lens until you have the other lens in-hand, ready to attach. It might feel like it requires three hands, but if you hang the camera around your neck and practice, you'll develop the coordination to make speedy lens changes.

Dusty New Camera

If you have lots of dust problems when you first get your camera, this might be because some of the materials inside the sensor chamber are shedding residues of different kinds. This should abate after a few months.

When you remove a lens, always put the end caps on before you put the camera in any kind of bag, and be very careful to keep the cap itself clean. This will keep the camera-end of your lens clean, which will reduce the chance of transferring dust to the sensor via the lens.

It's easy to tell if you have a sensor dust problem because you'll see the same smudge or spot appearing in the same place from one image to the next. If you see a spec or smudge in the same place in every image, then you probably need to clean your sensor. If you want to be sure, then put your camera in manual focus, point it at a blank white wall (or clear blue sky), defocus the lens, and take a picture. Bring this image into your image editor and increase the contrast using a Levels adjustment. (You'll learn how to do this in Chapter 15, "Correcting Tone.") Any dust problems should be readily apparent.

Cleaning Your Sensor

To clean your sensor, you'll need special cleaning tools and a little time. If you're not comfortable with this type of endeavor, you can send your camera to its manufacturer for cleaning. Consult your camera maker's Web site to find a nearby service center.

There are two types of cleaning: dry and wet. Dry cleaning involves using a special brush to remove debris from your sensor, while wet cleaning involves special swabs and chemicals for removing particularly stubborn particles. You can find both types of products and excellent sensor cleaning tutorials at *www.visibledust.com*. The Visible Dust Corporation has a long history of making cleaning materials for high-end microscopes and other optical devices, and they have top-notch products.

Don't Spray Compressed Air into Your SLR's Body!

Never, ever use compressed air to clean your sensor! The propellants used in cans of compressed air can leave a physical residue that can permanently mar your sensor.

Carrying a Long Lens

If you're an SLR user, then one of the easiest ways to protect your lenses is to follow this very simple tip. When you have a long lens mounted on your camera, pay attention to how you hang the camera on your shoulder. There's a big difference between the two approaches shown in Figure 3.25.

Figure 3.25 You can hang your camera over your shoulder with the lens facing out, where it can bump into things, or tuck it into your back, which keeps it much safer.

In addition to keeping the lens hidden behind you, where there's less chance of it bumping into something, you'll find that your camera moves much less. Also, the camera is less noticeable from the front, making it easier to approach people without scaring them.

Whether you're walking around town or scrambling up a trail, keeping your lens tucked into your back provides more stable carrying and more security for your expensive glass.

Water and Digital Cameras

Digital cameras and water definitely do not mix. Although a few sprinkles are nothing to worry about, you absolutely do *not* want to submerge your camera. The rule of thumb for manual film cameras has always been: if it falls in the water, grab the camera and put it in a bucket of that same water. Keeping a film camera submerged will prevent rust until you can get the bucket and camera to a repairperson who can take it apart, clean it, and dry it. (Of course, carrying a bucket in your camera bag can be a bit of a hassle.)

Unfortunately, this doesn't apply to today's electronics-laden digital and film cameras. If your camera goes in the drink, fish it out immediately and do everything you can to get it dry. Immediately remove the battery and media card; open all port covers, lids, and flaps, and wipe off any water you can see, no matter how small. Set the camera in a warm place and do *not* turn it on until you're sure the camera has had time to dry, both inside and out. At the least, give it a couple of days to dry.

After drying off the camera, some people suggest covering it completely with uncooked rice. Leave the camera covered for at least a day. The rice will act like a desiccant and absorb moisture from the camera. If the camera in question is an SLR, you'll obviously want to put the body cap on before ladling on the rice.

If you know you're going to be using your camera in potentially wet situations (kayaking, canoeing, taking your convertible to the car wash), consider buying a *drybag*, which is a sealable, waterproof bag that will keep your camera dry even if it gets submerged.

Your camera should be fine in light rain, as long as it doesn't get completely soaked. If you plan to spend all day in the rain, or are shooting in very heavy rain, try sticking your camera in a Ziploc bag. You'll still be able to access the controls, and you can always cut a hole for the lens (see Figure 3.26).

Figure 3.26

If you're shooting in light rain, consider using a Ziploc bag to protect your camera. Be forewarned that your camera is very sensitive to cold and damp.

One thing to note about rain: while a digital camera is an electronic device, it can be used in light rain. You don't want to take it out in a torrential downpour, but sprinkling and light showers should be fine, if you work to keep it as dry as you can. Some higher-end SLRs offer weather-sealing features that allow them to be used in more extreme environments, and some point-and-shoots are designed to be so waterproof that they can be submerged.

The point is, when it's raining, be careful, but don't use a little rain as an excuse not to shoot.

Weather Sealing Is Only as Good as Your Lens

If you have a higher-end SLR that offers a weather-sealed body, be aware that if you don't have a lens that offers a weather-sealed gasket where it joins the camera body, then your camera is no longer weatherproof. If you plan on shooting in very rugged environments, you'll need to choose your lenses with weatherproofing in mind.

Cold Weather

Shooting in cold weather presents a number of problems for the digital photographer. First, there are the LCDs on your camera. Remember that the "L" in LCD stands for liquid. As temperatures drop, your LCD will become far less "L," and the last thing you want is for it to turn into a solid crystal display. Although the LCD won't necessarily be damaged by cold weather, it might prove to be unusable.

Other, smaller electronic components might actually be damaged if you try to use them in cold weather. Extreme cold might cause small electronic components to expand or contract enough that using them will cause them to break. Your camera's documentation should list a range of operating temperatures, and although you might be able to push these an extra 20° on the cold end, it's safe to say that such use won't be covered by your warranty.

Even if you're shooting within your camera's proscribed operating temperatures, be very careful when you move the camera from cold temperatures to warm. Walking into a heated house from a day of shooting in the snow can cause potentially damaging condensation to form inside the camera. If you know you're going to be shooting in cold weather, take a Ziploc bag with you. Before you go into a warm building, put the camera in the bag and zip it up. Once inside, give the camera 20 or 30 minutes to warm up to room temperature before you let it out of the bag. If you don't have a bag, be sure not to turn it on until any condensation has had time to evaporate.

If the temperature is cold enough to freeze your camera, it's probably cold enough that you'll be wearing gloves. Because gloves tend to reduce your manual dexterity, be absolutely certain your camera has a neck or wrist strap and that it's securely attached to some part of your body.

In addition, if you're shooting in icy, slippery conditions where you might be prone to falling, attach a UV filter to the end of your lens. This will add an extra level of scratch and shatter protection that might save your lens in the event of a fall.

As discussed previously, batteries can be greatly affected by cold weather.

Hot Weather and Digital Cameras

Hot weather can also affect your camera, because as your camera heats up, noise in your images increases. If you're shooting in hot weather, this can cause a visible increase of stuck pixel noise—bright white pixels scattered about your image. This is especially problematic if you're in a hot environment, in direct sunlight, with a black camera.

You might also notice the LCD screen acting a little sluggish. Screen redraw may look weird, and some or all of the screen might appear black. Many LCD screens are not reliable above 32°C (90°F). Turn off your camera and try to get it somewhere where it can cool down. If you must shoot in high temperatures, consider keeping your camera in some type of dry cooler (an ice chest with some blue ice) until you're ready to shoot.

If you haven't exceeded the camera's recommended operating temperature, but your LCD has overheated and isn't working, it's probably safe to keep shooting using the camera's optical viewfinder (if it has one). Turn off the picture-review function because your LCD won't be visible anyway.

Media Cards

There are a few things you should know about removable media cards. Obviously, these cards are fragile, so treat them with care. Also, consider the following issues:

- **The bigger the card's capacity, the more power it takes to keep it running.** Consequently, in theory, smaller cards use less battery. Although it's difficult to tell if this has any bearing in the real world, switching to a smaller-capacity card when your batteries run low might garner you a few extra shots.

- **Larger-capacity cards generate more heat.** If you're using a tiny camera, which tends to get hot simply because of its design, it might be worth sticking to smaller-capacity cards. As you'll see later, excess heat can make your images noisier.

- **If something goes wrong with a larger-capacity card, you'll lose more images than you would if you had been using a smaller-capacity card.** Therefore, it might be worth buying a number of smaller cards instead of one big one.

- **X-rays don't seem to matter.** So feel free to take your camera with you to the airport, dentist, or thoracic surgeon.

Earlier in this chapter, you read about some image size/compression strategies for saving media. Although these practices can make your storage go farther, the ideal solution is simply to buy more media cards. The price of media cards continues to drop, but if you tend to shoot *lots* of images, or if you're planning an extended trip, consider some of these storage alternatives.

SD and CompactFlash Considerations

SecureDigital or *SD* cards come in two varieties: regular SD cards and newer *SDHC* cards, which have a higher capacity and offer faster transfer times. Be aware that SDHC cards do not work in every camera that has an SD slot. If your camera doesn't specifically support SDHC, then these cards won't work. If you have a newer camera, it probably supports SDHC.

CompactFlash cards now come in a variant called *UDMA* (*Ultra Direct Memory Access*). If you have a camera that supports UDMA cards, then you might find that they work faster than regular CompactFlash cards. If you put a UDMA card in a camera that doesn't support UDMA, it will still work, but there's a chance it will be slower than the fastest, regular CompactFlash cards.

How fast your cards need to be depends on the type of shooting you do. If you have a camera with a high pixel count, and you tend to burst a lot, or if you plan on shooting video, then a faster card will be important. If you don't regularly shoot bursts of images, then speed probably doesn't matter. Note that older CompactFlash and SD readers won't read the newer UDMA and SDHC cards, so you might need to upgrade your card reader if you opt for one of these newer formats.

Laptop Computers

If you plan on taking a long trip, you can augment your media cards with a laptop computer. In addition to giving you a place to store images, you'll have a complete darkroom with you. With a laptop and your favorite image editing application, you can assess right away whether your day's shooting was successful and determine if you need to reshoot something. What's more, if you begin organizing in the field—sorting, keywording, choosing select images—then you'll have a leg up on your postproduction when you get home. In fact, if you've got enough down time on your trip, you might arrive home with your postproduction chores finished!

Portable Battery-Powered Hard Drives

If you don't feel like lugging around your laptop computer, consider a stand-alone battery-powered hard drive device such as the Epson P-5000, shown in Figure 3.27. Measuring roughly the same size as a paperback book, these battery-powered devices contain a hard drive, a media slot, and an LCD screen. Simply insert the media from your camera into the slot, and you can back up your images to the internal drive. You can then put the card back into your camera, erase it, and start shooting again. These types of devices also allow you to view and delete images, build slideshows that can be output to a TV via a standard video out port, and even listen to MP3s. Because they're built around standard laptop computer hard drives, these devices deliver a much cheaper price-per-megabyte than any type of flash card. Although bigger and heavier than a handful of flash cards, they offer a tremendous amount of storage in less space than a full-blown laptop. Less-expensive models are available that lack an LCD screen for reviewing your images.

Figure 3.27

The Epson P-6000 provides up to 80GB of portable battery-powered storage providing a small, high-capacity location to offload your images, letting you free your storage cards for more shooting. The P-5000 lets you view and delete JPEG or raw files, listen to MP3s, and watch movies!

Smaller, less expensive models are also available. Lacking screens, but easier to carry (and afford) products such as the Photo Safe from Digital Foci (*www.digitalfoci.com*) can be had at very reasonable prices.

Netbook Computers

The latest generation of *netbook* computers are ideal photo accessories. Small, light, inexpensive (around $350–$500), and often packing built-in card readers, these computers are not significantly bigger or heavier than a device like the Epson P-6000, but they are significantly cheaper, *and* they're a full-fledged computer. They may not pack a screen that's big enough for serious image editing, but they come with lots of storage, and you can also use them for email and Web browsing, media playback, and all your usual laptop computer chores. Like a laptop, with a netbook, you have the option of starting (and possibly finishing) your post-production while you're still on the road.

Tablet Computers

At the time of this writing, the iPad is generating quite a stir, as it ushers in what will surely be a popular new computing paradigm. Currently, neither the iPad nor any other tablet device is a great option for offloading images, if for no other reason than price/gigabyte. These devices are expensive, and don't offer the features that you'll get on a netbook or a laptop.

If you tend to shoot low volume and carry an iPad with you anyway, then this might be an ideal choice. For the heavy shooter, lack of storage capacity on current tablets will probably be a deal-breaker.

Also, you won't be able to run your normal postproduction software, so inserting a tablet into your workflow might complicate things a bit.

Blank Discs, Cables, and PC Adapters

Finally, you can simply carry around some blank CDs or DVDs and all of your camera's connectivity options. Then you need only find a service bureau, an Internet café, or a friend with a computer to burn your camera's images to your blanks. Obviously, your service bureau or friend will need a burner and the appropriate port. If they're running an older operating system that doesn't automatically download images, you'll need to bring the transfer software provided with your camera.

Hedge Your Bets by Offloading

Even if you have a very large storage card—one that can hold all the pictures you might conceivably need to shoot—it's still a good idea to offload some images from time to time. Media cards can crash, and backing up to another form of media is a good way to ensure that you won't lose all your images in the event of a storage crash. If you have the space, consider making more than one backup.

IMAGE TRANSFER

Building a Workstation and
Transferring from Your Camera

Later in this book, we're going to spend a lot of time working with image editing software. Programs like Photoshop can be very complex, and sometimes confusing, but there's a simple way to console yourself when you get frustrated with your computer or a particular piece of photography software: remind yourself that at least you're not standing in the dark, breathing noxious fumes, and soaking your hands in toxic chemicals.

Digital cameras offer tremendous dynamic range and low-light performance that no film can match, but one of their best attributes is that you can quickly and easily take images out of the camera and start your postproduction process. This process begins when you transfer images from your camera to your computer.

In this chapter, we're going to take a quick look at image transfer, so that you can start working with the images that you've been shooting, and will continue to shoot as you work through the shooting chapters to follow. In later chapters, we'll be taking a very detailed look at *workflow*, the exact steps that you need to take to get your image from the camera to a finished print. Here, we're simply going to discuss strategies and practices for getting your images copied to your computer, and that discussion will begin with a quick look at what makes a good digital photography workstation.

Choosing a Computer

Whereas film photographers rely on rooms full of enlargers, plumbing, and photographic chemicals, the digital photographer needs a decent computer, a lot of storage, some image-processing software, and a printer.

When I wrote the first edition of this book, computer choice was a fairly delicate issue, as you needed to pick a machine with enough processing power to run an image editing program and enough storage to handle the demands of heavy shooting. These days, things are much easier for the simple fact that even entry-level computers today are very fast, and storage is extremely cheap.

If you've got a computer from the early 2000's (or earlier), then you might need to upgrade. Similarly, if you've got a new computer, such as a netbook-class machine, that's running on a slower chip like the Intel Atom, then you might need to upgrade, if you tend to do complex, processor-intensive edits. In general, newer machines will almost certainly have the processing power you need to drive today's digital photography applications.

However, if you have a camera with a sensor that packs a lot of pixels—25 megapixels or higher—then you will notice a difference between a machine with top-of-the-line performance and a lesser model.

One thing that's changed a lot in the last few years is that more image editing applications take advantage of the extra processing power that can be provided by a video card. The video card in your computer provides the interface between the computer and your monitor, and these cards often have their own dedicated graphics processing computers onboard. These *graphics processing units*, or *GPUs*, can provide an extra processing kick for those programs that exploit them. The latest versions of Adobe Photoshop and Apple Aperture can exploit a GPU to improve performance.

RAM is also an important consideration when working with digital images. If scrolling or zooming your images is slow, or if you see images paint in chunks onto the screen, then you might want to consider adding more RAM.

For editing images in Photoshop, Adobe recommends a RAM size equal to two to three times the size of your typical image. Although your image might be only 10MB, your RAM requirements can actually be much higher once you start using some of the more memory-hungry features in Photoshop, such as layers, complex filters, or the History palette.

It takes 24 bits—or three bytes—to store a single color pixel in an 8-bit, uncompressed image. If you have a 10 megapixel image, it takes roughly 30 megabytes to hold all of that data. Remember that JPEG images are compressed, though. So, when you open a 2 megabyte file in Photoshop, it will be expanded to its full 24 megabyte size. This is why you need a lot of RAM for image editing. For maximum performance, you'll want a RAM level closer to 20 times the size of your image. In addition, remember that your OS and other applications will also need some memory, so don't base your RAM needs on Photoshop alone (see Figure 4.1.)

Figure 4.1

If Photoshop's Efficiency meter drops below 100 percent, you know that it can no longer keep all of its image data in RAM. Less than 100 percent efficiency means it must spool information to disk, which leads to a slower performance. Keeping an eye on the Efficiency gauge is a good way to determine if your system could use more RAM. By default, that Efficiency gauge box shows the current image's file size. Click on the arrow to the right of the box, and you can select other things to display, including the Efficiency meter.

In the end, if you're on a budget, you might want to consider paying for a slightly slower, less-expensive processor and putting the money you save into more RAM.

Fortunately, RAM is cheap, so you should be able to easily outfit your computer with at least the recommended RAM specs provided by your image editing applications. You can always add more RAM later if you find out that your current memory capacity is too low.

Storage

The bad news is that digital images can take up a lot of space. The good news is that hard disk storage is really cheap. Simply put, the more storage you have, the better. Bear in mind that you'll need space for your OS, your image editing applications, and any other software you plan on using, and that's all *before* you've shot any pictures. However, a 500GB drive should keep you editing for a while.

If you have a desktop, tower-type computer, then the cheapest way to add storage is to put additional drives into the tower's internal drive bays (assuming it has any available). If you're using a laptop computer, or a desktop computer such as an iMac, which doesn't have drive bays, then you'll have to add storage using external hard drives.

Most external drives plug into the USB-2 port on your computer, though some can connect via FireWire or eSATA. Find out what kind of interface you have before you go drive shopping. Small 2.5" drives like the one shown in Figure 4.2 are great for portable use, because they don't require any external power connector. Instead, a single USB-2 or FireWire cable provides both the data connection and power. Larger 3.5" drives require a separate power supply. The advantage to larger drives is that they come in larger capacities and have a much lower price per gigabyte.

Figure 4.2

External USB-2 and FireWire drives make excellent storage add-ons for backup or additional workspace. Small 2.5" drives, like the one in the center, can take their power from the same cable that is used to connect the drive to the computer, making them ideal for taking on the road. Larger drives require separate power, but offer much larger capacities, and better price per gigabyte.

FireWire drives can be daisy-chained—as you need more storage, you can plug new drives into the FireWire connectors on your current drives. USB-2 drives require a free USB-2 port on your computer, although you can add a USB hub to gain more ports. USB hubs come powered and unpowered. (Powered ones simply have an external power supply of their own.)

Note that hard drives that do not have external power supplies will need to be plugged into a powered USB port. The ports built in to your computer are powered, so that's not a problem. If you're plugging one of these drives into a hub, it will have to be a powered hub.

Backup

Hopefully, you haven't already learned this the hard way, but eventually a hard drive will fail. A hard drive is a mechanical device with a lot of moving parts, and after a while, all that disk spinning and drive head moving takes its toll and a mechanical failure occurs. When this happens, your drive will most likely become unusable. While there are services that can attempt to get your data off the drive, they usually charge around $1,000 with no guarantee of success.

Of course, other things can happen to your drives—they can be lost, stolen, and so on. The best and only way to ensure that you don't lose images is to back up your files diligently, and the easiest way to back up is to buy additional hard drives. You can then simply copy your image folders to your backup drive or use backup software.

Recordable CDs and DVDs also make good backup media. While they take longer to record to, they're so cheap that you can make multiple copies easily. If you run out of disk space, burning off a few DVDs-worth of images can often free up enough space to keep working until you can get bigger drives.

RAID

You can configure multiple hard drives into a *RAID*, or *redundant array of independent disks*. RAIDs can be configured in several different ways, the most common methods being designated with the labels RAID0 through RAID6. The different categories of RAIDs provide different degrees of speed (how fast data is written to or read from them) and fault tolerance (the ability to recover data if a drive fails).

RAID0 uses "striping" without parity. (*Parity* simply means that some extra bits are written out to facilitate different recovery options, in the event of a failure.) This means that successive blocks of data are alternated between two drives. Since neither drive contains all of the data, if one drive is lost, all of the data are lost. RAID0 provides an increase in speed, but no increase in fault tolerance.

RAID1 uses "mirroring." This means that all of the data is written to both drives, so if one drive fails, all of the data can be recovered from the other drive. RAID1 provides a high degree of fault tolerance but little or no increase in speed. RAID2 through RAID6 utilize stripping with parity. These configurations provide various combinations of increased speed and fault tolerance, with RAID6 using dual parity, which gives it the capability to recover from the loss of two drives.

Many operating systems offer software-based RAID implementations, usually levels 0, 1, and 5 but sometimes others. Many motherboards and drive controllers offer hardware or firmware implementations. If you decide to use one of these, be aware that RAID0 provides no fault tolerance; if you lose one of your two RAID drives, you have lost all of your data. Any of the other implementations will provide fault tolerance.

Data Robotics has created a nonstandard RAID implementation, which they call *BeyondRaid*. It is available in their "Drobo" products, which is an incredibly easy-to-use package. A multiple-drive enclosure, the Drobo lets you add and remove drives easily, and doesn't require drives to be the same size. Intelligent software built into the device takes care of keeping your data redundant.

If you're comfortable with the process of assembling a PC, then you should consider an unRAID, an excellent, low-cost solution that offers the same kind of fault tolerance that RAID and Drobo systems do. It can use mixed drive sizes and can be expanded one drive at a time. If you have any spare PC hardware around, it can be a very cost-effective solution. You can learn more about it here: *www.completedigitalphotography.com/unraid*.

Remember that all of these systems provide a high degree of fault tolerance but are not bulletproof. Two drives can fail at the same time (more likely if they are the same model and the same age); drive controllers or power supplies can fail in such a way as to corrupt the data on all drives connected to them. All of these redundant systems provide a huge increase in fault tolerance over storage on a single drive. You must decide whether or not you want to back up the data on your array onto drives in a second enclosure (or perhaps on removable drives).

Backup Software

There are a number of backup programs that make short work of backing up your data. What you ideally want is some software that will perform a progressive backup, which means that the only files copied are files that have been changed since the last backup. Progressive backups are much faster than recopying files that haven't been altered. Some backup programs will even let you return to any of several different states. So, if you've backed up three times over the last month, these programs will let you return to any of those backup states.

During our discussion of workflow, we'll cover the details of when you should back up.

Monitors

You're going to be spending a lot of time staring at your computer screen, so it's important to choose wisely when you select a monitor. While it's possible to get a large LCD screen for relatively low cost, as a photographer, you have some color and contrast concerns that can really only be satisfied by a higher-quality display.

Hunt down reviews and, if possible, try to see the screen in person before you buy it. You want a bright display with good sharpness, a wide viewing angle, and with as broad a contrast range as you can get. If you're working with a laptop, try to avoid glossy screens because the extra gloss can obscure shadow details, and the extra reflections can make color assessment difficult.

Preparing Your Monitor

If you've ever stood in the TV department of an appliance store, you've seen firsthand how different an image can look on different screens. And, as you may have already discovered, prints can often look very different from the image on your computer monitor. *Monitor profiling and calibration* is the process of tuning your system so that your printed output better matches what you see on-screen, and so that the same image will appear consistent from one screen to another. How much effort you spend on this process depends on how picky you are, what kind of workflow you expect to have, and what kind of gear you use.

Fortunately, there's been a lot of good work done to improve color consistency from screen to print, so getting good results from your printer is not as complicated as it used to be. With the current generation of printer drivers from Epson, Canon, and HP, you can get very good results by simply using the automatic color-correction features built into the printer drivers. Note that these drivers probably won't produce prints that match the color on your monitor exactly, but you'll also probably find that with practice, you'll learn how things on your screen correspond to what comes out of your printer. For example, you'll get better at eyeballing when shadows in an image are too dark.

However, your screen will never *exactly* match your printed output, simply because the two technologies are very different. Your monitor and printer use different primary colors, which mix together in very different ways. Adding to the problem is the fact that your monitor is a self-illuminated display that generates its own light, while a photographic print is a reflective media that bounces light from another source. Finally, your monitor probably has a much wider gamut, or range of displayable colors, than does any printer that you'll find.

All of these parameters combine to create a very tricky situation for your computer. Trying to display an image in the same way that it will print is very tough. As such, you'll never get your monitor and prints to match exactly. However, with a little care, you can get them very close, which means you can greatly reduce the number of test prints that you need to make.

If you've ever worked in a darkroom, you know that it takes a fair number of test prints to discover exactly what printing exposure is best for a particular image. The same is true when printing digitally, but through calibration and profiling it *is* possible to greatly reduce the number of test prints. If you're frustrated with the wasted ink and paper that you have to go through to make test prints, just bear in mind that it's still much more cost effective than working in a chemical darkroom. And, as the technology improves, we may one day have much better screen-to-printer fidelity.

Online Printing

If all you're looking for is snapshot output, then you may be better off using an online printing service or a drugstore service. These often deliver simple 4″ × 6″ output at a much more affordable rate than you can get from your desktop printer.

In the following section, we'll discuss monitor profiling, and a few basics of color management. We'll have much more to say about this subject in Chapter 22, when we discuss printing.

A Little More Color Theory

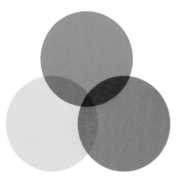

Figure 4.3

The primary colors of ink are cyan, magenta, and yellow. These colors differ from the primary colors of light—red, green, and blue—that your camera uses to create images. This difference is one of the things that makes monitor/printer calibration so complicated.

As you learned earlier, light mixes together in an additive process so that as colors are added together they appear more and more white. Ink, on the other hand, mixes in a subtractive manner. That is, as colors are mixed, they appear darker. While the primary colors of light—the fundamental colors from which all other colors can be made—are red, green, and blue, the primary colors of ink are cyan, magenta, and yellow (see Figure 4.3).

This difference in the way colors are made is what makes accurate calibration of your monitor and printer so difficult. Each time you print, your computer has to figure out how to take your image—which it represents as a combination of red, green, and blue light—and convert it into the mix of cyan, magenta, and yellow ink that your printer expects.

Special K—Why Printers Add Black

As you might already know, color printing uses four colors: cyan, magenta, yellow, and black. (Some printing processes add additional colors, but they all include these four.) Black is not a primary color, of course, but black ink is added to the mix because it is impossible to create perfectly pure ink pigments. Therefore, although the theory says that if you mix cyan, magenta, and yellow together you will eventually get black, the truth is you'll just get very dark brown because of impurities in the color pigments of your inks. Adding a little black ink is the only way to get true black. This is why most color printing is a four-color process called *CMYK*.

As if converting colors between these two different color spaces weren't difficult enough, accurate color reproduction is further complicated by the fact that not every monitor is the same. There are a number of reasons why, ranging from differences in color adjustments on each monitor, to differences in age, to differences in manufacturing. This is why a digital image or Web page on your monitor might look completely different on someone else's monitor.

Printers have their own collection of troubles. Each manufacturer might take a different approach to reproducing colors, and different brands of ink and types of paper have their own unique color qualities as well. Further complicating matters is the fact that different printing technologies can use completely different approaches to reproduce color. Some printers use four colors, some add extra colors to reproduce lighter tones, some use ink, some use solid wax, and so on.

Fortunately, with just a few simple steps, you can greatly improve color consistency.

Profiling and Calibrating Your Monitor

To improve color consistency across multiple devices, a group of camera, software, and display vendors created the International Color Consortium. The ICC has defined a standard method of profiling printers and monitors. An ICC profile contains a description of the color and contrast properties of a device, and these descriptions can be used by software in your computer to adjust color on-the-fly as it passes from one device to another. The color in your document is never actually altered. Instead, it is temporarily modified to try to preserve consistency from one device to another. Consequently, your image should appear consistent as you move it from computer to computer and from screen to printer.

This type of color management only works well when you have accurate, high-quality profiles for your monitor and printer. We'll talk about printer profiles when we discuss output. Right now, it's time to consider your monitor profile.

The Macintosh operating system includes a software monitor calibrator that lets you create a monitor profile by eye. (Go to System Preferences > Displays, click the Color tab, press the Calibrate button, and follow the on-screen instructions.) If you're using Photoshop on Windows, it should include calibration capability in its drivers. These programs yield profiles that are better than using no profile at all, but if you're going to bother with color management, it's best to use a hardware profiler to create a monitor profile.

There are several relatively inexpensive profilers on the market, ranging from the $99 PANTONE hueyPro or ColorVision Spyder2express ($79), to more expensive systems such as the $169 Spyder3Pro (see Figure 4.4) or the $249 Spyder3Elite.

These gizmos provide you with a piece of hardware that you attach or hang in front of your monitor. The included software then uses the device to measure the color and contrast properties of your monitor, and then it generates a profile that you install on your computer. The higher-priced profilers do a better job than the less expensive units, and their software provides more configuration options. However, even a $79 device will be better than no calibration or "eyeballed" calibration. The money you invest in a calibrator will more than pay for itself in saved ink and paper.

Figure 4.4

The ColorVision Spyder is just one of several different monitor calibrator/profilers. After hanging the device in front of your monitor, you use special included software to build a profile automatically.

All of these devices include detailed instructions on their use, as well as guides for getting better results. In general, the process is automatic and painless, and you'll probably want to reprofile at least once a month (more if your monitor is older).

Monitor Calibration Tips

Before you calibrate your monitor, whether by eye or with a hardware calibrator, let the monitor warm up for half an hour or so. This will give it time to get up to its usual operating temperature. For best results, turn down the lights in the room and block any reflections or glare that might be striking the monitor.

Set your desktop background or pattern to a neutral gray. (When you do any precise color manipulation or editing, you should set your desktop to gray to keep your eyes from getting confused.) If you want to get really picky, it's a good idea to move any large, brightly colored objects out of your field of view. In general, you want your working space to be neutrally colored.

Before you invest too much in calibration hardware, remember that not every monitor is capable of being calibrated. If your monitor lacks controls for altering contrast and brightness, then you probably won't have much luck calibrating it. In general, you won't have much calibration latitude on laptop displays, iMacs, Apple Cinema Displays, and other affordable LCD screens. CRTs fare much better, as do high-end LCD screens.

Software

These days, even lay people understand that digital image editing software can do things that would have been incredibly difficult or impossible in a traditional darkroom. People who have never picked up a digital camera will speak of images being "Photoshopped." And while it's true that good image editing software is now an essential part of the photographer's toolkit, it's important to understand that corrections and adjustments are just one part of your postproduction process.

Sorting, organizing, and selecting your choice images is often a bigger chore than any type of special effects or digital correction. In fact, as we'll discuss throughout the remainder of this book, if you do your job right while you're shooting, then you won't have to do much, if any, correction and manipulation later.

We'll discuss postproduction in detail in the second half of this book; however, the basic workflow goes like this: import your images from your camera or media card, identify the select images that you think are the keepers, apply metadata and keywords to your images to ease organization, adjust and correct your selects, output your images, back up and archive.

There are a lot of image editing applications out there, but still the most feature-laden and time-tested is Adobe Photoshop. The tutorials in this book will be built around Photoshop, and a demo version of the program can be downloaded from Adobe's Web site. I chose Photoshop for these demos because it's an excellent image editor, but also because when it comes to specific types of edits, you'll find that most other image editors use Photoshop-like controls. So the things you'll learn in Photoshop will apply to most other editing tools. Even if you don't go on with Photoshop, the lessons you learn in this book should carry over to other image editing programs.

However, there are a lot of applications out there that can help with various parts of your postproduction process. Over the next few pages, I'm going to give you a brief overview of the postproduction landscape. You'll learn about the workflow issues you'll face and what tools are available to help with these issues.

Two Approaches to Workflow

When it comes to choosing software (and an overall workflow approach), you have two choices. The first is a "manual" process that uses a few different applications in conjunction with your computer's file manager. In this approach, you will use the following procedures:

- Copy images to your computer.

- Organize your images by placing them in folders. Using the file manager on your computer, you can find, move, copy, and rename images, and perform any other organizational tasks.

- Use browsing software to view thumbnails and previews of all of the images in a folder.

- Launch images from your browser or open images from your file manager into an image-editing application.

- Output your images and then back up and archive the files using backup software or your program's file manager.

Alternatively, you can use a dedicated workflow application. Programs like Adobe Photoshop's Lightroom and Apple's Aperture and iPhoto take care of importing and organizing for you, giving you a one-stop location for organizing, editing, backup, and more. Dedicated workflow applications include image editing features, and often these are all of the editing tools you need to get the job done. To facilitate working with other programs, such as Photoshop, these tools also allow you to launch images directly into another application.

The advantage of the first, manual approach is that it provides tremendous flexibility. You can organize images however you want, and use any tool you like for any part of your workflow. The advantage to the second approach is that it might be easier if you're not comfortable with managing files on your own.

In the section that follows, we'll take a quick look at some of the applications you'll need if you want to piece together a workflow using the first approach.

Browsing and Cataloging Applications

While your file manager might provide good tools for copying, moving, deleting, and organizing files, it probably doesn't provide much of a facility for previewing images. With a browser application, you can view a folder of images as thumbnails, rather than as simple file names and icons. These thumbnails can usually be made larger or smaller, and most browsers also provide a way to view a larger preview.

Browser applications typically provide a lot of other image-related utility features, such as image rotation, batch renaming, metadata viewing and editing, and the capability to create folders and move and copy files. Many browsers also offer import features, raw conversion, and batch-processing capabilities that allow you to speed up your workflow. Some browser programs provide limited image editing and correction tools, but most assume that you'll perform serious editing in a separate, dedicated image editing program.

A browser serves as a halfway point between your file manager and image editor. While a browser provides viewing, editing, and metadata controls that aren't available in your file manager, it still relies on the directory system and file architecture provided by your OS. In other words, it's just a different way of viewing the folders and documents that you see in file manager. You can think of it as a more photo-friendly front end. By comparison, workflow applications like Lightroom and Aperture maintain their own database of images and file structure, and they manage the copying, moving, and organization of images for you.

If you don't want to commit to a workflow application like Lightroom or Aperture, then a browser program will be an essential tool for viewing, sorting, and launching images into your image editor. Some cross-platform browser applications include the following:

- **Adobe Bridge,** which has shipped with Photoshop since version CS2, offers all of the browser features you'd expect, wrapped up in an interface that integrates seamlessly with the other apps in the Adobe Creative Suite (Photoshop, Illustrator, InDesign, and so on). What's more, it provides access to Photoshop Camera Raw for raw conversion and offers excellent batch-processing capabilities. Bridge CS4 and CS5 are excellent workflow tools, and we'll learn more about them when we talk about workflow applications.

- **Camera Bits Photo Mechanic** provides most of the features you'd want in a browser, including capturing, renaming, raw conversion, metadata editing, and much more. In addition, the program provides batch processing features, the ability to import from multiple cards simultaneously, and extremely fast performance. If you work on short deadlines or have older hardware, Photo Mechanic's speedy performance might be the deal-making feature for you.

A cataloging application allows you to create a catalog of any folder or volume. Because you ultimately might end up with more images than you have hard drive space for, you'll want to organize images onto different hard drives or recordable disks. A cataloging application provides you with a way of keeping track of which images are located where. You can browse through thumbnails in the catalog to find the image you're looking for, and the catalog will list the location of the image. You can then go find that particular volume—be it a hard drive or recordable disk—and retrieve the image.

Cataloging applications typically provide extensive mechanisms for editing the metadata of images, as well as tools for searching and sorting images based on this metadata. You can also share catalogs with friends or coworkers so that they can browse your library.

Some very good cross-platform catalog programs that provide all the expected cataloging features include the following:

- **Extensis Portfolio,** which offers excellent features including the ability to view full-screen previews of any cataloged image, support for dozens of raw formats, batch file conversion features, one-click CD archiving, folder syncing, and excellent Web publishing features.

- **Microsoft Expression Media 2** also provides excellent cataloging features with superb Web output, very speedy performance, the ability to create stand-alone viewer documents, and much more (see Figure 4.5). Curiously, the package is now sold by Phase One software, under the name Microsoft Expression Media. You can find it at *www.phaseone.com/expressionmedia2.*

- **Canto Cumulus** is a high-end cataloging system that offers a sophisticated client/server architecture that is ideal for workgroups and large publishing organizations. If you want to create complex multiuser photo/print production workflows, then Cumulus might be the tool for you.

Figure 4.5

Microsoft Expression is a fine example of an image-cataloging program. With it, you can easily create catalog documents of folders, hard drives, or CDs and DVDs.

Image Editing Applications

Everyone knows you can use an image editing program like Photoshop to make wild changes to an image. Of course, what you'll use it for the most are less obvious edits. Cropping, and tone and color adjustments, and maybe the occasional retouching are the editing tasks you'll perform the most.

However, even what appear to be "simple" color and tone adjustments can be hard to pull off, which is why an advanced image editor provides so many different ways of making these adjustments. In addition to the adjustments just mentioned, you might also want the capability to make edits to just one part of an image, to stitch panoramic images, and more.

Here are a few of your image editing options:

■ **Adobe Photoshop.** This program is the standard-bearer for advanced image editors. Photoshop offers an enormous selection of tools, wrapped up in a very good interface, and all of it is built on top of an excellent color engine that yields professional-quality results. You'll be hard-pressed to find a feature that Photoshop doesn't have, and if you do manage to find one, you'll probably be able to hunt down a third-party Photoshop plug-in that adds that feature to the program. While this depth of functionality makes Photoshop hard to beat in head-to-head feature comparisons, it also makes for a program that can be fairly intimidating.

Photoshop is not just for photographers. The program has extensive Web development features, prepress tools, compositing and special effects features, scientific analysis features, and more. The fact is, most photographers don't need the bulk of the features included in the program. Fortunately, if you keep this in mind as you learn Photoshop,

you should find that you can safely ignore the features you don't need, and you can easily customize Photoshop's interface to hide the features you don't want.

Photoshop is an industry unto itself, so you should have no trouble finding all sorts of resources for learning the program, from books to Web sites, to training videos to classes. Also, Photoshop comes bundled with Bridge, making the package a complete workflow solution.

- **Photoshop Elements.** This is a stripped-down, under-$100 version of Photoshop that offers all of the essential photography features that you'll need. Photoshop Elements uses an interface similar to Photoshop CS's interface, so you get all of the advantages of Photoshop's UI design and most of the higher-end package's most important features and performance characteristics. What you *don't* get are some tools that you may or may not need. For example, Elements lacks the capability to work with CMYK images—the type of images you need to create if you're going to output to a professional offset press. You also cannot use Elements to edit and view individual color channels. As you'll see later, this can be important because channel editing is a necessary feature for creating certain types of effects. Finally, Elements does not include some of Photoshop CS's more advanced editing tools such as high-end masking tools and automation capabilities.

Elements is a great way to get into Photoshop. If you need more power later, you can always upgrade to the full version, which shares most of the Elements interface.

- **Nikon Capture NX.** While Nikon has offered a version of Capture for years, that program was intended simply as a raw converter. Nikon Capture NX allows you to process Nikon raw files, but it also lets you work with TIFF and JPEG images. Capture NX provides all of the editing power that most users will need, and it wraps up this power in a unique interface that combines nondestructive editing with some unique selective-editing tools (see Figure 4.6). The biggest strength of Capture NX is that you don't have to hassle with complex masking tools. Using the program's powerful UPoint tools, you can create sophisticated masks with just one or two clicks. If you're new to image editing, you'll find Capture NX's selection tools far easier to use than Photoshop, while experienced editors will probably be surprised at how much faster Capture NX's masking tools are to use.

Figure 4.6

Nikon's Capture NX provides unique, excellent editing tools that will appeal to any users who like to make selective edits. Not just for Nikon users, Capture NX can read and write TIFF and JPEG files.

If you use a non-Nikon camera and like to shoot raw, then you'll still need a raw converter application, but you may find that Capture NX is a great addition to your digital arsenal.

What About the Software That Shipped with My Camera?

Most cameras ship with some combination of image editing, importing, and image-browsing software. If your camera can shoot in raw format, then it might also include a raw conversion program of some kind. Some cameras are bundled with popular apps such as Photoshop Elements, but most include proprietary applications developed by the camera manufacturer.

In general, it's safe to say that these bundled apps are not as good as many inexpensive third-party alternatives. However, if you can't afford or don't have access to other applications, the bundled software will probably work fine.

Nondestructive Editing

Earlier, you learned that an image is composed of a number of pixels represented by numeric values. In most image editors, when you make an adjustment, the color values of the adjusted pixels are altered to reflect your changes. In a *nondestructive editing* system, actual pixel values are never altered. Instead, a description of any edit that you make is stored in a list. Any time the computer needs to display, output, or print the image, the original pixel values are processed according to the instructions stored in the list of edits (see Figure 4.7).

Figure 4.7 In a nondestructive editing system, all edits that you make are kept in a list. In real time, the editing software takes your original image data, processes it according to the instructions in the list, and then outputs it to whatever destination you need. This process happens continuously as you make edits and changes.

The advantage of a nondestructive editing system is that you can undo any edit at any time. You can also go back and alter the *parameters* of any edit at any time, making a nondestructive system far more flexible than a destructive editor. Photoshop's Adjustment Layers (which you'll learn about in detail later) are a form of nondestructive editing. Apple's Aperture, Adobe Photoshop Lightroom, and Nikon Capture NX offer completely nondestructive editing.

Why You Want a Pressure-Sensitive Tablet

If you routinely use the paint brush, rubber stamp (clone), or dodge and burn tools in your image editor, or if you do a lot of masking work, then you should seriously consider investing in a pressure-sensitive tablet. Tablets like the Wacom Bamboo Pen shown in Figure 4.8 provide a drawing surface and electronic stylus that do a great job of mimicking the experience of working with real-world tools.

With a pressure-sensitive stylus, when you push harder your brush gets bigger, or changes color, or becomes more opaque, all depending on how the software you're using is configured.

Some people find the "look at screen/draw on lap or tabletop" coordination to be a little confusing at first, but after only one or two sessions, you'll wonder how you ever managed to paint with a mouse or trackpad.

Wacom is the market leader, and with good reason. Their tablets are incredibly well designed and include excellent software. What's more, all the major image editing applications support Wacom's pressure sensitivity.

Figure 4.8

A pressure-sensitive tablet like this Wacom Bamboo Pen makes any brush, retouching, or masking operation much easier.

Workflow Applications

Workflow applications help you with the sorting, cataloging, organization, and archiving of your images, provide image editing tools of their own, and also give you a way to launch into the editing phase of your workflow. With a workflow application, you won't need a browser or cataloging application, and you will probably spend less time in the file manager of your operating system. Listed below are descriptions of the most popular workflow applications.

- **Adobe Bridge CS5.** Bridge has been around for a while, and has always offered good browsing features, meaning you can point Bridge at a folder, and quickly see thumbnails of all of the images contained within (see Figure 4.9). Bridge also lets you copy and move files, see large previews, compare images, zoom in close to assess fine details, and much more. With Bridge, you can quickly launch images into Photoshop and batch-process your images, making it simple to apply the same edits to huge groups of images. In Bridge CS5, Adobe has also added the capability to build virtual albums (called *Collections*), providing a way to keep your library organized as it grows. With its tight integration with Photoshop, speedy performance, great interface, and full feature set, Bridge CS5 is an excellent work-flow tool. Bridge currently ships with Adobe Photoshop CS5 and Adobe Photoshop Elements for the Mac. (Note that earlier versions of Bridge lacked the Collections feature that made them complete workflow tools.) For more details on how to build a workflow around Bridge CS5, check out *www.completedigitalphotography.com/bridgecs5*.

Figure 4.9

Bridge CS5 provides everything you need to build a complete workflow around Adobe Photoshop.

- **Photoshop Lightroom.** Available for both Mac and Windows, Photoshop Lightroom offers importing, sorting, comparing, organizing, keywording, editing, raw conversion, Web page output, and printing, all in a single application that provides different virtual "rooms" for each task (see Figure 4.10). Lightroom's strongest advantages are an entirely nondestructive editing approach, and the fact that it's built around Photoshop Camera Raw for raw conversion. This means that it supports a tremendous number of raw for-mats and provides all the tools you expect to find in a good raw converter.

Current users of Photoshop Camera Raw will find it easy to switch to Lightroom, while the huge number of third-party Web sites and books devoted to the product make it possible for novices to get up to speed quickly.

On the downside, Lightroom insists on managing your library for you, which can com-plicate the process of getting images into Photoshop for editing.

Figure 4.10

Adobe Photoshop Lightroom provides a single application that offers an integrated environment for importing, sorting, applying metadata, editing, and output.

You can download a free 30-day, fully functional trial version of Lightroom for Mac or Windows at *www.adobe.com/go/trylightroom*.

- **Aperture.** Apple invented the photography workflow genre with Aperture (you might even be able to argue that they invented it with iPhoto), a Mac-only product that combines all of the expected workflow features, including nondestructive editing, and adds book printing, automatic backup, tethered shooting, multicard importing, scriptability, and more. Aperture's raw converter is first-rate and includes good editing tools (see Figure 4.11). Its biggest strength is its exceptional interface, which allows for a fluid, ever-changing workflow. With Aperture, you're never stuck in any particular mode, making it easy to work the way you want to work and the way that is best for the particular images that you're processing.

Figure 4.11

Apple's Aperture offers a full assortment of workflow tools wrapped up in an excellent, fluid, nonmodal interface.

Like Lightroom, Aperture suffers from the enforced library that it imposes on you. In addition to complicating the process of getting images into Photoshop, things can be very complicated if you ever decide to stop using Aperture.

Aperture performs much of its editing work using the graphics-processing unit on your computer's video card. As such, it's very important to check that your Mac is Aperture compatible. A free 30-day trial version is available for download at *www.apple.com/aperture*.

Upgrade Complications

One thing to be aware of with Aperture and Lightroom is that if your computer runs out of disk space and you add additional drives, your library management will become more complicated with both programs. In addition, if you upgrade later to a new computer, moving and reorganizing your library can be confusing. Neither program is especially adept at handling large libraries that span multiple hard drives, and if you're not careful, it's possible to lose track of images.

Apple iPhoto

If you're a Mac user, you have another workflow management option in the form of iPhoto. Bundled free with all new Macs, or available separately as part of iLife (which includes video editing, DVD authoring, and blogging software), iPhoto is a very good image management, editing, organization, and output tool (Figure 4.12). Rather like "Aperture lite" iPhoto provides all of the workflow management features that most users will need, including importing, organizing, keywording, editing, and output. iPhoto supports JPEGs and raw files, providing you with the same workflow no matter what type of file you're working with. If you're a Mac user, it's worth giving iPhoto a close look before you invest in any additional software.

Figure 4.12 Apple's iPhoto is bundled with all Macs and provides an excellent workflow and editing solution. Because it's free and very capable, it's worth taking a close look at iPhoto before investing in other software.

Raw Converter Compatibility

If you plan on using raw, then you'll need to be sure that your raw conversion or workflow application supports your particular camera. A raw converter must have a special profile for each specific type of raw-capable camera. If your application doesn't specifically say that it works with the raw files from your camera of choice, then you'll need to consider a different program. Right now, Photoshop Camera Raw (which is built into Photoshop, Photoshop Elements, and Photoshop Lightroom) supports far more camera types than any other converter, though any of the major raw conversion apps will support all of the popular cameras.

Most software vendors are diligent about releasing updates to support cameras as they're released, but it can sometimes take a while for these updates to appear.

Other Software

Finally, there might be other utilities and applications that you'll find a use for. Panoramic stitching software can be used to turn multiple shots into a single, wide panorama; special high dynamic range software can be used to turn multiple exposures into a single image with expanded dynamic range; file recovery software can be used to recover images from cards you've accidentally erased. We'll cover all of these in more detail throughout this book.

Importing Images

Every image you shoot is stored on your camera's media card as an individual file. The file is a document just like you might create on your computer. Importing (some people call this step *ingesting*, but that sounds a little too biological for me) is simply the process of copying those image files from your camera's media card to your computer. To import, you can connect your camera to your computer via a cable (usually USB-2) or take the media card out of your camera and put it into a media card reader attached to your computer.

Card Readers

Depending on the type of reader, a media card reader can be faster than plugging your camera into your computer, and it doesn't drain your camera battery. Also, most card readers support lots of different formats, so if you have more than one camera (say, an SLR and a small point-and-shoot) that use different formats, then you need to carry only one card reader and a cable.

Check Your SD and CompactFlash Reader Carefully

If you're shopping for an SD card reader, be aware that some cameras that support SD also support a newer, faster, higher-capacity format called *SDHC*. If you're using any SDHC cards, you'll need to be sure to get a reader that can read SDHC. Similarly, if you use UDMA CompactFlash cards, you'll want to be sure to get a UDMA card reader.

Handling an Unreadable Card

Sometimes, you might find that a card that has always worked fine in your card reader suddenly doesn't read. If this happens, put the card back in the camera and see whether you can view images on the camera's screen. If you can, then you know that the camera can read the card just fine. Plug the camera into your computer and try transferring the images that way. It will usually work. When you're done, format the card. This will usually get the card working with your card reader again.

Multi-Card Importing

Photo Mechanic and Aperture allow you to import from multiple card readers simultaneously. You'll need card readers that can be daisy-chained together, like the Lexar Professional CompactFlash Readers. Load up the card readers and both programs will cycle through each reader, importing as normal. Multicard import allows you to perform a massive amount of importing without having to babysit your computer.

Transferring Images to a Windows XP or Vista Computer

Microsoft Windows XP and Vista will take care of a lot of image transfer hassles for you. In fact, you can easily customize your transfer experience to build the type of workflow that you like.

The first time you plug a card reader or camera into Vista or XP, Windows might make some kind of mention of installing a new driver (see Figure 4.13).

On-screen instructions will guide you through the process of getting the camera or card reader working. Once configured, Windows will show you a simple window that lets you specify what you want done with the images on the card (see Figure 4.14).

Figure 4.13

When you plug in a card reader for the first time, Windows might tell you it's installing a new driver.

Figure 4.14

In Windows, you can choose what you want to have happen when you plug in a card reader or camera.

In the window shown in Figure 4.14, you'll find the following controls.

- **Import Pictures.** Click this to copy the images on your card to a specific directory on your hard drive. By default, it copies into your Pictures directory. Import pictures also gives you an option to add a text tag to your images, which makes it easier to sort and filter your images later.

 After your images have been imported, you'll see them in Windows Photo Gallery.

- **View Pictures Using Windows.** Click this button to open the images in the Windows Photo Gallery. Here, you can look through large thumbnails of your images. The menu at the top enables you to import the images, print them, or even perform simple image edits.

- **View Pictures Using Windows Media Center.** This option lets you see the images on the card in the Windows Media Center (see Figure 4.15).

- **Finally, notice the "Always do this for pictures" checkbox at the top of the dialog box.** This enables you to specify default behavior for a card insertion.

Figure 4.15

Windows Media Center's full-screen environment lets you view images, present slide shows, and more.

If you think you can manage your entire postproduction workflow in Windows Gallery or Windows Media Center, these are good options. If you plan on using other software, you can still use the Import Pictures command to copy your images to a directory.

Alternately, you might want to use the Open folder to view files using Windows Explorer option, which gives you the chance to manually copy the files using Windows Explorer. After you've copied them, you can work with them using your choice of programs.

Transferring Images to a Windows 7 Computer

In Windows 7, when a camera or card reader is plugged in, you'll see the dialog box shown in Figure 4.16.

The "Import pictures and videos" option copies images from your camera or media card to the Pictures directory, and allows you to customize the import process. After the import is complete, the pictures are displayed on the *Imported Pictures and Videos* screen (Figure 4.17).

Clicking on one of the images on this screen will open the Windows Photo Viewer, which allows you to view all of the pictures in the directory (Figure 4.18).

Figure 4.16

Windows 7 presents this dialog box when a camera or media card is attached.

Figure 4.17

After importing, your images are shown in the Imported Pictures and Videos viewer.

Figure 4.18

Clicking on a thumbnail brings up the Windows Photo Viewer.

Changing Media Card Preferences

If you set an "Always do this for pictures" option and decide later that you want to change it, go to the Start Menu, choose Control Panel, and then select Hardware and Sound. Find the AutoPlay section on the following screen and click Change default settings for media or devices. Here, you can edit the Pictures category to select a different option, or choose "Ask me every time" to get Windows to present you with a dialog box of choices.

Using Adobe Photo Downloader

Adobe Photoshop Elements and Adobe Photoshop CS both include a Photo Downloader application that you can configure to launch automatically when a camera or card reader is attached to your computer.

Photo Downloader lets you choose a location to store your files, and it can automatically create subfolders based on the date and time stamp of each image. Photo Downloader can also rename your images from the meaningless names your camera creates to something more intelligible.

If you use a Photoshop-based workflow, this might be the way to go.

Transferring Images to a Macintosh Computer

Transferring images to your Mac is very simple, and you have a number of options for determining what happens when you attach the camera or card reader.

Depending on when you bought your Mac, you might have a copy of iPhoto, Apple's image organizing and editing program. iPhoto is very good, and can handle the transfer of images from your media card, and help you with the rest of your workflow, from organizing to editing to output. Be aware that iPhoto imports your images into its own library system. If you want to manage the location of your images on your own, then you'll want to skip iPhoto.

If your Mac doesn't have it, you can buy the latest version as part of the iLife collection from any vendor that sells Apple products.

Every Mac ships with a copy of Image Capture, a utility that helps manage the transfer of images into your computer. Image Capture has no editing or organizational features—its sole purpose is to get images copied onto your hard drive. Once they're there, you can decide what to do with them.

Configuring Your Mac for Image Transfer

You can tell your Mac what you want to have happen when you plug in a camera or a media card reader. This makes it simple to choose what software you want to use to transfer your images.

In your Applications folder there should be a program called *Image Capture*. By default, it will open automatically any time you plug in a camera or card reader, and will present a window for managing the transfer of images (see Figure 4.19).

Figure 4.19

All Macs ship with Image Capture, which provides a simple way to manage the transfer of images from a camera or media card reader.

With Image Capture, you can choose where you want your images downloaded, and what to do after they've copied. If you press the Download Some button, you can even select specific images to copy.

Image Capture also lets you specify what you want your Mac to do when you plug in a card reader or camera. If you go to the Image Capture menu and choose Preferences, you'll see a pop-up menu that lets you select which application you want to have launched whenever a camera or a media card reader is plugged into your Mac.

The menu will list iPhoto (if you have it), Image Capture, and possibly other applications if you have them installed. If you have a program installed that you'd like to use, but you don't see it listed, choose Other. Image Capture will present you with a dialog box that allows you to pick the program you'd like to use.

Finally, if you'd like complete manual control, you can choose No Application.

Transferring Images Manually Using Windows or a Mac

For complete manual control of your image transfers, configure your computer to do nothing when a camera or card reader is plugged in. When you attach a card reader or camera, it will appear on your desktop (or in Windows Explorer on Windows), just as if it were a hard drive, leaving you free to copy files as you please.

The advantage to this approach is that it puts you in control of where files are placed, so you can create a folder structure on your drive that makes the most sense to you.

The downside is that, depending on which version of your operating system you're using, you won't necessarily be able to see thumbnail previews of your images before you transfer, which means you won't be able to pick and choose which images to copy. Obviously, you can always sort through them later.

To transfer images manually:

1. Plug in the camera or card reader.

2. When the camera or card reader icon appears on your desktop, open it up. You should see a folder inside called DCIM. There might be some other folders, but DCIM is the only one you need to worry about. It is the standard location that camera vendors have agreed upon for storing images.

3. Inside the DCIM folder, you will find additional folders, usually named with some combination of numbers and the make of your camera (i.e., "100NIKON"). Depending on how many images you've shot, there may be more. Open each folder and copy its contents to your desired location.

Renaming and Organizing

Depending on your workflow, your archiving scheme, and your final output needs, you might need to rename your image files. Your camera generates fairly meaningless names, of course, but if you'll be searching and sorting your images using any kind of thumbnail viewer, filenames may not be so relevant. But, if you like to search for specific images by filename, you'll probably want to rename them. Some people use elaborate naming schemes that include shoot dates, project numbers, and so on.

If you attach metadata and keywords to your images, which we'll explore later, filenames aren't so important, as you can search your image library for specific metadata tags. Similarly, if your operating system lets you search by date, you may not need to include dates in your naming schemes. The decision to rename might become easier for you after we've considered some of the other workflow steps.

Adobe Bridge provides very good batch renaming commands, as do Camera Bits Photo Mechanic, Nikon Capture NX, Apple Aperture, and Adobe Lightroom.

When it comes to organizing, you can choose to arrange your images into folders and subfolders using your file manager. Image browsers like Adobe Bridge and Photo Mechanic can help you with this step, too. Programs like iPhoto, Aperture, or Lightroom manage organization for you, so the underlying folder structure might not be so critical to your workflow with those applications.

Moving On

Obviously, there are a lot more details that have to be understood in order to make a functional photo workflow. The goal here was to help you understand an overview of what your workflow will ultimately be and provide you with enough information so that you can start transferring your images and reviewing them on your computer as we continue to study exposure, composition, and other fundamentals of photography.

In the next chapter, we're going to take a technical detour that will lay the foundation for some of the exposure work that we'll do in later chapters.

5

IMAGE SENSORS

How a Silicon Chip Captures an Image

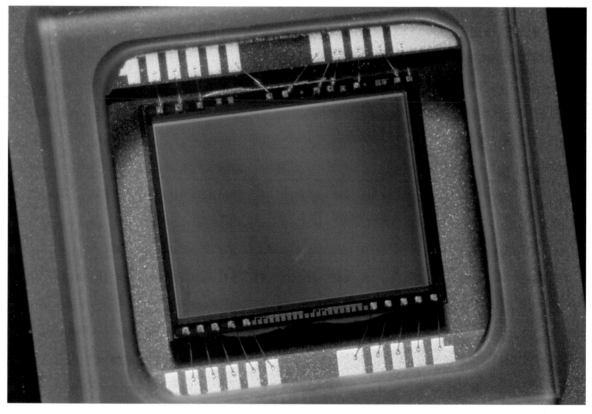

©iStockphoto.com/cullenphotos

I n the old days, photographers made their own photographic papers, films, and developing chemicals. Whether it was to achieve a particular style or texture or to gain more control over their printing processes, photographers such as Ansel Adams, Alfred Stieglitz, and Eduard Steichen had to know a good deal about chemistry to create their prints. Similarly, to really understand how to get the most out of your digital camera, it's important to understand some of the technology behind it. In this chapter, we're going to learn about how the image sensor inside your digital camera works, but first you need to have a basic understanding of the digitizing process.

The "real" world in which we live is an *analog* world. Light and sound come to us as continuous analog waves that our senses interpret. Unfortunately, it's very difficult to invent a technology that can accurately record a continuous analog wave. For example, you can cut a continuous wave into a vinyl record, but because of the limitations of this storage process, the resulting recording is often noisy, scratchy, and unable to capture a full range of sound.

Storing a series of numbers, on the other hand, is much simpler. You can carve them in stone, write them on paper, burn them to a CD-ROM, or, in the case of digital cameras, record them to small electronic memory chips. Moreover, no matter how you store them, as long as you don't make any mistakes when recording or copying them, you'll suffer no loss of data or quality as you move those numbers from place to place. Therefore, if you can find a way to represent something in the real world as a series of numbers, you can store those numbers very easily using your chosen recording medium.

The process of converting something into numbers (or digits) is called *digitizing*. The first step in digitizing is to divide your subject into distinct units. In the case of a digital camera, these units are called *picture elements*, or *pixels*. Your camera's image sensor is divided into a grid of pixels. When you take a picture, the sensor is exposed to light, and the light is sampled at each pixel in the grid. How fine your grid is (that is, what *resolution* it has) varies depending on the sophistication of your equipment.

Next, each pixel in the grid is analyzed to determine its content. Each sample is measured to determine how "full" it is; that is, a corresponding numeric value is assigned that represents that pixel's contents. Each of these values is processed by an analog-to-digital converter to produce a completely digital representation of the image. That means, a representation composed entirely of "digits" or numbers. Finally, these numeric values are stored on some type of storage medium.

Figure 5.1 is a simple image composed entirely of black-and-white pixels. As you can see, it's very easy to assign a 1 or a 0 to each pixel to represent the image. Because it takes only a single *bit* to represent each pixel, this image is called a *one-bit image*.

In the example shown in Figure 5.1, our individual samples can be only 0 or 1 because we are storing only one bit of information per pixel. If we want to record more than simple black-and-white images, we need to be able to specify more levels—that is, we need to have more choices than just 0 or 1. By going to a higher *bit depth*—let's say 8 bits, which allows for 256 different values—we can record more information, as seen in Figure 5.2.

With 256 shades from which to choose, we can represent a finer degree of detail than we could with only two choices. Capturing a full color image is more complicated, and you'll learn about that later in this chapter.

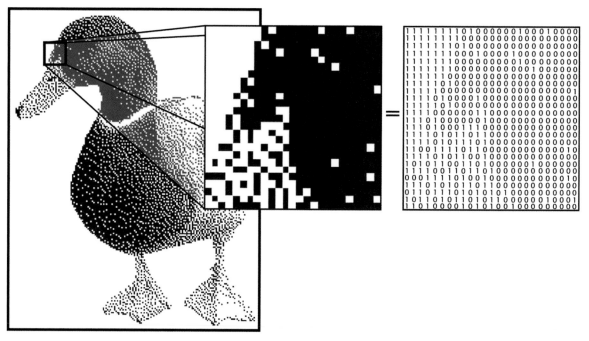

Figure 5.1 Each pixel in this one-bit image is represented by a 1 or a 0.

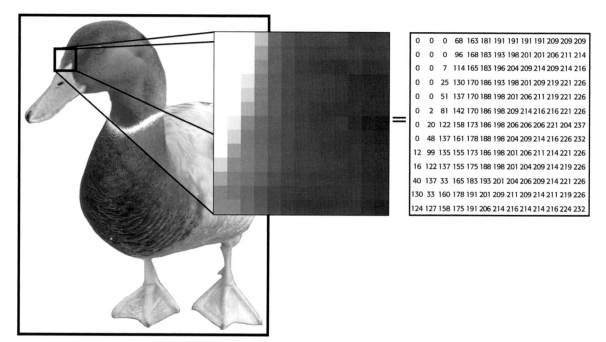

Figure 5.2 By storing bigger numbers for each pixel, we can store much more than simple black-and-white dots. With the ability to use gray pixels, the image looks much more realistic.

To sum up, two of the factors that determine the quality of a digitizing process are the number of pixels you capture and the dynamic range (how wide a range of levels you have for each pixel).

Many other factors affect the quality of a digitized image, from your camera's lens to its compression software. Before exploring these questions, let's look at how your camera manages all of this sampling, quantizing, and storage. Understanding how your camera perceives, captures, and stores color information will make certain types of editing operations easier later on.

How an Image Sensor Works

As you learned earlier, all cameras have certain things in common: they include a lightproof body, a lens, and a recording medium. In the 150+ years since the invention of photography, digital photography represents the first fundamental change in how a camera works. Sure, there have been a lot of advances along the way—color, roll film, light meters, autofocus, onboard flash, and much more—but through it all, the image was always recorded using a chemical process, usually onto a piece of celluloid film. Digital photography marks the first time that a nonchemical recording medium has been employed.

George Smith and Willard Boyle were two engineers employed by Bell Labs. The story goes that one day in late October, the two men spent about an hour sketching out an idea for a new type of semiconductor that could be used for computer memory and for the creation of a solid-state, tubeless video camera. The year was 1969, and in that hour, the two men invented the *charge-coupled device*, or CCD.

Roughly a year later, Bell Labs created a solid-state video camera using Smith and Boyle's new chip. Although their original intention was to build a simple camera that could be used in a video-telephone device, they soon built a camera that was good enough for broadcast television.

Since then, CCDs have been used in everything from cameras to fax machines. Because video cameras don't require a lot of resolution (only half a million pixels or so), the CCD worked great for creating video-quality images. For printing pictures, though, you need much higher resolution—millions and millions of pixels. Consequently, it wasn't until the mid-1990s that CCDs could be manufactured with enough resolution to compete with photographic film.

CCD Versus CMOS

Most of the digital cameras you see use CCD image sensors. The rest will use a CMOS chip of some kind. Because much more research has been put into CCD technology, it's more prevalent. CMOS chips are actually cheaper to produce than the difficult-to-make CCDs found in most cameras. CMOS chips also consume much less power than does a typical CCD, making for longer camera battery life and fewer overheating problems. CMOS also offers the promise of integrating more functions onto one chip, thereby enabling manufacturers to reduce the number of chips in their cameras. For example, image capture and processing could both be performed on one CMOS chip, further reducing the price of a camera.

These days, most higher-end SLRs use CMOS chips. Both types of sensors register light in the same way, and for the sake of this discussion, the two technologies are interchangeable.

Counting Photons

The image sensor in your digital camera is a silicon chip that is covered with a grid of small electrodes called *photosites*, one for each pixel (see Figure 5.3.). Each photosite contains a photodiode (as mentioned in Chapter 1, "Eyes, Brains, Lights, and Images") along with other electronic components, depending upon the type of sensor.

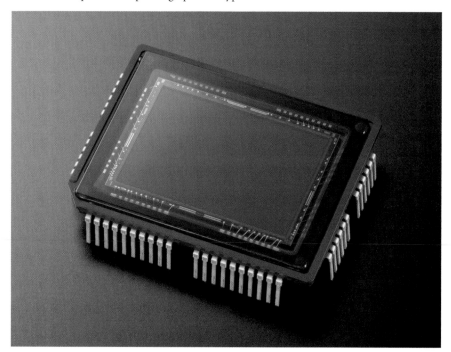

Figure 5.3

The sensor from a Nikon D70 has an imaging area of 23.7mm by 15.6mm.

When you turn your camera on, it places a uniform charge, or voltage, onto each photodiode on the surface of its image sensor. When light strikes a particular photosite, it causes the photodiode to lower some of its charge. The amount that the charge is lowered is directly proportional to the number of photons that strikes the photodiode.

By measuring the reduction in voltage at a particular photosite, your camera is able to determine how much light hit that particular site during the exposure. As described previously, this measurement is then converted into a number by an analog-to-digital converter.

Most cameras use either a 12-bit or 14-bit analog-to-digital converter, which means that the value from each photosite is converted into a 12- or 14-bit number. In the case of a 12-bit converter, this produces a number between 0 and 4,096; with a 14-bit converter, you get a number between 0 and 16,384. Note that an analog-to-digital converter with a higher bit depth (one with a wider range of numbers) doesn't give your sensor a larger dynamic range. The brightest and darkest colors the sensor can represent remain the same, but the extra bit depth does mean that the camera will produce finer gradations within that dynamic range. As you'll see later, how many bits get used in your final image depends on the format in which you save the image.

The term *CCD* is derived from the way the camera reads the charges of the individual photosites. After exposing the CCD, the charges on the first row of photosites are transferred to a read-out register where they are amplified and then sent to an analog-to-digital converter. Each row of charges is electrically coupled to the next row so that, after one row has been read and deleted, all of the other rows move down to fill the now empty space (see Figure 5.4).

In a CMOS sensor, each photosite can be read individually without the need for shifting.

Photosites are sensitive only to how much light they receive; they know nothing about color. To achieve color, some additional computing is required.

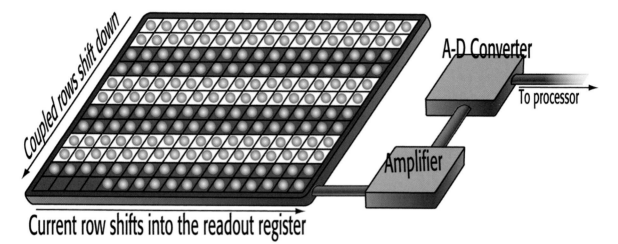

Figure 5.4 Rows of photosites on a CCD are coupled together. As the bottom row of photosites is read off the bottom of the CCD, all of the rows above it shift down. This is the "coupled" in charge-coupled device.

A Little Color Theory

In 1869, James Clerk Maxwell asked photographer Thomas Sutton (the inventor of the SLR camera) to take three black-and-white photographs of a tartan ribbon. Maxwell wanted to test a theory he had about a possible method for creating color photographs. He asked Sutton to place a different filter over the camera for each shot: first, a red filter; then a green; and then a blue. After the film was developed, Maxwell projected all three black-and-white pictures onto a screen using three projectors fitted with the same filters that were used to shoot the photos. When the images were projected directly on top of each other, the images combined and Maxell had the world's first color photo.

Needless to say, this process was hardly speedy or convenient. Unfortunately, it took another 30 years to turn Maxwell's discovery into a commercially viable product. This happened in 1903, when the Lumière brothers used red, green, and blue dyes to color grains of starch that could be applied to glass plates to create color images. They called their process *autochrome*, and it was the first successful color printing process.

If you read Chapter 1, then those three colors should be familiar to you; they're the additive primaries of light, which can be mixed together to create all other colors. They're also the same three primaries that your eyes are sensitive to.

Note that Maxwell did not discover light's additive properties. Newton had done similar experiments long before, but Maxwell was the first to apply the properties to photography.

A digital image is composed of three different black-and-white images, which are combined to create a full-color image.

The image shown in Figure 5.5 is called an *RGB* image because it uses red, green, and blue channels to create a color image.

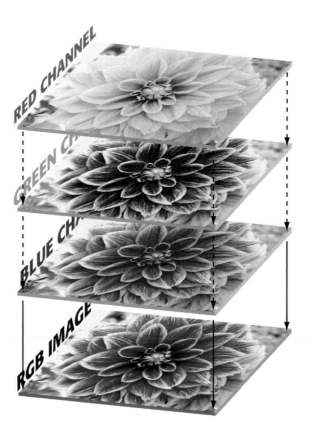

Figure 5.5

In a digital image, three separate red, green, and blue channels are combined to create a final, full-color picture.

This story is not just a trivial history lesson. Understanding that your full color images are composed of separate channels will come in very handy later when you start editing. Very often, you'll correct color casts and adjust your images by viewing and manipulating individual color channels.

You Say "Black and White," I Say "Grayscale"

Although film photographers use the term *black and white* to denote an image that lacks color, in the digital world it's better to use the term *grayscale*. A black-and-white image would be one that contained only black or white pixels, which is different from an image that is made up of varying shades of gray.

In the century and a half since Maxwell's discovery, many other ways of representing color have been discovered. For example, another model called *L*A*B color* (also known as *Lab color*) uses one channel for lightness information, another channel for greenness or redness, and a third channel for blueness or yellowness. In addition, there is the cyan, magenta, yellow, and black (CMYK) model that printers use.

Each of these approaches is called a *color model*, and each model has a particular *gamut*, or range, of colors it can display. Some gamuts are more appropriate to certain tasks than others are, and all are smaller than the range of colors your eye can perceive.

We'll deal more with gamuts and color models in later chapters. For now, it's important to understand that digital photos are made up of separate red, green, and blue channels that combine to create a color image.

Interpolating Color

By measuring photons, an image sensor can determine how much light struck each part of its surface. The data that comes off the sensor doesn't contain any information about color. At its heart, an image sensor is a purely grayscale device. To produce a color image, it must perform a type of interpolation (which is a fancy word for "very educated guess").

Each photosite on your camera's image sensor is covered by a filter—red, green, or blue. This combination of filters is called a *color filter array*, and most image sensors use a filter pattern like the one shown in Figure 5.6, called the *Bayer Pattern*.

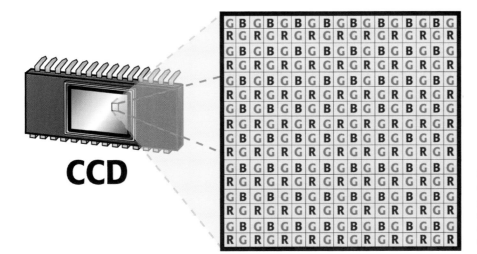

Figure 5.6

To see color, alternating pixels on an image sensor are covered with a different colored filter. The color filter array shown here is called the Bayer Pattern.

With these filters, the image sensor can produce separate, incomplete red, green, and blue images. The images are incomplete because the red image, for example, is missing all of the pixels that were covered with a blue filter, whereas the blue filter is missing all of the pixels that were covered with a red filter. Both the red and blue images are missing the vast number of green-filtered pixels.

The camera can calculate the color of any given pixel by analyzing all of the adjacent pixels. For example, if you look at a particular pixel and see that the pixel to the immediate left of it is a bright red pixel, the pixel to the right is a bright blue pixel, and the pixels above and below are bright green, then the pixel in question is probably white. Why? As you learned earlier, if you mix equal amounts of red, green, and blue light together, you get white light. (By the way, if you're wondering why there are so many more green pixels than red or blue pixels, it's because the eye is most sensitive to green. Consequently, it's better to have as much green information as possible.)

This process of interpolating is called *demosaicing*, and different vendors employ different approaches to the demosaicing process. For example, many cameras look at only immediately adjacent pixels, but some cameras analyze a region up to 9 × 9 pixels. The Fuji SuperCCD eschews the grid pattern of square photosites in favor of octagonal photosites arranged in a

honeycomb pattern. Such a scheme requires even more demosaicing to produce rectangular image pixels, but Fuji claims this process yields a higher resolution. Differences in demosaicing algorithms are one factor that makes some cameras yield better color than others.

Some cameras use a different type of color filter array. Some use a cyan, yellow, green, and magenta filter, while others use a red, green, blue, and emerald filter. These require demosaicing, just like an RGB filter.

After the demosaicing process is complete, each pixel is now a full-color sample, which can be represented as some combination of red, blue, and green components. Typically, each of these components is represented as an eight-bit number; thus, a full-color image requires 24 bits per pixel.

As you've seen, image sensors are often very small, sometimes as small as 1/4 or 1/2 inch (6 or 12mm, respectively). By comparison, a single frame of 35 mm film is 36 × 23.3mm. The fact that image sensors can be so small is the main reason why digital cameras can be so tiny.

By packing more and more photosites onto an image sensor, chipmakers can increase the sensor's resolution. However, there is a price to pay for this. To pack more photosites onto the surface of the chip, the individual sites have to be made much smaller. As each site gets smaller, its capability to collect light is compromised because it simply doesn't have as much physical space to catch passing photons. This limitation results in a chip with a poor *signal-to-noise ratio*; that is, the amount of good data the chip is collecting—the signal—is muddied by the amount of noise—noise from the camera's electronics, noise from other nearby electrical sources, noise from cosmic rays raining down from space—that the chip is collecting.

In your final image, this signal-to-noise confusion can manifest as grainy patterns in your image—visible noise like what you see on a TV channel with static—or other annoying artifacts.

To improve the light-collecting capability of tiny photosites, some chipmakers position tiny microlenses over each photosite. These lenses focus the light more tightly into the photosite in an effort to improve the signal-to-noise ratio. However, these lenses can cause problems of their own in the form of artifacts in your final image.

Image sensors suffer from another problem that film lacks. If too much light hits a particular photosite, it can spill over into adjacent photosites. If the camera's software isn't smart enough to recognize that this has happened, you will see a *blooming* artifact (smearing colors or flared highlights) in your final image. Blooming is more prevalent in a physically smaller image sensor with higher resolution because the photosites are packed more tightly together. This problem is not insurmountable, and even if your image does suffer from blooming problems from time to time, these artifacts won't necessarily be visible in your final prints.

Extra Pixels

Not all of the photosites in an image sensor are used for recording your image. Some are used to assess the black levels in your image; others are used for determining white balance. Finally, some pixels are masked away altogether. For example, if the sensor has a square array of pixels but your camera manufacturer wants to create a camera that shoots rectangular images, they will mask out some of the pixels on the edge of the sensor to get the picture shape they want.

Turning Data into an Image

Before the light from your lens ever strikes the sensor, it is passed through several filters. These include an infrared filter (some cameras use a very slight infrared filter, making them ideal for infrared photography, as you'll see later) and a low-pass filter. The infrared filter prevents false colors, which can be caused by infrared light that is not visible to the human eye. The low-pass filter helps prevent artifacts (such as moiré patterns) from being created during the digitizing process. This low-pass filter applies a slight blur to your image. Many photographers turn pale when they hear this, particularly those who have just spent lots of money on very sharp lenses. But, as we will see, this softening can be corrected later, either in the camera or during postprocessing.

After you take a picture, the data is read off the image sensor, amplified, passed through an analog-to-digital converter, and then passed to your camera's onboard processor. There, it is demosaiced to produce a color image. However, straight demosaicing does not produce an accurate, attractive color image. A little more calculation is required by the camera's onboard computer.

Colorimetric Adjustment

First, the image goes through a "colorimetric adjustment." During demosaicing, the camera's processor knows that a particular pixel was red or green or blue (or whatever colors are used in the color filter array), but it doesn't know which precise shades of those primary colors were used in the filters. So the color needs to be skewed slightly to compensate for the specific color qualities of the color filter array.

Color Space Conversion

At this stage, your camera knows a lot about what color each pixel in your image is. For example, it might know that one particular pixel is 100 percent of a particular shade of chartreuse. But what exactly does 100 percent mean? For this number to be meaningful, some boundaries need to be defined, so your image is mapped into a *color space*.

A color space is simply a mathematical model that can be used to represent colors. Some color spaces are larger than others, and so might allow for more variation in a particular color—reds, for example. Without a color space, your image would be a fairly meaningless array of numbers. Your camera probably provides a choice of two different color spaces: sRGB and Adobe RGB. You'll learn much more about color space choices later.

Gamma Correction

In an imaging chip, when twice as much light hits a single pixel, twice as much change in voltage is produced. In other words, the response of the pixels to light is linear—increase the light and you get a linear change in voltage. Your eyes don't work this way. When you increase brightness, your eyes register a logarithmic increase, rather than a linear increase. So a doubling of light does not make you perceive a scene as being twice as bright.

The practical upshot of all of this is that your eyes are able to see a lot of really fine detail in shadow and highlight areas. As an example, consider the upper image in Figure 5.7. This grayscale ramp goes from black to white in a linear fashion. This is how your camera sees a change in brightness.

The lower image goes from black to white in a nonlinear fashion. Notice that there is much more variation in the lower fourth and upper fourth of the nonlinear ramp. In other words, the shadows and highlights have been expanded to show more variation.

Because of their nonlinear nature, your eyes tend to expand the shadow and highlight areas, registering more subtle changes and allowing you to see more detail. As we'll discover in many places in this book, your eyes are extremely sensitive to subtle changes in contrast—much more than they are to changes in color. This is because the light-sensitive portion of your eye is composed mostly of luminance-sensitive rods, while only a tiny part is composed of color-sensitive cones.

In order to get accurate brightness values—to expand the highlights and shadows so they appear more like what your eye is used to—your camera applies a mathematical curve to all its brightness values. This is called a *gamma curve*, sometimes called *gamma correction* (see Figure 5.8).

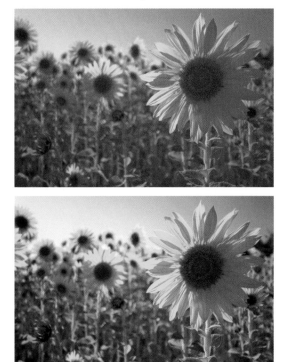

White Balance and Image Processing

As discussed in Chapter 1, your eye has the incredible ability to adjust its color perception so that colors are accurate under different types of lights. Like a piece of film (which must be formulated for specific types of light), a digital image sensor cannot automatically adapt to different types of light. Instead, the image data from the sensor must be calibrated to the type of light you're shooting in, a process called *white balance*.

The camera might also allow you to select several other adjustments, from contrast to brightness to color saturation. These adjustments are just like the ones you might apply in an image editor and are usually applied after the white balancing adjustment.

Sharpening and Noise Reduction

Finally, many cameras perform some type of noise reduction algorithm to reduce unwanted noise in your image, and almost all cameras perform some type of sharpening in order to compensate for the softening caused by the low pass filter.

JPEG Compression and Saving

At this point in the process, your camera has processed the image and is ready to save it to the camera's media card. Before saving, it applies JPEG compression, to save space and to speed the write-time.

All this processing takes place as soon as your image has been shot, and as you might imagine, it can take a while to perform all these calculations. I mean "take a while" in computer terms, but even though your camera's processor is very speedy, it can still be overwhelmed with image processing. To counter this, most cameras include an extra memory buffer that allows them to cache a few images for processing, freeing up the camera for immediate shooting.

The procedure described here is what is required to turn the image data your camera captures into a final image. When you shoot in JPEG mode, all of that processing happens in your camera's onboard computer. In Chapter 11, "Raw Shooting," you'll learn about another option, raw format shooting.

How JPEG Compression Works

After your image has been processed, it's ready to be stored on whatever storage medium is provided by your camera. While there are many different storage options for camera makers to choose from, they all have one thing in common: they're finite. Consequently, to make the most of the available storage, cameras compress their images, usually using a type of compression called *JPEG*.

Created by the *Joint Photographic Experts Group*, JPEG is a powerful algorithm that can greatly reduce the size of a photo but at the cost of image quality. Consequently, JPEG is referred to as a *lossy* compression format.

When saving in JPEG mode, the camera first converts the image data from its original 12- or 14-bit format down to an 8-bit format, reducing the range of brightness levels from 4,096 or 16,384 all the way down to 256. Once the data is in 8-bit mode, the camera is ready to start compressing.

Most cameras offer two forms of JPEG compression: a low-quality option that visibly degrades an image but offers compression ratios of 10 or 20:1, and a high-quality option that performs a good amount of compression—usually around 4:1—but without severely degrading your

image. Some cameras offer an even finer JPEG compression that cuts file sizes while producing images that are indistinguishable from uncompressed originals. In most cases, you'll probably find that any artifacts introduced by higher-quality JPEG compression are not visible in your final prints.

JPEG compression works by exploiting the fact that human vision is more sensitive to changes in brightness than to changes in color. To JPEG-compress an image, your camera first converts the image into a color space where each pixel is expressed using a chrominance (color) value and a luminance (brightness) value.

Next, the chrominance values are analyzed in blocks of 8 × 8 pixels. The color in each 64-pixel area is averaged so that any slight (and hopefully imperceptible) change in color is removed, a process known as *quantization*. Note that because the averaging is being performed only on the chrominance channel, all the luminance information in the image—the information your eye is most sensitive to—is preserved.

After quantization, a nonlossy compression algorithm is applied to the entire image. In the very simplest terms, a nonlossy compression scheme works something like this: rather than encoding AAAAAABBBBBCCC, you simply encode 6A5B3C. After quantization, the chrominance information in your image will be more uniform, and larger chunks of similar data will be available, meaning that this final compression step will be more effective.

What does all this mean to your image? Figure 5.9 shows an image that has been overcompressed. As you can see, areas of flat color or smooth gradations have turned into rectangular chunks, whereas contrast in areas of high detail has been boosted too high. Fortunately, most digital cameras offer much better compression quality than what you see here (see Figure 5.9).

Figure 5.9

This image has been compressed far too much, as can be seen from the nasty JPEG artifacting.

Meanwhile, Back in the Real World

If the information in this chapter seems unnecessary, it's probably because when you buy a film camera you don't have to worry about imaging technology—it's included in the film you use. However, if you're serious about photography, you probably do spend some time considering the merits of different films. And, just as you need a little knowledge of film chemistry to assess the quality of a particular film stock, the topics covered in this chapter will help you better test a particular camera.

Your camera is more than just an image sensor, and throughout the rest of the shooting chapters, you'll learn about the other components, controls, and mechanisms on your camera.

Note that if you're shooting raw, some of what you learned in this chapter will be a little different. You'll learn about raw shooting in Chapter 11.

Pixels Revisited

Pixel is a term we'll be using a lot, so here's a summary of what we've covered so far, as regards pixels. Pixel stands for picture element, and is used to refer to any individual unit of information in a *raster image*. A raster image is simply an image that's made up of colored dots. So the image on your computer screen is a raster image made up of pixels, and your digital camera produces a raster image of different-colored pixels.

Earlier, you learned about the photosites on an image sensor. There is one photosite for each pixel in the resulting image.

A pixel's color is represented as a numerical value. The range of color that any single pixel can be is limited only by the amount of memory that your imaging device devotes to that pixel. With 24 bits, you can count from 0 to roughly 16 million, which means that any pixel on your screen can be one of roughly 16 million colors.

6

EXPOSURE BASICS

The Fundamental Theory of Exposure

While photographic technology has changed dramatically over the last century and a half, one thing has remained the same: the physics of light still works just as it did when the first cameras were invented in the 19th century. This means that the basic skills that all photographers must learn have remained constant throughout the development of photographic technology.

In this chapter, we're going to look at some fundamental exposure concepts and theory. This is the sort of stuff that, only 25 years ago, you *had* to learn to be able to take good pictures. Nowadays, with the adept automatic modes provided by digital cameras, you don't actually have to know this stuff to take good pictures. However, as capable as automatic modes have become, the automatic mechanisms may be confused by some situations simply because there's no way for it to know what the final image is that you are envisioning when you frame a shot. With an understanding of the exposure concepts presented in this chapter, you'll be able to work around the limitations that can confuse your camera's automatic modes. With some manual overrides, you'll be able to achieve results that may not be possible with an automatic function.

Stops

In Chapter 1, "Eyes, Brains, Lights, and Images," you learned that a *stop* is a measure of light. Every time the light in a scene is doubled, we say the amount of light has increased by one stop. Conversely, a halving of light means the light has decreased by one stop. This is a term that will be used extensively throughout the rest of this book, as well as the rest of your photographic career. Experienced photographers are often able to recognize, by eye, how many stops of brightening or darkening have occurred in a scene or image. Good photography doesn't require this skill, but you *do* need to understand this term and how it applies to the different exposure settings, especially as we deepen our exposure discussion here, and in Chapter 7.

Over- and Underexposure Defined

As you'll learn throughout this chapter, the exposure-related decisions that you make can affect your image in a number of different ways. At the simplest level, though, the effect of exposure choice is fairly easy to understand.

If you turn out the lights in your house in the middle of the night, your eye won't be able to gather enough light to see very much. In other words, the inside of your house will be underexposed.

Conversely, when a doctor shines a bright light in your eyes, you probably can't see anything at all, because the sensors in your eyes will get overdriven. In other words, your field of view will be overexposed.

A digital image sensor (or a piece of film) works the same way. If a scene is underexposed, either because there's not enough light or because you choose bad exposure settings, then the scene will be too dark. If you overexpose a scene, then the resulting image will be too bright. See Figure 6.1 for some examples.

Both over- and underexposure can even be a problem in a single image, as some areas in an image might be overexposed, while others are underexposed (see Figure 6.2).

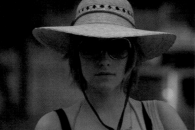

Figure 6.1

The first image is overexposed. Note how the bright areas of the hat have been blown out to complete white. The middle image is plainly underexposed. It's too dark overall, and the shadowy areas under the hat are going to complete black. The third image has a nice overall exposure with highlights that contain details and shadows that aren't too dark.

Figure 6.2

This image suffers from both over- and underexposure. The wall and some other highlights are overexposed to complete white, while the shadows are dark and murky.

As a photographer, one of your primary concerns is to make sure that you choose settings that expose the camera's image sensor to an amount of light that will render a scene that is neither too bright, nor too dark—that is, neither over- nor underexposed.

As you'll see in Chapter 7, there might be other times when you choose to intentionally over- or underexpose your images.

Exposure Control Mechanisms

Your camera provides two mechanical mechanisms for controlling the amount of light that strikes the image sensor: the shutter and the aperture.

The shutter is like a little door that opens and closes very quickly to control how much light passes through to the image sensor. Shutter speed is a measure of how long the shutter stays open, as measured in seconds. Because shutter speeds in most situations are very quick, you'll most often see shutter speeds that are fractions of a second—1/60th, 1/125th, 1/1000th, and so on. A faster shutter speed exposes the sensor to *less* light.

In an SLR, the shutter is composed of two curtains. The first curtain opens to expose the sensor, while the second curtain follows to close the opening. When using a fast shutter speed, the sensor will not be completely revealed at any particular time because the second curtain will start following the first curtain almost immediately. This creates a quickly moving slit that exposes the sensor.

You can see a movie of this whole process in action in the Chapter 6 section of the companion Web site at *www.completedigitalphotography.com/CDP6.*

On many point-and-shoot cameras, there is no mechanical shutter. Instead, the sensor is simply turned on for the desired amount of time. Because there's no shutter moving around, the camera can actually capture a picture without making a sound. Most cameras beep or even play a recorded shutter sound to let you know that the shot has been taken. This kind of feedback is helpful, but your camera probably allows you to disable the sound for times when you want to shoot silently.

The other mechanism for controlling light is a mechanical iris, or aperture. This concept should be familiar to you, since your eyes have irises that open and close as light levels change. If you've ever walked out of a dark movie theater in the middle of the day, then you've experienced what happens when your irises are open too wide; you must wait for them to close down so that your field of view is no longer overexposed.

The iris in your camera is composed of a series of interlocking metal leaves. The iris opening can be expanded and contracted to make a bigger or smaller opening (see Figure 6.3).

With a wider aperture, more light gets to the image sensor.

As you learned earlier, the shutter is held in the camera body, just in front of the image sensor. The iris is a part of the lens. It's positioned at the end of the lens, near the mount that attaches the lens to the camera body.

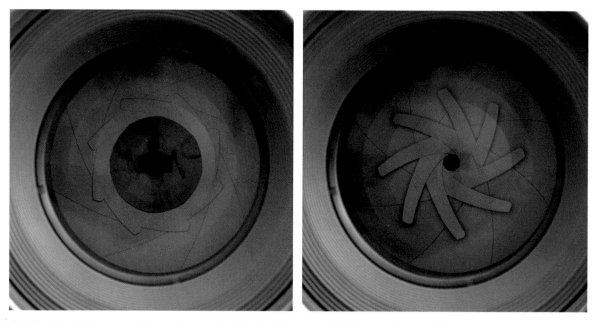

Figure 6.3 The iris in your camera's lens can be opened and closed to allow more or less light to pass through to the sensor.

Shutter Speed

To recap: Shutter speeds are measured in seconds, and a longer shutter speed exposes the image sensor to light for a longer time than a shorter shutter speed. Shutter speeds can range from 30 seconds up to 1/8000th of a second, depending on your camera's capabilities, and you can even create longer exposures lasting minutes, hours, or even days.

In the auto shooting that you did in Chapter 2, "Getting to Know Your Camera," the camera calculated an appropriate shutter speed for you automatically and showed it to you in its status display.

As mentioned in Chapter 2, the shutter speed display on your camera shows the denominator part of the current shutter speed. So, if you see "100" on the shutter speed display, then the camera is set to 1/100th of a second.

Most cameras go down to about a fourth of a second, which reads as 4 on the shutter. Once the shutter speed goes over 1 second, the display will switch to something like 0″3, which reads as "zero minutes, 3 seconds." If you see something like 1″6, then you have a shutter speed of one minute and six seconds.

The shutter speed on most cameras tops out at 30 minutes. However, many cameras will also include a Bulb setting. This will either be a dedicated mode that you can switch to using the same control that you use to select other shooting modes, or it will come after the 30-second mark on the shutter speed selection.

In Bulb mode, which is usually indicated with a B or the word Bulb, the shutter will remain open for as long as you hold the shutter button down. This allows you to shoot exposures longer than 30 seconds.

Aperture

The size of the aperture (which we discussed earlier) is controlled automatically by the camera when you shoot in Auto mode, as well as some other modes. However, as you'll see later, it can also be controlled manually. Aperture size is measured in f-stops, and like shutter speed, an f-stop number is often fractional, so you'll see f-stops with values like f5.6, f8, or f11 (see Figure 6.4).

An f-stop is a measure of the ratio of the focal length of the lens to the size of the aperture. Apertures are circular, so because you're dealing with the area of a circle, the math can yield fractional numbers. Don't worry about understanding that ratio; you don't have to know the math to effectively use f-stop values.

Figure 6.4

This typical camera readout is showing an aperture choice of f5.6.

Less Is More

Now the tricky part: f-stops can be a little unintuitive at first because of the way that they're measured. A larger f-stop number, say 16, indicates a *smaller* opening. For example, Figure 6.5 shows two lens apertures, one set to f-stop 8, and another set to f4.

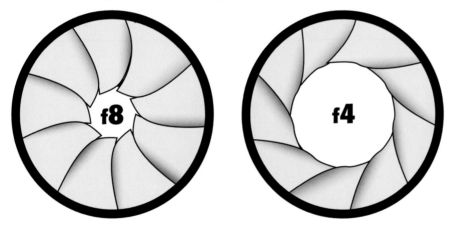

Figure 6.5

Here's a representation of two apertures, one set to f8 and the other set to f4. As you can see, the higher number corresponds to more closure, or a smaller opening.

When you choose a higher f-stop number, the aperture stops more light. With a lower f-stop number, the aperture is larger, and less light is stopped. Unfortunately, there's no real sure-fire way to learn this; you just have to memorize it. Over time, it will become intuitive, and we'll be doing more aperture work later in the book.

Aperture Experiment

If you are nearsighted enough to need glasses, try this quick little depth-of-field experiment. Take off your glasses and curl up your index finger against your thumb. You should be able to curl your finger tight enough to create a tiny little hole in the curve of your index finger. If you look through the hole without your glasses, you will probably find that everything is in focus. This hole is a very tiny aperture, and therefore provides very deep depth of field—deep enough, in fact, that it can correct your vision. On the downside, it doesn't let a lot of light through, so unless you're in bright daylight, you might not be able to see anything well enough to determine if it's in focus. The next time you're confused about how aperture relates to depth of field, remember this test.

Throughout the rest of this book, we'll use a few aperture-related terms. When we speak of "stopping down a lens," we mean choosing a smaller aperture (larger f-number). "Opening up the lens" means choosing a larger aperture (smaller f-number). "Shooting full wide" means to choose the largest possible aperture (the one with the smallest number).

Not all lenses can open up to the same aperture. Creating a lens that can open very wide requires a lot of high-quality glass, so you might find that some of your lenses only open to, say f4, while other lenses can open to f2 or even wider. The maximum aperture that your lens can open to will be written on the front ring of the lens.

If you're using a zoom lens, be aware that the largest possible aperture can vary depending on the focal length you've chosen. For example, if you look at the front of your lens, where the brand name and a bunch of numbers are printed, you might see something like "1:3.5-5.6." This tells you the aperture range, from full wide to full telephoto. On such a lens, the widest aperture you could use at full wide would be f3.5. At full telephoto, the widest aperture would be f5.6. As you zoom through the focal length range, the maximum aperture available will change from 3.5 to 5.6 (see Figure 6.6).

Figure 6.6

The lens on this Canon G9 indicates that it has maximum apertures of 2.8 at full wide to 4.8 at full telephoto.

Other zoom lenses might have a constant maximum aperture across the entire zoom range. It's a complicated engineering prospect to make a small zoom lens that has a constant maximum aperture, so lenses with a constant aperture are usually larger and often more expensive. The advantage of a zoom lens with a constant aperture is that you'll always know what your widest aperture will be because your lens won't close down as you zoom in.

A lens with a wider maximum aperture than another lens is said to be *faster*. In general, when someone talks about the speed of a lens—"Look at this really expensive, very fast 50mm lens that I just bought!"—they're referring to the fact that its maximum aperture can be very wide.

Why There Are Two Ways to Control Light

What you've learned here is that there are two ways by which you can limit the amount of light that hits the sensor: you can change the amount of time that the shutter is open, and you can change the size of the aperture in the lens, so that it creates a bigger or smaller opening. But why are there two mechanisms for controlling light? If your concern is just to ensure that the image is neither too bright nor too dark, wouldn't one mechanism be enough?

If good exposure were only a matter of brightness, then yes, one mechanism would be enough, but because of the physics of light, there can be a big difference in your final image depending on whether you control exposure using shutter speed or aperture. In fact, after compositional decisions, the bulk of your creative power as a photographer comes from how you choose to manipulate shutter speed and aperture.

How Shutter Speed Choice Affects Your Image

The effect of shutter speed is pretty intuitive. As you choose a faster shutter speed, you gain more ability to freeze the motion in your scene. That is, when the shutter is open for a very short time, a moving subject will be frozen. When the shutter is open for a longer time, a moving subject will be blurred and smeary.

You were introduced to this idea in Chapter 2, when you learned that a faster shutter speed could be necessary to prevent blurring caused by a shaky hand.

You may think that blurry and smeared is inherently bad, and that you will always want your images sharp and clear, but consider Figure 6.7.

Figure 6.7

This image was shot with a slower shutter speed with the goal of blurring the smith's hand.

By choosing a slower shutter speed, the blacksmith's hand was blurred as he hammered, and we got an image that's a little more dynamic than if his hand were rendered perfectly sharp without any motion blur. To get this shot, I had to make a concentrated effort to hold the camera steady. During a slow shutter speed, any camera motion will result in blur throughout the image. If you're shooting in very windy conditions, with a telephoto lens, or in a location where you can't get stable footing, then shooting with a slow shutter speed might not be possible. Of course, a tripod will help in any of these circumstances.

Depth of Field—How Aperture Choice Affects Your Image

Choosing a smaller aperture will keep more light from getting to the sensor. But changing aperture has another effect on your image.

As you go to a smaller aperture, the *depth of field* in your image gets deeper. Depth of field is simply a measure of how much of your image is in focus, as shown in Figure 6.8.

Depth of field is measured around the distance at which you're focused. So, if you've selected an aperture that gives you 10 feet of depth of field, then an area 10 feet deep will be in focus, centered around the distance where you focused.

It's very important to understand that focus is not always *evenly* centered on your focus point. At very close distances, depth of field will extend equally in front of and behind your focus point. But as the distance to your point of focus increases, the depth of field will increase more *behind* your subject. We'll discuss this in more detail later. For now, remember the one-thirds/two-thirds rule, which states that about one-third of your available depth will be in front of the point of focus and the other two-thirds will be behind it (see Figure 6.9).

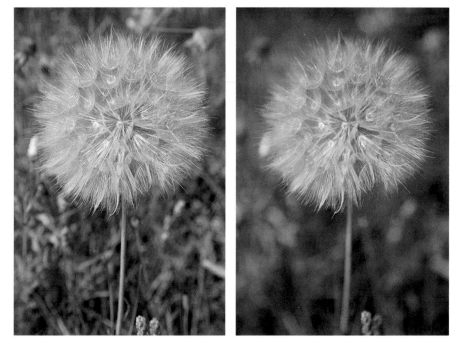

Figure 6.8

The image on the left has more depth of field—the focus stays sharp all the way into the distance. It was shot with a smaller aperture than the image on the right, which has a shallower depth of field. Focus drops off into the distance.

While it may seem like it would be best to have everything in your image in focus, there are times when having a sharply focused background can distract the viewer from your foreground subject. Portraits are the most common example of when to use shallow depth of field. If you choose a larger aperture for a portrait, you'll create a softer background that will bring more attention to the subject of the portrait (refer back to Figure 2.17 in Chapter 2).

So, just as you can use shutter speed to control motion stopping, you will sometimes want to consider when a depth of field change can be used to better express the subject or scene that you're shooting.

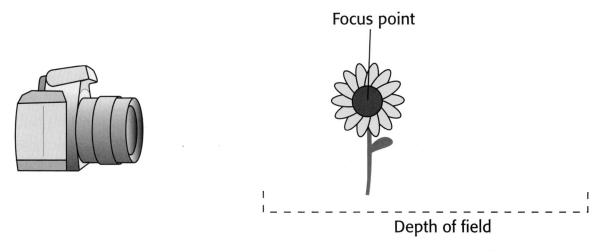

Figure 6.9 Depth of field is measured from your point of focus, not from the end of the lens. About one-third of your depth of field lies in front of the focus point, with the rest falling behind.

Also, know that every lens has an aperture "sweet spot." If you stop down too far, you'll suffer a noticeable sharpness penalty. Depending on how big you intend to print your final image, this loss of sharpness may not be noticeable.

This softening occurs because as light rays pass through a small opening, they begin to diverge and interfere with one another. This diffraction keeps them from all focusing at the appropriate locations.

To test your own lenses for their sharpness sweet spot, shoot the same image at a range of apertures from biggest to smallest and then compare the results in your image editor. You'll probably find that there is a noticeable drop-off in sharpness near the edges of your aperture range. On an SLR with a smaller sensor, you usually won't want to go much past f8. On a full-frame SLR, f11 is about as small as you'll want to go. However, everyone has his or her own idea of what is acceptably sharp, so it's worth doing some tests of your own. Find a scene with fine detail and shoot it at a range of apertures. Take the results into your image editor and see if you can spot a sharpness drop-off at a particular aperture.

Shutter Speed/Aperture Balance

Being able to blur motion or shoot with a shallower depth of field provides a tremendous amount of creative latitude. However, if you choose a longer shutter speed to create a blurrier sense of motion in a picture, then your image might end up *over*exposed. The slower speed will allow too much light to hit the sensor, and your image could end up too bright.

You can compensate for a slower shutter speed by using a smaller aperture (depending on what mode you're in, your camera will do this for you). A smaller aperture will allow less light to pass through the lens, and will restore a correct level of brightness to your image. Of course, a smaller aperture might mean more depth of field. So, if you want to blur motion and have shallower depth of field, *and* a scene that is properly bright, then you might have a problem. Balancing all of these factors is one of the obstacles you'll face as a photographer. (Are you beginning to see why there are *two* mechanisms for controlling light?)

Conversely, if you need a fast shutter speed to stop motion, then you can open the aperture wider. With a wider aperture, more light will pass through the lens, so you can get away with faster shutter speeds.

To better understand this balance, you have to learn a new term, *reciprocity*.

Reciprocity

Earlier, you learned that a stop is a measure of light. When you double the amount of light that hits the sensor, we say that you have increased the amount of light exposure by one stop. Conversely, if you halve the light, you decrease the exposure by one stop.

Consider these shutter speeds:

1/60 1/120 1/250 1/500 1/1000 1/2000 1/4000

Each one is double (roughly) the previous shutter speed. In other words, there is a one-stop difference in the amount of light exposure generated by each successive speed.

Now look at this list of apertures:

f4 f5.6 f8 f11 f16 f22

Because most of us aren't familiar with calculating the area of a circle, the relationship between these numbers isn't so obvious. But, trust me when I say that each one represents an opening that's twice as big as the previous one. In other words, there's a difference of one stop of light exposure between each successive aperture in this list.

When you encounter a situation where you need to balance motion-stopping power with depth of field and overall illumination, you can take advantage of the fact that both shutter speed and aperture can be adjusted by the same amount in opposite directions. In other words, the two values have a reciprocal relationship (see Figure 6.10).

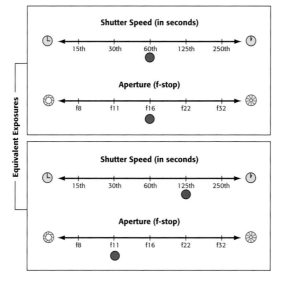

Figure 6.10

Because of the reciprocal nature of exposure parameters, if you change one parameter in one direction, you can move the other parameter in the opposite direction and still achieve the same overall exposure. In other words, both of the exposure settings shown in this chart result in the same amount of light striking the sensor.

For example, let's say your camera recommends an exposure of 1/500th of a second at f8. Because it can't make any creative decisions, it has no idea how much motion stopping or depth of field you might want, so it simply tries to recommend a shutter speed and aperture combination that will give you a good level of illumination and allow for a sharp image when shooting handheld.

If you decide that you want more motion-stopping power, and so increase shutter speed from 1/500th to 1/1000th (one stop), you'll run the risk of darkening your image. But you can open your aperture from f8 to f5.6 (one stop) to compensate for that one stop of darkening that you introduced with the shutter speed change (see Figure 6.10).

This reciprocal relationship means there are many different shutter speed/aperture combinations that yield the same overall exposure. That is, many combinations of shutter speed and aperture produce the same level of brightness in the final image. However, some combinations might produce an image with more depth of field than others, while others might yield an image that has blurrier motion.

For now, don't worry about how you control all of this on your camera. At this point, the goal is to understand the concepts.

ISO—The Third Exposure Parameter

One of the great advantages of shooting digitally is that you have an additional parameter that you can change to control exposure.

As you learned earlier, after the image sensor in a camera is exposed, the data is read off the sensor in the form of electrical voltages. These voltage levels are very, very small, so the first thing that happens to them is that they are amplified so that they can be measured more easily. As you amplify the voltages more, the sensor effectively becomes more light sensitive, because dimmer light levels will be boosted.

ISO is a standard for measuring the sensitivity of film. (ISO stands for *International Standards Organization*, the committee that specifies the standard.) Digital vendors adopted this standard early on as a way of specifying the sensitivity of an image sensor. When you increase the ISO setting on your camera, you're essentially making the sensor more light sensitive. As it becomes more sensitive, it will require less exposure to be able to "see" a scene. This allows you to shoot in very low light levels, because ISO, shutter speed, and aperture all share a reciprocal relationship.

Reciprocal ISOs

If your camera offers the ability to change ISO, and most do these days, then you probably will have a range of settings that goes something like this:

100 200 400 800 1600

As should be obvious, like aperture and shutter speed, each successive ISO setting is double the previous one, meaning there's a one-stop difference between each ISO. So, if you end up in a situation where your shutter speed and aperture choices have left your scene underexposed by a stop, you can increase your ISO setting by one stop to compensate.

For example, say your camera is set to ISO 100, and you meter a scene and find that the camera wants a shutter speed of 1/25th of a second—too slow for handheld shooting. If you increase to ISO 200, then your shutter speed will halve to 1/50th of a second. Increase to ISO 400, and you'll get your shutter speed to a zippy 1/100th of a second—fast enough for stable handheld shooting.

Adjusting ISO allows you to buy yourself more shutter speed or aperture latitude for times when you need more motion stopping power or depth-of-field control. Some cameras offer a wider range of ISOs than what you see here. On some cameras, ISO 50 is an option, while others push the opposite end of the scale all the way up to around 25,000. We'll learn more of the details of ISO later.

ISO and Noise

You might be tempted to just leave your ISO set high all the time, to ensure that you always get a fast shutter speed. Unfortunately, there's a price to pay for higher ISO—as you increase ISO, your images will get noisier. (Look ahead to Figures 7.27 and 7.28 in Chapter 7, "Program Mode," for examples of noise.)

Bad noise troubles can ruin an otherwise great image, so it's important to always keep your ISO as low as you can get away with.

Fractional Stops

If you're coming from the film world, and you learned to shoot on a manual camera, then you might not recognize all of the shutter speeds and aperture choices on your digital camera. In the old days, shutter speed and aperture controls used the progression of settings that we've looked at here, with one stop of exposure difference between each setting. Like your digital camera, the range was usually wider than what I've shown.

It is possible, though, to adjust shutter speed and aperture by intervals that are smaller than a whole stop. By default, your camera probably adjusts in one-third stop intervals. So, as you adjust the shutter speed control on your camera, you might see a progression that goes like this:

1/15 1/20 1/25 **1/30** 1/40 1/50 **1/60** 1/80 1/100 **1/125** 1/160 1/200

Here, the one-stop increments are in bold. The other values are increases of one-third of a stop. All the same reciprocal rules apply when dealing with fractional stops. These fractional values give you a more granular, finer level of aperture control.

On most cameras, apertures also progress in third-stop increments, as do ISOs.

Confused by "Speed"

The word *speed* comes up a lot when speaking of photography because it can be used to describe three different things: the quickness with which the shutter opens and closes, the maximum aperture of a lens, and the sensitivity of the image sensor (ISO). As you become more comfortable with these concepts, you should have no trouble determining which meaning is being used at any given time.

Summing Up

The relationship between shutter speed, aperture, and ISO setting can be confusing to new photographers. Hopefully, the chart in Figure 6.11 will clarify some of the information presented here.

Remember, if you move any one of these parameters in one direction, you must move one of the others in the opposite direction to maintain equivalent exposure, because all three parameters are reciprocally related. Of course, you can choose to move one parameter or another without moving any others to create an intentional over- or underexposure. Later, we'll learn why you might want to do this.

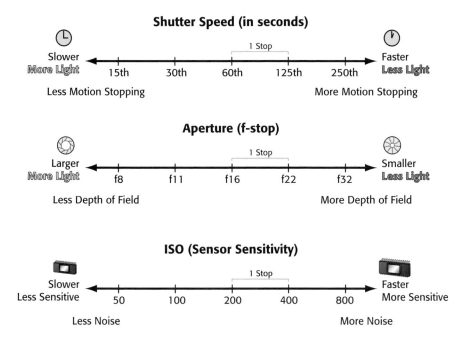

Figure 6.11

Shutter speed, aperture, and ISO are the three exposure parameters over which you have control. Each provides a different way of controlling the amount of light that strikes the focal plane. Each adjustment, in turn, affects your image in different ways.

Returning to Auto Mode

Now that you've learned about the mechanisms that control exposure, let's look again at the Auto mode on your camera. As you learned in Chapter 2, when you press the shutter button halfway down, the camera focuses and calculates exposure settings—aperture and shutter speed. If your camera is set to an auto ISO mode, then the camera may alter ISO as well. The result *should* be an exposure that is neither too bright nor too dark.

Once the camera has calculated these values and autofocused, it displays its choices, either in the viewfinder on the rear LCD, on a status LCD, or possibly in all of these locations. These numbers should make a little more sense to you now.

As you've seen, many combinations of shutter speed and aperture settings yield the same overall exposure. The camera's algorithms are designed to take the safest possible combination. That is, a shutter speed and aperture that will yield a good overall exposure without risking handheld shake from a slow shutter speed or image softness from an extreme aperture.

Later, you'll learn about one additional effect of your exposure choices, and that has to do with tonality—how light and dark particular images are—and how much editing latitude an image has.

7

PROGRAM MODE
Taking Control of Exposure, Focus, and More

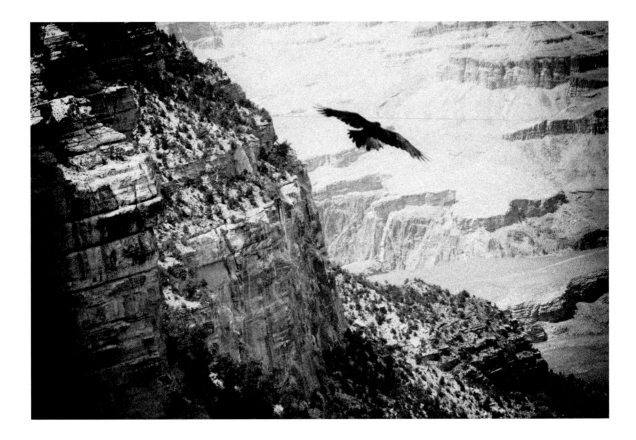

Your camera may be blistering with buttons and dials, or it might have a long list of menu options and functions, or maybe even have both lots of controls and lots of menu options. Most of these controls simply manipulate the three exposure settings that you learned about in the last chapter. The fact is, shutter speed, aperture, and ISO are really the only parameters that you need to understand. You don't have to use autofocus, and if your light meter broke, you could always learn to assess light by eye. But shutter speed, aperture, and ISO are the three critical decisions that all photos require.

Most of the controls on your camera simply provide you with different ways to manipulate those three critical exposure parameters, or change how the camera calculates those parameters, or allow you to perform slight modifications to those three crucial exposure settings. The good news is that, while there are still a lot of things to learn about shooting, most of them will involve nothing more than different ways of manipulating these three properties.

So far in this book, I've asked you to practice shooting in Auto mode. All digital cameras include an Auto mode, and when you use it, the camera automatically selects a shutter speed, aperture, and possibly ISO setting for you, based on what its light meter tells it about your scene. As you've probably discovered, for many situations Auto mode does a very good job. There are times, though, when its decisions don't yield images that match your creative vision. Or you might find lighting situations that sometimes confuse your camera's Auto mode. Fortunately, most cameras provide a way for you to take more control and configure some or all of the camera's settings yourself.

In this chapter, we're going to switch from Auto to Program mode, which provides some additional manual overrides. We're also going to learn more about autofocus and some other camera subsystems. We're still deeply in the realm of "craft" here, because you must know how to control your camera before you can begin to apply an artistic sensibility to your images.

Switching to Program Mode

If you followed along during Chapter 2, "Getting to Know Your Camera," you should have found the mechanism that your camera provides for changing modes. Not all cameras have a Program mode, but these days most SLRs and many point-and-shoots do. Look at your camera's mode control and see if it has a P on it. This stands for Program mode. Many SLRs have a mode dial, while Nikon SLRs have a mode button, which lets you select P. Smaller point-and-shoots that provide a menu for mode selection may or may not have a Program mode. No matter what kind of camera you have, you'll want to follow along with this chapter. Keep your camera's manual close by, so you can determine exactly which features your camera has.

Program mode is a lot like Auto mode because it automatically calculates aperture and shutter speed, and possibly ISO, but it also allows for a fair amount of manual override. In most Program modes, you'll be able to control white balance, Flash mode, and apply changes to aperture and shutter speed. In addition, you'll most likely have control of the camera's autofocus system, be able to choose whether it should shoot single shots or bursts of images, and much more. Depending on the controls on your camera, you might actually have as much manual control in Program mode as you have in some Manual modes on your camera.

Other Autofocus Mechanisms

If you have a higher-end digital SLR, your camera might use a more advanced form of autofocus called *phase difference*, or *phase detection*. Phase detection autofocus is a passive TTL metering system that uses a complex arrangement of prisms and two tiny CCD arrays that are placed next to the focal plane. Both CCDs see the same part of the image, but one CCD looks through the left edge of the lens and the other looks through the right edge.

When the lens is focused too close, the image in the left edge of the CCD will be slightly to the left of the right-edge CCD. When the lens is focused too far, the opposite occurs. By analyzing the two images and determining the difference in shift between them, the camera can calculate which way to move the lens and how far it needs to go.

As with other autofocus systems, the quality of a phase difference system depends on its capability to control the lens motor quickly and accurately, and to detect what area needs to be in focus.

Phase difference systems are incredibly accurate and generally speedy. In addition, many of these systems are capable of focusing in near darkness. On the downside, some phase difference autofocus mechanisms become less reliable at apertures below f5.6, because as the aperture gets smaller, the CCDs lose their line of sight out of the lens and the mechanism can become confused. In general, though, these systems, whether single- or multispot, are by far the most accurate, quickest autofocus mechanisms available.

Although less popular than it used to be, some lower-end cameras still provide active autofocus mechanisms because they're typically the cheapest system to implement. An active autofocus mechanism works by using an infrared beam to measure the distance to your subject; your camera then sets the focus accordingly. It's called an "active" system because the camera is actively emitting a signal in an effort to measure distance. The easiest way to tell if your camera uses an active system is to look at the technical specifications included in your camera's manual.

Although active autofocus mechanisms work fairly well, they have a number of limitations.

- You must have a clear line of sight between you and your subject. Bars in a zoo, fence posts, or other obstructions can keep the camera from measuring distance accurately.

- Because the infrared beam is not originating from the lens, the camera might not calculate focus correctly if you're using any type of lens attachment, such as a wide-angle or telephoto adapter. Consequently, most cameras with active autofocus mechanisms don't provide for such attachments.

- If you're standing close to another strong infrared source, such as a hot campfire or a birthday cake covered with candles, the heat from that source can confuse the camera's autofocus mechanism.

On the positive side, active autofocus systems work just fine in the dark.

Autofocus Modes

Your camera might provide a few Autofocus mode choices, which are completely independent of the shooting modes that we've already talked about. Autofocus modes typically change the approach that the camera takes for identifying a subject.

Focus Points

Obviously, you want your autofocusing system to focus on the subject of your image, not on something else in the scene. Therefore, most autofocus systems have a *focusing zone* or *spot* that determines which part of the image will be analyzed for focus. On a simple camera, this

will be a small area in the middle of the frame, and it's usually marked with crosshairs or a box. However, if your subject isn't in the middle of the frame, there's a good chance your camera is going to focus on the background of your image, leaving the foreground soft or outright blurry (see Figure 7.2).

Because your subject isn't always in the middle of your image, most cameras offer multiple focus zones. A camera with multiple focus spots analyzes several different points in your image to determine where your subject might be. Once it has decided where the subject is, it analyzes the focus spot or spots closest to that subject to calculate focus. This process allows you to frame your image as you like without having to worry about your subject being in the middle of the frame.

Modern autofocus systems are very good at identifying the subject in a scene, but it's still possible for them to mess up. Therefore, it's important to pay attention to where the camera is focusing. When the camera locks focus, it will illuminate or flash the focus point or points it chose (see Figure 7.3.). Get in the habit of paying attention to its choice. If it chooses the wrong spot, you'll need to try again.

Figure 7.2

I wanted to focus on the woman in the foreground, but the camera focused on the wall in the distance.

Sometimes your camera will light up several focus points at once. Remember that when you focus a lens, you're focusing it on a plane that's a particular distance from the camera. When your camera identifies the subject, it lights up any focus points that sit on that subject, but it also lights up any other points that sit on other objects *that are at the same distance as your subject.*

When multiple spots light up, the only thing you need to worry about is whether there's a lit focus point on the subject that you want in focus.

Different cameras offer different numbers of focus points. A less expensive camera might offer 7, for example, while a more expensive one might offer more than 20.

Because automatic mechanisms can't always choose the correct focus point, most cameras offer the option of manually selecting a focus point, which ensures that your autofocus mechanism analyzes the right area. You should have some type of control that will let you cycle through each of the camera's focus points (see Figure 7.4).

Figure 7.3

There are several potential subjects for the camera to focus on in this image—the carnival ride, obviously, but also the tree on the left and the sky in the background. Fortunately, the camera has picked the correct one. We can see what distance it has chosen to focus at by the focus points that it has lit up.

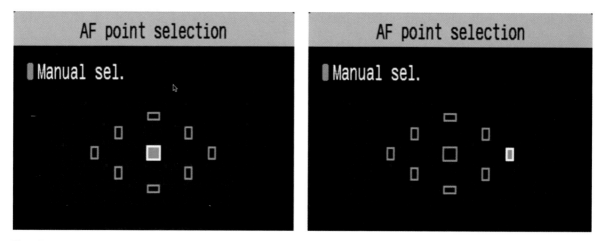

Figure 7.4 Your camera should provide some sort of mechanism for manually selecting a focus point.

When to Manually Choose a Focus Point

Certain types of scenes might consistently confuse an autofocus system. Landscape scenes can often yield bad focus point choices, as can shots of a still life, such as a picture of a product you want to post on eBay. You can solve all of these problems with manual focus point selection.

In addition to using the LCD display to choose a focus point (as shown in the previous example), your camera might also show your focus point choice in the camera's viewfinder or on the status LCD screen. Consult your manual for details.

Center-Point Focusing (for SLRs and Point-and-Shoots)

Most cameras with multispot autofocus mechanisms also allow you to put the camera into a single, Center-Spot Focusing mode (sometimes called *spot focus*), which forces the camera to behave like a single-spot autofocus camera. Very often, single-spot focus is the most reliable, fastest way to focus when creating an unusual composition. If your camera only offers a single focus point, then you'll find yourself using the following technique a lot. Even if your camera has multiple points, you may find that this technique is an effective way to work.

Say your camera is set for center focus (or only has a center focus point), and you want to focus on something on the right side of the frame. If you frame your shot the way you want it and half-press the shutter button, your camera will likely focus on the background, rather than on your subject. In these situations, you need to employ the following technique:

1. Point the camera's center focusing target at your subject.

2. Press the shutter button halfway to lock focus.

3. While holding down the shutter button, reframe your shot to your desired framing. When you press the button the rest of the way, the camera will take the picture using the focus it initially calculated.

Figure 7.5 shows an example of this method.

If your camera has multiple focus spots, possibly you could have framed this image as desired, and the camera would have properly identified the arrow as the subject and lit up the appropriate spot. You'll want to experiment with your camera's focus system to determine how good a job it does at identifying the subject in a scene.

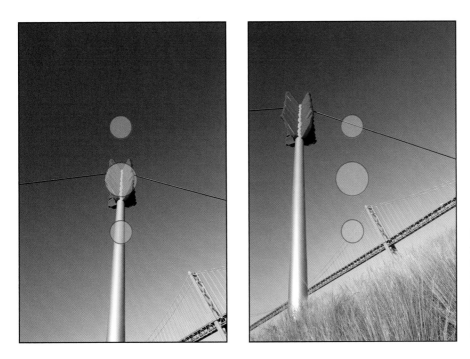

Figure 7.5

To keep the camera from focusing on the sky, the camera's focusing target was pointed at the arrow, and the shutter release was pressed down halfway to lock the focus. The image was reframed, and the picture was shot with the correct focus.

One advantage of choosing a center-based approach is that you always know where the camera is going to focus. If you're trying to shoot quickly, it can sometimes be quicker to lock focus and reframe, as described previously, rather than to worry about focusing and assessing whether the camera chose the right spot or not.

Be aware, though, that there are some potential pitfalls to a center focusing technique.

In addition to calculating focus, when you press down your shutter button halfway, your camera calculates exposure and white balance (if you're using automatic white balance). If the lighting in your frame is substantially different after you reframe from what it was when you locked focus, your camera's exposure could be off. (As you'll see in the next chapter, you can sometimes use this exposure change to your advantage.)

Camera manufacturers have come up with two solutions for these problems. The first is a separate *exposure lock* button that allows you to lock your camera's exposure and focus independently. Different exposure lock features work in different ways, but most allow you to do something like this: frame your shot, measure and lock the exposure, move your camera and lock focus on your subject, and then return to your final framing with everything ready to go. In the next chapter, we'll explore the vagaries of metering when reframing. Consult your camera's manual to learn about its exposure lock feature.

What to Do If Your Autofocus Won't Lock Focus

Autofocus mechanisms can get confused if you're trying to focus on something with low contrast. You might hear the lens searching back and forth, and the image in the viewfinder will swing in and out of focus, as the camera tries to hone in on the correct focus distance. This usually happens either because the camera's focus points are on a part of the scene that lacks contrast, or because they're centered on a textureless object (see Figure 7.6).

Figure 7.6

Since all of the focus points are sitting on fog, which has no contrast, the camera can't focus.

When this happens, as shown in Figure 7.6, you must use the same focus and reframe technique that we saw earlier.

1. Frame your shot so that the camera's focus points sit on something that's the same distance as your desired focus and then press the shutter button halfway to lock focus.

2. With the button held halfway down, reframe to your desired composition.

3. Take the shot (see Figure 7.7).

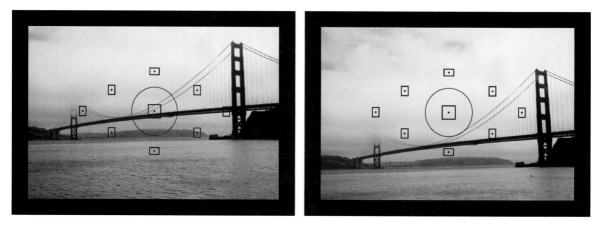

Figure 7.7 To focus on the bridge, we tilt down until the camera's focus spots are on the bridge, which has some contrast on it. We then half-press to lock focus and reframe to take the shot.

If your camera uses a TTL contrast-detection focusing system, the center focusing spot (no matter how many focus zones the camera has) is usually a *dual-axis zone*. That is, it examines contrast along both a horizontal and vertical axis. If the camera has multiple focus spots, there's a good chance that the other zones are *single-axis zones*, which measure only contrast (and, therefore, focus) along a horizontal axis. For locking focus on horizontal subjects, such as horizons, a single-axis zone can be problematic. For these situations, you might want to force the camera to use its center dual-axis zone.

Autofocus in Low Light

Sometimes, your scene might lack contrast because it's too dark. In these cases, the camera may have trouble locking focus. To give the autofocus system some help, your camera might light up its autofocus-assist lamp or flash its built-in flash. This extra light can help the camera lock focus.

Note that if you're using a camera that uses a pop-up flash for autofocus assist, you might have to pop the flash up manually to enable this feature. If you don't want the flash to fire during your shot, you'll have to do the following.

1. Pop up the flash.

2. Press the shutter button down halfway to focus. The camera will fire the flash to light up the scene, to help the autofocus system. Once focus is locked, the camera will beep, as normal.

3. Continue to hold the shutter button down halfway, while you close the flash.

4. Take your shot.

Be aware that a focus-assist light or flash has limited range, so it won't help if you're shooting a landscape shot or something far away. But if you're taking a portrait or snapshot, you should be fine. You might want to warn your subject that the camera is going to shine a light or flash at them, although these days most people are used to weird lights coming out of cameras.

Alternately, if you're using an SLR that has a lens with an Autofocus/Manual focus switch on its lens, you can let the camera use the flash to assist focus and then switch the lens to manual focus. Close the flash and then shoot.

If the focus-assist light doesn't solve your focus problem, try the focus and reframe trick we showed earlier. Very often, you can find a bright highlight, or a reflection in a dark scene, and focus on that, if it's at the right distance.

Face Detection Autofocus

While still rare on SLRs, most point-and-shoot cameras these days provide a focus option that can detect faces in your scene. Operating on the assumption that a face is usually a subject, these modes identify a face and then set focus on that subject. For portraits and quick snapshots involving people, this can be an ideal focusing mode.

Usually, a box or crosshair is placed on the detected face. If multiple faces are detected, the camera will probably provide a way to cycle through each face to the one you want to focus on. If all of the faces are the same distance from the camera, then it doesn't matter which one you pick.

Some face detection systems offer special modes for shooting groups of people. Others offer the additional feature of smile detection. In these modes, a face is detected, and focus is locked. You press the shutter button all the way down to shoot, but the camera doesn't actually take the picture until the subject smiles. You'll want to experiment with this feature to determine how much of a smile is required to trip the shutter. If your camera can only recognize a big, cheesy, unnatural smile, then this feature probably isn't worth using. At the time of this writing, smile detection still has a long way to go, so this is not a feature you should count on.

A variation of this feature tells the camera not to shoot until the camera is held still. This can be a great option for self-portraits where you have to hold the camera at arm's length, pointed at yourself. Before you rely on these features for a once-in-a-lifetime shot, experiment with them a little bit to see how to operate them and how effective they are.

Continuous Autofocus

Your camera might also have a continuous autofocus mode, which automatically re-focuses every time you move or zoom the camera. With continuous autofocus, your camera stands a much better chance of being ready to shoot at any time. However, continuous autofocus can drain your battery and sometimes be distracting, because you will constantly hear the lens working. If your camera has a speedy autofocus, you might find little advantage to a continuous mechanism.

Some cameras provide a variation of continuous autofocus that automatically starts the continuous autofocus mechanism when the camera is not moving. The idea is that if the camera has stopped moving, it's probably because you're trying to line up a shot. The advantage of these systems over continuous autofocus is that they're more battery efficient because they're not continuously focus hunting.

Focus Tracking—Sometimes Called "Servo Tracking"

It can be difficult to use an autofocus system while shooting a moving object. To keep your subject in focus, you must constantly reframe and refocus. To refocus, you have to let go of the shutter button and then give it another half-press. If you're using automatic focus point selection, then you have to ensure that the camera is choosing the right focus point. If you're using a single focus point, then you have to ensure that it stays on your moving subject.

If your camera provides a Servo Focus, or Focus Tracking mode, you have another option. Servo Focus is a special focus mode that automatically tracks a moving object and keeps it in focus, even as you reframe the shot.

To use most Servo Focus mechanisms, you activate the Servo mode and then focus on your subject as you normally would. Continue to hold the shutter button down halfway, and the camera will continually refocus and adjust its exposure as your subject moves.

Note that, because the camera is continuously focusing, it most likely will never beep or show you any of its normal "focus lock" indicators. So you can simply take the shot whenever you want. If the camera has not managed to lock focus, or is currently changing focus, then there might be a slight lag before the shutter is tripped.

For sports or wildlife shooting, Servo Focus can be a lifesaver. However, you'll want to experiment with your camera's Servo Focus to determine its effectiveness, before you commit to using it during an important event (see Figure 7.8).

Figure 7.8 A Servo Focus mode will keep your image in focus even if it, or the camera, is moving.

Manual Focus

Your camera's autofocus system is probably all the focusing control you'll ever need. However, if you run into a situation where your camera can't autofocus and you can't work around it, or if you have a particularly "creative" shot you want to compose, you might need to resort to your camera's manual focus.

On point-and-shoot cameras, manual focus is often a special focus mode that you have to activate. On an SLR, you usually activate manual focus by simply switching the AF/MF switch on the camera's lens, as you saw in Chapter 2.

Manual Focus on an SLR

Because SLR lenses all have focus rings on them, as well as bright viewfinders, manually focusing is fairly easy. On some lenses, you must first switch the lens to manual focus before the focus ring will work. On other lenses, manual focus will automatically work as soon as you turn the ring. So, if you don't like the results from the camera's autofocus, you can simply turn the focus ring to refocus.

Manual Focus on a Point-and-Shoot

Unfortunately, manual focus features on point-and-shoot digital cameras leave a *lot* to be desired. Between poorly designed controls and viewfinders that lack focusing aids, getting an accurate manual focus out of your point-and-shoot camera can be difficult. A few years ago, most digital cameras simply offered you a choice of distances. Consequently, in addition to trying to estimate the distance to your subject, you had to hope that the camera provided a preset focus distance that was close to what you needed.

These days, most manual focus mechanisms let you move smoothly throughout the focus range of your camera. However, determining when you've achieved focus is still difficult, because neither your camera's LCD screen nor optical viewfinder will be good enough to let you see focus.

Fortunately, because of their small sensor size, and because auto exposure mechanisms are sometimes biased toward smaller apertures, you often don't have to worry about your focus being dead-on, because your depth of field will be deep enough that everything in your image will be sharp (assuming that your focus is in the ballpark).

To ease manual focus, some cameras provide a special zoomed view that shows an enlarged crop of the center of your image. This can make it easier to assess focus (see Figure 7.9).

Even if your camera doesn't have a full manual focus control, it probably has a preset control for locking focus at infinity. This can be a handy feature for landscape photography or for other times when your subject is far away. Lock your camera's focus at infinity, and it will perform faster—it won't be trying to autofocus—and your batteries might last a little longer as the camera won't be moving the lens. If your camera has a Landscape scene mode, then it likely locks focus on infinity, in addition to aiming for a smaller depth of field. However, note that many scene modes require you to shoot JPEG files, so if you prefer to shoot raw, this isn't the best option for locking focus.

Consult your camera's manual for details on manual focus, and explore its scene modes to determine which ones might serve as useful manual focus controls.

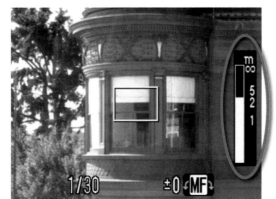

Figure 7.9

If your point-and-shoot camera offers a manual focus feature, it should provide some kind of indicator of focus. It might also allow you to display a magnified section of your image.

When to Use Manual Focus

If you use an SLR, then manual focus is much easier than it is on a point-and-shoot camera. Manual focus can often be very handy, and you'll want to think about it during situations like these:

- If your autofocus system isn't working because the light is too low or because your scene lacks contrast, consider switching to manual focus. Manually focusing in low light can be hard, simply because it's difficult to see when your subject is in focus, but it's worth a try.

- Manual focus can speed your shooting when working with a subject that isn't changing, such as a sit-down portrait. Set focus once, and then as long as neither you nor your subject moves forward or backward, you can continue to shoot without refocusing. This can greatly speed shooting. This is also a great technique for still life and product shots, and sometimes with landscapes.

- When shooting moving objects, some people find manual focus to be faster than autofocus. Once you've focused, any changes in focus as the subject moves will probably be fairly small. Many of the people who think this, though, are very experienced shooters with a lot of practice. Or they're just the type of people who like to show off.

With my SLR, I will often use a combination of auto and manual focus. For example, if I'm shooting a landscape and have set my camera on a tripod, or if I'm shooting someone on a stage, and I know neither of us will move, then I'll let my camera autofocus. Once it's focused, I'll switch the lens over to manual focus. Then I know that I'm focused at the right distance, and because I'm set to manual focus, the camera won't change that focus. This also works well for product shots. You must be very careful not to bump the focus ring, but if you're shooting from a tripod, this is usually not an issue. And, of course, you'll need to remember to switch the camera back to autofocus later.

This technique is also good for times when you're shooting in extremely low light—outside in the woods, for example—and your camera won't lock focus. In these situations, try using a flashlight to illuminate your subject. If you have a lantern, or some other point light source, place it in the scene at the distance you want to focus on. You might even be able to focus on the lantern itself. After you've achieved focus, switch the lens to manual focus and remove the light source from your scene. You're now ready to shoot.

Finally, you can always guess at the focus if your lens has distance markings. Either pace off or eyeball the distance to your subject and then set the lens to that distance (see Figure 7.10).

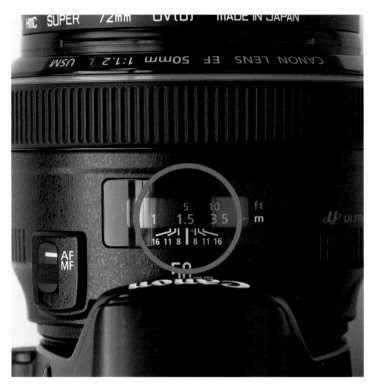

Figure 7.10

Many SLR lenses include markings that indicate the distance that the lens is focused on.

Other Focus Modes and Features

Some cameras include additional focus features that can be handy in some situations. For example, some cameras allow you to shrink the size of the area that's covered by their auto-focus points. If you have a complex subject in the center of the frame, this can help.

Some cameras also let you choose the place where you want to focus. By moving a cursor around on the LCD viewfinder, you can tell the camera the exact spot you want the autofocus to use.

Other cameras will have a combo manual/autofocus feature. Focus manually as best you can, and the autofocus will then refine your focus. In low light, or other difficult autofocus situations, this can be a good solution when your camera can't lock focus.

Check your manual to see if you have any of these features.

Evaluating Focus

One of the great advantages of a digital camera is its ability to display your picture immediately after shooting. However, don't expect to be able to accurately judge focus on your camera's LCD screen. At the time of this writing, even the highest-quality camera-mounted LCD is not good enough to check focus accurately, even when zooming in close to the recorded image.

If you're not sure whether your shot was in focus, try again. If the light is so low that you have to shoot manually, then shoot multiple shots with slight variations of focus.

Finally, if the lighting allows, switch to a smaller aperture. As you've learned, with a smaller aperture, you have deeper depth of field, which means more of your image will be in focus. You'll learn how to change aperture later.

You Say "Color," I Say "Color Temperature"

The color of a specific light is measured as a temperature using the Kelvin scale. For example, direct sunlight has a color temperature of 5500°K. You will often see photographers referring to the *color temperature* of a light source, and your camera's white balance setting might even prompt you to enter the color temperature of the current light.

The reason light color is defined as temperature is because of something called *black body radiation*. If you heat a black object, it will begin to change color. As it gets hotter, it will progress through a spectrum of colors from red through orange, then yellow, white, and blue-white. The color corresponds to the temperature to which the object has been heated. This, then, is why light is measured as a temperature.

One thing to note, as the temperature increases, the color shifts toward blue. So higher temperatures actually yield colors we traditionally refer to as "cooler."

Auto and Preset White Balance

Every time you take your camera into a new lighting situation, you need to consider how to best balance the white for that light. Proper white balance is essential to getting accurate color, and the only equivalent it has in the film world is the choice you make when you buy a particular type of film. Consequently, whether you're new to photography or you're an experienced film photographer, you must learn to start thinking about white balance!

All cameras have an automatic white balance feature and depending on the quality of your camera, this might be all you need to use to get accurate white balance. The simplest automatic white balance mechanisms look for the brightest point in your shot, assume that that point is white, and then use that point as a reference to balance accordingly. More sophisticated automatic white balancers perform a complex analysis of many different areas in your image. Both mechanisms are surprisingly effective, and you'll almost always get very good color when shooting in direct sunlight, and decent color in other lighting conditions. However, even a few clouds can confuse an auto white balance mechanism, and in other types of light you may find that your auto white balance works very poorly. So, even with the best cameras, you'll very often need to switch out of auto white balance mode.

Fortunately, most cameras offer preset configurations for different lighting conditions—Daylight, Tungsten, Fluorescent, and possibly a Cloudy or Overcast setting. (Tungsten is sometimes called "Incandescent" or "Indoors.") Because there are two different temperatures of fluorescent lights—"cool white" and "warm white"—some cameras offer separate settings for each fluorescent color.

White Balance in K°		
2700°K	-	Tungsten
3000°K	-	Halogen
4000°K	-	Flourescent
4500°K	-	Flourescent
5500°K	-	Sunlight
6500°K	-	Cloudy
7500°K	-	Shade

Figure 7.12

Some cameras use manual white balance controls that are measured in degrees Kelvin. If your camera simply presents a list of temperatures, here are the types of lights to which those temperatures correspond.

Other cameras will actually specify white balance presets in degrees Kelvin. Be sure you understand which setting corresponds to which type of light (see Figure 7.12).

These white balance presets are usually more accurate than automatic white balance in the situations for which they're designed. However, you can't always be sure that your lighting situation is exactly the color temperature your camera's preset is expecting. For these situations, some cameras offer white balance fine-tuning that allows you to alter a preset white balance to be warmer or cooler.

Manual White Balance

In general, you can expect your camera's auto white balance to do very well in direct sunlight. For other instances you can try white balance presets, which may not be tuned exactly right for the light you're trying to shoot in. Therefore, for the absolute best results under any lighting situation—and especially under mixed lighting—you'll want to use your camera's manual white balance.

To use a manual white balance control, hold a white object, such as a piece of paper, in front of the camera and activate the camera's manual white balance feature. The camera will study that white object and calculate a white balance based on the light in your scene.

Measure the Right Light with the Right White

When you manually white balance, be sure to hold your white card in the light that is hitting your subject. This is particularly critical in a studio situation where your camera might be sitting in very different light from your subject, or if you're standing outside in the sun, but you've placed a subject in the shade.

On some cameras, you set manual white balance by pointing the camera at a white object and then pressing a special button. On others, you take a picture of the white object and then tell the camera to use that image as the white reference. The advantage to the second approach is that you can store white pictures shot in different lighting situations and switch between them very easily. Check your camera's manual for more details.

Figure 7.13 shows an image shot with auto white balance in the shade. The color is not wildly out of whack, but it's too cool, and the flesh tones are not accurate. In the second image, the model held up a piece of white paper, and the camera's manual white balance feature was used to calculate white balance. The third image was taken using that manual white balance setting. As you can see, it's much warmer, with more accurate flesh tones.

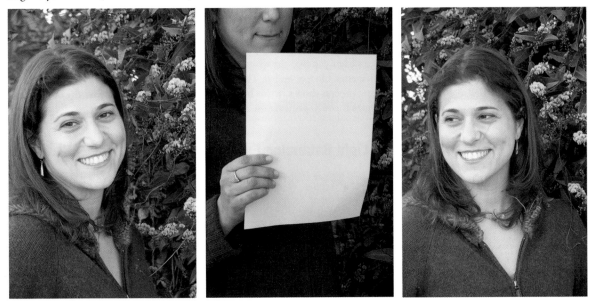

Figure 7.13 The first image was shot with auto white balance. For the second image, we had the model hold up a white piece of paper. We told the camera to use this image to set a manual white balance, and took the third image, which is much more accurate.

ExpoDiscs range in price from $70 to $170, depending on the size you need, and you can learn more about them, including detailed tutorials on how to use them, at *www.expodisc.com.*

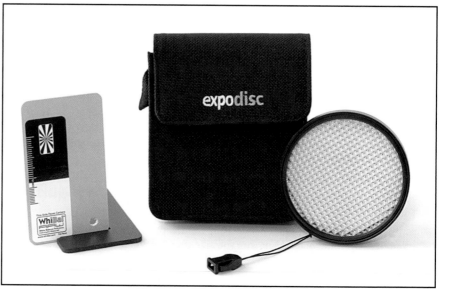

Figure 7.14

These two white balance aids can greatly improve the accuracy of your manual white balance operations. On the left is the WhiBal white-balance reference card, and on the right is the ExpoDisc.

Figure 7.15

For this image, we used the ExpoDisc to perform our manual white balance. As you can see, it's more accurate than the in-camera manual white balance shown in Figure 7.13.

While the ExpoDisc lets you get accurate color right out of the camera, it requires you to position the camera at your subject's location and then point back to your light source. This can be difficult if your light source is an on-camera flash or if you're standing in shade while your subject is illuminated. A white balance reference card such as the WhiBal card shown in Figure 7.14 provides a simple way to correct white balance *after* you've taken the shot. To use the WhiBal card, you place it within your light field, just as you do with a normal white balance reference, and then take a picture using auto white balance. Then remove the card and shoot your shots, also using auto white balance (see Figure 7.16). Later, you use your image editor to correct the white balance using your reference image. We'll discuss how to do this later in the book.

Figure 7.16

In the left image, our model is holding the WhiBal white balance reference. We took a picture and then removed the card. In our image editor, we used that reference image to correct the color in the right-hand image, resulting in a very accurate white balance.

A white balance reference card even works well for street shooting. If you find yourself in a weird lighting situation, just hold the card in front of the camera and take a shot. You can use that image later to correct the other shots you shoot in that light. Or if the situation you're in is changing rapidly, take the shot you want first and then grab the WhiBal shot afterward. Working with the WhiBal card offers the quickest way to record white balance (see Figure 7.17).

The WhiBal card is available from *www.whibal.com* and sells for around $30.

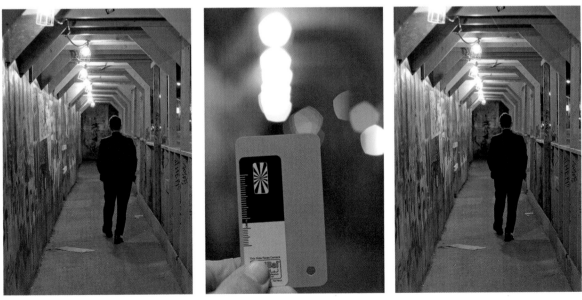

Figure 7.17 While walking down the street late at night, I took the shot on the left. Because I knew that auto white balance would be inaccurate, I immediately held up my WhiBal card and took a shot of it. Later, I used the WhiBal image to correct the color in my original shot.

Don't Plan on Correcting Bad White Balance

You might be tempted to assume that you don't have to worry about correct white balance because you can always use your image editor to correct white balance troubles. This is sometimes true, but it can take a lot of work to correct a bad white balance (see Figure 7.18). The color shifts that occur from incorrect white balance don't affect all of the colors in an image equally—for example, the highlights in an image might be shifted more than the shadows. Consequently, you won't be able to do a simple global correction. Moreover, as you'll see later, by the time you're done correcting the white balance, you might have used up enough of your image's editing capability so that it will be difficult to perform further corrections and adjustments without introducing artifacts. In the end, it's best to shoot with the most accurate white balance your camera can manage.

If you're shooting in Raw mode, you might feel like you don't need to worry about white balance, since raw files allow you to set white balance after the fact, without using up any of your editing latitude. This is true, but shooting with bad white balance means you'll have to do a lot of editing and adjustment later. Shooting as cleanly as possible in-camera will greatly speed your workflow. Also, just because raw images allow for fine white balance control, it can still be difficult to determine the correct white balance.

No matter what format you're shooting in, you may decide that you don't need to worry about white balance because you're ultimately going for a stylized look, not realistic color. That's fine, but you never know how you might want to repurpose your images later. Having accurate white balance will give you a record of what the real color was, and still allow you to perform your stylized adjustments.

So, in general, it's a good idea to give some thought to white balance while shooting.

Figure 7.18

The top image was accidentally shot with Tungsten white balance (instead of auto or daylight). The middle image shows my attempts to correct the color. Although the image is improved, completely removing the bad color casts is extremely difficult and results in an image with bad posterizing artifacts (which are difficult to see at this print size). The bottom image was shot with a correct white balance. As you can see, white balance choice is not to be taken lightly, because correcting it later is extremely difficult.

Drive Mode

Normally, when you press the shutter button down, your camera takes a picture. If your camera has minimal shutter lag, then it takes the picture seemingly instantly. If your camera has the ability to change its Drive mode, then you can tell it to shoot more than one picture when you press the shutter button.

Sometimes referred to as Burst mode, the Drive modes on different cameras work at different speeds, but they all have one thing in common: as long as you hold down the button, the camera will keep shooting.

Drive mode is most useful when you're shooting action scenes such as performances and sporting events, or wild animals, or any moment where you're concerned that your reflexes won't be fast enough to grab the decisive moment. When you use Drive mode, you can shoot a burst of images and pick out the best one later (see Figure 7.19).

Figure 7.19 Drive mode is ideal for shooting any type of action, since it allows you to shoot a burst of images, to capture a specific moment.

Drive mode can also be useful for more everyday events, especially when shooting candid shots of people. Because people's expressions can change very subtly from one moment to the next, shooting a burst of images lets you shoot a range of expressions (see Figure 7.20).

Some cameras can burst very quickly, zipping through five to seven pictures per second. Cameras designed specifically for sports shooting might even manage to go faster. Casio makes point-and-shoot cameras that can shoot 30 full-resolution images per second. Other cameras will clock slower burst speeds, sometimes dropping to 1.5 to 2 frames per second. Still, even this slow speed can be useful in some situations.

Figure 7.20

When shooting groups of people, it's tough identifying the precise moment when everyone's eyes will be open, and they'll all have good expressions. With Drive mode, you can easily shoot a burst and then pick out the best image.

Shooting in Drive Mode

First, activate your camera's Drive mode. Note that some cameras offer multiple Drive modes with different speeds. For example, they might have a slow Drive mode that can capture three frames per second and a faster mode that manages five. The slower mode will let you maintain a burst over a longer period of time, while the faster mode will shoot more often.

Shooting with Drive mode is just like shooting in Single-Shot mode: press the shutter button halfway to autofocus, make sure the camera is focused properly, and then press the button the rest of the way to take the shot. In Drive mode, though, as long as you hold the shutter button down, the camera will continue to shoot, bursting away at whatever speed it can manage.

While your camera might be able to capture a bunch of shots in one second, it can't write them out to the storage card that quickly, simply because current storage card technology doesn't allow for fast enough data transfer. To get around this problem, the camera contains a big memory buffer. As you shoot more images, they are quickly stuffed into the memory buffer, to free up the camera for shooting again.

Most cameras with a Drive mode have some kind of readout that tells you how much space is left in the internal buffer (see Figure 7.21).

Figure 7.21 Most cameras have some kind of readout that shows how many shots are available in the current buffer. When this number gets to zero, you have to wait for the camera to clear out buffer space.

The camera does not wait until the buffer is full before it starts writing. It continuously writes as you shoot, but when the counter hits zero, the camera will stop shooting. If you continue to hold the button down, the camera will shoot again as soon as some space is available, but you'll probably only get one shot off before you experience another pause.

If you lift your finger off the button for a few seconds, to give the camera time to dump more images, the number of shots that can be taken at full speed will go back up.

In practice, buffer limitations probably won't be a huge problem, because you'll rarely shoot long bursts. But it's still a good idea to keep an eye on the buffer number and to shoot small bursts with breaks in between. If the "big play" is about to unfold, don't just start bursting with the idea that you'll get the whole thing. Wait until the critical moment is as close as possible and then start your burst. Not only will this improve your chances of getting the shot you want without incurring a pause, but you'll also have fewer images to wade through later when you start processing your images.

Depending on the image format you're shooting in, the number of images that fit in the buffer will change. For example, the buffer can hold more low-resolution JPEG images than it can full-size TIFF or raw files. Also note that the time it takes the camera to write out images is partly dependent on the speed of the memory card you're using. These days, even inexpensive cards are fast, but investing in higher-end cards can result in speedier data transfer. If you find yourself shooting a lot of bursts and having to wait for the camera to finish writing, then you'll probably want to buy faster cards.

Drive Mode and Image Review

When you shoot in Drive mode, the camera does not display each image on the LCD screen. Instead, it waits until you're done with the burst and then displays the last image you shot.

Continuous Flash Shots

Most cameras can't use a flash when shooting in a Burst mode, because there isn't enough time for the flash to recharge. However, some cameras can manage roughly one frame per second when shooting with the built-in flash. If you regularly need to shoot with bursts of flash shots, you might want to shop for a camera with a good flash burst speed.

Don't Let Drive Mode Make You Lazy

While Drive mode can be a great way to capture a specific moment in a complex, rapidly changing scene, don't become too dependent on it. Learning to shoot in Single Frame mode is a very important skill that will greatly improve your ability to recognize the "decisive moment" in a scene. What's more, depending on the speed of your camera's burst feature, the decisive moment may happen between frames. Consequently, being practiced at recognizing, anticipating, and capturing single frames can be an essential skill.

Self-Timer

At some point, you've probably owned a camera that had a self-timer on it. You know: you set the timer and then run as fast as you can to try to get in the shot and look natural in the five seconds or so you have before the camera fires. Most digital cameras have this type of feature.

Your camera might offer a few self-timer options, such as the following:

- **Self-timer.** Press the button, wait the specified interval, and the camera takes a picture. These options usually have a fairly long interval, such as 10 seconds.

- **Self-timer with variable delay.** Some cameras let you specify any amount of delay, while others simply include an additional interval, usually a very short one, like two seconds.

- **Self-timer continuous.** Some cameras will fire a burst of two or three shots rather than a single shot. This can be handy when shooting groups of people, for the reasons mentioned earlier.

The 10-second interval is designed to give you enough time to get in front of the camera. The 2-second timer is not for self-portraits, but for when you want to take a shot with minimal camera contact. Any time you handle the camera, you risk introducing shake that can cause your images to be soft. This is especially problematic when shooting long exposures. So, with a longer exposure, you'll get the sharpest image if you put the camera on a tripod and use the 2-second timer. This is a good approach for low-light photos, astrophotography, or photos where you're using a small aperture for deep depth of field, and so must use a long shutter speed.

If you want to shoot a solo self-portrait, bear in mind that focus can be tricky. If your goal is to stand in an open area, then you have a focus concern. When you half-press the shutter button, the camera will focus on whatever might be behind where you intend to stand (since you'll be behind the camera), which could be a long way away. After you press the shutter button down all the way and run in front of the camera, the focus won't change, but it will still be locked on the distant point that it focused on when you half-pressed the button.

To compensate for this, tilt the camera down and focus on the spot on the ground where you plan to stand. In fact, you might want to mark the spot beforehand. Press the shutter halfway to lock focus; then frame your shot and press the rest of the way to start the timer.

With the camera focused, trip the shutter and run to the marked spot, and you should get good focus. To improve your chances, select a small aperture to increase depth of field. That way, if the focus is off by a foot or two, your image will still most likely be in focus (see Figure 7.22).

Figure 7.22

To shoot this self-portrait, I focused on a spot on the ground where I planned to stand. Then I switched the camera to manual focus to lock that focus and pressed the self-timer.

If you're shooting with an SLR, your camera might have come with an eyepiece cover attached to its strap. Without your face in front of the viewfinder, light can filter in through the viewfinder and throw off the camera's exposure. By covering the viewfinder with the eyepiece cover, you can protect the exposure from stray light (see Figure 7.23).

Figure 7.23

To use the eyepiece cover, remove the eyepiece and then fit the cover (which is usually attached to the camera strap) over the eyepiece mount.

Remote Controls

In the old days, you could attach something called a cable release to the shutter button of your camera. This was a long cord with a little plunger mechanism running through it. When you pressed the button at the top, the plunger was pushed forward, and a pin came out the other end and pushed the shutter button.

Since digital cameras all have electronic shutters, you no longer need such a crude mechanical device. Instead, you get to use an expensive electronic device.

If you have a point-and-shoot camera, it might provide an option for a separate wireless remote control; or, if you're lucky, it might even have come bundled with one. These controls usually include a shutter button and possibly a zoom control. A wireless remote is a great fix for the self-portrait problem described earlier.

Most SLRs include a port for attaching a cabled remote control of some kind. These remotes vary in features, but they'll all include a shutter button. Some might also include a long-exposure timer, which allows you to program an exposure of a particular duration, or a lock feature, for using Bulb mode. Others might include an intervalometer, which allows you to shoot time lapse movies (see Figure 7.24).

Figure 7.24 Some stills from a time-lapse movie, shot with a Canon G9, which features a built-in time-lapse feature.

An *intervalometer* will automatically take a shot at a given interval. Some intervalometers also let you specify the number of shots you want taken at each interval. This allows you to perform a time-lapse bracketed sequence, when used in conjunction with your camera's Auto Bracketing mode.

The shutter button on all remote controls works just like the shutter button on your real camera: press the button halfway to autofocus and then press it the rest of the way to shoot.

Remote controls are great for self-portraits, or for any time when you want to keep your hands off the camera to reduce vibration. They're also good for portrait shooting, because you can stay out from behind the camera and maintain eye contact with your subject.

Third-Party Remotes

The remote controls sold by your camera maker can be pricey, so you might want to look for a third-party alternative. If you have an SLR, you'll probably be able to find lots of third-party remote control alternatives, including simple wired remotes all the way to sophisticated remotes with intervalometers.

You can probably also find third-party wireless remotes for your SLR. These remotes include a receiving unit that you plug into the remote port on your camera and a small handheld unit for tripping the shutter.

Inexpensive Remote Alternatives

The wireless remotes available for most cameras can be pricey. However, if you have a universal remote control that you use for your TV or stereo, then you might be able to use that remote to control your camera.

Some universal remotes can be trained to drive a particular device, assuming you have the remote control for that device. So, if you have a friend who has the remote control for your camera, you might be able to train your universal remote. It might also be that someone else has already figured out how to get a specific remote to work with your camera. Google "universal TV remote [your camera name]" and you will probably find people explaining how to use a universal remote with your specific camera. Obviously, your camera has to have built-in support for a wireless remote.

If you can't find a solution for your camera, you can try a more manual approach. Set your camera to Wireless Remote mode so that it can receive remote commands, and then start working your way through your universal remote's controls. Try different brands and button combinations and see if any trigger your camera.

The wired remote port on many cameras uses a standard 1/32nd-inch jack, which is the same size as many cell phone headsets. If you have a cell phone headset with a mute button, and the jack fits the remote port on your camera, plug the headset in and see if pressing the mute button trips the shutter. Note that sometimes only a half or three-quarter press is required, so fiddle with it a bit to see what works.

Tethered Shooting

Your in-camera histogram provides an excellent way to judge your exposure, while your camera's LCD screen lets you see your exact composition. Your computer, though, has a much larger monitor than your camera, and offers software tools that provide far more powerful analysis. To take advantage of your computer's larger screen and more advanced software, you might want to consider tethering your camera to your computer *while* shooting.

When tethered, every time you shoot an image, it is automatically moved to your computer and displayed on-screen, giving you a much better view of your final image than what you get on your camera. This allows you to assess focus, color, and tone more easily, and then adjust your shot and reshoot.

Your tethering software might also allow you to control your camera. Many tethering programs let you see and adjust all exposure parameters, and then fire the shutter. So, once you get your shot set, you can return to your computer and try different exposures—and immediately see the results[md]without having to run back and forth between the camera and computer. Some can even show you the view through the viewfinder.

Tethered shooting is ideal for studio work, where you tend to set the camera in place and alter lighting and exposure. For live action studio work, such as portraiture, tethering is a boon both because of the better view afforded by a real monitor, and because your client can see your shots as you work.

(continued)

Tethered Shooting

If you're willing to lug a computer and relevant power, then you can even work tethered in the field. Whether location shooting or working with landscapes, tethered shooting can facilitate a speedy workflow, both because of the ease of review, and because you can so easily get images into an image editor to ensure that you've got your exposure the way you want it. When shooting wildlife, you can hide your camera and control it from a hidden location. Sports shooters often tether because it affords them the chance to install a camera in a difficult location, such as directly above a basketball goal.

Most cameras capable of tethered shooting ship with software that handles the real-time transfer to the computer. For more details, consult the software manual that came with your camera. These days, most cameras tether using USB-2 cables, although some still use a FireWire connection.

A variation of tethered shooting is to connect the video out port of your camera to a TV. After shooting, you can immediately view your image on the TV monitor, which can make it easier to assess fine details and allow your subjects to see the results.

Manual Override with Program Shift (Flexible Program)

You've already learned about the effects that different shutter speed and aperture choices have on your final image. Earlier, you saw that by controlling shutter speed, you could choose how much you wanted to freeze or blur motion, and that by controlling aperture, you could choose how much you wanted to blur out the background. You also learned that these parameters have a reciprocal relationship. If you change one, you can change the other to compensate.

Most SLRs, and quite a few point-and-shoots, provide a lot of different ways to change shutter speed and aperture, allowing you to take complete creative control of motion stopping and depth of field.

As I mentioned earlier, your camera's light meter aims for a shutter speed that is appropriate for handheld shooting and an aperture that's not so small that you'll suffer a sharpness penalty. (Remember, your lens has an aperture "sweet spot.") But as you've learned, many different combinations of shutter speed and aperture yield the same exposure. Some of these combinations will have a faster or slower shutter speed and, conversely, a larger or smaller aperture.

Some cameras provide a way to cycle automatically through reciprocal exposures after the camera has metered. Normally, it's very simple: half-press the shutter to meter and then use your camera's program shift equivalent to cycle through all the other combinations of shutter speed and aperture that yield that same exposure.

Other Names for Program Shift

Canon, Olympus, and Panasonic call this feature *Program Shift*, while Nikon and Fuji call it *Flexible Program*, and Sony calls it *Manual Shift*. Other cameras have the feature, but may not give it a specific name. Check your manual to see if your camera has such a feature and to find out how to control it.

So, if I press the shutter halfway to meter, and the camera yields a reading of 1/125th at f7.1, and I then move my Program Shift feature one notch, the meter reading changes to 1/200th at f6.3. Another move gives me 1/250th at f5, and so on. Each of these exposures is equivalent, but as I continue to shift, my shutter speed is getting faster, which gives me more motion-stopping power. The aperture is also getting wider, which might yield a shallower depth of field.

Here's a real-world example. The first image in Figure 7.25 shows the scene as the camera chose to meter it. It chose f11 at 1/400th of a second, and the resulting image has good overall illumination. However, I was curious to see what the image might look like with a shallower depth of field, so I took another shot. I pressed the shutter button halfway down to meter, and again the camera showed f11 at 1/400th. I then turned the Program Shift control on my camera until the aperture was open as wide as possible (that is, until the smallest f-number appeared). On this particular lens, at this particular focal length, the widest aperture was f5. The camera showed that, at this aperture, the exposure would change to 1/2000th of a second. These two combinations, f11 at 1/400th and f5 at 1/2000th, end up yielding the same overall illumination. But the second exposure has shallower depth of field, as you can see in the second image.

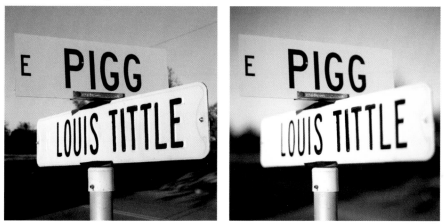

Figure 7.25

These two images have the same overall exposure, but in the second image, I used my camera's Program Shift feature to dial in a wider aperture, to yield shallower depth of field. Most importantly, I didn't have to leave Program mode to get this manual control.

By using Program Shift, I have effectively taken an important level of manual control without having to leave Program mode.

Your camera's Program Shift feature (if it has one) probably doesn't work in Auto mode, but should be active in Program mode. This means that, in addition to the full benefits of Auto mode, you've got Program Shift as a manual override for choosing a faster or slower shutter speed, or bigger or smaller aperture, all while maintaining a correct exposure. This allows you to quickly select a particular parameter without having to leave Program mode.

Say you're out shooting in Program mode and a portrait situation presents itself. You can meter just as you always would, and then use Program Shift to quickly change to a metering with a very wide aperture (low f-stop number) to blur out the background. You haven't changed any kind of mode—you're still in Program mode—so with your next image you'll be back to your camera's normal Program mode behavior.

This is a great feature, and an easy way to mix auto and manual shooting very quickly, so it's worth tracking it down in your camera manual.

Calculating a Safe Shutter Speed for Handheld Shooting

Once you start fiddling with shutter speed (which you can do with the Program Shift feature we just discussed), you have to be very careful about the shutter speed you choose. If you pick a shutter speed that's too low, you'll run the risk of getting blurry images due to camera shake. Or, even when you're shooting in Auto mode, you still need to know when the shutter speed that the camera has chosen is too low for reliable handheld shooting.

As bipedal animals, we don't stand still, we sway—it's a necessary part of balancing on two legs. When you throw in breathing, a beating heart, and possible windy conditions, holding a couple of pounds of camera perfectly still becomes impossible.

So what's the slowest shutter speed that you can use when shooting handheld? That depends on your lens and the focal length at which you're shooting.

The generally accepted rule for what makes a shutter speed acceptable for handheld shooting is to simply take one over your current focal length. So, if you're shooting with a 50mm lens (or a zoom lens set to 50mm), you shouldn't shoot any slower than 1/50th of a second. If you're shooting with a 200mm lens, you shouldn't shoot with a shutter speed slower than 1/200th.

The idea is that, as the image is magnified when you zoom in, so too is any motion within the frame. Thus, you have to use a faster shutter speed as you go to a longer focal length.

On a point-and-shoot camera, you may not have a readout that tells you what your current focal length is. However, these cameras will usually have a handholding warning indicator, which will flash if the camera thinks that your shutter speed is too slow for safe handheld shooting.

If you're shooting with a digital SLR, you'll be able to determine your current focal length by simply looking at your lens. However, as you learned earlier, lenses on a digital SLR are often subject to a focal length multiplier that changes the effective crop of the lens at a given focal length. If your lens has a focal length multiplier of 1.6, you'll first need to multiply your current focal length by 1.6 and then perform your handheld calculation.

Stabilization and Shutter Speed

In Chapter 3, "Camera Anatomy," you learned about stabilized lenses, which include technology that allows them to smooth out the vibration and jitters that come from your hands. Most stabilizers are rated in terms of how many stops of stabilization they provide. For example, a three-stop stabilizer lets you shoot with a shutter speed that is three stops lower than what you could shoot at with a nonstabilized lens (see Figure 7.26).

Figure 7.26

This 17–85mm lens is currently set to a focal length of 50mm. However, this lens is attached to a Canon EOS SLR that has a focal length multiple of 1.6. Therefore, the crop of this lens is equivalent to 50 × 1.6, or 80mm. Our minimum shutter speed for sharp handheld shooting is 1/80th of a second. However, because the lens has a three-stop image stabilizing system, we might be able to get away with shooting as low as 1/10th (80 ÷ 2 = 40; 40 ÷ 2 = 20; 20 ÷ 2 = 10, or three halvings, which means three stops).

Do You Really Need to Calculate Handheld Shutter Speed

Suddenly, it may sound like shutter speed is an incredibly complicated thing. If the last bit of calculation scared you, don't worry, this is not something you'll have to consider on every shot you take. The only time you need to start thinking about calculating handheld shutter speed is if you're in low light.

If you're out shooting at dusk with a 100mm lens, and you notice that the camera has chosen a shutter speed of 1/60th of a second, you should recognize that 1/60th is a little slow for a lens that long, because according to the handheld shooting rule, you shouldn't be shooting slower than 1/100th of a second.

Similarly, if you walk into a dark auditorium to shoot a play or concert, you might take a little time to meter the scene—look through the camera and press the shutter button halfway, and see what kind of shutter speed the camera picks. Once you know what the camera is suggesting for a shutter speed, you'll have a better idea of how long a lens you can use.

When you see that your shutter speeds are going long, you'll want to be extra careful to hold the camera steady. If you have a tripod or monopod with you, get it out. Otherwise, see if there's a place you can rest the camera.

Assessing Exposure with Your Ears

By now, you should have a good idea of what your camera's shutter sounds like. As shutter speed gets slower, the shutter sound changes fairly significantly. You can hear the delay between when the shutter opens and closes. Listening to the sound of your shutter can be an easy way to keep track of when your shutter speed might have dropped too low for handheld shooting. Also, you might notice that the viewfinder stays blacked out for longer. If you hear a slow shutter speed, you'll want to consider reshooting the shot with a more appropriate shutter speed.

Changing ISO

If your camera picks a shutter speed that is too low for handheld shooting, you have several options. By the time the camera has set the shutter speed down low, it's probably already opened the aperture all the way, so the odds are you won't be able to compensate for the slow shutter by going to a wider aperture. However, don't forget that you have a third exposure control: ISO.

In the previous chapter you learned that the ISO setting controls how light sensitive the camera's sensor is. A higher ISO number means the sensor is more light sensitive, which allows you to use shorter shutter speeds and smaller apertures. For times when you need lots of motion-stopping power or deep depth of field, the ability to increase your ISO can make the difference between getting and missing the shot that you want. Increasing ISO is also a great option when your camera has chosen a shutter speed that's too slow for steady handheld shooting. In fact, the image sensors in some digital cameras are so sensitive that you can shoot effectively with them in much lower light than you could ever manage with film.

When your shutter speed dips down low, it's time to raise the ISO. For example, say you're shooting with a 100mm lens at ISO 100, and your camera's meter has selected a shutter speed of 1/60th of a second. If you increase ISO to 200, you will gain one stop of sensitivity, and your camera will compensate by doubling the shutter speed to 1/120th—plenty fast for handheld shooting.

Or perhaps you're shooting with a 100mm lens at ISO 100, and it's now half an hour later than the first shot, and your camera is metering at 1/30th of a second. If you switch to ISO 200, shutter speed will go to 1/60th of a second—still too slow. If you go to ISO 400, you'll be back up to 1/120th of a second, well within the realm of safe handheld shooting.

As mentioned earlier, you'll also want to employ all the techniques that you can to stabilize the camera.

Remember to Breathe

When trying to hold the camera steady—which is especially important when using a slow shutter speed—remember to squeeze the trigger gently. Use the posture tips we discussed earlier, and don't hold your breath. Holding your breath actually makes you shakier. Take a breath, let it out, and squeeze the shutter release. If possible, try to find something to lean against or that you can use to steady the camera.

If a faster ISO offers better low-light performance and the ability to shoot with really fast shutter speeds and narrow apertures whenever you need them, why shouldn't you just leave the camera on ISO 1600 all the time?

Earlier, you learned that the camera increases ISO, the sensitivity of the sensor, by boosting the amplification of the voltages that are read off the sensor after an image is shot. Unfortunately, anytime you amplify any type of electrical signal, you increase any noise in the signal along with the data you're trying to read. Noise is just what you think it is—the extraneous, *static* signals that you hear on a radio. Noise is generated by components in the camera, by other electrical sources in the room, and even by the stray cosmic ray that might be passing through you and the rest of the planet. The practical upshot of this is that as you increase the ISO of the camera, you also increase the *noise* (grainy patterns that sometimes look a lot like film grain) in your image.

You always want to shoot at the lowest ISO that you can to ensure that you don't introduce extraneous noise. On most new SLRs, you'll probably find that there's very little difference in the amount of noise you see in an ISO 100 to 400 image. So you can safely choose these ISOs and see no discernible noise increase.

These cameras will see a visible increase as ISO climbs from there, but it's still very low and very usable.

With their smaller sensors, point-and-shoot cameras don't fare as well when ISO is raised, but they can still take good shots. No matter what type of camera you have, do some experiments at higher ISO to determine if your camera yields images with acceptable levels of noise.

Also, on many cameras, the noise they produce has such a nice quality, that you probably won't mind it. Sometimes a bit of texture can add a lot of atmosphere to an image. Most importantly, just because noise is visible on-screen doesn't mean it will show up in print. By the time you've scaled your image to your desired output size and the printer has processed it, the noise might be far less visible.

Two Kinds of Noise

Digital cameras generate two different kinds of noise, *luminance noise* and *chrominance noise*. Not all cameras produce both, and not all produce both at the same time. Luminance noise is simply noisy patterns of changing luminance—bright speckles that appear in your image, usually in the shadow tones (see Figure 7.27).

Chrominance noise appears as splotchy patterns of color, also usually in the shadow tones. Usually, chrominance noise appears as red or magenta splotches, but the color, splotch size, and density varies from camera to camera (see Figure 7.28).

Figure 7.27

Luminance noise appears as speckled patterns of varied luminance. If you have to have noise, this is the preferable type, as it looks more like a film texture–type grain.

Figure 7.28 Chrominance noise appears in your image as varying patterns of color. Chrominance noise has no film counterpart, and so looks very "digital." It's extremely difficult to remove.

Of the two, luminance noise is the less egregious, partly because it looks the most like film grain or texture. Color noise looks very "digital" somehow, and is extremely difficult to remove. Different cameras produce different amounts of noise, and some digital cameras produce "prettier" noise than others. Noise will always get worse as you increase ISO, and usually gets worse as light levels are lower.

ISO Changes in Bright Light

Adjustable ISO is not only valuable for shooting in low light, but by changing ISO, you can buy yourself more shutter speed and aperture latitude.

For example, let's say you're trying to shoot a close-up of a flower on a windy day. Your meter has recommended 1/125th of a second at f3.5, which on this particular lens is the maximum aperture. This is great because it gives you the shallow depth of field that you want, but unfortunately it's so windy that 1/125th of a second is resulting in an image that's too blurry. Increasing the shutter speed by two stops to 1/1000, will leave the image underexposed, because the camera's aperture can't be opened any further.

If you increase the ISO from 100 to 400 (a two-stop difference), you'll have enough exposure latitude to make your shutter speed change and get your shot.

Remember to Change Back!

When you raise your ISO for a particular situation, it's critical that you remember to change it back! If you're shooting in a dark environment at ISO 1600 and then move into bright daylight, your images will have extra noise, if you don't remember to change your ISO back to something more appropriate. Try to get in the habit of always thinking about what ISO you're set for when you enter a new lighting environment.

Auto ISO

Many cameras now provide an Auto ISO setting, which tries to calculate an ISO setting automatically. These mechanisms aim to keep ISO as low as possible, but your camera will know to kick in a higher ISO if shutter speed goes too low for acceptable handheld shooting.

JPEG Exposure Tips

If you're shooting in JPEG or TIFF mode (we haven't yet discussed shooting in Raw mode, but we'll get to that later), here are two simple things to keep in mind when choosing an exposure:

- **Protect your highlights!** Overexposed highlights are ugly! They're big, empty areas of white that are boring and distracting. When choosing an exposure, be sure to protect your highlights. While you want to have shadow detail, it's always better to risk losing shadow detail to be sure you've protected your highlights. A dark, black shadow will be less noticeable and distracting than a blown-out highlight.

- **Usually, a slight bit of underexposure will yield slightly better saturation.** In typical, evenly-lit daylight and indoor situations, leaving your camera set to –.3 stops will produce slightly "punchier" images. However, if you're in a bright location, or shooting something with a lot of white, you'll want to adjust your exposure accordingly.

Obviously, these two factors must be balanced with any other exposure concerns you're juggling (depth of field, motion stopping, tone mapping, and so on).

Fractional ISO Numbers

Like shutter speed and aperture, when you increase ISO by one stop, the ISO number doubles. Thus, increasing from ISO 100 to 200 is a change of one stop. Some cameras, though, allow you to change ISO in fractions of a stop. For example, you might be able to change from 200 to 250, a change of 1/3rd of a stop.

Most cameras that offer fractional stop increases also provide the option to change the interval, usually choosing between 1/3 and 1/2 of a stop. Here you can see 1/3rd stop ISO settings. Full stop settings are listed in bold.

100 125 160 **200** 250 320 **400** 500 640 **800** 1000 1250 **1600**

Putting It All Together

We've covered a lot of topics in this chapter, and it may sound like a lot to remember, but with just a little practice you'll find that the issues covered here will become second nature. With experience, you'll learn when you need to change the Autofocus mode on your camera and what the different modes are best for.

Similarly, with white balance, you'll come to recognize when you're in a situation that will trip up your camera's white balance mechanism—shade, for example—and you will know to use a preset or manual setting.

Drive modes and self-timers can be lifesavers when you need them, but you probably won't find yourself using them all the time. Like manual white balance and Servo Focus, these are features that are aimed at very specific problems. Now that you know these options are there, you can fall back on them when necessary.

Of all of the items in this chapter, the two that you will probably use most regularly are program shift and ISO change. As you learned, Program Shift gives you important manual overrides without having to give up the convenience of Program mode's automatic features. With it, you can take creative control of shutter speed and aperture.

In Chapter 2, you were encouraged to get in the habit of noting shutter speed while shooting. In this chapter, you learned how to know when shutter speed has gone too low for stable handheld shooting and how you can use ISO to get your shutter speed back up to acceptable handheld levels. These are essential skills that you'll use constantly.

Many people think that Program mode is for beginners, but I shoot regularly in Program mode. For everyday shooting, Program mode provides everything I need, and when I need an occasional manual override, Program Shift gives me the power to make a shutter speed or aperture change. If I know for sure that I'll be shooting a number of frames that have very specific aperture or shutter speed needs, then I'll switch to a more manual mode, so that I don't have to constantly use Program Shift to get where I want to be. (We'll learn about those modes in the next chapter.) But Program mode is not something you'll use while learning and then leave behind. It's a powerful, important tool in your photography arsenal.

8

ADVANCED EXPOSURE

*Learning More About Your Light Meter
and Exposure Controls*

According to Ansel Adams, when famed photographer Margaret Bourke-White was shooting, she would simply set her camera on 1/100th of a second and then shoot the same image over and over using every aperture her camera could manage. This, combined with her tremendous compositional skill, ensured that at least one of her images would come out the way she envisioned.

Although digital cameras make Bourke-White's approach far more cost-effective than it was with film, a much better practice is to spend some time learning how to use the tools and features found on your camera intelligently to ensure that you get a good shot with only one or two exposures.

At the simplest level, your exposure choice governs whether your image will be too bright or too dark. In this regard, your camera's automatic meter will almost always do a good job of keeping your image well exposed, but your choice of exposure also provides a tremendous degree of creative control. In the last chapter, you were introduced to the effects that different exposure decisions have on your final image. This was an essential concept, if you want to move beyond snapshot photography. In this chapter, we'll explore metering and exposure in greater detail.

In these days of fancy digital image editors, many people think, "Why should I worry so much about exposure? I can just fix it in the computer later." That may or may not be true because it is possible to shoot images that have problems that can't be fixed. So you'll stand a better chance of coming home with good images if you work to get exposure right in-camera. What's more, as you learn more about exposure, and what your camera is capable of, you'll begin to notice scenes that you might not have recognized as potential photos before.

If you've ever used a tape recorder or video camera to record someone's voice, you know that if he or she is standing on the other side of the room, you may get bad-sounding audio. Later, maybe you can turn the volume up louder to try to hear that person, but it still won't sound very good. Photography is the same way: if you don't capture high-quality data, no amount of image editing will be able to fix the problems in your image. Also, as you'll learn when we get into postproduction, there's a finite amount of editing that can be performed on an image before ugly artifacts begin to appear. If you get the exposure right in-camera, you won't have to make these types of broad, potentially damaging edits.

Finally, image editing takes time. Shooting with an accurate exposure will mean less post-production work, a more efficient workflow, and more time to spend shooting!

The Light Meter Revisited

Anytime you half-press the shutter button on your camera, the light meter activates. It measures the light in your scene and calculates a shutter speed and aperture (and ISO, if your camera is set to Auto ISO). By this point, you should be familiar with the process of metering, and hopefully have been practicing what we've covered in previous chapters. If so, then you might have discovered already that the automatic meter in your camera *can* be confused. When this happens, it won't calculate the best exposure for your scene. Consider the image shown in Figure 8.1.

Figure 8.1

This image suffers from bad
backlighting, which has left the
subject's face in shadow.

The meter has chosen settings
that will expose the bright sky
properly in the background,
both because it's such a large
feature in the scene, and
because the meter tries its
best to avoid overexposure.
However, exposing for the
brightness in the sky has
resulted in the subject's face
ending up too dark. This is
the most common bad meter-
ing problem, but you will find
other issues that occur as a result of bad metering. Highlights that blow out to complete white,
or an inability to show black objects as truly black, are both problems that can stem from
metering issues.

There are many ways to solve metering problems. You can use your camera's manual overrides
to compensate for what the camera has metered, but this requires you to know how much
compensation to use, which is a difficult thing to judge by eye.

Fortunately, most cameras include several different Metering modes. These modes take dif-
ferent approaches to measuring the light in your scene, and some are more appropriate to
some situations than others.

Your camera might have some, or all, of these modes. Consult your manual to learn what
modes your camera provides and how to select them.

- **Matrix meter** (sometimes called *Evaluative* or *Multisegment*). A Matrix meter divides
 your image into a grid and takes a separate meter reading for each cell in the grid. These
 cells are then analyzed to determine an exposure setting (see Figure 8.2).

Figure 8.2

Most cameras offer some form of
Matrix metering, which samples
light from all parts of your image
to come up with a final exposure
calculation.

The exact number of cells varies greatly from camera
to camera, and the total number is not nearly as
important as what the camera does with the data it
collects. Matrix metering algorithms are very closely
guarded trade secrets, and different cameras take
different factors into consideration. Some might con-
sider the autofocus point that has been selected, depth
of field, brightness differential across the image, and
possibly even color content.

Matrix metering is the best choice for most situations and is certainly the best option
when you're simply trying to get a quick shot using your camera's automatic features.
However, as you saw earlier, there will be times when you'll need to make some adjust-
ments to your Matrix meter reading.

- **Center-weighted averaging.** A variation of Matrix metering, Center-weighted averag-
 ing also divides your image into a grid of cells, but when analyzing the readings, a Center-
 weighted metering system gives preference to the cells in the middle of the image.
 Typically, the middle 80 percent of the cells are considered more important than the out-
 lying regions (see Figure 8.3).

Center-weighted metering is designed for those times when your subject is in the middle of your frame, and your background contains bright lights, dark shadows, or other extreme lighting situations that might throw off the metering in the center of your image.

Figure 8.3

In a Center-weighted averaging meter, readings are taken from the entire scene, but more statistical weight is given to the cells in the middle.

■ **Partial metering.** This setting meters only the cells in the center of your scene. The size of the area is usually about 10 percent of the total scene. Like Center-weighted metering, Partial metering also provides a way to address back-lighting troubles. Because the Partial meter completely ignores the cells that sit outside of the metered area, it's often better than Center-weighted averaging when dealing with extreme backlighting problems, as shown in Figure 8.4.

Figure 8.4

With Partial metering, we can fix the backlighting problem that we saw in Figure 8.1.

■ **Spot metering.** A Spot meter measures only a small area of your image, usually the center. The metering from this area is the only information used to calculate an exposure. This area is much smaller than what a typical Partial meter will provide, and it doesn't take any other areas of the image into account. Spot meters allow you to get very precise readings of particular areas of an image and are the best choice when there's something in a scene—a highlight or small detail—that you want to ensure is properly exposed. Place the center of your viewfinder on that detail when you meter, and the camera will calculate an exposure that will properly render that area. Depending on the scene, the rest of your image may or may not be properly exposed. Spot and Partial meters are often ideal for shooting performers on a stage, where the stage lighting can confuse a Matrix meter.

Locking Exposure

Different SLRs (and some advanced point-and-shoots) handle exposure locking in different ways. For example, on Nikon SLRs, if you press the shutter button halfway down, hold it, and reframe, the camera will automatically re-meter your scene and choose new exposure settings. In other words, the camera doesn't lock exposure automatically.

Canon cameras work this same way *if* you're using Partial, Center-weight, or Spot metering—that is, they will continuously re-meter as you reframe, even with the shutter button held down. However, if you're in Evaluative metering, then when you half-press the shutter button, the exposure will lock, and will not change as you reframe.

Other brands will work differently, but it's easy enough to figure out how your camera works:

■ Frame a shot with a bright subject.

■ Press and hold the shutter button. Take note of the exposure settings.

■ Reframe so that the majority of the frame is filled with dark areas and note if the exposure settings change.

If the exposure settings do not change, then you know your camera locks exposure when the shutter button is held down. You should try this experiment in each metering mode.

Most SLRs also include an exposure lock button that allows you to lock exposure so that it doesn't change when you move the camera around. However, many SLRs also include the ability to reprogram this button and change the behavior of the shutter button.

For example, using a custom function setting in most Canon and Nikon SLRs, you can set up the camera so that when the shutter button is half pressed, the camera meters, *but does not focus*. In this configuration, you use a button on the back of the camera to activate autofocus. This gives you separate control of metering and focus with separate locks for each.

For maximum flexibility—especially if you tend to focus and reframe a lot—configuring your camera this way can be very useful.

Consult your camera manual for details. Look for entries on exposure lock, focus lock, and custom functions relating to both of these subjects. (You'll sometimes see exposure lock listed as "AE Lock.")

What Your Light Meter Meters

Your light meter does only one thing: it measures the *luminance* of the light reflected by your subject. (Luminance is the same thing as brightness.) Whether it measures the luminance of the entire scene or just a part of it depends on the type of meter you are using.

Figure 8.5 shows an equal number of black-and-white boxes. If you were to measure this illustration with a light meter, you would find that it is reflecting 18 percent of the light that is striking it. Yes, it might seem like it should be reflecting 50 percent of the light, but it's not. The luminance of most scenes averages out to be the same as these boxes—that is, most scenes in the real world reflect 18 percent of the light that strikes them.

Figure 8.5

Although each of these squares is black or white, the entire field of boxes meters as 18 percent or middle gray.

Because this is a measure of luminance only (not color), you can also think of this 18 percent reflectance as a shade of gray. Therefore, this particular gray shade is known to photographers as 18 percent gray or middle gray.

The most important thing to know about your camera's light meter is that it always assumes it is pointed at something that is 18 percent gray. In other words, your light meter calculates an exposure recommendation that will accurately reproduce middle gray under your current lighting. Because a typical scene reflects 18 percent of the light that hits it, this assumption is usually fairly accurate. Obviously, if the lighting in your scene suddenly changes, the readings will no longer be accurate (even if the scene is still reflecting 18 percent of that light), and you'll have to re-meter.

However, because your scene might not be exactly 18 percent gray, to get the best results from your light meter, you'll want to meter off something that is middle gray, such as an 18 percent gray card. Readily available at any photo supply store, you can simply place this card in your scene and use it as the subject for your metering. That said, modern light meters can do a very good job, so gray cards are not as necessary as they once were. Personally, I wouldn't invest in a gray card until I'd spent a fair amount of time with my camera, explored its various metering options, and determined if there were consistent times when my meter failed me. If so, then a gray card might be a fix.

Unfortunately, although 18 percent gray is often a good assumption, it's not always correct. For example, the left image in Figure 8.6 was shot using the camera's default metering. The image is neither too bright nor too dark—in other words, the meter did a good job of picking an exposure that yields a good overall result. However, the black statue appears a little grayer than it did in real life. This is because the camera is *assuming* that the statue is gray, and so it is calculating an exposure that will correctly render the statue as *gray*.

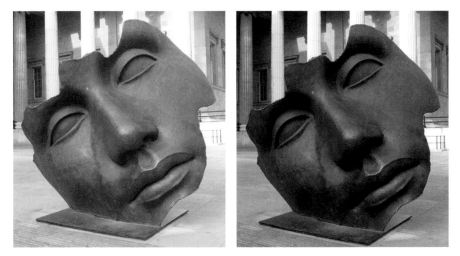

Figure 8.6

Here, the left image looks good, but the camera's default metering did not render the statue in its true black tone. By underexposing, we were able to produce a truer representation in the right image.

In the second figure, we underexposed the image to render the statue in its true, blacker tone. (Note that by underexposing, we also got a better rendering of the brightly lit columns in the background. Because they're not overexposed anymore, you can see more detail on them.) In other words, we took the camera's initial metering as a starting point and then modified it to capture a range of tones that is more accurate.

Note that this adjustment does not mean that there's something wrong with our light meter. The light meter was actually doing what it's supposed to do: calculate an exposure that's correct for a middle gray scene. The problem is that, in this case, our scene is not middle gray, it's darker.

Just as we underexposed to restore the blacks in the image, if you're shooting something white—or if you're in a white environment, such as snow—you might need to overexpose to correctly render white objects as white, rather than as middle gray. However, while this used to be a must-do practice when shooting bright scenes, such as snow-field landscapes or white sand beaches, today's meters are much better at evaluating these situations, so overexposure is rarely needed.

Colors have a luminance, or tone, just as black-and-white images do, and therefore need the same type of compensation for accurate reproduction. For example, look at Figure 8.7. The left image was shot with the camera's recommended metering, whereas the right image was underexposed by a third of a stop because the red color of the scooter was a bit darker than

18 percent gray. Simply put, by overexposing your images, your colors will become lighter; underexposing will make your colors darker. Such adjustments allow you to either restore the right color to the objects in your scene, or intentionally boost or decrease the saturation of objects within your scene.

Figure 8.7 Through careful choice of exposure when shooting, you can capture images with better color saturation.

As stated earlier, your camera's light meter generates exposure settings that create an adequate picture. In general, your camera's meter will yield images with good color and proper exposure throughout the shadows and highlights. However, because of your light meter's assumptions, your picture might come out lacking details in some highlights or shadows. Or it might look a little flat, because darker or lighter tones will all be rendered as middle tones. With some simple exposure adjustments, you can turn these images from adequate to exceptional, yielding pictures with improved color accuracy, contrast, and saturation (or tonal accuracy and contrast, if you're shooting black and white).

Note that the way you choose to create an over- or underexposure has no impact on the overall tonal adjustment. If you choose to change shutter speed, aperture, or some combination of both, you'll get the same tonal alteration in your final image. Which method you choose might depend on other exposure needs that you have—motion stopping or depth of field, for example. You'll learn more about this when we cover exposure controls later in this chapter.

The Risks of Over- and Underexposure

When you start fiddling with the camera's carefully calculated exposure settings, you'll risk over- or underexposing your scene to the point where bright things blow out to complete white, or dark shadows fall to complete black. Detail in a photo is constructed from contrasting tones, so if you overexpose an area until it is complete black or white, it will lose detail and look like a flat surface. Therefore, when an area in an image goes to all white or all black, it becomes an area with no detail.

This isn't so bad where shadows are concerned, because a black shadow simply looks like an area that's too dark to see. Unless the shadowy area has some detail that you really want to keep, letting a shadow darken is not too terrible (see Figure 8.8).

Overexposed highlights, on the other hand, are almost always distracting. An area of complete white acts like a magnet for the viewer's eye, and it can sometimes upstage your subject (see Figure 8.9).

At times, it's worth overexposing a highlight to get better tonality on your subject. In Figure 8.10, the clouds are completely blown out, but this was necessary to get good exposure on the subjects' faces. Because of the composition and the strength of the faces, the overexposure is not too distracting.

Figure 8.8

A lot of the shadows in this image have gone to complete black. Detail-less shadows, though, are not necessarily a detriment. In this case, they don't contain detail that we're interested in, and the dark silhouettes work well.

Figure 8.9

The overexposed window in this image is a big distraction. It acts like a magnet for the viewer's eye, and upstages our subjects.

Figure 8.10

There will be times when you might have to sacrifice highlight detail to get good tonality and detail on your subject.

Electronic Viewfinders and Metering

Using your camera's LCD screen as a viewfinder presents a significant limitation that you should be aware of. While your eye can see a huge range of light to dark, your camera can only capture a fraction of that range, and the image shown on your camera's LCD is even more limited (Figure 8.11).

Figure 8.11

The image on the left shows how this scene looks to your eye and how the camera will ultimately capture it. The image on the right shows how it looks through the more limited dynamic range of an LCD viewfinder. Since you can't see all the details, it can be more difficult to judge composition while looking at the viewfinder.

Therefore, when using an LCD or electronic viewfinder, it's very important to keep one eye on the actual scene. This will help you assess better what tones you have to work with, and it will remind you that there might be more detail in the scene than your camera is showing you.

Of course, you can also just take a shot and look at the resulting image on your screen to assess whether you got what you want. If you don't like what you see, you can adjust your exposure and try again. The important thing is simply to be aware that your LCD viewfinder is showing you a narrower range of tones than what you see and what the camera will actually capture.

Adjusting Exposure

As you've seen, there are many creative options to weigh and decisions to make when you choose an exposure for an image. For example, you might know that you want a shallow depth of field, so you will select a wide aperture. However, perhaps your images include many dark-colored objects that you feel need to be underexposed. At this point, you would probably choose to adopt a shorter shutter speed, rather than a smaller aperture, to preserve your shallow depth of field. Of course, if there are some fast-moving objects in your scene you were hoping to blur, you'll have to consider just how much you can speed up your shutter speed. All these different factors must be weighed and balanced.

Once you've made your decisions, you can begin to use your camera's settings to adjust your exposure accordingly. Fortunately, even if you have a less-expensive camera, you probably have enough controls to make some simple adjustments.

In this section, we'll cover all the ways you can adjust exposure on your digital camera. Which adjustments to make will depend on your image, and which controls to use to make your adjustment will depend on which exposure characteristics you want to change and which you want to preserve.

Exposure Compensation

These days, almost all digital cameras, from simple point-and-shoots to high-end digital SLRs, provide exposure compensation controls. Even some camera phones now include an exposure compensation feature!

With exposure compensation, you can specify an amount of over- or underexposure. Most cameras let you adjust exposure compensation in 1/2 or 1/3-stop increments, and allow you to over- or underexpose by up to two stops (see Figure 8.12).

Exposure Compensation Display

Figure 8.12

Different cameras show exposure compensation settings in different ways. On the left, the camera is simply providing a numeric readout of the amount of exposure compensation (-.3 stops). The display on the right is showing exposure compensation of +1 stop.

What's great about exposure compensation is that it lets you think in purely relative terms with no concern for a specific shutter speed or aperture. For example, if you decide your scene needs to be underexposed by a stop to properly render some black objects, simply press the minus exposure button twice (assuming your exposure compensation increments in half stops). Your camera will meter as normal to determine its usual adequate exposure, but will then shoot at one stop under that exposure. Exposure compensation controls are the quickest and easiest way (and on some cameras, the only way) to make exposure adjustments.

On many cameras, the fully automatic mode will not provide access to exposure compensation, so you'll have to switch to Program mode (or your camera's equivalent).

Most cameras try to achieve the requested change in exposure by changing shutter speed. When this isn't possible, either because the camera's shutter can't go any faster or because slowing the shutter speed would risk blurring the image, the camera will make changes to aperture. Sometimes, the camera will make slight changes to both shutter speed and aperture. Fortunately, these changes are usually minor enough that you won't see any change in the camera's ability to freeze motion or in the image's depth of field.

Exposure compensation controls are powerful tools, and you will continue to use them even after you've learned some of the other exposure controls at your disposal (see Figure 8.13). Get comfortable with your camera's exposure compensation controls, learn how to use them quickly, and begin learning how to recognize how much compensation is necessary for different situations. Because there are no hard-and-fast rules for over- or underexposing, you have to go out and practice!

Figure 8.13

Because of the bright sky, the camera's default metering left the tree just a little dark, so I dialed in +2/3 of a stop of exposure compensation to produce the image on the right, which has a slightly brighter tree. I've lost a tiny bit of detail in the clouds, but in this case it's acceptable.

Exposure Compensation and Program Shift

In the last chapter you learned about Program Shift, which lets you automatically change between reciprocal exposures after the camera has metered. With Program Shift, you can switch quickly to a different shutter speed or aperture, while maintaining the correct exposure.

Because Program Shift always changes to a reciprocal exposure, it will never result in an over- or underexposure. However, as you've learned, there are times when you *want* to over- or underexpose, perhaps to improve the tone of a color. For these times, you can dial in an exposure compensation, and you can easily use these two features together.

For example, perhaps you meter and then use Program Shift to switch to a wider aperture because you want a shallower depth of field. But maybe you're shooting something dark and

want a little bit of underexposure to render the proper tone. If you dial in -1/3 of a stop of exposure compensation, you can still get both your wide aperture and your underexposure. In many cases, these two controls will provide all of the manual power you need.

Fixing a Consistent Exposure Problem

I was shooting in Zion National Park recently, and noticed that my camera was consistently overexposing. It wasn't a camera I'd used very much, and I wasn't sure if this was simply a characteristic of this camera. Whatever the cause, the overexposure was consistent, so I just dialed in a -.3 exposure compensation and left it there. As you can see in Figure 8.14, this was a very slight adjustment, but it served to keep the images from being quite so "hot."

Figure 8.14 Exposure compensation is also an easy way to deal with repeating exposure problems. A -.3 exposure compensation was all I needed to improve this scene, and since my camera had been repeatedly overexposing, I just left this adjustment dialed in.

Of course, lighting changes with time of day and as you move around, so you'll want to check in with your exposures to ensure that any adjustment you've dialed in is still helpful.

Controlling Exposure with Your Light Meter

Using a built-in light meter, you can force an over- or underexposure by pointing the camera at something darker or lighter. Meter off a darker subject, and your camera will overexpose. Meter off a lighter subject, and you'll get an underexposure (see Figure 8.15). However, because your camera will probably lock focus at the same time as exposure, you'll need to be certain you are metering off something that is at the same distance as the image you would like to have in focus, or use your camera's exposure lock feature (if it has one).

Figure 8.15

The upper-left image was exposed using the camera's default metering, which exposed for the window, leaving the rest of the room in darkness. By tilting the camera down, as shown in the upper-right picture, we were able to force the camera to meter more accurately for the dark tones in the image, resulting in the lower-left picture. Finally, we cut the properly exposed window from the dark frame and then composited it with the well-exposed image to produce the final composite shown in the lower right.

For cameras that lack more sophisticated manual controls, such as small point-and-shoots, this may be your best option for trying to control exposure. Obviously, with this technique you have no control as to whether the camera changes shutter speed or aperture, but you can make an image brighter or darker using this approach.

Even if your camera *does* have manual controls, this technique can be handy in a pinch, when you need to shoot quickly and want to get a lighter or darker exposure.

Understanding Exposure Locking

This technique is basically a variation of the focus and reframing technique that you learned in the last chapter. As you saw earlier, some cameras will automatically re-meter as you reframe, and others won't. For this technique to work, you'll need to understand how and when your camera locks exposure.

Priority Modes

Priority modes provide a great balance of manual control with some automatic assistance. In a Priority mode, you choose either the shutter speed or aperture you want, and the camera calculates the corresponding value that is required to ensure a good exposure. For example, in Shutter Priority, you define a shutter speed, and the camera calculates the correct corresponding aperture. In Aperture Priority, you pick the aperture you want, and the camera calculates a correct shutter speed.

Typically, you'll select Shutter Priority when you want to control motion and Aperture Priority when you want to control depth of field. For example, if you're shooting landscapes and know that you're going to want a deep depth of field all day long, you can set the camera on Aperture Priority, dial in f11, and be assured that every shot will be taken with that aperture.

Or, if you're shooting a sporting event and know that you want lots of motion-stopping power, you can select Shutter Priority and set the shutter speed to something quick, like 1/1000th of a second.

Priority modes are a great way of taking some manual control, while still allowing your camera's sophisticated metering to stay involved in the choice of exposure settings (see Figure 8.16).

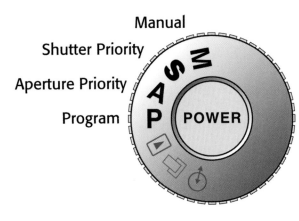

Figure 8.16

If your camera provides Priority modes, you'll most likely see something like this on the camera's mode dial or in its mode menu.

Canon's Goofy Mode Names

I shoot with a Canon SLR, so you can trust me when I say that Canon has stupid labels for their Priority modes. On a Canon mode dial, Shutter Priority mode is listed as Tv while Aperture Priority is listed as *Av. Av* is somewhat intuitive—you can just remember "Aperture value." For Tv, just try to think of it as "Time value."

Using a Priority mode is simple: after switching to the appropriate mode, select the aperture or shutter speed that's appropriate for what you're trying to achieve. When you half-press the shutter button to meter, the camera will calculate the corresponding other value.

Most cameras will warn you when they think you've chosen an exposure combination that will result in over- or underexposure. Don't worry, the camera will still shoot the picture; these warnings are simply there to tell you that your settings don't conform to the camera's idea of a good picture. Check your manual for details on how your camera indicates a bad exposure combination.

Priority Modes and Exposure Compensation

When you use exposure compensation in Auto or Program mode, you have no control over how it achieves its compensation—it might adjust shutter speed, aperture, or both. If you want to maintain control of a specific parameter, put your camera into the appropriate Priority mode. For example, if your camera is in Shutter Priority mode, any exposure compensation adjustments will be made by altering aperture, ensuring that you retain control of shutter speed. In Aperture Priority, compensation will be achieved through shutter speed changes.

Manual Mode

Manual mode gives you control of both aperture and shutter speed. However, because some digital cameras have cumbersome manual controls, you might find it easier to simply use a Priority mode. In Manual mode, your camera should have one control for choosing shutter speed and another for choosing aperture. You can set these to anything you want and still take a picture, which means that in Manual mode it is possible to take an image with very bad exposure.

Fortunately, you can still use your light meter when in Manual mode. On most cameras, when you use Manual mode, the same display that is normally used to show exposure compensation will serve as a guide to whether or not your exposure is good. When you half-press the shutter button, instead of choosing a shutter speed and aperture (since you will already have done that by hand), the camera will meter your scene and show you whether your chosen settings are under- or overexposed or okay.

For example, Figure 8.17 first shows a typical in-viewfinder status display. You can see that I've set shutter speed to 1/125th and aperture to f8. After pressing the shutter button down halfway, the Exposure Compensation shows +1 stop, indicating that the meter has determined that our current settings are overexposed by one stop. If you're trying to intentionally over-expose, you can leave them this way. Instead, I adjusted the exposure settings one stop down by increasing the shutter speed from 1/125th to 1/250. This faster shutter speed lets in one stop less light, and now the meter shows a good exposure.

Figure 8.17 Here, in Manual mode, the camera is telling us that our initial exposure settings will yield an image that's overexposed by a stop. After a simple adjustment, the meter reads a good exposure.

On most meters, if your over- or underexposure is beyond two stops, the indicator will flash.

Obviously, readouts can differ on different cameras, so check your camera manual to learn exactly how yours works. You'll also need to learn how to adjust both shutter speed and aperture when shooting in Manual mode. Again, your manual will detail these controls for you.

Manual Mode Practice, or "Shoot Photos the Old-Fashioned Way"

If your camera has a Manual mode, you might be interested in trying a truly all-manual exercise.

In the very old days, before light meters, photographers had to calculate exposure by hand (or rather, by eye). A lot of experience was necessary to properly assess exposure for a complicated scene, but there were a number of tricks that eased the process. Switch your camera to Manual mode, be sure you know how to alter shutter speed and aperture in Manual mode, and you can give this type of shooting a try.

In most cases, when shooting in bright sunlight, you can use the "sunny 16 rule" for calculating exposure. Set aperture on f16 and use a shutter speed equal to 1 over your ISO. In other words, if you're shooting at ISO 100, you would set aperture to f16 and shutter speed to 1/100th of a second. If you're shooting at ISO 400, you would set aperture to f16 and shutter speed to 1/400th. Those settings should produce an image with correct brightness when shooting in bright sunlight.

The sunny 16 rule gives you a good baseline for calculating an exposure. From this baseline, you can think about how to over- or underexpose to compensate for lighting situations that aren't completely sunny or for times when you need to alter an exposure to improve tone.

For example, say it's a sunny day, but you're shooting in shade using ISO 100, and you think it might be shady enough to reduce the overall brightness of the scene by one stop. How do you know it's one stop? After a while, you would know this by experience. When you're starting out, you have to guess. Because your scene is one stop darker than bright sunlight, you need to overexpose.

Overexposure means you need more light. If you slow your shutter speed down by one stop, you'd get more light, but then you'd be shooting at 1/50th of a second, which might be too slow for handheld shooting. (Remember, because of the sunny 16 rule, at ISO 100 your baseline shutter speed is 1/100th, so one stop down would be to cut your shutter speed in half, to 1/50th.) A better approach might be to open your aperture wider. As you know, lower f numbers mean a wider aperture, so you could switch from f16 to f11, a widening of one stop. (Consult the list of apertures that you saw in Chapter 6, "Exposure Basics," if you're unsure as to what a one-stop aperture change is.)

Another option would be to leave shutter speed and aperture where they are and increase ISO to 200.

Now let's complicate things further and say that you're shooting in shade that's one stop darker than bright sun, but you want a shallow depth of field. Because you need to overexpose by one stop, you've already decided to widen your aperture, so you're shooting at 1/100th of a second at f11. But you want an even wider aperture to ensure a shallow depth of field. If you just keep opening the aperture, you'll continue to brighten the exposure. So, as you widen the aperture, you want to make a corresponding shutter speed adjustment. Changing from f11 to f8 opens the aperture one more stop. To preserve your overall exposure, change your shutter speed from 1/100th to 1/200th. Opening from f8 to f5.6 gets your aperture one stop wider, so you move your shutter speed to 1/400th. Finally, your lens can go one stop wider, so you open to f4 and make a corresponding shutter speed shift to 1/800th. Now you've got a wide aperture for shallow depth of field, and you've preserved your one stop of overexposure to compensate for the shade.

Trying a few shots this way in Manual mode gets you deep into the interrelationship between shutter speed, aperture, and ISO, and can be good practice. Fortunately, for everyday shooting, your light meter does all of this thinking for you.

Which Method Should You Use

You've learned a number of different ways to control exposure here. Hopefully, along the way you've also learned that there's no one method that is ideal for every situation. You should have seen that underneath each of these methods, there's still just aperture, shutter speed, and ISO. Each of the modes and techniques we looked at here simply provides a different way of controlling those three parameters, and you should have seen that the actual controls in each mode or method are pretty simple.

There's no "magic" to a Priority mode, and there's no picture you can take with a Priority or Auto mode that you can't take with a Manual mode. Similarly, Manual mode does not open up some extra power that you can't achieve in Auto mode. But, in some instances, one or another will make it easier to get the results you want.

Your goal is to understand the use of shutter speed and aperture, as well as how they're related. Your choice of exposure control method will be fairly obvious if you have a good understanding of what each exposure parameter is used for and how they interrelate.

There's no hierarchy to shooting modes. You don't start in Auto mode, then graduate to Priority modes, and then one day become so sophisticated that you finally switch to Manual mode and never use anything else. Rather, your goal is to simply understand exposure theory well enough that you can recognize which mode is going to provide the control that you need.

If you're trying to shoot fast-moving subject matter, then you'll probably opt for Shutter priority mode. If you're shooting landscapes, street scenes, or portraits—any situation where you want depth of field control, then Aperture priority is probably your best bet. I frequently use Program mode if I know that a mid-range aperture setting will be fine, and I want to shoot quickly. Manual mode is handy if you're using an external light meter.

The point is, you want an understanding of all of these modes, so that you can choose the one that is best for your current shooting situation.

In-Camera Histograms

First, the bad news. The LCD viewfinder on your camera will greatly increase the brightness, and possibly color contrast and saturation, in any image you view. This is because the camera's designers want to ensure that the image on the viewfinder is visible in bright, direct sunlight. Because of this, your camera's LCD screen does not actually present an accurate representation of what the colors and tones in your image actually look like. This means that when you shoot an image and then look at the results on the viewfinder, you won't necessarily be able to spot over- or underexposure or assess contrast and color.

The good news is that if your camera includes a built-in histogram, you can easily determine if your image has certain exposure problems. Not all cameras have histograms, but your camera's manual should make it easy to determine how to activate the histogram view for any image you've taken.

Figure 8.18 shows a histogram display from a Canon SLR. In addition to displaying the histogram, the thumbnail display flashes any areas that have clipped highlights or shadows.

We'll be spending a lot of time with histograms when we start postproduction, so an understanding of the use of a histogram is very important. But histograms can also help you when you're shooting by making it easier to identify when you've selected a good exposure.

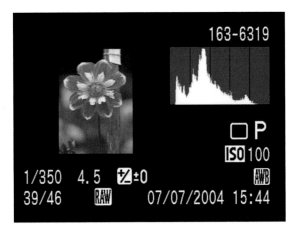

Figure 8.18

Many cameras can display a histogram of any image you've shot. In addition to this histogram, this display from a Canon SLR shows date, time, and all exposure parameters. In over- or underexposed images, the display also flashes areas in the image thumbnail that are "clipped" in the histogram.

Histograms Defined

A histogram is a simple graph of the distribution of all the tones in your image. Histograms can be easily created by most image editing applications, and they are a great way to understand exposure.

Look at Figure 8.19 and its accompanying histogram.

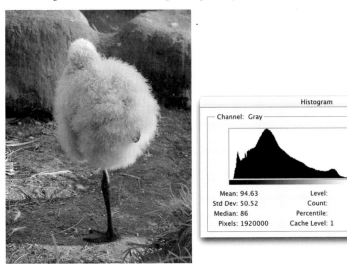

Figure 8.19

With a histogram, you can analyze your images to determine which type of exposure corrections they might need.

A histogram, such as the one shown in Figure 8.19, is simply a bar chart showing how much of each shade of gray is present in the image, with each vertical line representing one shade. Black is at the far left, and white is at the far right.

From the histogram, you can see that the image in Figure 8.19 is fairly well exposed. It has a good range of tones from black to light gray, which means it has a lot of contrast. Most of the tones are distributed toward the lower end because of the dark grays and shadows in the background. However, even though the background is dark, there is still a good range of middle gray tones and lighter tones from the gray of the baby flamingo.

Notice that the shadow areas do not *clip*. That is, they curve down to nothing by the time the graph reaches the left side. This means that the shadowy details in the image have not gone to solid black. In fact, there is very little solid black in the image at all. Also notice that there are a large number of tones overall, meaning the image has a good dynamic range, and therefore a lot of editing potential. Although the brighter areas are a little weak, we can correct for this in our image editor.

Now, look at Figure 8.20.

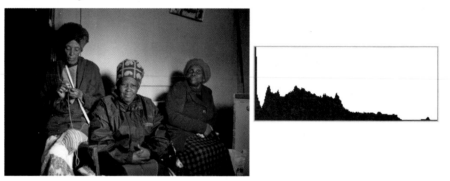

Figure 8.20

An underexposed image has a characteristic histogram.

You can probably tell by looking at Figure 8.20 that the image is underexposed, but the histogram still provides some interesting information. As you can see, there is no white in this image at all and very little medium gray, but at the lower end there is a preponderance of solid black. Notice that the shadow areas don't curve down to black as they do in Figure 8.19. Rather, they are "clipped" off the edge of the histogram—the image is so dark and underexposed that many of the darkest tones have piled up on the very left end of the histogram. In a well-exposed image, the shadow areas would be spread over a larger number of darker tones with only a little solid black. If you look in the shadow areas of the image, you'll see that they look completely black, rather than having any variation or range in their dark tones. In other words, the shadows have lost detail.

In a grayscale image, a histogram is literally a graph of the gray tones in an image. As you saw earlier, colors have a tone that roughly corresponds to the tonal qualities of a shade of gray. When you take a histogram of a color image, the resulting graph shows a composite of the red, green, and blue channels in the image. The practical upshot is a graph that is still an accurate gauge of the contrast and tonal information in your image.

An image that is overexposed will exhibit a similar histogram but weighted on the other end with tones grouped in the white areas and with clipped highlights (see Figure 8.21).

Figure 8.21

An overexposed image—the tones are weighted to the right of the histogram. In this image, you can see that the highlights are clipped—they get cut off by the right side of the histogram. In the image, the white parts of the lion's face have blown out to complete, detail-less white.

The histogram is an exceptional exposure tool for shooting in a difficult lighting situation. Set your exposure, shoot a test shot, and then take a quick look at the image's histogram. If you see clipped highlights or shadows, you'll need to try a different exposure and shoot again.

Histogram Thought Experiment

If you were to take Figure 8.23 and flip it horizontally to create a mirror image—that is, the telephone poles would be on the right side of the screen, tilting to the left—how would the histogram change? If you answered "it wouldn't change at all," you're correct. There is no "geographic" correspondence between a location in the image and a location on the histogram. The histogram simply shows distribution of tones. When the image is flipped, the same number of each tone still exists, and so the histogram looks identical.

Assessing Contrast

In addition to spotting over- and underexposure problems, you can use your camera's histogram to determine the amount of contrast in an image. Take a look at Figure 8.22.

The image has little contrast and appears "flat." A quick look at the histogram shows why. Most of the tones are grouped in the middle of the graph—they don't cover a broad range.

After consulting this histogram, you would know that it was worth trying a second, additional exposure. In this case, I shot the image again with one stop of overexposure (see Figure 8.23). (I applied the overexposure using the exposure compensation control, because I didn't have specific shutter speed or aperture needs.)

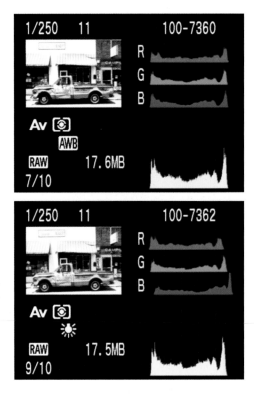

The Three-Channel Histogram

Your histogram can't tell you too much about the color in your image, but if your camera displays a three-channel histogram, you might be able to get a sense for bad white balance. A three-channel histogram simply shows a separate histogram for each color channel (red, green, and blue). If the three channels are way out of registration, there's a chance your image has a white balance problem (see Figure 8.26). Note, though, that this is a difficult thing to assess, because sometimes images simply have very different amounts of different colors, which can also skew your histogram.

Figure 8.26

A three-channel histogram can sometimes help identify white balance troubles in the field. If the three channels are way out of registration with each other, then there's a chance that your image will have a visible white balance issue. The second image was shot with an incorrect tungsten white balance setting.

Recording Your Exposure Settings

To really understand exposure, how it works, and what decisions to make, you must practice. However, for your practice to do you any good, you need a record of what exposure settings you used for each image. In the old days, you had to carry around a notebook and record your exposure settings by hand. You can still do that, of course, and make any other notes you feel are important to remember, but the odds are that your camera will remember your settings for you, because most digital cameras record a number of shooting parameters along with the image data. Figure 8.27 shows the information stored by a Nikon point-and-shoot camera.

Figure 8.27

Most cameras will store a record of all the parameters you used for each shot. This data is stored with the file and can be read using special software.

Recording Your Exposure Settings (continued)

This information is stored using a standard format called *Exchangeable Image File (EXIF)*, which was created by the Japan Electronic Industry Development Association in 1995. If your digital camera is EXIF compatible (and most are), all its files are EXIF files, whether they use JPEG or TIFF compression.

The great thing about EXIF files is that their image data can be read by any program, even if that program isn't specifically EXIF compatible. The EXIF data is simply stored in the header information of the file, so any application that can read JPEG or TIFF files can still read an EXIF-compatible file.

These days, most image editing, cataloging, and browsing applications allow you to look at an image's EXIF data (as shown in Figure 8.28). As you'll see later, this data is often very helpful when editing.

Figure 8.28

Adobe Bridge displays an EXIF readout for each image you select.

Bracketing

While it's important to understand all the exposure theory we've discussed here, there's a very simple practice you can employ to help ensure that you get a correct exposure, no matter what shooting situation you're in.

Bracketing is the process of shooting extra exposures above and below your target exposure to give yourself a margin of error in your exposure calculation or adjustment. If you've made a somewhat accurate, educated guess about exposure, one of your bracketed images will most likely be good, even if your original guess was off. Bracketing is a tried-and-true practice of film photographers, but it's much easier with a digital camera.

For example, if you're shooting a scene with a big mix of bright and dark tones, then you might want to bracket your shots. Or, if you're shooting a very bright or very dark object, and you aren't sure how to expose to render the tones properly, then bracketing may be your answer.

9

FINDING AND COMPOSING A PHOTO

Learning the Art of Photography

So far, in this book, we've been studying the theory behind all the different parameters that affect the creation of an image, as well as the controls that you have for manipulating those parameters. I have been calling this the *craft* of photography. Photographic *artistry* is the process of using these craft skills to represent a scene—whether it's a portrait, still life, event, landscape, or abstract—in a way that evokes some of what the subject makes you feel.

You can study theory and button pushing for the rest of your life, but if you don't know how to recognize a potential image and then how to compose it in a way that is compelling, then your craft skills will have no purpose. Similarly, no matter how great an eye you have, if you don't understand how focal length, camera position, shutter speed, aperture, and overall exposure affect your image, then you will have a very limited photographic vocabulary. In this way, both art and craft are essential to good shooting. In this chapter, we're going to focus on the artistry side of things and explore how you find, visualize, and compose an image.

Looking Versus Seeing

Does this sound familiar? You're trying to get out of the house in a hurry, but you can't find your keys (or your sunglasses, your wallet, your goggles, riding crop, or whatever). You look on your desk, through the pockets of all of the coats you've worn recently, on the kitchen table, in the bathroom—then you start all over again. You try to retrace your steps to determine where you might have been when you last had the keys. Finally, after 20 minutes of increasingly maddening searching, you find them sitting in plain sight in the middle of your desk—in the very first place you looked.

This frustrating situation happens because, while it's very easy to look at the world, it's far more complicated to actually see it. While we generally use the words "look" and "see" synonymously, for a photographer there are very important differences between the two terms.

How is it that you can look at the desk where your keys are sitting, but not see them? The answer has to do with what we learned in Chapter 1, "Eyes Brains, Lights, and Images": Your eyes are far more than a simple optical instrument. While it's easy to think of the eyes as being just like a camera—they have a lens and an iris and a light-sensitive focal plane—they differ from a camera in one very important way: they're attached to a human brain. As you learned in Chapter 1, our brains dramatically alter our perception of what we're seeing, and not seeing the keys on the desk in front of you is a prime example of this phenomenon. Although it might be frustrating, there's a good reason why your brain evolved to work this way.

Consider the process of running a typical errand in town, either in a car or on foot. As you travel about, you will be acutely aware of dozens, or even hundreds of cars, and possibly dozens or hundreds of people. Not to mention bicyclists, baby strollers, and many other things. If the day goes well, you will navigate successfully alongside, in-between, and past all these cars and people without ever colliding with one. Although you will engage in a complex choreography with these objects, when you get home you will most likely be hard-pressed to describe the details of the majority, if any, of these vehicles or people.

There might be one or two cars (or people) you took note of because they were particularly attractive or unusual looking, but you will have perceived most of the cars you looked at as simple generic objects. Upon returning home, you might not register any of them as specific types of vehicles, and instead report that "traffic was really heavy today." In a sense, you're not seeing the trees for the forest.

As you learned earlier, your eye packs far more luminance-sensitive cells than it does color-sensitive cells. As such, it is much more sensitive to contrast than it is to color, so light with strong contrast is usually far more compelling than flat light.

Sunlight yields more contrast when it is shining from a low angle. So early morning and late afternoon light is far more interesting than the light of mid-day. Low-angle light casts longer shadows, which makes for surfaces that have more texture and visible detail. In the middle of the day, when the sun is shining straight down, there is very little shadowing, resulting in a flat, boring look.

You'll often work with existing light in two ways. When you find an area of particularly compelling light, stop to see if there's any type of picture to be had. As you explore the area, you might find a texture or subject that is worth shooting, since it is in good light, or you might find that a subject comes along if you wait long enough. (see Figure 9.4). Conversely, if you're out and about and discover an interesting subject, try to assess if better light will fall onto it at some point. Perhaps the sun will pass out of shadow and illuminate your subject in a more interesting manner (Figure 9.5).

Figure 9.4

I came across this splash of light that I liked, both because it mixed nicely with the texture on the street, and because of the shadowy detail in the background. I waited until someone walked into the light, and then took this shot.

Early morning and late afternoon light have a very different color than mid-day light. While it will vary depending on atmospheric conditions, where you live, and the time of year, you'll generally find dusk and dawn to be warmer. Late afternoon light is especially warm and colorful, and can be ideal for landscapes and portraits (see Figure 9.6).

The light of the early morning and late afternoon changes *very* quickly, which can work both for you and against you. If you see something that isn't particularly well lit, it might change very soon. At the same time, when you see the image you want, you might have to work very quickly to capture it before you lose the light.

In the spring and fall, when the sun doesn't climb very high in the sky, you'll find good light during more of the day. The specific hours will vary, depending on your latitude.

All that said, just because it's raining or dingy doesn't mean there aren't still good photos to be had. Sometimes, too much contrast can be a bad thing, as it can serve to make your image harsh and complex. Also, shooting when there is less contrast affords you the opportunity of adding more contrast where you want it, later on (see Figure 9.7).

Figure 9.5

Normally, I wouldn't be interested in taking a picture of this statue, but the light was hitting it so that it lit up a bright white, against the darker background. I shot several shots until I found one that had people in the foreground in interesting positions, but it was the light that drove the shot.

Figure 9.6

These images differ in terms of their shadows and the clouds in the sky, but note the difference between the morning light on the left and the warmer afternoon light on the right.

Figure 9.7

Just because it's overcast doesn't mean you can't get good shots. Many situations fare better without high contrast. This image was shot under completely overcast skies.

Look Through Your Camera

If you find you've been walking around for a while and you aren't seeing anything you want to shoot, even though the light is good, you might simply be in a location that isn't providing good subject matter. However, it might also be that your eyes and brain just aren't seeing things photographically. Sometimes you have to look through the camera before you begin to see potential photographs. If you're not seeing compelling subjects, lift the camera to your eye and look through it. The frame of your viewfinder often crops the world in ways that you can't visualize when you're walking around, and those crops often reveal interesting compositions.

Also, remember that you may have to shoot your way through some unusable, outright bad images before your photographic senses get working. If you suffer through this process, you may find yourself seeing more things to shoot.

If you try all this and still aren't finding images, then either there really isn't anything worth shooting, or your photographic juices just aren't flowing. Don't let this discourage you. Relax, give it a rest, and come back another day.

Photography as Abstraction

We've all probably experienced something like this: you're standing somewhere spectacular, like the edge of the Grand Canyon, and you think: *This is so amazing, I must take a picture of it!* You pull out your camera, hold it up to the scene, and capture a few images. Later, at home, you look at your prints, only to be disappointed. *You think: I dunno, somehow, I remember it being more…grand.*

The fact is: No one can take a photo that will make their viewers feel like they're standing on the edge of the Grand Canyon. It's simply not possible any more than it's possible for a dancer to choreograph a dance that will make someone feel like he or she is standing at the Grand Canyon. Although it appears that a photograph can capture an incredibly believable facsimile of a scene, you must remember that photography is a representational medium. Your live experience of the Grand Canyon involves much more than the visual stimulation you're receiving. First, it involves

a very complex visual stimulus—a 3D panoramic stimulus with far more color and brightness information than your camera can capture. In addition, all of your other senses are mixed in as well, along with other emotions that you might experience for other reasons (happiness from being on vacation, the culmination of a dream to see the Grand Canyon, etc.).

However, although you may not be able to create a photograph that truly re-creates the *experience* of standing in a particular location, you can create a photo that evokes some of the *feeling* you had while you were there. Your job as a photographer is to determine what it is about a particular scene or moment that is compelling to you. In the case of the Grand Canyon, it might be the size or the colors. Perhaps it's the sense of geologic time that you can see in the layers of sediment. Or perhaps it's the people you're with, or simply something about the way the light is playing off a particular rock formation.

Rather than trying to capture the entire experience of where you're standing, you need to try to identify a more refined feeling of what it is about that moment that compels you. Then you can employ your craft skills to figure out how to represent that feeling as a flat, two-dimensional photo. Remember, photography is a representational medium, not a literal duplication of an experience.

Alfred Hitchcock once described drama as "life with all the boring parts removed." Dramatists very often take a normal, everyday event and blow it up into drama. They exaggerate some things, remove others, and make up entirely new things to create a representation that the audience will respond to. Photography is the same way.

For example, a few years ago I was in Death Valley. Because of the extreme geography of Death Valley (parts are below sea level), there is an interesting phenomenon where sand blows off the surrounding mountains, hits the weird air currents of the valleys that sit below sea level, and immediately falls to the ground, to form giant sand dunes. There are four such dune fields in the park, and when you see them from afar, they're quite striking. The dunes are huge, and when viewed from above, you get a tremendous sense of scale—you can imagine the sand flying off the mountain to be deposited on the valley floor.

One morning, I was driving out of the mountains and came across such a vista. I grabbed my camera and took the picture shown in Figure 9.8.

Figure 9.8

This isn't much of a picture. There's no real composition, and nothing for the eye to follow. What's more, the majestic dune field on the valley floor appears merely as a fairly boring, small patch of beige. The picture in no way captures what I was seeing and feeling.

Figure 9.9 This isn't much better than Figure 9.8. There's no sense of scale and still no real composition to speak of. Your eye doesn't know how to read the image, and it's not particularly evocative of anything.

Figure 9.10

Finally, by getting into the dunes themselves, and working the shot, I came up with something that may not show a broad vista of scenery, but still captures the feeling of the place.

So I drove down to the valley floor to get closer to the dunes and took the picture shown in Figure 9.9.

The next day, storm clouds blew in, and I hiked into the dunes themselves. Being in a dune field is a unique experience. The scenery is a constantly shifting play of geometry, and the mountains of sand are huge. All these factors add up to a profound sense of other-worldliness. I took my time, worked my subject, and shot the image shown in Figure 9.10.

I can say outright that it didn't look exactly like the image in Figure 9.10. However, it did *feel* like that image—mysterious, beautiful, and strange. So, although that photo is not a literal image of the sand dunes, it still effectively captures something about the truth of the experience I had there. This is your goal as a photographer.

Know Your Audience

Photography is a strange medium in that it's used for so many things. Journalism, documenting everyday moments of your life, advertising, fine art, surveillance—photography is applied to all of these situations. Obviously, depending on what you'll be using your images for, you'll have different concerns. If you're a photojournalist, you'll probably need to get images of very specific things, whereas if you're a street shooter who's just trying to find some interesting images, then you most likely won't know what you want to shoot until you come across it.

You might be thinking: *I'm not interested in having a gallery opening, I just want to take better pictures of my kids.* Don't worry, the things that make a good photo, and the artistic and craft issues you face as a photographer are the same whether you're shooting your family or fine art shots.

Sometimes, of course, you just need to grab a quick shot to document something, and won't care too much about the "artistry" of the results. But with most any shot that you actually take time to work on, it's worth thinking about light, composition, and the other topics covered in this chapter.

Building a Shot

There are two different kinds of photographic subjects: those that you take, and those that you make. If you're standing near the Eiffel Tower just as the sun comes from behind a cloud to light up a beautiful supermodel who happens to be walking by, then there might be little that you have to do to get a good shot. That's simply a picture you can take.

Every so often, my grandmother goes to the portrait studio to, as she says, have her picture made. This idea of making a photo is kind of old-fashioned, but the concept of *making* an image is much closer to how good photographs often happen. No matter what the subject, effective photography involves making a lot of decisions and solving a lot of problems. You'll often have to shoot a lot of test frames as you experiment and try different ideas. Most of the time, good images are not taken; they are made from the raw material of your scene.

In the last section, we talked about how to recognize a shot. Shot recognition will happen in different ways, depending on the type of shooting you're doing. If you're working an event—a wedding or birthday party, for example, your recognition will probably come very quickly, as you move amongst the crowd looking for nice compositions, good moments, compelling expressions, and good light. If you're shooting on the street, you might happen upon split-second moments that require more reflex than thought.

But there might be other types of street shooting that require more consideration. Perhaps the light has fallen on a particular location in a beautiful way, and you want to try to take advantage of that light. Landscape shooting can be the same way: you spot the beautiful vista and then try to figure out what the picture is.

Depending on the pace and style of shooting, the way you decide to shoot will vary. Sometimes, you'll have to move quickly and shoot reflexively, while trying to keep one eye trained on your settings. At other times, you will have an impulse that a potential shot lies before you, but you'll have to spend time (and probably a lot of test shots) to work out what the image should be.

Often, I catch a glimpse of something out of the corner of my eye, and when I turn to look, I don't have the foggiest idea what it is that caught my attention. But once I raise the camera to my eye, I can see it. At other times, I'll shoot some frames and not feel like I got anything, but later when I'm back at my computer, I'll try some adjustments, and suddenly an idea for what

the image is supposed to be will come to me. Your subconscious is often a good photographer in its own right, so when you get an impulse—any kind of impulse at all—you need to stop and examine it. The image won't always be obvious until you start trying to build a shot.

Learning to pay attention to these impulses takes practice because they don't always announce themselves very loudly. When you go out to shoot, you need to be present and concentrate while you walk around, so that you can pick up on even the slightest impulse. If you're talking to other people, or listening to music, or thinking that maybe you'll do a little window-shopping too, then you probably won't find many images. Photography is an active process.

Once you've identified a shot that you want to start building, you'll need to think about the following issues:

- **Shooting mode.** By now, you should be very comfortable with your camera's modes, and should have an understanding of what each one does. When you're ready to build a shot, you need to decide which mode is most appropriate. For many (or even most) shots, Program mode might be fine. Think about whether you'll want depth of field or motion-stopping control. If so, pick a mode that will facilitate the control you need. If your camera offers a Scene mode that's appropriate to your shot, you might want to try it.

 Very often, the subject matter or style of shooting will dictate a mode immediately. For example, when shooting an event, you may walk into the room and realize the light is very low, and that you will need to choose a mode that allows you control of shutter speed, to guarantee sharper images. You'll probably stick with that mode for the duration of the shoot. Or perhaps you're off to shoot a social occasion with good lighting, and you decide to choose a mode that will allow control of aperture, so that you can opt to blur out the background behind people.

 For some subjects, you may try several different modes as you work the shot and change your idea of what it should be. For example, you might start out in Program mode, and then realize later that to capture the image you want, you need more control.

- **White balance.** We've covered white balance extensively, so you should already know that when you move into any new lighting situation, you need to think about what white balance setting is required.

- **Metering.** While Matrix metering is good for most occasions, in some situations you'll need to switch to a different meter to handle difficult lighting or to ensure that your subject is properly exposed. You may not know exactly what meter to use until you take a few shots.

Choosing a Camera Position and Focal Length

After you've spotted a scene and decided to try to make a photo out of it, you need to decide where to stand. You may think: *Where to stand? Can't I just shoot from where I spotted the scene? After all, that's where it came to my attention.* Most of the time, just because you were able to recognize a scene from a particular location doesn't mean you're standing in the best location to shoot that photo.

Obviously, standing closer or farther, or off to one side or the other, can make a big difference in your shot. But camera position also affects your choice of focal length, and focal length choice can have a huge impact on the sense of space in your scene.

Focal Length

The great thing about a zoom lens is that it provides tremendous flexibility when you frame a shot. Without changing your position, you can zoom in to a subject quickly to get a tighter view and a different framing. However, it's important to recognize that as you zoom, many things change in your image besides the field of view and magnification. A zoom lens is more than just a convenience. As you go from one focal length to another, you will alter the sense of space and depth in your composition, so focal length choice becomes another creative option at your disposal.

It's easy to think of your zoom lens as a big magnifying glass and, to a degree, it is. As you zoom in, your subject appears larger and larger. This is why digital camera manufacturers often label their lenses with a magnification factor 2x, 3x, and so forth. However, a few other things happen to your image when you zoom.

As you go to a longer focal length (zoom in), your field of view gets narrower. The human eye has a field of view of about 50° to 55°. This is considered a normal field of view, and any lens that produces a 50° to 55° viewing angle is said to be a normal lens.

More important, though, is to pay attention to the way your perception of the depth in your scene changes. Consider the images in Figure 9.11.

Figure 9.11 Although these two images are framed the same, notice how different the backgrounds are. In the left image, the camera was positioned close to the subject and zoomed out, whereas in the right image, the camera was pulled back and zoomed in. Note how much closer the background chairs appear in the telephoto (right) image. The sense of depth in the scene changes as we change camera position and corresponding focal length. In general, the entire sense of space differs in the two images, even though the subject didn't move.

In these two images, the subject remained in the same place, but I stood at different distances and used a different focal length to keep the images framed identically. Notice how much closer the tables and chairs look in the second image. As I moved back and zoomed in, the depth in the image became compressed, resulting in the background elements appearing closer. The result is an image that has a far more intimate sense of space than the first image, which has a very expansive sense of space.

As you can see, both field of view and the sense of space in an image are functions of the position of your camera and the focal length you choose to use. These two factors combine to create a very different sense of depth and space.

Controlling depth and perspective in your scene is yet another creative option you have available. Next time you're shooting a location, consider how you want to represent that space. Do you want it cramped and claustrophobic? Or deep and expansive? Choose your camera position and focal length accordingly.

Correcting a Mistaken Explanation

Photography textbooks for the last 150 years (including some previous editions of this book) have explained that as you change focal lengths, different parts of your image are magnified by different amounts. *This is not true!* For any given focal length, all elements of an image are magnified by the same amount. The change in perspective occurs because of your changing camera position and the field of view differences provided by different focal lengths. To see proof of this claim that all lenses magnify by equal amounts, take a look at the `Camera Position.pdf` movie which you can download from the Chapter 9 section of the companion Web site at *www.completedigitalphotography.com/CDP6*.

Portrait Distortion

At some point, you've probably looked at a photograph of yourself and thought, *That doesn't really look like me.* One reason for the poor result might be that the photographer used a wide-angle lens. Shooting a portrait with a wide-angle lens can be problematic because of the weird perspective it provides. Check out the pictures in Figure 9.12. The image on the left was shot with a slightly telephoto lens and really does look like the actual person. The image on the right is not such a good likeness. The nose is too big, and the ears have been rendered too small. In addition, the distance between the nose and ears is too long. (Of course, although the picture on the right is less literally correct, it might be a better expression of the person's character. This is a creative, interpretive choice you get to make while shooting.)

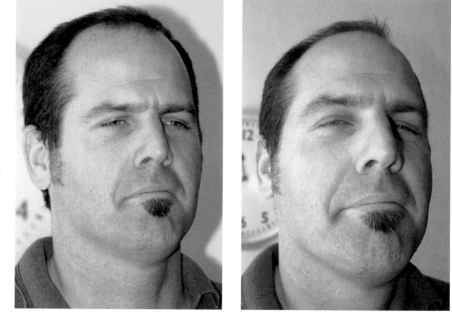

Figure 9.12

A change in focal length can make a huge difference in the appearance of your subject. The image on the left was shot with a long (telephoto) focal length. Next, I zoomed out to produce the oddly distorted image on the right. (As in the previous example, note how the depth in the telephoto image appears different. The clock over the man's shoulder appears much closer in the left image.)

Typically, portrait photographers use a slightly telephoto lens, which almost always yields a more flattering look. A slightly telephoto lens will guarantee that people's noses don't look too big, their faces aren't elongated, and their eyes won't bulge. Well, no more than normal.

Geometric Distortion

Most zoom lenses exhibit some form of barrel or pincushion distortion when zoomed to either of their extremes. With barrel distortion, horizontal and vertical images will bow outward. Pincushion distortion bows lines inward. These distortions will show up as curves and warps around the edges and corners of your image (see Figure 9.13).

Figure 9.13

Wide-angle lenses often suffer from a bit of barrel distortion. Although it's slight in this image, note that the top of the garage door is curved, not perfectly straight.

When you find yourself at the limits of your zoom range, check the edges of your image to see if there's any distortion. If there is, and you can live with it, then by all means take the shot. If it bothers you, you might need to reposition your camera and select a new focal length. If the distortion isn't too bad, you might be able to remove it with your image editing software, as we'll see later. Barrel distortion is especially prevalent when shooting macro photographs because you tend to zoom out all the way and position yourself very close to your subject. It's not necessarily a problem, but it's good to keep an eye out for it while you're shooting. If you get an unacceptable level of distortion, you may want to zoom in some and go for a shot that isn't as close to your subject.

Shooting Shallow Depth of Field

Making the decision to shoot with a shallow depth of field (to blur the background in your image) will dictate a few choices as you build up your shot.

The depth of field in your scene is dictated by three parameters: aperture size, the size of objects in the background of your image, and sensor size. As you've learned, larger apertures yield shallower depth of field, so if you want to shoot with very shallow depth of field, you'll want to choose a lower-numbered f-stop.

However, the only way that shallow depth of field is apparent is if there's something in the background that is noticeably soft and blurry. In other words, having larger, easier-to-see objects in the background will make your shallower depth of field more apparent. This means that you'll usually want to choose a longer focal length. As you've seen, shorter focal lengths make the background appear smaller and farther away (Figure 9.14).

Figure 9.14

The depth of field in both of these images is exactly the same. However, the depth of field in the second image seems less shallow because of the wide-angle lens. The objects in the background are so small that you can't see that they're soft and blurry. So focal length choice and camera position are critical when trying to shoot shallow depth of field.

Depth of Field with Point-and-Shoot Cameras

If you have some experience with 35mm or larger formats, it is important to realize that because of the tiny sensors found on most point-and-shoot digital cameras (which are inherent to the small designs of those cameras), depth of field is much deeper than you might be used to. (Sensor size has a large bearing on depth of field, for optical reasons that are too complex to go into here.) On a typical point-and-shoot digital camera, the depth of field produced by an f5.6 aperture works out to be more like the depth of field produced by an f16 aperture on a 35mm camera. This is great news for users who want really deep depths of field. However, photographers who are used to being able to separate foregrounds from backgrounds using very shallow depths of field might be frustrated (see Figure 9.15).

Figure 9.15

Most point-and-shoot digital cameras are not capable of capturing very shallow depth of field. Although this is great for maintaining sharp focus, you might be frustrated if you want to intentionally blur out the background. The slight blurring of the background in this image is about the most you can expect from a point-and-shoot digital camera.

Use an SLR for Very Shallow Depth of Field

If you want the option to shoot very shallow depth of field, then you'll want to shoot with an SLR. With their larger sensors, you can shoot shallower depth of field on an SLR than you can with a point-and-shoot. Also, their interchangeable lenses let you opt for lenses with very wide apertures and for longer focal lengths.

Focal Length Only Appears to Affect Depth of Field

There is a long-held, long-taught belief that longer focal lengths yield a shallower depth of field. This isn't true. Longer focal lengths yield an apparently shallower depth of field. You can learn more about this by reading Focal Length and Depth of Field.pdf, which you can download from the Chapter 9 section of the companion Web site, at *www.completedigitalphotography.com/CDP6*. For all intents and purposes, though, when you want an image that appears to have shallower depth of field, use a longer focal length.

How Shallow Should You Go?

1.2

1.8

2.8

When you want to shoot with shallow depth of field, it's tempting to just crank your aperture open all the way, but this is not always the best choice. First, as depth of field gets shallower, your background becomes more blurred and abstract. You may not want to make your background completely indistinguishable, so choose an aperture that gives you some blur, but not too much (see Figure 9.16).

Your other concern when shooting with shallow depth of field is *focus* (see Figure 9.17). As depth of field gets shallower, focusing can become more difficult. For example, if you're shooting with a very wide aperture—1.8, for example—then your depth of field might be so shallow that if you focus on someone's nose, their eyes will be a little soft. When you shoot with extremely wide angles, know that accurate focusing becomes critical!

If you're in a situation and you need to shoot very quickly, you might not want to shoot with super shallow depth of field, simply because you'll have to take more time worrying about focus.

Figure 9.16

It's important to consider just how much you want to blur out the background when shooting with shallow depth of field. You may not want background details to go indistinguishably blurry. Note the difference in background blur with these three apertures.

Figure 9.17

When shooting with extremely shallow depth of field, be very careful about focus. Here the subject's face was tilted slightly, leaving her right eye slightly farther away from the camera than her left.

It's a good idea to do some tests with your camera and shoot the same scene with different apertures, to get an idea of how much change happens from one aperture to another. At the wider end of your aperture range, you should see quite a change. Of course, if your lens doesn't offer a particularly wide aperture (f4, for example), then you won't be able to get super shallow depth of field. And, as mentioned earlier, if you're working with a point-and-shoot camera, you won't be able to attain very shallow depth of field because of the camera's small sensor size.

Depth-of-Field Preview

If your SLR has a depth-of-field preview button (see Figure 9.18), you can use it to get an idea of the depth of field that will be provided by your current exposure settings. Until you press the shutter button, the iris in your lens is open as wide as it will go, regardless of the aperture choice you've made. This allows you to see a bright, clear view through the viewfinder, because as much light as possible can pass through the lens. When you press the shutter release to take a picture, the iris is closed down to your desired setting and then reopens to full wide after the picture is taken. Obviously, this all happens in a fraction of a second. This means that the viewfinder is always showing you the depth of field that you'll get with your lens' maximum aperture.

If you've chosen a small aperture, then the depth of field in your final image may be greater than what you see when you look through the viewfinder. If you press your depth-of-field preview button (after metering and setting your desired aperture), the aperture will close down and stay closed as long as you hold the button. This allows you to see the image through the actual aperture size that will be used when you take the shot. However, with the iris stopped down, your viewfinder will become much dimmer, which can make it hard to see your image at all, much less notice depth of field.

Give your eyes time to adjust to the dimmer viewfinder, and if need be, cover your other eye with your hand to give yourself as dark a viewing environment as possible. As your eyes adjust, you should be able to get a better sense of the depth of field in the image.

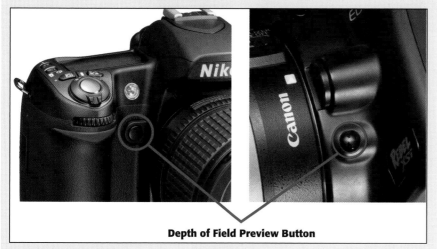

Depth of Field Preview Button

Figure 9.18 Most SLRs have a depth-of-field preview button, which shows the actual depth of field in your scene. Not all DOF preview controls are in these locations. Check your camera manual for details.

Composition

Just because something looks cool in real life, doesn't mean you can simply point a camera at it and get a good picture. Unlike the real world, a photograph is bounded by a frame. When looking at a photo, the viewer reads the contents of that frame to try to determine and understand what it is you're showing them. The simplest definition of composition is that it's the way you frame your scene, but good composition means much more than simply choosing a way to crop the world to fit into a rectangle.

Good composition is the process of arranging forms and tones in a way that is pleasing, and that guides the viewer's eye to bring attention to your subject. In a good composition, you will know precisely what the subject of the image is. In a bad composition, your eye will wander and search, and if pressed, you may not be able to identify the subject of the image. Good composition can also reveal things in the scene that viewers might not notice on their own—repetitive patterns, a play of light and shadow, or even a feeling about the particular moment you're photographing.

Earlier, we looked at some simple composition rules—fill the frame, lead your subject, and don't be afraid to get in tight. These guidelines can greatly improve your snapshots, and are relevant to all kinds of shooting. For more complex subjects, and to produce more compelling images, you'll want to think about some additional compositional ideas.

There are no hard-and-fast rules that will guarantee good composition all the time, but there are some guidelines you can follow that will usually improve your shots. These guidelines can be mixed and matched and, of course, they can be ignored and abandoned. Every image is its own unique challenge, but in general you'll want to consider the following when composing a shot.

Balance

Elements in your shot have different weights. A heavy element on one side of the frame might need to be balanced by an element on the opposite side of the frame. For example, in Figure 9.19, the two large birds on the left are balanced by the smaller bird on the right. The smaller bird manages to create balance because it is positioned in the lower-right corner. This shifts the center of balance to a different place in the image, just as a real weight would.

Figure 9.19

The elements in this image are positioned in a balanced way in the frame. Each has a weight that balances the other.

If we remove the right-hand bird from the image, as shown in Figure 9.20, the picture falls out of balance. Now the two left-hand birds are simply positioned oddly in the frame, flying out of the picture with a big empty space behind them.

Figure 9.20

If we remove the bird on the right side, the image is no longer balanced—the left side is too heavy.

Placing something in the dead center of the frame can also create a balance, as shown in Figure 9.21. In this case, center framing works fairly well because of the hills on either side that guide the viewer's attention to the middle of the frame.

Figure 9.21

Balance can even be created by placing an element in the center of the image. Here the sloping hills on either side serve to create an even balance.

Compositional balance can be tricky because you don't have to have elements of equal size to create balance. Just as a small piece of lead on a scale can balance a tremendous number of marshmallows, some small graphic elements can balance elements that are much larger. This is almost always the case with people. We put a lot of import on people, and a single person in a frame can balance a huge amount of other compositional elements (see Figure 9.22).

Sometimes, empty space can create a balance, as in Figure 9.23.

Figure 9.23 is also a good example of breaking a rule, because we're plainly ignoring the "lead your subject" rule that we talked about in Chapter 2, "Getting to Know Your Camera." In this image, though, it works. The woman's pensive, reflective expression makes the empty space behind her more powerful. That space is evocative of emotional weight that is bearing down on her. It also might evoke the weight of her past. Graphically, the mostly empty space on the left balances out her presence on the right.

Finally, balance is not created just with geometry. You can also balance tones against each other. For example, in Figure 9.24, the dark tones on the left side of the image are balanced by the light tones on the right side. The bicyclist on the right side of the image also adds some additional weight.

Figure 9.24

You can also create balance tonally by balancing light tones against dark tones. Here, the dark left of the frame is balanced by the lighter right half of the frame.

The Rule of Thirds

You can often achieve good composition by dividing your image into thirds and placing elements on your scene at the intersection of any of the grid lines. In Figure 9.25, the geometric components of the scene have been placed accordingly.

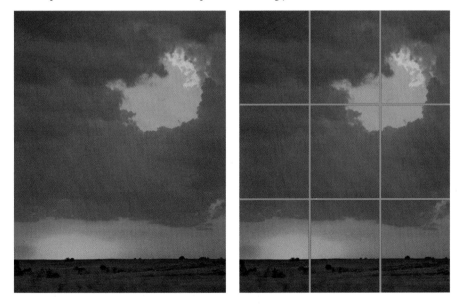

Figure 9.25

To employ the rule of thirds, you divide your image into equal thirds, and try to place elements close to the intersections of the divisions.

Repetition

Repeating patterns are often very interesting, like the repeating pattern of the fence you saw in Figure 9.2. Figure 9.26 shows another image with some simple repetition.

Figure 9.26

Repeating forms—geometric or tonal—are often interesting, and make for good composition.

Geometry

Geometric patterns are also very compelling (and often include an element of repetition). Figure 9.27 is composed around a number of interlocking and overlapping triangles.

Figure 9.27

Geometric patterns, in this case triangles, are often compositionally interesting, and usually have an element of repetition.

Sometimes, even pure geometry can be interesting, as in Figure 9.28.

Figure 9.28

Playing purely with geometry can be interesting.

Lines

Like geometry, strong lines often make for good composition, especially strong diagonal lines. Figure 9.29 is a prime example of this, with the rock included to break up the repetition and to provide a focus for the eye. (Note too, that it's mostly placed according to the rule of thirds.)

Figure 9.29

Strong lines make good compositional elements. This image obviously also has strong repetition.

Figure 9.30 is another example of diagonal lines, although not necessarily so literal. The wires, the lines of the sidewalk, and the repeating telephone poles all create a sense of lines receding to a vanishing point.

Curvy lines are often interesting, such as the path shown in Figure 9.31. This image also features a tonal balance. By placing the dark path more to the right, we balance the darker tones of the path with the larger bright area to the left.

Figure 9.30

Line and geometric elements don't have to be overly pronounced or literal. This image has a strong sense of diagonal lines.

Figure 9.31

Strong curvy lines also make effective compositional images.

Mixing and Matching

As you've seen in many of these images, you can mix and match different compositional elements and ideas, combining them to create a stronger effect.

Foreground/Background

This may sound simple, but it's one of the most oft-violated compositional rules. A photo needs a foreground and a background. Or, to put it another way, a subject and a background. What's more, the relationship between those two things is very important.

In Chapter 2, you learned about the idea of filling the frame. Choosing what to fill the frame with is an important part of good composition. For example, Figure 9.32 shows a person standing in front of the Golden Gate Bridge.

Figure 9.32

While we've filled the whole frame with potentially interesting things here—a person, the Golden Gate Bridge—what we don't have is an obvious subject. Is it the man? Or the bridge?

While we've filled the entire frame, and though we can see the bridge and the man's whole body, the image still doesn't really have a strong subject. In fact, the bridge is as much the subject as the guy, who serves little purpose other than to provide a sense of scale.

A better composition would be to go tighter, as in Figure 9.33.

Figure 9.33

By going in tighter, our subject is more clear. This is plainly a portrait. However, we can still see enough of the bridge to get a sense of his environment.

Here we've filled the frame with more of the person, and we know now that he is definitely the subject of the image. Yes, we've had to crop the bridge, but the image still plainly conveys the person in his environment. If you want a picture of the bridge, that's a different subject, and a different photo, and you probably don't need a person at all.

In most cases, it's safe to say that you shouldn't try to take a single picture that encompasses everything in a scene. Sometimes, all you end up with is a picture with no discernible subject or purpose.

There will be times when you'll come across a beautiful or compelling vista which will be strong enough to stand on its own as a subject. You'll still need to think about framing and composition, and will want to go over the rules we've discussed, but you won't have a definite foreground and background (see Figure 9.34).

Figure 9.34

Sometimes, especially with landscapes, you won't have a definite foreground and background. The background itself will be strong enough to act as a subject.

At other times, you might find a compelling vista, but not be able to find a composition that feels right. This might be because the scene lacks a subject, and your eye doesn't really know how to read the image. If you can find something to use as a subject, you'll probably find it's easier to compose a shot (see Figure 9.35).

Patience is often the most important photographic tool at your disposal. If you find a nice background, wait and see if someone walks into it to complete the composition or to serve as a subject.

If nothing in the scene changes, then change your vantage point to find something that can serve as a subject (see Figure 9.36).

Figure 9.35 On the left is an interesting locale, but it's not an interesting picture because our eye doesn't really know what to do—there's no subject. But, after waiting a minute or so, the funicular came into view. It provides a subject, as well as some balance, and a sense of scale.

Figure 9.36

This sandstorm was interesting, but even finding a simple mundane subject, like this bucket that was sitting out in the desert, made for a more compelling image.

Composing with Light and Dark

In Figure 9.24, you saw an example of an image that was balanced on one side by a dark area and on the right by a light area. You'll often build compositions out of light and dark, not just out of geometry.

Light is the raw material of photography, so pay attention to light and dark elements within an image, as they can make great compositional elements.

Remember, too, that a completely black shadow is sometimes just what an image needs. We don't always need to see detail everywhere in an image, and choosing what to show and what to hide is part of what makes a composition compelling and an image easier to read (see Figure 9.37).

Figure 9.37

You don't have to see detail in every part of an image. Letting some parts go out to complete black often helps bring more attention to your subject.

Less Is More

There are so many ways that the world can be annoying, but for photographers, one of the biggest is that there's just too much extra stuff in the world.

Painters have it easy because they start with nothing and add only the things they want in their scene. Photographers, though, have to figure out how to compose with (or in spite of) power lines, street signs, parked cars, people who walk into the compositions, moving cars, trees that have one branch that's pointing in the wrong direction, and so on and so forth.

One of your most difficult compositional tasks is to reduce the clutter in a scene, so that the viewer is not confused about what to look at, and so that his or her eye finds its way through the image.

Figure 9.38

While the whole panel from this old elevator is interesting in person, the more interesting photo is to get in close and focus on a single detail.

If you work to fill the frame, as we've discussed, you'll have a head start on reducing the clutter in your scene. One of the easiest things to try when you're looking for the right composition is simply to get in closer, as shown in Figure 9.38.

Getting in closer is a great way to reduce clutter and get a cleaner composition. When shooting people, getting in closer can be intimidating because you must move physically closer to your subject. Obviously, you shouldn't make them uncomfortable, but don't be afraid to entertain the idea of moving a little closer if the situation presents itself.

When you're in a crowded area, getting closer often means separating yourself from the crowd and moving toward a scene. This can make you feel like everyone is looking at you, but in reality, they probably aren't. These days, everyone is used to seeing people with cameras. More importantly, though, so what? They notice you for a few moments and then go on with their day, while you go home with an interesting photo.

Don't Be Afraid to Put Things in the Middle

A lot of people think that if they put their subject in the middle of the frame, they're shooting an uncreative, boring picture. While worrying about the rule of thirds, balance, and all of these other concepts, it's easy to forget that, sometimes, the best composition is to leave your subject in the dead center of the frame, as shown in Figure 9.39. It is possible to get too creative, so don't forget the value of simple composition.

Figure 9.39

Often, the best composition is the simple composition—place your subject in the middle and trust that they can carry the scene.

Mixing, Matching, and Ignoring

Look closely at the example images I've presented here, and you'll find a lot of overlap of compositional ideas. For example, in the funicular picture, note that the funicular is positioned according to the rule of thirds.

You can easily mix and match the compositional ideas that I've presented here, and as we've seen, you can also throw them out altogether. There will be times when you're conscious of these rules, and other times when you simply go by feeling. However, if you practice these ideas a lot, you'll soon find that the images you shoot by feeling still conform to these compositional concepts.

These rules can be especially helpful when you come across a scene that you want to capture, but you don't have any idea where to begin. Start by thinking about camera position and focal length, and look through the lens to see how the sense of depth and space in the scene changes as you change position and focal length. Then start thinking about subject and background, and about geometry, pattern, repetition, and the rule of thirds. These can serve as guidelines as you explore the scene through your camera lens.

Over time, you will internalize these ideas and find yourself employing them by feel. That is, you'll simply find that a particular composition feels right because it is properly balanced and composed. Until then, you'll want to try practicing with these concepts.

Exercise: Composition

One of the great things about composition is that you can often correct it after the fact. The crop tool in your image editor gives you the capability to recompose and change the balance of your images. Ideally, you want to get your composition as right as possible inside your camera, to save postproduction time and to maximize the use of your image sensor. But there will be times when cropping is the only way to get the shot you want.

Cropping is also a great way to practice composition. Print the `Cropping Tutorial.pdf` document, which you can find in the Chapter 9 section of the companion Web site, at *www.completedigitalphotography.com/CDP6*. On it you will find a collection of pictures shot by some vacationing tourists. With a pen, mark the image with a new crop. If you don't think it needs a crop, leave it alone. When you're finished, watch the `Cropping Tutorial.mov` to see how I recropped the images.

Six Practices for Better Shooting

While practicing how to see may seem abstract, it is something you can work at and improve. You will continue to explore and refine your composition skills for the rest of your life as a photographer. To help you along, there are some practices you can employ to improve the quality of your images.

Seeing *in* the Camera, not *Through* the Camera

The brain has an amazing ability to focus your attention on something within your field of view. So much so, that it becomes very easy *not* to notice all the other things that are in your field of view.

For example, while walking downtown in San Francisco one day, I spotted the scene shown in Figure 9.40.

It may not look like much in the picture because, well, it's not. There's no real composition, and nothing for your eye to follow. Mostly, it looks like a photo of an empty parking space. Granted, this is often a photo-worthy event in San Francisco, but while standing at the scene, what I was really struck by was the building with the tall facade in the distance. I found it striking for some reason, and then noticed that the strong, rectangular shape of that building was balanced by the round turret of the building across the street.

In other words, my attention was focused on a very small part of my field of view, and I completely ignored all the clutter around it. Holding a camera up to my face didn't change this perception—my brain continued to focus my attention on one small part of what was in the frame. When shooting, it's very important to pay attention to the entire image that is being shown in the viewfinder, not just the small part that your brain might be paying attention to. This is a return to the idea of making an effort to fill the frame with your subject. Here, my frame is filled with far more than my subject.

The best way to guard against this is to trace your eyes around the edge of the frame before you press the shutter button. This will make you pay attention to other elements in your shot, and will also help you notice any strange intersections in your composition, such as telephone poles sticking out of people's heads and that sort of thing.

Figure 9.40

While walking down the street in San Francisco one day, I came across this scene.

Work the Subject

We've all done this: while walking down the street, something catches your eye that you think will make a great picture. So you stop where you are, compose your shot, calculate your exposure, and fire away. Now think about it: what are the odds that you just happened to be standing in the one ideal spot to take a photo of whatever the thing is you saw? Of course, if it's a fleeting moment, you might very well have been in the only place possible to get the shot, but if it's something more persistent, there's a very good chance that there's a better place from which to build your shot.

To carry on from the previous example, after coming across the scene I described earlier, I zoomed in and started to take some pictures of the two buildings I had spotted. I shot several different frames from slightly varying distance, some with cars passing in front and some without. You can see a few of the results in Figure 9.41.

One of the great advantages of digital photography, of course, is that we can see our compositions right away by looking at the LCD screen on the back of the camera. A quick check of my shot showed me something I was having trouble seeing through the viewfinder: the two buildings were too far apart to reveal the contrasting geometries that had struck me when I first saw the scene. This, again, is an example of my brain focusing my attention on something in the scene that wasn't actually being captured by my composition.

So I moved across the street and tried a few more frames, and finally ended up with a composition I liked, the one in Figure 9.42. While I was visualizing the scene in black and white, I chose an exposure that would allow me to render the final image in a particular way. We'll look at that process in Chapter 19, "Black-and-White Conversion."

Figure 9.41 To attack this scene, I tried a number of different shots from slightly different positions, with slightly different framings, with and without cars.

Figure 9.42

To get the scene I wanted, I finally had to move across the street and try a few more shots and angles.

The point is that you have to work your subject. Move around, try it from different angles get closer, get farther, stand on your toes, get down on your knees, try different focal lengths. Figure 9.43 shows another example, a series of images of the great jazz drummer Jack DeJohnette. This scene had to be worked for quite a while to find a combination of interesting composition, good facial expression, and dynamic movement. The smeary effect was creating using a Lensbaby, a cool SLR attachment you can learn more about at *www.lensbabies.com*.

Figure 9.43

It took a number of experiments with composition and camera position, and a lot of frames containing different positions and facial expressions, to get a shot I liked.

Many people think that professional photographers go out, shoot 30 frames, and return home with 30 great shots. They don't. They work their shot, trying different angles, exposures, and ideas. Very often, they don't know which idea is best until they get home and look at their images. The more you work your shot, the more choice you'll have when you get to postproduction.

Narrative

Narrative is the process of telling a story. Narrative is a fairly simple thing to understand when you're writing or shooting video because there's a temporal component that you can control. Consequently, it's possible to convey a series of events that have a beginning, middle, and end. In photography, narrative can be a little more ephemeral.

Obviously, you can shoot multiple images to create a diptych or triptych that tells a straightforward story. But a single frame can also have a narrative. An image of a small child next to a broken vase tells a definite story of something that has just transpired. The image in Figure 9.44 also conveys a narrative, the promise of a big concert.

When trying to construct a photographic narrative, it's important to think about what information is required to tell your story. For example, this image from the same shoot simply shows clarinet player Don Byron. Unlike the previous picture, this image doesn't have a lot of definite narrative. We don't know where he is, if he's playing with anyone else, whether he's preparing to play, or finishing (see Figure 9.45).

Figure 9.44

Although a single frame, this image tells the story of an impending event.

Figure 9.45

This figure doesn't convey quite as much narrative because we can't tell the location, the nature of the event, whether he's finished playing, or going to play, and so on.

As we've learned, the viewer will project a lot of information into a scene. An empty, lit concert hall implies rehearsal, which probably means daytime, which means there's going to be a show happening in the future. As a photographer, you can use the viewers' automatic projections to build a story, as long as you give them enough clues to point them in the right direction.

However, don't expect that every single image can convey an entire narrative. If you try this, you'll be more prone to wide shots that lack an obvious subject. Sometimes you can get a narrative shot, while at other times, you'll have to rely on good single images that build up to a narrative. At still other times, narrative is simply not an issue. Some scenes are purely attractive for their visual qualities, not their narrative ones.

Simplify

The less complex shot is almost always the better shot. I don't mean the shot that was easier to shoot, but the shot that contains fewer elements, so the viewer's eye is easily directed to the subject at hand. As mentioned earlier, good photography is a subtractive process. Where painters start with a blank canvas and get to add whatever they want, photographers start with the entire world and have to try to figure out ways to hide and remove elements from a scene, to reduce it to the bare essentials that convey their photographic idea. And so we choose our camera position very carefully, we crop, we make particular exposure choices, and we edit and adjust our images, all to reveal certain elements of a scene.

It's very rare that you won't get a better picture by moving closer to your subject. This is often the easiest way to simplify your composition and remove unwanted elements. When that isn't possible, think about other ways to streamline your image: postproduction cropping, exposing to bring attention to one element or another, and so on. You'll learn more about these processes later in the book.

Don't Be Afraid

It may sound strange to talk about fear in terms of shooting photos. After all, unless you're shooting in particularly harrowing conditions, there's no real risk involved in photography. Nevertheless, most people still employ risk management behavior while shooting. To get good images, you have to have the courage to try something new, to experiment, and to consider compositions and ideas you might not have shot before.

Why are people afraid to try new shots? Sometimes, it's because they're in public and are afraid of looking stupid. Don't worry about this. Most people in public are so busy worrying about whether *they* look stupid that they don't have time to notice what you may or may not be doing with your camera.

More often, the fear of trying new shots is the fear of coming home to find that you shot bad photos. This is an awful feeling because it usually makes you question if you really have any photographic skill at all. To become more courageous in your shooting, accept this right now: the majority of the images any photographer takes are not keepers! And some are outright bad!

You probably have a comfort zone of some kind, a type of shot you have been pleased with in the past. So you will continue to shoot this type of shot because, even if you're bored with it, you won't get home later and end up feeling discouraged by having taken something bad or stupid. The problem with this comfort zone is that eventually you will become bored with it, feel like you can only shoot one type of photo, and so be convinced that you have no photographic skill.

When you work a subject as described in the previous section, you will get a lot of unusable images, possibly some stupid ones and maybe some bad ones. And none of that has any relationship to your skill as a photographer. Working a subject is just like sketching, and just as not every line in a sketch is the correct line, not every photo you take is the correct photo, but like the lines in a sketch, your incorrect photos serve to help you zone in on the keeper shot. Painters don't worry about what their sketches say about their painting skill. Similarly, you shouldn't worry about what your "sketch" photos say about your photography skill.

You won't get that keeper image if you don't have the nerve to try some new ideas. So shoot a little extra—shoot on impulse and take chances. After all, you can always delete them later.

Equipment Doesn't Matter (Usually)

Photography gear is so cool and so much fun that it can be very easy to think that buying more of it will make you a better photographer. It won't. Don't get me wrong: some cameras take images that are much sharper and possess much more vibrant color than other cameras. For certain types of work, these technical specifications are imperative. But still, you can take a good picture with any camera. For example, Figure 9.46 shows a three-image panorama shot with an old 640 × 480, first-generation digital camera.

Figure 9.46

It's possible to take good images with any type of camera. Don't fall back on the excuse that you just need better gear to be a better photographer.

It was not possible to take a razor-sharp, finely detailed image with that camera, but that didn't mean it wasn't possible to shoot other types of images that worked fine. If your gear has weaknesses, it might be possible to exploit them.

If you are editing an image and find a technical flaw you feel truly compromises the image—maybe the edges are soft, or the high-contrast areas suffer from distracting color fringes—and this flaw continues to plague you in more and more shots, then you might want to invest in some different gear. Or, if you find that what would have made the image great is if you'd been able to shoot with a wider angle or shallower depth of field, then expanding your toolbox might be a reasonable idea. But if you think that any one piece of gear is going to make you take more interesting photos, you're wrong. Henri Cartier-Bresson, arguably the most influential photographer of the 20th century, shot most of his images with a 35mm camera with a fixed, 50mm lens. No autofocus, no auto metering, no auto winding, and only one focal length. The cheapest decent digital point-and-shoot offers more features and flexibility, and often better image quality, than what he used.

If you want to take better pictures, spend your time worrying about light and seeing, not on gear envy.

Combining Art and Craft

When you practice the creative process we've looked at in this chapter, you will employ the technical concepts that we covered in previous chapters.

For example, you might be working a scene—moving in, getting close, doing all that good stuff we've talked about—when you find a focal length and camera position that creates a wonderful sense of space, and that allows a composition that is balanced, with a nice subject/background relationship. At that point, you might realize that all it needs is a softer background to highlight the subject just a little more. So you choose to go to a wider aperture using Program Shift. You look for an exposure combination that has a smaller aperture number, and then you activate your camera's depth of field preview to check it out.

But then maybe you realize that your composition's balance is based on the left side of the frame being in shadow, and the shadow isn't quite dark enough. So you dial in a 1/3rd-stop underexposure using your Exposure Compensation control to darken the shadows.

You shoot the shot and then review the image to check out both the composition and the histogram, which will give you an idea of how well your exposure choice worked. In this way, your technical knowledge is combining with your artistic choices as you build your final shot.

10

LIGHTING

The Process of Controlling Light

In an ideal world, the light would always be perfect. Shadows wouldn't be too harsh, but your subject would still have enough light on it to show contour and texture; your image would be filled with an appropriate warm (or cool, depending on your need) glow; and all of this light would be constant and last for hours, giving you plenty of time to get your shot.

Of course, it's not an ideal world, which means that very often you'll find wonderful subject matter, but it just won't be worth shooting due to bad, flat, or boring light. While there's not much you can do but wait and hope when you're shooting landscapes under bad lighting, if you're shooting portraits or still lifes you have a tremendous number of options that allow you to craft the light exactly the way you want it.

In this chapter, we're going to look at a few different options for lighting portraits. If you think that lighting is beyond your skill, budget, or interest, take a look at some of these techniques. You may be surprised to find that with just a few dollars and some simple tools, you can greatly improve your portrait shots.

Controlling Available Light

Your camera might have a built-in flash or a hot shoe for connecting an external flash (or multiple flashes). Later in this chapter, we'll explore electronic flashes in detail, but it's very important to understand that you can often achieve all of the lighting control you need by simply working with available light and simple reflectors and diffusers.

It's hard to beat the sun as a light source. It's bright, it's there half the time, it produces a strong even light, and it's a great color that both your eyes and camera are well adapted to. The problem with sunlight is that there are times when there's too much of it. When shooting in bright sunlight, one of your biggest problems will be to reduce the amount of light hitting your subject.

For portraits, too much contrast is not flattering. Strong light, like what you get from the sun on a clear day, produces dark shadows under eyes, makes lines and wrinkles more pronounced, and can cause skin texture to appear exaggerated.

Figure 10.1 shows a portrait shot in direct sunlight. Overall, the image is too "contrasty." Notice the strong shadow under her chin and how her eye sockets are dropping into shadow (and the bright sun is making her squint). Her nose and cheekbones are also making harsh shadows.

Figure 10.1

This image, shot in direct sunlight, is too contrasty. The dark shadows created by the intense light are unflattering and distracting.

What we really needed (both to improve the lighting and because it was 103°F) was for a cloud to pass over the sun to cut the intensity of the light. Since no clouds were in sight, we employed a diffuser.

Diffusers are simply large pieces of white cloth that serve to diffuse light, casting a very soft shadow. Diffusers come in many varieties. The best are round diffusers that collapse easily to become portable. Photoflex (*www.photoflex.com*) makes diffusers in many different sizes and colors, but you can find similar reflectors from a number of other vendors, such as Calumet Photo (*www.calumetphoto.com*).

To use a diffuser to attack our high contrast problem, we simply held it above our subject to cast a shadow onto her face (see Figure 10.2).

Figure 10.2 To reduce the contrast on our model, we held a diffuser above her to cast a soft shadow onto her face.

With our "cloud" in place, the harsh shadows on our model's face were greatly reduced, making for a more flattering light (see Figure 10.3).

Our work is not finished, though. While the shadows are softer, the left side of her face is a little darker than the right. We can eliminate these by using a reflector to bounce some light up into her face, as shown in Figure 10.4.

When working with silver or gold reflectors, one of your biggest problems will be that the reflector will bounce *too much* light onto your subject. Fixing this is very easy: simply move the reflector farther away. This is true with any light source, be it a flash or a reflector (see Figure 10.5). As you move the light source farther away, the highlights it creates will become more diffuse.

Figure 10.3

With the diffuser in place, the shadows on our model's face are now far less harsh.

Figure 10.4 Here, we're using a diffuser to soften the light striking the model and a reflector to bounce some light back into her face from below. By controlling and redirecting the light, we can eliminate shadows to produce the portrait shown on the right.

Unfortunately, the small flash units provided by most cameras are low powered, and because of their positioning on the camera, they don't often produce very flattering light. However, your camera's built-in flash does have its uses, and with a little knowledge, you can get it to yield good results.

When you shoot a picture using your flash, many things happen in a short amount of time. First, the camera opens its shutter and begins exposing the image sensor according to the settings defined by you or your camera's light meter. Then the camera turns on the lamp in its flash unit. With the lamp on, the camera begins measuring the flash illumination that is bouncing off the subject and returning to the camera. In this way, the camera can meter the light of the flash while it is flashing. When it has decided that the flash has cast enough illumination, it shuts off the flash, finishes the exposure, and closes the shutter.

Flash Modes

Most digital cameras provide several different flash modes. If you're shooting in a fully automatic mode, your camera will try to determine, on the fly, whether the flash is needed. If it deems the flash necessary, it will fire it for the appropriate amount of time. In addition to this mode, your camera probably provides the following:

- **Fill.** This mode uses the flash to fill in shadows. It is typically used for backlit situations or other instances where you're shooting in bright light but your subject is in shadow. Usually, the camera uses a lower power flash setting so as not to overexpose the shadows in your image.

- **Red-Eye Reduction.** The "red-eye" effect (see Figure 10.8) occurs when the light from your flash bounces off the retinas of your subject's eyes as he or she looks into the lens. If the flash on your camera is placed close to the lens, there's a much better chance of getting red-eye, because it's easier for the light to bounce straight back into the lens. Red-Eye Reduction modes work by firing a flash, or the camera's autofocus-assist lamp, to close the subject's pupils. When you use these modes, be sure to inform your subject that there will be two flashes. Otherwise, your subject might move or close his or her eyes after the first firing. Whether you're shooting with or without a red-eye reduction flash, moving slightly to one side before you shoot can prevent your subjects from looking directly into the camera's lens. You can also try turning on all the lights in the room in an attempt to narrow everyone's pupils.

- **Cancel.** This feature simply deactivates the flash. This isn't exactly a mode, but it is important for times when you're shooting in an area where a flash is not appropriate or when you want to handle low light in a different way.

Spend some time using the different flash modes on your camera to learn their characteristics. In particular, determine if the flash consistently over- or underexposes, and if it tends to produce odd color casts. If so, you might want to adjust its settings as described in this section.

After the flash has fired, any leftover charge is saved for the next firing. Consequently, your flash's recycle time can vary depending on how much it had to fire. In other words, you'll get faster recycle times when you use your flash in brighter light, because the flash won't have to fire for as long and won't have to recharge as much.

One problem with on-board flashes is that they're really not positioned to provide flattering light. Our eyes are used to a strong overhead light source, so flashing a bright light directly in front of a subject usually produces a somewhat weird lighting perspective. In addition, a poor flash exposure can result in harsh lighting with overblown highlights and hard-edged black shadows if the flash fired too much, or an underexposed image if the flash fired too little (see Figure 10.9).

Figure 10.8

Red-eye is prevalent in small cameras because of the position of the flash. Fortunately, correcting the problem is fairly simple using tools found in most image editors.

Figure 10.9

At times, you might find that your camera's on-board flash creates harshly lit scenes with blown-out highlights. Flash exposure compensation lets you dial down the power of the flash for better exposure.

Fortunately, many cameras offer flash power adjustment controls—sometimes called *flash exposure compensation*—that let you increase or decrease the power of the flash by one or two stops in either direction. After a test shot, you might find that your camera's flash is too strong. Dialing down the power by a stop or so might be enough to produce a much better exposure.

Remember that your camera's flash has a limited range, usually no more than 10 or 15 feet. Consequently, as your focal length increases, your flash's effectiveness decreases. That is, if you zoom in on an object 20 feet away, don't expect your flash to do a great job of illuminating it. Increasing the flash power by a couple of stops might improve your flash performance at these distances.

Flash White Balance

Your flash is usually not the only source of light in a room. In most cases, you'll be shooting flash photos in a room that also contains incandescent or fluorescent lights and maybe even sunlight. All of these light sources can serve to create a complex, mixed lighting situation that requires a special white balance.

Some cameras have a separate white balance setting for flash that can often correct color-cast problems, but on most cameras, manual or automatic white balance will yield the best results.

To get an idea of how your camera white balances when you use the flash, take some test flash pictures indoors under normal incandescent (tungsten) lighting using the camera's automatic white balance. If the images come out with a slightly blue cast or if the highlights are blue, the camera's white balance chose to favor the room's tungsten lighting. If the images come out a little yellow or have yellow highlights, the camera white balanced in favor of the flash.

There's little you can do about these color casts. Sometimes, dialing down the flash's power will reduce the effect, or you can try to filter your flash. If you find blue highlights in your flash pictures, buy some yellow filter material at your camera store and tape a piece of it over your flash. This will balance your flash for tungsten, making it match the indoor lighting better (which your camera is white balancing for anyway).

Using Flash in Low Light

When you shoot with a flash, your camera chooses an exposure that's appropriate for exposing the flash-illuminated area, which is usually a fairly small zone in front of the camera. However, if you're shooting in low light, everything outside of this zone will be underexposed, resulting in your background appearing as a dark limbo space.

If you're gunning for a quick snapshot in a dark situation, this may be your only option. But, if you have more time, you should consider two other possibilities: using a higher ISO or a slow sync flash.

High ISO Low-Light Shooting

As you've already learned, as you increase your camera's ISO, it becomes more sensitive to light, which means you can shoot in lower light. Shooting in low light without your flash will produce a more natural-looking scene, but you might have to shoot with a slower shutter speed, which means you'll run more risk of blurring due to camera shake and possible movement of your subject.

If your camera has a Shutter Priority mode, try locking the shutter speed on something that offers good motion-stopping power, for example, 1/30th or 1/45th. Your images might still come out too dark, but you'll be able to brighten them later.

If you're shooting a subject that isn't moving, you can use your camera's recommended shutter speed, as long as you have a way to stabilize your camera (see Figure 10.10).

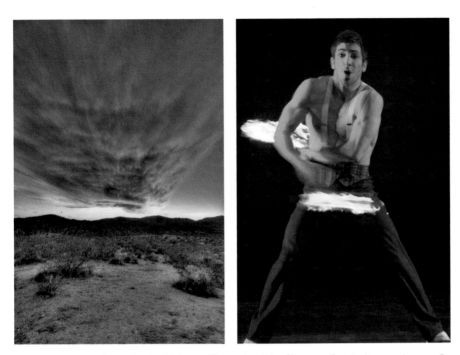

Figure 10.10

Raising your camera's ISO makes it possible to shoot in situations that would otherwise be impossible or inappropriate. For this sunset, we set the camera on ISO 1600, mounted it on a tripod, and used a long exposure. For this flame juggler, we set for ISO 1600, put the camera on aperture priority, and shot at a 50th of a second to ensure good motion stopping.

Anytime you switch to a higher ISO, you'll run the risk of increased noise in your images. In addition to producing noisier images, at longer shutter speeds, many of the individual pixels in the camera's sensor might begin to behave strangely, sometimes getting "stuck" so they appear bright white.

Some cameras employ special noise-reduction schemes when you shoot at speeds longer than one second. Most of these schemes employ some form of dark frame subtraction. When this feature is enabled, anytime you shoot an image with an exposure longer than one second, the camera automatically shoots a second frame, this time with the shutter closed. Because the exposure is the same, the pixels in the camera's sensor have time to malfunction exactly as they did in the first image. However, because the shutter is closed, the resulting black frame is essentially a photograph of only the stuck, noisy pixels from the first image. The camera then combines the images, essentially subtracting the second frame from the first. Because the second frame contains only the noise, the resulting image is much cleaner.

ISO choice when shooting long-exposure images can be a bit tricky. On the one hand, you might want to shoot with a higher ISO to reduce the shutter speed and avoid stuck pixels. On the other hand, shooting with a higher ISO introduces high ISO noise. So you might want to try both techniques and see which one ends up noisier.

Slow Sync Flash Mode

One problem with using flash in very low light is that, while the flash is capable of exposing your foreground properly, everything in the background lies out of range of the flash and ends up so underexposed as to be completely dark (see Figure 10.11).

Most cameras offer a special Slow Sync mode that uses a combination of a flash and a slow shutter speed to expose the foreground and background properly. The flash exposes the foreground, freezing any motion, while the slow shutter speed allows the camera to capture a good exposure of the background (see Figure 10.12).

Figure 10.11

This exterior night shot was illuminated only by our flash. Although it did a good job of exposing our subject, nothing in the background is visible, because the camera chose a shutter speed that was appropriate only for the flash-illuminated woman.

Figure 10.12

This image was shot a few seconds after Figure 10.11, using the camera's Slow Sync mode. The flash was fired to illuminate the subject and freeze her motion, but the shutter was left open for several seconds to capture the background, resulting in an image that reveals far more detail.

On many cameras, Slow Sync is a special Scene mode—just like Landscape or Portrait—that you select from the Scene Mode control.

On a higher-end camera that doesn't offer a Scene mode, or if you're using an external flash, you usually achieve Slow Sync effects by putting the camera in Manual or Priority mode. Consult the documentation for your camera or flash for details.

When shooting people using Slow Sync mode, be sure to tell them to hold still after the flash fires. Many times, people will start moving after the flash has fired, while the long exposure is still going. This can result in weird blurs in your image.

Many Slow Sync modes offer the choice of first curtain or second curtain sync. This simply denotes whether the flash will fire before or after the long exposure, allowing you to control where you might want blur in your image.

Using Fill Flash in Bright Light

Most people assume that you use flash when it's dark and turn it off when you're back in bright light or daylight. While this is occasionally true, you can also argue that it's often the exact opposite of correct flash philosophy. As you saw in the last section, using a flash well in low light is very difficult, and doesn't often yield the best result—sometimes, shooting with no flash and a higher ISO is a better way to go. You'll probably find that your flash is *more* useful in the daytime than it is at night.

When shooting outside, you'll often find that the sky is much brighter than your subject. Most Matrix metering systems will favor the sky when metering, causing your subject to be rendered too darkly. If your camera has a spot meter, you can work around this problem by spot-metering off your foreground subject, which will cause the background to overexpose and wash out completely.

A better solution is to activate your camera's fill flash. This will throw enough light on your foreground that the camera will expose both the foreground and background properly (assuming that your foreground is within range of your flash). See Figure 10.13.

Figure 10.13

Your camera's flash is not just for shooting in dark, low-light situations. Even in bright sunlight, you might need to use your camera's flash to compensate for a bright background or for shadow-producing hats, trees, or buildings.

This is the same practice you'll use in a brightly lit room to counter any backlighting caused by bright windows. Fill flash is also great for subjects who are wearing hats or are shaded by overhanging trees or other foreground objects. Usually, the bright outdoor light will be so strong that your flash will provide a rather soft fill light, with none of the harsh shadows you might see indoors or in lower light.

Finally, in Figure 10.13, note that the flash has also resulted in a nice catch-light in the model's eyes. This simple highlight makes the eyes look much more alive. You can create catch lights with flashes or reflectors.

External Flash

Although built-in flashes offer a measure of convenience, they also suffer from some significant liabilities:

- **Range.** Built-in flashes are usually very small, so they have very limited range. Once your subject goes beyond 10 feet, most built-in flashes are useless.

- **Propensity to red-eye.** Because they're positioned so close to the lens, most built-in flashes are very prone to producing red-eye effects.

- **Unflattering position.** Because light almost always comes from overhead, firing a flash directly into someone's face rarely looks natural. Shadows get cast in weird places, skin tones pick up unusual highlights, and dark shadows get thrown behind the person's head.

- **No creative control.** Since built-in flashes can't be moved, you have very little control over your lighting effects.

- **Slow recycle times.** Most built-in flashes take several seconds to recycle, which can often be long enough that you'll miss some shots.

With an external flash, you can eliminate all these concerns. Granted, you'll have to spend some money, and you'll have a little more gear to carry, but if you regularly shoot in situations that require a flash, you'll find an immediate improvement in your images if you use an external flash. To use an external flash, you must have a camera with a flash hot shoe.

What to Look for in an External Flash

Shopping for an external flash is pretty easy because there usually aren't too many options available for a specific camera model. While you can use almost any flash with almost any camera, you'll want to refine your selection immediately to flash units designed specifically for your camera. These models will integrate very tightly with the camera's metering system, which will make for much easier, better-quality flash exposure.

Once you've zeroed in on the models built for your camera, you'll want to consider the following criteria:

- **Power.** All flashes have a guide number that tells how much output they provide. Higher numbers will yield a longer range, but will also result in a physically larger flash unit. Think about the type of flash work you do and decide if you really need a flash with a huge reach or if you could get away with a smaller, less-expensive unit.

- **TTL metering.** If you're looking at a flash designed specifically for your camera, it will most likely have through-the-lens metering. If it doesn't, you'll want to consider going with a different unit.

- **Zoom.** If you're looking at a flash unit designed specifically for your camera, it should offer the capability to zoom automatically based on the focal length you've set your lens to. If you're shooting with an SLR, be aware that not all lenses transmit focal length information back to the camera. If some of your lenses don't, a flash zoom feature won't be of any use when you shoot with those lenses.

- **Tilt and swivel.** You want a flash head that can at least tilt, and ideally you want one that can swivel. As you'll see in the next section, the capability to tilt and swivel to bounce the flash off walls, ceilings, and reflectors allows you a tremendous amount of creative freedom (see Figure 10.14).

Figure 10.14

A flash unit that can tilt and swivel offers many more options for creating flash shots with natural-looking lighting.

- **Exposure compensation control.** While your camera probably provides an exposure compensation control that will work with an external flash system, having such a control onboard the flash is often a great convenience. Look for a control that's easy to access and use.

- **Slave control.** If you think you might want to eventually work into multiple-flash lighting setups, you'll want a flash system that allows one flash to trigger other, multiple slave flashes. This topic is beyond the scope of this book, but it's something to consider if you want to buy a flash that will grow with your shooting needs.

Fortunately, Canon, Nikon, Sony, Olympus, and Pentax all make very good flash systems, so you should be able to get a full-featured flash setup no matter what brand of camera you buy. Your main choice will simply be to decide about the level of flash power you want.

Shooting with External Flash

So now that you've bought the thing, what can you do with your external flash? Right off the bat, you'll probably notice that your external flash produces *much* more illumination than your camera's built-in flash. In fact, you may find that you regularly need to use flash exposure compensation to dial back the power a little bit. If your flash images look a little too "hot," you'll need to try lowering the flash exposure.

The most significant advantage of an external flash is the capability to bounce its light off other surfaces. In general, the light sources we're used to seeing the world under are very large and diffuse. Your flash, by comparison, is a small, point light source, and it creates a very harsh light. However, if you tilt the flash so its light bounces off the ceiling, the ceiling becomes the source of illumination for your scene. Because the ceiling is very large, it creates a wide, diffuse, more natural light, as shown in Figure 10.15.

Figure 10.15 In the left image, we've fired the flash directly at our subject, resulting in a harsh front lighting. In the second image, we bounced the flash off the ceiling. In addition to being less harsh, we can see more contour on her face and the background gets illuminated.

On most flashes with tilt, the camera automatically adjusts its exposure to adjust for the amount of tilt you have on your flash. As long as you're using a flash with automatic TTL metering, the camera will be able to adjust flash exposure as you tilt and swivel the flash. Nevertheless, you'll want to keep an eye on your histogram and see if your flash exposure is correct. If it's not bright enough, use a positive flash exposure compensation. If it's too bright, set flash exposure compensation lower.

Direct flash has the advantage of "flattening" facial features. Notice in the direct flash image in Figure 10.15 that there are no shadows under her eyes or eyebrows. This can often be a good thing, as it affords you a way to, for example, reduce the apparent size of someone's nose. However, you'll run the risk of picking up dark shadows under the chin, as our model has in Figure 10.15.

If your flash can swivel and tilt, you can bounce the flash off walls or reflectors to create side lighting effects, which allow you more control over the shadows in your image.

Tilting and swiveling also enables you to reposition the direction of the flash easily as you change from portrait to landscape mode (see Figure 10.16).

Figure 10.16

If your flash can tilt and swivel, it's easy to keep it pointed at the ceiling as you change from portrait to landscape orientation.

Getting Your Flash off the Camera

Like any light source, an external flash will cast a shadow behind your subject (assuming there's something there for the shadow to be cast onto). Perhaps you've noticed this before in flash pictures—a dark shadow behind your subject (see Figure 10.17).

In the case of a picture like Figure 10.17, you can try to get the person to move away from the wall, but this isn't always possible, especially when you're shooting candid shots.

Using an off-camera flash cable or a flash bracket, you can raise the flash up higher, so the person's shadow will be cast lower. This will often result in your subject's body hiding the shadow, as in Figure 10.18.

An off-camera flash cable simply provides an extension cord that allows you to hold the flash away from the camera, usually higher, although you can also position it from side to side to create different lighting effects. Off-camera flash is essential for creating flash shots that don't look like they were taken with a flash (see Figure 10.19).

Figure 10.17

People in flash pictures often have annoying shadows behind them.

Figure 10.18

By raising the flash off the camera and using a bracket or off-camera cable, we can try to hide the shadow with the subject's body.

Figure 10.19

Here, the window is serving as a main light, and we're using a flash to fill in the darker side of the woman's face. Key to getting this effect is to use a flash cable to get the flash off the camera.

If we had left the flash on the camera, it would have fired directly at her face. By getting it away, it becomes an overhead light, which creates a fill light that's very natural.

Another option for getting your flash off-camera is to use a flash bracket, which allows you to continue shooting with both hands for greater stability and shooting flexibility (see Figure 10.20).

Figure 10.20

Off-camera flash brackets enable you to get your flash away from your camera and into a position that will allow you to reduce annoying shadows behind your subject. If you don't have a bracket, you can use an off-camera cable and simply hold the flash in a better position. (Note that, to use a flash bracket, you must have an off-camera flash cable.)

Slow Sync Flash

Earlier, we looked at special Slow Sync Flash modes that can be used with your camera's built-in flash. On many cameras, the same slow sync shooting mode you use with the built-in flash will work with your external flash. If it doesn't, or if your camera doesn't have such a mode, you'll need to use a Priority mode.

Set your camera on either Aperture or Shutter Priority mode. The camera will meter for the ambient light in the scene, and will choose an exposure that will properly expose your scene. But it will then fire the flash to illuminate the foreground in your scene. The result will be an image with a flash-illuminated foreground and a properly exposed background. (This is just like the Slow Sync Flash modes that we discussed earlier.)

Why Can't I Use a Fast Shutter Speed?

All cameras have a maximum shutter speed they can use with a flash. These typically vary from 1/90th of a second up to 1/250th of a second on higher-end cameras. This is sometimes referred to as *flash sync* or *x-sync speed*.

For many low-light situations, using manual exposure with your external flash is the best way to go. Put your camera in Manual mode, set your shutter speed to 1/30th of a second, and set your aperture to f5.6. Your flash will be used to illuminate your foreground elements and the longer shutter speed will help to expose your backgrounds better. If you're shooting scenes with a lot of motion, 1/30th of a second might result in your subjects being blurred. Consider switching to a higher ISO—say, 200—so you can change your shutter speed by one stop, to 1/60th of a second.

The flash-illuminated foreground in a slow sync image has a very different color temperature than the long-exposure background. If this bugs you, you can try placing a gel, or colored filter, over your flash to balance its output so that it's the same color temperature as the background.

Further Lighting Study

Lighting is a very complex discipline—one that you can spend a lifetime studying. This chapter is by no means a comprehensive look at lighting techniques and options. Practice with the techniques that you've learned about here, and if you find you want to know more, you'll be ready to take a class or find a book on lighting. As you progress, you'll learn about multiple-flash units, studio lights, lighting modifiers like diffusers and reflectors, and many other important lighting techniques.

For now, we're going to move on to a discussion of raw format photography. Whether or not you have a camera that supports raw, you'll want to take a look at the next chapter in order to understand why this important shooting option might matter to you.

11

RAW SHOOTING

Gaining More Editing Power Through Raw Format

Many cameras these days (mostly SLRs, but also a few point-and-shoots) offer a raw format, in addition to their various JPEG settings. You might have heard of raw as something that high-end photographers use, and therefore might have assumed that it's a very complicated thing that requires vast technical knowledge and complex shooting theory. Fortunately, this isn't the case.

Shooting raw changes very little about the way you shoot your image, but offers great advantage over JPEG images once you start editing and adjusting your images. While raw files used to present a big workflow headache, with modern image editing tools, working with raw files is not necessarily any more complicated than working with JPEG files. In this chapter, we're going to look at what raw is, and what its advantages and disadvantages are. By the time we're done, don't be surprised if you eschew JPEG shooting entirely.

What Raw Is

In Chapter 5, "Image Sensors," you learned how the image sensor in your camera detects light and turns it into a finished JPEG file. In that discussion, you saw how the camera takes the image sensor's captured data and performs a number of processes to it, from white balance adjustment to gamma correction, and how it also performs some of the same types of corrections and adjustments that you might apply in an image editor.

As you'll recall, one of the last things the camera does before saving a JPEG image is to throw out a lot of color data so that the 10 to 14 bits of data that your camera captures can be stored in the 8-bit space that the JPEG format specification dictates. (Different cameras capture different bit depths, but JPEG files are always limited to 8 bits.) You won't necessarily notice a lack of color in a JPEG file, but once you start editing, and begin to brighten or darken areas, you might notice that gradient areas of your image—skies, shadows, or reflections on a curved surface, for example—start to look chunky as you push your edits farther. This is a result of the camera having to jettison some of its color data to save the file as a JPEG. In other words, because of that missing data, you won't be able to push your edits as far as you would have been able to if all of the color had been preserved.

You've also learned that JPEG is a lossy compression scheme that can, when used aggressively, degrade your image. The high-quality JPEG compression on most cameras is very good, and you'll probably be hard-pressed to find evidence of compression artifacts in JPEGs shot with your camera's best setting. But, if you later perform a few edits in your image editor and save the file *again* as a JPEG—something you'll want to do if you're going to post the file to the Web—then you might start seeing some blocky patterns.

When you shoot raw, your camera does not perform any image processing steps. Instead, the raw data that is captured by the image sensor is read and saved. There's no bit depth conversion or JPEG compression, no demosaicing or color conversion is performed, no sharpening, no adjustment of contrast, saturation, or tone, no conversion down to 8 bits, and no JPEG compression. The data is saved, and all of the processing that the camera would normally perform is skipped entirely. Instead, you will use special software later on your computer to perform the calculations that are necessary to turn the raw data into a usable image.

Why Use Raw

You've already learned two important reasons to shoot raw—the fact that the full bit depth of your image is preserved, and that there's no JPEG compression—but there are other reasons, which are even more compelling.

Editable White Balance

White balance is a function that is applied to your image data by the camera, after the data has been read off the sensor. This white balance adjustment alters the colors in your image so that they are properly calibrated for the type of light under which you were shooting.

As I explained in the previous section, when you shoot raw, *none* of those adjustment functions are applied by the camera. Instead, they are performed later, on your computer, using special software. This means that you can set the white balance to anything you want *after you've shot the image!* For example, if you have images shot in an especially tricky white balance situation—perhaps a room with many different types of lights—then you can adjust the white balance to anything you want when you're back in your image editor. You can think of it as performing the equivalent of a manual white balance while editing your image on your computer (see Figure 11.1). What's more, it's a "free" edit, in that it won't ever lead to the type of posterization artifacts that normal image editing can produce.

Figure 11.1

With a raw file, you can adjust the white balance of your image after you've shot it. In the left image, the camera chose a white balance that was a little warm. In the right image, I made a simple adjustment to make the colors more accurate.

Highlight Recovery

As you've learned in your study of exposure, when you overexpose highlights, they turn to complete white and lose all detail. If you're shooting JPEG, there's no way to restore that lost detail because it's simply gone. With a raw file, though, there's a good chance that you'll be able to *recover* the lost detail in your overexposed highlights and restore detail to areas that have gone to complete white (see Figure 11.2).

Figure 11.2

With raw files, you can often restore detail to highlight areas that have been overexposed to complete white. Note restored detail in the sand and the woman's shoulders.

While recovering image data from nothing might seem magical, the explanation is actually pretty simple. You've already learned that a pixel is composed of separate red, green, and blue elements. Sometimes when you overexpose an area in a scene, you don't overexpose all three color channels. Sometimes only one or two channels get overexposed, while another channel is properly exposed.

Your raw conversion software can often reconstruct the wrecked channels by analyzing the channel that's still intact, and thus restore image data. This means that you can't recover *all* clipped highlights. Any highlight that is completely overexposed—for example, a highlight that has clipped all three channels—will be unrecoverable.

The ability to recover highlights doesn't mean that you can become careless about exposures, but it does give you a safety net for times when you, or your camera, choose an exposure that results in overexposed, blown-out highlights (see Figure 11.3).

Figure 11.3

The highlights in this image are so overexposed that, while some areas are recoverable, others are not, and remain completely blown out to white.

More Editing Latitude

Shooting with raw is kind of like having a box of 64 crayons, rather than a wimpy box of 16 crayons. You'll be hard pressed to tell the difference between a 16-bit processed raw file and an 8-bit JPEG file when you take them straight out of the camera, but once you start editing, you'll find that raw files offer a lot more flexibility.

Smooth gradients and transitions are a critical component of quality color. For example, it's easy to think of the sky as simply "blue," but the sky is actually a huge range of colors from dark blue up high to light blue near the horizon. Later in the day, you might see it go from blue to purple to red, all in a perfectly smooth gradient.

Shadows often have a tremendous amount of gradient variation, as do reflective surfaces, shiny surfaces, and even skin tones. Because the visual world is made up of all these gradients and subtle variations of colors, it's essential that that your camera be able to capture a huge range of intermediate tones. For a gradient to appear realistic and smooth, you want it to be composed of as many colors as possible. While an 8-bit JPEG file can render smooth gradients, when you begin to edit that file—brightening and darkening, or changing colors—the smooth color transitions in your image may start to suffer.

As you learned in Chapter 8, "Advanced Exposure," if you have only a few colors to work with, it can be hard to build a gradient that looks smooth and natural. While an 8-bit image includes enough tones to make nice gradients, once you start to edit them, things can fall apart quickly. For example, consider this nice smooth gradient that goes from dark gray to light gray in Figure 11.4.

Figure 11.4

This gradient shows a smooth ramp from dark gray to light white.

Let's say that we want to improve the contrast in this gradient, which is the type of edit that you'll commonly make to an image. To achieve this, we want to darken the dark tones and lighten the light tones so that the gradient stretches from full black to bright white. The problem with such an edit is that your image editing software cannot make up new, intermediate tones because it's simply not smart enough. Instead, it has to take the existing tones and brighten them or darken them. The result looks like the gradient shown in Figure 11.5.

Figure 11.5

After editing the gradient to improve the contrast, visible bands appear. The gradient has been posterized.

Those ugly banding patterns are the same posterization troubles that you saw in Chapter 8. Every edit that you make to an image "uses up" some of the editing latitude that's inherent in the file, because each edit—whether it's a change in brightness or a change in color—shifts some tones around and introduces the risk of posterization.

Because a raw file has so much more color data in it than what you have in a JPEG file (since it hasn't been reduced to 8-bit color), you'll have much more editing latitude. You'll be able to perform more edits and push them much farther before you see any posterization artifacts. If you do a lot of adjustment and editing, this is a critical reason to use raw.

White Balance and Posterizing

Another great thing about raw files is that when you make a white balance adjustment, it doesn't use up any of your editing latitude, giving you a "free" way to make color adjustments. This is because rather than darkening or lightening tones in your image, like a normal edit does, when you change white balance in your raw converter, you're simply redefining what the converter thinks red, green, and blue are.

Digital "Negative"

Remember that when you shoot a JPEG image, the computer in your camera takes care of all of the processing that needs to happen to turn the raw sensor data that you've captured into a finished image. When you shoot raw, the camera does nothing to the raw sensor data but write it to the card. Later, you use software on your computer to perform all the processing that your camera would perform.

This computer-based raw processing has certain advantages. Because you're in control of the processing, you can tailor it exactly to your taste. So, if you want, you can choose to recover highlights, or render some areas brighter, or change the white balance.

There's a good chance that your computer will do a better job of raw conversion than your camera will, simply because your camera is designed to perform as quickly as possible. Because it needs to be sure that it's always ready to shoot, it can't sit around all day meticulously processing an image. Consequently, the processing employed inside the camera uses slightly less-sophisticated algorithms than what a desktop raw converter will use. This means that there's a chance that you'll get better color out of your desktop raw converter than you will out of a JPEG file that's been processed by the camera.

Because there are so many different ways to interpret raw data, your raw file is truly like a negative. Just as a film negative can be processed by using different techniques to achieve different results, the raw data in your camera can yield many different final results, depending on the software you use to process it. Raw conversion software is improving all the time as imaging engineers discover new algorithms and refine old ones. So years from now, you might be able to reprocess the same raw files in a newer raw converter and get better results.

But even if you never try a different raw converter, the fact that you can process the same raw file in different ways means that you can easily experiment with different looks and adjustments—all from the same original file. For example, you might process the image one way to produce a very warm result and another way to produce something much cooler (see Figure 11.6).

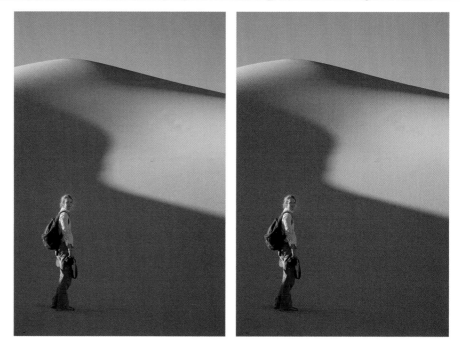

Figure 11.6

On the left is a fairly accurate representation of this scene, and on the right is one that has been warmed up. Both were processed from the same raw file.

Batch Processing

When working with raw files, it's very easy to apply the same edits to multiple files. For example, if you come back from a shoot and find that the white balance is off on all of your images, and that they're all about a half-stop underexposed, you can easily apply a white balance change and exposure adjustment to the entire batch. In most programs, trying to do the same thing with JPEG files is more complicated.

Nondestructive Editing

When you edit a raw file, the original file is never altered. In fact, it can't be because it doesn't contain any finished image data—your raw converter has to make that. Consequently, when you edit a raw file, you will always be working in a non-destructive editing environment. With a non-destructive editor, you can go back at any time and alter or remove any edit that you make. You'll learn more about non-destructive editing when we get to postproduction.

The Downsides of Raw

For all of the reasons listed above, I shoot exclusively in raw on all of the cameras that I have that support raw format. However, before you decide that you're going to change over to raw mode, you should know that raw files can present some extra complications that you won't find when shooting JPEG images. As software improves, these complications are getting fewer and fewer, and it's easy enough to work around them. Before you dive into the world of raw, you'll want to consider these caveats.

Raw Files Use More Storage

Because they're not compressed, and because they store more color data per pixel, raw files are larger than JPEG files. Sometimes a *lot* larger. JPEG compression is very effective at squeezing the size of an image. On a camera with 10–12 megapixels on the sensor, you'll typically find that shooting in raw adds about 10 megabytes to the size of *every image* you shoot.

For example, on a Canon Rebel XSi, you can fit about 174 JPEG files on a 1GB card, but only about 56 raw files. (These are approximate numbers because file size varies depending on the content of the file.)

Obviously, larger files mean you'll need more storage cards for your camera, more disk space for your postproduction work, and more long-term storage for archiving—whether that's hard disks or recordable CDs and DVDs.

These days, storage of all kinds is cheap, so ramping up to a raw-worthy storage capacity is not too expensive.

Other People May Not Be Able to Read Your Files

While there is a codified standard for JPEG and TIFF files, every camera maker uses a different raw format, and sometimes they even change formats from camera to camera. Because JPEGs are a standard, it's easy to hand other people images straight out of your camera and know that they'll be able to read them. With raw files, they'll have to have a raw converter that supports your camera.

Your Software of Choice May Not Support Your Camera

Since there's no raw format standard, anyone who makes raw conversion software must build custom raw profiles for every camera that they want to support. When a new camera comes out, this often means you have to wait until your software of choice supports it. In some cases, your favorite camera may never be supported. For example, Nikon Capture NX, an excellent raw converter, only supports Nikon cameras.

Workflow Can Be a Bit More Complicated

Because JPEG files can be used with any program that can read JPEG files, workflow is pretty simple: take the images out of the camera and view them. Your operating system probably shipped with a JPEG viewer; you can open them in any Web browser; you can open them in almost any image editing program, and your email program and cell phone can probably read them, so it's not too hard to build a workflow that you like.

Of course, a raw file has to be passed through a raw processor before you can even look at it. Windows 7 and the Mac OS both have raw converters built in, which means you should at least be able to see a preview of the raw file (assuming your camera is supported), but if you want to edit, or create a file that you can give to someone else, then you'll have to run the images through a raw converter first.

In the early days of raw photography, this was a big hassle, but today it's not so bad. Raw processing software has improved tremendously over the years, and raw workflow is now very smooth in programs like Adobe Photoshop Elements, Adobe Photoshop, Adobe Photoshop Lightroom, Apple iPhoto and Aperture, Nikon Capture NX, and many others.

There might be one or two extra steps, but once you learn them, you'll probably find that raw workflow is no more difficult than shooting JPEG, and well worth the extra control.

Configuring Your Camera to Shoot Raw

Not all cameras provide raw capability. Today, most SLRs do, and a few high-end point-and-shoot cameras can shoot raw. Most point-and-shoots, though, are JPEG only. If you're not sure if your camera provides raw support, you can check the manual or just try the next step.

Figure 11.7

If your camera provides raw support, you'll find an entry for raw in the same menu where you select a JPEG format.

Configuring your camera to shoot raw is usually very easy, because you simply choose a raw option from the same menu where you select the JPEG option. There, if your camera provides raw support, you will see an entry for raw (Figure 11.7).

In addition to raw, you might find an entry, or several entries, for Raw + JPEG. In these modes, the camera will simultaneously record a raw file *and* a JPEG file. If the camera has multiple Raw + JPEG entries, these are probably there so that you can choose raw plus a specific level of JPEG quality.

Why would you choose both? The advantage of Raw + JPEG is that when you get home, you have a JPEG file that you can use right away without hassling with any raw processing.

If you're on a tight deadline, and your client only needs JPEG files, you can shoot Raw + JPEG and pull deliverable JPEGs right out of the camera. If any of the images have a bad white balance or clipped highlights, then you've got the raw file to use for correction. Later, you can write out a better JPEG from the raw file and send that off.

Shooting Raw + JPEG takes more space, and your camera will require more time to write out the files, so if you need to shoot sustained, speedy bursts, then Raw + JPEG is probably not a good idea, especially if you have a slower media card. But if you're not ready to commit completely to raw, then Raw + JPEG is a good intermediate step.

After you choose your raw format option of choice, you can start shooting.

12

SPECIAL SHOOTING

Camera Features and Techniques for Specific Situations

At the end of the Apollo 11 moon landing, Neil Armstrong and Buzz Aldrin blasted off from the moon in their tiny lunar module, aiming for a rendezvous with crewmate Michael Collins in the orbiting *Columbia* service module. As the tiny speck of a spaceship rose up from the moon, ground controllers recorded Collins saying, "I got the Earth coming up behind you—it's fantastic!" Back on Earth, after the rocks and spacesuits and Hasselblad cameras were all unloaded, and the film was developed, Armstrong and Aldrin were able to see what Collins had been so excited about: a photograph of the earth rising above the moon, with the lunar lander flying close by in the foreground. In other words, a single picture encompassing all of humanity except for one man: Mike Collins, the photographer.

Like all the astronauts, in addition to having the "right stuff," Collins had to have a comfortable knowledge of basic photographic principles. A quarter of a million miles from Earth, he still had to worry about f-stops, shutter speeds, and film stocks in addition to worrying about asphyxiation, burning up on reentry, and drowning in the ocean.

Hopefully, you won't ever have to face such photographic concerns. However, it is important to realize that certain types of photography require special equipment, techniques, and preparation. In the case of lunar photography, you would need a massive government-funded space program in addition to your digital camera and a decent computer. Web photography, on the other hand, requires a camera with appropriate resolution and a good understanding of how your images will be sized and compressed for delivery.

In this chapter, you'll learn about all types of special shooting considerations, ranging from shooting in black and white to shooting in extreme weather.

Black and White

Because digital cameras default to shooting in color, it's easy for the digital photographer to become something of a color chauvinist. While learning to use and manipulate color effectively is an essential skill, it's important to remember that some of the most effective photos in history were shot in black and white.

Many of those photos, of course, were shot at a time when color film didn't exist, and photographers had no choice. Given that we see the world in color, and that our digital cameras can capture exceptional color images, it may seem strange to consider shooting a color-free image. However, as you learned in Chapter 1, "Eyes, Brains, Lights, and Images," color is a very small part of our visual system. Most of your eye is black-and-white vision, with only a very small portion devoted to sensing color. As light levels dim, your color vision becomes less pronounced, and in the dark you can see very little color at all. So black-and-white images— images that record only luminance, or brightness—are not completely foreign to what your eye sees in the real world.

Black and white is also a form of abstraction, and as you make an image more abstract, you ask your viewers to do more work when they partake of your image. Very often, this results in the viewers becoming more engaged and involved with the image, since more of it will be created inside their heads.

The goal of any image edit or adjustment—whether it's a color or tonal adjustment, a crop, or the decision to convert to black and white—is to make your image easier to read. In a well-made photo, the viewer's eye is led through the image to provide a clear understanding of subject, background, and the relationships of the shapes and tones in the image. Black and white is another tool at your disposal to help guide the viewer's eye.

In many photos, color can be a distraction—it becomes another element that the viewer has to process and understand—and that distraction can make an image harder to read. For example, consider Figure 12.1

Figure 12.1

In color, this image is a little busy and hard to read. But if we remove the color, the subject becomes much clearer.

While the leopard is a pretty color, it doesn't really stand out against the background. Some of that is because of all of the lines created by the branches. But it's also because of the color. If we change the image to black and white, the leopard becomes more prominent, making for a better separation between the subject and the background.

Sometimes, an image will look *more* real in black and white. Stripped of their color, some images can achieve an immediacy that you can't get in color.

You Say Red, I Say Gray

Technically, when we speak of "black-and-white" images, what we really mean is "grayscale" because, as you learned in Chapter 5, "Image Sensor," an image that lacks color, still has far more than only black and white in it—it will have a full range of gray tones.

One thing that makes black-and-white photography compelling is that there's no quantifiable, absolute "correct" correspondence between a particular color and a specific shade of gray. A light blue sky, for example, can be represented reasonably by *any* shade of gray from dark to light.

In Figure 12.2, you can see two different black-and-white images created from the same original. In the first image, the sky is rendered with very light dark tones and the plant has been rendered white. In the second image, the sky is lighter and the plant is grayer. Notice also that the green plants in the background have a very different tone. One image is not more "correct" than the other, but you might have a preference for one or the other, or a completely different approach. Fortunately, there are ways to take control during the grayscale conversion process, to get the results that you like best.

Figure 12.2

There's no "correct" gray tone that corresponds to a particular color value. As such, grayscale conversion can be very subjective. These two images were converted from the same color image, using different conversion settings in my image editor. Which one is "correct" depends entirely on your personal preference.

In the previous image, what struck me at the scene was the plant standing out against the sky. In color, this contrast was not apparent. At the time, I recognized this as a potentially good black-and-white image, because I knew I could render the plant as white against a dark sky.

Seeing in Color, Shooting in Black and White

Learning to recognize good black-and-white subject matter as you walk through a color world takes practice. The fact is, you might walk by scenes that don't catch your attention as a good picture, because they're not especially compelling in color, but that would make excellent subject matter when visualized in black and white. As you've seen, color can be distracting in an image, so it can often keep you from seeing a potential black-and-white shot. Sometimes, you have to actively look for black-and-white images, or keep the idea of black and white in mind while you move about.

To find good black-and-white scenes, you want to keep your eyes peeled for contrast. Black-and-white images are all about luminance, or brightness. Anytime you see a particularly interesting play of light, or dramatically contrasty scene, you might be in the realm of a good black-and-white photo. Of course, with digital, if it turns out later that the image works better in color, then you still have the full-color image.

One day I was walking in downtown San Francisco and saw this building. It's not especially interesting as a color image, but what struck me was the brightness of it and how it looked like the prow of a ship. I was also intrigued by the contrast between the top and the bottom. With a little editing, it was easy to get a good conversion that turned this scene that I normally would have ignored, because it was boring, into a compelling black-and-white image (see Figure 12.3).

Figure 12.3

It would have been easy to walk by this building and not recognize that there was a potential black-and-white image there. Keeping an eye out for light-and-dark interplay helped me see the shot.

Since black-and-white images are often driven by form and tone, they become very good composition exercises. As you shoot more black and white, you may find your composition skills developing in new ways.

Black-and-White Exposure

When shooting black and white, your main concern will be to capture as much contrast as possible. Since black-and-white images are all about tone, you want to be sure you have as many shades of gray to work with as you can get. That means you'll want to see a histogram that's spread out as much as possible (see the contrast histograms in Chapter 15, "Correcting Tone").

If you come from a film background, then you might be familiar with the Zone System, a complex procedure for calculating exposure so that when you process your film a particular way, you can ensure that different elements in the image are targeted to specific tones. With digital black and white, the Zone System is not so critical, because you'll control the toning of specific elements using your image editor when you perform your black-and-white conversion.

This is why capturing as much contrast as possible is so important: You want plenty of image data to work with, so that when you start skewing tones around, you don't see the posterization and banding artifacts that we saw in Chapter 8.

Of course, in addition to keeping an eye on contrast range, you'll also want to ensure that you don't blow out your highlights. Even if you envision the image as having overexposed highlights, it's still best to expose your shot to keep all of the tones well exposed, because you can create your blown-out effect later in your image editor.

Don't Use Your Camera's Grayscale Mode

Some cameras have a special mode or setting for shooting grayscale images. With this feature, your camera still shoots a color image, but it then does a grayscale conversion for you, in-camera.

The problem with this feature is that a stock grayscale conversion is not always the ideal choice. Because grayscale conversion is subjective, you might have a very specific idea about how you want the colors in your scene converted, and a stock conversion may not yield the results you want. It's better to stay away from these modes and perform your grayscale conversion by hand.

Use Raw + JPEG for Black-and-White Shooting

If your camera has the capability to shoot raw and JPEG files simultaneously, consider using this mode and configuring the JPEG image to be black and white. When you shoot, your camera will show the black-and-white JPEG on its screen, so you can see the image in black and white immediately, but you'll still have the raw file for performing your own custom black-and-white conversion later. If you're not comfortable visualizing in black and white, this feature can provide you with immediate feedback. Not all cameras have both of these features—check your camera manual for details.

Infrared Photography

Infrared light is not visible to the human eye. However, special infrared-sensitive films can be used to capture infrared light, allowing you to record scenes in a very different...er, light. Skies and foliage are particularly well suited to infrared photography—leafy greens will appear white and skies will be rendered with much more contrast.

Your digital camera might also be capable of infrared photography. By fitting an infrared filter to the end of your lens—just as film photographers do—you can capture images in infrared light, as shown in Figure 12.4. However, there are some caveats to digital infrared shooting.

Figure 12.4

With an infrared filter, you can capture just the near-infrared spectrum of light. In infrared, vegetation appears very bright whereas skies turn very dark.

Most image sensors are so sensitive to infrared light that camera makers have to put a strong infrared "cut" filter between the lens and the sensor. Without this filter, the sensor will yield images with very strong color casts. Despite these filters, some infrared does get passed through to the camera's sensor, allowing you to use your digital camera for infrared photography. Unfortunately, there's no hard-and-fast rule for how strong a camera's IR filter is—the only way to find out is to experiment. Before investing in an infrared filter, you can get a rough idea of a camera's infrared sensitivity with the help of the remote control from a TV, VCR, or stereo. Just point the remote at the camera's lens, press and hold a button on the remote, and then take a picture of the remote. If the camera can see the light of the remote (see Figure 12.5), you'll know that the sensor is picking up some IR. The brighter the light, the better your camera will be for infrared shooting.

As with a film camera, you'll still need an infrared filter on the end of your lens. A number of filters are available for infrared photography, but the most popular are the Kodak Wratten 89B, 87, and 87C filters. Hoya makes two filters, the R72 and RM72, which are equivalent to the Kodak 89B. B+W also make Wratten equivalents, the 092 and 093.

The right filter is partly a matter of taste, because different filters yield different levels of contrast. Depending on your camera's infrared sensitivity, you'll need either a brighter or a darker filter. Note that infrared filters are expensive, and the larger the diameter, the more you'll have to pay. Before buying a particular filter, you might want to poke around some of the more popular digital photography online forums for advice from other users who have shot infrared with your type of camera. If you can't find any usable advice, you'll simply have to experiment with different filters. Because they are so dark, you can expect infrared filters to cut four to ten stops from the available light! That means you'll be using very long exposures even in bright daylight. Obviously, a tripod is essential for infrared photography. To pick up some extra stops (and reduce lengthy exposure times), you can set your camera to a higher ISO, but this will make your images noisier. Typically, Wratten 87 exposures in bright daylight at ISO 200 start at around five seconds. Because the filter can confuse your camera's light meter, you might have to do a little experimenting to find the right exposure.

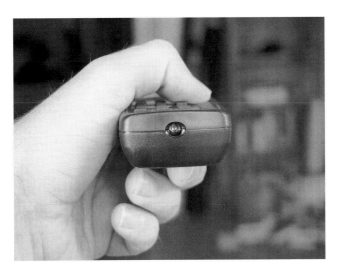

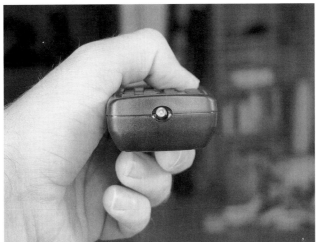

Figure 12.5

You can get a pretty good idea of the infrared capabilities of your camera by taking a picture of a remote control's infrared emitter. Note that, in the second image, the remote's emitter is "lit up" with infrared light.

Focusing

Because the infrared filter is so thick, your camera's autofocus will be useless—there simply won't be enough light for you to focus. Also, your exposure times are going to be very long, so you'll definitely need a tripod or something sturdy to set your camera on. Unfortunately, the filter is also thick enough that you won't be able to see through the viewfinder either, so manual focus isn't really an option. To shoot with an infrared filter, you'll need to do the following.

1. Before putting on the infrared filter, put your camera on a tripod and frame your shot.

2. Autofocus, just as you normally would. When the camera has locked focus, switch the lens to manual focus. This will ensure that you don't accidentally re-autofocus.

3. Put the IR filter on your lens. Be *very* careful not to bump the focus ring, or you might throw the lens out of focus.

As long as you don't accidentally re-focus, you should be ready to consider exposure.

Choosing an IR Exposure

Because of the huge reduction in light caused by the IR filter, you'll be shooting with a very long shutter speed. Fortunately, your camera should still be able to calculate a good exposure. After focusing, and installing the IR filter, as described above, do the following:

1. Put the camera into Aperture Priority mode and set the aperture to f8 to f11. This will give you a deep depth of field that will help compensate for any focus problems you may have.

2. Meter as normal.

3. Take a shot.

It's a good idea to bracket your shots, simply because IR exposure can be tricky. After taking your first shot, you might want to try a few more with even slower shutter speeds. You can slow the shutter speed down by dialing in some overexposure with your exposure compensation control (a +1 exposure compensation will double your shutter speed, +2 will quadruple, etc.). Or you can switch to Manual mode, enter the shutter speed and aperture that you were using in Aperture Priority mode, and then change shutter speed manually.

Because you'll be shooting with a slow shutter speed, you'll ideally want to use your camera's mirror lock-up feature and a remote control or self-timer. This will help reduce camera vibration. Also, bear in mind that because of the long exposure times, shooting moving objects or landscapes on a windy day can be problematic, as your results can be smeared or soft.

You don't have to have a Black-and-White mode on your camera to shoot infrared images. When you shoot color through an infrared filter, most images will appear in brick red and cyan tones, rather like a duotone (see Figure 12.6). You can easily convert these to grayscale later.

Because of the bright light required, you'll typically shoot infrared only outdoors. Any incandescent objects—glowing coals, molten metal—will emit a lot of infrared radiation. The thermal radiation produced by the human body, however, is way beyond the sensitivity of the near-infrared capabilities provided by your camera.

Modifying Your Camera for Infrared Shooting

If you're serious about infrared shooting then you might want to consider looking into a modified digital SLR for infrared work. There are several companies that will open up your SLR and remove the IR cut filter that compromises infrared shooting. This will result in a camera that can shoot infrared using much shorter shutter speeds, making far more subject matter suitable to infrared shooting. The downside is that the camera's ability to reproduce normal color will be compromised. Check out maxmax.com for more details.

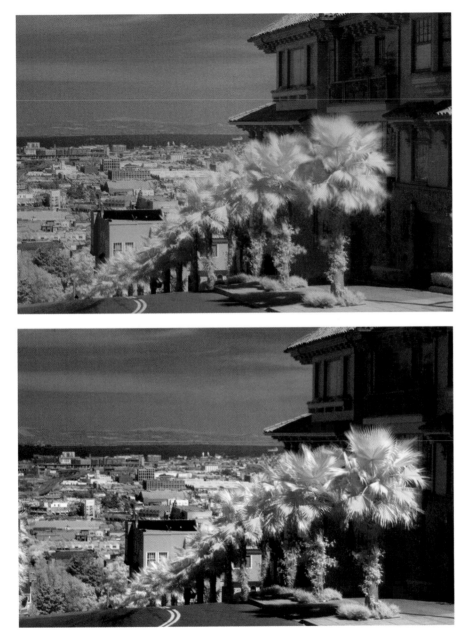

Figure 12.6

When you first pull an infrared image out of your camera, it will have a strong red cast. You can correct that with a white balance adjustment, to achieve a color image, and then convert that image to grayscale.

Stable Shooting

No matter what your shooting conditions are, from simple street or event shooting to more complex shooting in harsh environments, keeping your camera stable is an essential part of shooting sharp images and having maximum creative control.

Many people believe that if you're shooting with a fast shutter speed, you don't have to worry about camera stability, but camera shake can impact your images at even very fast shutter speeds. What's more, camera stability becomes more important if you're shooting with a camera that has a very high pixel count. A camera with 10 or 12 megapixels is capable of revealing the softness that can be caused by very fine camera shake and vibration.

First and foremost, you'll want to remember the camera holding tips that were covered earlier. For maximum stability, you should shoot with a tripod. We will cover tripod buying in Chapter 23, "Choosing a Digital Camera," which is available for download from the companion Web site, and that is where you can find a discussion about weight versus stability. Once you have a tripod, there are a few things to keep in mind when using it.

- **Use a remote control or self-timer.** As long as your camera is on a tripod, you might as well get your potentially shaky hands completely off the camera by using a remote control or the camera's built-in self-timer.

- **Don't use the center column if you don't have to.** If you can get your camera to the height you want using the legs, do that rather than using the center column. With the center column extended, your camera is not as stable as when it's resting directly on top of the main platform.

- **When in muddy, dirty terrain, extend the tripod legs from the lowest segment first.** This will ensure that the majority of the leg latches are lifted off the ground, away from the mud and dirt that could gum up the latch workings.

- **Make sure the tripod is level.** Some tripods have a built-in level, (as do some cameras). If yours doesn't, you need to pay particular attention to horizontal lines in your image to ensure they are level. Yes, you can straighten an image in postproduction, but straightening requires a crop. If you're shooting with a ball head, remember that just because the tripod is level, the head may be askew.

- **Pay attention to wind.** Wind can cause vibration in even the heaviest tripod. If you're shooting in a very windy environment, you will most likely not want to use the center column.

Figure 12.7

For extra stability in this shot, I attached the weight hook to the bottom of the tripod and hung my camera bag from the hook. Note, too, that I have not elevated the center column.

- **Use the weight hook.** Hang your camera bag or a sandbag from the weight hook at the bottom of the center column (if there is one) for additional stability (see Figure 12.7).

- **Make sure the camera is not front-heavy.** If you have an especially big lens on the camera, and the tripod is on uneven terrain, be sure the tripod is stable before taking your hands off the camera. You don't want a heavy lens to tip the entire apparatus forward, so make sure one leg is extending under the lens. Also, be sure the tripod is not in danger of tipping or being blown over if you leave it unattended.

- **When appropriate, use mirror lockup.** If you're shooting a long-exposure using a digital SLR, activate the camera's mirror lockup feature, if it has one. This feature prevents small extra vibrations caused by the mirror flipping up and down.

- **Finally, the best advice for shooting with a tripod is to remember to take the tripod.** If your tripod is so big, heavy, or unwieldy that you don't ever take it shooting, maybe you should consider getting a smaller, lighter tripod. Even though a smaller tripod offers less height and stability than a larger tripod, if it means you'll carry it more often, it's a more useful piece of gear.

Monopods

A monopod does not provide as much stability as a tripod, but they're usually lighter and easier to carry, so there's often a better chance you'll take a monopod with you. Monopods are also ideal in situations where you need stability but don't have the time or space to set up and move a tripod from place to place. Sporting events and live shows are ideal situations for monopod use. Monopods are also extremely handy if you're shooting with a heavy lens. In addition to providing more stability, the monopod will give your arms and hands a break when you're shooting.

Landscape Photography

While landscape photography is not significantly different from any other type of shooting—you still have to find your subject, calculate an exposure, and work the scene to find the shot that's right—there are a few things to keep in mind when shooting landscapes.

While it might be tempting to just use the widest angle you can, to capture as broad a vista as possible, bear in mind that as you go wider, the objects in your scene will become smaller and less distinct. You're not going to be able to take a single image that encompasses your entire field of view, so try to find a slice of that vista that is compelling. You'll need to employ all the same compositional ideas we discussed in Chapter 9, "Finding and Composing a Photo," as you strive to create a landscape image that works. Your landscape shots still need to have a subject, and you'll look for balance, repetition, good light, and all of the other usual compositional elements when working on landscapes.

One of the most difficult things about landscapes is trying to choose one frame's worth of imagery out of the entire 360° that you can see. If you're looking at a forest, a huge canyon, a massive valley, or endless prairie, there might not be obvious "boundaries" that mark the beginning and end of your picture. Again, finding a subject will provide a point of focus around which you can compose additional elements (see Figure 12.8).

While you might find occasions to shoot with shallow depth of field, in most landscape shots you'll want to ensure that everything in the shot is in focus. The great landscape works of Ansel Adams and others are notable partly because of the photographer's attention to focus. With great detail throughout the image, you really feel like you can walk right into the picture.

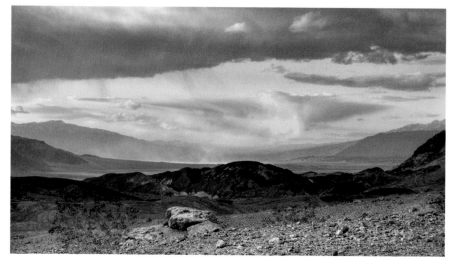

Keep an Eye out for Flare

When shooting landscape images, especially with a wide lens, you'll want to be very careful to avoid flare. Any time your camera is pointed toward the sun you'll run the risk of lens flares. Sometimes flares are very obvious because they'll appear as bright circles. At other times, you may not notice a flare problem, because it might manifest as a broad reduction in contrast across a big part of your image.

If you're shooting with an SLR, then your lens might have come with a lens shade. These can often reduce or eliminate flare. If you're using a point-and-shoot or an SLR that doesn't have a lens shade, then try holding your hand up to shield the lens (see Figure 12.9). This will often eliminate flare.

The closer you get to shooting directly into the sun, the more difficult it will be to shield flare without getting your hand in the frame, but you'll usually only encounter this trouble when shooting close to sunset.

Exposing for Extreme Depth of Field

Obviously, to get deep depth of field you'll want to use a smaller aperture (high f-stop number). This will require a longer shutter speed, so you might need to use a tripod.

However, even with the deep depth of field provided by a small aperture, it's still possible for your image to have focus problems. Remember, depth of field is centered on the point you focus on, and when shooting landscapes, there's usually less depth of field in front of that point, and much more behind. When you shoot a landscape and focus on distant mountains (which usually means that you're focusing on infinity), there's a chance that your foreground will be out of focus because there's not enough depth of field in front of your focus point to render near details in sharp focus. Plus, all that potential depth of field behind your focus point will be wasted.

Every lens has a hyperfocal distance. When you focus your lens on infinity, the nearest point that is also "acceptably sharp" is the hyperfocal distance, and this distance changes with your aperture setting (see Figure 12.10).

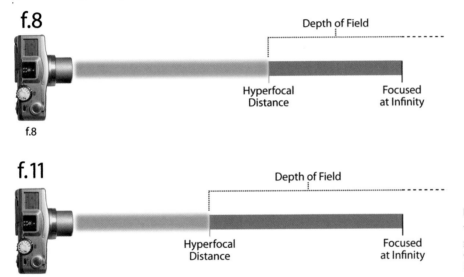

Figure 12.10

When focused on infinity at a given aperture, the hyperfocal distance is the nearest point that is acceptably sharp.

"Acceptably sharp" is a purely subjective measure, and varies depending on how big an image you want to output. When focused on infinity, your depth of field extends from the hyperfocal distance to infinity and possibly beyond. This "beyond" distance can be considered wasted depth of field because, obviously, there's nothing beyond infinity, and there might be a considerable amount of foreground that's not within your depth of field.

If you set the camera's focus to the hyperfocal distance, your depth of field will extend from half of the hyperfocal distance to infinity—a much deeper depth of field (see Figure 12.11).

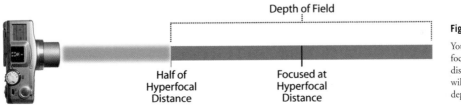

Figure 12.11

You'll get deeper depth of field by focusing at the hyperfocal distance from the camera. This will keep you from "wasting" depth of field behind infinity.

In the old days, lenses included markings that let you identify the depth of field range for any aperture/focus combination. Today, zoom lenses for SLRs and the lenses on point-and-shoot cameras lack these markings, as do many SLR prime lenses, meaning it's much more difficult to make these kinds of depth-of-field calculations. However, making these calculations work well was always somewhat difficult, as they required a good capability for estimating distance.

However, whether you have lens markings or not (or understand any of the theory), there are some simple rules you can follow to ensure deeper depth of field in your landscape images.

- **Think about where you're focusing.** When you focus on the horizon, or another point in the very far distance, there's a good chance that you'll lose depth of field in the near foreground. If you are unable to calculate the exact hyperfocal distance for your lens, focus on a point halfway to two-thirds of the distance to the farthest point in the scene. You can do this by selecting a different focus point or by using the focus and reframe technique we discussed earlier. If you're working on a tripod, then choosing a different focus point might be the easiest method. Some SLRs that offer Live View let you move a cursor to any point on the screen and use that as your focus point.

- **Remember the 1/3rd 2/3rds rule.** In typical landscape situations, one-third of your range of depth of field falls in front of your point of focus and two-thirds falls behind.

- **Bracket your apertures.** As you already know, smaller apertures yield deeper depth of field. However, if you simply set your camera on the smallest aperture, you'll run the risk of incurring diffraction artifacts, which can result in a softening of your image. So, when closing down your aperture, you may find that you lose as much sharpness from diffraction artifacts as you were hoping to gain from depth-of-field control. To be safe, take several shots with different-sized apertures.

- **Bracket your focus.** As you can see, your choice of focus point is critical to getting the deepest possible depth of field. To be safe, take a few shots with the same aperture at varying focal distances. This will improve your chances that one of them will have very deep focus.

If you're shooting with a point-and-shoot camera, you will inherently have deeper depth of field than you will on a camera that uses a bigger sensor. Consequently, these issues might not be as critical.

Portable Depth of Field Calculators

If you have a smart phone or PDA that allows you to add additional applications, you can get apps that will perform depth-of-field calculations for you. These programs generally let you enter your current focus distance and aperture, and the software will yield depth of field and hyperfocal distance. To make use of these, though, you need to be able to calculate distance to your subject. If your lens has focus markings on it, you can get a rough idea by looking at the lens after the camera autofocuses. If you're really serious, you can carry some kind of laser range-finding device. In general, it's easier to just bracket your images.

If you're shooting in low light, shooting with deep depth of field becomes more complicated. The small apertures will require longer shutter speeds and higher ISO settings, both of which will lead to increased noise.

Using A-DEP on Canon SLRs

Some Canon digital SLRs include a special shooting mode called *A-DEP*, which can automatically calculate an exposure that will yield the deepest depth of field. You'll find A-DEP alongside the camera's other shooting modes. Frame and focus just as you normally would. The camera will measure the distance to the nearest and farthest points automatically, and select a focus distance and aperture that will yield the deepest depth of field. After prefocusing, you can use the Depth of Field Preview button to see how much depth of field you have.

A-DEP can work well, but you might want to experiment with it to get an idea of its effectiveness.

Depth of Field and Focal Length

While the "one-third/two-thirds" rule discussed earlier will get you through most landscape situations, the fact is that depth of field doesn't always distribute this way. As the distance to your subject increases, depth of field increases, but it increases more rapidly *behind* the focus point. When the focus point is roughly one-third of the hyperfocal distance, the one-third/two-third rule applies. When you're focused at the hyperfocal distance, the depth of field extends to half the hyperfocal distance in *front* of the focus point and to everything behind.

Tilt-and-Shift Lenses and Depth of Field

If you're using an SLR, you have another option for capturing deep focus, which is to use a tilt-and-shift lens. These lenses allow you to shift the front and back planes of the lens in different ways to correct for perspective distortion and to ensure that things both near the lens and far away are in focus. Shooting with tilt-and-shift lenses takes more time, as you can't autofocus, and metering can sometimes be a little complicated. In addition, these types of lenses are usually pretty pricey. If you're interested in experimenting with one, you might try a rental. Web sites such as *www.rentglass.com* offer inexpensive lens rental by mail.

Tilt-and-shift lenses are also commonly used in architecture and product photography, because they allow you to reduce or eliminate perspective distortion (see Figure 12.12).

Figure 12.12

In addition to controlling depth of field, you can use a tilt-and-shift lens to adjust perspective, allowing you to straighten horizontal or vertical lines.

Shooting Panoramas

No matter how wide your lens, there will be times when you want to shoot a vista that simply can't be captured with a single image. However, by shooting a series of images that overlap, and then using special panoramic stitching software, you can create panoramic images that encompass a much wider field of view than you can capture within a single shot (see Figure 12.13).

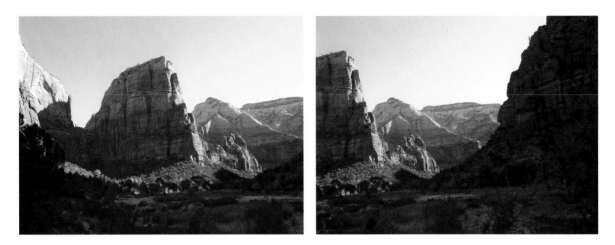

Figure 12.13 These two images were shot separately with the idea that they would be stitched into a panorama. Panoramic images can be stitched together from any number of overlapping images.

Panoramic software can take a series of overlapping images and stitch them together to create a single image (see Figure 12.14).

Besides blending the seams of an image, panoramic software corrects the perspective of each original image by essentially mapping the images onto the inside of a giant virtual cylinder. The curvature of the imaginary cylinder corrects the perspective troubles in your image.

In addition to printing wide panoramic prints of your images, you can deliver your panoramas as virtual reality (VR) movies that present a window onto your panoramic scene and allow users to "navigate" the scene by pivoting and tilting their view (see Figure 12.15).

You'll learn all about stitching later, but getting a good-looking panorama begins with your shoot.

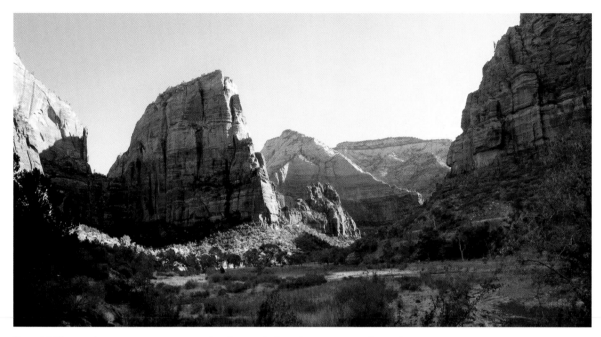

Figure 12.14 Here, the two images in Figure 12.13 have been stitched together to create a single, seamless image.

Figure 12.15

If you store your images as VR movies, users can use special viewing software to pan and tilt around your scene. With more advanced authoring tools, you can build fully navigable VR environments.

Preparing Your Camera

You can use any focal length to shoot a panorama; however, your focal length choice *will* affect your final image, just as you learned earlier. With a longer focal length, objects that are more distant will appear larger in your final image; however, you'll see less foreground. With a shorter focal length, you'll see more foreground, but distant objects might be very tiny (see Figure 12.16). As your focal length increases, the number of shots required to shoot your panorama will increase. If you need to work in a hurry because of changing weather or moving subject matter, you may be better off with a wider angle that will allow you to shoot fewer frames.

Note that shorter focal lengths (wider angle) are more prone to vignetting, which can lead to visible seams in the final panorama. Also, wider angles are more prone to flares, which can be difficult to manage when panning across a wide range of brightness values.

Panoramas can be shot in either Portrait or Landscape mode. Portrait mode will allow you to capture more vertical details (such as sky or foreground), but will also require more shots, because a portrait image is not as wide as a landscape image.

Figure 12.16 Your choice of focal length has a big impact on your final panorama. In the upper image, we used a shorter focal length, which allowed us to shoot a wider panorama with fewer shots, but left the mountains a little small. In the lower image, we used a longer focal length, which obscured much of the foreground, but rendered the landscape larger.

One disadvantage of having to shoot *more* frames is that more frames mean more opportunities for mistakes in your final image. Each time you shoot an additional frame, you create at least one additional seam, and seams are where artifacts and troubles can develop.

There are two ways to shoot panoramas: the correct way, which involves a lot of special equipment but produces very precise, accurate images for stitching; and the sloppy way, which can be more prone to error, but is far easier and usually produces perfectly usable results.

Proper Panoramic Panning

The most critical steps of shooting a panorama are panning the camera properly and overlapping your separate frames.

For best results, mount your camera on a tripod and set the tripod to be level. Note that if your camera's tripod mount is positioned off-axis (see Figure 12.17) from your lens, you're not going to be able to use your tripod for shooting full 360° panoramas, and you might even have trouble with landscape panoramas comprised of three or four frames. Because of the off-axis rotation, the ends of your panoramas won't necessarily fit together. For smaller panoramas, you should be fine no matter how your tripod mount is positioned.

Tripod Mount

Lens Axis

Approximate rotation point

Figure 12.17

If your camera's tripod mount is off-axis from the rotational center of the lens, you'll have a hard time shooting full 360° panoramas from a tripod.

If your camera provides an exposure lock feature, you can lock your exposure after the first frame to ensure that the second frame is exposed with the same values. Or you can meter off a more intermediate part of the image, lock that exposure, and then shoot each frame with that metering. If your camera includes a panoramic assist mode of some kind, it will lock the exposure automatically after each frame.

If you're shooting a scene that encompasses a bright light on one end (say, the sun or the lamp in a room) and ambient light or dark shadow on the other end, things are going to be a bit more complicated. The simplest way to handle this situation is to shoot the same way you would an evenly lit scene: choose an intermediate exposure, lock your camera's exposure settings, and then shoot your panorama. Your bright light source will be overexposed, but your midtones and shadows will probably be okay (unless you have some exceptionally dark areas). However, despite these potential issues, your finished panorama will be evenly exposed and free of banding.

If you're willing to do a little more work, set your camera to Aperture Priority and pick an aperture that will give you the depth of field that you want. Then take an initial, intermediate exposure reading and lock it into your camera. For frames that are significantly brighter or darker, use your camera's exposure compensation control to over- or underexpose on particularly bright or dark frames. To prevent banding, keep your compensations to within 1/2 to 1 1/2 stops. Because you're in Aperture Priority mode, your camera will only alter shutter speed, so your depth of field will not change.

If you're using a point-and-shoot camera that lacks Aperture Priority, then you can do this same trick in Program mode. Your camera's small sensor probably gives it very deep depth of field, anyway, so slight aperture shifts shouldn't be an issue.

Shoot with Care

When you shoot around people, animals, or other moving objects, pay attention to where you position the seams of your image. A person who is present in one image and gone in the next might turn partially transparent if he or she falls on a seam in the final panorama (see Figure 12.21).

If the objects in your panorama are moving in a particular direction, shoot in the opposite direction. That is, if a person is walking across your scene from right to left, shoot your images from left to right. This is assuming that you *don't* want to see multiple copies of the person across your panoramic field of view. If you *do*, then by all means, shoot from right to left, in the direction of the movement, and ensure that the person is in the middle of each shot when you shoot (see Figure 12.22).

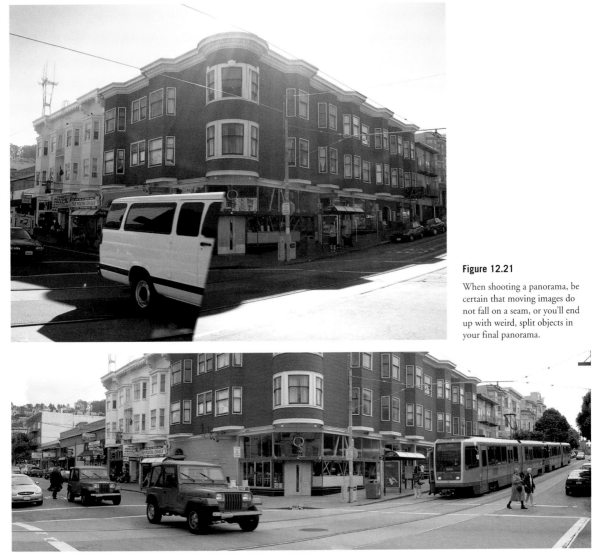

Figure 12.21

When shooting a panorama, be certain that moving images do not fall on a seam, or you'll end up with weird, split objects in your final panorama.

Figure 12.22 Because we were shooting our panorama images from left to right, we shot the Jeep twice. Consequently, when stitched, there are two identical Jeeps in the shot.

Finally, learn to think of the panoramic process as a complex—but free—super-wide-angle lens. Don't just use panoramas for capturing wide vistas; use them for any occasion when you'd like to have a wide-angle or fisheye lens (see Figure 12.23).

She shot "coverage" of the scene by shooting many overlapping images of the entire scene, not just of a single panoramic swath. These were layered on top of each other in Photoshop, and special selection masks were used to alter the transparency in different places within the image. You'll learn about this type of masking in Chapter 14, "Editing Workflow and First Steps."

Collaging is also a great way to salvage panoramas that don't stitch properly.

Macro Photography

Although the term *macro photography* would seem to describe a process of photographing very large objects, it's actually the opposite. With your digital camera's macro feature, you can take high-quality images of extremely small things.

Digital point-and-shoot cameras are particularly well suited to macro photography. They generally have excellent optics, which make for sharp, clear images, and their low light sensitivity means you can get them into small spaces to capture images up close. The macro features of some cameras allow for amazingly close shots—as close as one inch in some cases! (See Figure 12.26.)

Figure 12.26

Your digital camera's macro feature lets you take close-up photos that would require a very expensive lens if you were shooting with a film camera.

If you're shooting with a digital SLR, you'll need to buy a special macro lens that allows you to focus at macro distances. An alternative to a macro lens is to buy a point-and-shoot camera with a good macro feature. These are often less expensive than a macro lens, and usually easier to work with because they can be positioned in strange locations more easily.

Whatever you use for your macro shots, you'll face some special shooting issues.

Finding the Optimal Macro Focal Length

Most point-and-shoot macro features are optimized for a particular range of focal lengths. Although most cameras will let you shoot macro pictures with your lens zoomed to any point, you'll get much better results if you put your camera in the macro "sweet spot." For some cameras, this is full wide, while for others it's somewhere else in the zoom range. Some cameras won't focus at all in Macro mode unless they are set within a particular focal range. Cameras that usually require you to be in a specific zoom range will have some kind of indicator in the viewfinder that will show when you're in the optimal macro focus range.

Macro Focusing

Your camera's autofocus mechanism should work normally when you shoot in Macro mode. However, be aware that at very close distances, even slight, subtle changes in camera position can ruin your focus.

When shooting macro photographs, your camera must be extremely close to your subject, which means there's a good chance that you and your camera will be blocking out much of the light in your scene. If light levels drop, you'll have to use a slower shutter speed, so you'll want to increase ISO to get the shutter speed back up. Often, a tripod is your best option when shooting macro. If you do a lot of macro shooting, you might want to consider getting a little tabletop tripod or a Gorilla Pod–type device that can attach easily to different objects (see Figure 12.27).

If you don't have a tripod, consider activating your camera's continuous autofocus feature, if it has one. This will help keep the image in focus even if you accidentally jiggle the camera. Some cameras also have a

Figure 12.27

With a Gorilla Pod, you can easily attach your camera to poles, fences, or any number of other found objects. Smaller than a tripod, they provide a light way to get some camera stability.

special shake detection mode. When activated, you press the shutter button as normal, but the shutter won't trip until it detects that the camera isn't moving.

It's usually easier to hold the camera steady if you *don't* try to press the camera's zoom buttons. Instead of using the camera's zoom controls to frame your shot, simply move the camera in and out. At macro distances, you won't have to move it very far to get a reframing.

The best rule of thumb is simply to work quickly. Get the image framed, prefocus, and then shoot right away. Finally, just to be safe, shoot a few frames. If your first is out of focus, perhaps the second or third will be okay. If your camera has a Drive mode (also known as *Burst mode* or *Continuous mode*) that is capable of shooting at the resolution you want, consider turning it on. If you're facing a difficult macro shot, shooting a burst of images will improve your chances of getting a good shot.

Some Nikon cameras include a unique "Best Shot Selection" feature that is ideal for macro photography. This feature shoots a burst of images and tries to identify the one that is in sharpest focus. The others are automatically discarded.

Poor Depth of Field

Be warned that when you are in Macro mode, your camera will have a *very* shallow depth of field. Although this can create nice effects and excellent isolation of your subject, if your subject is large enough, you might have trouble keeping all of it in focus.

Consider the image in Figure 12.28.

Figure 12.28

This flower was shot with the camera's Macro mode. Although it's not a particularly large flower, it is deep enough that, at macro photography distances, the image has a depth-of-field problem. The flower's stamen is in focus, but the petals are blurry.

The depth of field in this image is so shallow that the flower's petals are out of focus. In fact, the depth of field is short enough that this image might have been better served by switching out of Macro mode, pulling the camera back, zooming in, and shooting the image normally. Another option would have been to autofocus on the petals and reframe the shot. However, the stamen in the center of the flower would then be out of focus.

If you're shooting a flat subject, depth of field won't be a problem. If you're shooting something that's even a few inches deep, though, you need to think about which parts will be in focus. Judging depth of field on your camera's LCD can be very difficult because the screen is simply too small to reveal which parts of your subject are in focus. Sometimes, you can use your camera's playback zoom feature to examine different parts of your image up close. Even with a 4x magnification, however, you still probably won't be able to see subtle changes in focus. If you're concerned about depth of field, your best option is to protect yourself by shooting multiple shots with a number of different focal lengths—including some nonmacro shots. You should also take some shots with your autofocus locked onto different parts of the subject.

If you're shooting a flat subject, try to keep the camera parallel to the plane of your subject. Any tilt will introduce extra depth into your image. Those areas of depth might be rendered blurry by your camera's shallow depth of field.

Improving Macro Depth of Field

Finally, you have one more option for shooting images with deep focus. Software programs such as Adobe Photoshop CS4 (and later) and Helicon Focus allow you to achieve deep focus by combining multiple images shot with different focal points. You set your aperture to one setting and then shoot multiple frames, each focused to a different distance. These images can then be combined into one completely focused image. Obviously, this technique is not suitable for moving subject matter, which means it may not work if you're trying to shoot a flower on a windy day. Also, you have to have a manual focus capability to use this technique.

High-Dynamic Range (HDR) Imaging

As already discussed, your eye can perceive a much greater dynamic range than your camera can. In other words, your eye can register far more tones from dark to light. If you find yourself in a scene with a very extreme dynamic range, you have a few options. First, you can elect to capture just one part of the scene—either light or dark—and let the other part of the scene plunge into shadow or blow out to complete white. Depending on the nature of the shot and your composition, this can end up looking like a very stylized abstraction, since your eye doesn't normally perceive bright or dark areas this way.

If you're going for more realism, you can shoot two images—one exposed to capture the lighter parts of the image, and the other exposed to capture the darker parts. You can then composite these two images using compositing software. This type of compositing can vary in difficulty depending on the content of your scene. Fine details such as leaves or complex transparent textures can be extremely difficult and time-consuming to composite. In some cases, getting a good composite might be impossible.

Over the last few years, a new postprocessing technology has developed that allows you to represent the full dynamic range of a scene by shooting multiple images, which are then combined using special software to create a high-dynamic range image (see Figure 12.29).

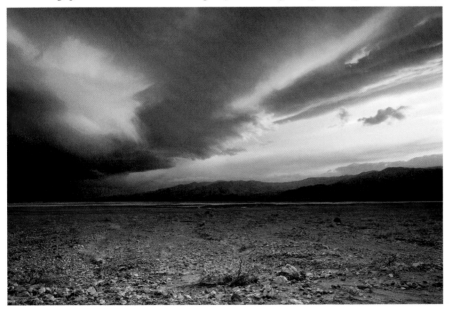

Figure 12.29

In a scene like this, you can choose to expose either for the bright part of the sky or for the dark ground. If you use HDR techniques, though, you can create an image that has good exposure throughout the entire tonal range.

In an HDR image, different tones are selected automatically from each of your source images to produce a final image with a full range of tones. HDR images can have dark shadows *and* bright highlights, each culled from a different source image. Notice in Figure 12.29 that the clouds and background have tremendous amounts of detail. This is because the HDR process yields so much tonal data, it's possible to bring out detail in every part of the image, rather than having some fall into shadow and other parts blow out to white.

Shooting and processing HDR images is not difficult, but there are a few caveats to accept before you begin:

- Because HDR images require multiple source images, each shot with a different exposure, shooting HDR imagery of moving subjects is very difficult. In fact, it's often impossible to get usable results if there's a moving object in your image such as blowing trees or moving people. With some work, you can often save these images in postproduction, but you shouldn't count on it.

- A little bit of HDR goes a long way. Sometimes, HDR images end up looking very stylized, and many people do not like the hyper-reality of HDR. We'll discuss HDR processing in detail later.

- HDR requires a camera with an Aperture Priority mode.

- Because you must shoot multiple images with identical framing, HDR usually requires a tripod. I say *usually* because some HDR processing programs can align images automatically. If your software is good enough and your hand is not too shaky, then you might be able to get away without using a tripod.

Shooting HDR

Your goal when shooting HDR is to shoot a series of identically framed images, each exposed one stop apart. Because you don't want any change in depth of field between the images, you'll need to shoot in Aperture Priority mode to ensure that your aperture doesn't change from one shot to the next, since a change in aperture could result in a variation in depth of field.

To shoot an HDR image:

1. Mount your camera on your tripod and frame your shot.

2. Set your camera to shoot in raw mode. HDR can work with JPEG files, but raw preserves more color information, which can make for better merging later.

3. Set your camera to aperture priority and dial in an exposure compensation of −1.

4. Shoot the first image and then change exposure compensation to 0. Shoot the next image and then shoot an image at +1 (see Figure 12.30).

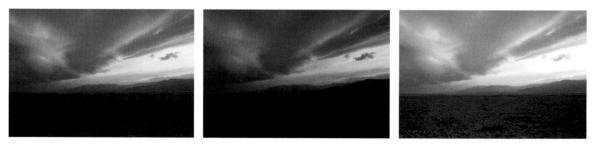

Figure 12.30 These source images were used to create the HDR image in Figure 12.29.

That's all you need to do. You'll need to employ all the camera stabilization techniques we've discussed to achieve maximum stability.

If you're shooting a scene with clouds, bear in mind that if it's windy, the clouds might move between shots, resulting in blurry skies. Also, wind might cause vegetation to wave and move. So you'll want to work as quickly as possible. To speed things up, you can consider using your camera's autobracketing features with Drive mode. This will allow you to rattle off an auto-bracketed set quickly.

One caveat to be aware of when using Drive mode: It can often cause your camera to shake enough that your images will be slightly out of registration. Instead, you might want to try both an Autobracket/Drive mode series of shots and a manually adjusted series of shots.

Some people prefer a wider bracket of five or six shots. In other words, they shoot at -2, -1, 0, +1, +2. This larger bracket gives your HDR merging software more to work with, and can result in finer details and better gradients. However, depending on your software, the extra frames may not add much. Shooting more shots will mean that blowing clouds and vegetation will have moved farther between the first and last shots.

If your camera only allows a three-stop bracket, and you want to shoot more than three frames, you'll need to do two different bursts, one at −2, −1, and 0, and another at 0, +1, and +2. Obviously, you'll discard one of the images shot with 0 exposure compensation.

Personally, I've never found that shooting more steps yields any advantage over shooting three. Occasionally, you might find that you get a slight increase in editing latitude, but mostly the only difference is more complex postproduction. If you're shooting landscapes on a windy day, then shooting more steps simply means more blur as clouds and vegetation move between shots. With your images shot, you'll need to transfer them to your computer and process them with HDR software.

Are HDR Images Really Higher Dynamic Range?

The term "high dynamic range imaging" is actually a little misleading. The HDR process does not actually yield any more dynamic range in the final image. In fact, if you were to look at the histograms of the three source images I showed earlier, you'd find there is perhaps more dynamic range in a couple of the original images than there is in the final HDR. (Examine the histograms of some of your own HDR images, and you'll probably find similar results.)

The HDR process does two things. First, it compresses the extremes of your exposures—the highlights and shadows—into the available dynamic range space. (In the previous example, this would be the almost blown-out sky and the almost totally dark mountains just below.) Second, it changes the exposure selectively throughout the image so that more detail is seen (the desert floor and clouds).

So your final image has a selection of stops that have been cherry-picked from your source images (this process is called *tone mapping*), but the total range is not necessarily expanded.

Shooting Concerts and Performances

Thanks to their exceptional low-light performance, digital cameras are ideal for shooting concerts and performances. In general, the problem with concerts and performances is that you're shooting a moving subject and the lighting conditions are generally dim. Because your subject

is moving, you'll need a faster shutter speed, but because of the low light conditions, you'll have to increase your ISO to afford the faster shutter. Depending on your camera, this ISO increase might lead to more noise in your final images.

Obviously, if you're shooting outdoors on a bright sunny day, you won't have these issues, so you can focus more on composition and content.

For shooting in an auditorium, though, battling the lighting conditions will be an extra chore that you'll have address. You'll need to consider the following.

- **ISO.** First, you need to know what the noise penalty is on your camera as you shift to a higher ISO. As you've seen, all cameras produce more noise as you increase the ISO, but some noise is more palatable than others. So, before you head into a concert or performance-shooting scenario, spend some time working with your camera in low light at various ISO speeds. Process your images, and if your ultimate goal is print, then print out some tests. Then determine how high you can crank your ISO before the images become unacceptably noisy. Once you know your highest acceptable ISO, you'll be able to make some informed decisions after doing some metering tests at the venue.

- **White Balance.** The point of white balance is to calibrate your camera for the inherent color of different types of light, but stage lighting is almost always *intentionally* colored. This presents an interesting white balance quandary. You don't *want* to correct away the color that the performers have intentionally added, but that color could confuse your camera's automatic white balance to the point where it gets *all* the color wrong. Unfortunately, in most cases there's no way to white balance manually, because there's simply no place to take a white balance reading off of—one part of the stage might be lit with red lights, and another blue, and those lights may change during the show.

Your best bet is to stick with auto white balance and hope your camera is good enough. If your camera provides a raw mode, then *definitely* turn it on. With raw files, you'll be able to correct your color later. If you can't shoot raw, then you'll have to hope that your auto white balance is up to the task, and if it's not, that you can perform some correction later.

Setup

When you get to the venue, try to determine a location where you can get a good angle on where you think the performers will be, but one that doesn't interfere with any audience member's line of sight. If you don't have open access to the venue and will only be able to shoot from a specific seat, then you'll just have to do the best you can.

Be Sure You Have Permission

Many performers do not like to have their shows photographed, both because it is distracting and for copyright reasons. If they've paid a license for the right to perform a particular piece of music or theater, that license may not include any electronic reproduction, so follow their wishes and don't shoot. If you've been asked to shoot a performance, contact the venue and make certain that shooting is allowed. In some venues, union rules may prohibit nonunion shooters.

If you're allowed to move around the hall, try to assess the best angles before the performance starts and identify the easiest, least intrusive way to move between those locations.

Turn the beep on your camera off. If you're shooting with a point-and-shoot camera that has an LCD viewfinder, turn the brightness down as far as possible (assuming your camera has a brightness control). If you're shooting with an SLR, turn the image review feature off. Bright LCD displays can annoy audience members, and can wreck your low light vision, which can slow down your shooting.

Obviously, with most performances, a long telephoto lens will be the order of the day, so that you can get close-ups of performers and action. However, if your goal is to document the event, you might also want to have a wider angle lens for capturing a few shots of the entire stage. If you're shooting in an auditorium, you'll want the fastest lenses you can lay your hands on. A faster lens can have a wider maximum aperture, which means you can use faster shutter speeds. (The wider aperture allows more light, so your shutter speeds can be slower.)

Finally, be *absolutely certain* that your flash is off. Flash photography can be distracting to performers (or even dangerous, if they're engaged in a physical activity), and it is definitely annoying to the rest of the audience. Besides it doesn't do anything to improve your pictures. So turn your flash off and leave it off!

Exposure Strategy

Your first few shots will most likely be experimental, as you determine the best exposure. Again, your main concern will be motion stopping. However, if the stage is too dark, you may have to accept that it's not possible to get a good exposure in-camera, and that you may have to do some brightening later. Work through the following steps to find a good exposure:

1. Put your camera in Shutter Priority mode. Since shutter speed will be your main concern, you'll want control over it during your entire shoot.

2. Start at your slowest ISO.

3. Using the handheld shutter speed rule, shoot some shots with the "correct" shutter speed.

4. Discretely review your image. (You don't want the screen disturbing other patrons.) If the image is grossly underexposed, raise the ISO until you get a good image. If you have to go into an ISO that you've already deemed too noisy, then stop at your maximum acceptable ISO.

5. Now try lowering the shutter speed to brighten your image. Review your image to determine if the slower speed results in motion blur. If it doesn't, then you're good. If it *does*, then you'll have to go back to a faster shutter speed and accept underexposed images. Fortunately, you can probably brighten these back up later (see Figure 12.31).

After you've identified a workable shutter speed, you can probably shoot with it for the entire show. If the lighting changes dramatically or the action speeds up, you may need to perform more experiments. Motion stopping is your primary concern, so you might have to settle for images that need brightening later.

Bear in mind that when shooting in low light with a fast shutter speed, your camera will open its aperture all the way, which means depth of field will go down. Since this can mean that backgrounds will go blurry, you'll need to keep a close eye on the focus in your image. If you're autofocusing, make sure that your camera is selecting the right points.

If the venue is dark enough that your camera has trouble focusing, you'll need to employ some of the low light focusing tips we discussed earlier.

Figure 12.31

The only way to get a sharp shot of this moving musician was to use a fast shutter speed that resulted in an underexposed image. Fortunately, it was no trouble to brighten the picture back up to something usable.

If performers are wearing white shirts, bear in mind that these can easily overexpose, so you'll want to do some test shots and check your histogram to ensure that white clothing isn't over-exposing. If it is, then you'll need to adjust your exposure accordingly.

Shoot Sound Checks and Rehearsals

If you know the performers, see if you can get permission to shoot rehearsals. If it's a musical performance, find out if you can shoot the sound check. With sound checks and rehearsals, you don't have to worry about disturbing other audience members, the lighting is often better, and you might even be allowed on-stage, where you can get close-ups. Even if the performers say that what they want are shots from an actual performance, remind them you'll shoot those also, but that a rehearsal or sound check is a nice place to get close-ups that aren't possible during a performance.

Performance Composition

Composing during a concert or performance can be tricky because your situation is ever-changing. You'll have to work quickly and be ready to adapt and change as the performers move and the lighting changes. Keep the following tips in mind:

- **If you're shooting a play or musical, don't try to tell the story that's being presented.** You don't have to worry about showing the relationship between characters or shooting sequences that convey what's going on.

- **Less is more.** Generally, nice close-ups of performers are going to be the most successful shots. If you think about close-ups, you'll be less inclined to try to tell the story. If two performers are having a very compelling interaction, then go for wider two- and three-shots.

- **Be careful of mouths.** It's easy to take an unflattering shot of an actor or singer if you catch them speaking or singing, simply because their mouth might be in a weird position. While it's important to try to get good shots of these actions, it's also good to get shots of performers when their mouths are closed. Sometimes the best shots will be shots of a performer listening to other performers. Similarly, musicians who play wind instruments often have to hold their mouths in unflattering positions. Shots of them not playing, but reacting to other musicians, are often the most successful.

- **Keep your nonviewfinder eye open.** Because your attention will usually be drawn to whomever is currently speaking or playing, it can be easy to miss a nice reaction shot somewhere else on stage. Similarly, because action can change quickly, you want to be sure you can see the rest of the stage. Keeping your other eye open, and trying to pay attention to the whole stage as you shoot, can help you spot the less obvious shot.

- **Look for the interesting angle.** A few shots of an actor speaking, or a trumpet player blowing, go a long way. If you're free to move around, then bring all of your composition skills to bear and look for interesting ways to compose shots of the performer with other elements on-stage. Also, remember that often the most interesting compositions are created from light and dark, which can be easy to find on a lit stage.

- **If you're shooting musicians, be ready to work around microphones and music stands.** You'll probably quickly learn to hate all of the hardware—amplifiers, stands, microphones, cords, and more—that accompanies a group of musicians. It will block mouths, faces, and hands, will interfere with your compositions, and will generally look ugly. Usually, your only recourse when confounded by an ugly stage implement is to move. If you aren't allowed to move, then you'll just have to suffer the extra visual element.

Finally, give some thought to battery and storage. If you're going to be shooting for a couple of hours, you'll want a fully charged battery. You'll also need to think about how much storage you need. As I mentioned earlier, I usually use two-gigabyte cards because I don't want all of

my photos in one place. When shooting a long-duration show, though, I might switch to a larger card, so that I don't have to perform a card switch in the middle of a performance. Having to swap cards can disturb other audience members, and it can cause you to miss a shot.

Shooting Events

Event shooting—be it a wedding, conference, or party—presents a tricky balance. On the one hand, you need to be nonobtrusive, but on the other hand you've got to get where the action is and get the good shots.

It's easy to be shy during an event shoot, and a lot of beginning shooters will make the mistake of erring too much on the side of being unobtrusive. They'll hang back and shoot lots of wide shots of groups of people. The results will be lots of pictures of the sides and backs of people's heads, with the occasional shot of someone who happened to have turned toward the photographer.

To be a good event shooter, you have to be willing to engage with people and get into the action. Few people at an event—especially at a wedding—are surprised to see a photographer, and won't resent it if you take their picture. You've been invited to shoot the occasion, and the guests will know it. You don't want to interrupt the proceedings, or get in the way of people conversing, but it's okay to move about, get in front of people, and even talk to them. Turn on some charm, and you'll stand a better chance of getting good smiles and expressions.

For many events, there will even be a photographic agenda for you to follow. At a wedding, for example, you will most likely be expected to shoot the bride getting ready, the cutting of the cake, the kiss, the toast, and so on. What's more, you will be expected to get good shots of these moments, which often means being right in the thick of the action.

Similarly, at a corporate event of some kind, there might be specific moments you're expected to shoot—two CEOs shaking hands after signing a deal, and so on. Such an occasion usually demands a close-up.

As with most event shoots, you'll need to try to get the shots you need, without getting in the way of the event that's happening. Just remember that if you're there in any kind of official capacity, then you *are* part of the event. So you can be a little proactive in getting into position and getting the shots you need.

To that end, you'll want to talk to the client ahead of time and find out if there are specific shots that they're expecting. Be sure you are clear on what your deliverables are and try to get a sense of whether they have specific needs for the final output.

Event shoots are usually fast-paced, and you can often find yourself having to move, compose, and expose one shot after another. To facilitate this, you'll want a lens with a versatile focal length range, from fairly wide to somewhat telephoto. A 35–135mm range is ideal. Sure, you can carry shorter or longer focal lengths, but you probably won't have time to do a lot of lens changing, so have a good *all-arounder* with you.

Similarly, plan your storage strategy carefully, as discussed in the last section.

As always, look for the interesting angle when you can find it. Don't get too creative—the goal is to cover the people who attended the event, so follow the basic people composition rules presented in Chapter 2, "Getting to Know Your Camera." As with performance shooting, you don't have to get images that tell grand stories or complex relationships. You're just looking to document attendees and simple moments.

Exposure Strategy

Your exposure strategy will vary depending on the type of event you're shooting. If you're indoors shooting people at a conference, party, or meeting, then your main concern will probably be depth of field, since you'll want the option to blur out backgrounds. So you'll probably want to shoot in Aperture Priority mode or, if you think depth of field control won't be especially critical, then stay in Program mode and ride your camera's Program Shift feature. As always, keep an eye on your shutter speed and get ready to raise the ISO if light levels get too low.

If you're shooting an outdoor event such as a fair or music festival, then you might have either aperture or shutter speed concerns. If it's an event with fast-moving people or activities, you'll want to switch to shutter priority to give yourself control of motion stopping. If you're just walking around shooting candids of people, then you'll probably be more concerned about depth of field, and so will switch to Aperture Priority. Program mode with Program Shift is a good way to have access to both of these options.

In either event, be aware of backlighting and stay ready to use your camera's exposure compensation feature or fill flash.

Shooting Sports

As a sports shooter, one of your biggest assets is an understanding of the game that you're shooting. It's usually pretty easy to go out and compose nice shots, but what you want are nice shots of critical moments or especially impressive achievements. The more you understand the game you're shooting, the better your chances of anticipating and capturing key moments. As with performance shooting, you'll want to keep your nonviewfinder eye open and track your entire field of view. Keeping your off-eye open can also let you see what's about to move into the frame, making it easier to know when to fire.

In general, long, fast lenses are the lenses of choice for sports shooting. In addition to giving you the ability to get close-ups and to work in low light, with a long, fast lens you can shoot shallow depth of field that will let you separate your subject from what is usually a very complicated background. Note that if you're going to a game as a spectator, the venue may not allow you to carry a long lens, so if you're going to try to use one, be prepared to take a trip back to your car to drop off your larger lenses. In general, a point-and-shoot camera is a safer way to go if you're going to a commercial event and don't have a press credential.

It's often said that sports writing is the hardest type of writing, because you have to find a new way of writing the same story over and over. Sports shooting can be the same way.

To avoid shooting the same shots over and over (and the same shots that everyone else is shooting), try to find a different angle. This often means getting in close and finding vantage points that are a little unusual, as you can see in Figure 12.32.

Obviously, you won't always have the kind of access shown here. Also, there are times where your best choice is not to be *too* clever. In these instances, you'll want to go for the more "straight-ahead" sports journalist shot.

Figure 12.32

To get the shot in Figure 12.32, photographer Janine Lessing had to get in close and find an unusual angle. With her camera in Burst mode, she didn't even look through the viewfinder, but simply tried to imagine a dramatic vantage point for her camera.

Exposure Strategy

Shooting sports is a lot like performance and concert shooting. Your main concern is shutter speed. If you're shooting a day game in bright daylight, then your shutter speed choice will largely be about how much motion stopping you want (see Figure 12.33). In most cases, you'll want all the motion-stopping power you can get, so you'll opt for fast shutter speeds that go well beyond the handheld shutter speed rule. To achieve these, you might need to go to a faster ISO. Fortunately, a few quick experiments should help you zero in on the correct speed.

Figure 12.33

In general, your main concern when shooting any kind of sports or action is to decide how much motion stopping you want. Do you want a blurry action shot, a razor sharp freeze, or something in between?

For some shots, you might want to try a slower speed and pan your camera to blur out the background.

If you're shooting a night-game under more limited lighting, then your shutter speed options will be a little more limited. While most arenas and fields will be lit well enough for the players to see, they might not be bright enough for a super-fast motion-stopping shutter speed. Again, you'll need to crank your ISO up. Note also that some areas may be brighter than others, so you might need to adjust ISO as you shoot into different parts of the venue. As with concert shooting, you may have to plan on shooting some underexposed images with the idea of brightening the images later.

Bright lights on white uniforms can play havoc with uniforms, causing them to overexpose, so keep an eye on your histogram until you determine if you need to dial in some negative exposure compensation to get detail back in overexposed uniforms.

If you're shooting in an indoor arena, then white balance will be an issue, due to the colored lights used in most arenas. Shooting in raw format is your best bet here, as you'll be able to adjust white balance later. Try to find something gray on the floor of the stadium and take a shot of it. This will give you a white balance reference for postproduction correction.

If your camera doesn't have raw, then see if you can get to the floor of the stadium and perform a manual white balance.

Street Shooting

Earlier I mentioned that you shouldn't have to go to an exotic location to find good subject matter. No matter where you live, shooting on the street will often yield the best shots that you might ever find.

By "street shooting," I'm talking about getting outside in your neighborhood or town and shooting the people and situations that you find there. Some of the most famous photographic images in history have been candid street shots, and you'll often find that your most interesting, dramatic, and often pretty shots occur on the street.

Street shooting is also the scariest type of shooting for most people. Approaching strangers and taking their picture can be terrifying. With an increasing focus on privacy issues, and with more and more people being suspicious of strangers (especially those with cameras), shooting candids on the street can be very intimidating.

Unfortunately, there's no way around the fear problem, other than to face it and dive in. It *will* be scary, and it will continue to be scary for quite a while. However, this doesn't mean you shouldn't do it, and more importantly, just because it *feels* scary doesn't mean there's any actual risk.

Street shooting is something you can practice, and there are some guidelines you can follow that will help mitigate some of the fear.

For the most part, approaching strangers just involves common sense. While you can choose to skulk around with a long, telephoto lens, so that you don't have to confront people, this is not really "street shooting" but is more akin to "surveillance," and it's a sure way to make people angry with you.

The best way to shoot candids on the street is to engage with people and establish a dialogue with them. When you find someone doing something interesting, go up and talk to them about it. Ask them about what they're doing and try to learn more. At some point, if you're

still interested, and you feel the person is open, then ask if you can take their picture. Most of the time, you'll find that people will say yes. If they don't, then you can simply thank them and move on.

Obviously, this approach doesn't work if you see someone involved in an activity that is fleeting. Often, engaging with a person will destroy the very moment you want to capture. If that's the case, get the shot, and then consider talking to the person and establishing some kind of rapport. This is the "shoot first, ask questions later" approach. At the very least, you'll establish good will and leave the scene without worrying that you've invaded someone's space. But what you may find if you go up and engage with the person is that there's an even more interesting story to be had. After talking to them, they may lead you to more shots.

When grabbing shots like this, you don't always have to have a conversation with your subject, but after taking the shot, you should at least try making eye contact with them and giving them a nod of thanks.

If, at any time, you get the feeling that someone doesn't want to have their picture taken, or that you're invading someone's privacy, then don't take the shot. There are plenty of pictures in the world, and there's no need to make someone angry. By being polite, you make the world a better place for other photographers.

Technically, when you're in a public space, you're allowed to take pictures of people, buildings—anything you want. If someone tells you you're not allowed to take a picture of their house or storefront, or whatever, they're not actually correct. But is this a fight you really need to bother fighting? In most cases, it's easier—and less stressful—to simply move on and find something else to shoot.

Sometimes, you'll find that people might give you a puzzled, "Did you just take my picture?" look. In these cases, take the time to say, "I'm just out shooting some pictures, and I got a nice shot of you doing [whatever.]" Once you speak, you become more of a normal human to them and less threatening. But you might also consider offering a little bit more.

Often, you can get great shots by shooting a little more surreptitiously. Keep your camera at waist level or carry it in front of your chest and shoot without looking through the viewfinder. It can take practice to understand your framing, but this "from-the-hip" shooting can often yield images with a more casual feel.

Offering Something in Return

One of the great things about street shooting in the digital era is that you have a way of showing your final work to the people you shoot on the street. If you engage with your subject before or after a shot, you can ask them if they have an email address. You can then email them pictures or a link to a photo-sharing site. Or you can simply tell them your Web address and let them know that the pictures might be appearing there within a certain time frame.

A lot of photographers have business cards made with their photo-sharing address on them. There are lots of free, online business card printing services, so it's very easy to have cards made that you can hand out to people who might be interested in seeing what you're doing. This is a great way to give something back to your subject.

You can also choose to show them the image right then and there on the back of your camera. However, it's usually best to wait and let them see the finished work. There's no guarantee that you won't hold up your camera, only to find that the shot was somehow unflattering.

When shooting kids on the street, you want to be particularly careful about letting them see the results. They will often become so interested in seeing the results that they'll simply start mugging and performing for the camera.

When shooting people in other countries, especially those who don't have much, you will often find yourself facing a subject who wants money. Whether you choose to pay or not, is up to you—there's no right or wrong answer. There's some compelling data that shows that, if you're shooting in a heavily trafficked tourist spot, then giving away money for shots is not great for the locals. Kids, especially, will learn that they can simply go hang around and get their picture taken for money, rather than trying to find more gainful employment.

Nevertheless, when faced with extreme poverty, it's very hard not to want to help the people you're shooting. When I spend 15 minutes (or longer) with someone in a poor, remote village, I give them money afterward. (They invariably ask, so it's not a difficult situation to broach.)

For kids, consider carrying pencils, nuts, balloons, or stickers. What they really want is sugary candy, and you can always indulge that, but it's not necessarily in their best interest.

Using Street Shots

Now the bad news: It's hard to do much legally with images you shoot on the street. Images shot in public can be used for journalistic purposes, and you're free to upload them to a photo-sharing site or post them on a Web page. But if you want to use them for any purpose that generates a profit for you—selling fine art prints or including them in a book, for example—then you can't legally use the image without a signed release form from the subject. If this is your goal, then you need to either carry release forms with you (you can find generic ones online) or be sure to get an email address or phone number of anyone whose image you think you might want to use. Or you can simply choose to risk it and hope that you won't be discovered using the image, or you can choose images that aren't recognizable (see Figure 12.34).

Figure 12.34

You must be careful to have proper permissions when using images for any for-profit venture, such as book use or fine art printing.

Release Form for Your Smart Phone

You can find model release applications on the iPhone and other smart phones. These provide an electronic model release form that a subject can sign directly on the phone. These applications often also have location release forms, which can be necessary if you're shooting inside a location such as a restaurant or store.

Exposure Strategy

Depth of field is usually your main concern with street shooting. In a rapidly changing street environment, you might want to opt for deeper depth of field to improve your chances of getting images in focus. This is especially true if you're shooting "from the hip" and can't be sure about focus. The deeper depth of field will help ensure that your images are sharp.

Street scenes often have very busy backgrounds, so there will be times when you'll prefer a shallower depth of field to create separation between your subject and background.

Shooting at Night

We've spent a lot of time in this book talking about light and what makes good light, but often dark is just as compelling as light. As a digital photographer, you can shoot in low-light situations that film photographers could only dream of. Digital image sensors are incredibly sensitive to light, and at the time of this writing, cameras with ISO settings as high as 25,000 are commonplace and yield very good images.

At night, the world is lit up in a very different way. Street lighting illuminates things from different angles and at different intensities than what you're used to during the day. The upshot is that at night you might find subject matter in places that are featureless and boring during the day (see Figure 12.35).

Figure 12.35

The world lights up in a very different way at night and reveals an entirely new range of subject matter. Digital cameras are ideally suited to capturing low-light imagery.

Low-light images are largely about luminance. We don't perceive a lot of color at night, so you might often find yourself working in black and white when shooting at night. Here are some things to consider:

- You'll need to be careful about white balance, and will probably want to manually white balance off a gray white balance card. Or you'll want to shoot in raw mode and shoot a white balance reference shot, as shown in Chapter 7, "Program Mode."

- You'll typically be shooting at higher ISO, so you'll want to be aware of how high your camera can go, ISO-wise, before its images get too noisy.

- In low light, you'll usually be shooting with longer exposures, so you'll need to be careful about stabilizing the camera and shooting subjects that move. You might also want to use faster lenses, which will mean shallower depth of field, which will require you to be very careful about focus.

- One of the trickiest things about shooting in low light is that, when it's very dark, you won't be able to see your subject through the viewfinder. This can make composition more difficult. If you're working on a tripod, take a shot, then review the image to test composition, and reframe accordingly.

Low Light Focus

Your camera's autofocus requires a fair amount of light to be able to achieve focus. This means that low light can render your autofocus useless. You can try manually focusing, but if it's dark enough to trip up your camera's autofocus, then you may not be able to do much better.

Try to find something bright that's at the same distance as your subject and focus on that. Then reframe and take your shot. If you're trying to shoot a person, ask them to turn on their cell phone and hold it up where you can see it. Your camera can probably focus on that light.

If you have a really bright flashlight, you can try shining it into your scene to create a spot that's bright enough to focus on. Then shut the flashlight off and shoot.

If you're going to take multiple shots of the scene, and you're working with an SLR, then switch your lens to Manual focus after you've achieved focus. As long as you don't turn the focus knob, this will lock in the correct focus.

Real-World Low Light Shooting

Consider Figure 12.36, a 25-second exposure shot in Monument Valley. The only light in this scene was the full moon, which was shining brightly enough to cast hard-edged shadows. Still, when looking through the viewfinder, it was hard to see the edges of the frame, so composing was difficult.

To get the shot, I mounted the camera—a Canon EOS 5D Mark II—on my tripod and tried my best to get a rough composition. I had to look through the viewfinder for a long time before my eyes adjusted, and even then I could only see vague forms.

I put the camera in Aperture Priority mode because I was concerned about depth of field. I didn't want to use any mode that would let the camera choose the aperture, because I figured it would choose a wide-open setting (to help reduce shutter speed), which would wreck my depth of field.

Figure 12.36

This image was illuminated solely by the full moon. Capturing this image required some very specific techniques.

I chose an aperture of f5.6. In daylight I would have chosen f11, but I didn't want to go that small, because I didn't want a very long shutter speed. When shooting low-light landscapes, shutter speed choice is tricky. With an aperture of f11, I would have been looking at an exposure of around a minute-and-a-half. At that length, the stars would begin to leave trails. While star trails are often a nice effect, for this image, I wanted pinpoint stars, so I had to do whatever I could to shorten exposure time.

Note too, that with a longer exposure time, you stand the chance of getting a noisier image. As exposure time lengthens, some pixels on the sensor can get stuck in the on position. They'll appear in your final image as yet another type of noise.

The 5D Mark II can't shoot with shutter speeds over 30 seconds. For longer shutter speeds, you have to put the camera in Bulb mode and time the exposures yourself, so that was another reason I wanted to keep the exposure under 30 seconds.

I figured, though, that at f5.6, I could get the depth of field that I needed for the shot.

The next issue was focus. In low light, your camera's autofocus will not work—it's simply too blind to be able to function. So you'll have to focus manually. Unfortunately, in low light, manual focus is very difficult because *you* will have as hard a time seeing as the camera's autofocus system does. Don't expect to be able to see well enough through the optical viewfinder to be able to focus, and any type of LCD viewfinder will be far too noisy in low light to judge focus. Instead, you have to go by the numbers.

For a landscape shot, it's tempting to simply turn the manual focus ring to infinity. But as you've already learned, if you focus on infinity, you'll be wasting a lot of depth of field, because it will fall *behind* the infinity point. Instead, you'll want to focus just a little short of infinity. Note that on most lenses, as you approach infinity, a tiny turn of the lens ring can equate to a big change in focus, so you'll want to make very small moves when you pull back from the infinity mark.

On the focus readout of some lenses, such as most lenses from Canon and Sigma, infinity is denoted by an L-shaped mark. The vertical mark represents infinity at normal temperatures. As temperatures rise, infinity moves more to the right. Most of the time, the normal infinity mark will be your reference point (see Figure 12.37). For this type of shooting, you'll want to focus just a little bit short of that mark.

Figure 12.37

On some lenses, infinity is indicated by an L-shape. The vertical mark represents infinity at normal temperatures, with infinity moving to the right as temperatures rise.

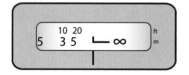

With an initial stab at framing and focusing, I'm finally ready to take a test shot. As already mentioned, exposure time on a shot like this is really long for my test shot, I'm only interested in getting a better view of my composition and checking my focus.

So I set my ISO up very high—in this case, 6400. This produces an image that's noisier than I want, but I don't care, because I'm just after a quick reference shot. With the reference taken, I can adjust my composition as necessary, zoom in to the playback display to examine focus (not the ideal way to check focus, but the only option in these circumstances), and adjust accordingly. If need be, I can take another reference shot.

When I'm ready for a final image, I turn my ISO back down to what I want to use for my final shot—in this case, 1600, which provides a clean image without lengthening my exposure time so much that I lose sharpness in the stars—and take the shot.

On long-exposure shots, you'll either want to use the self-timer or a remote control to help reduce camera shake. With an SLR, the movement of the camera's mirror can also cause camera shake, so if your camera has a mirror lock-up feature, you might want to activate that as well. With mirror lock-up, the camera flips up the mirror when you press the shutter button, but doesn't trip the shutter until you press the button a second time. So you can flip the mirror up, wait a moment for any vibration to die down, and then trip the shutter. Because the mirror isn't clacking around before the shot, chances are better that the camera will be more stable.

As you can see, this type of shooting is a process of balancing noise with motion, and all while trying to compose and focus in the dark. If your camera can display a status display on the rear LCD, activate this feature, as it will make it much easier to check your current settings. The 5D Mark II even lets you change settings using this screen. With the camera mounted on a tripod and light levels low, this is usually the easiest way to change settings.

Long Exposure Noise Reduction

Some cameras have a noise reduction feature that's tailored specifically to long exposures. However, sometimes, these features require processing time that's equivalent to your exposure time. For example, if you shoot a minute-long exposure, then the camera will sit for another minute and process after the shot. You can't use the camera while it's performing its long-exposure noise reduction. Other cameras can perform the reduction in real-time, while the shot is being taken. It's almost always worth using this feature, but you'll want to check out your camera ahead of time to find out how it processes. If this noise reduction will effectively double your exposure times, then you may want to shut it off if you plan on very long times and you want to do a lot of shooting.

Underwater Photography

Thanks to their small size and excellent low-light capabilities, digital cameras make for excellent underwater photography. To shoot underwater, you'll first need an enclosure for your camera. Some camera vendors make their own underwater housing, but if yours doesn't, you can probably find a third-party housing. You want to be sure to get a housing designed for your specific model of camera. An ill-fitting housing might leak, which would, obviously, be very bad. A good housing will provide access to all of the camera's menus and controls, and if you plan to do a lot of underwater photography, you should consider the availability of underwater housings when you're shopping for a camera.

Once you have a housing, your next step will be to get underwater. Each type of housing will be rated to be safe to a specific depth, so make sure you don't exceed the capabilities of your housing.

Today, many point-and-shoot cameras have special white balance settings for shooting underwater. If yours has one, give it a try. It can be dim and murky underwater, so you may need to switch to a higher ISO. In many cases, you'll be using the camera's flash, which means you can stick to a lower ISO setting. Depending on your subject matter, you might need to use your macro setting (see Figure 12.38).

Figure 12.38

Thanks to their low-light sensitivity, digital cameras allow for excellent underwater photography. You'll need a special housing designed for your specific camera.

Image © 2007 by Derrick Story.

Vacation Shooting

When shooting on your vacation, you'll have all of the same photographic concerns that you do with any other kind of shooting—shutter speed, aperture, ISO, finding a good place for lunch. In the face of exciting new vistas and venues, though, it's easy to fall back into bad habits as you find yourself overwhelmed by new imagery. To come home with good results, you'll want to avoid certain common pitfalls.

- **Get closer.** Remember that, just because a big wide vista is beautiful, you don't need to try to capture all of it—in fact, you probably can't. Rather than zooming out to your widest angle and coming home with shots of a distant, small horizon, zoom in and work the details of the scene. Sure, you won't be able to show your friends the huge view that you saw, but sometimes that's just how it is —a photograph is no substitute for being there.

- **Balance your sunsets.** Remember that shooting someone in front of a sunset is a bad backlighting situation. The sun is going to cause your camera to err on the side of underexposure, so you'll lose all details in your subject. Use your camera's fill flash to illuminate them.

- **Be selective in your presentation.** When you get back home, keep in mind that a few, really good photos will deliver more impact than a never-ending stream of every detail of your trip. When it comes to looking at someone's vacation pictures, less is *always* more, so give careful consideration to the images you choose to show.

- **Put down your camera.** Remember: you went on vacation to vacate. Leave your camera in your room from time to time. If you're worried that you'll miss some kind of "once-in-a-lifetime" photo, don't. There will always be another, and having actual memories of your trip might be more valuable than only having memories of taking photos.

Product Shots

Product photography is a very specialized skill, and good product photographers command very high fees. There's a reason for this—quality product photography is hard. Managing light and creating a compelling staging of static objects are not easy tasks, and they're made even more complicated if you're shooting food, as it has a tendency to change color and texture under hot lights.

Normally, I wouldn't cover such a specialized form of photography, mostly because, in the past, few people have had a need for product photography. But with eBay, Craigslist, Amazon, and other online sales venues, more people need to take quality photos of objects.

At the most basic level, lighting products is just like lighting people, and you can start with the same two- or three-point lighting schemes that we looked at in Chapter 10, "Lighting." The easiest solution for simple product shots like you need when posting items online is to invest in a light tent. Available at most chain photo stores and easily found online, these tents are composed of light diffusing material. Put the object you want to photograph inside the tent and point your camera through the door. Place any kind of lights outside the tent and shine them through the walls, and you'll get nice, even lighting. The resulting shots will have a white, limbo background that is ideal for showing off products.

Tethered Shooting

Tethered shooting is the process of connecting your camera to your computer so that as soon as you shoot, the image is transferred to the computer and becomes immediately viewable. For product photography, tethered shooting is a great convenience because you can review your shots immediately on a nice, large monitor, and even try some edits and adjustments. When carefully setting lights or product placement, reviewing images on the camera's LCD screen often doesn't allow you to assess subtle lighting changes.

If you're working with a client, tethered shooting allows them to immediately see the images and provide comments or approval. (Needless to say, this can be a good or a bad thing.)

Most cameras these days tether through a USB connection, although a few high-end cameras still use FireWire. Your camera might have shipped with tethering software. If it didn't, then you may have to purchase it separately. Unfortunately, there's no standard for camera-to-computer communication protocol, so it's difficult for third-parties to support particular cameras. So, while some applications, such as Apple's Aperture, provide tethering support, they may not provide it for your particular camera.

Another option to tethering into your computer is to simply take the video out from your camera and plug it into a large TV. Most cameras these days provide either composite S-video connections or HDMI HD connections. When working this way, you can shoot normally and then put your camera into Playback mode to review your images on the big screen, or shoot in Live View mode and use the big monitor as a viewfinder.

Using Filters

Lens filters can be used for everything from creating special effects to correcting image problems, but before you can start using a filter, you have to figure out how to get it onto your camera.

First, check the lens on your camera for lens threads. If the front of the lens is too curved, you may not be able to attach any filters, unless the camera provides some kind of filter adapter that attaches by using some other kind of mount. The filter size for your lens is probably written on the end of the lens (see Figure 12.39). If not, check your manual.

When you buy filters, be sure to get filters that have the same thread size as your lens. Most filters will have threads of their own, which will allow you to stack filters.

Filter size

Figure 12.39

If your lens has threads, you can find out what size filters you need by looking for a thread-size marking on the end of your lens. The lens shown here needs 49mm filters.

Other filters might not be available in the right size for your lens, and they might require the use of a *step-up ring*, a simple adapter that screws onto the front of your lens and provides a bigger (or sometimes smaller) set of threads for accepting filters with different thread sizes. Be careful with step-up rings because if they're too big, they might block your camera's metering sensors, flash, or optical viewfinder.

Lens filters are completely flat, meaning they don't add any magnification power to your lens. Although optically they are simpler than a lens, you still want to be careful about your choice of filter. There *is* a difference between a $100 ultraviolet filter and a $35 ultraviolet filter. A more expensive filter will be flatter and will have higher-quality glare-reducing coatings on it. Just as an element in your lens can introduce aberrations, a poorly made filter can introduce flares and color shifts. Although it can be tempting to go for the less-expensive filter, spend a little time researching the more costly competition. You might find there is a big difference in image quality.

Types of Filters

There are many types of filters—too many to cover here. However, if there were a group of "essential" filters, it would probably include the following.

- **Polarizers.** *Polarizers* allow light that is polarized only in a particular direction to pass through your lens. The practical upshot is that polarizers can completely remove distracting reflections from water, glass, or other shiny surfaces. To use a polarizer, you simply attach it to the end of your lens and rotate it until the reflections are gone. Polarizers can also be used to increase the contrast in skies and clouds (see Figure 12.40).

- **Ultraviolet filters.** Ultraviolet filters are used to cut down on haze and other atmospheric conditions that can sometimes result in color shifts in your image.

Figure 12.40

These images show the difference in shooting with and without a circular polarizing filter. In the top images, you can see how a polarizer lets you control the color and contrast of skies and clouds, whereas the bottom images show how you can use a polarizer to eliminate reflections. No postprocessing was applied to any of these images.

- **Neutral Density filters.** They cut down the amount of light entering your lens, without altering the light's color. By cutting down the light, you might find that you have some extra flexibility with regard to exposure.

Neutral density filters are usually rated using an ND scale, where .1ND equals 1/3 stop. Therefore, a .3ND filter will reduce the incoming light by one full stop. Neutral density filters can be stacked on top of one another to add or subtract more stops selectively. However, even the best filters are not optically perfect, so it's better to use as few as possible to reduce the chance of introducing optical aberrations into your lens system. In other words, if you want a one-stop filter, use a single .3ND filter instead of three .1ND filters.

Here's a great neutral density–filtering trick: Say you want to photograph a building on a busy street corner at noon, but you don't want to include any of the people who are pouring into and out of the building. Stack up a few neutral density filters until you have an 8- to 10-stop filter. This will increase your exposure time to 10 or 15 minutes, meaning that anything that's not stationary for at least that long won't be included in the shot. Obviously, you'll need a camera that provides a manual shutter speed control and allows for such long exposures. When the exposure is finished, you'll have an image of just the building.

- **Graduated Neutral Density filters.** These filters cut the light from one-half of the lens while leaving the other half untouched. A graduated filter provides another way to shoot high dynamic range landscape scenes. With the graduated filter, you can reduce the exposure of the sky, allowing you to get a more even exposure in the sky and foreground.

- **Effects filters.** There are any number of effects filters, ranging from filters that will render bright lights as starbursts to filters that will soften, or haze, an image. Major filter manufacturers such as Tiffen, B+W, and Hoya publish complete, detailed catalogs of all their filter options.

- **UV filters.** Ultraviolet filters cut out the little bit of ultraviolet light that makes it through the atmosphere. With a film camera, UV light can sometimes lend a blue cast to your images. This is not really a concern with digital cameras, but UV filters still serve a valuable purpose in that they protect your lens. If you drop the lens, slip and fall, or crash the lens into something, a filter can bear the brunt of the damage, usually leaving the lens unharmed. UV filters also offer great protection in harsh environments, such as beaches or wet environments where you need to be able to wipe off the lens quickly without worrying about scratching the front element. When shopping for a UV filter (or Skylight filter, a variant of the normal UV filter), don't settle for anything but a multicoated filter, which helps reduce glare, and helps with light transmission, resulting in a brighter image.

- **Clear filters.** If you're only interested in protecting your lens, then you might want to consider a clear filter, which serves no function except to shield the front element of your lens. In addition to protecting it from scratches, a filter can also prevent dust from getting inside the lens.

If your camera does not have a TTL light meter, you're going to have to do some manual compensating when you use a filter. Because the metered light is not passing through the filter, the meter will lead you to underexpose. Most filters will have a documented filter factor, which will inform you of the exposure compensation (in stops) required when you use that filter.

Similarly, if your camera does not use a TTL white balance system, your white balance might not be adjusted properly for the filter's effect. The only way to find out for sure is to do a little experimenting.

These days, it's very rare for a meter or white balance system not to be TTL.

Obviously, if your camera is not an SLR, you won't see the effects of the filter when you look through the camera's optical viewfinder. Switch to the camera's LCD.

In general, except for polarizing filters and possibly neutral density filters, you can use your image editor to achieve all the effects that can be created with lens filters. Lens filters have the great advantage of not requiring additional edits, so if you know you need an effect, and can achieve it with filters, this will greatly speed your workflow. However, if you shoot "clean" images and add filter effects later, you'll also have the option of repurposing that image for nonfiltered uses.

Lens Extensions for Point-and-Shoot Cameras

Some point-and-shoot cameras support screw-on lens extensions that attach to your camera's filter threads, or to a special bayonet mount on the front of the camera, to create a more tele-photo or wide-angle lens. As with filters, these extensions might require a step-up ring. Also note that some cameras require you to choose special settings—usually accessed through a menu option—when using a lens extension. If you don't let the camera know that an extension is attached, its focus and metering operations can become confused.

Spend some time experimenting with your camera's extensions to determine their idiosyncrasies. For example, some lenses might have bad barrel or pincushion distortion or vignetting problems.

Finally, if the extension or step-up ring is very large, it might obscure the camera's optical viewfinder or on-board flash. If the extension protrudes too far in front of the flash, it will cast a shadow when you take the shot. Usually, the only solution is to use an external flash.

Exploring on Your Own

There are many specialized forms of photography, and the topics we've discussed in this chapter can be explored in much greater depths. Hopefully, you've gotten an idea of the types of issues you'll face and how to think about solving them. To get good at any of these types of shooting, you'll need to practice. But perhaps the most important thing to remember is that there are many different solutions to the problems that you'll encounter when shooting in any of the situations described in this chapter. Don't hesitate to improvise and try to find your own solutions.

13
WORKFLOW
Managing Your Images and Starting Postproduction

In the rest of this book, you will learn about what happens after you've finished shooting. From color correcting to editing to printing, the following chapters will cover the processes that have traditionally happened in the darkroom but that now happen inside your computer.

One of the reasons we all love digital photography is the ease with which it makes it possible to get images off our cameras, into our computers, and out into the world. One of the other great advantages of digital over film is that it really doesn't cost anything to shoot, so you can experiment and explore with much less financial concern than you ever could with film. Freed from film's financial constraints, you'll most likely find yourself shooting a *lot*. As your image count grows, the process of managing all of those pictures as you move them from your camera to your computer, edit them, and then output them can quickly become overwhelming.

Workflow is the process of managing this whole business. The workflow you choose will govern how you import images, keep them organized, edit and correct them, tag them with searchable metadata, output them, and archive them for safekeeping. As discussed in Chapter 4, "Image Transfer," there are several approaches to workflow. You can find a single application that can manage all of the steps of your workflow, or gather a collection of applications, each aimed at a specific part of your workflow needs.

If you're in a hurry to get to the image editing chapters of this book, you might be thinking "Workflow, right… I'll figure that out later, when I get more serious. Right now I just want to correct my images." Bear in mind, though, that image editing takes time, and you don't want to waste time editing an image and then discover later that there's another shot of the same subject that you like even more. Also, remember that those hundreds of images that you've imported have arcane file names, and are not organized into any particular file structure. As your image library grows, it will become harder and harder to find images and to keep track of different versions you may have created (perhaps you've got color *and* black-and-white versions of some images, or different versions edited in different ways). If you're not careful, you can easily end up accidentally deleting images or saving over older versions with newer files.

Defining a good workflow process will not only help you stay organized in the long run, but it will also help your short-term image editing goals by forcing you to evaluate intelligently which images are worth editing and which are not.

No matter what software you use, your workflow will probably follow roughly the same steps. So before we consider specific software applications, we're going to define exactly what needs to happen in a typical workflow.

Postproduction Workflow

If you're coming from a wet darkroom background, this whole "workflow" discussion may seem a little strange. But even in a traditional darkroom, you have a workflow, a method for keeping track of your negatives and prints, and the custom instructions you might come up with for printing each image. As much as anything else, defining a workflow is a process of figuring out how to stay organized, both in your current project and as your library of archived images grows.

While your camera probably came with some software manufactured by your camera vendor, this software is almost always second-rate, so you'll probably want to find a different method for managing your postshoot workflow.

Whether you choose to handle your workflow using a dedicated workflow application or a combination of applications (we discussed various software options in Chapter 4), you can break down the most complex postproduction workflow into eight steps:

- **Import.** Before you can do anything else, you need to get your images off your camera's media card. It doesn't really matter if you choose to import your images directly from your camera using a cable or from a storage card using a media card reader. However, importing directly from your camera will drain your camera battery.

- **Renaming and organizing.** If you use multiple applications for managing your workflow, you probably use your operating system's file manager to rename your images and to organize them into folders. There's no right or wrong way to name and organize your files, so do whatever makes the most sense to you and feel free to experiment with different schemes. If you use a dedicated workflow application like Aperture or Lightroom, you'll possibly skip this step.

- **Metadata tagging and keywording.** Metadata tags are simple bits of text that can be stored in your image file. There are several different kinds of metadata tags. As you've already learned, your camera stores EXIF metadata tags to record the parameters that were used for shooting. IPTC metadata is a standard set of metadata tags that lets you record copyright information, keywords, location, and many other pieces of standardized information. Metadata tagging and keywording can be an essential step for the long-term organization of your image archive. For example, with categorical keywords assigned to your images, you'll be able to search easily for images later that fit a particular description. With metadata and keywords stored in your image, you aren't limited to organizing only by filename.

- **Selecting your pick images.** You'll typically shoot far more images than you will actually deliver or use. There's no reason to spend time correcting and editing images that aren't going to make the cut for final delivery, so once you've tagged and keyworded your images, you're ready to start selecting your *pick* images—the "keeper" or "hero" images that you'll pass on to the rest of your workflow. Note that some people swap this step with the last one, figuring they'll delete any images that don't get selected as picks, so there's no reason wasting time keywording and tagging nonpick images. Other people feel it's a mistake to delete any images, as you never know what you might need later. Storage is cheap these days, and workflow tools make it easier to manage large numbers of images, so there's little reason not to keep your secondary images.

- **Correct and edit.** Now you're ready to perform any corrections, edits, or special effects you have in mind. This stage can involve anything from the simplest contrast and tone adjustments to complex compositing and filtering operations. If speedy workflow is a must, you'll try to minimize this step by shooting your images so they're as correct as possible when they come out of the camera.

- **Output.** With your images edited, you're ready to output to your final media. This step often involves sharpening and resizing operations. You'll then print your images or save them as files for electronic delivery via email, the Web, or disk.

- **Archiving and backup.** Accidents happen, and you don't want to lose images in a disk crash. Be sure to archive your project once you've delivered your final images. Archiving

can be achieved by copying images to a second hard drive, burning them to optical media, or uploading them to a server.

- **Cataloging.** As you amass more images, you'll want a way to browse and search your ever-growing library, so you'll need to catalog the archived volumes you create in order to find your images later.

These are the steps you'll take with just about any type of photo work you do. Obviously, there will be times when you might grab a shot or two and move them into your computer to edit and output quickly without going through the rigama-role of an entire workflow. However, for most shoots, you'll perform some varia-tion of the workflow just described. Depending on the software you use, you might perform those first three steps simultane-ously, since some programs allow you to add metadata and perform rudimentary organization upon import (see Figure 13.1).

Figure 13.1

Most workflows can be broken down into eight steps. Depending on the software you use, you might perform those first three steps simultaneously.

If you're working with a client, you may find yourself performing the last part of the work-flow a little bit differently. For example, you might have a quick output step before the cor-rect and edit step, so you can post your pick images to the Web for client approval. If they don't like some images, you'll want to select alternates and out-put them again. When they sign off on the images, *then* you can start editing and post a final Web gallery of edited images for approval. If they like those, you'll do your final output to electronic files, print, or whatever your client may need (see Figure 13.2).

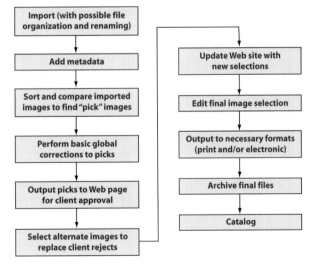

Figure 13.2

More advanced workflows allow for client approval before your final edit step.

If you're delivering elec-tronic files (for, say, pub-lishing in a magazine), you may have to use particular naming conventions. You'll have a specific naming step at some part of your workflow to get your files renamed properly.

Some people like to do an initial archive immediately after they import images into their com-puter, which gives them a backup copy of all their original files. In addition to security in the event of drive trouble, this process also provides a fallback plan should they end up creating edits they don't like.

Different types of images and different types of jobs might require slightly different variations of the workflow described here. Consequently, you'll probably find yourself regularly making little tweaks and adjustments to the way you do things, both because you'll need to experiment to work out the best workflow for you and to tailor your workflow to your current needs.

Raw Workflow

If you're working with raw files, your workflow will still proceed as explained here. You'll learn the details of raw processing in Chapter 17," Image Editing in Raw."

In the rest of this section, we'll take a closer look at each of these steps.

Importing and Organizing

We looked at these steps in Chapter 4. Importing is the first part of any workflow, and as you saw, there are many tools available to tackle your importing and organizing chores.

Backing Up Your Image Faster

After you've copied your entire shoot's worth of images to your drive, it's a good idea to back up all of your original image files. This will protect you in the event of a hard drive crash, as well as ensure that you have an original set of images in case you end up making changes or edits that you can't back out of. Also, some photographers like to preserve the original camera-generated names, since these names are guaranteed to be in the order that the images were shot. By backing up your files, you'll have one set of images with your original camera-generated names, allowing you to freely rename the images on your drive as you please.

Metadata Tagging and Keywording

Good metadata and keywords can make it much easier to keep your image archive sorted and organized, and can greatly simplify the task of finding images later. If you're posting images to the Web, you will at least want to add your copyright and ownership metadata. If you're serious about maintaining a large library of images, you'll want to apply keywords as well.

Ultimately, metadata provides an easy way to sort, filter, and organize your images as your library grows. If each individual image in your library includes metadata, you can easily search your entire collection based on metadata tags. For example, you could search for images shot on a particular date. If you've been diligent about adding good metadata to your images, you could search for images shot on a particular date, in a particular location, and related to a particular subject matter—landscape, for example.

Searches like these are only possible if you've done a good job of adding metadata. If you have, then you're not constrained to one particular organizational strategy; you can view your image library by any criteria that you want and change that criteria at any time.

You can use any keywording scheme you want, but it's best to start with broad categories and then add more specific categories for specific shoots. For example, you might apply very general keywords such as "Interior" and "Exterior," "Travel," "Landscapes," "Family," and

"Candids." If you're on vacation and you take a nice candid shot inside a museum, you could tag that image with "Travel, Candids, and Interior." As you shoot images of specific family members, you might want to create keywords with those people's names. Similarly, you might want to create specific keywords for subject matter: "Animals, Architecture, Forest, Desert, Dessert, Entrees," and so on. There's no right or wrong to keywording, but it is of little value if you don't keep a consistent set of keywords, and you don't tag your images.

File browsers such as Adobe Bridge and Photo Mechanic provide very good keywording and metadata editing tools, as do image catalogers such as Extensis Portfolio. Adobe Photoshop, iPhoto, Lightroom, and Apple Aperture also provide very good keywording and metadata tools (see Figure 13.3).

Figure 13.3

As with other workflow, cataloging, and browsing applications, Bridge provides you with a simple interface for adding and editing metadata.

Selecting Your Pick Images

As mentioned earlier, you won't want to edit and adjust *every* image you shoot. Instead, before you start editing, you'll want to identify the "keeper" images that should be passed on to the rest of your workflow. Selecting your picks is usually a simple process of browsing through thumbnails or preview images to compare different shots and find the ones you like best. Usually, you give the pick images some kind of rating that indicates they're the best image (five stars, or something like that, depending on the browser you're using).

While searching for the best images, you'll also want to apply ratings to alternate images—four stars to the second best, for example—so you can find alternative images easily when you need them.

Picking your selects is sometimes easier if you're using an application that provides a compare feature; that is, some way to view images side by side. Ideally, you also want a zoom or magnifying tool to view the images at 100 percent to check sharpness and detail. Aperture provides excellent comparison tools, as do Lightroom and Adobe Bridge. Other image browsers, such as iPhoto and PhotoMechanic, also make good tools for picking your select images.

If you shoot raw, you'll want to pick a tool that can display thumbnails and previews of your raw images without requiring any kind of complex conversion step. All the applications mentioned here can do that.

When working through your images, there are a few things you should consider when making your selections. Obviously, good composition and subject matter will probably be the first characteristics that attract your attention. When you see an image that you like, you'll want to assess the following information:

- **Sharpness.** Is the image in focus? If not, can it be saved through sharpening in an image editor?

- **Exposure.** Is the image well exposed? Are the highlights blown out? Are the shadows too dark? Does the image have the detail, color, and tonal qualities that you want?

- **Noise.** Does the image suffer from noise problems or other lens or camera artifacts? Bear in mind that just because an image looks noisy on-screen, it might still print okay. With more experience, you'll get a better eye for how much noise is acceptable.

- **The data in the image.** Does the image provide the data that you need for the types of edits that you want to perform? This is especially true when evaluating raw images. You'll learn more about how to recognize good image data when we start editing.

Correcting and Editing

After selecting your pick images, you're ready to start editing and correcting. Which software to choose for this depends on the amount of work your images will need. If your images only need simple tonal corrections, your browser might be able to make these for you. If you need to make more complex edits, you may need to go to a more advanced image editor. Your browser software probably provides a convenient way to launch images into an external editor. If it doesn't, you might want to consider a new browser.

Apple Aperture and Adobe Photoshop Lightroom both provide a full suite of raw conversion and image editing tools, and these will probably be all you need for most of your image editing chores.

Don't Forget Photoshop Elements

When we mention Photoshop in these descriptions, we mean either the Creative Suite version of Photoshop or the much more affordable Photoshop Elements, which offers all the Photoshop features most users need.

Outputting

Output covers everything from printing your images, to posting Web pages, to emailing pictures, to creating files that can be given to a friend, publisher, or printer. Depending on the editing you've been doing, you'll probably output your images using your image editor or your workflow application. If you're using your image editor, you'll have to take care of resizing and saving in the appropriate format. If you're using a workflow management tool or file browser, you might have options for automatically outputting Web galleries and email, complete with automatic resizing.

Output will be discussed in detail in Chapter 22, "Output."

Archiving and Backup

With your work complete, you'll need to make backup copies of your edited images and your original files (if you haven't already). You can create backups by simply copying images to another drive or by burning them onto optical media such as recordable CDs and DVDs. When a project is completely finished, you might want to back up all the images and remove them from your drive to free up space.

You'll probably want to keep many of your pick images on your everyday drive for easier access, so you can create portfolios and prints with less hassle.

When backing up your images, you should exercise all the same concerns as when backing up any kind of digital data. For extra safety, use multiple backups and check your backup media from time to time to ensure that it's still readable. Some people have expressed concern over the longevity of optical media, such as recordable CDs and DVDs, so you might want to recopy your backup disks periodically onto new media.

To perform your backups, you can use the file manager in your OS, CD burning software, or backup software.

When considering backup software, look for a package that allows you to do a *progressive* backup. In a progressive backup, only files that are new or changed (since the last backup) are copied. This makes for a much speedier process than recopying all of the files you want to back up.

The capability to create a perfect duplicate of your images is yet another digital advantage over film. For extra safety, you can create a copy of your images to store off-site, allowing you to ensure that your images will remain secure even in the face of property damage.

Cataloging

If you've archived images to another drive or to optical disks, you'll need to keep track of the images on each backup volume. A cataloging program such as Extensis Portfolio or Microsoft Expression is the easiest way to do this. Some browser/workflow applications, such as Adobe Bridge CS4 (and later), Adobe Lightroom, and Apple Aperture, include cataloging functionality. For maintaining a large library, cataloging software is essential.

No Right or Wrong Approach to Workflow

There's no right or wrong approach to postproduction workflow. If you can find a system that makes sense to you, allows you to identify selects quickly, perform edits, output files, and offers a long-term mechanism for managing your image archive, then you've got a good workflow.

Bear in mind that your workflow methodology might change many times before you settle on something that you like. As you refine your organizational ideas or try new or different pieces of software, you might rethink how your workflow process will go.

When altering your workflow process, there are some concerns to bear in mind:

- **Be very careful when moving your images.** If you implement a workflow change that requires a reordering of your files—maybe to new folders or to a different drive—then you'll want to be very careful about moving your files. You don't want to misplace or forget to copy any images.

- **Ratings aren't universal.** Unfortunately, there is currently no standard for how to store the rating of an image. If you rate a bunch of images in Lightroom and then decide you want to try Aperture, those ratings will not transfer. You can work around this by storing ratings in a metadata field that is common—maybe in a field you're not using, like Headline—but this is a lot of work.

- **Organizational structures aren't necessarily universal.** If you've organized images in your file manager and then want to try a program like Lightroom or Aperture, you may need to be careful about preserving organization as you transfer from one system to another. Aperture has a great command for importing a hierarchy of folders while preserving the structure. If the program you're moving to can't help you translate your organizational system automatically, then you'll need to spend extra time doing this yourself.

- **Edits don't necessarily travel.** If you've made lots of edits to an image in a program like Aperture, or Nikon Capture NX, or Adobe Lightroom, you might lose these edits when you switch to a new system. You'll be able to "bake" the edits into a finished image, but you won't be able to go back and alter them again later. Note that when moving from Bridge/Photoshop to Lightroom or vice versa, you won't have this problem.

Making minor changes to your workflow—adjusting the order you do things, adding an additional backup step, and so on—shouldn't create any additional headaches or troubles.

 Getting Started with Bridge

The easiest way to learn some of these workflow concepts is to try them out, and Adobe Bridge is a good example of a workflow tool. As mentioned earlier, the image editing examples in this book are built around Photoshop, and Bridge ships with Photoshop. If you install the demo of Photoshop (which you can download from *www.adobe.com/photoshop*), you'll also get a demo version of Bridge that you can use for the following tutorial.

Previous Versions of Bridge

If you already own a copy of Bridge CS2, CS3, or CS4, you can still use it with this tutorial. For the most part, the functions are the same, although you will be lacking a feature or two, and there will be one or two interface differences.

Non-Bridge Users

If you don't use Bridge for your workflow, and have already started using another program of some kind, work through these Bridge tutorials anyway. All of the concepts we'll explore here are the same no matter what program you ultimately choose to use, and almost all browsers and workflow tools have analogs to what we'll see here.

To prepare for this tutorial, you'll need to copy some files from the companion Web site. Go to *www.completedigitalphotography.com/CDP6* and download the Bridge Tutorial file from the Chapter 13 section. You can put it anywhere on your drive. Just be sure you know where it ends up.

STEP 1: LAUNCH BRIDGE
You can launch Bridge just like you would any other application. Note also that Bridge can be launched from within Photoshop by choosing File > Browse in Bridge (or pressing Ctrl-Alt-O on a Windows computer or Cmd-Option-O on a Mac).

STEP 2: CONFIGURE BRIDGE
If you're launching Bridge for the first time, it will present you with a dialog box asking if you want to automatically launch Bridge every time you boot your computer. For now, tell it *no*. As you use Bridge more, you may find that it's so handy that you want it launched on startup.

You should now be looking at the default Bridge interface (see Figure 13.4).

Figure 13.4

This is Bridge CS5's default interface. If you've used previous versions of Bridge, it should be familiar. If you've used other browsers, you should be able to find your way around Bridge easily.

STEP 3: NAVIGATE TO THE TUTORIAL FOLDER

In the upper-left corner of Bridge's window, you should see two tabs, Favorites and Folders. Click the Folders tab to see a hierarchical view of your computer and all its attached drives. From here, you should be able to navigate to the location of the Bridge Tutorial Folder that you copied to your drive before you began this tutorial (Figure 13.5).

When you click the folder, a number of things should happen, and your screen should look something like the one in Figure 13.6.

In the Content area in the middle of the Bridge window, you should see thumbnails of all the images in the folder. You should also see that there's a folder called "Gas Station and Aliens."

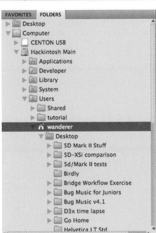

Figure 13.5

Using the Folders pane, navigate to the Bridge Workflow Exercise folder.

Figure 13.6

After clicking the folder in the Folders pane, your Bridge windows should look something like this.

STEP 4: OPEN THE SUBFOLDER

In the Content area, double-click the "Gas Station and Aliens" folder to get to that folder. You'll see thumbnails of all the images in that folder, the Folders panel will update to show your new location in the directory hierarchy, and the "breadcrumbs" along the top of the Bridge window will update (see Figure 13.7).

Figure 13.7

Bridge shows your current folder location using these "breadcrumbs" at the top of the Bridge window.

No Breadcrumbs in Previous Versions

Bridge CS2 and CS3 lacked this breadcrumbs feature.

You can click any of the breadcrumbs to navigate back to that location. This makes it easy to work your way back up your directory hierarchy. You can also use the back and forward arrows to the left of the breadcrumbs display and the Folders pane.

STEP 5: RETURN TO THE BRIDGE WORKFLOW EXERCISE FOLDER

Using the back arrow or the breadcrumbs, return to the Bridge Workflow Exercise folder. You should see the image thumbnails and "Gas Station and Aliens" folder again.

STEP 6: CHANGE THE SIZE OF THE THUMBNAILS

You can make the thumbnails bigger, to give yourself a better view, by dragging the slider at the bottom of the window (see Figure 13.8).

Figure 13.8

You can use the thumbnail slider at the bottom of the window to make the thumbnails larger or smaller.

STEP 7: VIEW AN IMAGE

Click any image to select it, and several things will happen. First, the image will appear in the Preview window in the upper-right corner of the Bridge window. This gives you a larger view of the image (assuming your thumbnails are still set small).

Second, the Metadata panel fills with all of the metadata that is stored in the image file. At the top of the Metadata panel, there's a small window that looks somewhat like the status display on your camera. It shows the essential exposure settings (see Figure 13.9).

Figure 13.9

At the top of the Metadata panel is a readout that shows all of the essential exposure information for the currently selected image.

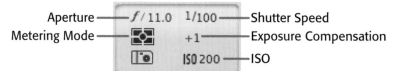

Below that readout (or beside it, depending on the width of the pane) is another small display that shows the pixel dimensions of the image, the file size, resolution setting, color space, and color mode of the image.

Below those two displays are collapsible displays that show additional categories of metadata.

EXIF metadata can be handy for answering questions you might have about your image. For example, if an image appears out of focus, you might look at the metadata and see that the shutter speed was 1/50th. Digging further, you might see that you were using your 300mm lens, and that it was focused at a distance of 180 feet. Note that not all cameras record all of these specifics.

From this data, it's obvious that, according to the handheld shutter rule, your shutter speed was too low. So you can rest assured that the camera did not misfocus. Similarly, you can use EXIF metadata to answer other questions: Was that a flash shot? Why is there bad backlighting? What meter was I using? Is this image part of a bracketed set?

Not all cameras store the same metadata. For example, you might not always find the exact focal length that was used.

You'll use IPTC metadata to keep your images organized and to search for particular images.

STEP 8: RECONFIGURE BRIDGE'S PANELS

You can resize any of Bridge's panels by dragging the borders between panels. An easier approach is to use the eight buttons at the top of the screen, which are Essentials, Filmstrip, Metdata, Output, Keywords, Preview, Light Table, and Folders. (If not all of these buttons are visible, the list can be dragged to the left, or the entire list can be viewed by clicking the drop-down arrow at the right of the list). Click the Filmstrip button, and Bridge will reorganize its panels (see Figure 13.10).

Figure 13.10

You can change Bridge's window layout to see certain information more easily.

Different Controls in Previous Versions

Bridge CS2 and CS3 use different buttons for changing window layouts. They sit as a series of small icons at the bottom of the Bridge window. They aren't labeled, but if you hover the mouse over them, a tool tip will pop up to tell you what they are.

In Filmstrip view, Bridge displays a large Preview pane, runs the Content strip along the bottom of the window, and hides Metadata altogether. Filmstrip view makes it easier to work through a shoot with a good view of your images.

Click the other buttons, and you'll find that the Metadata option offers a layout optimized for metadata editing, while Output provides tools for creating Web pages and contact sheets.

STEP 9: NAVIGATE YOUR IMAGES

If you're not already there, switch to Filmstrip layout by clicking the Filmstrip button. You'll see the currently selected image. Obviously, you can click other images to view them, but an easier way to navigate is to simply use the arrow keys on the keyboard. Use the left arrow to go to the previous image and the right arrow to go to the next image.

STEP 10: USE THE LOUPE

If you click the image in the Preview panel, a small loupe will appear, which gives you a magnified view of the area you clicked on, as shown in Figure 13.11.

Figure 13.11

Click an image in the Preview panel to activate the loupe.

You can drag the loupe around by clicking within the loupe and dragging, and you can close the loupe by clicking the Close button in the loupe's lower-right corner.

The loupe is a great way to assess the sharpness of an image. Note that when you first open the image, Bridge may have to think for a moment before it shows you a full, high-res image. Once it has calculated this information, you should be able to move the loupe around and see quick updates. On a low pixel count image, like the ones we're using for this tutorial, the loupe will work very quickly.

STEP 11: COMPARE IMAGES

Click image number 8274 to view it in the Preview panel. Now hold down the Shift key and click image number 8271. The two images should appear side-by-side (see Figure 13.12).

Figure 13.12

You can compare images side-by-side by selecting multiple images in the Content panel.

You can select a contiguous group of images by clicking the first image and then Shift-clicking any other image. All of the images in between will also be selected. To make a noncontiguous selection, hold down the Ctrl/Cmd key when clicking on additional images.

You can also select contiguous images with the keyboard. With one image selected, hold down the Shift key when you use the arrow keys to select next or previous images.

STEP 12: USE MULTIPLE LOUPES
Both of these images appear to have blown highlights in the clouds. Let's use the loupe tool to examine them more closely. Click in the clouds on the leftmost image to open the loupe. Now click on the clouds on the rightmost image. Now you can see a close-up view of each image.

You can drag either loupe around, as normal. But, if you hold down the Ctrl/Cmd key while dragging, both loupes will drag at the same time, making it easy to examine identical sections of the same images.

Close the loupes by clicking the close box on each loupe.

STEP 13: USE FULL-SCREEN MODE
Select an image in the Content panel and then press the spacebar. Your screen will go gray, and the image will be displayed as large as possible. All of Bridge's interface will be hidden, giving you a clear view of the image. (This feature is not available in versions of Bridge prior to CS4.)

You can continue to navigate forward and backward with the arrow keys. Press the spacebar again to exit full-screen mode.

Full-screen mode works in any layout, so you can also use it when using the Essentials layout.

STEP 14: CREATE A FAVORITE
We'll be using this particular folder of images in the next two tutorials, so let's create a Favorite, which will make it easier to navigate to this folder.

Switch back to Essentials view by clicking the Essentials button. In the breadcrumbs control at the top of the window, click the part of the path just *before* the folder name. Your breadcrumbs might look something like Figure 13.13.

Figure 13.13

Click the breadcrumb just before the current folder location to navigate up one level in the directory hierarchy.

You should now see the folder that encloses the tutorial folder. (Alternately, you can press Ctrl/Cmd-Up Arrow to go up one level in the hierarchy.)

Click the Favorites pane to bring it forward. Now drag the tutorial folder from the Contents pane to the Favorites pane. Anytime you want to navigate to that folder, all you have to do is click it in the Favorites pane. This gives you a way to add shortcuts easily for current projects, or any locations where you regularly add images.

To remove a Favorite, right-click it and choose Remove from Favorites from the pop-up menu. (If you're using a Mac with a single-button mouse, Ctrl-Click to access the pop-up menu.)

That's basic Bridge navigation. As you can see, it's very easy to navigate folders and view images, either as thumbnails or as full-screen images. There are more keyboard shortcuts and features to aid your navigation, so consult the Bridge help to learn more. In the next tutorials, we'll see how Bridge handles more of your workflow duties. ◣

Making Selects and Rating Images with Bridge

After you've copied your images to your drive, you're ready to start digging through them to find your select, "pick" images—the ones that you want to take through the rest of your workflow, all the way to output. Tools like Bridge make it easy to find the shots you like. In this tutorial, we'll see how to use ratings to streamline the process of making selects.

STEP 1: LAUNCH BRIDGE

STEP 2: NAVIGATE TO THE TUTORIAL FOLDER

If you worked through the last tutorial, then you should already have a Favorite defined for the tutorial image folder. If not, use the Folders panel to navigate to the location where you copied the folder.

STEP 3: SWITCH TO FILMSTRIP LAYOUT

Click the Filmstrip layout at the top of the Bridge window. We explored this layout in the last tutorial, so you should already know that it shows a nice big preview and a strip of thumbnails along the bottom of the window.

STEP 4: SELECT THE FIRST IMAGE

When you switch to Filmstrip layout, Bridge does not select an image automatically. Click the first image in the filmstrip, and it will appear in the Preview window. It should be image number 6532 (see Figure 13.14). If it's image number 8406, then Bridge is sorting in reverse order. Choose View > Sort > Ascending Order. (In Windows, the "Gas Station and Aliens" folder will appear before the first image; on the Mac, it will appear after the last image.)

Figure 13.14

Select the first image, number 6532, by clicking it.

STEP 5: VIEW THE NEXT TWO IMAGES

The image you just selected should be an image of a rocky peak in the middle of a plain. This is Shiprock in northwestern New Mexico. If you look at the filmstrip, you can see that there are two more shots of Shiprock.

We want to find out if any or all of them are worth keeping. They might all be good, but often you'll find that you only need one shot of a particular subject. In a case like this, before deciding if the current image is a keeper, it's worth taking a quick look at the other two images. Using the right and left arrow keys, navigate between the three Shiprock images to get a better idea of what they are.

STEP 6: CHOOSE A PICK

While the first and second images have some nice clouds in them, and could possibly be cropped to a more interesting composition, I think I like the third one the best (number 6544).

Bridge lets you assign a rating of zero to five stars to any image. Select the third image (number 6544) and choose three stars from the Label menu. Both the thumbnail image in the Content pane and the large image in the Preview pane should have three stars underneath them (see Figure 13.15).

Typically, I choose three stars to mark my pick images because this gives me a little extra rating "headroom." Image 6544 is strong, but as we go along, we might find other images that are stronger, which we'll want to rate as such. Having the possibility for four and five stars gives us options later.

Figure 13.15

Ratings are displayed beneath image thumbnails and previews.

STEP 7: RATE A SECOND IMAGE

I like the idea of trying to crop one of those other images later, so let's give it a two-star rating. It's not a strong contender, but something we might want to play with.

Select image 6535. Note that there are five little dots beneath it. In the Filmstrip panel, you can click on these dots to assign ratings. (The dots appear in the Preview panel, but you can't click them.) If the dots do not appear beneath the images, move the slider to the right to make the filmstrip images larger. Give this image two stars.

I chose this one rather than the first image because I like the position of Shiprock a little more, and I like the option of having more sky, if I want it.

STEP 8: CONTINUE RATING

Move on to the next images, the flowers. A quick look at them makes me think that 6660 is the best one. Give it three stars. Image 6661 is okay, but not great. As you've seen, you don't have to give every image a rating. We'll leave this one as-is.

STEP 9: REJECT AN IMAGE

Image 6662 is definitely *not* a keeper. The stick above the flower messes up the composition, and the image is not as interesting as the ones that have a bit of horizon in the background. Let's mark this image as a reject. You can either choose Label > Reject, or use the keyboard shortcut Ctrl/Cmd-Delete (see Figure 13.16).

Later, you'll see how the reject label can be useful.

Figure 13.16

You can also label images as rejects.

STEP 10: MOVE ON TO THE NEXT BATCH

Next are a series of shots of a tree. Again, take a quick pass through all of them to see if any stand out. You can also line them up side-by-side by Shift-clicking each of them.

Personally, I'm partial to the first image, just because of the three birds. I'm not crazy about the branches on the right side of the image, but I figure I can paint those out later, so I'm going to give image 6741 three stars. (If you have selected all five images by Shift-clicking, you will notice that assigning a rating to one of the images assigns it to all that are selected, so you should deselect all images except the one you want to rate.)

The rest of the tree images are pretty redundant, and there's not really any need to keep them. Sometimes, you keep alternates because you never know if you might need additional coverage of a subject. At other times, it's worth having additional shots because you might be able to use data from one to repair troubles in another. In this case, I'm going to delete all of the tree images except for the pick, 6741.

STEP 11: DELETE EXTRA TREE IMAGES

Click on image 6742 to select it, hold down the Shift key, and press the right arrow three times to select the rest of the trees (see Figure 13.17).

Figure 13.17

Select the four trees that aren't worth keeping.

Press Ctrl/Cmd-Delete, or choose File > Move to Trash. Bridge will delete the files. Bear in mind that it is throwing the *original image files* into the trash. Bridge allows you to perform file management tasks that you would normally use your file manager for. You can delete files, create folders, move and copy files, all from within Bridge.

STEP 12: RATE THE REST OF THE IMAGES

You've seen the basics of rating images. Work through the rest of the pictures in the Tutorial folder and rate them as you see fit. In the next tutorial, you'll see what you can do with these ratings. Note that images 6764 through 6766 are intended to be part of a panorama. Give them each three stars, and we'll get back to them later. Remember, not every image has to have a rating. For now, leave any unrated images in the folder and don't delete them.

You've seen three different ways to assign ratings here: by choosing a rating from the Label menu, by clicking on a dot beneath an image, and by using a keyboard equivalent. Each of these techniques works on all of the currently selected images. Note that you can also remove a rating by assigning a rating of no stars (either from the label menu or by clicking just to the left of the first star). Next, we'll see what you can do with these ratings.

Filtering Images

After you've made your picks, you're ready to start editing your images. However, as you continue to work with the folder full of images, it's nicer if you don't have to look at the images that you have *not* picked as selects. This is especially true if you're dealing with a lot of images, and don't want to have to scroll through pages of thumbnails that you're not currently interested in. Fortunately, once you have rated your images, Bridge provides some handy functions for filtering and sorting the images in a folder.

STEP 1: SWITCH TO ESSENTIALS VIEW

To get a better idea of what's going on during this tutorial, we're going to work in Essentials view, so that we can see as many thumbnails as possible.

STEP 2: LOOK AT THE FILTER PANEL

When you navigate to any folder, Bridge automatically analyzes the images in that folder and builds a set of criteria by which you can filter the folder's contents. Your Filter panel should look something like the one in Figure 13.18.

STEP 3: FILTER YOUR SELECTS

Click the three-star entry in the Filter panel. The Content panel should change to show only those images that have a three-star rating. The other images are not gone; they're simply being filtered out.

Click the three-star rating to turn the three-star filter off. All of your images should be visible again.

STEP 4: FILTER AGAIN

Click the two-star entry in the Filter panel. You should see only the two-star images in the Contents panel. Now click the three-star entry, and you will see both the two-star and three-star images. Each filter entry acts as a toggle that adds that entry to the criteria used to filter your images.

STEP 5: CHANGE A RATING

Select one two-star and one three-star image. Choose Label > Increase Rating or press Ctrl/Cmd-period. The two-star image will become a three-star image, and the three-star image will disappear. By increasing the rating of the three-star image, it becomes a four-star image and is filtered out because you've told the Filter panel to only show two- and three-star images.

But, if you look at the filter panel, you should now see a four-star entry (Figure 13.19).

Figure 13.18

The Filter panel shows you filterable criteria for the images in the folder you're currently browsing.

Figure 13.19

The Filter panel automatically updates itself every time you make a change. Note that the number of images that matches each criteria is listed on the right side of the Filter panel.

STEP 6: FILTER FOR NON-RATINGS

You can also filter for Reject images by clicking Reject in the Filter panel. For example, you can see all of the images you've marked as Reject and decide if you want to keep them or delete them en masse.

You can also click No Rating to see the images that currently don't have a rating of any kind. This can often be helpful if you want to make a second pass through your images to see if you missed anything.

STEP 7: FILTER FOR OTHER CRITERIA

The Filter panel contains a lot more than just ratings. You can filter for all sorts of criteria. For example, if the Orientation entry is not open, click its reveal arrow. It should open to show Landscape and Portrait. Click Portrait, and Bridge will show you only the images that have a portrait orientation.

You can use the Filter panel to filter for exposure settings, particular ISO speeds, for images shot on specific dates, and more. And you can stack these criteria. So you can check off a group of items to create a filter that shows, for example, three-star landscape-oriented images shot on a particular date at ISO 800. (Filtering by ISO is a good way to zero in on night shots.)

The Filter panel is a powerful tool, and it's an easy way to view only the images that you want to work with through the rest of your workflow. ◄

Tutorial Stacking Images

As we discussed in Chapter 4, you can organize your images into folders, using whatever organizational scheme you want. Within a folder, Bridge provides an additional organizational scheme, called a *Stack*.

STEP 1: LAUNCH BRIDGE
STEP 2: NAVIGATE TO THE BRIDGE TUTORIAL FOLDER ON YOUR DRIVE
STEP 3: TURN OFF ALL FILTERS

If you still have any filters activated from the previous tutorial, turn them all off so that you're viewing all of the images.

Figure 13.20

You can group a collection of images into a stack.

STEP 4: SELECT IMAGES 6764, 6765, AND 6766

I shot these three images with the idea of stitching them into a panorama later. There's no reason for our view of the images to be cluttered with all three.

STEP 5: WITH THE IMAGES SELECTED, CHOOSE STACKS > GROUP AS STACK OR PRESS CTRL/CMD-G
STEP 6: THE IMAGES WILL "COLLAPSE" INTO A SINGLE IMAGE THAT LOOKS LIKE FIGURE 13.20

The number "three" in the upper-left corner indicates that there are three images in the stack.

STEP 7: OPEN THE STACK

Click the three to open the stack and see all of the images contained within (see Figure 13.21).

Figure 13.21

When a stack is opened, you can see all of the images contained within.

You can open and close the stack by clicking its number. You can rearrange the items within the stack by dragging them into a new position within the stack. You can also assign ratings just as you would to any unstacked images. Note that, by default, all of the images are selected when you open a stack, so if you open a stack and choose a rating, all of the images will receive that rating.

Stacks and Filtering

It's very important to understand that only the first image in a stack—the one that's shown when the stack is closed—is found by filtering operations. For example, five-star images that are not the first image in a stack will *not* be shown if you elect to filter for images with five stars. If you have more than one image in a stack that you want to be able to see with a filter, then you need to make multiple stacks or pull that second image out of the stack.

STEP 8: REMOVE AN IMAGE FROM THE STACK
Click the middle image in the stack and drag it to a location outside of the stack. It will now be an individual image again.

STEP 9: ADD AN IMAGE TO A STACK
Now drag the image that you removed in step 8 back into the stack. You can easily add and remove images by simply dragging them in and out of a stack.

You can choose to group any type of image that you want. For example, the shots of the snack bar could all be grouped into a stack because they're all shots of the same subject, and you probably only need one of them. I use stacks to group panorama shots with their resulting, stitched panoramas, related subject matter, groups of shots where I've bracketed exposure, and so on.

Autostacking in Bridge

In the Stacks menu, you'll find a command called *Auto-Stack Panorama/HDR*. This feature attempts to identify which images are part of an HDR or panorama set, and then stacks them accordingly. While this is a great idea, Bridge's implementation is so slow that it's really not worth using. If you're curious, give it a try and see what you think.

Sorting Images

You've seen that you can filter images by different criteria, but you can also sort images. The easiest way to sort images is to simply drag them into the order that you want them. This is a custom sort, and you'll perform this type of sort if you use Bridge's Web output features and want your images in a particular order.

Bridge also has automatic sorting facilities. Choose View > Sort, and you'll see a sort menu with a large number of options, including the ability to sort in ascending or descending order.

Slideshows in Bridge

You can use Bridge to show a slideshow by choosing View > Slideshow. If you want the images in a particular order, sort them first, either manually or by using any of Bridge's sort options.

IPTC Metadata

By now you should be fairly familiar with EXIF metadata, the exposure and shooting information that your camera embeds in your images, which Bridge shows in the Metadata panel. But there's another type of metadata called *IPTC* (for International Press Telegraph Committee, the organization that defined the standard).

If you open the IPTC Core section of Bridge's Metadata panel, you'll see the IPTC fields that you can fill out (Figure 13.22).

If you use nothing else, you'll want to fill in the Creator field and Copyright Notice fields. This information will travel with the image even if you post it to the Web.

To apply metadata to an image:

1. Select the image(s) you want to add metadata to.

2. Fill in the appropriate fields in the Metadata panel.

3. Click the checkbox at the bottom of the Metadata panel.

Figure 13.22

The IPTC metadata fields let you store all sorts of extra, searchable information in your images.

Create and Use a Metadata Template

Because you'll often want to apply the same metadata to many images, and usually want to apply at least your name and copyright to every image you shoot, Bridge allows you to create a metadata template to speed the application of metadata.

STEP 1: LAUNCH BRIDGE

STEP 2: OPEN THE METADATA MENU

Click on the Metadata tab to activate it. If your Metadata panel isn't visible at all, choose Window > Metadata.

In the Metadata panel, open the menu in the upper-right corner (see Figure 13.23).

STEP 3: CHOOSE CREATE METADATA TEMPLATE

Bridge will present the Create Metadata Template dialog box. Fill out the fields any way you want. For a template, you typically want to keep the entries general—things that you want to apply to

Figure 13.23

You can access metadata template controls from the Metadata menu.

every image. However, if you regularly shoot specific events—weddings, for example—then you might want to get more specific. We're going to make a template just for copyright and ownership information.

STEP 4: FILL IN THE CREATOR AND COPYRIGHT FIELDS

To type a © in Windows, press Alt-0169. On the Mac, press Option-G (see Figure 13.24).

Figure 13.24

You'll want to fill in at least the Creator and Copyright fields. You might need to scroll the dialog box to find them.

STEP 5: GIVE THE TEMPLATE A NAME

You can call the template anything you want. In this case, "Ownership and Copyright" might be appropriate.

STEP 6: SAVE THE TEMPLATE

Click Save to save the template. Now let's apply this metadata to some images.

STEP 7: NAVIGATE TO A NEW FOLDER

Navigate to a folder that contains some images you've taken. You can use the Folders panel if you haven't already created a shortcut.

STEP 8: SELECT IMAGES

Select the images you want to add the metadata to. If you want to select all of the images in the folder, press Ctrl/Cmd-A.

STEP 9: APPLY THE TEMPLATE

From the metadata menu in the upper-right of the metadata template, choose Replace Metadata > [your template name]. The metadata fields of the selected images will be configured exactly as you defined in your template.

STEP 10: VIEW THE METADATA

In the Metadata panel, you should be able to see the metadata that has been entered.

The difference between Append Metadata and Replace Metadata is that Append will only alter those fields that have not already been edited. This allows you to add the contents of a metadata template to images that already have metadata without messing up those original entries.

IPTC metadata is searchable in Bridge and many other programs. You can also filter by IPTC metadata using the Filter panel, which provides yet another layer of organizational structure. ◣

Keywords

Figure 13.25

The Keywords panel makes it simple to define and add keywords.

Figure 13.26

Here's a partial list of the keywords that I have defined and used when managing my images.

While filtering by metadata is a great way to identify particular types of images—those with a particular rating, for example—there's an additional set of sorting features at your disposal.

If you haven't noticed already, one of the IPTC metadata fields is *Keywords*. You can place any words that you want in here, with specific entries separated by commas. To ease this process, Bridge provides a Keyword editing panel in the same pane as the Metadata panel (see Figure 13.25).

Bridge ships with a stock set of keywords, which may or may not be useful to you. As with folder structure, there's no right or wrong way to use keywords. You need to think about what you might want to search for—family members, specific events—and define keywords that are appropriate (see Figure 13.26).

Bridge lets you arrange keywords hierarchically within the Keywords panel. This has no impact on actual use. For example, using the list shown in Figure 13.26, if I assign a California keyword, Places is not assigned also. The hierarchical view is purely to make it easier to find a particular keyword.

Creating Keywords

To create a keyword, click the New Keyword button at the bottom of the Keywords panel. It's the one next to the Trash can, and it looks like a +.

A new keyword will be created *at the same level as the currently selected keyword*. If no keywords are currently selected, then it will be created at the root level.

If you click the New Sub keyword button, then a new keyword will be created as a subkeyword of the currently selected keyword.

Applying Keywords

Once you've defined keywords, you can apply them easily by selecting the images you want to apply the keywords to and then checking the appropriate keywords in the Keywords panel. You must check the box next to a keyword, not just select it.

Filtering by Keywords

After you've assigned keywords, a new Keywords section will appear in the Filter palette (see Figure 13.27).

You can now filter using these keywords just as you filter using anything else in the Filter panel.

▼ Keywords	
No Keywords	24
Nevada	1
Places	1

Figure 13.27

If any of the images in the current folder have keywords, then those keywords will appear in the Filter panel.

Keywords may not seem that useful when you're working with an individual shoot, but as your library grows, the ability to search for images based on keywords can make short work of finding specific images from amongst a huge library.

Collections

While you can organize your images into folders and view the contents of your folders within Bridge, there will be times when you'll want to view images from multiple folders.

One way to do this is to open up more than one Bridge window. If you choose File > New Window, you can open up an entirely new Bridge window, which lets you navigate to another folder. You can then resize your Bridge windows to view multiple folders on-screen (see Figure 13.28). You can even drag and drop files from one to the other.

A better option, though, is to create a Collection, which functions as a virtual album.

Figure 13.28

You can open multiple Bridge windows to view multiple folders.

Creating a Collection

Bridge provides easy-to-use tools for managing Collections. In this short tutorial, we'll take a look at the basics of making a Collection.

STEP 1: DESELECT CURRENT IMAGES
Click in a gray area of the Content panel to ensure that no images are selected.

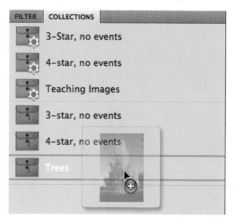

Figure 13.29

Here, I'm adding an image to a Collection by dragging it from the Content window.

STEP 2: CREATE A NEW COLLECTION
Click the New Collections button at the bottom of the Collections panel. A new Collection will appear.

STEP 3: NAME THE COLLECTION
Name the new Collection whatever you want.

STEP 4: FIND A FOLDER TO ADD
Navigate to a folder that has images you want to add to the Collection. Drag the images from the Content window into the Collection (see Figure 13.29).

Making Collections from the Current Selection

If you have images selected when you click the New Collection button, those selected images will be added automatically to the new Collection.

To view the contents of a Collection, click the Collection in the Collections panel and its contents will appear in the Content and Preview window just as if you'd clicked a folder.

The important thing to understand about Collections is that they only contain *references* to the images you include in them. Your original image files are left alone, and a reference to that location is placed in the collection. This means that Collections can contain images from multiple folders or drives.

Any changes you make to an image in a Collection—adding or changing a rating or other metadata—are made to the original image. Collections, therefore, provide you with a way of storing permanent albums of images from multiple sources.

For example, you might have a Collection called *Family*, with family pictures that are gathered up from many different folders. Similarly, you might have a Collection called *Vacation*, which contains images from many vacation folders. These two Collections might have some overlap, as some of the images in Family might also appear in Vacation.

Collections and Offline Volumes

If you add images to a Collection from an external hard drive (or any other type of remote volume, such as a shared folder on a network) and later un-mount that hard drive, those images will no longer appear in the Collection. However, Bridge will display a warning at the top of the Content pane and display a Fix button. Click this button, and you'll see simple controls for specifying a new location for the images, as well as the option to remove them from the Collection. Or you can simply leave things as they are. The next time you plug in the drive, the images will reappear.

Smart Collections

Smart Collections are Collections that automatically populate themselves with images based on a specified criteria. For example, you can build Smart Collections that automatically look inside specific folders for images with particular keywords.

 ## Creating a Smart Collection

Creating a Smart Collection is easy, as you'll see in this walkthrough. You can work through this tutorial using any images that you choose.

STEP 1: CREATE A SMART COLLECTION
Click the Smart Collections button at the bottom of the Collections panel. The Smart Collections dialog box will appear (see Figure 13.30).

STEP 2: CHOOSE A SOURCE OF IMAGES
Choose the location that you want the Smart Collection to cull its images from. This can be any folder of any volume attached to your computer.

STEP 3: DEFINE CRITERIA
Specify the criteria that an image must have to be included in the Smart Collection. In Figure 13.30, the Smart Collection is configured to find all three-star images. If you click the + button to the right of the first criteria row, you can add additional criteria, allowing you to create complex searches.

Figure 13.30

The Smart Collections dialog box lets you define the Criteria that a Collection will search for.

STEP 4: CONFIGURE RESULTS
In the Results section, specify whether all the criteria should be met, or any one of the criteria. You can also specify that you want subfolders searched.

STEP 5: SAVE THE COLLECTION
Click Save. Once you save, Bridge will start searching and populating the Smart Folder with images that match the specified criteria. ◄◢

The final results of a Smart Collection search are not remembered by Bridge. If you click off the Smart Collection to look at another directory, when you click back on the Smart Collection, the search will start over. If you're searching a large folder or using complex criteria, the search could take a while.

After a Smart Collection finishes building itself, you might want to select all of the images that have been found and make a normal Collection out of those images. Normal Collections appear as soon as you click them.

Searching Without Making a Smart Collection

If you simply want to search a folder for images that match specific criteria, you can use Bridge's Find command. Choose Edit > Find. You'll see the same dialog box that you use to define a Smart Collection. Configure it and click Find. Bridge will search and display the results in the Content panel. You can work with the images there or put them into a Collection.

One Approach to Applying Collections

I keep all of my images in one folder of a very large hard drive in my computer. It's called *Images*. I have other images as well—images from projects that I no longer need ready access to and have offloaded onto recordable disks—but the rest of my images live on this one large drive. As the library grows, I copy it to an increasingly larger drive, and I use progressive backup software to create a backup onto another drive.

To find all my three-star images, I created a Smart Folder that searches my main Images folder. It took it a while to find everything, but when it was finished, I turned all of those found images into a normal Collection called "Three-Star images." I then did the same thing with four-star images.

As I add new images and rate them with three stars, I simply add them to the three-star Collection by dragging them in. From time-to-time, I'll let the Smart Collection rebuild itself and save the results into the three-star Collection.

With Collections, Bridge lets me manage my entire archive and easily search, sort, and filter.

Batch Rename

Hopefully, by now you've seen that keywords, ratings, and labels provide you with a tremendous amount of organizational flexibility. The ability to assign and filter keywords, and to put images in collections, makes it possible to create multiple organizational schemes. For example, the same image can sit in different collections and have keywords that can be searched in different ways. For those reasons, actual file names aren't very significant. Since your camera numbers file names sequentially, many people choose to leave them as they come out of the camera, so as to have a record of shot order.

However, there will be times when you need to rename files, either for organizational reasons, or because you want to deliver a set of processed images to a client or post them to a Web site or server. Bridge includes a powerful batch renaming feature that makes it easy to rename a slew of images automatically.

Choose Tools > Batch Rename, and you'll be presented with the Batch Rename dialog box (see Figure 13.31).

Figure 13.31

The Batch Rename dialog box lets you rename groups of images with names that can include sequential numbers, dates, and other metadata.

In the Destination Folder section, you can choose whether you want the files to be renamed, or copied, or moved in addition to being renamed. The New Filenames section lets you define what naming scheme you want. From the pop-up menu, you can choose text, dates, the current filename, a metadata field, or more. Click the + button to add an additional criteria (or the – button to remove a criteria). By stacking up criteria, you can create complex naming schemes. The Preview section at the bottom of the dialog box lets you see what your final filenames will look like.

The Options section allows you to specify Windows or Mac file naming compatibility, as well as the ability to store the original name in an XMP sidecar file that gets created alongside your original image. Using this tool, you can look up the original name later, should you find it useful.

With the dialog box configured, click the Rename button to rename your files.

String Substitution

With Bridge CS5, Adobe added a powerful new renaming option called *String Substitution*. You can now create batch renaming operations that search an existing filename for a string and replace it with different text. String substitution is very handy if you've already got filenames that follow one naming scheme, and you want to change them to another, or if you want to change the sequential numbering on a file. If you accidentally batch rename a mess of files, String Substitution might be a fix for getting them renamed properly.

To access the String Substitution controls, choose Tools > Batch Rename; then open the Preset menu at the top of the Batch Rename dialog box and choose String Substitution (see Figure 13.32).

Opening Images in Photoshop

One of the most important things you can do with Bridge is to use it to open an image in Photoshop. Double-click any image in a Bridge window, and it will open automatically in Photoshop. Or you can simply press the Return or Enter key on your keyboard or press Ctrl/Cmd-O.

After finding your selects and preparing to start your editing, you can easily use Bridge to pick out an image to work on and then immediately send it to Photoshop. If you would like to open the image in another application, select the image and choose File > Open With. (You can also get to the Open and Open With commands by right-clicking on the image.)

Other Bridge Commands

While we've covered a lot of Bridge's functionality here, there's still more than we have space for in this book. However, Bridge has many other functions.

Some other things to notice and play with include the following:

- In the File menu, you'll find commands for moving or copying the currently selected file(s), as well as commands for revealing the original file in your file manager.

- If an image is rotated the wrong way, you can rotate it using Ctrl/Cmd-[to rotate counterclockwise or Ctrl/Cmd-] to rotate clockwise. You'll find these commands under the Edit menu.

- In addition to ratings, you can also apply any of five different labels. You'll find these under the Labels menu. They offer another type of "flagging" that can be useful for keeping track of specific images. As you would expect, you can filter, sort, and find based on labels.

- You can rename images in Bridge by simply selecting the file name beneath a thumbnail and typing a new one. Bridge renames the original file. The Batch Rename command under the Tools menu lets you rename an entire folder full of images. Bridge will automatically add text, a sequential number, and other data to the name. One reason I haven't stressed renaming more in this chapter is that I tend to keep my original camera-generated file names. With them, I know the images are displayed in the order I shot them, and I don't really need file names, since my images are placed in folders organized by topics, and keywords allow me to find images with specific content.

Finally, we'll explore a few other Bridge features as we get into specific Photoshop tasks.

Mini Bridge

While Bridge is well integrated with Photoshop, when you want to move quickly from one image to another, and you don't want to keep lots of big files open, then CS5's Mini Bridge might be the speediest way to handle multiple files.

Mini Bridge is a scaled down version of Bridge that sits within Photoshop itself. You won't be doing any keywording or metadata editing in Mini Bridge, but if you want a quick, thumbnail-based way to open more images, Mini Bridge might prove very useful.

To open Mini Bridge, choose (in Photoshop) Window > Extensions > Mini Bridge.

The Mini Bridge controls should be pretty intuitive. You can navigate your system using the Navigation pane and view thumbnails in the Content pane. The icons at the top of the Content pane let you filter and sort your items, while thumbnail size can be controlled with the slider at the bottom of the palette.

Note that Bridge must be running for Mini Bridge to work. If it's not, Mini Bridge will automatically launch Bridge.

You might find that, by the time you've dealt with opening and closing the Mini Bridge palette, it's not actually any easier or quicker than simply switching to Bridge to open a file (something you can do very easily with Ctrl/Cmd-Tab in either the Windows or Mac OS). However, Mini Bridge becomes a little more useful if you move it.

If you click and drag on the Mini Bridge tab, you can undock it from the rest of the palettes. Drag it to the bottom of your screen, and you should see a faint horizontal box appear. Let go of the mouse and Mini Bridge will dock to the bottom of the screen. Resize it into a strip, and you'll find you have more of an Aperture/Lightroom type interface to your images. You can quickly double-click on an image to get it open, while still seeing a filmstrip of images along the bottom of the screen (see Figure 13.33).

Figure 13.33

Mini Bridge provides a simple file browser within Photoshop. While Mini Bridge can float anywhere on-screen, it can also be docked to the bottom of the screen to create a workspace that allows simultaneous document editing and thumbnail viewing.

If you want to close Mini Bridge, open the menu in the upper-right corner of the Mini Bridge palette and choose Close.

Image Forensics

While the shooting may be over by the time you get to your image editor, there's still a lot you can learn about exposure and shooting once you get into postproduction. Paying close attention to the metadata for your image can help you understand why certain problems may have occurred.

In Bridge, you can see the metadata of the currently-selected image by simply looking in the Metadata panel (Figure 13.34). By default, the Metadata panel is open when you use the Essentials layout. You can open it in any other layout by choosing Window > Metadata.

The metadata panel mimics the status display on a camera and shows you the shutter speed and aperture at which the image was shot. If you scroll down to the Camera Data (EXIF) section of the Metadata panel, you'll find even more camera settings, usually including the shooting mode you were in, the lens you were using, the focal length of the lens at the time the image was shot, and more.

Studying this metadata can often cue you in to why an image might have gone wrong. For example, if an image appears out of focus, but you look at the shutter speed and see that it was a quarter of a second, it's probably safe to assume that focus was not the problem—hand-held camera shake was the problem.

Figure 13.34

The Metadata panel lets you see all of the camera settings that were used to shoot the currently selected image.

f / 2.8	1/250	2912 x 4368
(meter)	-0.67	12.21 MB --
AWB	ISO 1600	Untagged RGB

▼ **Camera Data (Exif)**

Exposure Mode	Auto
Focal Length	50.0 mm
Lens	50.0 mm
Max Aperture Value	f/1.2
Flash	Did not fire, compulsory mode
Metering Mode	Evaluative
Custom Rendered	Normal Process
White Balance	Auto
Scene Capture Type	Standard
Make	Canon
Model	Canon EOS 5D
Serial Number	2021200004

Or maybe your image was too dark. Looking at the metadata might reveal that you had some negative exposure compensation dialed in—an easy mistake to make if you'd used it in for a previous image and then forgotten to reset it.

Conversely, maybe an image has a lot of harsh highlights. A quick look at the metadata might tell you if the flash fired, or not, which might explain some of the overly bright spots in your image.

If your images appear excessively noisy, double-checking the ISO readout can tell you if the problem was an excessively high ISO setting.

Checking in on the metering mode can often be a clue to problems. If bright parts on the edges or in the background of your image are overexposed, check the metering mode to see if your meter was in a spot, or center-weight, mode. If it was, then it's safe to assume that this is what caused the peripheral elements to be improperly exposed.

When combined with a little deduction, the Metadata panel makes a great forensics tool for identifying shooting mistakes, and this can help you prevent those mistakes from happening again.

It's Not Which Software, It's What You Do with It

As stated earlier, whether or not you use Bridge, the concepts presented in this chapter should give you an idea of what a digital photo workflow typically looks like. While you might do it slightly (or entirely) different, you'll probably have some version of these steps.

Note that the rating and metadata steps are tasks that don't necessarily happen at any particular time. You might find yourself frequently changing ratings, adding more metadata, or changing your metadata taxonomy. With good software, it's easy to make these changes at any time when you handle your images.

Once you've chosen your picks, you're ready to start editing. We'll be dealing with image editing from here on, all the way up to the last chapter, when we'll talk about output.

EDITING WORKFLOW AND FIRST STEPS

*Understanding the Order of Edits and
Making Your First Adjustments*

After the last chapter, you may find yourself a little weary of "workflow," but the workflow we're going to talk about in this chapter is not the organizational workflow that we discussed in Chapter 13, "Workflow." Rather, we're simply going to take a quick look at the order in which you need to perform specific edits.

When working on an image, in addition to making it look better, you want to make sure that you preserve as much quality as possible. As you've learned, it is possible to degrade an image by introducing posterization—banding artifacts that can occur when you push certain edits too far. In addition to these concerns, you want to be sure that you don't perform certain operations, especially sharpening, at the wrong time.

In this chapter, we'll look at an ideal order for performing edits, and we'll get started editing.

Editing Order

For maximum flexibility and to preserve image quality, you'll usually want to perform your edits in a particular order. For example, you almost always want to apply any sharpening operations *after* you've performed all of your other corrections and edits. Because sharpening can be a very destructive operation, you want to do it only once, after you're sure nothing else in your image will change.

There are some edits that you need to get out of the way early, such as cropping and spot removal, while many of the operations in the middle of your editing cycle can be performed in any order.

In this book, you'll be learning editing operations in the order they should be performed, and as you learn them, the reasons for this order should become obvious.

You'll typically perform your edits in this order:

- **Geometric corrections.** Cropping, straightening, perspective distortion—all of these edits can all result in a crop of your image. You want to perform these functions first, so your histogram (which you'll use heavily when adjusting tone and color) doesn't include irrelevant data. Often, a big crop is required to achieve the composition you originally envisioned, so cropping first is required simply to find out if the image is one that you like. If cropping doesn't achieve the composition you thought it would, you might want to abandon the image. Finding this out early will save you from wasting time with additional edits.

- **Dust and spot removal.** If you shot with an SLR, and your image has sensor dust issues, or if your image has lens flare troubles (which can happen with both SLRs and point-and-shoots), then you want to address those early. If you can't adequately address spot concerns, you might need to give up on the image.

- **Tonal adjustment.** Good contrast is essential to a good image, so your first major adjustment after cropping and spotting will be to correct the tone in your image. In this step, you'll adjust the black-and-white values in the image to correct any contrast troubles. Often, these will be the only adjustments your image needs because correcting contrast sometimes fixes color problems as well.

- **Color correction.** After handling the contrast in your image, you'll move on to adjusting color. Color adjustments can include everything from changes in saturation, to removing a color cast, to radically altering a particular color in the image.

- **Grayscale conversion.** If you ultimately plan to convert your image to grayscale, that adjustment will happen during your tone correction stage.

- **Retouching.** If you need to remove bags from beneath a model's eyes, improve skin tones, take out ugly telephone wires, or perform any other type of retouching, you'll do that now. Retouching comes after tone and color correction, because retouching operations often involve copying data from one part of the image to another, so you want to ensure that the tone and color in your image is good overall. Also, because tone adjustments can reveal or hide detail in your image, you should perform those operations before retouching, so that you don't waste time retouching something that then gets hidden by a tonal adjustment.

- **Additional color and tonal corrections, special effects, compositing.** Any additional edits come next.

- **Noise reduction.** If your image has any noise problems, you'll attack them now. Tone and color corrections can often exaggerate noise troubles, so you want to have all your other edits out of the way before you take the time to address noise. There's another school of thought that says you should address the noise *first* before you do anything that might exaggerate it. On a particularly troublesome image, you might want to try it both ways.

- **Sizing, sharpening, and output.** Your very last step is to resize and sharpen your image in preparation for output.

Obviously, this workflow is not carved in stone, and you'll often move back and forth between different steps, as some edits and adjustments will predicate a change or alteration in other edits and adjustments.

Also, just as you crop first to determine if your image is worth editing further, if an image has a very bad color problem, you might need to perform an initial color adjustment early on, simply to find out if the image can be saved.

For example, if you shoot at night or in a dark theater, you'll probably have a white balance problem. Before you go too far into editing one of those images, you'll want to ensure that you can get the white balance back to something close to normal. Similarly, if your night shots are very dark, you might want to perform a quick brightening, simply to find out if you can see anything at all in the images. These types of adjustments can be rough initial adjustments that get refined in the normal tone and color correction parts of your workflow.

If you're working on a panoramic shot or a high-dynamic range image—images that require a preliminary process of stitching or merging, then you'll have to perform those steps *before* any of the steps mentioned here.

The ultimate goals of the workflow presented here are to preserve the highest-quality image data throughout your editing cycle and to ensure that you don't get too far into the work on an image before you discover that it's not a keeper. A slight variation is not going to destroy your image. In fact, you might do things very much out of order and still not see a difference. However, if you want to make more edits later, or different edits, you might wish you'd been a little more careful with your data.

Editing Order in a Nondestructive Editor

If you're working with Aperture, Lightroom, Capture NX, or any other nondestructive editor, order of edits is less important because your edits will be applied in the correct order by the program at the time of output. However, it's still a good idea to work in the order described here. You'll want to crop before making tonal adjustments to ensure a more relevant histogram, and you'll want to perform any geometric corrections and grayscale adjustments before you start editing in earnest, so you're editing on something closer to your final composition. If you're using Photoshop nondestructively (as you'll learn to do in this book), you'll find similar flexibility, but again you'll be best served by following this order.

About the Tutorials in This Book

The tutorials in this chapter are all built around Photoshop CS5. Photoshop's tools and interfaces have been widely imitated (and, in some cases, improved) in other applications, so you shouldn't have any trouble following along in your image editor of choice. If you're using an earlier version of Photoshop, you'll see some differences in interface, but the controls and steps described here should still work.

You can download a 30-day, full-featured trial version of Photoshop from *www.adobe.com/downloads*. This will provide everything you need to perform the tutorials. If you'd like to check out some Photoshop alternatives, you might want to download the trial version of Adobe Photoshop Lightroom from that same link or a trial version of Nikon Capture NX, which you can download at *www.capturenx.com*. If you're a Mac user, you might want to give Aperture a try. You can download a trial version from *www.apple.com/aperture*.

Histograms Revisited

In Chapter 8, "Advanced Exposure," you learned about histograms, which are graphical representations of the tonal values within an image. If you'll recall, a histogram is essentially just a bar chart of the distribution of different colors and tones in a picture, with black on the left and white on the right. Most cameras can produce histograms of images you've shot, making it easier to determine if you have over- or underexposed an image while you're in the field.

Your image editor can also produce a histogram of an image. Consider Figure 14.1.

Figure 14.1 is a simple gradient from black to white, created using the Photoshop Gradient tool. The histogram confirms that the image goes from complete black to complete white with most of the tones distributed at either end of the spectrum. You can also see from the histogram that there is a lot of contrast in this image—that is, the range of black to white covers the entire spectrum of the histogram.

Figure 14.1

This gradient from black to white yields a simple histogram.

Now look at Figure 14.2.

Also created in Photoshop, this gradient was specified as having a range from 80 percent black to 20 percent black instead of pure black to pure white. If you look at the histogram, you can see that the tones in the image fall in the middle of the graph. There are no dark or completely black tones, nor are there any light or completely white tones. In other words, there's not much contrast in this gradient—the range from lightest to darkest is very small.

Figure 14.2

This grayscale ramp from 80 percent black to 20 percent black yields a histogram similar to the one shown in Figure 14.1, but the tones are centered in the middle of the spectrum.

Why Is the Histogram of a Gray Ramp Curved?

If a grayscale ramp is just a progression from black to white, why does the histogram show more data at the dark and light end of the scale? Remember, your eyes don't see things in a linear fashion; they expand highlights and shadows to reveal more tones and detail in bright and dark areas, so the edges of the histogram accurately show more tonal information there.

Cropping

It may not be the most technically impressive tool in your digital toolbox, but over time, you'll probably find that your image editor's crop tool is one of the most powerful editing features at your disposal. With it, you can actually recompose your image after you've shot it.

Cropping is a very important first step because, in addition to changing the composition of your image, when you crop you will also remove tones from your image, which will affect your final histogram. For example, you might crop out areas of overexposed highlights, which will greatly change the appearance of your histogram. As you'll see later, this will ease your editing process.

In Chapter 9, "Finding and Composing a Photo," you performed a cropping exercise on paper as a way of exploring composition. You'll apply those same ideas when you use the crop tool in your image editor.

In this section, we're going to look at the Crop tool in Photoshop, but you'll find the same features we describe here in the Crop tools provided by Aperture, Lightroom, Nikon Capture NX, iPhoto, and most other image editors.

Cropping an Image

The hardest part of cropping is simply to decide what kind of crop you want. Using an actual Crop tool is fairly simple. Fortunately, most crop tools make it easy to explore different crops. We'll be using Photoshop for this tutorial, but you should be able to follow along in any editing program that has a Crop tool.

STEP 1: OPEN THE IMAGE

In your image editor, open the image `crop me.jpg` located in the Chapter 14 section of the companion Web site at *www.completedigitalphotography.com/CDP6* (see Figure 14.3). Copy this file to your desktop and then open it in Photoshop. You can open the image by using Photoshop's File > Open command. If you're using a Mac, you can drag and drop the image onto the Photoshop icon in the dock. If you're using Windows, and Photoshop is currently running, then you can drag and drop the document into the Photoshop window.

The subject of this image should be the birds on the telephone wire, which, with the telephone pole, look sort of like musical notes. Because I didn't have a long enough lens, I shot this image with the intention of cropping it later. I tilted the camera to straighten out the telephone wires, but now we need to crop out a lot of extraneous detail.

Figure 14.3

We didn't have a long enough lens to get this shot framed the way we wanted, so we'll use the Crop tool to recompose it.

STEP 2: DRAG OUT A CROP

Select the Crop tool. In Photoshop, you can do this by simply pressing C. Click to define the upper-left corner of the crop you want and then drag out a rectangle to define the crop (see Figure 14.4).

Figure 14.4

Using the Crop tool, drag out an initial crop. It doesn't matter if you don't get it correct right away, as you can fix it later.

STEP 3: ADJUST THE CROP

A rectangle of dotted lines will be displayed to indicate where the image will be cropped. In Photoshop, you also have the option of masking out the uncropped part of your image. Blocking out the uncropped areas makes it much easier to tell what your finished, cropped image will look like. In the Control Bar at the top of the screen, you can define the color and opacity of the crop mask, which Adobe calls the *Shield* (see Figure 14.5).

Figure 14.5

In Photoshop CS2 and later, you can specify how you want the cropped area of your image to be masked.

One advantage of using a semi-opaque Shield is that you can see what else is in the image. Personally, I like a solid Shield so I can focus on just the cropped image.

The crop rectangle provides control handles at the corners and in the middle of each edge. You can drag these to reshape the crop. Click the bottom handle and drag up to crop out the tree. Make any other adjustments you want (see Figure 14.6).

STEP 4: MAKE THE CROP

Press Return or double-click within the crop rectangle to accept the crop. Your image will be cropped and will appear in a new, smaller window.

Sometimes, it can be hard to tell if you like a crop until you've accepted it. If you decide it's *not* what you want, undo and try again. If you're using a nondestructive editor like Aperture, Lightroom, or Capture NX, you can readjust your crop at any time, meaning you're never committed to a specific crop, as you are in a destructive editor.

In this example, we performed a free-form crop. That is, our final image has a different aspect ratio than our original. There will be times, though, when you want to ensure that your final result has specific proportions. For example, if you're cropping to fit a specific design or layout, or if you're planning to print at a particular size, you'll want to constrain your crop to a specific aspect ratio.

Figure 14.6

Using the handles on the cropping rectangle, you can resize your crop.

STEP 5: REVERT TO THE PREVIOUSLY SAVED VERSION
We want to try a different crop of this image. Choose File > Revert to return to the original, previously saved version. (If Revert is not an option, simply choose Edit > Undo to undo your crop.)

STEP 6: CONFIGURE THE CROP TOOL
Our goal is to print this image out on a 4" × 6" piece of paper, so we want to ensure that our final image has the proper aspect ratio. Select the Crop tool. On Photoshop's Control Bar, enter "6 in" in the Width field and "4 in" in the Height field (see Figure 14.7).

Figure 14.7

With the Crop tool selected, the Photoshop Control Bar lets you specify an aspect ratio for cropping.

STEP 7: MAKE YOUR INITIAL CROP
Click and drag to define a cropping rectangle, as you did before. This time, your crop will be constrained to a rectangle with a 6:4 aspect ratio (or 3:2, if you prefer thinking that way).

STEP 8: ADJUST THE CROP
When working with a constrained tool, it can be difficult to nail the crop exactly right on the first try. Fortunately, after you've defined an initial crop, you can then click within the cropping rectangle and drag the crop around to position it (see Figure 14.8).

Figure 14.10

This image needs to be straightened, a task that can be performed using Photoshop's Ruler tool.

Figure 14.11

Click and hold on the Eyedropper tool to open a pop-out menu containing, among other things, the Ruler tool.

STEP 2: SELECT THE RULER TOOL

Many of the tool icons in the Photoshop toolbox are actually pop-out menus. If there's a black tick mark in the lower-right corner of a tool in the toolbox, then there are additional tools hidden "beneath" that tool. Photoshop's Ruler tool lives in the Tool palette in the same cell as the Eyedropper tool, six tools down from the top of the toolbox (see Figure 14.11).

Selecting the Ruler from the Keyboard

The keyboard shortcut for the Ruler, and all the other tools that live in the same menu as the Ruler, is I. If you press Shift-I repeatedly, you'll cycle through the Eyedropper, Color Sampler, Ruler, and Count tools. All Photoshop tools work this way. For example, L is the shortcut for the Lasso tool. Pressing Shift-L will cycle through the various Lasso tools.

STEP 3: DEFINE A STRAIGHT EDGE

Click with the Ruler tool on one end of something in the image that should be straight, such as the bottom of the metal garage door. While holding down the mouse button, drag to the other end of the garage door bottom. A straight line will be superimposed over the image.

STEP 4: STRAIGHTEN THE IMAGE

With the Ruler tool selected, the Control Bar at the top of the screen should show the Ruler tool parameters. Toward the right end of those parameters, you should see a button that says Straighten (Figure 14.12). Click the Straighten button, and your image will automatically be straightened and cropped. (If you want to erase the line and start over, click the Clear button.)

Figure 14.12

After you've defined a line with the Ruler tool, the Control Bar will present a Straighten button.

After the image is rotated, it's no longer rectangular, so straightening always requires a crop. With CS5, Photoshop automatically performs this cropping for you. In earlier versions, you'll need to crop the image yourself.

This necessity of cropping is one reason that it's best to try to get your image straight in-camera. Note that the Straighten function performs two actions, a rotate and a crop. So, if you want to undo a straightening, a simple Undo will only undo the Crop. To also undo the rotation, you'll need to choose Edit > Step Backwards or use the History palette, which you'll learn about later in this chapter.

Aperture, Lightroom, and Capture NX provide excellent straightening tools that also perform rotation and cropping at the same time, making for a simple straightening process. And since these are nondestructive editing systems, you can adjust your straightening at any time. ◪

Straightening in Previous Editions of Photoshop

Versions of Photoshop prior to Photoshop CS5 lacked the Straighten button that you saw here. If you're working with an earlier version of Photoshop, check out the Pre CS5 Straightening tutorial located at *www.completedigitalphotography.com/CDP6*.

Correcting Geometric Distortion

As with straightening, there are certain types of geometric distortions you need to correct early in your workflow because they will also require a crop. If you're a stickler for geometric accuracy, you may want to try your geometric corrections right away because if it turns out that you *can't* correct your image to your liking, you'll want to know that early so you won't waste time on other edits.

Barrel and pincushion distortions are simple geometric distortions that occur in images shot with extreme wide-angle or telephoto lenses. If you had to zoom way out when you were shooting your image, there's a good chance the vertical and horizontal lines in your picture would be bowed outward. Conversely, if your lens were zoomed in all the way, there's a chance that your image would be bowed inward. If you're using a wide-angle or fisheye attachment on your lens, your images will almost certainly be distorted (unless you're using a *rectilinear* wide-angle lens on a digital SLR).

These distortions don't occur in all lenses. In fact, the lack of them is the mark of a very good lens, and even lenses that *do* have trouble with geometric distortion probably exhibit these issues only in specific, somewhat rare, circumstances. If you find yourself facing distortion problems, you can correct them easily using Photoshop CS2 or later.

Correcting Barrel and Pincushion Distortion in Photoshop CS2 or Later

Photoshop CS2 and later provide an excellent tool for correcting all kinds of lens distortions. We'll be looking at all their features throughout this chapter, but first we're going to look at how to correct barrel and pincushion distortion.

STEP 1: OPEN THE IMAGE

Open the image `graphwall.tiff`, located in the Chapter 14/Lens Distortion document that you can download from *www.completedigitalphotography.com/CDP6* (see Figure 14.13).

Figure 14.13

This image suffers from barrel distortion, a problem we can correct easily in Photoshop.

STEP 2: APPLY THE LENS CORRECTION FILTER

Choose Filter > Lens Correction to open the Lens Correction filter. This filter provides a number of tools for correcting various lens issues (see Figure 14.14). When you first activate the filter, you'll find yourself in the Lens Correction dialog's Auto Correction tab. These controls provide automated correction for specific lenses, and we'll look at this in detail later. For now, click the Custom tab to go to Lens Correction's manual controls.

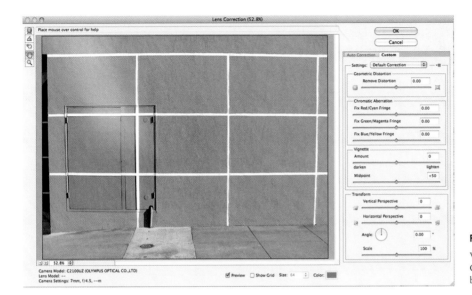

Figure 14.14

We'll use Photoshop's Lens Correction filter to eliminate the barrel distortion in our image.

STEP 3: CONFIGURE THE FILTER

The Lens Correction filter provides a simple utility function that we need to configure for our correction. Lens Correction can superimpose a Grid over your image to make it easier to see when we've restored our lines to true vertical and horizontal. Check the Show Grid checkbox at the bottom of the Lens Correction dialog box, and a grid will appear over your image. If you want, you can change the density of the grid, though the default value of 64 should be fine. You can also change the color of the grid, if you find it too hard to see.

STEP 4: REMOVE THE BARREL DISTORTION

The Remove Distortion slider at the top of the Settings pane allows you to easily correct either barrel or pincushion distortion. Slide it to the right to correct the barrel distortion. A value of +3.8 should do it (see Figure 14.15).

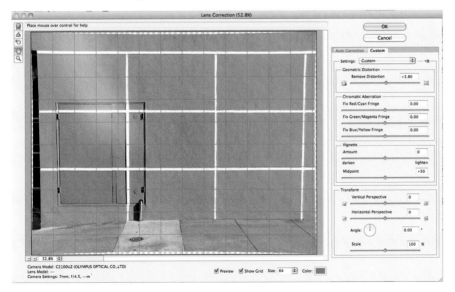

Figure 14.15

By simply sliding the Remove Distortion slider to the right, you can remove the barrel distortion from this image. To correct pincushion distortion, slide to the left.

Click OK, and you're done. That's all there is to it! Note that if you had to remove a *lot* of distortion, your image might require a crop. CS5 will add the crop for you; in previous versions of Photoshop, you'll need to do it yourself.

Straighten with Lens Correction

The Lens Correction filter also provides a Straighten tool, which you'll find in the small toolbar on the left side of the filter window (see Figure 14.16), This tool works just like the Ruler tool—simply drag to define a line that should be straight. When you release the mouse button, your image will be straightened automatically. CS5 will also automatically crop your image. In previous versions, you'll have to crop the image yourself.

If you're using an older version of Photoshop that doesn't provide a Lens Correction filter, you might still be able to perform some barrel and pincushion distortion. Check out the `Lens Distortion.pdf` document located in the Chapter 14 section of the companion Web site at *www.completedigitalphotography.com/CDP6.* ◪

Figure 14.16

You can also use the Lens Correction filter to straighten an image by selecting the Straighten tool.

Auto Lens Correction

You're going to learn a lot more about the Lens Correction filter and its abilities to correct all sorts of lens-related troubles. But while the manual controls are very effective, you can also ask the Lens Correction tool to correct your images automatically.

When you first open the Lens Correction filter, it shows its Auto Correction tab (Figure 14.17). Adobe includes profiles for many lenses and cameras, which specify exactly what optical issues they have. When you check the correction buttons in the Auto Correction tab, Photoshop reads the EXIF information to determine what type of lens and camera you're using. If a profile is available for that lens/camera combination, it will automatically correct geometric distortion, chromatic aberration, and vignetting.

If Lens Correction doesn't find a profile, you can help it out by telling it specifically what camera and lens you have. If it still doesn't come up with anything, you can press the Search Online button to see if an updated database of profiles is available.

Note that, if you choose to use automatic correction, the Custom parameters still work, so you can refine your correction further.

Figure 14.17

The Lens Correction filter in CS5 can automatically correct optical troubles, based on profiles for specific camera/lens combinations.

Correcting Perspective

There might be times when you want to adjust the perspective in an image, most commonly if you're shooting architecture. For example, when you're standing at street level shooting up at a building, the top of the building will be narrower than the bottom. This is another edit you want to perform early in your workflow because it requires cropping.

If your image editor provides free distortion tools that allow you to stretch and squash parts of an image, you can try to perform a horizontal stretch on the top of the image to make the top of the building the same width as the bottom.

If you have Photoshop CS2 or later, the easiest way to correct perspective is to use the same Lens Correction filter you used in the last tutorial.

Correcting Perspective in Photoshop CS2 and Later

Using the Lens Correction filter, we'll correct the perspective in a simple architectural snapshot.

STEP 1: OPEN THE IMAGE
Download the image `Perspective Correx.tif` from the Chapter 14 section of the companion Web site (see Figure 14.18). Shot from street level, this image has a strong perspective "distortion" that results in the top of the building appearing smaller than the bottom. This is, of course, how the building actually looked at street level. However, when walking down the street, you would most likely recognize the building's rectangular shape, which has been lost due to the perspective shift. Using the Lens Correction filter, we can adjust the image to reduce the perspective and restore the building to a stronger rectangular shape.

STEP 2: APPLY THE LENS CORRECTION FILTER
Choose Filter Lens Correction to invoke the Lens Correction filter, which you should be familiar with by now. As before, turn on the grid, and make certain it's set to a size of 64. Click the Custom tab to change to the manual Lens Correction controls.

Figure 14.18

We can correct this image to adjust the perspective distortion so it looks more rectangular.

Correcting Dust Problems

In this tutorial, we're going to use Photoshop's Spot Healing Brush tool to remove some dust from an image.

STEP 1: OPEN THE IMAGE

Open the file sensor dust.tif in the Chapter 14 > Tutorials folder on the Web site. The sensor dust should be pretty obvious—it's that big black smudge in the sky, as shown in Figure 14.23. If you look closely, you'll see some additional, smaller dust problems along the edge of the image. One of the lessons to learn from this image is that shooting on a sandy beach can lead to sensor dust problems.

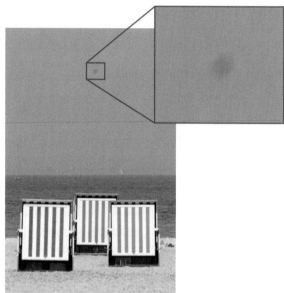

Figure 14.23

This image has a problem with some dust spots. We'll remove them with a very easy-to-use tool.

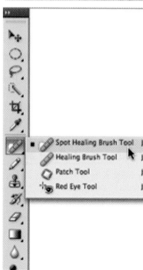

STEP 2: SELECT THE SPOT HEALING BRUSH TOOL

Select the Spot Healing Brush tool from Photoshop's tool palette (Figure 14.24).

If your version of Photoshop doesn't have a Spot Healing Brush, then you can either install the CS5 demo and work along with this tutorial, or wait until we learn about cloning later.

Figure 14.24

Photoshop's Spot Healing Brush will make short work of the sensor dust problem in our image.

STEP 3: LOOK AT THE BRUSH SIZE

With the Spot Healing Brush selected, you should see a circle when you hold the mouse over the image. This shows the current brush size. If you don't see a circle, make sure that the Caps Lock key is not activated. Place the brush over the big dust spot in the sky (see Figure 14.25).

STEP 4: SET THE BRUSH SIZE

You can change the size of any of Photoshop's brushes by using the [and] keys. The left bracket makes the brush smaller, and the right bracket makes it bigger. Adjust the brush size until the brush covers the dust spot.

Figure 14.25

You want to ensure that the current brush size is big enough to cover the dust spot you want to remove.

STEP 5: CLICK TO ERASE THE SPOT

A single click is all it takes to remove the dust spot. The Spot Healing Brush tool copies the pixels from around the area you click on *into* the area you click on. It then performs some additional blurring and adjustment to create a smooth patch over the affected area.

As you can see, there's not much to using the Spot Healing Brush. For the most part, it just works. Adjust the size accordingly and take out the rest of the dust in the image. Note that if the dust is sitting on an area that's not an even color, the Spot Healing Brush might not work as well. In these cases, the data that it copies won't necessarily merge well into the affected area. For times when the Spot Healing Brush doesn't work, you'll need to resort to cloning, which we'll get to later.

Other Spot Removal Tools

If you're using Aperture, the Spot and Patch tool will make short work of dust problems. In Lightroom, you'll want to use the Remove Spots tool. In Nikon Capture NX, you can use the Auto Retouch Brush.◤◢

Red Eye

Because of their small size, many digital cameras are particularly prone to *red-eye*, that demonic look that can appear in your subjects' eyes when the flash from your camera has bounced off their retinas and back into the camera's lens. Although there are ways to avoid red-eye when you shoot (see Chapter 10, "Lighting"), there will still be times when you will face this problem in an image and need to remove it. *Pet-eye* is a variation of this that can cause dog and cat eyes to appear blue or other incorrect colors. Some cameras now include built-in red-eye and pet-eye removal.

There are several effective methods for removing red-eye in your image editor. Which one to use depends mainly on the capabilities of your image editing software.

- **Use a red-eye removal filter or tool.** Many editing programs include special tools and filters for automatically removing red-eye. Photoshop (both the Elements and CS versions) has good red-eye reduction tools. CS5's Red Eye tool is in the same menu that includes the Spot Healing Brush tool that you just used. If you're using an earlier version of Photoshop (7 or earlier), there are some good third-party plug-ins for performing red-eye removal. Aperture, Lightroom, iPhoto, and Capture NX also provide automatic red-eye reduction tools.

- **Desaturate the red area.** Because the pupil turns red, and pupils are usually black or very dark brown, simply desaturating the red area will drain it of color and restore it to its normal dark tone. Select the affected area (you'll probably want to feather the edge of the selection by a pixel or two) and then use your desaturation method of choice. In Photoshop, you can use the Sponge tool or the Hue/Saturation dialog box. You'll learn about all of these tools later.

- **Repaint the area by hand.** If there's any natural color visible in your subject's eyes, you can try to select it with the Eyedropper tool and repaint the rest of the area with a Paintbrush or Pencil tool. This is probably the most difficult technique because you will need to be careful to preserve any highlights or catchlights in the subject's eyes. An eye without a glint of light does not look natural. Examine some non–red-eye flash photos to see what this highlight should look like.

With your geometric corrections out of the way, your image should now be at its final crop. This means that you're ready to move on to the next stage of your image editing process, tonal corrections, which we'll cover in detail in the next chapter.

Undo and History

A standard feature of both the Mac and Windows operating systems is Undo. After you perform an action in just about any program, if you want to undo that action you can simply choose Edit > Undo or press Cmd/Ctrl-Z. If you decide that you want to restore the edit, just Undo again.

In addition to allowing you to back out of a bad edit, Undo provides you with a quick and easy way to see a before-and-after view of a specific effect. Repeatedly pressing Cmd/Ctrl-Z lets you quickly toggle your last edit on and off.

Of course, sometimes you don't realize that you'd like to undo a particular edit until you've performed some other edits, at which point, the offending edit may be too far back in the editing stream. The brush tools make you especially prone to this problem as even a single brush stroke can count as a new edit, which will put the previous brush stroke beyond the reach of Undo.

The good news is that, by default, Photoshop remembers the last 20 edits that you've made. Choosing Edit > Step Backwards (Cmd-Option-Z on the Mac; Ctrl-Alt-Z on Windows) lets you work your way back through those edits, while Edit > Step Forward lets you reapply them.

You can also use the History palette to step forward and backward through edits. If the History palette isn't already visible, choose Window > History to make it active.

The History palette shows you a list of the last 20 edits (see Figure 14.26). Click on any one, and your document will revert to that state.

Note that you cannot go non-linearly. That is, you can't pick and choose a few different steps to activate. The History palette simply gives you a visual way to work back through the cached history states.

Figure 14.26

The History palette makes it easy to step back through any of the previous states of your document.

At the very top of the History palette, you'll see a thumbnail of your image. This is the last History Snapshot. Click it, and your document will return to that state. By default, it's set to whatever your image looked like when you opened it, but at any time, you can create a new snapshot by opening the pop-up menu in the upper-right corner of the History palette and choosing New Snapshot.

Since the History palette only holds 20 steps, and you can work through those very quickly, the ability to take a snapshot gives you a bit of a safety net. Before you perform any brush-heavy operations, or any time you get the image to a point where you like it, but maybe just want to try one more thing, then you should take a snapshot. If need be, you can easily revert to that snapshot by simply clicking on it.

Adding More History

In Photoshop's Preferences dialog box, under Performance, you can change the number of steps the History palette saves. While it may be tempting to crank this up real high, bear in mind that more history states will consume more RAM, and possibly lower Photoshop's performance.

Saving Your Image

Now that you've made some edits to your image, you need to save it. It's important to give a little thought to the way that you save your image, both to preserve the maximum amount of image quality and to ensure that you don't wipe out your original. No matter how many changes you might want to make, it's always a good idea to leave the original image file intact, so that you can always return to it if something goes wrong, or if you change your mind about the edits you've made.

Understanding Save and Save As

Most image editing programs have two save commands: Save and Save As. If you choose Save, your current document is saved back into the same file that you originally opened, in the same format. If you choose Save As, the image is saved into a new document. With most Save As commands, you also have the option of choosing a file format.

If you're working with a JPEG file, after you make your edits you'll want to execute a Save As command to make a new file. This will protect your original. Just as importantly, though, it will give you the option to save into a different file format. Photoshop can read and write a huge number of different file types. I typically use Photoshop format (which has a .PSD extension) or TIFF. TIFF files are a little more universal, but Photoshop usually works fine for my needs.

Both TIFF and Photoshop format are lossless, meaning you won't introduce compression artifacts into your image. As you learned earlier, when you save an image as a JPEG file (which your camera does when shooting in JPEG mode), the image data is compressed, and this compression can sometimes leave visible artifacts. If you save in TIFF or Photoshop format, you won't have to worry about further degrading your image.

After your initial save, you'll have two files: the original JPEG and the new TIFF or PSD. You can work on the new file as much as you want and even Save As again to create additional versions or to experiment with different editing ideas. The only time you'll need to save a JPEG file is if you want to create a version to post to the Web or to email. We'll discuss this process later when we talk about output.

If you're working with raw files, things will be a little different, as you'll see in Chapter 17, "Image Editing in Raw."

If you're using Aperture, iPhoto, or Lightroom, there is no saving step. Those programs automatically save images for you. You don't have to worry about creating new files until you're ready to perform your final output, at which time you might write out JPEG files for online delivery or TIFFs or PSDs for a different type of workflow. Similarly, if you're using Nikon Capture NX, it will be saving out .NEF files. You'll need to do a separate export step to output TIFFs or JPEGs.

Remember that you *only save to JPEG when you expressly need a JPEG file*. Saving as JPEG degrades your image, so you want to use a lossless format like TIFF or PSD.

After you've done a Save As to create a new file, you can continue to edit and then simply press Save to save your new changes into the TIFF or PSD that you created with your Save As command. Your original image will be safe and untouched.

Forensics in Photoshop

In the last chapter, we discussed how you can use the Metadata panel in Bridge to learn why certain mistakes might have happened. You can also check the metadata of the current image in Photoshop by choosing File > File Info, and then clicking the Camera Data tab.

15

CORRECTING TONE

Ensuring That White, Black,
and Overall Contrast Are Correct

In general, when shooting you'll want to try to calculate exposures that will allow you to capture "finished" images directly in your camera. It's very easy to get into the mindset of "I can fix it later in my image editor," and it's very likely that you *can* fix it later in your image editor. But this is not a good habit to get into. First of all, if you're shooting a lot of images, this approach can mean a *lot* of image editing work later.

But also, a good understanding of exposure—the kind of understanding that will allow you to capture good images in-camera—will expand your creative options. As discussed throughout this book, good photography is a combination of both artistic vision and hands-on understanding of craft.

However, there will be times when conditions don't allow for an ideal exposure, and other times when the image you see in your head is impossible to produce without additional editing. Finally, there will also be times when you simply mess up and don't choose the right exposure, or a moment passes so quickly that you don't have time to adjust exposure to the ideal. For all these times, you'll want to turn to your image editor.

With your image editing software, you can perform some amazing manipulations (some would say "deceptions") of your images. It's easy to be wowed by image editing tools that allow you to wildly alter the content of your image. And while creating extreme special effects and dramatic changes to an image are very technically impressive, the most useful features of your image editor are its capabilities to alter the tone and color so that the image—no matter what its content—looks better in final output. Sometimes, you'll use tone and color adjustments to correct the exposure you initially shot, and at other times, you'll use these features to *finish* the image you originally shot.

In terms of fundamental image editing, little has changed since the first edition of this book. The main tools you'll use to achieve your adjustments are Levels and Curves controls, which provide very similar functionality using two different interfaces. Most image editing programs include a Levels adjustment, and higher-end applications include both Levels and Curves. For the purposes of these tutorials, you can use any application that provides Levels and Curves. These tutorials are built around Photoshop, and while all imaged editors these days have Photoshop-like Levels controls, they don't all offer Curves. Even if you won't be using a Curves-equipped image editor regularly, it's worth going through the Curves tutorials simply for the theory that is explained.

Be Sure You Know What a Histogram Is

In this chapter, we're going to be spending a *lot* of time looking at histograms. If you aren't clear on what a histogram is, reread the histogram discussion in Chapter 8, "Advanced Exposure," and the recap in Chapter 14, "Editing Workflow and First Steps."

Correcting Tone

Tonal correction is simply the process of ensuring that the contrast in your image is good. You correct tone to ensure that the blacks, whites, and gray levels look the way you want them to look. Very often, tonal corrections are the only adjustments your image will need. With a simple tonal change, you can take an otherwise dull, hazy image and turn it into a scene that pops off the page.

Because colors also have a tone, many of your color problems will disappear with tonal correction. There are many tonal correction tools, and different ones are used to solve different problems. However, the tool you will probably find yourself using most often is a Levels adjustment, which can be found in all major image editors.

Levels

In Chapters 8 and 14, you spent some time reading histograms. From the histogram, you saw that you could easily determine when an image was too dark, too bright, or lacked contrast. What you cannot do with a histogram is correct these problems.

A Levels control lets you alter the value of the blackest and whitest points in your image and make the midtones brighter or darker. Most importantly, you can adjust any of these regions without affecting the others. For example, you can brighten dark areas without also brightening highlights.

We're going to begin our Levels work by correcting the grayscale ramp we saw in Figure 14.2. As you'll recall, this image suffers from low contrast. The brightest areas aren't white, and the darkest areas aren't black, which means that, overall, there's not much range from the darkest tone to the lightest. In other words, the darkest and lightest tones don't contrast very much.

Fortunately, if your image editor has a Levels control, you have a solution to these problems. The Photoshop Levels control can be opened by clicking Image > Adjustments > Levels or by pressing Cmd/Ctrl-L. (In previous versions of Photoshop, you'll look under Image > Adjust > Levels.) Aperture, Lightroom, Capture NX, and iPhoto—and most other image editing programs—also offer a Levels adjustment that works like the one we'll see here. The Levels dialog box is shown in Figure 15.1.

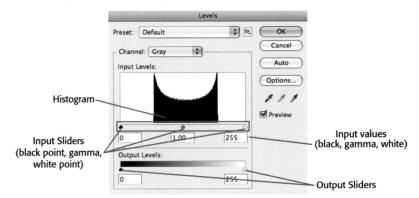

Figure 15.1

The Photoshop Levels dialog box offers a number of features. Right now, you'll be using only the histogram, input sliders, and Input Levels fields.

First, you can see that a Levels control is built around a histogram of your image. The Levels dialog in Figure 15.1 shows the histogram from the grayscale ramp we saw in Figure 14.2. Directly beneath the histogram are three input sliders. The left slider shows the position of

black in the histogram—that is, it points at the location on the graph that represents 100 percent black. The right slider shows the position of white, while the middle slider shows the gamma, the midpoint of the tonal range. The text fields below the histogram are simply numeric readouts of the positions of the three input sliders—0 represents black, white is represented by 255, and shades of gray are somewhere in between.

The easiest way to understand what these sliders do is to use them. Therefore, let's go back to the image shown in Figure 14.2 and try to correct it so it looks like the one shown in Figure 14.1.

Using Levels Input Sliders

Our goal is to correct the grayscale ramp shown in Figure 14.2 so that it has better black-and-white values and improved overall contrast. We want it to look like the smooth gradient in Figure 14.1. Although we'll be using Photoshop for this example, you can easily follow along in any image editor that provides a Levels control.

STEP 1: OPEN THE IMAGE

Open the file `grayramp.tif`, which you can download from the Chapter 15 section of the companion Web site at *www.completedigitalphotography.com/CDP6*. Once the image is up, open your Levels control. In Photoshop, choose Image > Adjustments > Levels.

If you're using Aperture, iPhoto, or Lightroom, you'll need to import the `grayramp.tif` file into your library.

STEP 2: ADJUST THE BLACK POINT

Figure 15.2 shows the grayramp document and the corresponding Levels dialog box. As you can see from the histogram, the darkest tone in this image is not full black, but is closer to 80 percent black. Make sure the Preview checkbox in the Levels dialog box is checked. Drag the black triangle at the far left of the histogram to the right until it is directly beneath the left value of the histogram (see Figure 15.2).

Now look at your image. The left side—that is, the black side—of the grayscale ramp should be black. With our Levels adjustment, solid black is no longer at 0 on the histogram. (Remember, the histogram is a graph of values from 0 to 255.) Therefore, everything to the left of our new black point is considered black. Notice that our gamma point—the middle slider—has moved automatically to the right to preserve the relationship between black, midpoint, and white.

Look at the right side of the image and notice that the lightest value has not changed. This is one of the great advantages of the Levels adjustment: we can edit different parts of the tonal range independently, while preserving the tonal relationships in our image.

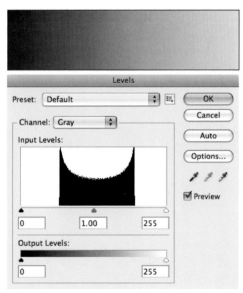

Figure 15.2

Setting the black point using the Levels control results in a gray ramp with correct black levels.

To understand this better, click OK to accept the changes. Now, open the Levels control again to see a new histogram of the image (see Figure 15.3).

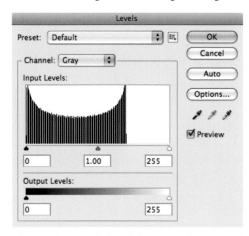

Figure 15.3

After our black point adjustment, our histogram looks different. The darker tones have been stretched all the way to black, but the overall shape of the histogram has remained the same.

You might be a little surprised to see that the histogram looks different than it did when you closed the Levels box before. Remember that after you performed your black point adjustment, the image still had a full range of tones from 0 to 255. But after the adjustment, our image looks different, so the histogram has changed to reflect the altered image.

As you can see, some bars are missing, indicating that we've lost some data. This makes sense when you think about what your black point adjustment did. You moved the black point in to specify the value that you wanted to be black.

The Levels control placed that new value at 0 and stretched all the values between 0 and your midpoint (the Gamma slider) to fill the space. Unfortunately, there wasn't enough data to fill the space, so some tonal values were left empty. To make the absence of those tones less noticeable, Photoshop has spaced these missing tones across the tonal spectrum.

The good news is that the distribution of tones within the image—as represented by the shape of the histogram—has been preserved, so the ramp still has the progression from black to white we want.

STEP 3: ADJUST THE WHITE POINT

Now we need to adjust the white point, just as we did the black point. The Levels dialog box should still be open. Take a look at the histogram. The rightmost data in the histogram stops long before white because the lightest tone in the image is not white, it's light gray.

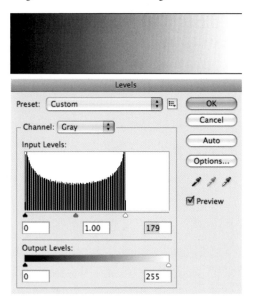

Figure 15.4

After adjusting the white point, your Levels dialog box should look something like this.

Drag the White Point slider to the left so it points to the right data in the image (see Figure 15.4).

Now look at the right side of your image. It should be a brighter white. The good news is that your shadows are still nice and dark! As with the black point adjustment, adjusting your white point also adjusted the midpoint to keep the relationship between the white point and midpoint the same. The black point was left untouched. When you brightened the whites in the image, you didn't also brighten the blacks.

To the right of the Preset pop-up menu is a small pop-up menu with commands for loading and saving Presets. These allow you to reuse your adjustments later. For example, if you've shot a series

of images in the same lighting or exposure situation, you might find that the same Levels adjustment is appropriate for all of them. In this case, you could save a Levels adjustment that could be loaded and applied to all your images. The Preset menu comes loaded with a few different adjustments.

Loading and Saving in Photoshop CS3 and Earlier

In previous versions of Photoshop, you'll find Load and Save buttons beneath the OK and Cancel buttons in the Levels dialog box. You can use these to save small files that contain your Levels adjustments. This provides the same functionality as CS5's Presets menu.

Click OK to accept your new white point and then open the Levels dialog box again to see the new histogram (see Figure 15.5). As with the black point adjustment, we've lost some more image data, but as before, we've preserved the overall tonal distribution in our image.

STEP 4: PLAY WITH THE GAMMA SLIDER
This particular image doesn't need a gamma adjustment, but there are some interesting things to learn by moving it around and observing the results. Slide the Gamma slider to the left and watch what happens to your image, as shown in Figure 15.6.

As you move it, the midtones in your image become much lighter. Slide it back to the right past its original location, and you'll see your midtones get darker. As you move the Gamma slider, your black-and-white values stay locked down at black and white. Gamma lets you adjust the midtones of your image to shift contrast more toward shadows or toward highlights. With it, you can often bring more detail out of a shadowy area, but you'll never have to worry about your blacks or whites turning gray.

Type 1.0 into the gamma readout (the middle text box above the histogram) to return the Gamma slider to its original location.

With the Levels dialog box still open, zoom in on your image. (In Photoshop,

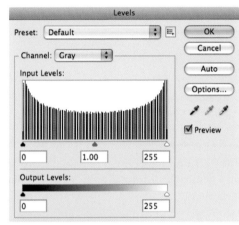

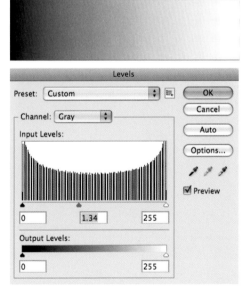

Figure 15.5

After adjusting our white point, a new histogram shows that we have lost some data, but notice that the overall distribution of tones has retained its original shape.

Figure 15.6

As we move the Gamma slider, the midtones in our image shift toward black or white.

you can do this by pressing Cmd-+ on a Mac or by pressing Ctrl-+ if you're using Windows.) Now, drag the Gamma slider to the left. Again, you'll see your midtones lighten, but now watch what's happening in the shadow areas. If you look closely, you'll probably see some slight tone breaks.

Tone breaks are the result of the loss of data that results from the Levels control stretching the tonal values in your image. In other words, as you stretch the tonal values, Photoshop is discarding data and your image is posterizing. Drag the slider in the other direction, and you'll begin to see banding in the highlights of your image as you darken the midtones, causing the highlights to stretch to fill in the now empty space.

Play around with these controls to get a feel for their effect and to see how the image changes and degrades. These changes and problems are particularly easy to see in this document because it is a simple linear gradient.

Earlier, when I discussed the concept of an image having a finite amount of editability, this is what I meant. You can only push an edit so far before you start to see breaks like this in the gradients in the image—gradients such as skies, or reflections, or shadows. An image with more data will stand up to more of these types of Levels adjustments before tone breaks appear. ◼◀

Adjusting a Real-World Image

Using a Levels control on a real image is no different from the process you just performed on the grayscale ramp. You'll set your black-and-white points and then adjust the gamma, or midpoint. In this tutorial, we're going to correct the image shown in Figure 15.7.

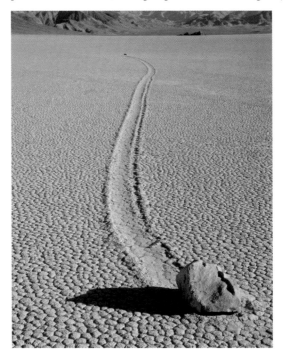

Figure 15.7

We didn't do a very good job with the exposure of this image when we shot it. It has a murky quality that stems from a lack of contrast.

STEP 1: OPEN THE IMAGE
Open the image `Real World Lefels.jpg`, which is located in the Tutorials/Chapter 15 folder on the Web site (*www.complete digitalphotography.com/CDP6*).

STEP 2: EXAMINE THE HISTOGRAM
Before you can begin making any corrections or adjustments, you need to devise a plan of attack, and the easiest way to do that is to examine your image's histogram. The histogram will help you determine what adjustments will be necessary and in what order. This is why we made certain to perform any cropping operations right away. We need to be sure our histogram contains only relevant data.

Photoshop CS and later provide a Histogram palette that lets you see a histogram of the current image. If it's not already visible, you can open the Histogram palette by selecting Window > Histogram (see Figure 15.8).

By default, the Histogram palette shows a histogram that's a little different than what you're used to. Rather than showing you a simple black histogram, it displays separate histograms for the red, green, and blue color data in your image. This can sometimes be handy when performing color corrections, but let's change it back to a histogram that's more suitable for tonal work.

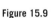

Figure 15.8

Photoshop's Histogram palette lets you see a histogram of the current image.

STEP 3: EXPAND THE HISTOGRAM DISPLAY
In the upper–right-hand corner of the Histogram palette is a small menu. Open it and choose Expanded View. This will expand the palette to include some additional information.

STEP 4: CHANGE THE HISTOGRAM DISPLAY
At the top of the menu, there should now be a Channel pop-up menu. Open it, and you'll see a number of options (see Figure 15.9).

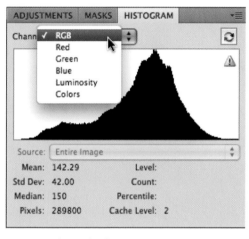

You can choose to view a histogram of the individual red, green, and blue channels, or a histogram of only the brightness information in the image (Luminosity). For tonal work, Luminosity is a good choice, but so is RGB, which builds a single composite histogram of the red, green, and blue data. That's what we'll use, so choose RGB.

Figure 15.9

In Expanded view, the Histogram palette offers some additional data, as well as the option to change the type of data the Histogram displays.

If you want to regain some screen space, use the Histogram palette's pop-up menu to change back to Compact View.

STEP 5: EVALUATE THE HISTOGRAM
As you can see from the histogram, this image has some contrast problems. There's no black or white in the image, and this lack of contrast is giving it an overall dull appearance.

STEP 6: SET THE BLACK POINT
Choose Image > Adjustments > Levels or press Cmd/Ctrl-L to open the Levels dialog box. We're first going to set the black point in the image to restore the dark tones to their proper values. There's no objectively correct black point; you can set it to wherever you want, depending on how much contrast you want to have in the image and how worried you are about shadow detail. (As you darken shadows, they'll lose detail.) The Levels dialog box provides a handy utility for determining exactly which tones are clipped by your black point adjustment.

Hold down the Option/Alt key while you drag the black point to the right. As soon as you begin to drag, your image will turn completely white. Don't worry—your picture hasn't been erased. As you continue to drag, any pixels that are getting clipped by your black point adjustment will be highlighted. This is referred to as a *threshold view* (see Figure 15.10).

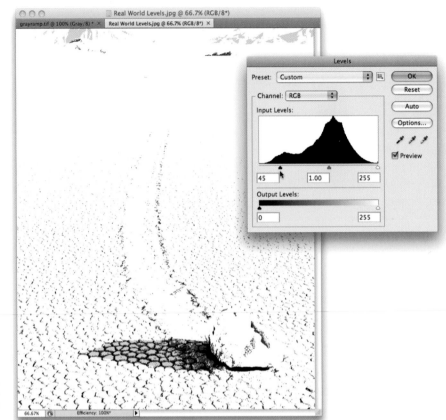

Figure 15.10

The threshold view in the Levels dialog makes it easy to see exactly which pixels are being clipped by your black point adjustment.

In Figure 15.10, some of the clipped pixels are colored. This indicates pixels that are being clipped in only one channel. For example, blue pixels are pixels that have been clipped only in the Blue channel.

We aren't as concerned about these as we are the black pixels, which indicate clipping in all three channels. The first pixels to appear are the dark shadows directly beneath the rock. If you want, you can back off until these pixels are no longer visible, to guarantee you don't clip any tones. However, if some of the shadow underneath the rock turns completely black, it doesn't really matter since there's no meaningful detail in that part of the image anyway.

You can freely release and press the Option/Alt key to toggle in and out of threshold view, allowing you to easily determine the effects of your black point adjustment.

We went for a fairly aggressive black point change to produce stronger contrast in the image, and we set the black point to 18. Note, though, that we didn't go so far that all the detail in the rock's shadow has gone to black (see Figure 15.11).

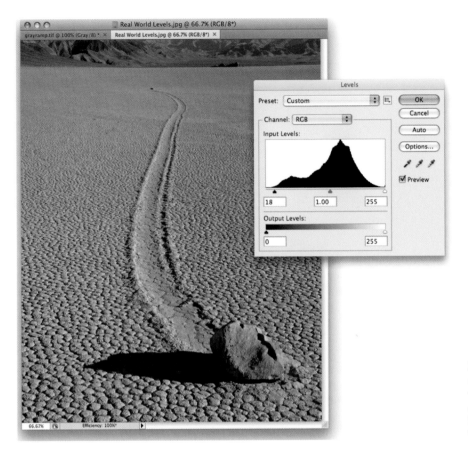

Figure 15.11

We settled on a black point of 18. While this clips some tones, they're not areas that contain important detail, and we wanted the stronger contrast.

STEP 7: SET THE WHITE POINT

You can use the same threshold view when setting the white point—just hold down Option/Alt while dragging the White Point slider to see a threshold view. In general, you can't push a white point adjustment as much as you can a black point adjustment because clipped highlights are much more noticeable than clipped shadows. So I set the white point to around 232 (see Figure 15.12).

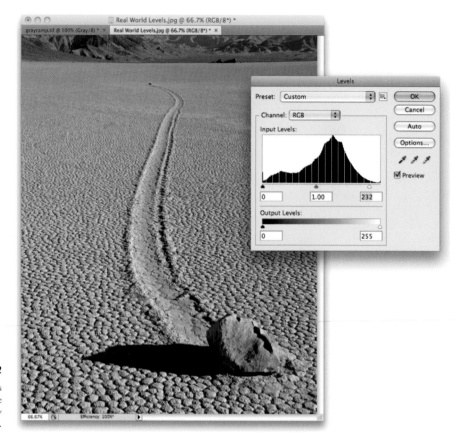

Figure 15.12

A white point of 232 brightens the image, removing some of the dullness, without blowing out any important details.

STEP 8: ADJUST THE MIDPOINT

Our image already looks much better. The dull cast is gone, and there is a "punchier" level of contrast. However, we can improve the image a little more with a midpoint adjustment.

The textured surface is composed of mid-range values. If we could darken some of those values, the texture would become more contrasted. Slide the Midpoint slider to the right to about .83 to darken the midtones (see Figure 15.13).

We lost a little detail in the rock's shadow, but not all of it, and this is an acceptable loss to pick up the extra surface texture.

That's it! Click OK to accept the Levels adjustment, and our image is corrected.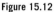

Figure 15.13

We can increase the contrast of the texture on the lakebed with a simple midpoint adjustment.

Should You Worry About Data Loss?

In the last two tutorials, you engaged in image editing operations that removed data from your image. That really sounds like something you should be worried about, doesn't it? In some cases, it is.

Fortunately, the type of data loss you just saw was not readily apparent on-screen—you had to make a fairly extreme adjustment and zoom in very close to the image—and the data loss was certainly far too slight to appear in a printout.

However, if you were to make the change you just made, and then go back and make two or three more edits that also produced some data loss, your image might visibly degrade. This is why it's so important to capture as much data as you can *when you're shooting*. If your image has a lot of tonal range to begin with, you won't have to make adjustments that are too extreme when you're editing, and your image editor won't have to throw out so much data as it manipulates the image's tones. Controlling data loss is just one more reason why it's important to choose a good exposure when you take a picture.

Once you have your image in your image editor, you'll want to think carefully about your edits to minimize your data loss. When you are editing, try to achieve as much as possible with the fewest tonal corrections. In other words, don't use a Levels command to fix your black point, and then use an additional Levels command later to adjust your white point.

Make your tonal corrections count by accomplishing as much as you can with each correction. (In the grayscale ramp tutorial, we used two separate commands, but that was only for the sake of getting to look at the intermediate histogram. Normally, we would have done the white-and-black point adjustments in one command.)

Earlier, you learned about posterization. Posterization (sometimes referred to as *tone breaks*) is the key to knowing when you've exhausted your tonal range. Posterization is also a great way to tell if you should make an edit or not. Your image editor provides a huge number of options and alternatives. If you're wondering if you should make an edit, or if you're wondering how far to push an edit, check to see if the edit introduces any posterization. If it does, back off on the edit.

Remember that posterization that shows up on-screen may not be visible in print.

Another Way to Think About Edits

As you've seen, you can make some profound adjustments to your image using just the Levels tool. In the next section, you'll see similar capabilities with the Curves tool, and later some other options. In the end, these tools all perform slight variations of the same function: they allow you to selectively brighten or darken specific pixels in an image. Some of them allow you to brighten or darken only the red, green, or blue component, but still they all function by performing a controlled increasing or decreasing of pixel values.

When you adjusted the black point in the grayscale ramp, you told Photoshop to darken a specific set of tones in the image. Photoshop was smart enough to darken the tones by varying amounts to try to create a smooth transition from the adjusted to nonadjusted tones.

The histogram provides a great visual aid for this lightening and darkening—it allows you to think of the tones in your image as a quantity that can be pushed around to different parts of the tonal range. So you might think of pushing tones down to fill in empty regions in the shadows. However, in the end, you're simply darkening tones that are already there so they fall onto a different place in the histogram.

Auto Levels

Clicking the Auto button in the Levels dialog box automatically moves the black point to the leftmost tonal value in the histogram and moves the white point to the rightmost value. Why not just use Auto every time? Because sometimes, the rightmost point on your histogram is not what you want as white in your image. The rightmost point might be a specular highlight (the type of highlight that you might see on a rippling lake in bright sunlight) or a bright flare, whereas true white is farther to the left. You might also find that, for printing purposes, you want to leave a little "headroom" above and below your tonal range.

Look at Figure 15.14. On the left, you can see an original image, with its corresponding histogram.

In the second image, I dragged the Black-and-White sliders to the edges of the data. The image is a little better, but it still lacks punch. The blackest parts of the image are probably those shadows up there in the mountains, while the very brightest parts are probably a very few pixels scattered about the snow on the top of the mountains. While those little bits are now properly exposed, the bulk of the tones in the image still lack proper contrast.

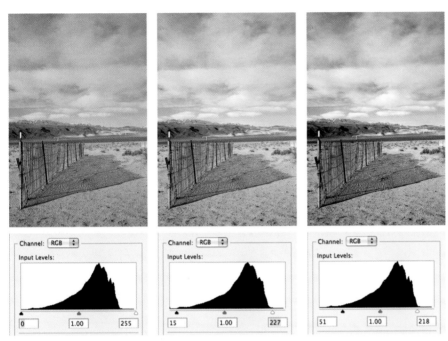

Figure 15.14

Simply moving the black and
white points to the edges of the
data isn't enough to make this
image look its best. Instead, you
need to identify the darkest and
lightest relevant data.

In the third image I dragged the black point farther in to ensure that some of the darker tones in the foreground of the image were deepened. Next, I slid the White Point slider farther to the left so that it's impacting the sky.

Very often, Auto Levels will figure out these same sort of "relevant data" issues, and if you're trying to automate your postproduction, Auto Levels can be a real time-saver. But for manual editing, it doesn't take that long to position the white-and-black point levels yourself, and learning to recognize which tones are more relevant in your image is a valuable skill.

Curves

The Levels control provides the simplest way to perform the basic tonal adjustments you will need to make regularly, but it's not the answer for all corrections. Curves is a tool that can do everything Levels does, but also provides a few other capabilities. Note that Elements 7, 8, and 9 included a curves control but it only had four fixed points. You can open the Curves dialog box by clicking Image > Adjustments > Curves or by pressing Cmd/Ctrl-M.

Curves in Other Applications

Lightroom and Capture NX also provide curves.

A typical Curves interface (see Figure 15.15) is really just a different interface to the same adjustments you were making with the Levels control.

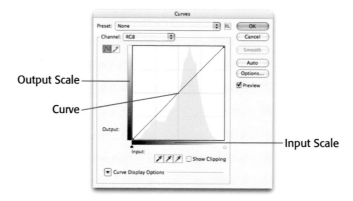

Figure 15.15

The Photoshop Curves dialog box is typical of most Curves tools, offering a simple graph of input (the tonal values before the edit is applied) values to output (after the edit is applied) values.

Like a Levels dialog, the Curves dialog box also presents a graph of the data in your image. Instead of graphing the distribution of tones, however, it shows a graph of the unaltered versus altered pixels in your image. The horizontal gray ramp along the bottom of the Curves dialog box represents the tones in your image before they are altered by the Curves command. The vertical gray ramp along the left side of the Curves dialog box represents the tones in your image *after* they are altered.

When you first open the Curves control, the Curves graph shows a 45° line from black to white, indicating that the input tones (the ones along the bottom) are identical to the output tones (the ones along the side). If you change the shape of the line, you change the correspondence of the input tones to the output tones (see Figure 15.16).

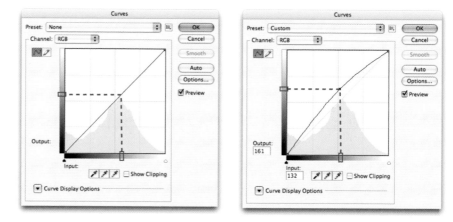

Figure 15.16

In the left diagram, before editing, each point on the input ramp corresponds to the same spot on the output ramp. After adding a point, the corresponding spot on the input graph in the right diagram is equal to a lighter spot on the output graph. What's more, all of the surrounding points have been altered along a smooth curve.

When you adjusted the black point using your Levels control, you told your image editor that there was a new value it should consider black. The image editor then stretched and squeezed the values in your image to make your desired adjustment. The curve in the Curves dialog box, which starts out as a straight line, lets you see clearly how all the tones in your image are being stretched and squeezed.

To redefine your black point using Curves, for example, you move the black part of the curve to a new location. Figure 15.17 shows the Curves adjustment required to turn the gray ramp shown in Figure 14.2 into the full ramp we saw in Figure 14.1. In other words, this curve performs the same correction we created earlier with the Levels control (see Figure 15.17). The

black-and-white points—the ends of the curve—have been dragged inward, remapping the not-quite-black and not-quite-white tones in our image. All the other tones on the curve have been adjusted accordingly.

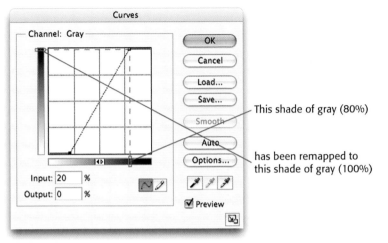

This shade of gray (80%)

has been remapped to this shade of gray (100%)

Figure 15.17

This Curves adjustment performs the same black-and-white correction as the Levels adjustment you saw earlier, effectively turning the 80–20 gray ramp shown in Figure 14.2 into the black-to-white gray ramp you saw in Figure 14.1.

The main advantage of Curves is that it lets you edit as many points as you want, whereas Levels only lets you edit three points: white, black, and mid.

Would You Like a Histogram with That Curve?

Photoshop CS3 and later show a histogram display behind the curve, making it easier to see which parts of the curve correspond to which parts of your histogram. Earlier versions of Photoshop do not include this feature. However, the Histogram palette included in Photoshop CS and CS2 (and several versions of Elements) solves this problem. Open the Histogram palette before you open the Curves dialog, and you'll be able to keep an eye on the histogram while you set up your Curves adjustment.

A Quick Word About Tone

When you are correcting and adjusting color, it's important to remember that when you add more red, green, or blue to an image, you're adding more light, and your color will get lighter. In other words, some colors are inherently brighter than others. A pastel blue, for example, in addition to being a different hue and having a different saturation, is lighter than a dark red or dark blue. Therefore, if you perform adjustments that change the color in your image, you might be changing the overall lightness or darkness of your image. In other words, color adjustments can alter the tone of your image.

Correcting Tone with Curves

The easiest way to learn how the Curves control works is to try it. In this tutorial, we're going to use the Curves tool to color-correct the fence image that you saw earlier.

STEP 1: OPEN THE IMAGE

In Photoshop, open the image fence.jpg, which is located in the Chapter 15 folder on the companion Web site (see Figure 15.18). You can use any version of Photoshop for this lesson, or install the Photoshop demo, which you can download from *www.adobe.com/downloads*.

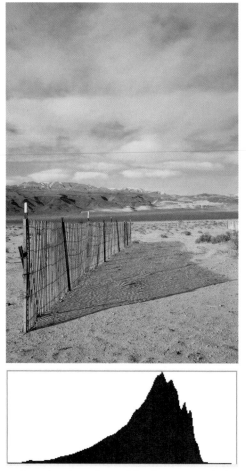

As you can see from the histogram, the image has a good amount of dynamic range. However, as is obvious from both the image and the histogram, the picture lacks contrast, so we need to reset the white-and-black points.

STEP 2: SET THE BLACK POINT

Open the Curves dialog box. In Photoshop, you can open it by clicking Image > Adjust > Curves or by pressing Cmd/Ctrl-M. The black point on the curve is the point at the bottom of the 45° line. This point indicates that black on the input scale corresponds to black on the output scale. We want to change it so that dark gray corresponds to black on the output scale. Because the input scale goes horizontally from black to white, we need to move the black point to the right.

Click the black point and drag it to the right. If you have the Histogram palette open, you can watch the black point on the histogram shift to the left, indicating that we are effectively moving the darkest point toward black. Remember, we don't want to clip the blacks, so don't let the tones in the histogram fall off the left side. When adjusted properly, the Input box should read approximately 35, and Output should stay at 0. With this move, you're saying that values at 35 or lower are equivalent to 0, or black. The dark areas in your image should now look black. What do those numbers mean? The 35 value you just selected in the Curves dialog box is equivalent to about 87 percent black (black is 0, white is 255).

Figure 15.18

The histogram confirms what your eyes will tell you: this image is too dark and needs better contrast.

STEP 3: SET THE WHITE POINT

Now adjust the white point by dragging the point on the upper-right end of the curve to the left until the Input box reads about 229. The Output value should still read 255. In other words, the value 229 has been stretched out to 255 (see Figure 15.19). So far, this is no different from the type of adjustment you make when you move the black-and-white points in the Levels dialog.

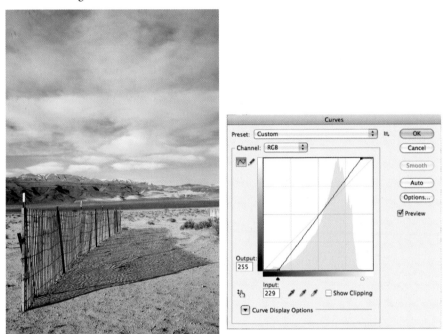

Figure 15.19

Black-and-white points are set in the Curves dialog box by sliding the endpoints toward the center of the graph.

In Photoshop CS4 and later, the Curves dialog box actually has Black-and-White sliders below the curve, just like what you see in the Levels dialog box. Sliding these does the same thing as moving the points that you just moved.

With the black-and-white points adjusted, the image should have better contrast and be slightly brighter.

STEP 4: ADJUST THE GAMMA

In the Levels tutorial, you saw how you could use the Midpoint or *Gamma* slider to adjust the midtones in an image. You can do the same thing in Curves by clicking the middle of the curve to add a new point and then dragging that curve up and down. The great thing about Curves is that, while Levels offers you three points of adjustment, Curves lets you have up to 15 points. This allows you to make subtle adjustments to very specific parts of the tonal range of your image.

Anytime you add an S-shape to a part of the curve, you increase contrast because you're darkening dark tones and lightening light tones. We're going to do that now.

The grid behind the curve makes it easy to divide the curve into four different sections. Click on the curve to add a point near the lowest quarter-tone. The Input field should read about 75.

Drag that point down and to the left until the output reads about 31. The darkest tones in the image should get darker (see Figure 15.20).

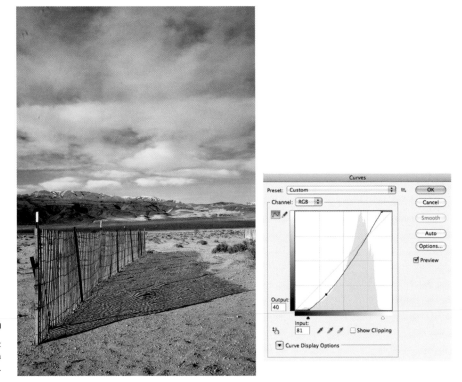

Figure 15.20

We begin our midtone contrast
adjustment by adding a point in
the lower part of the curve.

As you move the point, notice that the curve changes shape. With Curves, as you can see, your adjustments create a smooth curve of change throughout the tonal range. What this means is that in addition to adjusting that single point, you have adjusted the nearby points by varying degrees. Levels works the same way, but with Curves you can really see how other tones are affected.

STEP 5: ADD ANOTHER POINT
Now let's brighten the brightest quarter tones. Click on the curve where the grid lines meet near the upper-right corner. Input should read about 174. Drag to the upper left until Output reads 190.

This will brighten the lighter tones in your image. The gentle S that you've added to the curve gives a nice contrast boost, without disrupting the white-and-black tones (see Figure 15.21). ◄▪

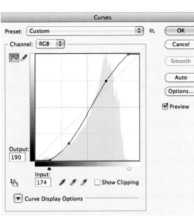

Figure 15.21

Our final curve, with a slight, contrast-increasing S-curve.

Which Should I Use? Levels or Curves?

Getting competent with the Curves dialog takes a lot of practice. If you find yourself more comfortable working with the Levels dialog box, then by all means, use it instead of Curves. Not using Curves does not make you a wimpy photographer. Curves is ideal for times when you want to make an adjustment that only affects a tiny part of the tonal range in your image. However, as you'll see in Chapter 18, "Masking," there are other ways to constrain edits.

In Aperture, you can activate a special Quarter Tones feature (see Figure 15.22), which adds two additional points to the Levels control. This gives you the equivalent of a Curves control with five points on it. In addition, the three middle points allow you to move their upper handle, so you can specify exactly which part of the tonal range you want those points to operate on.

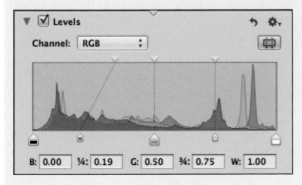

Figure 15.22

Aperture's Levels control lets you activate additional control points and change which part of the histogram is affected by each point.

(continued)

Which Should I Use? Levels or Curves? (continued)

Lightroom provides a different workaround for simplifying Curves. In Lightroom, the Curves control has separate sliders beneath it that allow you to adjust the curve with a slider interface, rather than by dragging points (although you can edit with points as well). In addition, the Lightroom curve shows a shadowed preview of what the adjusted shape of the curve is at any particular point, making it easier to predict how the curve will change as you adjust it (see Figure 15.23).

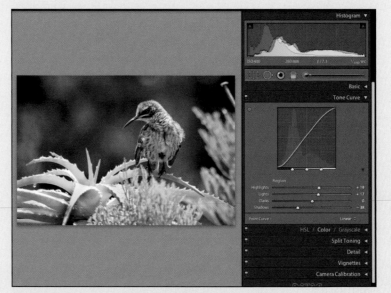

Figure 15.23 Lightroom's Tone Curve provides both point and slider controls, and innovative displays that make it easier to understand how the tone will change as you adjust it.

An Easier Way to Edit Curves

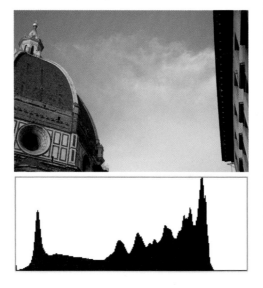

Figure 15.24

Photoshop's Curves tool provides a simple, interactive way to adjust curves. In the companion video, you'll watch me use this feature to improve the contrast in this image.

Starting with Photoshop CS4, Adobe added a new tool to the Curves dialog box that makes it much easier to identify exactly which point on the curve needs editing. In fact, with CS4 and CS5, you may not have to edit the curve directly at all.

One of the great advantages of the tool is that it is very "interactive." Unfortunately, this makes it a difficult thing to explain in print, so I've created a video called `Interactive Curbe.mov`, which you can download from the Chapter 15 section of the companion Web site. In it, you will adjust the contrast of the image shown in Figure 15.24.

Brightness and Contrast

Some image editors, Photoshop included, provide a Brightness and Contrast control. These controls are like the brightness and contrast controls on a TV set. However, depending on the application you're using, you may not want to use this feature. In all versions of Photoshop prior to CS3, the Brightness and Contrast control was pretty much useless. Unlike Levels and Curves, Brightness and Contrast in older versions of Photoshop didn't let you independently adjust separate parts of the tonal range, making it virtually impossible to make the types of corrections we've seen in this chapter. With CS3, Adobe fixed the Brightness and Contrast control, making it a far more useful tool. However, you'll still probably find Levels more flexible and easier to use.

Learning to See Black as Black

One of the most important senses you'll develop as you grow as a photographer is the ability to recognize black and white. This may not sound especially difficult, but it is important to understand that "black" is not a subjective term. While an image may have some very dark tones that you recognize as representing black, they may not really be black.

For example, consider Figure 15.25, which has shadow tones that look very dark.

But the dark shadows aren't actually black, and this is something you need to be able to recognize. On the next page, look at Figure 15.26, which has shadows that are truly black.

Figure 15.25

This image has a wide tonal range with bright highlights and dark shadows.

Figure 15.26

This image has true blacks, which Figure 15.25 lacks.

In this case, it doesn't matter if you think one image looks better or not. The point is simply to recognize that there can be a subtle, but very important difference between very, very, very dark gray and black. In most cases, very, very, very dark gray will not yield as good a print as true black.

You will not necessarily be able to get the tone in your image adjusted completely with these tools. There might be isolated shadows that need to be brightened or midtones that have gone a little dark. For these troubles, there are specialized tools, which you'll learn about later.

But before you address specific areas, you want to ensure that the baseline tone in your image is good. After the Crop tool, of all of the editing tools we'll look at in this book, the tools you learned in this chapter are the ones you'll use most often.

While we'll continue to work with these tools, if you're not feeling confident with them, try doing some experimentation on your own. Competency with tonal adjustments is essential to getting good results from your postproduction process, and like many tools, the ones you've learned here will get easier with practice, as you begin to develop a sense for how a particular adjustment will work.

16

CORRECTING COLOR

Repairing, Improving, and Changing Color

Despite the advantages of digital cameras, in one way, it's a little harder to learn photography with a digital camera than with a film camera. In the film days, you typically learned to shoot exclusively in black and white, for the simple reason that a color darkroom was very expensive.

The upside to this was that working in black and white meant you only needed to concern yourself with tone and luminance. As a digital photographer, it's every bit as important to concern yourself with tone and luminance, but because we all shoot in color with our digital cameras, we have to learn luminance and color simultaneously—both how to capture them and how to use them creatively.

You might think "but color's easier, because it's how I see the world." But as we've already discussed, a photo is not a perfect recording of your experience of the world. It's a flat, small sample of the world, represented with far less color than what your eye can perceive. So color and tone have to be used very skillfully to create a resonant image. Fortunately, most cameras today are very good at capturing accurate color, and most image editors have very sophisticated tools for manipulating and altering color.

As discussed already, you'll perform your color correction after your tonal adjustments, for the simple reason that, once you've corrected the tone in your image, you may no longer have any color problems. (Bear in mind, that on many images, you'll make initial tonal corrections, then initial color corrections, and then possibly continue to tweak both through the rest of your editing workflow, as you refine your sense of how the image should look. If you haven't read the tonal correction lessons in the previous chapter, you need to do so before proceeding.)

You'll adjust color to make it more accurate, to make it more aesthetically pleasing, or because you want to change the color of a specific object to make it more visible, more stylized, or more hidden.

In this chapter, we'll look at a number of tools for editing color. As with the tonal correction tools we looked at in the last chapter, most image editors will have similar features to the Photoshop tools we'll look at here. Also, as with the tonal corrections you've learned, the color correction tools we'll see here will be *global* tools. That is, they'll affect your entire image. Later, you'll learn how to constrain the effects of your color correction tools to specific parts of your image. But, as with tone, it's important to have the color correct in your image before you begin working on localized problems or manipulating the color in more "creative" ways.

Levels and Curves and Color

So far, you've seen how Levels and Curves controls can be used to adjust tone and contrast, whether in color or grayscale images. These tools, however, can also be used to adjust, correct, and change color. In previous chapters, you read about many ways in which color could go wrong when you shoot. Levels and Curves are two tools that allow you to fix color problems that arise from bad white balance, improper exposure, or a bad camera.

To understand how Levels and Curves affect color, you have to understand how color is stored in an image. In Chapter 1, "Eyes, Brains, Lights, and Images," you learned that digital cameras make color by combining red, green, and blue information. These separate red, green, and blue components are referred to as *color channels*, or just *channels*, and many image editors allow you to perform corrections and adjustments on these individual channels.

In Photoshop, you can access the different color channels through the Channels palette (click Window > Channels). The Channels palette includes separate rows for the Red, Green, and Blue channels, and for your image—the RGB channel (see Figure 16.1). By clicking each channel, you can view its contents.

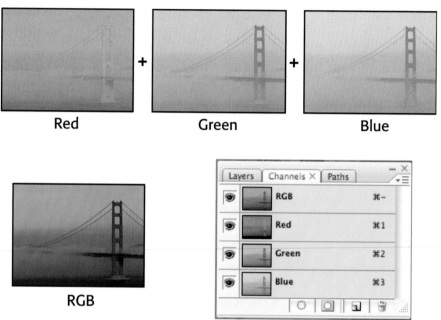

Figure 16.1

The Channels palette lets you view and edit the individual Red, Green, and Blue channels that make up your RGB documents.

If you click the Red channel in the Channels palette, you'll see a grayscale image that represents all the red in your image. Why is it grayscale? Because, if you'll recall, one *24-bit image* is made up of three separate *8-bit images*, and with 8-bit images you can have up to 256 shades of gray. When you look at an individual color channel, you're looking at the grayscale image where that particular component color information is stored. A bright white pixel in a Red channel equates to full red in your final image, because bright white has a value of 255, the maximum allowed in an 8-bit image (see Figure 16.2).

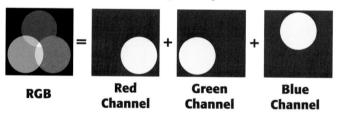

Figure 16.2 Individual channels are displayed as grayscale images. White indicates the full amount of that channel. Here, you can see the individual color channels that add up to create a finished color image.

Combine a bright red pixel in a Red channel with identical pixels in the Green and Blue channels and you'll have a white pixel in your final image, because full red, plus full green, plus full blue equals white. In other words, what you see in individual channels are a representation of the quantity of that particular color.

For example, Figure 16.1 is a picture of the Golden Gate Bridge against a blue sky. The bridge, of course, is a deep reddish orange. If you look at the Red channel, you'll see that the bridge appears white. This is because it has a lot of red in it, and lighter pixels in the Red channel mean more red in those pixels in the final image.

Now look at the Green channel. The bridge is very dark because the particular reddish-orange color of the bridge contains very little green. Same with the Blue channel. So, a color channel is simply a map of each of the three color components in your image, showing how much of each occurs at each pixel in the final image.

It's possible to edit the color channels directly, and there are a number of editing tricks you can employ that rely on individual channel edits. In addition, through the Channel pop-up in Photoshop's Levels and Curves dialog, you can perform Levels or Curves adjustments on specific color channels. When you view a channel in Photoshop, you can use all of the editing, painting, and manipulation features that you would normally use. This is a very handy feature for digital camera users, because digital cameras sometimes have trouble with specific channels. For example, some cameras produce more noise in one channel than another. With your image editor, you can try to attack the noise in an individual channel directly by applying special noise-reducing filters or blurs—or even painting by hand—directly into that channel.

Similarly, you may find that the color in your final image is off because one particular channel is out of balance. When this happens, you can correct the color in your final image by manipulating an individual channel.

Depending on how you like to perform your edits, you may not find that you ever need to edit an individual channel directly. However, an understanding of separate channels is necessary to understand how certain color correction operations work, such as the one we'll see in the next tutorial.

 ## Correcting a Color Cast

So far, you've used the Levels control to adjust contrast and tone in an image by changing the white-and-black points. You've performed these adjustments by moving the White-and-Black Point sliders. Most Levels adjustment tools provide an additional way to set white-and-black points, and a way to neutralize color casts easily. In this tutorial, we'll explore both of these features.

STEP 1: OPEN THE IMAGE
In Photoshop (or your image editor of choice), open the image `Tumbleweed.tif`, located in the Chapter 16 section of the companion Web site at *www.completedigital photography.com/CDP6.*

This image needs a contrast adjustment, but it also has a reddish color cast that should be corrected (see Figure 16.3).

Figure 16.3

This image needs a Levels adjustment to correct contrast and its color cast.

STEP 2: OPEN THE LEVELS DIALOG BOX

Choose Image > Adjustments > Levels or press Cmd/Ctrl-L to open the Levels dialog box. From the histogram, you can see that the image lacks any true white—there's no data extending all the way to the right side of the histogram. As you learned in previous tutorials, you can adjust the White Point slider to define a new white point, but you can also use the White Point eyedropper, the rightmost eyedropper located directly beneath the Options button.

STEP 3: SET THE WHITE POINT

Click the White Point eyedropper to activate it and then click with the eyedropper on something in your image that is supposed to be white (see Figure 16.4).

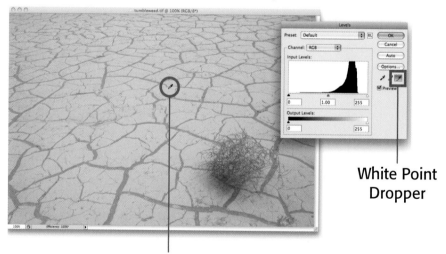

White Point Dropper

Figure 16.4

The White Point eyedropper lets you set the white point by simply clicking on something in your image that is supposed to be white. Here, you can see where we've chosen to click.

Setting white point here

After setting the white point, the image will immediately look better (see Figure 16.5).

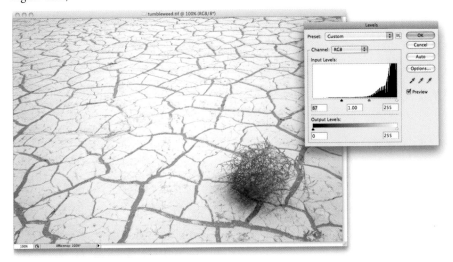

Figure 16.5

After setting our white point, the image has much improved contrast, but it still has a slight reddish cast and a weak black point.

STEP 4: SET THE BLACK POINT

The image still lacks contrast, so you need to set the black point, just as you did in the previous chapter. Slide the Black Point slider to the right to improve the contrast. Unlike the white data on the right side of the histogram, the black data does not make a sharp transition. There's no clear "start" point for the black end of the data, so you've got some room to play with. So, to a degree, you can simply darken to taste. I kept a close eye on the shadows under the tumbleweed to ensure they didn't go too dark and that no posterization occurred (see Figure 16.6)

Figure 16.6

Drag the Black Point slider to set the black point.

STEP 5: CORRECT THE COLOR CAST

There are two other eyedroppers in the Levels dialog box. The Shadow dropper lets you set the black point of an image by simply clicking on something black—just as you corrected the white point by clicking on a white area. We didn't use it for this image because there's nothing in the image that is supposed to be pure black, so there would be no place to click the dropper.

The middle dropper lets you define something in the image that is supposed to be neutral or middle gray.

Select the Neutral eyedropper and then click on one of the gray parts of the image, as shown in Figure 16.7.

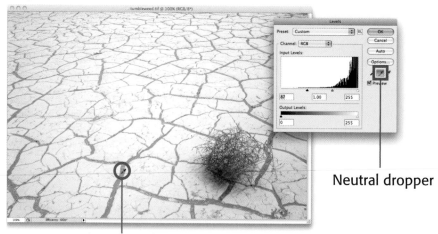

Neutral dropper

Setting neutral point

Figure 16.7

By selecting the Neutral eyedropper and clicking an area in our image that is supposed to be a neutral gray, we can neutralize the color cast in the image.

When you use the Neutral eyedropper to tell Photoshop that a particular pixel is supposed to be neutral, it automatically performs separate Levels adjustments on the individual red, green, and blue channels so the resulting tone is neutral. In a way, it's kind of like white balance. By setting the neutral point correctly, all the other colors fall into line and the color cast is eliminated.

STEP 6: CLICK OK TO ACCEPT THE EDITS

If you like the new color, you're done with the image. If you don't like the new color—or if the color cast has changed—you might not have clicked on a pixel that was truly supposed to be neutral. Click again in a different place until you find a point that results in a neutral image.

All the eyedroppers work this way. If you don't like the initial result, simply click again in another location. You can also use the droppers and sliders interchangeably. So you might set the white point with the dropper, but then set the black point with the slider, as we did earlier. As you practice more with the Levels control, you'll get a better idea of which controls are best for which operations.

When you're finished adjusting your image, click OK. ⬛

Bad White Balance in JPEG Images

The tumbleweed file that you used for this tutorial was in TIFF format, but you can also use this technique with JPEG or any other type of image.

Shoot with a Gray Card

In Chapter 7, "Program Mode," you learned about shooting with a gray card to ease your white balance correction (see Figure 7.16). As you just saw, when you have an area that you know is supposed to be gray, correcting a color cast is very simple. So you could use the technique you just learned and click on the gray card shown in Figure 7.16 to help reduce the color.

Neutralizing Images in Aperture, Lightroom, and Capture NX

In Aperture, you can neutralize color casts using the Gray Tint slider located in the Exposure adjustment; however, you might also find that the White Balance dropper will fix your color cast problems.

In Lightroom, you'll use the White Balance dropper, while in Capture NX, you use the Set Neutral Point dropper in the Levels & Curves edit.

Correcting Color with Curves

Whereas Levels lets you edit the black, white, and midpoints, with Curves you can set up to 14 different points at any location along the curve, allowing you to precisely edit particular tonal ranges. Earlier, you saw how to use Curves to achieve a Levels-like correction. In this tutorial, you're going to use Curves to perform a color correction that would be impossible with Levels.

STEP 1: OPEN THE IMAGE

In Photoshop, open the image bud.jpg located in the Chapter 16 section of the companion Web site (see Figure 16.8).

Figure 16.8

Using a single curves control, we're going to brighten this image and adjust the color to make the yellow stand out a little more.

STEP 2: CHECK THE HISTOGRAM

A quick look at the histogram shows that our blacks are not clipped, meaning we don't really want to move the black point. Nevertheless, the image is too dark so the shadow areas are going to need to be lightened. As you've already seen, the background of the Curves dialog box provides a reference grid that shows midpoints and quarter-points along the curve. Click the bottom-left quarter-point and drag up to brighten the shadow areas, as shown in Figure 16.9.

There's no right or wrong place to start when correcting this image. However, when using curves, it's usually a good idea to begin with either the highlights or shadow areas to map out the extremes of contrast in your image before you worry about the midtones.

Figure 16.9

For this image, we're leaving our white-and-black points where they belong and beginning our editing by adding a point to brighten the shadow details.

STEP 3: ADJUST THE WHITE POINT

With this single adjustment, the image already looks better, but we've lost a little contrast (a fact that is confirmed by the histogram). Lower contrast means less information between the black-and-white points, so we're going to restore our highlights by adding a point in the upper quarter of the curve. (See Figure 16.10.)

Figure 16.10

To restore some lost brightness, we apply another point in the highlight region of our curve. Our curve now has two additional points, and the contrast in the image is improved.

STEP 4: ADD MIDPOINT AND TWEAK

As is clearly visible in the Curves dialog, a change in one part of the curve can greatly affect another part of the curve. Consequently, correcting with curves is not usually a straight procedural process. You often have to move between points, tweaking and re-tweaking them as you reshape the curve. For this final step, we moved the first point to deepen the shadows a little more, and we added an additional point to brighten some of the middle tones to produce the image in Figure 16.11.

Figure 16.11

Finally, we add an additional point to darken the shadows and then tweak the midpoint to brighten the image. Our curve now has three additional points.

STEP 5: WARM UP THE FLOWER

For our final correction, we want to add some warmth to the flower to separate its yellow-ish/green tone from the predominantly green background. Earlier, you saw how you could use the Channels palette in Photoshop to view individual color channels in your image. Because some edits are easier to perform on individual color channels than on the entire composite image, the Curves dialog allows you to adjust the curve of individual color channels. (Similarly, the Levels dialog lets you perform levels adjustments on individual color channels.)

Therefore, to warm up the flower, we want to add some red to the yellow tones that make up the flower. In the Curves dialog, open the Channel pop-up menu and select Red. You should see a new flat curve. Don't worry, the curve you just built is not gone—you can switch back to it by selecting RGB from the Channels pop-up menu. The Curves dialog lets you keep separate curves for each channel, plus the RGB composite.

Your goal is to shift the curve to the top left to add more red. However, you only want to move the part of the curve that contains the yellow information of the flower, so as not to adjust the red in the green tones of the background.

With the Curves dialog open, click in the image and drag around. A circle will appear on the curve and move around as you drag the mouse. This circle is showing you where the selected pixels map onto the curve. In this way, you can easily identify the part of the curve that needs editing.

Cmd-click (or Ctrl-click if you're using Windows) on part of the yellow flower. Photoshop will automatically add a point to the part of the curve that corresponds to this color. Drag this point up and to the left to add more red. This will warm up the flower, but will also add a red cast to your image. To compensate for this, add one point on each side of your first point and then drag the points back down to flatten the curve. (See Figure 16.12.)

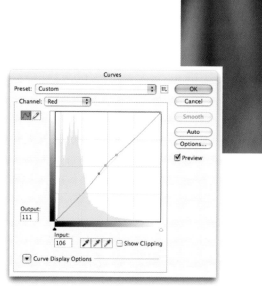

Figure 16.12

The final Red channel adjustment shown here isolates a very small part of the curve and boosts the red just a tiny bit, resulting in our final image, which has a much warmer flower.

Learn Your Curves Keyboard Shortcuts

For making smaller adjustments to a point on the curve, you'll have an easier time using the keyboard. Select a point with the mouse and then use the arrow keys to move it up, down, left, and right. Hold down Shift to move the point 10 units at a time.

Hue/Saturation

While both Levels and Curves are great for altering color and improving tone, when it comes to adjusting the saturation of an image or altering a specific color, there is a better choice: Hue/Saturation. In this tutorial, we're going to take a quick look at saturation adjustment using Hue/Saturation. Later, we'll see more about altering color using this powerful tool.

The goal of this tutorial is to fix up the image shown in Figure 16.13. While the image looks okay as-is, it's a little bit flat. We're going to use a saturation adjustment to give it more punch.

Figure 16.13

This image looks okay in terms of contrast and tone, but we want to liven it up a little.

 Adjusting Saturation

STEP 1: OPEN THE IMAGE

In Photoshop, open the image `saturation buildings.tif` located in the Chapter 16 section of the companion Web site at *www.completedigitalphotography.com/CDP6*.

STEP 2: PERFORM SATURATION ADJUSTMENT

In Photoshop, choose Image > Adjustments > Hue/Saturation or press Cmd/Ctrl-U. The Hue/Saturation dialog box appears.

Drag the Saturation slider to the right to about +23 to increase the saturation in the image (see Figure 16.14).

Figure 16.14

We'll begin our edit with an overall saturation increase.

Using the Hue slider, you can choose to alter the hues in the image or lighten or darken the image using the Lightness slider.

STEP 3: ADJUST THE SATURATION OF THE BLUE BUILDING

The Hue/Saturation dialog box also lets you make adjustments to specific color ranges.

From the Edit menu, choose Blues. Now, hold your mouse over the blue building. The pointer should change to an eyedropper. Click with the dropper on one of the darker blue tones on the building.

The color ramp at the bottom of the dialog box will immediately show you the range of colors you have selected. The name of that color range will appear in the Edit menu. You are now configured to edit just the blue tones in the image. (Your original master adjustment is still there, and you can switch back to it by selecting Master from the Edit menu.)

Drag the Saturation slider to the right to edit only the blue building (see Figure 16.15).

Figure 16.15

You can also use the Hue/Saturation adjustment to alter specific color ranges.

STEP 4: ADJUST THE YELLOW BUILDING

Now select Reds from the Edit menu and then click the orange building to select its color range. Drag the Saturation slider to the right to increase the saturation of the orange building.

You can control how wide a range of colors is adjusted by dragging the sliders on either end of the color range selector. On each end are two sliders, an inner one and an outer one. The inner sliders control the range of tones that will be adjusted, while the outer sliders control the falloff, or transition zones, between the edited and unedited colors.

Your final image should look something like the one shown in Figure 16.16.

You can also use the Hue/ Saturation control to *reduce* the saturation in an image, which is often a good way to tone down distracting colors and tones that are just a little too "hot." Simply apply a negative Saturation adjustment to reduce saturation. ◄▮

Figure 16.16

After our saturation adjustments, the final image has a better, more saturated color.

Vibrance

It's very easy to be taken in by the Saturation slider in your image editor. Saturation often seems to make an image look better immediately. However, it's usually best-used sparingly. While the image might look better at first, as you look at it further, you might find posterized colors (areas where fields of color have lost all gradation and transition from one color to the next), and you might start realizing that the color looks completely unnatural. More is not always better; sometimes, it's just more.

You must be particularly careful with saturation when working on shots of people. Skin tones very rarely respond well to a saturation adjustment. In addition to appearing too red, a saturation adjustment can reveal ugly patterns and mottling.

Photoshop's Vibrance adjustment (Image > Adjustments > Vibrance) provides a simple dialog box with two sliders (see Figure 16.17).

Figure 16.17

The Vibrance adjustment is a better tool to use when adjusting the saturation of images that contain people.

The Saturation slider works just like you would expect. The Vibrance slider also works much like you'd expect a saturation control to work, but it protects skin tones. In general, you'll find that when you use Vibrance, saturation increases, but skin tones don't see much of a change (see Figure 16.18).

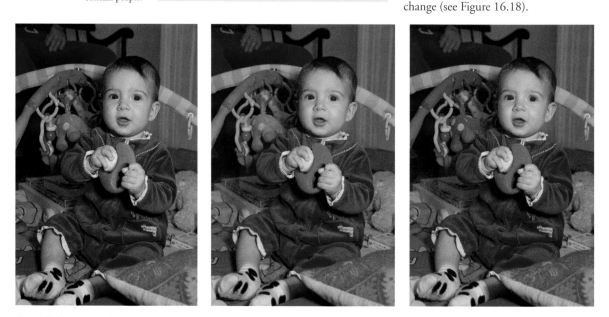

Figure 16.18 On the left is our original image. The center has seen a saturation increase, which has yielded stronger colors, but produced harsh flesh tones. The right image has had a strong Vibrance increase, which has boosted saturation while protecting the flesh tones.

Obviously, your results will vary depending on your image and the specific flesh tones you're working with.

The Story So Far

At this point, you should feel very comfortable reading histograms to assess what corrections are necessary in your image. You should also know how to perform basic contrast and tone corrections using Levels and Curves, and you should feel comfortable adjusting some of your own images. Before you head off to your photo archive, though, look at one more example that might save you a little frustration.

You should also now be pretty comfortable with using Hue/Saturation to adjust the color in your image. Photoshop provides other color adjustment tools, such as Color Balance, which is a good tool to know about, though not one that you'll use very often. Check out the details of Color Balance in the Photoshop Help menu.

As you've already seen, you can use Levels, Curves, and Hue/Saturation to adjust the tones and colors in your image. However, it's important to note that even though Curves provides a lot of flexibility in terms of being able to limit your corrections to a particular color, there will still be times when you cannot set enough control points on the curve to constrain your edit to a particular part of the image.

Consider Figure 16.19. The two figures in the foreground are way too dark and need some major midtone adjustments. (Plainly, we're dealing with a bad backlighting condition here. Using the camera's pop-up flash would have been a good option in this situation.) However, using Curves, there's no way we can select a part of the curve that targets only their midtones, because other parts of the image—the ground and the grass—fall on the same part of the curve. So, as we boost the midtones in the figures, we end up wrecking the contrast in the ground and grass and quickly posterizing it.

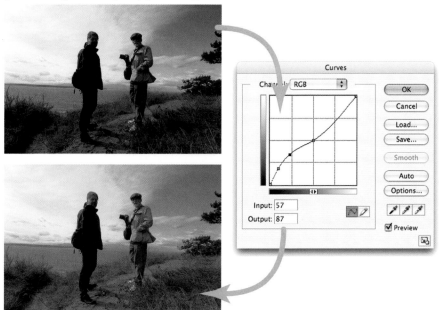

Figure 16.19

As powerful as the Curves tool is, it still doesn't provide a way for us to isolate only the tones in the two figures in the foreground. As such, there's no way to change their tones without also changing the tones in other parts of the image.

Remember that the points along the curve in the Curves dialog aren't related to a specific part of your image. Rather, they represent *all the pixels* in your image that have that color. Right now, we haven't covered the tools necessary to fix this particular image, but you'll get to them soon enough. In the meantime, try out some Levels and Curves adjustments on your own images to get a better feel for the effects of these tools.

17

IMAGE EDITING IN RAW

Correcting the Tone and Color of Raw Files

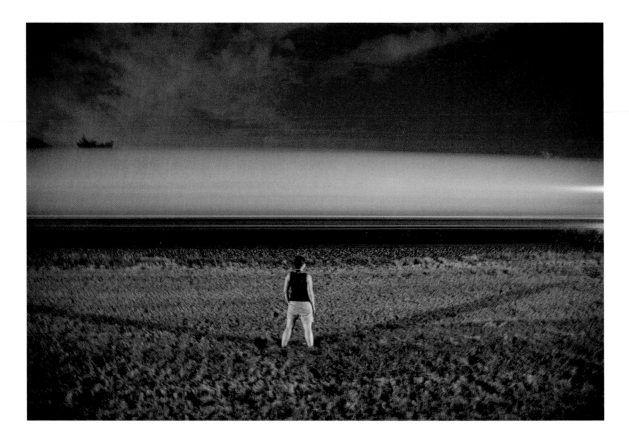

If you've made the decision to shoot raw, then your images must go through a raw conversion step before you can work with them. As you learned in Chapter 11, "Raw Shooting," when you shoot in raw mode, all the processing that normally happens inside your camera is offloaded to your computer where you have more control and flexibility. However, depending on the software you've chosen, raw conversion can make your editing workflow a little different from what it is when you shoot JPEG.

Fortunately, modern image editors have made raw workflow much easier. In fact, you may find that your raw workflow is not any different from a JPEG workflow. However, when working with raw files, your editing options will differ from working with JPEG files because you will have some additional tools and capabilities.

In this chapter, we'll explore all the specifics and strategies of raw conversion. You'll learn how best to approach your raw workflow and how to use your raw converter to edit and adjust your raw images.

Getting Started with Raw

The easiest way to learn to understand raw editing and workflow is to dive in. I recommend following this next, Photoshop-based tutorial, no matter what raw conversion software you use, as it will introduce you to a number of essential raw concepts that will apply to any raw editor. You can download a trial version of Photoshop CS5 at *www.adobe.com/photoshop*.

Nondestructive Editing

Your raw converter provides tools that will let you alter exposure, white balance, color, and many other image parameters that your camera adjusts automatically when you're shooting in JPEG mode. Some of these tools are no different than what you'll find in your regular editing program, while others provide capabilities you won't find when working with non-raw images in a normal editor. However, all the edits you make in your raw converter are nondestructive.

No matter what raw converter you use for your images, your original raw files are *never* altered. In fact, they really *can't* be, because raw files don't contain usable image data. So there's no way for you to apply an edit that increases the contrast in a raw file, say, because the raw file doesn't have any finished image data.

Like any nondestructive editing system, your raw converter stores the adjustments you make in a list that is kept separate from the original raw file. Anytime you want to view a particular file, the program consults the edit list and looks up the edits you've specified, and then applies them to that original raw file. If this is confusing, take a look at the nondestructive editing section of Chapter 4, "Image Transfer."

Because the edits are kept separate from the original image data, you can go back and change them at any time. This is one of the great advantages of raw editing. Once you're used to the flexibility of nondestructive editing, it's hard to go back to normal destructive editing like you perform on a JPEG file.

Basic Raw Adjustments

In general, you'll approach raw conversion the same way you approach any type of image editing: you'll begin with cropping and straightening, correct the image's tone (white point, black point, and contrast), and then correct the color. Depending on which raw converter you're using, you'll probably also be able to tackle dust, spot, and red-eye troubles.

Figure 17.1 shows the Camera Raw toolbar and the tools you'll need for the first part of your image editing workflow. With these tools, you can crop, straighten, and rotate, as well as zoom and pan about your image. Additional tools let you remove red-eye and spots, set white balance, selectively adjust your image, and more.

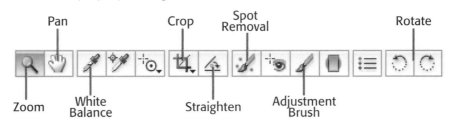

Figure 17.1

The Camera Raw toolbar provides all the tools you need to crop, straighten, rotate, navigate, set white balance, and more.

Most other raw converters have similar tools for performing these tasks, and you shouldn't have any trouble finding the equivalents in your converter of choice.

There is one slight workflow change you'll want to consider when working with raw files, and that is to address the white balance of the image before you begin any additional edits. In this section, we'll look at each of the basic raw conversion parameters, in the order you'll often want to employ them.

Navigation and Zooming

You should find that all of the navigation and zooming controls that you're used to in Photoshop still work in Camera Raw. Cmd/Ctrl-+ and Cmd/Ctrl- – still zoom in and out. Cmd/Ctrl-0 fits to window.

You'll also find a zoom pop-up menu in the lower-left corner of the Camera Raw window. When zoomed in, you can pan by pressing and holding the spacebar while you click and drag in your image.

Initial Settings

When you first open a raw file, your raw converter will process the image. Some raw converters use a stock, default conversion recipe, while others perform a simple analysis on the image and try to tailor the initial conversion settings to the image's needs. The settings you see when the image opens are the ones used for this initial conversion.

Tutorial Performing Basic Edits in Camera Raw

The best way to learn Camera Raw is to dive right in, so we're going to take a quick look at some basic Camera Raw tools.

STEP 1: COPY THE IMAGE

Copy the image `basic raw adjustments.CR2`, located in the Chapter 17 section of the companion Web site at *www.completedigitalphotography.com/CDP6*.

STEP 2: OPEN THE IMAGE

Now open the `basic raw adjustments.CR2` image in Photoshop. Open it just as you would any other image that you wanted to open in Photoshop. The Camera Raw dialog box should appear.

STEP 3: ASSESS THE IMAGE

Camera Raw provides a nice big preview window so you can get a good view of your image. Note that the image is not quite level. On the right side of the window are Camera Raw's adjustment controls, and above these controls sits a big, three-channel histogram. You should spot immediately that the image is overexposed, which you can tell by the spike of data on the right side of the histogram.

STEP 4: STRAIGHTEN THE IMAGE

Click the Straighten Tool to select it. With the Straighten tool, click and drag across something in the image that should be horizontal (see Figure 17.2).

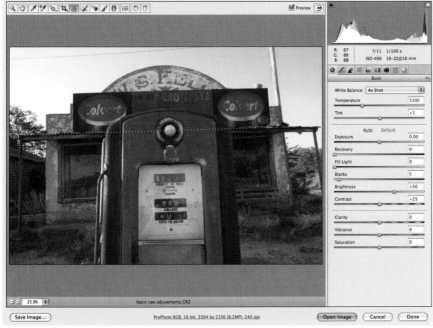

Figure 17.2

Using the Straighten tool, you straighten an image by dragging across something that is supposed to be horizontal.

When you release the mouse button, Camera Raw will show you a rotated crop box that indicates how your image will be rotated and cropped. If you like, you can drag the crop handles to refine the crop even further. When the crop is configured the way you want it, press the Return key, and your image will be straightened and cropped.

Cropping Is Nondestructive

At any time, you can reopen the image in Camera Raw and adjust your crop. Just click the Crop tool, and the cropping rectangle will appear again. You can refine its boundaries and then reaccept your crop.

STEP 5: ADJUST WHITE BALANCE

Slide the Temperature slider back and forth and notice how the white balance changes.

As you learned earlier, when you shoot in JPEG mode, your camera adjusts the color in your image so it is properly *white balanced*, or calibrated for the color of the light under which you are shooting. When you shoot with raw, this adjustment is performed within your raw converter, so it's easy to change the white balance of your image *after* you shoot, during raw conversion.

Because it's impossible to build a light source out of completely pure, refined substances, most man-made light sources have a little bit of a tint to them, which can often introduce slight color casts that can't be corrected with a simple white balance adjustment. The Tint slider in Camera Raw (and most other converters also have a Tint slider) lets you adjust the color in your image from green to magenta, and is intended to allow you to correct any extra tint introduced by impurities in your light source.

STEP 6: USE THE WHITE BALANCE DROPPER

One of the easiest ways to correct white balance is with the White Balance eyedropper. Select it now and then click one of the gray pebbles at the bottom of the image (see Figure 17.3).

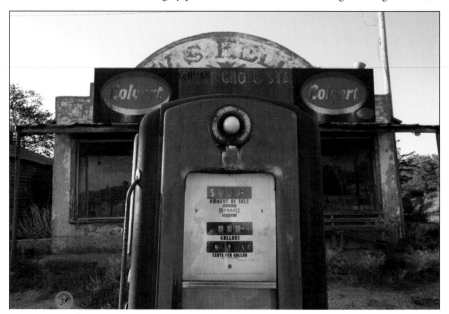

Figure 17.3

Click the gray pebbles at the bottom of your image to define white balance.

When you click with the White Balance tool, Camera Raw analyzes the color at the location you click and calculates a white balance adjustment that will render that tone neutral. So, while it might look like you should click on something white, the white balance dropper actually works best when used on something gray.

STEP 7: FIND CLIPPED HIGHLIGHTS

As we've already established, this image has a problem with overexposure. In the upper-right corner of the histogram is a triangle. If you hover your mouse over it, its Tool Tip will appear and tell you that this triangle activates the Highlight Clipping Warning. Click the triangle now. Camera Raw will highlight any overexposed pixels in red.

We knew from the histogram that this image had overexposure problems, but this display makes it easier to find them.

Turn off the Clipping Warning by clicking the Highlight Clipping Warning again or by pressing O.

STEP 8: RECOVER HIGHLIGHTS
As you saw in the last step, this image doesn't have terribly bad highlight troubles—just some overexposure in the sky—but it's still worth correcting these problems.

Drag the Recovery slider to the right until the spike on the right side of the histogram goes away. A value of around 30 should do it.

As you increase the Recovery amount, Camera Raw identifies the clipped regions of your image and performs recovery calculations on them. It also alters surrounding areas to make a smooth transition between the altered and unaltered pixels.

STEP 9: EXPLORATION
Now try a few experiments to see what the rest of Camera Raw's tonal controls do. Move the Exposure slider left and right. You'll see your entire image brighten and darken, and take note of what happens to the data in the histogram—it shifts left and right. Note, too, that it's possible to overexpose your image using this control. The Exposure slider is measured in stops and alters your image in the same way that shooting with an exposure compensation setting would. So, if you dial in +1 on the Exposure slider, your image will be exposed by one stop more.

Slide the Fill Light Slider to the right, and you'll see that the shadows in your image become lighter.

Move the Blacks tool to the right and watch what happens to the left end of the histogram. The lower fourth of the data gets pushed off the left. This is just like moving the Black Point slider in the Levels dialog box, which you got a lot of practice in earlier.

Move the Brightness slider back and forth, and you'll see the midtones in the image get brighter and darker. This is just like moving the middle, or Gamma, slider in the Levels dialog box, and this allows you to brighten or darken the midtones in your image. Note that it is possible to clip highlights with this control.

The Contrast slider lets you increase or decrease contrast in your image, as you probably already guessed. As you slide it, you'll see the tones in your image expand and contract. As they spread out, your image gets more contrast; as they mush together, the contrast lessens. Note that it is possible to clip the highlights and shadows with this adjustment.

The Clarity slider makes lots of tiny contrast adjustments along the edges of detail in your image. It's like a very mild form of sharpening, but it can make details more distinctive.

The Saturation slider increases and decreases saturation, just like you've seen in the Hue/Saturation dialog box. Vibrance is akin to Saturation, but has little effect on flesh tones, allowing you to increase saturation without making flesh tones look awful.

STEP 10: FINISH UP
When you're done fiddling, click the Done button to store your changes.

Hopefully, this quick walk-through will give you a feel for Camera Raw's basic controls. Through the rest of this chapter, we're going to look at these controls in more detail, in order to gain a better understanding of when and how you might use them. ◄

Nondestructive Editing Revisited

Remember that a raw file contains no actual finished image data. It does not contain values that correspond to colored pixels. Instead, it has values that can be translated into colored pixels by raw conversion software. When you cropped, straightened, and adjusted tone in the Camera Raw dialog box, you were changing the parameters that Camera Raw used when translating from the original raw data to a finished image.

When you pressed the Done button, this list of parameters was stored in a tiny text file with an XMP extension. This is called an *XMP sidecar file*.

Go look in the folder where the raw image is stored. Next to the original raw file, you should see a small document called "basic raw adjustments.xmp." This file is nothing more than a text file containing a bunch of XML code. (XML is similar to HTML, the markup language that specifies what a Web page looks like.) This XML code tells Camera Raw how you want your raw parameters configured for this specific image.

Anytime you open a raw file, Camera Raw looks in the same folder as that file to see if an XMP file exists. If it finds one, it converts the raw file using any instructions stored in that file. If it doesn't find one, it uses its default parameter settings.

A Simple Experiment

Try this: delete the `basic raw adjustments.xmp` file. Now open the `basic raw adjustments.CR2` file in Photoshop again. The Camera Raw dialog should come up, and you should see your original, unstraightened, unadjusted image.

When you deleted the XMP file, you threw out all the edits that you had made. But your original raw file is still perfectly intact, so you can start editing all over again.

Figure 17.4

After you've edited a raw file in Camera Raw, Bridge shows small badges to indicate how the image has been manipulated.

Now try this. Make some adjustments in Camera Raw and then press Done to save the edits. In Bridge, navigate to the folder where the raw file is stored, and look at its thumbnail. Above the image, you should see two little badges (see Figure 17.4).

The left-most badge shows that the image has been cropped (it's the one that looks like a little crop tool), while the right badge shows that the image has had adjustments applied to it (the badge is showing little sliders). If you've got a lot of similar images, this gives you an easy way to keep track of which images you've edited.

While the Camera Raw included with Photoshop CS5 defaults to the behavior described here, some earlier versions of Camera Raw defaulted to storing edits inside an internal database.

The Camera Raw Preferences dialog box provides a simple option for switching between storing edits in the internal database or as sidecar files (see Figure 17.5). Sidecar files have the advantage that you can easily move them around with your images, so it's simple to pass raw files and sidecar files to other people, move them to other computers, back them up, or recover from a crash.

Figure 17.5

Using Camera Raw's Preferences dialog box, you can specify whether you want your edits stored in Camera Raw's internal database or as separate, sidecar XMP files.

Keeping Track of XMPs

When you move a raw file, if you want your edits to travel with it, you need to be sure that you also copy the associated XMP files. You can use Bridge to copy and move files by selecting an image within Bridge and then choosing Move To or Copy To from the File menu. (You can also right-click on the image thumbnail to get a pop-up menu that contains these options.)

When you copy or move an image with Bridge, the XMP files are automatically copied along with the raw file.

Raw Workflow

Now that you've had a quick look at raw and have seen how raw edits are stored, let's go back a step and look at how raw files affect your workflow.

As with JPEG images, your first postproduction step as a raw shooter is to import your images from your camera's media card (or cards). You move raw files just like you do JPEG files, by copying them with a card reader, or by transferring them directly from your camera through a cable. If you're using a workflow application like Bridge, Aperture, iPhoto, or Lightroom, those applications can import images directly from your card. Otherwise, you can use your OS's file manager to copy the images over.

As you learned in Chapter 13, "Workflow," one of your first workflow steps (after importing) is to sort through your images to find the keeper images that you want to pass through to the editing and correction stage. So how can you browse raw files quickly if they haven't been converted yet? Remember, a raw file just contains raw data, not an actual viewable image.

All cameras store a low-res JPEG preview of your raw file inside the raw file itself. This is the image that the camera shows on its LCD screen when you review your images in-camera. Many applications can show you this preview as a way of letting you review your raw files quickly. But applications like Bridge, Lightroom, Capture NX, Aperture, and others go a step

farther and actually perform an initial raw conversion based on automatic settings. These conversions usually yield a very good image—sometimes good enough that you won't need to perform any additional corrections.

In most of these programs, when you first browse a collection of raw files, the thumbnails that you see are nothing more than the JPEG file that's stored inside the raw file. As soon as those are displayed, the program will immediately get to work generating new raw conversions. As it finishes each conversion, the image's thumbnail will be updated.

In Bridge, for example, thumbnails of raw files will have a black border around them, indicating that the thumbnails have not yet been updated with a Bridge-generated raw conversion.

Depending on how many images you have and the pixel count of your raw files, it can take a while for your browser of choice to prepare all of the thumbnails and previews that it needs. What's more, as it updates, you may find that the thumbnails do look slightly different from what you initially see, because your raw converter will process the raw data in a different way than your camera did when it built its JPEG thumbnails.

Reviewing Raw Images in Your File Manager

The file manager of your operating system (the Finder on the Mac, Windows Explorer on Windows) lets you look at JPEG files and possibly a number of other image formats. Or your operating system might ship with a simple graphics viewing application of some kind.

The latest versions of Windows and the Mac OS include built-in, OS-level raw conversion software that allows you to view raw files just as you would JPEGs. However, if the conversion software built in to your OS doesn't support your camera, you may not be able to view your images with the simple tools provided by the operating system.

If you're a Windows user, some simple applications will allow you to view raw thumbnails and previews from within Windows Explorer. dpMagic (*www.dpmagic. com*) makes a $24.95 program for Windows XP and Vista called dpMagic Plus that allows you to view thumbnails inside Windows Explorer, see full-screen previews, read EXIF data, view histograms, and more. As with all raw converters, the dpMagic converters may or may not support your chosen camera, so you'll want to check the Web site to see if your camera is supported. Google's Picasa (*picasa.google.com*) is also a great option that's worth trying out simply because it's free. FastPictureViewer (*www.fastpictureviewer.com*) works with Windows XP, Windows Vista, and Windows 7, both 32- and 64-bit versions.

While viewing from the file manager can be handy, the browsers that are built in to the image editing applications we've been talking about are far more useful. With Aperture, Lightroom, Capture NX, iPhoto, and Adobe Bridge, you'll be able to browse and compare thumbnails of your raw images easily, just as you can with JPEG images.

Raw Conversion Software

If you don't already have a raw converter that you like, or if you're wondering what the advantages are of some other packages, here's a quick overview of the leading raw conversion/workflow tools.

- **Photoshop/Bridge.** Adobe Photoshop uses a plug-in called *Photoshop Camera Raw* for its raw conversions. This plug-in is included with Photoshop, so you don't have to install anything else to use Photoshop for your raw conversions. Bridge also uses Photoshop Camera Raw for raw conversions, and with it, you can view thumbnails and previews of

your raw images quickly and easily, and assign ratings and metadata, just as you did in Chapter 13. If you worked through the earlier tutorial, then you've already gotten a taste of how Camera Raw and Bridge work together.

The advantage of choosing Photoshop as your raw converter is that, in addition to the fact that Camera Raw is very good, you also get all of Photoshop's other editing tools. If you're already a comfortable, regular user of Photoshop, then this is kind of a no-brainer. Also, Camera Raw supports more cameras than any other converter, and Adobe is very quick to release updates that provide raw support to new models.

- **Aperture/Lightroom/iPhoto.** Raw workflow is very straightforward with any of these apps because, workflow-wise, they treat raw files just like JPEG files. Import them into your library, and you'll be able to preview your images immediately and begin comparing, rating, and picking. When you've chosen the images you like, you're ready to move on to editing.

- **Nikon Capture NX.** Currently, Capture NX only works with Nikon raw files, so if you're using a different type of camera, you'll need to perform your raw conversion somewhere else before bringing your images into Capture NX for editing. If you're a Nikon shooter, Capture NX raw workflow is very simple. The program's built-in browser lets you view thumbnails of raw images, make comparisons, and then open images for editing.

- **Bundled raw converters.** If your camera has raw capability, some kind of raw conversion software will most likely come bundled with the camera. You can use these applications to perform your raw conversions, and they often include simple browsers that enable you to view thumbnails of your raw images. If your image editor of choice doesn't support your camera's raw format yet, these tools might be your only option. Your workflow will be to perform your raw conversion with one of these programs, save the result as a TIFF or Photoshop file, and then open that file in your image editor of choice.

No matter what application you choose, once you've selected the images you want to work with, you're ready to begin correcting and adjusting your images. If you're using Photoshop or your camera's bundled raw converter, you'll convert your image first, save it (usually as a TIFF or a Photoshop file), and then perform any additional edits in your normal image editor. Because most raw converters provide a tremendous amount of image editing power, you won't always need additional editing after raw conversion, and in the rest of this chapter, you'll get a better idea of which edits will be performed in your raw converter and which will be performed later.

If you're working with Aperture, Lightroom, iPhoto, or Capture NX, you won't have separate raw conversion/editing steps. In these programs, you can freely adjust raw conversion parameters alongside "normal" edits.

Which Camera Raw Are You Using?

Different versions of Photoshop and Photoshop Elements support different versions of Camera Raw. So, if you're using an older version of Photoshop or Photoshop Elements, you may not be able to use the latest version of Camera Raw. In addition to not having access to the latest features, if you're running an older version of Camera Raw, you probably won't have compatibility with the latest cameras. Unfortunately, the only way around this is to upgrade your copy of Photoshop, which will give you access to the latest Camera Raw. In other words: Adobe uses Camera Raw as a lever to get you to upgrade.

DNG—the Adobe Digital Negative Specification

As you've learned, different cameras produce different types of raw files. Unlike JPEG or TIFF files, there is no generally accepted standard for raw. That means that anyone who wants to make a program to process raw files has to figure out how to decode each vendor's raw file format. Since most of these formats aren't published, this can be a very time-consuming, tedious process. This is also why raw converters must be updated every time a new raw-capable camera comes along.

Photoshop Camera Raw currently supports more raw formats than any other converter, which means that Adobe has done a lot of hard, diligent work in learning to process lots of raw formats. In an attempt to simplify this situation, Adobe has published the Adobe Digital Negative specification, an open standard for raw format data. Their hope was that camera manufacturers would embrace the digital negative spec and create cameras that output digital negative files natively. So far, this hasn't happened. While one or two smaller vendors make a few cameras that can produce DNG files (the digital negative format), the big players—Nikon, Canon, Olympus, Sony, Panasonic, Fuji—have largely stayed away from it.

Similarly, not many software vendors have embraced DNG. While Aperture offers DNG support, Apple's involvement in DNG has revealed that the format is not as universal and open as we would all like it to be.

Most vendors have stayed away from the format for the simple reason that Adobe is in control of it. While Adobe's interests are likely purely benign, many companies fear investing time and energy in a technology controlled by one of their rivals. In the end, this is probably wise, and we will most likely not see a wide acceptance of DNG until a truly open standard—one controlled by a standards committee such as the ISO—is developed.

In the meantime, you can use the free Adobe DNG Converter to convert your raw files to DNG format. Why would you bother to do this? Currently, DNG files offer the following advantages:

- They guard against obsolescence. With your images in DNG format, you'll presumably always be able to open them, even if the giant international electronics conglomerate that made your camera goes out of business. Because DNG is an openly published standard, many people feel there will always be support for it.

- In addition to storing your image in DNG format, DNG files can include a copy of your original raw data, so you don't have to give up any extra proprietary information that may be buried inside.

- DNG files serve as a wrapper that holds both your original raw file and the associated XMP data file (the list of raw conversion parameters Photoshop Camera Raw generates). This makes the files more easily moved, backed up, and emailed.

On the downside, converting to DNG takes time, consumes more storage, complicates your workflow, and, for the most part, doesn't buy you any new capabilities. For the time being, it's pretty safe to ignore DNG files, unless you have a specific workflow need they can help address.

Workflow with Bridge/Camera Raw/Photoshop

Earlier, you got a taste of workflow using Photoshop/Bridge CS5, but there are a few things that probably need clarifying.

Typically, your workflow will go as described previously: you'll browse your images in Bridge, rate them, keyword them, and then when you're ready to start editing one of them, you'll double-click on it, or press Return, and the file will be passed to Photoshop. Because it's a raw file, Photoshop will open it in Photoshop Camera Raw.

Once in raw, you can make adjustments and edits, as you did in the previous tutorial. When you're finished with your edits, you have four options:

- **Done.** If you press the Done button, Photoshop saves your edits in the associated XMP sidecar file and closes the raw file and Camera Raw. With this option, you've simply socked your raw edits away, but have not yet made a finished image. Later, you'll see the advantage of this approach.

- **Cancel.** The Cancel button discards all edits and closes the raw file and Camera Raw.

- **Open Image.** Click this button to process the raw file and open it up in Photoshop.

- **Save Image.** When you click this button, you'll have the option of saving the processed raw file in a number of different formats. We'll cover this in more detail later.

There are some important things to understand about opening an image. Once open, the title bar in Photoshop will show the same name as your raw file. However, your original raw file has not been altered in any way. Photoshop will never write over an original raw file, nor will any other raw converter, so your raw file is truly akin to an original negative.

Because the window's title bar shows a file name, it's not obvious that what you're actually working with is a new, unsaved image—one that was handed to Photoshop by Camera Raw.

Try this:

1. Double-click on a raw image in Bridge to open it in Camera Raw.

2. Click the Open button in Camera Raw. This will process the raw file and open it in Photoshop.

3. Choose File > Save. Photoshop should now present a standard Save dialog box, just as if this were a completely new document that had never been saved.

When you save a raw image, you have to choose a file format to save it into. You can't save into raw format because raw files don't contain finished image data.

Choosing a File Format for Saving Raw Files

Photoshop offers a huge assortment of file formats, but for most work you only need to consider two or three. In general, you should always choose Photoshop format, which is the very first entry in the list. (Note that you might also have options for things like Photoshop 2.0, Photoshop Raw, and Photoshop PDF. These are different. You want to choose simply Photoshop.)

If you need to give the image to someone who doesn't have Photoshop, then you should choose TIFF. Most image editors and image viewing programs can open TIFF files.

Both of these format choices will present a dialog box with further options. Take the defaults, and you'll be fine.

The only time you ever want to choose JPEG files is if you need a JPEG file to post to the Web, send via email, or perhaps to give to a photo printing service. We'll discuss JPEG output in more detail in Chapter 22, "Output." But remember, because JPEG is a lossy image format—that is, you lose quality every time you save in JPEG format—it's not a format you want to choose until you have to.

More About White Balance

You've already learned how data can be lost as you brighten and darken the tones in your image, pushing them from one part of the histogram to another. As you saw, if you stretch the tones in your image around too much, you begin to see tone breaks and other visible artifacts in your image. One of the great things about the white balance control in your raw converter is that it's a completely "free" edit. No tones are used up as you make white balance adjustments, because the raw converter simply changes its fundamental assumptions about the primary colors that it uses to decode the color in your image. Therefore, if possible, you should make your color adjustments using the white balance adjustment.

White balance adjustments can also sometimes yield a change in contrast, so it's not a bad idea to perform your white balance adjustment first, to get a better sense of the actual tone in your image. You can then move on to your tonal adjustments.

When you first open a raw file, Camera Raw (and most other converters) read the white balance setting that the camera stored. For example, if your camera was set on Auto White Balance, and it determined that 4800° was a proper white balance, then this is where Camera Raw's Temperature slider will be set. The White Balance pop-up menu, located directly above the Temperature slider, allows you to change from the camera's specified white balance (which is listed as "As Shot" in the menu) to a preset white balance. You can also choose Auto, which tells Camera Raw to perform its own auto white balance process on your image.

If you've been careful to set white balance while shooting, then As Shot might be a perfect white balance setting. If your white balance is off, then Camera Raw's preset white balance options might fix your image.

Manual White Balance

As you saw in the last tutorial, you can use the White Balance eyedropper to set the white balance in your image. The trouble with the dropper is that there's not always something gray in your image, and if you're shooting in low light, or under mixed lighting, it can be difficult to find something that you can plainly identify as gray.

For these situations, you might want to use a White Balance card like the one discussed in Chapter 7, "Program Mode" (see Figure 7.17). As you'll recall, in that mixed-lighting night shot, I shot a second frame that included my WhiBal White Balance card. Because I know the WhiBal card is neutral, I can click it with the White Balance dropper in my raw converter to calculate an accurate white balance (see Figure 17.6).

After clicking on the gray card, our white balance will be set properly, and the Temperature and Tint sliders will have new values. However, so far all we've done is correct the white balance in the shot of our White Balance card—we also want to correct white balance in our original shot. You can either take note of the new Temperature and Tint values and manually change them in your original image, or you can copy them into your original image, a process we'll explore later in this section.

Correcting white balance in a raw file is much easier, and typically more effective, than trying to correct white balance in a JPEG file using any type of technique. As you play with the white balance adjustments in your raw converter, you will get a feel for the huge amount of latitude you have to adjust color.

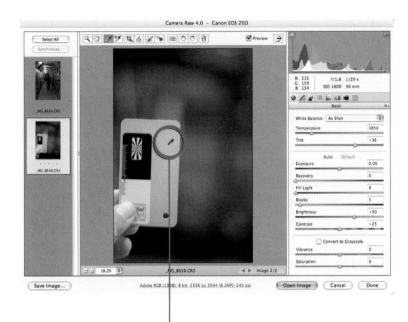

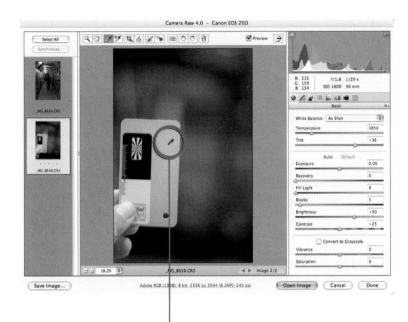

White balance dropper

Figure 17.6

We're using Photoshop Camera Raw's White Balance dropper to sample our gray card. This will give us an accurate white balance, like you saw in Figure 7.17.

Correcting White Balance When There's No Gray to Sample

There will be times when there's no gray in your image from which to sample white balance. For example, Figure 17.7 shows an image with a white balance that's plainly wrong. Shot on a stage, under stage lighting, there was no way to do a manual white balance at the time, and no way to get a gray card on-stage.

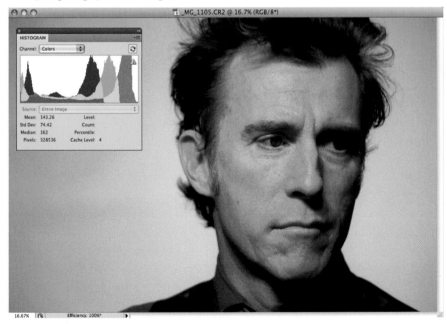

Figure 17.7

This image has a white balance that's off, but no gray in the image for us to use as a reference point.

Unfortunately, because there's nothing in the image that's gray, we can't use the White Balance dropper in Camera Raw, so we'll just have to move the Temperature and Tint sliders by hand. Sometimes, this is easy to do by eye, but at other times, it can be tricky to figure out exactly where "correct" color is, especially with flesh tones. Fortunately, the histogram can help us out.

Earlier, you saw Photoshop's three-channel histogram, which shows a separate histogram for the red, green, and blue channels in the image. Camera Raw also has a three-channel histogram that works the same way, and it makes achieving accurate white balance easier. (Note that in the interest of saving space on the page, and to ensure these figures can be as large as possible, I'm showing Photoshop's three-channel histogram, rather than Camera Raw's. The resulting histogram data is exactly the same in both.)

In the histogram in Figure 17.7, the three different channels are wildly out of registration. As you know, equal parts of red, green, and blue make white. Figure 17.7 has a preponderance of red information in the brighter areas, and all of the blue information is dropping down into the shadows. It's all that bright red data that's giving the image a red cast.

The Temperature slider goes from blue on the left to yellow on the right. If we move it to the left (since blue is away from red), the three channels in the histogram begin to converge. We can't get them to overlap perfectly because the image has quite a bit of red in it that's supposed to be there. But if we register them as closely as possible, then we have fairly accurate color (see Figure 17.8).

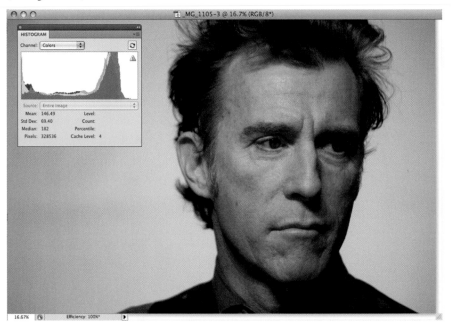

Figure 17.8

With the three-channel histogram as our guide, it's easier to zero in on the correct color.

Note too, that that this image was shot under stage lighting, and it has some extra red due to the red-gelled lights. So what's accurate in this situation are the skin tones, which are a little red.

If we prefer them to look a little more natural, we can dial down the Saturation slider in the Camera Raw dialog box (see Figure 17.9).

Figure 17.9

After lowering the saturation, we get an image with very natural color.

White Balance and Posterizing

Be aware that a wildly incorrect white balance can make an image appear to be posterized. Notice that in Figure 17.10 the tones on his forehead appear to be flat and posterized. They're not, actually, and if we correct the white balance, we can see that there's a full tonal range in the image (see Figure 17.10).

Figure 17.10

The uncorrected image on the left looks like it suffers from posterized color, but there's actually plenty of data in there, which we see as soon as we perform a white balance adjustment.

The lesson here is that if you have an image that appears to lack detail, but that also has a bad white balance, don't discard the image until you try a white balance correction. The image might turn out to be more usable than you initially thought.

When "Correct" White Balance Isn't the Best Choice

Some images look better when they're a little warmer or cooler than normal, and the ability to manipulate the overall color tone of an image is part of your creative palette. However, before taking artistic license, it's best to get the white balance as accurate as possible, and then decide from there how interpretive you want to go. This is especially true with skin tones, because even subtle variation in skin tone can have a profound impact on an image. Though not always voluntary, skin tone is part of the way we express ourselves ("feeling blue," or being "red with anger" are just two examples) so you want to be careful about the emotional impact of warming or cooling people's faces.

More About Highlight Recovery

As you saw earlier, Camera Raw has the capability to recover overexposed highlights sometimes. These days, most other raw converters also have this capability. I say "sometimes" because highlight recovery only works on highlights that are overexposed in one or two color channels—for example, when just the Red and Green channels are overexposed, but not the blue. Highlight recovery allows you to restore detail to areas that have been overexposed to what appears to be complete white.

Highlight recovery can't always recover clipped highlights—sometimes you'll only be able to recover some of them. It all depends on whether a highlight was partially or completely clipped, and some raw converters do a better job with highlight recovery than others.

In most raw converters, you perform highlight recovery by simply sliding the Exposure slider to the left. As you slide, the spike on the right side of the histogram should get smaller, and the detail in your highlights should improve. You may have to underexpose your image a lot to recover all the highlights, but you can brighten it back up again using the Brightness slider.

This is one reason why you have both Exposure and Brightness controls. Since you'll sometimes be using the Exposure slider to *lower* the exposure in your image to recover highlights, you'll use the Brightness slider to brighten it back up again with your new recovered highlights intact.

Note that while highlight recovery is a great tool, it's *not* a magic bullet. When you engage in a highlight recovery operation, your raw converter must perform a tremendous amount of interpolation. Simply put, it makes up a lot of data, and obviously there will be times when it may not be able to do an especially good job of this. It's much better to try to expose to avoid overexposed highlights than to rely on highlight recovery.

The Recovery Slider

Photoshop Camera Raw 4.0, Lightroom, and Aperture all provide a Recovery slider, which lets you recover clipped highlights without lowering the overall exposure of your image. While you can still perform highlight recovery with the Exposure slider, the Recovery slider means you won't have to try to brighten your image later to compensate for any darkening introduced by your highlight recovery operations. This can be a great timesaver, and can speed up your overall editing workflow. The tutorial image we used earlier didn't show a lot of detail recovery because the overexposed highlights were in a detail-less sky. Let's work with some images that have more significant highlight trouble.

Recovering Overexposed Highlights

STEP 1: COPY THE IMAGE

Copy the image `out standing in its field.CR2`, located in the Chapter 17 section of the companion Web site at *www.completedigitalphotography.com/CDP6*.

STEP 2: OPEN THE IMAGE

Open the image in Camera Raw. You can do this from Bridge, from Photoshop's Open menu, or by using any of the other usual methods for opening an image in Photoshop.

STEP 3: ASSESS THE IMAGE

It's not too hard to see that this image has overexposed highlights. Most of the detail in the clouds has been blown out to complete white. The histogram, with its huge pile of data on the right side, confirms the problem (Figure 17.11).

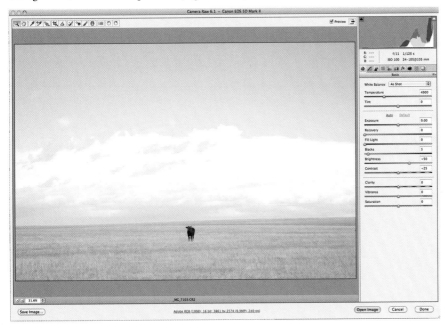

Figure 17.11

The overexposure in this image is fairly obvious—the clouds have gone to complete white in many places.

STEP 4: RECOVER THE HIGHLIGHTS

Anytime you face an image with overexposed highlights, your first step should be to attempt highlight recovery. If you can't recover the highlights, then you might decide you want to abandon the image, so it's good to figure out the highlight situation right away.

Slide the Recovery slider to the right, and watch the clouds. You should see detail reappear. Also take a look at the histogram. As you slide more to the right, you should see the pile of data on the right side get lower and lower, until there's no spike at all (see Figure 17.12).

I prefer not to use the Recovery slider any more than I have to, so I stopped as soon as the highlights were completely recovered. You can go further, and the clouds will improve some more. However, I'd rather perform any additional darkening with Exposure or Brightness, simply because it will be easier for me to return to the image later and quickly assess how the image has been adjusted.

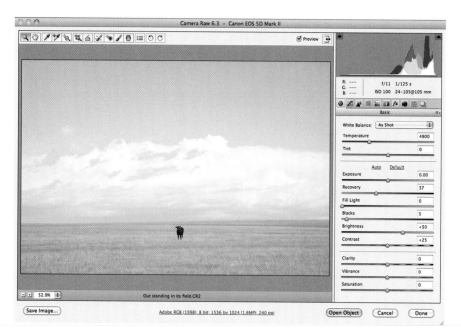

Figure 17.12

With the Recovery slider, we can restore detail to the overexposed parts of the image.

STEP 5: ADJUST EXPOSURE

While the highlights are recovered, most of the tones in the image are still piled up on the right end of the histogram. This image is mostly midtones, with some brighter-than-mids in the sky, so it would be better if the tones were more in the middle of the histogram. Drag the Exposure slider to the left to reduce the exposure in the image. I went to -1.10 stops, both because this looked good to my eye, and because it placed the tones about where they should be in the histogram—a little brighter than the middle (see Figure 17.13).

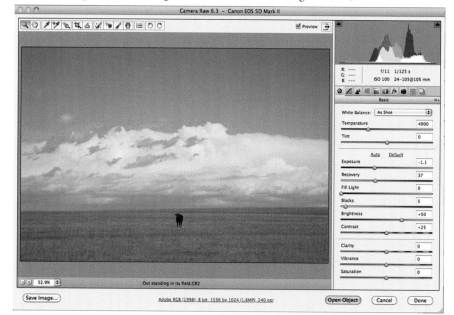

Figure 17.13

Using the Exposure slider, we can pull the brightness of the image down to something more reasonable.

Note that we've picked up more detail in the sky. This wasn't actually highlight recovery. Rather, some of the lighter tones have been darkened, and are now easier to see, but no new data was made up by Camera Raw.

STEP 6: ADJUST CONTRAST

While we've got nice detail in the sky, the image still lacks contrast, which makes sense given that the bulk of the tones are gathered in the middle of the histogram. Let's stretch them out. Slide the Contrast slider to the right to increase contrast. I found that a value of about +93 gave me a nice contrast improvement without overexposing my image.

There's still very little data at the left side of the histogram, which might lead you to think that you need to increase the Blacks slider. But note that there's very little in the image that is actually black. The cow's the only black thing, and the rest of the dark tones are not super dark. This is, inherently, a low-contrast image, so we should leave it that way (Figure 17.14).

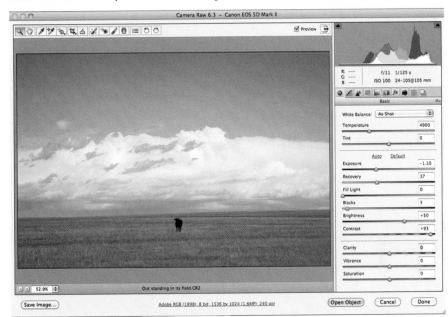

Figure 17.14

After a Contrast adjustment, the image has a little more punch.

STEP 7: FINISH UP

The foreground in the image is still a little dull, and could use some brightening. However, performing any brightening, either with the Brightness or Exposure sliders, is going to cost us detail in the sky. So, at the moment we've done everything we can with this image. Click the Done button to save your adjustments. We'll be returning to this image later.

Highlight Recovery and Color

It's easy to spot overexposure in a bright feature like clouds. But overexposure can also cost you detail in colored objects, and it may not be obvious that there's more detail to be had in some areas until you perform your recovery. This is another reason that it's critical to pay attention to the histogram, and when you see that there's overexposure, attempt a recovery. You may be surprised at how much new detail comes into your image.

Recovering Overexposed Highlights

STEP 1: OPEN THE IMAGE

Download the file `sunflowers.CR2` from the Chapter 17 section of the companion Web site. Open the image in Camera Raw.

STEP 2: ASSESS THE IMAGE

These sunflowers were heavily backlit, so they don't look obviously overexposed, they simply look like flowers with sun behind them. The image is a little low in contrast, but otherwise looks mostly okay (see Figure 17.15). However, the histogram shows a spike on the right side. It's not a white spike, which means not all three-color channels have been clipped. Rather, it's a yellow spike, which means that the Red and Green channels have been clipped (red and green make yellow).

Figure 17.15

While it's not necessarily obvious from looking at the image, the histogram shows that this image has some overexposure.

STEP 3: RECOVER HIGHLIGHTS

As always, we begin with highlight recovery. Slide the Recovery slider to the right until the spike on the right side is gone.

STEP 4: ADJUST BLACKS

The image is sorely lacking in contrast, so before we spend too much time assessing our highlight recovery, let's get the black point where it needs to be, to give our image a more reasonable amount of contrast (see Figure 17.16).

Figure 17.16

After recovery and a black point adjustment, our image looks a lot different.

STEP 5: COMPARE TO ORIGINAL

Above the image, in Camera Raw, you should see a checkbox that says Preview. Uncheck it to see your original image. By turning it off and on, you can easily see the effects of your adjustments.

Note the overall improvement in detail on the petals of the flowers. Also, notice that, with the adjustment, there's been a color shift—the flowers are now more orange than they were before.

At this point, you might decide that you like the extreme backlit flowers better. That's fine, but the point of this exercise was to demonstrate that lost detail from overexposure is not always obvious.

Another Highlight Recovery Example

On the companion Web site, in the Chapter 17 section, you'll find a QuickTime movie called `Highlight Recovery.mov`. This short clip will show you another real-world highlight recovery example.

More About Fill Light

Photoshop Camera Raw 4.0 and later (4.0 is the version of Camera Raw that is included in Photoshop CS3), Lightroom, Aperture, and Nikon Capture NX all include special adaptive tools for performing highlight recovery. Sometimes called *perceptual* adjustments, these tools let you automatically perform dramatic edits to only the shadows and highlights in an image without having to create complex selections or masks.

Consider the Levels control you used in Chapter 11. With the Levels adjustment, you can easily alter the values of specific tones in your image. However, when you change the value of a particular tone, *every* pixel in your image that has that tone gets adjusted. So, for example,

maybe you feel that a shadow area in a portrait image needs to be lighter, so you use a Levels adjustment to brighten it, only to realize that the same adjustment also brightens the dark irises in your subject's eyes.

The problem is that the Levels adjustment doesn't know whether specific pixels are shadow tones or not. It simply alters all pixels that have a particular value.

Adaptive tools are more intelligent about the way they operate. When you use an adaptive Shadow tool to brighten shadows, your image editor analyzes your image to determine which pixels are shadows, and it brightens only those. In addition, because shadows are usually bordered by a transition zone that blends into nonshadowy areas, an adaptive shadow tool "rolls off" the adjustment it applies to pixels bordering your shadow areas to create smooth transitions into nonaffected areas (see Figure 17.17). Adobe calls this a "Fill Light" because it's roughly akin to firing a fill flash into your scene.

Figure 17.17

The Fill Light slider in Camera Raw 4.0 and later lets you brighten or darken only the shadow tones in your image. Here you can see how it successfully identified the shadow in the image and brightened it without creating a conspicuous boundary between the adjusted and unadjusted areas.

Ultimately, these types of adaptive tools do nothing more than brighten or darken pixels in your image. Although they do a great job of determining *which* pixels to alter, you still need to keep an eye out for all the same artifacts you are wary of when using Levels or Curves.

Also, be aware that these tools can quickly reduce the contrast in your image. Remember: just because there is detail in a shadow, doesn't mean you need to see it. Sometimes an image is more compelling if the shadows are left dark.

Fill Light in Previous Versions of Photoshop Camera Raw

Previous versions of Camera Raw don't have a Fill Light slider or any type of adaptive shadow control. So, if you're using an earlier version, you'll have to wait and perform your shadow brightening in Photoshop. In Chapter 20, you'll learn about the adaptive shadow tool that's built in to Photoshop CS and later.

Highlights and Shadows in Aperture

In Aperture, you can use the Highlights and Shadows sliders to adaptively adjust both the highlights and shadows in your image. Both sliders provide additional options, which let you refine their effect, and we'll cover the details of these adjustments in the next chapter.

D-Lighting in Capture NX

In Nikon Capture NX, you'll find adaptive shadow control in the D-Lighting edit. Like the Fill Light slider in Camera Raw, you simply slide the D-Lighting slider to brighten shadow tones. Capture NX automatically calculates which tones in your image get adjusted.

Additional Adjustments in Photoshop Camera Raw

Both Lightroom and Camera Raw provide a few additional controls. Depending on the version of Camera Raw you're using, you'll find these additional controls:

- **Saturation (all versions).** The Saturation slider increases or decreases the saturation of the colors in your image, just as you would do so by using the Hue/Saturation adjustment in Photoshop.

- **Vibrance (version 4 and later).** The Vibrance slider performs the same operation that you saw in the Vibrance section in Chapter 16, "Correcting Color."

- **Clarity (version 4 and later).** You can perform a very subtle, effective form of sharpening by sliding the Clarity slider to the right. When you do, Camera Raw will make tiny little contrast adjustments throughout your image to give it a little improvement in detail.

The best way to learn these controls is simply to use them. Play with the sliders and watch both your image and its histogram to get an idea of what Camera Raw is up to.

Additional Tabs

So far, all of the controls that we've been looking at are contained within the Basic tab. You may not have noticed it before, but above the White Balance controls in Camera Raw are a series of little icons, which are actually tabs that allow you to access additional controls. As

with everything else in Camera Raw, each of these adjustments is nondestructive, and every setting gets saved in the XMP file that's associated with your raw image.

Tone Curve

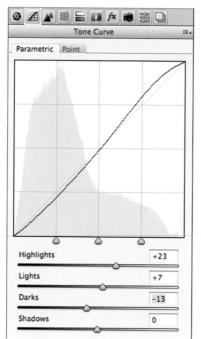

All versions of Photoshop Camera Raw provide a tab containing a tone curve. Just like the Curves adjustment that you learned about in the last chapter, the Curve tab selectively brightens and darkens specific tonal ranges in your image, and it provides an additional level of adjustment power over the basic raw conversion sliders.

Note that the Camera Raw curve differs from Photoshop's in that it offers a Parametric mode that provides Levels-like sliders for adjusting specific parts of the tonal range (see Figure 17.18). What's more, changes to the curve don't appear in your image until you let go of the mouse, and you'll probably find that the adjustments that you make are much smaller than what you may be used to in Photoshop.

Figure 17.18

The Tone Curve tab in Camera Raw gives you a Curves interface for adding additional tonal adjustment to your image.

Detail

The Detail tab contains controls for sharpening and noise reduction. These sharpening controls are intended to restore some of the detail that was lost through the demosaicing step that you learned about in Chapter 5, "Image Sensors." They're not meant to provide a final level of sharpening for your image. We'll look at more serious sharpening tools in Chapter 22.

In the Camera Raw Preferences dialog box (press Cmd/Ctrl-K while in Camera Raw), you can set the Apply Sharpening To pop-up menu to specify that the sharpening settings should be applied to your final images or only to the preview you see within Camera Raw. Setting your Camera Raw preferences to sharpen previews lets you work in Camera Raw with an approximation of what your final sharpening will be, but without actually sharpening your final image. You can sharpen your image by hand later, just as you always would. For people who want only one sharpening step in their workflow—at the end—this is a nice way of seeing some sharpening without actually applying it.

With CS5, Adobe has introduced dramatically improved noise reduction to Camera Raw. As you've learned, there are two types of noise: luminance noise, which appears as speckly patterns throughout your image; and chrominance, or color noise, which appears as colored splotches. The Detail tab provides both luminance and color sliders for targeting the noise in your image.

The reason that noise reduction is grouped with sharpening is that noise reduction almost always results in a softening of your image, so you'll want to balance noise reduction with sharpening. And as the Camera Raw dialog box suggests, be sure you perform these adjustments when zoomed to 100%.

HSL/Grayscale

Under the HSL/Grayscale tab, you'll find controls very similar to the Hue/Saturation controls you used in Chapter 16. These sliders let you adjust specific color ranges in your image, allowing you to alter hue, saturation, and lightness.

The Convert to Grayscale checkbox performs a grayscale conversion on your image. We're going to discuss grayscale conversion in more detail in Chapter 19, "Black-and-White Conversion."

Split Toning

A variation on straight grayscale conversion, Split Toning creates duotone-like effects. The highlights in your images can be toned with one color, while the shadows can be toned with a separate color. These controls will also be covered in Chapter 19.

Lens Corrections

These controls allow you to perform the same type of distortion, chromatic aberration, and vignette correction that you can perform in Photoshop with the Lens Correction filter that you saw in Chapter 14, "Editing Workflow and First Steps." Its controls, and the automatic profiling feature, are identical to what you saw there.

Effects

With the Effects tab, you can add grain to your images (see Figure 17.19). After all this talk about reducing noise, why would you want to add grain? Grain and texture can be evocative and atmospheric, and if you need to achieve a film-like look, grain management can be essential. Also, if you're going to composite a raw image with an image shot on film, you might need to add grain to the raw image to make for a better match.

To further enhance your "grungy film" efforts, you might want to add a vignette to an image. While you can add a vignette using the Lens Correction controls, those vignettes are applied to the original, full-size image. So, if you've cropped the image at all, you won't necessarily see the effects of vignettes applied with the Lens Correction tools because the crop is applied after the vignette.

The Post-Crop Vignette sliders in the Effects tab add a vignette to your cropped image.

Figure 17.19

The Effects tab in Camera Raw lets you add grain and vignettes to your image.

Camera Calibration

If you're very picky about color management, you can carefully, meticulously light and shoot special color targets, with the goal of creating a custom color profile specifically for your camera. Check out the Photoshop Help file for more details.

Presets

You can save the current settings in Camera Raw as a Preset, allowing you to easily apply those settings to images later on. Obviously, some edits are specific to a particular image, but if you regularly shoot in the same lighting conditions, and you've found specific settings that always give good results, then try creating a Preset for those settings. This will greatly speed your editing workflow.

Workflow Options

A raw converter has to go through many steps to produce a final, usable image. In addition to calculating color and adjusting the image according to the settings you defined using the raw conversion sliders discussed earlier, your final image has to be mapped into a specific color space and rendered at a given bit-depth. In Photoshop Camera Raw, you can control these steps in the workflow section of the Camera Raw dialog box (see Figure 17.20).

Adobe RGB (1998); 16 bit; 4752 by 3168 (15.1MP); 240 ppi

Figure 17.20

At the bottom of the Camera Raw window, you'll see a link that looks something like the one shown here. Click it, and you'll see the Workflow Options dialog box. In previous versions of Camera Raw, these options were permanently displayed at the bottom of the main dialog.

Workflow Options

Space: Adobe RGB (1998)

Depth: 16 Bits/Channel

Size: 3504 by 2336 (8.2 MP)

Resolution: 240 pixels/inch

Sharpen For: None Amount: Standard

☐ Open in Photoshop as Smart Objects

OK

Cancel

Depth allows you to select either 8 or 16 bits per pixel. If you're ultimately going to save into a JPEG file, you'll want to select 8 bits. If you want to have as much editing latitude as possible—that is, to be able to make many adjustments before you see tone breaks and posterization—select 16 bits.

Earlier, you learned about color spaces. Camera Raw enables you to select from among several color spaces. sRGB is the smallest, while ProPhoto RGB is the largest. Adobe RGB is a good general-purpose color space. While you might think it's best to simply choose the largest color space possible, there are times when a larger color space can cause problems. If your image doesn't have a tremendous amount of color information in it, trying to stretch that data to fit into a larger color space will result in tone breaks and posterization. Fortunately, with a raw file you can easily try converting into different color spaces to test the results.

Figure 17.21 shows an example of when to switch to a larger color space. In the first image, color space is set to Adobe RGB. Note that the right side of the image shows a red spike, while the left side shows a blue spike. This indicates that highlights in the Red channel, and shadows in the Blue channel, are both being clipped. But, if we change the color space to ProPhoto RGB, the clipped information disappears. This situation occurs because the color of the image is now being mapped into a color space that has "room" for those bright reds and dark blues.

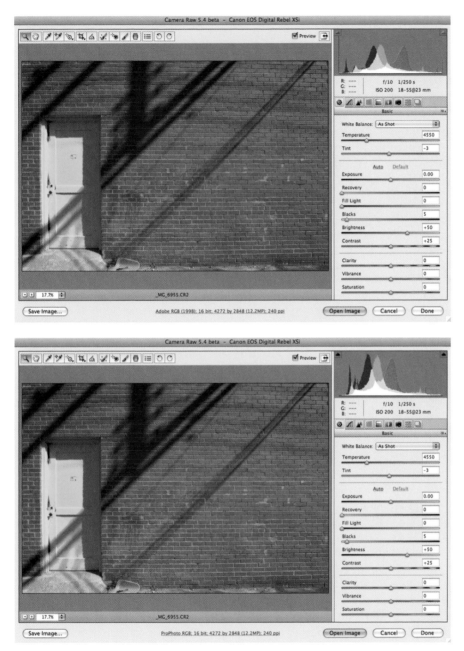

Figure 17.21

Note the Red channel and Blue channel clipping the ends of the histogram in the upper image. After changing to ProPhoto color space, in the lower image, those clipped channels disappear, because the larger color space can accommodate those tones.

Camera Raw also allows you to specify pixel dimensions for the resulting file. This simply provides you with a quick way to produce a smaller image if your ultimate goal is Web output, email, or a smaller print size. You can perform this same resizing later using Photoshop's Image Size command.

The Sharpen For pop-up menu, new in Camera Raw 6, allows you to apply preset sharpening operations, optimized for screen, glossy, or matte printing. For batch processing operations that

don't require localized or custom sharpening jobs, the sharpening controls in the Workflow Options dialog box can be a quick and easy way to get your images sharpened for output.

Why Don't Lightroom, Aperture, and Capture NX Have These Features?

In Lightroom, Aperture, and Capture NX, you don't configure these parameters until you're ready to write a final file.

Copying Your Edits from One Image to Another

Because raw conversion is a nondestructive process—that is, because your edits are kept separate from your image data—you can copy raw parameters that you've specified for one raw image to a bunch of other raw images. White balance, exposure, brightness, and contrast adjustments, even cropping and straightening, can all be easily applied to multiple raw files. Very often, images shot under the same lighting conditions can be corrected using the same edits. Consequently, you might be able to quickly process an entire batch of images by editing the first image and then copying those settings to the other images in the batch.

Copying Raw Edits in Photoshop Camera Raw

If you're using Camera Raw, you have a few options for performing the same raw adjustments on multiple images. First, you can open several images simultaneously into Camera Raw. Each image will be displayed in a filmstrip view on the left side of the window. You can switch from one image to another by clicking it. Click the Select All button and then use the Synchronize button to synchronize your edits (see Figure 17.22).

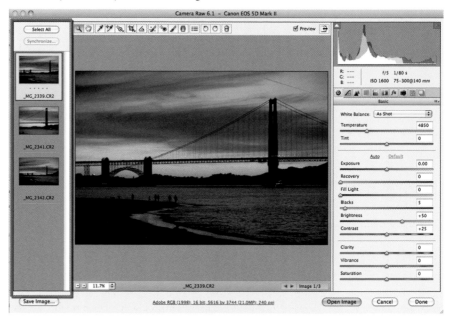

Figure 17.22

You can open several images simultaneously in Camera Raw and then synchronize your edits between all of them.

Any edits you make will be applied to all the currently synchronized images. Synchronization breaks as soon as you click to select a single image.

You can also use Adobe Bridge to copy edits from one file to another. After you've made adjustments to one raw file, those edits can be copied and pasted onto another file, as shown here.

- If you're using Bridge CS3 or later, select that image in Bridge and choose Edit > Develop Settings > Copy Camera Raw Settings to copy the settings from the selected file. Next, select the raw files you want to copy the settings to and choose Edit > Develop Settings > Paste Settings. Alternately, you can choose Develop Settings > Previous Conversion from either menu to apply the last performed raw adjustment to the currently selected image.

- If you're using Bridge CS2, select the image whose settings you want to copy and choose Edit > Apply Camera Raw Settings > Copy Camera Raw Settings. Then select the image(s) you want to apply the settings to and choose Edit > Apply Camera Raw Settings > Paste Camera Raw Settings.

Both versions also offer a "Previous Conversion" option in the same menu. This simply takes the last settings you applied to any image and applies them to the current selection of images. This saves you the trouble of doing a copy step, if the settings you want to copy were the ones you just applied.

Right-Click to Copy Edits in Bridge

If you right-click on an image in Bridge (or Ctrl-Click if you're using a Mac with a one-button mouse), you'll see a pop-up menu that gives access to the Develop Settings menu. From here, you can copy and paste Camera Raw settings.

Copying Edits in Aperture

In Aperture, you can use the Lift and Stamp tool to copy edits from one image to another. Select the Lift tool and then click the image whose edits you want to copy. The Lift tool will automatically change into the Stamp tool. Click with the Stamp tool on any images you want to copy settings onto.

Copying Edits in Lightroom

Lightroom provides the same options as Camera Raw. By using the Edit > Develop Settings menu, you can copy edits from one image to another. This menu also lets you synchronize settings between images and apply auto adjustments.

Copying Edits in Nikon Capture NX

In Capture NX, you'll find options for copying and pasting settings in the Batch menu located at the bottom of the Edit List palette.

Batch Processing in Camera Raw

Earlier, you saw how the Done and Open buttons at the bottom of the Camera Raw dialog box work. You saw that Done simply saves the current settings, while Open performs a raw conversion according to your settings, and opens the results in Photoshop.

Let's say you come back from a shoot with 100 select images, and you want to create finished Photoshop documents. Let's also say that a lot of the images were shot in similar lighting and required similar exposure, meaning you can copy settings from one document to another. This makes it possible to easily get your raw settings correct for each image.

However, opening each one and then executing a Save command can take a little time, both because raw processing can be slow, and because manually filling out 100 Save dialog boxes is simply tedious.

Fortunately, you can tell Camera Raw to automatically process an entire batch of images. Select all of the images in Bridge, and open them in Camera Raw.

The Save Image button at the bottom of the Camera Raw dialog box lets you batch process your raw files, providing you with a way to skip the onerous process of opening and saving each document.

First, select all of the images in Camera Raw that you want to save or click Select All to select them all.

When you click Save Image, you'll see the dialog box shown in Figure 17.23.

Figure 17.23

The Save Options dialog box lets you batch process your raw files easily.

From Save Options, you can specify where you want your images saved and give them a naming scheme, which can include the addition of sequential numbers, dates, and other text. Finally, you can choose an output format. When you click Save, Camera Raw will process your image and save it.

Each image will be processed according to its associated XMP sidecar file. If you didn't manually adjust the settings for an image, then it will be processed using Camera Raw's default settings.

Choosing Where to Host a Batch

Camera Raw is a plug-in, not a stand-alone application. As such, it has to be hosted by another application. When you double-click an image in Bridge, the raw file is passed to Camera Raw, hosted by Photoshop, meaning that Photoshop will activate, and then the Camera Raw dialog box will appear. Alternately, you can select an image in Bridge and press Cmd/Ctrl-R to open that image in Camera Raw, hosted by Bridge.

The option to host Camera Raw in either application means you can let Photoshop batch process your raw files while you work in Bridge, or let Bridge batch process raw files while you work in Photoshop. For more information on Camera Raw workflow, practices, and editing, consult my book *Getting Started with Camera Raw*, which you can order from *www.completedigitalphotography.com*.

If you drag and drop a raw file onto Photoshop's icon, or choose File > Open from within Photoshop and select a raw file, Photoshop will open that file with Camera Raw, just as if you had selected the file from within Bridge.

Adjust in Camera Raw? Or Photoshop?

As you've seen, Camera Raw lets you perform many of the same edits that you can perform in Photoshop. This leaves many people wondering where they should do certain corrections and edits. Should they perform them in Camera Raw? Or wait until they get the image into Photoshop and make them there?

Highlight recovery and white balance adjustment are not possible in Photoshop, so those edits obviously have to be done in Camera Raw. Similarly, Photoshop lacks the sophisticated noise reduction features of Camera Raw 6. For the most part, though, all other Camera Raw edits can be performed just as handily in Photoshop.

So why would you choose to do them in Camera Raw? There are a few reasons. First, all edits in Camera Raw are nondestructive, so the more you can do in Camera Raw, the more you'll be able to adjust and edit later.

Second, Camera Raw edits can be batch processed easily. So, correcting one image in Camera Raw possibly gets you a bunch of other images edited "for free."

With practice, you'll find a division of labor that works for you. Currently, I try to perform as much editing as possible within Camera Raw, simply because of the nondestructive nature. But also, if I get into Photoshop and start working, and then make a mistake, I can go back to my raw file, reopen it in Photoshop, and not have to re-perform a bunch of edits.

What More Do You Need?

Raw conversion used to be a hassle, requiring a complex assortment of programs and a cumbersome workflow. Fortunately, with the current generation of tools, you can work with your raw files just as you would with JPEG, TIFF, or Photoshop files. What's more, if you've done a good job with your exposure, you may find that you don't need to perform any processing beyond your raw conversion settings.

Because it's possible to copy settings from one raw file to another, it's easy to create complex batch processing schemes that make short work of processing huge numbers of images. In this regard, working with raw files can actually be easier than working with JPEGs.

Once you've made your raw conversion, you'll be ready to consider any additional edits you might want to make. We'll cover these edits in the next few chapters, and will be returning to Camera Raw to look at some of its other tools.

18

MASKING

Using Masks to Constrain Your Adjustments

I n the last few chapters, you've learned how to use some very important, very powerful adjustment tools. Levels, Curves, Hue/Saturation, the adjustments that you can perform in a raw converter application—all of these tools allow you to dramatically improve your images. With them, you can correct problems, fix mistakes, or "finish" an image—altering its tone and color until it looks like what you saw in your mind's eye when you took the shot.

However, all of these tools are global tools. The adjustments they make affect the entire image. Unfortunately, you'll very often encounter tone and color problems in just one part of your image. For these instances, you'll need to employ masking tools.

A mask is really nothing more than the digital equivalent of a stencil. With it, you can constrain an edit to a particular spot in your image, just the way a stencil constrains paint to one place on a canvas.

Many photographers feel that masking is not such an important tool because they're not interested in creating weird special effects or wacky composites. Masking, however, can be an essential color-correction tool, allowing you to create adjustments and corrections that would otherwise be impossible. For example, if you want to color-correct only the foreground of an image, you might build a mask over the background elements (see Figure 18.1).

Figure 18.1

To adjust the saturation of only the flower without altering the sky, I created a mask that protects the sky during the Hue/Saturation adjustment that alters the flower.

Similarly, a mask can serve as a stencil when you're combining separate images to create a single composite. If you want to superimpose a new element into an image or replace a background image, good masking skills and tools are essential (see Figure 18.2).

Like many editing tasks, knowing how and when to use a mask is a skill. However, learning the basics of your masking tools is pretty simple once you understand a few simple concepts.

Figure 18.2

A digital mask sits between two different elements in an image, to control which parts of each image are visible. Similar to stencils, digital masks have the advantage of allowing for varying degrees of transparency. Here, the top layer is being composited with the bottom layer, with a mask knocking out the background of the top layer so only the blue text gets combined with the flower.

Mask Tools

Most image editing applications offer many tools for creating masks, and you'll often find yourself using these tools in combination. Some tools, for example, are more appropriate for masking complex subjects, such as hair or fine detail. Other tools are more appropriate for masking geometric shapes or large areas of color. For building complex masks, you'll use a mixture of these tools.

We don't have enough room to go into each of these tools in detail, but this overview should give you an idea of what can be done with each of these tools. A little experimentation should help you understand when and how to use them, and Photoshop's built-in Help files can provide details on specific parameters and adjustments.

Selection Tools

The simplest mask tools are the selection tools—the Lasso and Rectangular and Circular Marquees—that let you create basic selections by outlining areas of your image (see Figure 18.3).

Figure 18.3

Photoshop provides a few different selection tools, including the Marquis and Lasso tools. Most image editors offer something similar, although note that nondestructive tools like Aperture and Lightroom typically don't offer these types of selection tools.

You might not think of these as mask tools, but the selections they produce work just like a mask. Create a rectangular selection around an object, for example, and your editing tools will work only inside that selection. In other words, everything outside the selection is masked out (see Figure 18.4).

Figure 18.4

I used Photoshop's Rectangular Marquis tool to create a rectangular selection around the lower half of this image. I then used the Levels dialog box to increase the contrast of that selection. As you can see, the effects of my Levels adjustment were constrained to the inside of the rectangular selection.

Of course, it's very rare that you'll need to make adjustments that are circular or rectangular. Fortunately, most image editors that provide such tools allow you to add and subtract from the selections you make. In Photoshop, you can add to a selection by holding down the Shift key while you select more of the image. This method enables you to use different tools for different parts of your image. For example, you can use the Circle tool to select a curvy section of an object and then hold down the Shift key and use the Lasso tool to outline the rest of the object (see Figure 18.5).

Figure 18.5

By holding down the Shift key when you use a selection tool, you can add to a selection, allowing you to use different tools to select different parts of an image. In this image, we used the Rectangular Marquee to select a rectangular-shaped area of the chair and then used the Lasso tool to trace around the edge detail.

Similarly, Photoshop lets you use the Option key (Alt if you're using Windows) to subtract from a selection. The ability to keep adding and subtracting to and from a selection with different tools is essential for building complex masks.

In the same family as the selection tools are the Magic Wand tools that automatically hunt down similar colors to create selections automatically. As with other selection tools, you can combine Magic Wand selections with selections made using other tools by simply holding down the Shift or Option (Alt) keys.

Quick Selection Tool

In Photoshop CS3 and later, you have a powerful selection option in the form of the Quick Selection tool, which is located in the same Toolbox slot as the Magic Wand. (Click and hold on the Magic Wand to pop out a menu of other tools.) With Quick Selection, you simply brush across an object you want to select. Photoshop automatically finds the edges of the object for you and selects them. While it can't handle extremely fine detail like hair and semitransparent objects, in many cases, it builds very accurate masks, *very* quickly (see Figure 18.6).

Figure 18.6 Using Photoshop Quick Selection tool, we quickly selected just the dog's head with a single, rough brush stroke.

QuickMask

Figure 18.7

The QuickMask button in Photoshop creates selections by simply painting over them using Photoshop's brush tools.

The Photoshop QuickMask mode lets you create a mask by painting (see Figure 18.7).

To use QuickMask, click the QuickMask icon at the bottom of the main tool palette and then use any of Photoshop's brush tools to paint the area of your image that you want to select. Any areas that you paint black will appear as red. You can switch back to white and paint over

these areas to remove the red. When you leave QuickMask mode (which you can do by clicking the QuickMask icon again), any red areas will be selected (see Figure 18.8).

Figure 18.8

In QuickMask mode, you can select areas simply by painting. Areas painted red in QuickMask mode are unselected when you switch back to normal mode. You can then choose Select > Inverse to reverse the selection so that the areas you painted red become selected. QuickMask is an easy way to make odd-shaped selections.

You can switch in and out of QuickMask mode as much as you like, meaning that you can combine its mask selection tools with your image editor's other masking and selection tools.

Brush Basics

If you're new to Photoshop, there are a few simple things you should know about the program's brush tools (see Figure 18.9). Photoshop's paint brushes work pretty much like you'd expect: you simply click and drag in your document to make paint strokes. You can select the Brush tool from the keyboard by pressing B. Press Shift-B repeatedly to cycle through all of the brush tools.

Figure 18.9

Photoshop provides a Brush tool that you'll use for many different editing operations.

When you select the Brush tool, the Control Bar at the top of the screen fills with controls for configuring the Brush tool. We'll explore some of these parameters later.

(continued)

Brush Basics (continued)

You can change the size of the brush using the Control Bar or by pressing] to make the brush bigger and [to make it smaller.

The color controls at the bottom of the main tool palette are used to specify what color the brush paints with (see Figure 18.10).

Figure 18.10 You'll use these controls for choosing a color to paint with. Keyboard shortcuts are shown in parentheses.

Photoshop lets you choose both a foreground and background color. For the Brush tool, you only need to worry about the foreground color. (The background color is used by other tools and operations.) Clicking the Black/White control resets the foreground and background to black and white, respectively. Clicking the swap button swaps the foreground and background colors.

You can choose a new foreground or background color by clicking on either swatch and then choosing a color from the color picker that Photoshop presents.

Color-Based Selection Tools

Many applications provide special tools for selecting certain colors automatically. Photoshop CS and later include a Color Range command (Select > Color Range) that can automatically select all occurrences of a particular color in an image (see Figure 18.11).

Figure 18.11

The Photoshop Color Range command selects all the occurrences of a particular color in your document. Here, we've selected a dark green. (Remember, white areas in a mask indicate selected areas.)

Color Range will almost always select more pixels than you want, but the extra pixels can usually be easily removed with another selection tool.

Special Mask Tools

There are several third-party masking plug-ins that can be added to any image editor that supports Photoshop plug-ins. Programs such as Vertus Fluid Mask (see Figure 18.12) provide a simple way to create complex masks. If you find yourself consistently trying to mask difficult subjects such as hair or other objects with fine detail or transparency, it might be worthwhile to look into one of these options.

Figure 18.12 Masking plug-ins, such as Vertus Fluid Mask, allow you to create sophisticated masks with very simple tools. Fluid Mask does an excellent job of masking fine detail by first converting your images to vectors it can then easily manipulate.

Altering the Edge of a Selection

You usually don't want the border of a selection or mask to have a hard edge. Instead, you often want to feather or blur the edge of a selection so it blends smoothly into the background. This will make any edits or adjustments you make integrate more seamlessly into the rest of your document.

Photoshop and Photoshop Elements have long provided a Select > Feather Selection command that blurs the edge of a selection by a specified number of pixels. In Photoshop CS3 and later, you'll find a Refine Edge command (Select > Refine Edge), which provides a profound level of control for altering the edge of your selection. The Refine Edge dialog also provides a preview of what your edge will look like when composited against a background (see Figure 18.13).

Refining an edge is an almost mandatory step when working with selections. Without a feathered edge, the boundaries of your adjustment will be clearly visible.

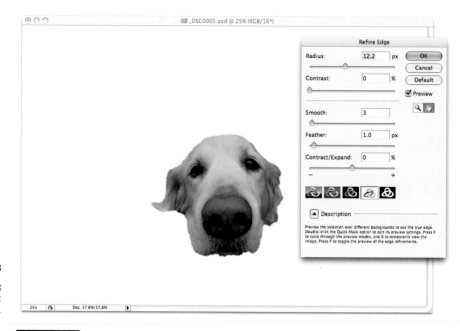

Figure 18.13

Photoshop's Refine Edge dialog
box let's you feather and adjust
the edge of a selection.

Using Refine Edge and Smart Radius

While Photoshop's selection tools make it possible to loop a selection around just about any object, and while the Feather command lets you soften the edge of that selection, the fact is a lot of things in the world don't have clearly defined edges. What's more, their edges vary from one point to another. At other times, you might be stymied by extremely complex edges, such as hair or fluffy fur. How can you select each strand of hair?

Fortunately, Photoshop CS5 provides an excellent addition to the Refine Edge dialog box, which can make short work of such difficult masking chores. In this tutorial, we're going to create a mask and perform an edit that would have been extremely difficult in previous versions of Photoshop.

STEP 1: OPEN THE IMAGE

Download the image Heather.jpg from the Chapter 18 section of the companion Web site at *www.completedigitalphotography.com/CDP6*. Open the image in Photoshop (Figure 18.14).

Shot at an aperture of f1.2, this image has extremely shallow depth of field, which gives it a nice, dreamy quality, and lends a lot of focus to her eyes. However, her coloring so closely matches that of the mural on the wall behind her that she's a little lost in a field of pink and red tones. We want to desaturate the background to bring more focus to her.

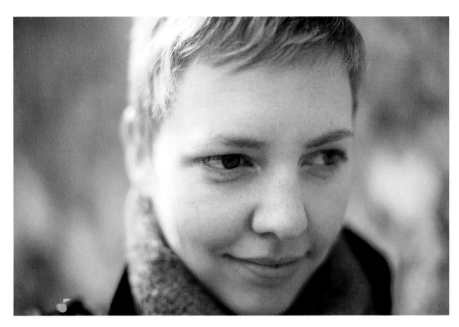

Figure 18.14

Using Photoshop CS5's Refine
Edge control, we're going to
perform a very difficult masking
operation on this image.

STEP 2: CREATE A MASK

Using your choice of masking techniques, create a mask for the woman. I used the Quick
Selection tool and simply painted over her. There were times when Quick Selection would
also select the background. For these instances, I held down the Option/Alt key and painted
with the Quick Selection tool on those background areas. Holding down Option/Alt while
painting with Quick Selection removes the painted area from the selection.

Changing brush size is also a good way to improve the effectiveness of the Quick Selection
tool. Because the edge of her face, and her body are so blurred, you're not going to create a
selection that tightly wraps around her (see Figure 18.15).

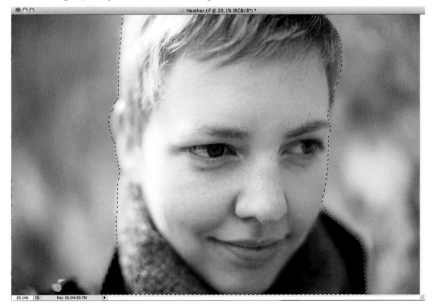

Figure 18.15

With the Quick Selection tool,
we created this very rough mask
of the woman.

STEP 3: INVERT AND HIDE YOUR SELECTION

Remember, when you painted with the Quick Selection tool, you selected the woman. But we want to operate on the background, not on her. Choose Select > Inverse to reverse the selection. You will now see that the selection traces around the edge of the background.

Now choose View > Show > Selection Edges to turn off the "marching ants" of the selection. You can also press Cmd/Ctrl-H to hide the selection. When you do this for the first time, Photoshop on the Mac will ask you if you want to hide extras or the application. Click extras.

By hiding the selection edges, we'll have a clearer view of our edits. However, we'll also have no visual clues that there is a current selection, so it's important to remember to turn the selection edges back on when we're done.

STEP 4: TRY A DESATURATE

Choose Image > Adjustments > Hue/Saturation to bring up the now-familiar Hue/Saturation dialog box. Drag the Saturation slider all the way to the left (Figure 18.16).

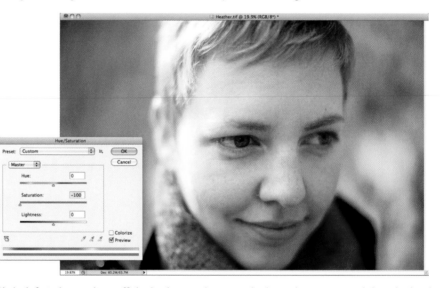

Figure 18.16

After desaturating the selected background, we get this image that doesn't look quite natural.

She's definitely standing off the background more, which is what we wanted, but the hard edge around her face—the sudden shift from color to black and white—doesn't look real at all. We've plainly discolored the background, and the effect is distracting.

Click Cancel in the Hue Saturation dialog box to cancel the desaturation option. You should see your full-color image again. Though you can't tell, your selection is still active.

STEP 5: INVERSE THE SELECTION AGAIN

This step isn't going to be intuitive, but trust me on this one, you want to inverse the selection again by choosing Select > Inverse. We're about to open the Refine Edge dialog box, and our Refine Edge action will be much easier if she's selected, rather than the background.

STEP 6: REFINE EDGE

Choose Select > Refine Edge to call up the Refine Edge dialog box.

By default, Refine Edge will show your selection on a completely white background. If you'd rather see it on a different type of background, you can choose a different one from the View pop-up menu at the top of the Refine Edge dialog box. White works well for this chore.

Now you can see why we needed to inverse our selection first. We need to be able to see where the edges of the woman are.

STEP 7: SMART RADIUS
Check the Smart Radius checkbox, and then click on the Brush tool next to Smart Radius. Set the Radius slider to about 2 pixels. (I'll explain this in a minute.)

With this brush, you're going to brush along the edges of the selection—that is, the edges of the woman. Your painting is going to give the Refine Edge function a hint as to where the edge is. It will analyze that area and calculate a new edge for the mask.

You can change the size of the Smart Radius brush with the [and] keys, just as you can in Photoshop. I chose a diameter roughly the size of about half of one of her eyeballs. The goal is to have a brush that's as wide as the entire blurry edge that we want to refine.

Paint a stroke down the left side, and when you let go of the mouse, you should see a very soft edge (Figure 18.17).

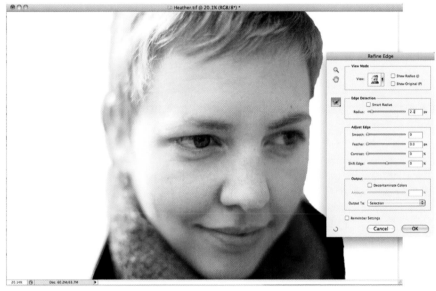

Figure 18.17

After painting with the Smart Radius brush down the left side of the selection, I have a smooth, well-masked edge.

STEP 8: PAINTING THE OTHER SIDE
Now paint the other side. In general, it's best if you can do it all in one stroke.

STEP 9: REFINE
When you painted the right side, there's a good chance that some weird stuff happened around her eye (see Figure 18.18).

Refine Edge very likely selected too much of her face.

Click and hold on the Refine Edge brush, and a pop-up menu will appear, revealing the Erase Refinements brush. Select this brush, change to a small brush, and paint over the parts of her face that you'd like to restore. You should see them reappear.

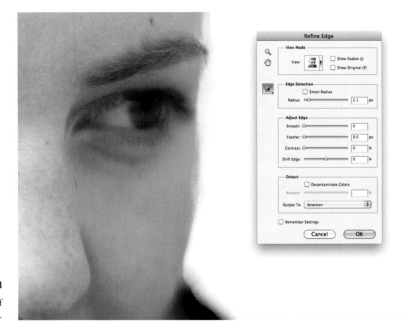

Figure 18.18

Refine Edge selected too much of her face here.

STEP 10: ACCEPT THE SELECTION AND DESATURATE

After you've got the edges refined, press OK to make the selection. Choose Select > Inverse to inverse the selection, so that the background is selected.

Invoke the Hue/Saturation dialog box and desaturate. After seeing the completely desaturated results, I decided not to desaturate entirely, so that a little bit of color remains in the background. Your results should like something like Figure 18.19.

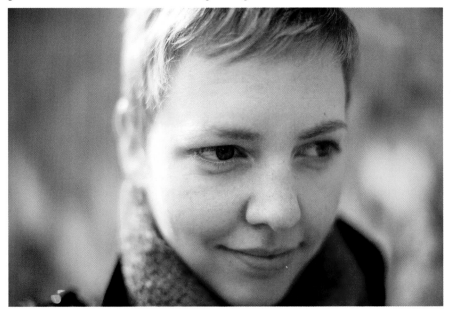

Figure 18.19

Our finished image with the background desaturated.

Note how the transition zones around her face look very realistic. She doesn't look "cut out" from the background, but blends with the background realistically. Refine Edge did an excellent job of masking around her hair and of creating a smooth transition along the soft edges of her face. ◤▌

Masking Hair with Refine Edge

Hair is one of the most difficult masking challenges that you'll face. Consider Figure 18.20. If we wanted to create a mask around the woman, we'd have a very difficult time selecting each strand of hair.

Figure 18.20

Masking successfully around all this hair is no easy task. Fortunately, Photoshop's CS5 Refine Edge feature can handle the problem.

In Photoshop CS5, the Refine Edge dialog box now includes all the tools you need to handle a complex masking task like this. To learn how to do this, watch the `Masking Hair.mov` tutorial, located in the Chapter 18 section of the companion Web site. ◤▌

Saving Masks

Once you've used the various tools at your disposal to create a selection, you can save that selection as a mask for later use. In Photoshop, selections can be saved by clicking Select > Save Selection. At any time, you can use the Select > Load Selection command to restore your selection.

Earlier, you saw how separate red, green, and blue channels were used to create a full-color image. You also saw that you could access those individual channels using the Channels palette. Selections, or masks, are stored in a similar fashion. When you save a selection, your image editor creates a new channel in your document—called an *alpha channel*—and stores an image of your selection (see Figure 18.21).

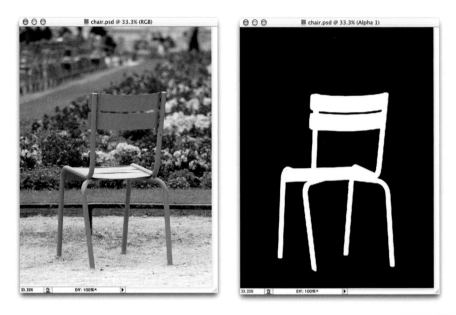

Figure 18.21

When you save a selection, Photoshop stores a grayscale, 8-bit alpha channel. Black areas of the image are masked, but white areas are not. If you load this alpha channel as a selection, the white area will be selected, just as if you had traced it with a Lasso or any other selection tool.

As you can see, any selection can be represented by a grayscale image—areas within the selection are stored as white pixels; areas outside are stored as black. (Another way of thinking of it is "black conceals, white reveals.") In Photoshop, you can create as many different selections as you want and store each in its own alpha channel. From the Channels palette, which you can open by clicking Window > Show Channels, you can access each mask by simply clicking its name (see Figure 18.22).

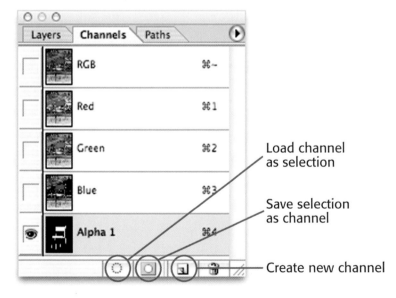

Figure 18.22

You can see and access the alpha channel from the Photoshop Channels palette.

A Mask by Any Other Name

"Mask," "channel," and "selection" are all synonymous, and I'll be using them interchangeably throughout the rest of this book. A selection simply creates a mask, just as any other masking tool does. All masks are saved in your document as alpha channels—8-bit channels in your image where black represents fully masked, white represents unmasked, and gray is partially masked. We'll be freely interchanging these terms throughout the rest of this book.

The Limits of Selection Tools

For many images, the easiest and best way to create a mask is to use a combination of selection tools with a refined edge. The selection tools are easy enough to use that you should be able to learn them on your own very quickly.

At this point, what's most important for you to understand, regarding masks, is the idea that they can be stored as grayscale images, with black representing masked out areas, and white being unmasked.

The next tutorial will help you better understand the nature of masks.

Creating Complex Masks

In this tutorial, you'll create and use a mask to perform a complex color correction. You won't be able to perform this tutorial in Photoshop Elements. But even if you plan to use only Elements, it's worth working through this tutorial to get a better understanding of how masks

work and to learn about the Photoshop masking workflow.

This tutorial does not show a typical, everyday masking process, but it does introduce you to some techniques that you might use from time to time. Most importantly, it's a chance for you to dig deeper into selection and masking concepts, to get a better understanding of how masks work.

STEP 1: OPEN THE IMAGE

Open the image tree.jpg, located in the Chapter 18 section of the companion Web site (see Figure 18.23). Your goal in this tutorial is to try to emphasize the foreground elements—the tree and the bent wrought-iron cage—by lightening the background. To edit the background without disturbing the foreground, you need to mask out the tree.

Figure 18.23

Because we want to edit the background of this image without disturbing the tree, we need to create a tree mask.

Figure 18.24

This mask was built using the QuickMask tool and is included on the companion Web site. Black areas are masked, white areas are not. So this mask protects the tree from adjustments.

STEP 2: CREATE A MASK

Using your choice of masking tools, create a mask for the tree and the entire wrought-iron cage that surrounds the tree. Save the mask by clicking Select > Save Selection. To save time, the file tree with mask.psd has been included on the companion site. This image includes a prebuilt mask you can use for the rest of this tutorial (see Figure 18.24). (In case you're wondering, this mask was created by simply painting over the tree and fence using the Photoshop QuickMask tool.)

STEP 3: LOAD THE MASK

Before you can use a mask, you must load it. Open the Channels palette. You should see separate channels for red, green, blue, and your mask (called *Alpha 1*). At the bottom of the Channels palette are a series of buttons. The far left button is the Load Channel as Selection button (see Figure 18.25). Drag the Alpha 1 channel on top of this button; Photoshop will load the channel as a selection, and you should see the "marching ants" display. (If you end up clicking the Alpha 1 channel, your document will switch to a view of that channel. Click the RGB channel at the top of the Channels palette to return to viewing the entire, full-color image. Then try again to load your selection.)

Figure 18.25

You can load a mask as a selection by dragging its icon in the Channels palette to the Load Channel as Selection button at the bottom of the Channels palette.

Sometimes, after loading a mask, it can be difficult to tell what is selected and what isn't. For example, with the tree mask loaded, it's difficult to tell whether the foreground or background is masked. To find out, click the Brush tool and brush around the image. You should see that the paint is going only into the background because the tree is completely masked. Click Undo to remove your brushstrokes. (If Undo doesn't undo all the strokes, use the Edit > Step Backwards command or the History palette.) If the paint is going into the foreground, your mask is backward. From the Select menu, click Invert Selection to reverse your mask. Now when you brush, your paint should go into the background.

STEP 4: FADE THE BACKGROUND

With your mask loaded, you can start manipulating the background. If the goal is to emphasize the foreground, you should try lightening the background using a simple Levels command.

Click Image > Adjust > Levels to open the Levels dialog box. (If you find the Levels selection grayed out, look in the Channels palette and make certain that the RGB channel is highlighted.) In previous tutorials, you used the Input controls exclusively and learned how they allow you to change the distribution of tones within your image. So far, though, your Levels adjustments have redistributed the tones in your image so they fit between full black and full white.

However, what if your printer can't print full black? Many offset printers can't hold more than 85 percent black—any more ink, and they jam up. Therefore, Levels includes a pair of output sliders that adjusts the limits of the tonal range in your image. The distribution of tones specified by the input levels remains the same.

Let's eliminate many of the darker tones without changing the tonal relationships in our image. Slide the left output slider to roughly the midpoint (around 126) and click OK. This step should create a faded background (see Figure 18.26).

Output Sliders

Figure 18.26

We've faded everything but the tree. Unfortunately, we've faded more than just what was behind the tree in the scene. The sidewalk in front of the tree has been faded as well.

STEP 5: ASSESS THE CHANGE

Now it's time to assess if this was the right edit. With all those selection lines marching around, it can be difficult to see the image clearly. Choose View > Show > Selection Edges, which lets you toggle the display of selection edges.

Sure enough, as we planned, the adjustment faded the background. The tree didn't fade because that part of our mask was completely black, thus preventing the Levels adjustment

from affecting the tree. Unfortunately, because we faded everything but the tree, our edit has also caused elements in front of the tree to fade. This is not really the desired effect. Click Undo to remove the Levels adjustment.

What we want is a Levels adjustment that won't affect the entire image uniformly, but will be stronger in parts of the image that appear farther away. It's time to create another mask.

Choose Deselect from the Select menu to deselect the current selection. We don't want anything selected right now.

STEP 6: CREATE A GRADATED MASK

Although you can use any number of selection tools to create masks, you can also paint them by hand, directly into an alpha channel. In the Channels palette, click the Create New Channels button (the second button from the right). A new channel will be created, selected, and filled with black.

Remember that black areas in a mask are completely opaque, white areas are completely transparent, and gray areas are somewhere in between. We want a mask that fades from fully opaque to fully transparent.

Figure 18.27

The Black/White switch lets you immediately set the foreground and background colors to black and white, respectively.

Set the foreground and background colors to black and white by clicking the Black/White switch next to the Photoshop color swatches in the main tool palette (see Figure 18.27).

Now select the Gradient tool and drag from the bottom to the top of the image to create a complete black-to-white gradient. To make it easier to drag a straight vertical line, hold down the Shift key while dragging to constrain movement to 90° angles. You've now got a mask that fades from completely unmasked at the bottom to completely masked at the top.

Figure 18.28

We get a better fade with a graduated mask, but now our tree is fading along with the background.

STEP 7: TRY THE NEW MASK

Click the RGB channel in the Channels palette to switch back to full-color view. Now load the new channel by dragging the Alpha 2 channel to the Load Channel as Selection button. A selection will appear that covers about half the image. Don't worry—Photoshop has loaded the complete mask; it's choosing to outline only areas that are more than 50 percent masked. Choose View > Show > Selection Edges to hide the selection and then apply the same Levels adjustment as you did in step 4 (see Figure 18.28).

This is the effect we wanted—a lightening of the image that gets stronger from bottom to top. Unfortunately, the effect is no longer confined to just the background, it's fading the tree as well. Click Undo to remove the Levels adjustment, and let's make another new mask.

STEP 8: CREATE YET ANOTHER MASK

Go back to the Channels palette and delete the Alpha 2 channel by dragging it to the trash can at the bottom of the palette. Now make a new channel by clicking the New Channel button at the bottom of the Layers palette.

We want to create a gradient that fills the entire document *except* where the tree is. Unfortunately, the Gradient tool will fill the whole channel unless we use the tree mask we already created. Load the first mask (the tree) by dragging the Alpha 1 channel to the Load Channel as Selection button. You should see the outline of the tree mask.

Now click the Gradient tool and make a bottom-to-top, black-to-white gradient. You should end up with something like the mask shown in Figure 18.29. The tree is completely black, meaning it's completely masked and will not be affected by any editing operations, whereas the background is masked with a gradient, meaning the effect of any editing operations will vary from top to bottom. Click the RGB channel to view your color image.

Figure 18.29

This mask provides the gradient we need to create our fade while masking out the tree.

STEP 9: FADE THE BACKGROUND

Now load your new mask by dragging it to the Load Channel as Selection button on the Channels palette and apply your Levels adjustment. You should see a Levels change that affects only the background but varies from the bottom to the top of the image.

With this mask, you can edit the foreground and background independently of your image. Try experimenting with different color corrections and filters. The image in Figure 18.30 has had a more severe Levels adjustment applied to it and some subtle desaturations of the foreground and background. ◀

Figure 18.30

Our final tree image includes some extra color desaturations and levels adjustments.

Adjustment Layers

As mentioned earlier, selection tools can be a good way to constrain the effects of your image edits. They might also be the only masking tools that your image editor of choice provides. If you're using Photoshop, though, you have another option.

One of the most powerful editing features in Photoshop and Photoshop Elements is their Adjustment Layers, which let you apply Levels, Curves, Hue/Saturation, and many other image-correction functions as layers. For example, when you add a Levels Adjustment Layer to your document, you have access to a normal set of Levels controls. But instead of applying the Levels adjustment to the image—and altering the pixels in your document—it stores the adjustment in a separate layer that appears in your Layers palette (see Figure 18.31).

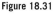 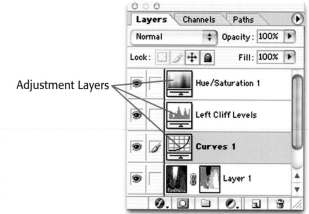

Figure 18.31

The top layers in this image are Adjustment Layers. They apply, respectively, Hue/Saturation, Levels, and Curves adjustments to the underlying layer. Their settings can be altered or changed at any time.

If you imagine your image as a print sitting on a table, then an Adjustment Layer is like a transparent filter that you lay on top of your image. Perhaps it's a transparent filter that increases contrast, or alters color, or converts your image to black and white. Like a transparent filter on a piece of paper, you can remove the Adjustment Layer later, if you want.

An Adjustment Layer affects all the layers beneath it. (You can constrain the effects of an Adjustment Layer by grouping it with underlying layers; see Photoshop online Help for details.) The real strength of Adjustment Layers, though, is that you can go back at any time and change the Adjustment Layer's settings. Therefore, if you decide at some point that your Curves adjustment is not quite right, you can simply alter the parameters of your Curves Adjustment Layer. In addition to providing flexible editing, Adjustment Layers keep you from reapplying effects that result in data loss. You'll be using Adjustment Layers extensively throughout the rest of this book.

Destructive Versus Nondestructive Editing

If you open a Levels or Curves control (or any of the other adjustments you've worked with so far) and apply a change to your image, you are actually changing the original pixel data in your image. This is called *destructive editing* because you are destroying your original pixels. Adjustment Layers do not affect your original data. Instead, they are adjustments that are applied on-the-fly to your image data as the data is written to the screen or output to a printer. These types of corrections are called *nondestructive edits* because your original image data is still there, allowing you to go back and change your edits and adjustments later. In programs like Aperture, Lightroom, and Capture NX, all edits are nondestructive. In Photoshop, only edits applied through Adjustment Layers are nondestructive.

One of the other great advantages of Adjustment Layers, is that they have a masking capability built in. In the previous tutorial, you saw how alpha channels could be used to create masks. Adjustments Layers have a special Layer Mask built in, which allows you to create complex mask effects easily (see Figure 18.32).

Layer ContentLayer Mask

Figure 18.32

Each of these Adjustment Layers has a Layer Mask, which constrains the effects of each Adjustment.

To continue our analogy of an Adjustment Layer being a transparency sitting on top of a printed image, a Layer Mask would be a stencil that sits between that transparency and your underlying print.

The easiest way to learn how Adjustment Layers and Layer Masks work is with a quick tutorial. Note that this tutorial requires either Photoshop 7 or later, or Photoshop Elements 2 or later.

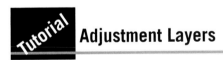 **Adjustment Layers**

STEP 1: OPEN THE IMAGE

Download the image underexposed.jpg from the Chapter 18 section of the companion Web site. Open it in Photoshop.

Because of the backlighting situation here, the foreground figures are very underexposed (see Figure 18.33). We can improve their contrast with a Levels adjustment, but because the background—especially the sky—is reasonably exposed, doing so would quickly blow out the clouds. We need to create a mask to limit our edits to only the figures in the foreground. As you learned earlier in this chapter, we could select the figures by outlining them with the selection tools (Lasso, Magic Wand, and so on), or paint over them in QuickMask mode, and then use that selection as a mask to constrain your Levels operation. We're going to take a very different approach for this image.

Figure 18.33

Our camera's Matrix meter favored the sky in this image, resulting in the foreground figures being overexposed. (To avoid this problem, we should have used the camera's Center-weight meter.)

Figure 18.34

The Layers palette includes a pop-up menu with commands for adding and managing Adjustment Layers.

STEP 2: CREATE AN ADJUSTMENT LAYER

Add a new Levels Adjustment Layer by opening the Adjustment Layer pop-up menu at the bottom of the Layers palette (see Figure 18.34). You might need to open the Layers palette if it's not visible.

Another Way to Make an Adjustment Layer

The Adjustments palette (which is only available in CS4 and later) provides another way to create Adjustment Layers. When no Adjustment Layers are selected in the Layers palette, the Adjustments palette provides icons for each type of Adjustment Layer. Just click an icon to add that type of Adjustment Layer above the currently selected layer. If you hover your mouse over each icon, you'll see a Tool Tip that will tell you what type of Adjustment Layer each icon represents.

A Levels Adjustment Layer will appear in the Layers palette, and the Adjustments palette will appear above the Layers palette. (If it doesn't appear, choose Window > Adjustments.) Any time you click the Levels Adjustment Layer to select it, its controls will appear in the Adjustments palette (see Figure 18.35).

Figure 18.35

When you select an Adjustment Layer in the Layers palette, its controls appear in the Adjustment palette.

Previous Versions of Photoshop

If you're using a version of Photoshop prior to CS4 (but one that still includes Adjustment Layers), then your Adjustment Layers will work a little differently. You won't have an Adjustment palette. Instead, when you create an Adjustment Layer, the standard dialog box for that type of adjustment will appear (the Layers dialog box for a Layers Adjustment Layer, the Curves dialog box for a Curves Adjustment Layer, and so on). You can configure the controls as needed; then press OK to dismiss the box. Any time you want to alter the parameters of the Adjustment Layer, you'll double-click that layer in the Adjustment Layer palette to invoke its dialog box.

STEP 3: CONFIGURE THE ADJUSTMENT

By default, the Levels Adjustment Layer isn't doing anything, because its controls are set to neutral positions. Our next step, therefore, is to configure the Adjustment Layer to perform the brightening we want.

While looking *only at the figures*, (since they're what we're trying to brighten), make your adjustment to improve their exposure. This will affect the background exposure adversely, but don't worry about that right now. To heighten the contrast, you'll want to move both the black and white points, and you'll need a severe midtone adjustment to brighten their details. Consider a black point around 11, midpoint around 2.2, and a white point of roughly 170. Afterward, the figures will look better, but the rest of the image will be overexposed (see Figure 18.36).

Figure 18.36

The faces look better now, but the image is overexposed.

STEP 4: EXAMINE THE ADJUSTMENT LAYER

The Adjustment Layer is represented in the Layers palette as a layer called *Levels 1*. Click the eyeball icon on the left side of the Levels 1 layer to hide the Adjustment Layer. Your image will now appear normal because you've deactivated the effects of the Adjustment Layer. Click the eyeball again to reactivate it. This is nondestructive editing in action. Because the original pixels in your image are never altered, as soon as you turn off the Adjustment Layer, you'll see the original, unaltered image.

Double-click the name of the layer, "Levels 1," to make it editable and change the name to "Faces." Keeping your layers named can make things easier as you add more and more layers to your document.

Each Adjustment Layer displays an icon that tells what type of adjustment it performs. Next to this icon is another icon that represents the Adjustment Layer's mask (see Figure 18.37). This mask is just like the masks you worked with in the last tutorial. If you paint black into the mask, the Adjustment Layer will not affect those areas of the image.

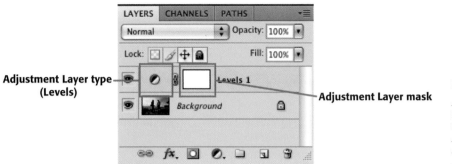

Adjustment Layer type (Levels)

Adjustment Layer mask

Figure 18.37

Adjustment Layers show two icons in the Layers palette: one indicates what kind of Adjustment Layer it is, and the second shows a thumbnail of the Adjustment Layer's mask.

STEP 5: PAINT THE MASK
Click the Layer mask icon in the Levels Adjustment Layer to select it. A black highlight will appear around it.

Select the Paint Bucket tool and choose black as your foreground color. Because we have the Adjustment Layer's mask currently selected, painting operations will affect only the Adjustment Layer mask. With the Paint Bucket tool selected, click somewhere in your image to fill the Adjustment Layer mask with black. Your image will return to its original state, because we have completely masked out the Adjustment Layer. In other words, the Adjustment Layer is not affecting any part of your image. You can see that its mask is completely full, because the Adjustment Layer icon on the Levels layer is completely black.

STEP 6: PAINT IN THE FIGURES
Select white as your foreground color and choose the Brush tool (which you can do from the keyboard by pressing B). Select a large, soft-edged brush. The easiest way to do this is to open the Brushes palette on the Control Bar.

Paint on the figures in the image. As you brush, you will punch a hole in that part of the Layer mask, allowing the Adjustment Layer's effect to filter down to your image. As such, the figures should brighten up according to your Levels adjustment (see Figure 18.38).

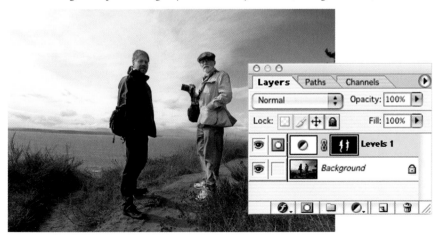

Figure 18.38

By painting into the Adjustment Layer's mask, we can punch a hole in the mask, so the Adjustment Layer's effect filters through only to the figures.

(If, at any time, you see white paint going into your canvas, it means that you've clicked on the image thumbnail in the Layers palette. Click Undo and then select the mask icon in your Adjustment Layer.)

If you make a mistake—perhaps you paint into the background—switch to black paint and paint over the mispainted areas. You may need to switch to a smaller brush for this. You can freely switch between black and white paint to alter the mask.

STEP 7: ADJUST THE LEVELS SETTINGS

Very often, in an edit like this, after your mask is in place, you'll realize that your initial Levels settings weren't quite right. It can be difficult to assess the proper adjustment when looking at the entire image. In this case, we've gone a little too bright because the figures look artificially brightened.

In the Adjustments palette, pull the White Point slider back to around 200. This will make the faces a little darker, but it's a level that will look a little more realistic.

If you're using an earlier version of Photoshop, you'll double-click the Adjustment Layer to open the Levels dialog box. You can change the parameters there.

STEP 8: EXAMINE THE DIFFERENCE

Click the eyeball icon on the Levels Adjustment Layer to deactivate the layer. You should see the figures darken. Now reactivate it to reapply the layer. This gives you a clear view of exactly what has changed.

Sometimes, when you see the original exposure, you may change your mind about your mask. For example, I think I like the blue jeans on the right-side figure more when they're darker. So I took black paint and painted back over the jeans to patch that part of the mask. Now the jeans receive no brightening.

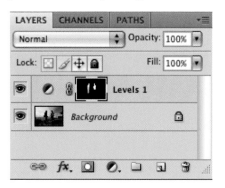

Figure 18.39

As you paint into the mask, the mask icon in the Layers palette updates to show you what the mask looks like.

Note too that the mask icon in the Adjustment Layers palette updates to show you a thumbnail of your current mask (see Figure 18.39).

STEP 9: PAINT IN THE FOREGROUND

The ground in the foreground could also use some adjustment, although not as much as what we applied to the figures. We could create another Adjustment Layer specifically tailored to the ground, but there's an easier way. Remember that in an alpha channel mask, black areas mask completely, white areas don't mask at all, and shades of gray fall somewhere in between. Adjustment Layer masks work in the same way. So, if we want to apply only *half* the adjustment that we applied to the figures, we need to do nothing more than paint with a 50 percent gray color.

Set the foreground color to roughly 50 percent gray and paint over the ground (see Figure 18.40). Note that you can use any painting tools. If you want to cover a large area quickly, grab the rectangular selection tool, select the bottom of the image, and then use the Edit > Fill command or Paint Bucket tool. You can then switch back to a paintbrush to paint the borders and fine detail.

Note that if you make any mistakes, you can simply grab the appropriate color—black, white, or gray—and repaint the damaged areas of your mask.

The advantage of Adjustment Layers with Layer masks is that you don't have to go through separate masking and filter steps. What's more, because your mask is dynamically applied to your Adjustment Layer, you can go back and edit it at any time. With normal masking techniques, you'd have to make your mask, select it, apply your adjustment, and then, if it wasn't right, click Undo and start over.

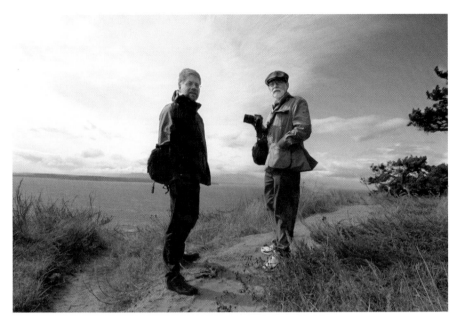

Figure 18.40

For our finished image, we used various shades of gray to paint more or less effect into different parts of the image.

A Critical Adjustment Layer Tip

Once you start adding Adjustment Layers to your image, it becomes critical that you always pay attention to which layer is selected before you start adding adjustments and edits. This is the most common problem that I find in Photoshop classes. Students say that a particular filter or effect isn't working, and then it turns out that they have an Adjustment Layer selected, rather than their base image layer. So always be sure you're clear on which layer you're working on, and if you find that an effect doesn't seem to be doing anything, check your current layer selection before trying anything else.

More Layer Masking

Because Adjustment Layers and Layer Masks are so important, we're going to work on them some more. The techniques you're seeing here are everyday processes that you will use regularly, so it's important that you have a strong understanding of how all this works.

STEP 1: OPEN THE IMAGE

Download and open the image big sky.psd, located in the Chapter 18 section of the companion Web site. This image shows a well-exposed sky, but because this scene poses a big backlight problem, the foreground has gone way too dark (see Figure 18.41). We want to brighten the foreground without overexposing the sky.

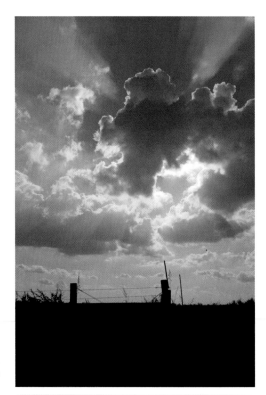

Figure 18.41

The foreground in this image is too dark. We're going to fix it with some Adjustment Layers.

Figure 18.42

Brightening the foreground requires a very aggressive Levels Adjustment.

Here are some handy Photoshop shortcuts. You can use Ctrl/Cmd-+ to zoom in to an image and Ctrl/Cmd- – to zoom out. Ctrl/Cmd-0 (that's a zero) will zoom the image to the largest possible size that will fit on your screen, and it's an easy way to see the whole picture.

STEP 2: ADD A LEVELS ADJUSTMENT LAYER

Using the Layers palette, add a Levels Adjustment Layer, just like you did in the last tutorial. The foreground is very dark, so we're going to need a very aggressive adjustment. Move the white point in the Levels control to the left. I set mine at 74. As before, you're not going to pay any attention to what happens to the sky because you will mask it from the effect later. You're only concerned about what the foreground looks like (see Figure 18.42).

STEP 3: CONFIGURE THE GRADIENT TOOL

As you've learned, you can constrain the effects of an Adjustment Layer by painting into its mask. So, if we paint black into the area of the mask that covers the sky, the sky will be masked from the Levels Adjustment, and will not change. The problem with trying to paint a mask of the sky is all of that detail on the horizon. It will be very difficult to paint around all of the trees, the telephone pole, and the fence. Rather than trying such refined painting, we'll use the Gradient tool to create a graduated effect.

Select the Gradient tool, set the foreground color to white, and set the background color to black (pressing D will set the colors for you). Open the Gradient pop-up menu on the Control Bar (see Figure 18.43) and ensure that the gradient is set to "Foreground to Background."

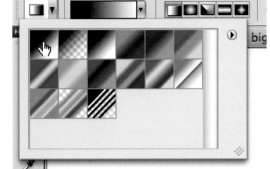

Figure 18.43

Select the Gradient tool; then, from the gradient pop-up in the Control Bar, choose Foreground to Background, which is the gradient swatch in the upper-left corner.

STEP 4: BUILD THE MASK

As you learned earlier, the Gradient tool automatically creates smooth gradients from one color to another. Since you're now configured to make a gradient from black to white, you can easily make a mask that blends from fully masked to fully unmasked.

Make sure the mask is selected in the Layers palette and then click and drag in the image, as shown in Figure 18.44.

Click here

Drag to here

Figure 18.44

If you drag with the gradient as shown here, you'll get the results shown in the right-hand image.

With the gradient in the mask, we now have a smooth transition from the masked to unmasked areas. Look at the mask thumbnail, and you can see that the bulk of the mask is black because we're completely masking out the top of the image where the sky is. Then there's a very short gradient of intermediate gray tones, and the mask is completely white at the bottom of the image.

That transition zone looks natural because the sky has a gradient of its own near the horizon, so the graduated increase in brightness produced by the Levels Adjustment creates a natural looking sky.

STEP 5: IMPROVE THE FOREGROUND

The foreground is still a little dark. We could alter the Adjustment Layer to brighten up the foreground a little more. A simple tweak of the Gamma slider would do this. But if we go brighter, the image starts to look very unnatural. Also, the problem with the foreground is not just that it's a little dark, but that it's very "flat." There's no real contrast, because the scene simply wasn't illuminated very well—as you can see, the sun was behind a cloud.

However, very often, in this kind of light, stray bits of light will illuminate highlights in a very dramatic manner. That didn't happen here, but there's no reason we can't fake it.

Add another Levels Adjustment Layer and set its white point to 199. This will make the entire image way too bright, but as before, you only need to pay attention to the foreground. However, with this setting, even the foreground is starting to look a little garish. Don't worry, we're about to fix that.

STEP 6: MAKE A MASK AND FILL IT WITH BLACK

Click the mask of the new Adjustment Layer to select it. We need to fill the mask with black so that its effects are completely masked out. Here's a shortcut: select the entire mask by pressing Ctrl/Cmd-A. Press the X key to swap the foreground and background colors, so that black is now the background color. (In other words, press X until the rear swatch is black.) Now press the backspace key (Delete, on the Mac).

Pressing Backspace/Delete always fills the current selection with the current background color. We just selected the entire layer, set the background color to black, and pressed Delete to fill our selection with black.

STEP 7: REFINE THE MASK

Make sure the foreground color is set to white and then choose the Brush tool. Select a soft-edged, fairly soft brush and begin painting on the upper part of some of the more prominent blades of grass—the ones that would naturally catch a bit of sun. It doesn't take many, but a few well-placed strokes can give the foreground some effective depth, and your image is done! (See Figure 18.45.)

At this point, you should be pretty comfortable with the concept of Adjustment Layers and Layer Masks. These are techniques you will use repeatedly, and we'll be returning to these concepts later to discuss how to perform more effects in a localized, nondestructive manner.

Figure 18.45

Our final image, after all of the layers and masks are in place.

Targeted Hue/Saturation

In Photoshop CS4 and later, the Hue/Saturation dialog box provides an additional control that can make manipulating the saturation in your image a little easier.

 ## Targeted Saturation Adjustment

STEP 1: OPEN THE IMAGE

Download the image `Fall Tree.jpg` from the Chapter 18 section of the companion Web site. Open it in Photoshop, and you'll see an image of a tree with full fall colors, against a blue sky (Figure 18.46).

Figure 18.46

We're going to adjust the color in this image to help the tree stand out more against the background.

While the tree stands out well against the background, there's no reason it couldn't stand out even a little more. We could try to darken the background, to make a tonal difference, but let's try the effect with color alterations, instead.

STEP 2: ADD A HUE/SATURATION ADJUSTMENT LAYER

In the last chapter, we discussed how there's no quantifiable, objective shade of gray that corresponds to any particular color. This allows you a wide range of interpretation when converting to black and white. Color images can often also withstand a high degree of interpretation, for the simple fact that color varies a lot. The same object might look different under different types of light, so people are already used to the idea that there's not always perfect, objective color in a scene.

So there's potentially nothing wrong with us draining a lot of saturation out of the sky, in order to try to make the red tree stand out more against the blue.

From the Layers palette, or the Adjustments palette, add a Hue/Saturation Adjustment Layer.

STEP 3: ADJUST THE SKY

With the Hue/Saturation Adjustment Layer selected, click on the finger icon next to the pop-up menu at the top of the Adjustment palette (see Figure 18.47).

Mouse over your image, and the cursor should turn into an eyedropper. Click somewhere on the sky and drag to the left. As you do, the sky should begin to desaturate (Figure 18.48).

Obviously, dragging to the right will increase the saturation of the tone that you've clicked on. Note that the tool is not lowering the saturation of the sky, but of anything in the image that is the color of the sky. As with other targeted adjustment controls, the tool samples the color you click on and automatically adjusts the appropriate parameter. In simplest terms, this tool keeps you from having to hassle with the pop-up menu that you normally use to select the color range that you want to operate on.

Figure 18.47

The Hue/Saturation Adjustment Layer has its own Targeted Adjustment tool.

Figure 18.48

With a little desaturation, we can calm down the blues in the sky to make the red tree stand out more.

If you hold down the Command key while dragging, then you can adjust the hue of the selected color.

Don't desaturate the sky completely. To keep the image believable, change the sky from its original bright blue to a darker, slate blue. This is still a believable color for the sky, but it's also one that helps the tree stand out more.

STEP 4: ADJUST THE TREE

Now click on the tree and drag to the right to increase the saturation of the reds. This is an edit that you have to be very careful with, because as you increase the saturation you're going to reduce the level of detail in the leaves and possibly create a red color that's simply not believable. Keep it subtle, around +10 to +15 (Figure 18.49).

Any time you do a saturation increase, you'll want to keep an eye out for posterization. Very often, as you up the saturation of a tone, surrounding, subtler tones will become eliminated. As always, watching for posterization is a great way to determine the acceptable "boundary" of an edit. ◢

Figure 18.49

Our final tree image, after desaturating the sky and slightly bumping up the saturation on the red leaves.

More Adjustment Layer Practice

If you'd like further Adjustment Layer practice, try the following. On the companion Web site, Chapter 18 section, there is a Cloud folder. Inside that folder, there are two images, `original.psd` and `finished.psd`, both shown in Figure 18.50.

Figure 18.50

If you want more practice, see if you can make the original.psd image look like the `finished.psd` image shown below.

On your own, see if you can make the original image look like the finished image. The `finished.psd` document includes my final, layered version, so you can see exactly what edits I made.

Selective Edits in Camera Raw

You've already seen how Camera Raw lets you edit your raw files. What we haven't looked at yet are some tools built in to Camera Raw that let you apply selective adjustments, very much like the ones we've been creating with Layer Masks.

Newer Versions Only

Versions of Camera Raw prior to version 5.3 lack the selective editing features discussed here.

Selective Editing in Camera Raw

Camera Raw's Adjustment Brush lets you brush on effects to create localized adjustments, just like you would create with an Adjustment Layer and Layer Mask in Photoshop. In this tutorial, we'll perform a localized adjustment directly in Camera Raw.

STEP 1: OPEN THE IMAGE

Download the image Couch.CR2 from the Chapter 18 section of the companion Web site. Open the image.

STEP 2: INITIAL, GLOBAL ADJUSTMENTS

Right off the bat, you can see that the image needs some significant adjustments, because it was severely overexposed. This was a fairly high dynamic range situation, and even with the external flash (you can see the reflection in the woman's sunglasses), it was still difficult to get the exposure evened out.

Begin, just as you always would, by addressing the overexposure problem. The Recovery slider will recover most of your overexposed highlights. You have to slide the Exposure slider to the left to recover the rest.

When you're done, you should have an image with a well-exposed sky, but the process of recovering the sky should have a foreground that's a little dark (see Figure 18.51).

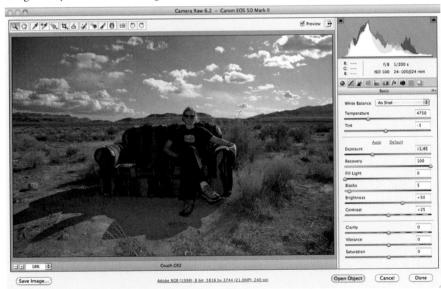

Figure 18.51

After our initial edits, we end up with an image that has a well-exposed sky, but that is too dark in the foreground.

STEP 3: ADJUST BRIGHTNESS

Move the Brightness slider to the right to try to brighten up the foreground. Pay close attention to the sky, though. Increase Brightness too much, and the clouds will overexpose again. To brighten the foreground, we're going to have to use a localized adjustment.

STEP 4: SELECT THE ADJUSTMENT BRUSH

The Adjustment Brush is the fifth tool from the right on the Camera Raw toolbar. Select it now and hold the mouse over your image. You should see a brush tool composed of two circles (see Figure 18.52).

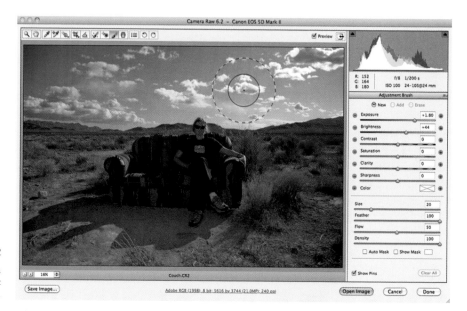

Figure 18.52

With the Adjustment Brush selected, we have a brush built out of two circles.

The inner circle shows the main part of the brush, the part that receives a 100 percent stroke. The outer area represents a feathered circle that surrounds the brush, to give it a soft edge.

Adjust the brush size (you can use [and], just like you can in Photoshop) to about 20. I chose this size because it's about the size of the top part of the couch, which is what we want to brighten.

STEP 5: BRUSH ON THE ADJUSTMENT

Set the Exposure slider to +1 stop. Ensure that the other adjustment parameters are at 0. Then brush with the Adjustment Brush across the woman and the top of the couch. The area you brush across will brighten because it will receive a one stop increase in exposure (see Figure 18.53).

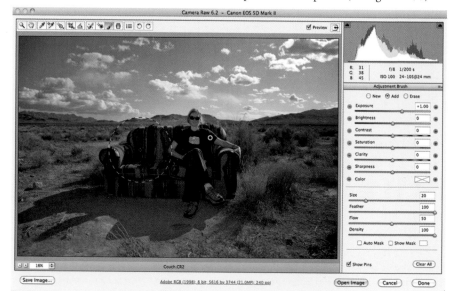

Figure 18.53

Painting over the couch adds our adjustment to only that area.

STEP 6: EDIT THE ADJUSTMENT

We want the foreground to be a little brighter, so dial the Brightness slider up to around 30.

Note the green circle that appeared where you first clicked the mouse. This "pin" represents the brush stroke. If you mouse over the pin, a gray overlay will appear, which shows the area covered by that stroke (see Figure 18.54).

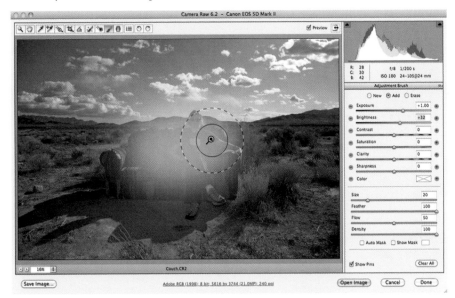

Figure 18.54

If you mouse over a stroke's pin, you can see exactly what the stroke covers.

If you have multiple strokes in an image, you can click a stroke's pin to call up its settings. In this way, you can alter the parameters for any stroke at any time.

Note the New, Add, and Erase buttons above the Exposure parameter. When Add is selected, any new brush strokes will be added to the currently selected brush stroke, which means that new strokes will apply the same parameters as the currently selected stroke.

When New is selected, any additional strokes will create an entirely new adjustment that can have its own set of parameters.

Erase lets you erase parts of a stroke. This is handy for times when your brush was too big, or you simply did some sloppy painting.

The Stroke Is Really a Mask

The way that Camera Raw is working this effect is the same as when you paint a stroke into the Layer Mask of an Adjustment Layer. If you imagine the entire image being covered with a black mask, then the stroke that you just painted represents a white hole in that mask. When you mouse over the Pin marker, Camera Raw is simply displaying the hole as gray instead of white.

STEP 7: DELETE THE STROKE

In addition to altering the parameters of a stroke, you can also delete a stroke. We're going to try a different way of performing the same edit we just made, so click the stroke to select it and press the Delete key to delete it. Undo to restore the brush stroke.

Like all edits in Camera Raw, the Adjustment Brush tool is nondestructive. You can alter or delete brush strokes at any time. Whether you want to perform a localized edit in Camera Raw or in Photoshop is up to you. The Adjustment Brush is a little harder to control than the paint brushes in Photoshop, so for some edits you'll probably have an easier time working with Adjustment Layers.

However, with the Adjustment Brush, you have the ability to perform localized highlight recovery, using the Exposure slider. So you might find that it allows for some edits that aren't possible in Photoshop.

 Gradient Adjustments in Camera Raw

Camera Raw provides an additional tool for making localized adjustments. The Graduated Filter tool makes it easy to create adjustments that smoothly blend from one part of the image to another.

Figure 18.55

The foreground in this image is a little dark. We'll fix it in Camera Raw with a different type of localized adjustment.

STEP 1: OPEN THE IMAGE

Download the image ig desert.CR2 from the Chapter 18 section of the companion Web site. Open it in Camera Raw, and you'll see an image that has a fairly good exposure. However, the bright sky resulted in our foreground being a little underexposed. We could try to paint some brightness into the foreground, but there's an easier tool (Figure 18.55).

STEP 2: SELECT THE GRADUATED FILTER TOOL

Just to the right of the Adjustment Brush is the Graduated Filter tool, which applies settings through a gradient, to create the same type of graduated effects that we created in the last section.

STEP 3: MAKE A GRADIENT

Set the Exposure slider to +1 stop. I don't know if this is the right amount of brightening, but we can always adjust this later.

Click near the top of the ground area and drag up through the mountains (Figure 18.56). You'll see two lines, a green one and a red one. Green represents the beginning of the gradient—where the full effect gets applied, and Red represents the ending—where no effect is applied.

The foreground immediately looks better, but let's punch it up a little more. Drag the Contrast slider to the right and notice that only the foreground receives a contrast adjustment. I found a Contrast setting of about 50 looked good.

Figure 18.56

The foreground in this image is a little dark. We'll fix it in Camera Raw with a different type of localized adjustment.

Like Adjustment Brush strokes, you can click the ends of the gradient to move them and adjust the size of the gradient. You can also alter the parameters of the gradient after selecting either point, or delete the gradient by clicking it and then pressing the Delete key.

The Brush and Graduated Filter tools let you perform a tremendous amount of selective editing in Camera Raw—possibly all that you'll need. For this last tutorial, you might still want to brighten some of the grass, as we did previously. Whether you choose to do that in Camera Raw or Photoshop doesn't matter; you can choose the tools you find easiest to work with. Both approaches are nondestructive, meaning you can return to them later.

Targeted Adjustment

Camera Raw offers one other selective editing tool, the Targeted Adjustment tool. With the Targeted Adjustment tool, you can click and drag any color in your image, and it will get brighter or darker—brighter if you drag to the right, darker if you drag to the left (see Figure 18.57).

It's important to understand that the Targeted Adjustment tool does not just adjust the colors of the object you clicked on. It has no way of knowing what that "object" is. Instead, it samples the color at the point that you clicked and adjusts all the colors in the image that match. As you can see here, it targets a wider range than just the single red pixel I clicked. It adjusts a range of red tones.

Targeted Adjustment can be a great way to brighten skies or other large areas of color.

Figure 18.57

Here I clicked on the red door with the Targeted Adjustment tool and then dragged to the left, darkening the red tones in the image.

The Masks Palette

Photoshop CS5 presents another way to create masks on layers. The Masks palette doesn't do anything you can't do with techniques you've already seen here, but its controls provide some handy shortcuts.

To understand the Masks palette, you must understand a fundamental concept about layers. When you open up a new image, it has a single layer, which contains the image. That layer is listed in the Layers palette as Background (Figure 18.58).

The background layer cannot be moved around, nor can anything sit behind it, meaning you can't composite it on top of something else. If you want to put another layer behind it, you must first "float" the background layer. Double-click the Background layer in the Layers palette, and it will turn into Layer 0, a floating layer that can have things behind it.

Figure 18.58

The image data in a new image always sits on the Background layer, as shown in the Layers palette.

One-Click Layer Masking

Open an image—for the sake of this example, one that only has a Background layer—and make a selection. Then open the Masks palette. If the Masks palette isn't visible, you can activate it by choosing Window > Masks (see Figure 18.59).

The Masks palette will show you a small thumbnail of the current layer. If you have a selection made, then the Add Pixel Mask button will be active, just to the right of the thumbnail in the Mask palette. Click it, and several things will happen:

- Because your image only has a Background layer, Photoshop will automatically float it.

- Your selection will be turned into a Layer mask, attached to the floating layer.

Again, this is nothing you can't do with controls you've already learned, but the Masks palette provides a nice, single-click solution. If you're working in a multilayered document, then the Masks palette will add its mask to the currently-selected layer.

Figure 18.59

The Masks palette provides some simple tools for applying changes to your mask.

The Masks palette provides some additional controls for manipulating your masks:

- The Density slider automatically changes the overall opacity of the mask.

- The Feather slider feathers the edges of the mask.

- The Mask Edge button brings up the Refine Edge dialog box.

- Color Range brings up the Color Range selection dialog box.

- Invert inverts the mask.

Again, none of this is stuff you can't do in other ways, but if you do a lot of masking, the Masks palette might save you a few clicks and keystrokes, here and there.

Advanced Masking

As you've already seen, Photoshop has a number of excellent masking tools that let you paint, select, or outline masks. Masking is an essential imaging tool, though, so we're going to go even deeper into it in this tutorial and explore a more advanced masking technique. This is not a technique you'll use every day, but it can still be handy, and you'll learn a lot more about masking as a result of trying this.

Photoshop has some great analysis tools that let you quickly identify particular tones and colors within an image, and we've used those already for several different tasks. If the goal of masking is to select particular parts of an image, and Photoshop already knows how to identify particular colors, you should be able to use the image data that's in the image to create masks.

Consider the image in Figure 18.60.

Figure 18.60

Because we metered to ensure the sky wouldn't blow out, the building in this picture ended up a little dark and dull. We want to apply a Levels Adjustment to the building, without editing the sky at all.

The building is underexposed, but the sky looks okay. None of the highlights are blown, and the blue color is nice. We need to perform a midtone adjustment on the building, but if we open a Curves dialog box and click around with the Eyedropper tool, we'll find that the sky and the building share many midtone values. Therefore, if we start adjusting the building, there's a good chance we'll ruin the sky. A better choice is to build a mask for the building. The shape of the building is simple enough that it easily masks with the QuickMask tool.

However, because we want to achieve a slightly different effect, we're going to take a different approach. The texture of the building contains a wide variety of midtones of slight variation. To achieve better contrast on the building, we don't want to adjust all of those midtones uniformly. This means we need to create a very complex mask—one that will allow us to apply varying degrees of adjustment to different midtones. We're going to create this mask using the image data within the image itself.

We know that we want to target the midtones. What's more, we know that alpha channel masks are simply 8-bit grayscale pictures. Photoshop, of course, is a great tool for creating 8-bit pictures, so we're going to create a modified version of our image that we will use to mask our original image.

Note that this tutorial is not possible using Photoshop Elements.

Advanced Masking in Photoshop

STEP 1: OPEN AND PREPARE YOUR IMAGE

Download and open the file `Initial building.jpg` located in the Chapter 18 section of the companion Web site. This is the file we will ultimately edit. Right now, we want to make a copy of this file, and then we'll manipulate the copy into our mask. In Photoshop, click Image > Duplicate to create a new document containing the exact same image data.

STEP 2: ISOLATE A GRAYSCALE CHANNEL

Again, our goal here is to use the copy of the image as a mask. But as you've already learned, masks are grayscale images. So the first thing we need to do is concoct a grayscale version of the image. We'll use this gray version as the starting point for our mask.

As you'll see in the next chapter, there are many ways to convert an image to grayscale. For this example, we're going to isolate the luminance information in the image because we're interested in working with the subtle changes in brightness on the surface of the building. Click Image > Mode > Lab to convert the image to L*a*b color mode. Rather than representing an image using separate red, green, and blue channels, L*a*b images are represented by a lightness channel and two separate color channels.

STEP 3: VIEW THE LIGHTNESS CHANNEL

In the Channels palette, click the Lightness channel to view it. The image will change to a grayscale image. Of course, we haven't actually converted to grayscale, we're simply looking at the lightness values of each pixel.

STEP 4: CREATE YOUR MASK

This Lightness channel will serve as a starting point for our mask, but to use it, we need to move it to our original image. With the Lightness channel selected, open the pop-up menu in the top-right corner of the Channels palette and select Duplicate Channel (see Figure 18.61).

In the resulting dialog box, select `initial building.jpg` from the Document pop-up menu in the Destination box. Click OK. Now close the copy. Don't bother saving, because we won't need it for anything else. Instead, return to your original document.

Selected in the Channels palette should be the new alpha channel we just copied. Because it's selected, your image will appear in grayscale. This channel already functions as a mask, but before we start using it, we want to make some modifications to it.

Figure 18.61

Open the Channels palette menu to access the Duplicate Channel command.

STEP 5: ADJUST THE MASK

As previously discussed, we want this mask to exclude the sky completely because we're pleased with the sky exposure. We want to create a mask that focuses on the midtones. As you've learned, in a mask, black areas are completely protected, so we know that if we can get the sky reduced to absolute black, it will be completely masked.

We've already learned about several tools that can be used to adjust tones within an image, and this grayscale mask is no different from any other image, so let's put our toolset to work. With the Alpha 1 channel selected, click Image > Adjustment > Curves to open the Curves dialog box. (We can't use a Curves Adjustment Layer because there's no way to limit an Adjustment Layer to a particular channel.)

We know that for the time being, we don't want to alter our midtones, so click the midpoint to lock it down with a control point. We also know that the tones we want to darken are the brightest tones in the image, so bring the white point all the way to the bottom (see Figure 18.62).

Figure 18.62

We're using a Curves adjustment to edit our mask. We begin by trying to reduce the sky to complete black, a process that begins by lowering the white point.

STEP 6: REFINE THE MASK

This is a good starting point. Our building has not been masked at all, and the sky is much darker. However, it's not completely masked out. To eliminate it completely, we want to clip all its tones out of the curve, which we can do by moving our white point directly to the left. Don't be timid—slide it almost until it collides with the midpoint. The sky will turn completely black, but the building will turn a light gray.

If you used this mask as it is now, you would have a partially selected building with the sky completely masked.

STEP 7: FINISH THE MASK

As it is right now, the building is not sufficiently selected. Remember, the whiter the building is, the more selected it is. Right now, with its predominantly middle-gray tones, the mask is fairly uniform. We want a higher-contrast mask, and so we should adjust our curve accordingly (see Figure 18.63).

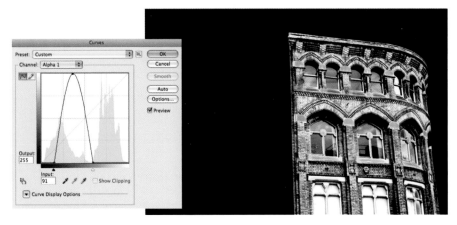

Figure 18.63

Our final curve results in a mask that isolates only certain midtones in the image.

STEP 8: LOAD AND USE THE MASK

In the Channels palette, click RGB to return to viewing and editing the full image. Now load the new mask by dragging it to the Load Channel as Selection button at the bottom of the Channels palette (see Figure 18.64).

Press Ctrl/Cmd+H to hide the selection, so it's easier to see our upcoming edits. If we've built our mask properly, we should have a selection that is grabbing only certain midtones in our image. At the beginning, we said that the building midtones needed to be brighter, so now that we've selected them, we're going to lighten them up.

Figure 18.64

You can load the new mask as a selection by dragging it to the Load Channel as Selection button at the bottom of the Channels palette.

In the Layers palette, create a new Levels Adjustment Layer. When you create an Adjustment Layer with something already selected, Photoshop automatically uses that selection to create a Layer Mask for the new Adjustment Layer, meaning that our new Adjustment Layer will affect only the areas defined by our mask.

In the Levels Adjustment Layer, shift the white point to the left. As you move the sliders, you should see the midtones in the building brighten and change without altering the shadow tones or the sky (see Figure 18.65).

Figure 18.65

After loading our final mask, we can apply a Levels adjustment that is constrained to a specific range of midtones.

STEP 9: EDIT THE SKY

After editing the building, you might decide that the sky could be a little more dramatic. Using the same technique, you can easily create a mask that protects the sky but knocks out the building. Create a new Luminance channel from a duplicate of the image, copy that channel into your document, and then use a Curves adjustment to increase the contrast of the mask drastically, until the building is black and the sky is white. You probably won't be able to increase the contrast to the point where all the windows and details will go black, but you'll get a good edge on the building. You can quickly paint out the windows by hand. Then load the new mask and alter the sky to taste. The image in Figure 18.65 has had the contrast in the sky beefed up, using the mask shown in Figure 18.66.

Figure 18.66

With an additional mask, we can edit only the sky to boost the contrast and make the clouds slightly more dramatic.

This technique of using adjusted, altered channels to create masks for editing is one we will return to for other operations. Although it may seem complex at first, as you gain more experience with masks, it will be easier to envision ways you can use your image itself to create usable masks. ◣◗

Simplifying Photoshop's Interface

As mentioned earlier, one of the things that makes Photoshop so complicated is that it contains features tailored to far more than simple photography. Fortunately, in the CS versions of Photoshop, you can streamline Photoshop's interface through the use of Workspaces, which allow you to highlight features tailored to a particular task.

From the Window > Workspace menu, you can select workspaces by task, or you can define your own workspace. For example, if you select the Color and Tonal Correction workspace, any menu items related to color and tonal correction will be highlighted, making it easier for you to ignore features you don't need.

Workspaces can also be used to control palette location and to hide menu items. So, for example, you could completely deactivate menu items you don't need. Consult Photoshop's Help file for more info.

Simpler Masking Using Nik Viveza

While Photoshop provides excellent masking tools, there are third-party, plug-in mask options available as well. Masking plug-ins are often tailored to specific tasks—extracting foregrounds from images shot in front of a blue or green screen, for example; or creating masks around complex subjects such as hair and transparent objects. Some programs create masks that get stored in your image as alpha channels.

Nik Software's Viveza plug-in for Photoshop, Aperture, and Lightroom provides an exceptional tool that makes any type of masking easier than in any other image editing program (except for Nikon's Capture NX, which has these controls built-in). In Viveza, when you want to edit a particular area in your image, you click with the Color Control Point tool on the area you want to edit. Viveza analyzes the color you clicked on automatically, and then calculates and builds a mask. You can then use Viveza's tools to alter color and tone. If that sounds too good to believe, believe it! The masking tools in Viveza (and Capture NX) really work, and really are that easy to use (see Figure 18.67).

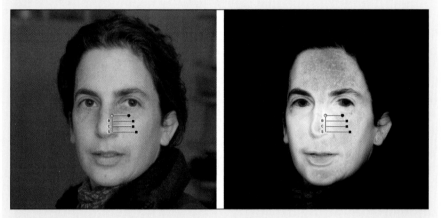

Figure 18.67 In Viveza, we created the mask shown on the right with a single click of the Control Point tool. Viveza automatically analyzes the image to create this complex mask.

Novice image editors will find masking simple to pick up in Viveza, while more experienced users will find they can create complex masks far more quickly than in any other program.

Saving Revisited

Of course, you'll want to save all this work you've been doing. As discussed in Chapter 14, "Editing Workflow and First Steps," you'll want to perform a Save As command to save a new copy of your image. Both PSD and TIFF files support Photoshop's layers, meaning when you reopen your image, the Layers palette will still show all of the layers you created. Later, we'll see how you can manage these layers, so that you can save JPEG files that include your layer effects.

Masking in one form or another is something you'll do in just about every postproduction session. No matter how careful you are when shooting, there is almost always an image that needs some form of localized adjustment, and masking tools are essential to making these edits. We'll continue to use masking techniques throughout this book, so you'll get some more practice. But first, we're going to take a detour into the world of black and white.

BLACK-AND-WHITE CONVERSION

Turning Your Color Images into Black-and-White Images

I n Chapter 12, "Special Shooting," we looked fairly extensively at the process of shooting black-and-white images. Your digital camera, though, is a color device and always captures color images. (Even if you put it in a black-and-white mode, it still shoots a color image—the camera simply converts this image to black-and-white using its onboard computer, after the exposure has been made.)

Black-and-white conversion is the process of using your image editor to turn a color original into a black-and-white image. As you learned in Chapter 12, there is no objective "correct" correspondence between color and gray. There's no specific shade of gray that is always used to represent red, for example. So, when you perform a grayscale conversion, you are potentially facing a lot of options and decisions—you can choose to convert your image into a stark, high-contrast grayscale image with strong blacks and whites or a soft, low-contrast image with subtle shades of gray.

Because there are so many different options and interpretations that can be derived from a single color image, you'll almost always want to use a fairly manual approach to grayscale conversion, rather than a predefined "recipe," such as your camera might use internally.

There are lots of different ways to convert a color image to grayscale, and you might use different techniques for different images. Obviously, which techniques are available to you depends on what software you're using. In this chapter, we'll look at a few different approaches and techniques.

Simple Grayscale Conversion

Photoshop allows you to convert an image to grayscale simply by selecting a new color mode (Image > Mode > Grayscale). This type of conversion uses a stock recipe for mixing the image's red, green, and blue channels to produce a grayscale result. In theory, the recipe produces an image that is well suited to the eye's different color and luminance sensitivities.

If you're in a hurry, this is a good way to convert your image; however, you might find that the resulting image lacks solid blacks and bright whites, and is generally kind of flat. With its color removed, your image might be less "punchy." Fortunately, several other methods provide more control and frequently better results.

In many cases, you might want to color-correct your image before using any of these methods. This might sound strange because you're just going to remove all the color, but an image with accurate color will often produce a more pleasing grayscale image.

Back Up Your Original

If you're using a destructive grayscale conversion method, you should make a backup copy of your original image. Although you might want a grayscale image now, you never know when you might need to go back to your original color version.

Photoshop's Black-and-White Command

Photoshop versions CS3 and later provide an excellent method for converting an image to grayscale. If you select Image > Adjustments > Black and White, you'll activate the Black-and-White command. The Black-and-White dialog provides a number of color sliders. As you drag any of these sliders to the left or right, those tones get darker or lighter.

The coolest feature of the Black-and-White dialog box, though, is that you don't have to use its controls. As you'll see in the next tutorial, once you've invoked it, you can click on tones *in your image* and drag left or right to adjust their brightness.

 ## Using the Black-and-White Adjustment

You'll need Photoshop CS3 or later for this tutorial. Note that Lightroom also offers a similar black-and-white feature.

Figure 19.1

We're going to convert this image to black and white, with an eye toward emphasizing the brightness difference between the foreground and background trees.

STEP 1: OPEN THE IMAGE

Open the image `black and white tree.tif`, located in the Chapter 19 section of the companion Web site at *www.complete digitalphotography.com/CDP6* (see Figure 19.1). When I shot this image, there were a lot of birds flying around the trees, but what struck me even more was the light tree in front of the darker green trees. I figured that this was a good candidate for a black-and-white image. So our goal in the conversion will be to figure out how much that brightness difference can be played up, and whether or not it's interesting.

STEP 2: ACTIVATE THE BLACK-AND-WHITE ADJUSTMENT

In Photoshop, choose Image > Adjustments > Black and White. The image will immediately turn to monochrome, and the Black-and-White dialog box will appear. The black-and-white conversion you're seeing is the default one, and it's one that serves most images pretty well.

STEP 3: TRY A SLIDER

Drag the Blues slider to the right, and you'll see the sky get brighter (see Figure 19.2).

When you drag a particular slider, the Black-and-White adjustment finds all of the tones in the image that are within the color range of that slider. If you've dragged the slider to the right, those tones will get brighter; if you drag to the left, they'll get darker.

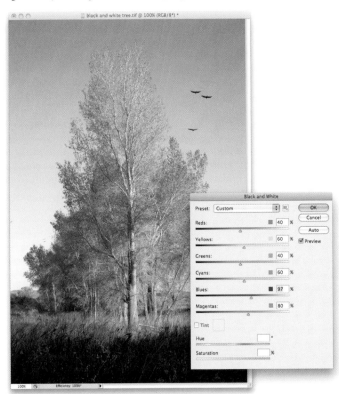

Figure 19.2

Here I've dragged the Blues slider to the right, resulting in a lightening of the sky (because it's blue).

STEP 4: DRAG WITHIN THE IMAGE

Move the mouse over the image, and the pointer will turn to an eyedropper. Click in the sky, near the top of the image, and drag to the left. Watch the sky, as well as the Blues slider in the Black-and-White dialog box (see Figure 19.3).

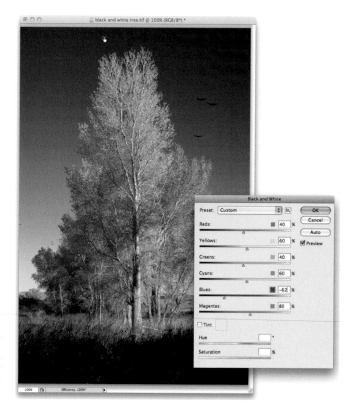

Figure 19.3

In addition to moving sliders, you can brighten or darken tones simply by dragging on them in the image.

When you drag within the image, your mouse pointer will change to a hand with a little arrow. When you click, Photoshop automatically analyzes the original color of the area you clicked on, and adjusts the appropriate slider as you drag. So when you click on the sky and drag to the left, the sky darkens, and the Blues slider moves to the left.

Note that *anything* else in the image that is blue will also get darker. The edit is not constrained to just the sky. You can't make localized adjustments with the Black-and-White adjustment. It will always affect all targeted colors within the image.

STEP 5: ADJUST THE TREES

As I mentioned, my original impulse with this shot was driven by the difference in brightness between the foreground tree and the darker green trees in the background. Right now, they're kind of all uniformly gray. Let's darken the greener trees.

Click one of the green trees in the background and drag it to the left. It turns out that they're more yellow than green, so you should see the Yellows slider move to the left and the trees darken (see Figure 19.4).

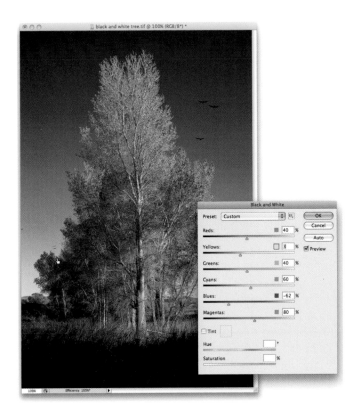

Figure 19.4

We can darken the trees to help them stand out more behind the light tree in front.

STEP 6: SAVE THE IMAGE

Using Save As, save a copy of this image. We're going to want to return to it later.

That's really all there is to the Black-and-White adjustment. As you can see, it's an incredibly powerful tool that lets you tone your grayscale images precisely and easily just the way you want.

Black-and-White Adjustment Layers

You can also apply the Black-and-White adjustment as an Adjustment Layer, to gain all of the nondestructive advantages that you learned about in the last chapter. With Black-and-White Adjustment Layers, you can easily try different black-and-white conversions without compromising your original. For example, you could take the image we used in the previous tutorial and create one Black-and-White Adjustment Layer that toned the sky dark. You could then deactivate that layer and create another with a lighter sky.

Because you can simply click the eyeball icon next to any Adjustment Layer to deactivate it, it's easy to quickly turn one black-and-white conversion off, and the other on, to see the different results.

Like all Adjustment Layers, Black-and-White Adjustment Layers have built-in Layer Masks, which allow you to constrain the effects of the Black-and-White adjustment. This gives you a way to easily create a black-and-white image that preserves a color element (see Figure 19.5).

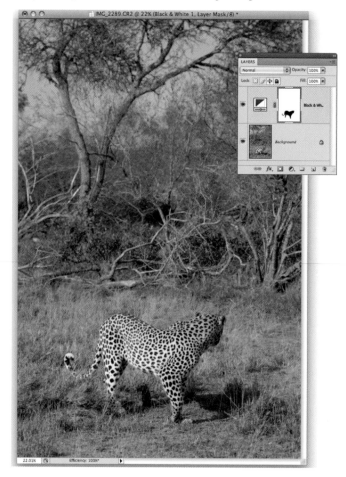

Figure 19.5

Here, I've added a Black-and-White Adjustment Layer to convert this image to black and white. But I've painted into the Layer Mask of the Black-and-White Adjustment Layer. As you can see, the black areas in the mask are protected from the black-and-white conversion, meaning they're left in color.

Figure 19.6

After adding a Black-and-White Adjustment Layer, you can click this tool in the Adjustments palette, and then click and drag in your image to adjust tones.

If you're using Photoshop CS4 or later, when you add a Black-and-White Adjustment Layer, its controls will appear in the Adjustments panel, just as with any other Adjustment Layer. If you want to be able to click and drag in your image to alter tones, then you must first click on the modify button in the upper-left corner of the Adjustments palette (see Figure 19.6).

Sepia Toning

In the old days, photographic paper would turn a yellowish-brown as it aged. This *sepia* tone is now generally recognized as the look of a very old, antique photo. Sepia toning your grayscale prints is a nice way to give them a bit of atmosphere, and it's easy enough to do in Photoshop, with a simple Adjustment Layer.

To add a sepia tone to an image:

- Open the image in Photoshop and then add a Photo Filter Adjustment Layer.

- Select the Photo Filter Adjustments Layer, and its controls will appear in the Adjustments panel. Change the Filter pop-up menu to Sepia.

- Dial in the amount of toning you want by using the Density slider (see Figure 19.7).

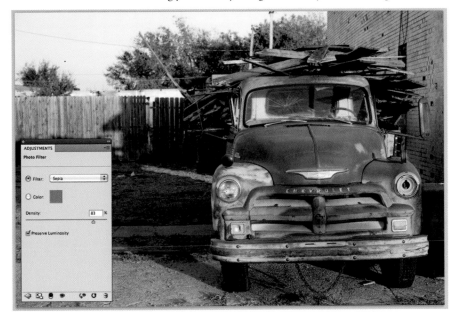

Figure 19.7

Using the Photo Filter Adjustment Layer, you can easily add a sepia tone to an image, which will create a traditional, antique look.

You can also apply the Photo Filter destructively, by choosing Image > Adjustments > Photo Filter. The Photo Filter dialog box will provide the same controls that you saw in the Adjustments panel.

In addition to this toning effect, Photo Filter simulates the types of filters that you might put over the lens of your camera. You can use it to warm or cool images (black-and-white or color images) or add color casts.

Other Black-and-White Conversion Techniques

There are far more black-and-white conversion methods than we can cover in this book. If you're using CS3 or later, you'll probably find the Black-and-White adjustment to be the best way to convert to black and white. If you're using an older version, or something other than Photoshop, then you'll probably have access to one or more of the following features.

Channel Mixing

Photoshop, Aperture, Lightroom, and Capture NX all provide a variation on "channel mixing." As you've learned, your image editor can convert your image to a Grayscale mode by using a stock formula for combining the red, green, and blue channels in your image. Using a Channel Mixer, you can specify your own recipe for how the red, green, and blue channels should be combined.

As you mix more of a particular channel, those tones will get brighter. For example, in a landscape scene with a big blue sky, if you mix in more of the Blue channel, your sky will get lighter. How you choose to mix your channels will depend on the colors in your original image and how light or dark you want them rendered.

However, note that unlike the Black-and-White adjustment that we just saw, the Channel Mixer is adjusting a *component* of color, rather than specific colors. For example, if you mix in more of the Red channel, blue skies will get brighter, but so will any color that contains red. So orange tones will also lighten up. In this way, a Channel Mixer is a little more limited than Photoshop's Black-and-White adjustment.

Fortunately, these controls are very interactive, so you don't need to be able to pre-visualize the effects of different combinations. Understanding that a higher percentage of a particular channel equates to lighter shades of that range of tones will make your mixing efforts less random.

- **Photoshop CS and later.** In Photoshop, you access the Channel Mixer by choosing Image > Adjustments > Channel Mixer. In the Channel Mixer dialog box, check the Monochrome check box. Your image will change to grayscale, and you can now adjust the color sliders to select a channel mix that you like. The Constant slider enables you to brighten or darken your image overall. The Photoshop Channel Mixer can also be applied as an Adjustment Layer, giving you the option of performing a nondestructive, grayscale conversion. You can use multiple Channel Mixer Adjustment Layers to convert different parts of your image in different ways and constrain the results using Layer Masks.

- **Aperture.** In Aperture, you can convert an image to grayscale by adding a Monochrome Mixer adjustment. Select Monochrome Mixer from the Action menu in the Adjustments panel or press Ctrl/Cmd-M. In the Monochrome Mixer, adjust the Red, Green, and Blue sliders to taste.

- **Photoshop Elements.** In Photoshop Elements 5 or later, you can choose Enhance > Convert to Black and White to invoke Elements' version of a channel mixer. The simple dialog box provides you with a collection of presets, as well as sliders for dialing in varying amounts of each color channel. Because Adobe has provided such a nice collection of preset conversions (called *Styles*), you may find that you don't need to worry too much about adjusting the individual color channels yourself.

Note that with the Photoshop and Aperture channel mixers, you want to keep an eye on the total sum of your three channels. If the three channels add up to more than 100 percent, the overall exposure of your image will have increased, and you may have lost some highlights. If the sum of the channels is less than 100 percent, your image will have darkened.

Photoshop and Aperture also provide preset mixes that mimic the effect of using colored filters with traditional black-and-white film. For example, a red filter will usually produce a very *contrasty* image.

Converting to Luminance

In Photoshop, just as you can select a single color channel in RGB mode, you can convert your image to L*a*b mode and select just the Luminance channel. This will throw out all the color information in your image. After you convert to L*a*b mode, click the Lightness channel in the Channels palette and select Image > Mode > Grayscale.

Desaturating an Image

You can perform a grayscale conversion by using the Saturation control to drain all the color out of your image. When your picture is completely desaturated, you'll have a grayscale image. Photoshop Camera Raw, Aperture, Lightroom, and Capture NX all provide a Saturation slider you can use for this effect. Photoshop also has a Desaturate command (Image > Adjust > Desaturate) that performs the same function, as shown in Figure 19.8.

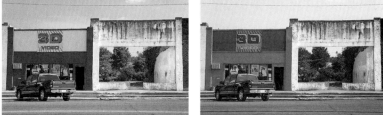

Grayscale Mode Blue Channel

Lightness Channel Desaturated

Figure 19.8

Here you can see the same image converted using a Photoshop Grayscale mode change, by selecting just the Blue channel, by selecting just the Lightness channel (after converting to L*A*B color), and by desaturating.

Black-and-White Conversion in Camera Raw

If you're using Camera Raw version 5 or later (the version number is listed in the title bar of the Camera Raw window), then you can perform black-and-white conversion within Camera Raw.

If you click the HSL/Grayscale tab, you'll be presented with a collection of controls for adjusting the hue, saturation, and lightness of specific color ranges within your image. At the top of the panel is a box labeled "Convert to Grayscale." Check this, and you'll get a set of Grayscale Mix controls (see Figure 19.9).

Figure 19.9

Camera Raw provides its own grayscale conversion tools, which work like the Black-and-White adjustment in Photoshop.

These sliders work like the sliders in the Black-and-White adjustment in Photoshop. Dragging a slider to the right brightens any tones in your image that originally had that color. Sliding to the left darkens the tones.

With the HSL/Grayscale tab selected, choose the Targeted Adjustment tool (see Chapter 18, "Masking," if you're not familiar with the Targeted Adjustment tool in Camera Raw). You can then click within your image and drag left to right to darken or lighten that particular color range. This works just like the Black-and-White adjustment command.

The advantage of performing your black-and-white conversion in Camera Raw is that once you get a conversion you like, you can easily copy it to other images, allowing for speedy batch processing. Because your original raw file is never altered, you can also open the same raw file and process it with different grayscale mixes to experiment with different black-and-white looks.

Split Toning

Earlier, you saw how to add a sepia toning effect, which adds a yellowish-brown cast to your entire image. Camera Raw also provides a split toning effect, which allows you to add separate color tones to the shadow and highlight areas of your image.

After converting to grayscale in Camera Raw, click on the Split Toning tab, which sits just to the right of the grayscale conversion tab.

Set the color of the highlight tone that you want, by adjusting the Hue slider in the Highlights area. You can control the degree of toning with the Saturation slider under highlights.

Next, set the color of the shadow tone that you want by adjusting the controls in the Shadows area. The Balance slider controls whether midtones are shifted more to the highlight or shadow tone.

Figure 19.10 shows an image that has been split-toned. The shadow areas have been toned with a dark blue, while the highlights have been toned with a sepia color.

Figure 19.10

Split toning allowed me to tone the shadow areas a deep blue, while rendering the highlights sepia.

Black-and-White Plug-ins

Black-and-white conversion is such a critical task for the black-and-white shooter that there are programs and plug-ins dedicated entirely to the process of converting images from color to monochrome. Most of these tools ship as plug-ins, and they work with Photoshop, Aperture, and Lightroom.

Alien Skin Exposure is a nice plug-in for Photoshop and Photoshop Elements that provides very nice black-and-white conversions. In addition, Exposure provides presets for emulating specific types of film. Choose a preset—Kodak Velvia, for example—and Exposure will adjust the tone and contrast in your image automatically to mimic the properties of Kodak Velvia film. In addition, it will try to simulate the grain of each film type.

Nik Software Silver Efex Pro is a plug-in for Photoshop, Lightroom, and Aperture. Like Exposure, it provides a full library of stock film types, and can emulate their tonal characteristics, as well as grain and texture. Silver Efex also offers localized toning tools in the form of the same automatic masking tools found in the Viveza plug-in mentioned in Chapter 18. These tools make it simple to brighten or darken specific parts of an image without having to craft complex masks (see Figure 19.11).

Figure 19.11

Nik Silver Efex provides sophisticated black-and-white toning tools, as well as the ability to mimic the characteristics of real-world film types.

Refining a Grayscale Image

No matter which grayscale conversion approach you use, you might not be able to get the tonal relationships in your image exactly the way you want. However, using the same Levels, Curves, and other tonal adjustment tools you've already learned about, you can easily refine your grayscale images.

For example, consider the tree image you worked with earlier. As discussed, one of the goals was to play up the difference in tone between the foreground and background trees. While Photoshop's Black-and-White adjustment allowed you to adjust the tones of the yellow/green trees in the background, we still couldn't get a huge differentiation between the foreground and background.

But with a simple Levels Adjustment Layer and some Layer Mask painting, we can perform a localized brightening to make the front tree "pop" a little more (see Figure 19.12).

Experiment with your saved version of this image and see if you can create an Adjustment Layer and mask that brighten the foreground tree.

Figure 19.12

With a Levels Adjustment Layer to perform a little brightening, we can make the front tree stand out a little more.

Low Contrast Images

Throughout this book, you've been learning about the importance of contrast, and you've seen how to use various tools to "properly" set the black-and-white points on your images. But while we've been focusing on adding more contrast to images, there are times when the best choice for an image is *less* contrast. For example, Figure 19.13 shows an image that I intentionally adjusted to have low contrast.

The lack of strong blacks creates a dreamier, more abstract feel. Also, the original color image was not shot under especially interesting light, and a faint cloud cover meant the sky was a featureless white. With my low-contrast approach, the white sky doesn't look out of place.

In Chapter 18, you learned about the Output sliders in the Levels control. This is the easiest way to lower the contrast in an image. Move the Blacks slider to the right, and the blacks will get lighter and lighter. The overall tonal relationships in your image will remain the same.

Figure 19.13

A low-contrast black-and-white conversion of this image makes for a nice result that's dreamy and abstract.

Figure 19.14 shows the original color image and a typical conversion with more normal contrast.

When working with grayscale conversions, don't just always go by the numbers and construct conversions that yield "correct" histograms and tonal ranges. Remember that blown-out, low-contrast images are often the best choice for some subject matter. As you've seen here, a little stylization can also save an otherwise boring, unusable image.

Figure 19.14 Here you can see the original color image and a more typical grayscale conversion.

20

LAYERS, RETOUCHING, AND SPECIAL EFFECTS

Additional Editing Tools and Concepts for Improving Your Images

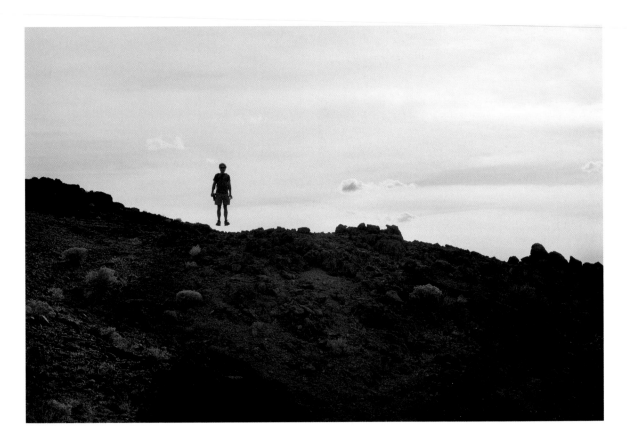

The tools you've learned to use so far are essential, everyday tools that you'll use on many (if not most) of the images that you shoot. Of course, every shoot yields its own editing challenges and problems, which is why an image editor like Photoshop is loaded with so many tools, commands, and features.

Photoshop can be intimidating because it presents so many options, but one of the first things you need to understand is that you *don't* have to know how to use every tool and feature of the program to get good results. One of the great things about Photoshop is that there are many different ways to achieve the same edit, meaning you can pick the one that makes sense to you, but you don't have to know how to do them all. It's also important to realize that many of its tools are not designed for the working photographer. Web slicing tools, scientific analysis tools, the Animation palette—these are all for other professions, and you don't have to worry about them for the type of work that we're doing.

In this chapter, we're going to look at some additional tools and processes. These are tools that you won't use every day, but which are still essential features for times when you encounter certain problems. Some of the capabilities we'll look at here will be targeted at solving specific problems, while others will be combined with other things we've learned, to provide more flexibility to the tools you've already learned about.

Layers

In the last few chapters, you've been using Adjustment Layers, so you should already be familiar with Photoshop's Layers palette. Adjustment Layers contain an editing operation that gets applied to all underlying layers. You've seen how you can use the Layer Mask that's included in every Adjustment Layer to constrain the effects of an Adjustment Layer's edit.

Photoshop also lets you create layers that hold normal image data. In this way, you can create stacks of multiple images to create a final composite (see Figure 20.1).

Figure 20.1 I combined these two exposures to create a composite that allows you to see both the sky and the dark tones at the bottom of the canyon.

Layers are pretty easy to understand. If your image editor provides a layer facility, you'll be able to stack images—and parts of images—on top of each other within a document. A robust layer facility provides you with the capability to easily make complex edits and composites.

Some Layer Basics

If your image editor provides layer controls, you'll need to spend some time learning how they work. Following are some of the basics of using the Layers control in Photoshop and Photoshop Elements. (Note that Layers weren't added to Photoshop until version 3. If you're using an earlier version, it's time to upgrade!)

Creating, Deleting, and Moving Layers

Layer management is very simple in Photoshop or Photoshop Elements—you simply use the Layers palette. On the bottom of the palette are all the controls you need to create and delete layers (see Figure 20.2). Right now, you only need to worry about the Create layer and Delete layer buttons located on the right side of the palette.

Add Layer Mask

Create Adjustment Layer Create new layer Delete layer

Figure 20.2

The Photoshop Layers palette includes simple button controls for creating and deleting layers.

When you create a new layer, it will appear as part of the layer stack in the palette. Because new layers are empty, your image won't look any different. All edits—whether painting, filters, or image adjustments—happen in the currently selected layer, and you can select a layer by clicking it in the Layers palette. Note that you can turn off the visibility of a layer by simply clicking its eye icon.

Layers that are higher in the Layers palette obscure any lower layers, and you can rearrange layers by dragging them up or down the stacking order. Note that you cannot change the order of the lowest layer—the Background—unless you double-click it to turn it into a normal, floating layer.

New layers are completely transparent, whereas the Background layer is completely opaque. In the Layers palette, transparent areas of a layer appear in the layer thumbnail as a checkerboard pattern. (Obviously, as you paint into a layer, Photoshop changes the opacity of that part of the layer so your paint is visible.)

Compositing

Compositing is the process of stacking layers of images on top of each other to create a final result. There are a lot of reasons to create composites. Sometimes you'll create composites to keep different edits isolated in separate layers, so that you can manipulate each layer without affecting the others. You might create a composite to achieve a special effect, such as the sky replacement you saw in Figure 20.1. There are other layering options that allow you to perform tone and contrast manipulation, as you'll see later.

In this tutorial, we're going to look at a fairly practical example of compositing and explore some essential layer and compositing techniques.

STEP 1: OPEN THE IMAGES

Download the images `Palace of Fine Arts1.jpg` and `Palace of Fine Arts2.jpg` from the Chapter 20 section of the companion Web site at *www.completedigitalphotography.com/CDP6*. Open the images in Photoshop.

These pictures were both shot at the Palace of Fine Arts in San Francisco (see Figure 20.3). I wanted to get a shot of the rotunda without any people in it, but it was a nice day, and lots of visitors were milling around the area. I shot a whole bunch of images, figuring that there would be some time when every part of the structure was unobscured by a person. Using some simple layering techniques, we can combine the images to create a final version that doesn't show any people.

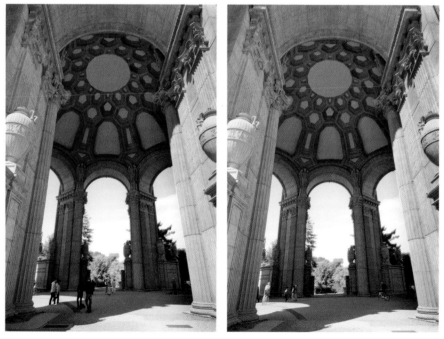

Figure 20.3

I want a shot of this rotunda, but I don't want any people in it. Fortunately, between these two images, it's possible to see every part of the rotunda. We'll composite them to yield a final image without people in it.

STEP 2: PREPARE THE IMAGES

Both images should be open in Photoshop. For our composite to work, though, we need each image in its own layer within the same document.

Bring the `Palace of Fine Arts1.jpg` image to the front. Make sure the Layers palette is open. (If it's not, select it from the Window menu.) Then choose Duplicate Layer from the menu in the upper-right corner of the Layers palette (see Figure 20.4).

Figure 20.4

You can use the Duplicate Layer command to copy an individual layer from one document to another.

Photoshop will present the Duplicate Layer dialog box, which lets you specify where you want to copy the layer to (see Figure 20.5). From the Document pop-up menu, choose `Palace of Fine Arts2.jpg`. This tells Photoshop to copy the currently selected layer into a new layer in the document `Palace of Fine Arts2.jpg`. If you had chosen `Palace of Fine Arts1.jpg`, then the layer would be duplicated within the current document, while if you had chosen New, a new document would be created, and the layer would be placed there.

Figure 20.5

Here, we're selecting the destination for our duplicate layer.

If you want, you can give the layer a name, but there's no need, given how simple this operation is going to be.

Note that there is an easier way to perform this last task. In Bridge, select the images you want to work with and choose Tools > Photoshop > Load Files into Photoshop Layers. This will create a single document with each separate file that you selected on its own layer.

STEP 3: EXAMINE THE NEW DOCUMENT

Now switch to the `Palace of Fine Arts2.jpg` document and look at the Layers palette. You should see two layers. Click the eyeball next to the topmost layer to hide it. The lower layer will become visible. Now click the eyeball again to toggle it back on. The upper layer is now visible.

As you turn the upper layer on and off, you will see some people in the image disappear. This is because they are not present in the lower layer, so when it becomes visible, they appear to vanish.

You've probably already noticed a problem—the images are not in perfect alignment. I didn't have a tripod at the time, and could not shoot perfectly registered frames. However, because individual layers can be moved and rotated, there's no reason we can't register the images in Photoshop and then perform our compositing operations.

Fortunately, Photoshop provides an automatic way to do this.

STEP 4: ALIGN THE LAYERS

With the upper layer selected in the Layers palette, hold down the Shift key and click the lower layer. Both layers should now be selected.

Now choose Edit > Auto-Align Layers. The Auto-Align Layers dialog box will appear (see Figure 20.6). Both layers have to be selected before Auto Align Layers will be active.

In the Projection section of the dialog box, click Auto and press OK.

Photoshop will think for a while and then present its results. You should see the upper image rotate and move a bit, and some checkerboard patterns will appear around the edges. Photoshop has had to expand the size of the canvas to fit both images and some transparent areas have been introduced. We'll crop these out later.

In the Layers palette, click the eyeball icon next to the upper layer to hide and show it, as you did before. You should see that the images are in alignment, and that the people appear and disappear.

Figure 20.6

The Auto-Align Layers command automatically examines the selected layers and aligns them into perfect registration.

STEP 5: CREATE A LAYER MASK

When you worked with Adjustment Layers, you learned about Layer Masks. You painted into Layer Masks to constrain the effects of each Adjustment Layer. You can also use Layer Masks to hide and reveal parts of a regular layer.

In the Layers palette, click the upper image to select it and choose Layer > Layer Mask > Reveal All.

A Layer Mask icon will appear next to the layer in the Layers palette, and it will be filled with white (see Figure 20.7).

As you learned, where white appears in a Layer Mask, that part of the layer is visible. Right now, the entire Layer Mask is white, which means the entire layer is visible.

With the upper layer visible, note the people in the middle of the frame. Now hide the upper layer by clicking its eyeball in the Layers palette. The people will disappear. If we mask those people in the upper image to reveal the empty image below, we will effectively remove them from the image.

Figure 20.7

You can add a Layer Mask to any layer in the Layers palette. With it, you can selectively hide and show different parts of each layer.

STEP 6: REMOVE THE FIRST PEOPLE

Choose the Brush tool and set the foreground color to black. (There are many ways to do this, including clicking on the foreground swatch and selecting black from the resulting color picker.)

In the Layers palette, click the Layer Mask of the upper layer to ensure that it's selected. Then choose an appropriate brush size and paint over the people in the middle of the frame. (You can change brush size using the [and] keys.)

Figure 20.8

After painting, a small black circle will appear in the Layer Mask.

After painting, you should see a small black circle in the Layer Mask that's shown in the Layers palette (see Figure 20.8).

This black blob corresponds to the area you just painted, and it shows that particular area of the upper layer is masked out, in order to reveal the underlying layers.

Now switch to white paint and paint over the same area. The people should reappear as you modify the mask to reveal the lower layers.

STEP 7: REMOVE EVERYONE ELSE

Now paint out the rest of the people using the same technique. When you're finished, your Layers palette should look something like the one shown in Figure 20.9.

Note that, in the top image, you'll see a little bit of a bicycle showing from behind one of the columns on the left. Unfortunately, in the bottom image there's a person in the same location, so you're not going to be able to completely remove one or the other. If I had a third image, with nothing there, then we'd be okay. In instances like this, you will need to go to more "traditional" means to touch up those areas. Using the Clone Stamp tool you

Figure 20.9

After painting out all of the people in the upper layer, our final Layer Mask looks like this.

can remove the bicycle from the upper image.

STEP 8: FINISH UP THE IMAGE

Now you can crop, straighten, and perform any other edits that you want to make to the image. You might also want to flatten the image to reduce it to a single layer. You can flatten an image by choosing Layer > Flatten Image or by choosing Flatten Image from the menu in the upper-right corner of the Layers palette.

Sometimes, you'll want to save a layered version of a document, so that you can go back and refine masks or edit individual layers later. Both Photoshop and TIFF format support multiple layers with masks.

You could have performed this same edit by stacking the layers and then using the Eraser tool to erase the people from the upper layer. However, erasing is a destructive edit because once you erase those pixels, they're gone. By using a Layer Mask, you can go back and restore the masked elements, or paint with shades of gray to partially mask an area. Overall, using masks—rather than altering layers—is always a better way to work. ◣

Opacity and Transfer Modes

You can change the opacity of the currently selected layer by simply sliding the Opacity control in the Layers palette back and forth.

You can also change how the currently selected layer interacts with layers that are lower in the stacking order by selecting a Blending (or Transfer) mode from the pop-up menu in the Layers palette. Normally, the pixels in a layer simply overwrite any pixels that are lower down the stack. By changing the Blending mode, you tell Photoshop to mathematically combine pixels, instead of simply replacing lower pixels with higher pixels (see Figure 20.10).

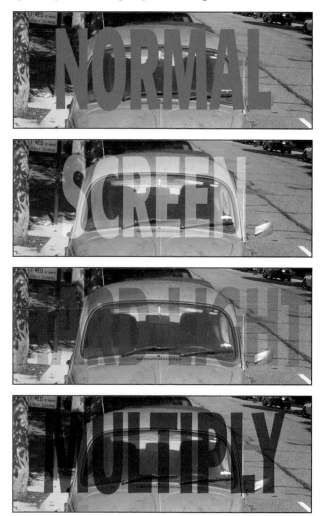

Figure 20.10

A few of Photoshop's Blending modes, which control how one layer—in this case, the text—mixes with a lower layer.

As you work more with Blending modes, you'll get a better idea of what they do. At first, don't worry about being able to predict their results. Just start playing around with them until you find the effect you like. You can lessen the effect of a mode by lowering that layer's opacity.

Blending modes are essential for creating some types of compositing effects. Figure 20.11 shows the creation of a virtual tattoo. When the tattoo image was layered directly on top of the body image, it looked like a simple overlay. Changing the tattoo layer's opacity helps some, but to create a realistic blending of the colors, we need to change the tattoo's Transfer mode to Multiply.

100% Opacity, Normal Transfer

48% Opacity, Normal Transfer

Figure 20.11

To create this tattoo effect, we used a combination of an opacity change with a Multiply Transfer mode to blend the tattoo layer with the skin.

48% Opacity, Multiply Transfer

In addition to compositing, you can use Layer modes for hand-coloring grayscale images (see Figure 20.12) and creating certain types of color corrections.

Figure 20.12

We created this hand-painted image by converting our photo to grayscale and then hand-painting color into a new layer that was blended with our grayscale image using a Transfer mode.

Watch That RAM!

As you add layers to your image, its RAM requirements will skyrocket quickly. Nothing affects Photoshop's performance as much as RAM, so if you find your computer getting sluggish, it might be that Photoshop is running out of memory. The easiest way to shrink the RAM requirements of your document is to eliminate extra layers. If you think you've finished editing an individual layer, consider merging it with other layers using the Merge Linked or Merge Visible commands, located in the Layers menu.

To Flatten or Not to Flatten

If you're performing a lot of complex, layer-based edits and effects, your document will quickly get overloaded with layers. In addition to possibly slowing your computer, extra layers can make it trickier to understand how a particular adjustment is achieved. As mentioned previously, merging layers that you're through editing can keep your documents from getting swollen with layer bloat.

The Flatten command (which you can get from the Layer menu, or from the pop-up menu in the upper-right corner of the Layers palette) combines all layers in your document into a single layer. This can be a way to dramatically reduce file size, but when you "bake" your edits this way, you can't go back and adjust them later.

I typically keep my documents layered, so that I know I always have access to my edits and adjustments. If I need to send a copy of an image to someone else, then I flatten and do a Save As into a new document. That way, I have my original, layered version and a flattened copy.

Note that if you're using a version of Photoshop prior to CS5, then you must Flatten before you can save into a format that doesn't support layers, such as JPEG. With CS5, Photoshop will take care of the flattening step for you.

Brushes and Stamps

Many of the retouching and editing tasks performed in a real darkroom are dependent on brushes, masks, and paint. Your image editor is no different, except that your brushes and tools are digital. To get good results from them, you still need a good hand, a trained eye, and well-designed tools, just as in a real darkroom.

The documentation that came with your image editor should offer plenty of information on how to use your editor's tools. In this section, you're going to learn what each tool is good for. You'll need to refer to your image editor's manual to learn the details of how to modify and adjust each tool. Being able to identify the right tool for a particular job will often save you a lot of time.

Brushes

Hopefully, your image editor includes a good assortment of paintbrushes and airbrushes. A good Brush tool offers an easy way to select different brush sizes and shapes, has antialiased (smooth) edges, pressure sensitivity when used with a drawing tablet, and variable opacity (see Figure 20.13).

Figure 20.13

The Photoshop Brush controls—scattered between the Brush palette and the toolbar—let you select Brush size, Transfer mode, and Opacity. As you've already seen, you'll use these tools for painting masks, retouching, color correction (certain types), and many other image editing and correction tasks.

To use a Brush tool well, you need good hand-eye coordination and a feel for the brush. Your brush skills will develop over time and will be aided greatly by the use of a drawing tablet. In addition to providing a more intuitive interface, a drawing tablet is *much* easier on your hand than a mouse is. If you plan to do a lot of image editing, consider investing in an inexpensive pressure-sensitive drawing tablet such as the Wacom tablet shown in Figure 20.14. At the time of this writing, you can get a good Wacom pressure-sensitive tablet for around $80.

You'll also want to spend some time learning the different keyboard shortcuts that augment your Brush tool. Learn your brush's features, including parameters such as opacity, spacing, and repeat rate.

If you're using Photoshop, you'll quickly become dependent on these brush-related keyboard shortcuts:

- **B:** Selects the Brush tool.
- **Shift-B:** Toggles between the Brush and the Pencil tools.
- **[:** Shrinks the size of the current brush.
- **]:** Enlarges the size of the current brush.

Figure 20.14

A pressure-sensitive drawing tablet such as this Wacom Graphire is a must-have for serious image editing.

Rubber Stamp or Clone

One of the most powerful—and seemingly magical—tools in your image editing toolbox is a Rubber Stamp tool (also known as a *Clone* tool), which provides a brush that performs a localized copy from one part of your image to another as you brush (see Figure 20.15).

You'll use the Rubber Stamp tool for everything from removing dust and noise to painting things out of your image, to painting things into your image. The advantage of a Rubber Stamp tool over normal copying and pasting is that the tool's brush-like behavior lets you achieve very smooth composites and edits.

Figure 20.15

When you paint with a Rubber Stamp (Clone) tool, your image editor copies paint from your source area (the crosshairs) to your target area (the circle).

In Photoshop, Change Your Painting Cursor

You'll have a much easier time with the Rubber Stamp tool, and all of Photoshop's Brush tools, if you make a simple change to Photoshop's preferences. In the Preferences dialog (Edit > Preferences), select Cursors (in previous versions of Photoshop, this was Display and Cursors), and then change Painting Cursors to Normal Brush Tip. This will show a cursor that's the exact size of your chosen brush, making it much easier to see the effect your brush strokes will have.

If you're using something besides Photoshop, you'll need to study your Rubber Stamp tool's documentation to learn the difference between absolute and relative cloning, and how to set the tool's source and destination points. When you rubber-stamp an area, you want to know how to select a source area quickly, so it's imperative to learn the tool's controls.

Your image editing application provides many more tools and functions, but you'll use the brushes and stamps the most. These are also tools that will not be heavily discussed or documented in the rest of this book.

 ## Video Tutorial: Cloning

To learn more about cloning, watch the Cloning Tutorial movie located in the Chapter 20 section of the companion Web site (see Figure 20.16). ◄

Figure 20.16

We used nothing more than the Photoshop Rubber Stamp (or Clone) tool to remove the wires from in front of this hippo. A Clone tool is a must for even the simplest touch-ups, so make sure you know how to use one.

Patch and Heal

Photoshop CS and later, and some versions of Elements, include special variations on the normal Rubber Stamp tool. The Healing Brush works just like the Rubber Stamp tool, but with a bit more intelligence. Rather than copying pixels directly from the source location to your brush position, copied pixels are adjusted automatically for texture, lighting, transparency,

and shading, so that your cloned pixels blend more seamlessly with the surrounding parts of your image. You can achieve the same results with a regular Rubber Stamp tool, but the Healing Brush is much easier to use. The Spot Healing Brush tool lets you instantly repair spots, dust, and other small, localized troubles with a single click. The Spot Healing Brush is especially useful for removing dust, slight lens flares, stuck pixels, and certain types of noise, and is also great for removing skin blemishes and spots.

The Patch tool uses the same underlying technology as the Healing Brush tool, but it lets you patch an area by drawing around it with a lasso and then dragging that area over a part of your image that contains the texture you'd like to have in your selection. That texture is copied and blended automatically into your selection.

 ## Video Tutorial: Painting Light and Shadow

No matter what tools or procedures you choose to use when making your edits and corrections, one of the most important things to learn is to recognize the effect of light and shadow on your images. A photo is a flat object; the sense of depth in your scene comes from the interplay of light and dark. As you learn to think more like a painter who wrestles with adding or subtracting light from specific areas in a work, you'll find yourself creating more compelling adjustments and corrections. Located in the Chapter 20 section of the companion Web site is a tutorial movie, `Color Correction.mov`, which walks you through the process of adjusting the top image in Figure 20.17 so it looks like the botom image. This tutorial will introduce you to the idea of thinking about your image edits as placement of light and shadow. ◀

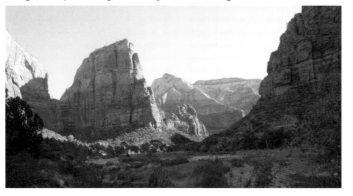

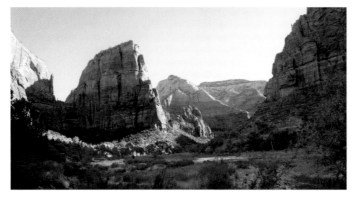

Figure 20.17

The top image doesn't look bad, but with some subtle color corrections, we can make it look much better. To learn how, watch the Color Correction video in the Tutorials/Chapter 20 folder located on the companion Web site at *www.completedigitalphotography. com/CDP6* .

Applied Editing Techniques

With the adjustment tools, layering features, and masking capabilities that you've learned about, there are a number of other edits that you can pull off. In this section, we're going to mix and match some of the techniques you've learned about in order to solve some different types of problems. These are not everyday adjustments and problems, but you might occasionally need to tackle a situation like what you'll find in this section.

Adaptive Shadow/Highlight Correction

Adaptive correction tools automatically figure out which pixels in your image are shadows and which are highlights, and then brighten or darken just those areas. As you saw, Photoshop Camera Raw and Lightroom provide a Fill Light slider that lets you automatically brighten shadows and darken highlights. But you'll find a similar tool in other applications. Photoshop has a control called *Shadow/Highlight adjustment*; Aperture's equivalent is called *Highlights and Shadows*, while Capture NX's tool is called *D-Lighting*.

- **Shadows/Highlight in Photoshop CS2 and later.** To invoke the Shadow/Highlight tool, choose Image > Adjustments > Shadow/Highlights. By default, the Shadows/Highlights dialog box opens with a Shadows amount of 50, so you will see an immediate brightening of the shadows in your image. Move the Shadows slider to the desired setting (see Figure 20.18).

Figure 20.18

Photoshop's Shadows/Highlights adjustment provides a simple dialog box for automatically brightening shadows or dimming highlights.

If you want to darken highlights in your image, slide the Highlights slider to the right. As with Shadows, the Shadows/Highlights tool will automatically determine which tones in your image are highlights.

- **Highlights and Shadows in Aperture.** If you're using Aperture, you should have a Highlights and Shadows adjustment in the Adjustment pane by default. If not, you can add one by choosing Highlights and Shadows from the Action menu in the upper-right corner of the Adjustments pane. Move the Highlights slider to the right to darken the highlights and the Shadows slider to the right to lighten the shadows.

Photoshop, Aperture, and Lightroom all provide additional options for their adaptive shadow and highlight tools.

These adaptive tools intelligently roll off their adjustments through the transition zones that occur between shadows and midtones, and midtones and highlights. Using the extra options provided by each tool, you can gain more control over what constitutes a shadow and a highlight, and how much to roll off the adjustment through the transition zones. Consult your program's documentation for more details.

The most common use for these tools is when an image simply needs to be brightened up. In general, you'll find that you use these types of adaptive tools for two other common operations.

- **Fill flash.** If you have images that should have been shot with a fill flash, but weren't, try hitting them with an adaptive shadow adjustment. You'll probably find that it often makes a good substitute for a fill flash, lightening shadows and generally evening out exposure (see Figure 20.19).

Figure 20.19

The top image should have been shot with a fill flash to illuminate the left side of this man's face. With an adaptive shadow adjustment, we can easily brighten the darker areas.

- **Reducing contrast.** While we often strive to increase contrast through the use of exposure adjustments and image editing techniques, there are times when an image can have too much contrast. For these instances, darkening highlights with an adaptive highlight adjustment while brightening shadows with an adaptive shadow adjustment can restore the overall contrast in an image back to something less harsh (see Figure 20.20).

Figure 20.20

The upper image has too much contrast, so we used adaptive shadow and highlight adjustments to lighten the shadows and darken the highlights, to produce an image that's not as harsh.

Nondestructive Shadow/Highlight

While Photoshop provides Adjustment Layers for many of its effects and adjustments, the Shadow/Highlight adjustment is not one of them. Consequently, once you've applied it, you're stuck with it. If you'd rather have a less destructive way of applying the edit, try this:

1. Duplicate the layer you want to adjust with Shadows/Highlight. You can duplicate a layer in the Layers palette by dragging the layer to the New Layer button at the bottom of the palette.

2. Add the Shadows/Highlights adjustment to your duplicate layer.

Now, if you ever want to remove the adjustment, just throw out the duplicated, edited layer. If you want to change the amount of adjustment, throw out the duplicate and reapply the entire duplicate/adjust operation. You can also use a Layer Mask to constrain the effects of the adjustment.

 ## Correcting a Bad White Balance in a JPEG File

Figure 20.21 shows a scene with a typical white balance problem. I had been shooting indoors with an appropriate indoor white balance, and then went outside and started shooting in daylight. The resulting image has a bad blue cast. (See Figure 20.21.)

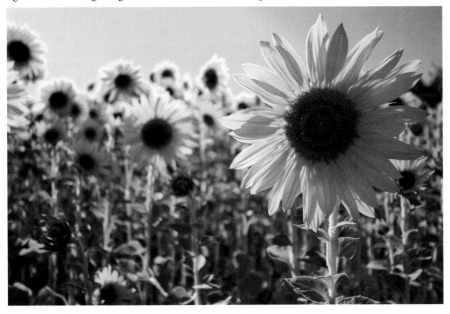

Figure 20.21

This image was shot with the wrong white balance, so we're going to have to do some work to get it back to something close to normal.

If we had been shooting in raw, correcting this image would be simple, and we could restore our color with great accuracy. Because we were shooting in JPEG mode, correcting the cast will be much more difficult, and we won't be able to restore to completely accurate.

STEP 1: OPEN THE IMAGE

Open the Bad White Balance.tif image, located in the Chapter 20 section on the companion Web site.

STEP 2: CHANGE THE HISTOGRAM DISPLAY

If Photoshop's Histogram palette is not already open, open it now by choosing Window > Histogram.

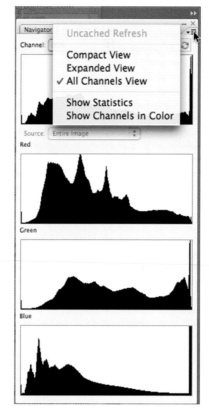

In the upper-right corner of the Histogram palette is a small pop-up menu. Open this and choose All Channels View. The histogram display should now show the usual histogram, and separate histograms for the red, green, and blue channels (see Figure 20.22).

Notice how the separate channel histograms have wildly different shapes. The data in the Blue channel is bulked up on the left side, while the Green channel is more to the right, and the Red channel is spread across the entire range. As you can see, the Red channel has more data in it than the Blue or Green channels.

STEP 3: OPEN THE LEVELS DIALOG BOX

We're going to correct this image using Levels. Open the Levels dialog by choosing Image > Adjustments > Levels or by pressing Cmd/Ctrl-L. Alternately, you can add a Levels Adjustment Layer.

Sometimes, you can correct a bad white balance by selecting the Neutral eyedropper and then clicking on something in the image that is supposed to be neutral gray. There's nothing gray in this image, and the Neutral dropper is usually best for simple color casts, not wildly wrong white balance. We're going to have to use a more complex approach.

Figure 20.22

Using Photoshop's Histogram palette, we can get a view of the histograms for all three channels in the image. From these, we can see that the Red channel contains the most data.

STEP 4: SELECT THE RED CHANNEL

From the Channel pop-up menu, select Red. The histogram in the Levels dialog box now shows the Red histogram, and any changes we make will only affect the Red channel. We started with the Red channel because it has the most data in it. With more data, we'll be able to perform more editing without worrying about tone breaks or banding.

This is a very bright, high-key image. We want more of our red data to be in the bright areas of the image, to warm up those areas. Slide the Midpoint, or Gamma, slider to the left to about 1.85 (see Figure 20.23). This will cause our midtones to shift to the right. If this doesn't make sense, don't worry, you can always just fiddle with the slider to figure out which direction means more or less red.

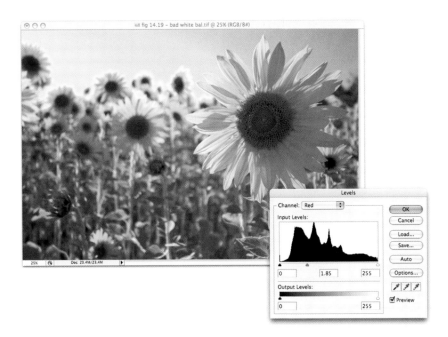

Figure 20.23

By adjusting the midpoint on the Red channel, we can warm up the image considerably, countering the ugly blue cast.

STEP 5: EDIT THE GREEN CHANNEL

The image is already much better. However, while the sunflowers have a better, warmer color, the green stalks are now a little too red. Let's restore some green to them by editing the Green channel.

Change the Channel pop-up menu to Green.

Slide the Midpoint slider to the left to about 1.37. This will restore a nice level of green to the flower stems without compromising the yellow of the flower (see Figure 20.24).

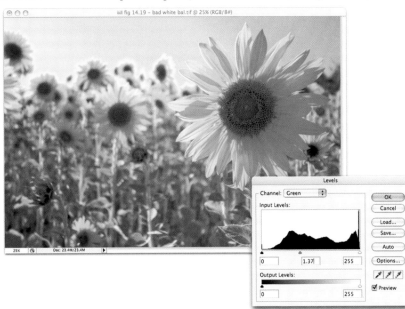

Figure 20.24

With a Green channel adjustment, we can restore the greens to the flower stems.

Note that I didn't pick a value of 1.37 for any reason other than it looked right, by eye. In this case, I wasn't actually paying attention to the numbers when making this edit, I simply made the adjustment that looked right.

STEP 6: ADJUST TONE

Our color is much better, but the image also needs a general tone adjustment. Because we've been skewing our color channels around, the image has seen a change in brightness in some of its shadow tones.

Choose RGB from the Channel menu in the Levels dialog box. We can now perform a regular Levels adjustment to improve contrast. Slide the Black Point slider to about 35 to darken the blacks in the image (see Figure 20.25).

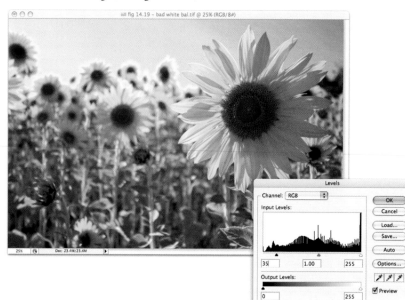

Figure 20.25

A black point adjustment will restore the contrast in our image.

STEP 7: CLICK OK

Click OK to accept the Levels adjustment.

As you can see, you can perform separate adjustments to component channels and to the entire composite RGB image with a single Levels command. The image still isn't perfectly accurate, but it has a much more natural look than it did before. Hopefully, the biggest lesson you'll take away from this discussion is that, when shooting, you must *always remember to consider white balance when you change lighting conditions!* ◢

 Retouching with Content-Aware Fill

Photoshop CS5 provides an astonishing new technology that can greatly simplify certain types of retouching. For a lot of edits, Content-Aware Fill is faster and much easier than using a cloning tool.

STEP 1: OPEN THE IMAGE

Open the `Stop Sign.jpg` image, located in the Chapter 20 section of the companion Web site (see Figure 20.26). There's some extra junk in this image that we'd like to remove to clean up the composition. The bright bit in the lower-left corner and the bright pole next to the stop sign are both distracting. We could remove these with the Clone Stamp tool, but Content-Aware Fill is going to be a little easier, especially because of the repeating patterns on the wall.

We're going to select the areas that we want to get rid of, and then automatically fill those areas with appropriate content.

STEP 2: LASSO THE PIPE

Select the Lasso tool from the Photoshop toolbox or just press L to select it. Drag a rough circle around the lower part of the pipe (see Figure 20.27).

Before you can use Content-Aware Fill, you have to select the area that you want to fill. We've selected only the lower part of the pipe because Content-Aware Fill often works better on smaller areas.

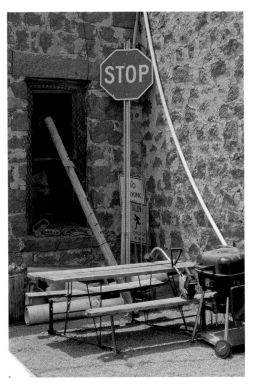

Figure 20.26

We're going to use Content-Aware Fill to remove the white pipe and the bright thing in the lower-left corner.

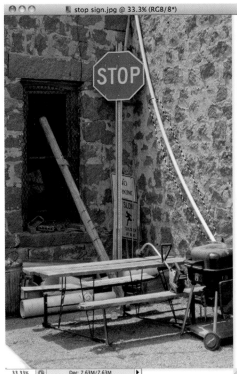

Figure 20.27

Using the Lasso tool, select the lower part of the pipe.

Figure 20.28

After Content-Aware Filling,
the lassoed area is filled
with wall texture.

Figure 20.29

The finished image, after lots of
Content-Aware Filling.

STEP 3: FILL THE SELECTION

With the pipe selected, we're ready to fill it. Choose Edit > Fill or press Cmd/Ctrl-Delete. The Fill dialog should appear. Change the Use pop-up menu to Content-Aware. Click OK, and the lassoed area should be filled with appropriate wall texture (see Figure 20.28).

Content Aware Fill analyzes the area around the selection, and attempts to concoct appropriate content to fill the selection with. As you can see here, it did a great job of creating stone texture that looks natural.

STEP 4: SELECT AND FILL THE OTHER AREAS

Continue to make selections and fill with Content-Aware. If you find a fill doesn't work, undo it and then select a smaller area and try again. For the little bit where the white pole falls along the stop sign, I used the Rubber Stamp tool. But 95% of the correction was performed with Content-Aware Fill (see Figure 20.29).

As you work with Content-Aware Fill, you'll probably be amazed at how good a job it's capable of. It can copy complex textures with amazing accuracy. At other times, like in our example here, you'll probably have to try a few times to get a good fill and possibly augment the job with other retouching tools.

Because it's so easy to use, and easy to undo, it's always worth taking an initial stab at a retouching with Content-Aware Fill, before trying the more labor-intensive Clone tool.

Cleaning Portraits

No matter how young and fit your portrait subjects may be, there will be times when a little digital makeover is just the thing to turn a decent portrait into an exceptional one. Facial retouching can include everything from removing wrinkles and blemishes to altering shadow details to making facial contours less pronounced. As you've probably already guessed, Photoshop provides excellent tools for this type of cleanup. If you're using a different image editor, it probably has tools similar to the ones described here.

You mostly use two tools for the majority of your facial retouchings. The Rubber Stamp (or Clone) tool is good for completely removing features like dark wrinkles, assuming there's enough clear facial tone around the wrinkle to get a good clone. For the rest of your touch-ups, you'll use the Dodge tool (see Figure 20.30).

The Dodge and Burn tools let you brush lighter or darker "exposure" into any part of your image. With a few simple dodges, you can usually lighten wrinkles or other fine lines to make them less pronounced, or to completely eliminate them. Dodge can also be used to lighten shadow areas to make contours less extreme (see Figure 20.31).

Figure 20.30

The Dodge and Burn tools in Photoshop and Photoshop Elements are essential retouching tools for removing lines and blemishes.

Figure 20.31

Using a combination of the Rubber Stamp and Dodge tools and a separate blur layer, we retouched the image on the left to produce the result on the right.

For the retouching shown in Figure 20.31, blemishes and discolorings were removed with the Dodge tool, as were most faint wrinkles. For larger wrinkles, the Dodge tool was used to lighten the wrinkle, and then the Clone tool was used to paint over the wrinkle with appropriate skin tone. The Dodge tool was also used to balance color overall. The whites of the eyes were dodged, and the teeth were whitened by using a Hue/Saturation layer. Finally, to selectively soften some skin tones, a copy of the image was created in a second layer and blurred with the Gaussian Blur filter. A Layer Mask was applied to the blurred layer, allowing us to paint blurred texture into some areas, leaving other details—eyes, eyebrows—sharp. The entire process took about 45 minutes.

Nondestructive Dodge and Burn

The downside to dodging and burning is that, like any of Photoshop's painting tools, once you make the stroke, your pixels are altered, and there's no way to change your mind if you decide you need more or less of an effect. As we saw earlier, many effects can be isolated into individual layers, allowing you to paint effects into your image in a nondestructive manner that allows you to reedit your image later.

Dodging and burning effects are no exception. To create a dodging and burning layer, add a new layer above the layer you want to edit and change the layer's blending mode to Overlay. Painting into the layer with a color that's darker than 50 percent gray darkens the underlying image; painting with colors that are lighter than 50 percent gray will lighten the underlying image.

To remove a wrinkle, select a color that's lighter than 50 percent gray and begin brushing into your Overlay layer. For more control, it's best to lower the opacity of your paintbrush to around 20 or 30 percent, so you can paint in your effects gradually. If you make a mistake, you can simply use the eraser to erase your brushstrokes.

Healing Brush

If you're using a copy of Photoshop or Photoshop Elements that has a Healing Brush tool, you might find that it works very well for correcting certain types of facial blemishes.

Better Skin Through Plug-ins

If you do a lot of portrait work, then you might want to consider investing in a plug-in designed specifically for improving skin tones. Imagenomic's Portraiture is one such plug-in, and it does an exceptional job of improving skin tones with just a single click (see Figure 20.32). Check out *www.imagenomic.com* for more details.

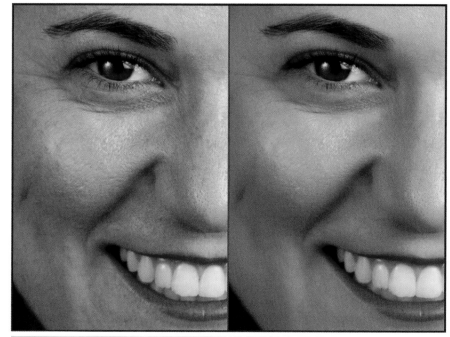

Figure 20.32

Imagenomic's Portraiture makes skin retouching a snap, offering incredible ease of use and a lot of customizability.

Noise

Of all the retouching chores that you'll come across, noise will be the most troublesome artifact to get rid of. Although modern digital cameras are extremely good in their ability to produce images with low noise, many will still generate some noise, particularly in shadow areas and bright skies, and especially when you shoot at higher ISOs.

Noise is produced by any number of components in your camera, ranging from the image sensor to the support circuits to the analog-to-digital converter. Earlier, you learned how image sensors represent light exposure as variations in voltages across the surface of the sensor. Unfortunately, the semiconductors used in your camera can generate electrical signals that are indistinguishable from the signals produced by your camera's sensor. These extra signals can leak into your image in the form of noise.

There are two types of noise that you'll encounter in your image. *Luminance noise* does not alter the color in your image at all, but instead looks very similar to the static "snow" that you see on an untuned TV set. Luminance noise is almost always caused by the type of ambient electrical signals described previously. The good news is that it's not always an unattractive noise—it looks a lot like traditional film grain—and although it might be easily visible on-screen, it probably won't show up in print.

Chrominance noise is more troublesome. If you see blue or red dots in an image—and these will be especially prevalent in low-light/high-ISO images—you have some chrominance noise to deal with. Many image sensors, especially CCDs, are more sensitive to red and infrared light than to blue light, so special filters are used to cut certain frequencies of red light to improve the blue response. Unfortunately, because the sensor is weak in its blue perception, the Blue channel is often the first thing to be compromised when you start amplifying the sensor signal to increase ISO. Consequently, on many cameras you'll see pronounced noise in the Blue channel of an image. As such, chrominance noise is sometimes referred to as *Blue channel noise*.

The problem with trying to remove noise from an image is that there's no way to do it without altering your image. Removing luminance noise will tend to soften and smooth fine details, whereas trying to eliminate chrominance noise can alter the colors in your image. Noise reduction also often results in a loss of saturation.

Nevertheless, a slightly softer or less-saturated image is usually preferable to an image covered with distracting, ugly noise.

Fortunately, with each new generation of digital camera, noise becomes less and less of a problem, even at high ISOs. If you're working with an older camera, or have found some noise issues in images from a newer camera (and it does happen), there are some things you can do. Check out the Noise Reduction.pdf located in the Chapter 20 section of the companion Web site, for more details about how to perform noise reduction.

Vignetting

While vignetting is something you usually try to avoid (and the only way to do this is to invest in high-quality lenses), there are times when an intentional vignette will help you bring more attention to your subject.

For example, consider Figure 20.33, a fairly boring shot of a tree in the middle of nowhere. With a little color adjustment and a strong vignette, the image becomes far more compelling.

21

PANORAMIC STITCHING AND HDR MERGING

How to Process These Multi-Shot Effects

In Chapter 12, "Special Shooting," you learned about two special shooting processes: panoramas and high-dynamic range imaging, or HDR. Panoramic shooting allows you to capture a very wide field of view by shooting a series of overlapping images. HDR shooting allows you to capture a scene with a very high dynamic range by shooting a series of identical compositions, each with a different exposure.

To produce a final image, both of these techniques require you to process your source frames using special software. Photoshop CS5 (and some earlier versions of Photoshop) provides built-in facilities for both panoramic stitching and HDR processing. In addition, there are lots of third-party plug-ins and add-ons that allow you to perform these tasks.

Stitching Panoramas

As you saw in Chapter 12, the process of making a panorama begins when you shoot a series of overlapping images, each with the same exposure. If you've panned, exposed, and overlapped properly, your stitching software can take those images and merge them together into a seamless, wide image.

Every image has a vanishing point, which is a single point that all lines converge on. Panoramic stitching software corrects the perspective differences in each shot so that the resulting image has correct perspective. The images are then blended and combined along their seams to create a single, finished shot (see Figure 21.1).

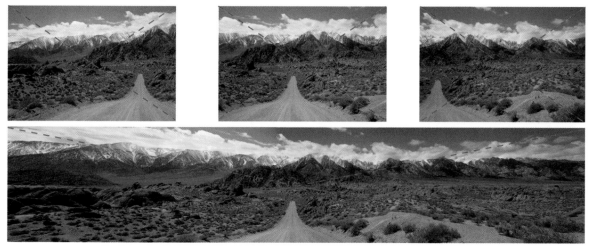

Figure 21.1 Every source image in a panorama has its own vanishing point where all lines in the image recede to this point. During the stitching process, the source images are warped so that the resulting image has a common vanishing point.

Stitching Workflow

Shooting panoramas, of course, involves creating a lot of different images. Staying organized during your postproduction then becomes essential. If you normally rename your images on import, you'll want to be very careful to ensure that you maintain the original shooting order; otherwise, it will be very difficult to determine which images go together to create a finished panorama.

Here's how I usually handle panoramas.

- After uploading all of the images from a particular shoot into a folder, I work through the folder with Bridge. Anytime I find a set of images that go together to make a panorama, I group them into a Stack by selecting all of the images and choosing Stacks > Group As Stack or simply pressing Cmd/Ctrl-G (see Figure 21.2).

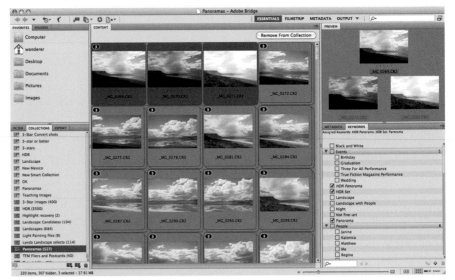

Figure 21.2

You can use Bridge's Stacks feature to keep panoramic source images and final results grouped together. This makes it easier to stay organized.

- Next, I add a Panorama keyword to each image, as this makes it easier for me to search for panoramas later.

- I then stitch the images together, which we'll cover in the next section.

- Finally, I add the finished, stitched image to the top of the relevant stack.

Even if I have a number of panoramic sets from the shoot, this process allows me to keep everything fairly well organized.

If you're using Lightroom or Aperture, you can follow a similar procedure, as both of these programs offer stacking features.

Launching a Stitch from Within Bridge

Photoshop includes a built-in stitching feature called *Photomerge*, and you can launch a stitch directly from within Bridge, which can greatly ease your postproduction panorama workflow.

To start a panoramic stitch from within Bridge:

- Select the images you want to stitch. If you've already grouped the images into a stack, open the stack and select all of the images within. If you don't know how to select multiple images, check out the tutorials in Chapter 13, "Workflow."

▪ Choose Tools > Photoshop > Photomerge to launch the images into Photoshop's Photomerge feature (see Figure 21.3).

The images will open in Photoshop's Photomerge dialog box, which we'll cover next.

Figure 21.3

Photoshop's Photomerge dialog lets you select images to stitch and choose parameters for stitching. You can load images into Photomerge directly from Bridge.

Launching a Stitch from Within Photoshop

You can also start a panoramic stitch from within Photoshop. The easiest way to do this is to first open all of the images you want to stitch, but *only* the images you want to stitch. Make sure that you don't have any other images open.

Choose File > Automate > Photomerge to bring up the Photomerge dialog box.

The Source Files list will be empty. If you click the Add Open Files button in the Photomerge dialog box, then all of your current images will be added to the Source Files list. This is why it is essential that you do *not* have any additional images open.

Alternatively, you can open the Photomerge dialog box and then use the Browse button to add files that you want to stitch.

You can use any Photoshop-compatible file format with the Photomerge feature. After you've selected the files that you want to turn into a panorama, you're ready to configure the rest of Photomerge's options.

Configuring Photomerge

In the Layout section of the Photomerge dialog, you'll find six different options that allow you to specify how you want the source images in your panorama overlapped and distorted. As you'll see, there's no one, single approach to panoramic layout that's best for all images. However, the Auto feature almost always does a good job of selecting a layout that will be best for your particular panorama. So you'll usually have the easiest time with your stitching efforts by trying an initial stitch with the Auto layout option. If the result is distorted in a way that you don't like, or will require you to crop out an essential element, then you'll want to consider manually selecting a different option.

The Auto option simply picks which one of these five options is best (obviously, you can also choose one manually).

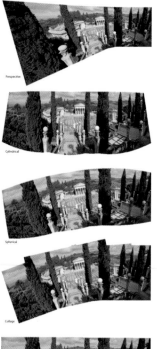

Figure 21.4

Here you can see the effect of different Photomerge layouts on the same set of panoramic source images.

- **Perspective** layout tells Photomerge to choose one of your source images—almost always the center image—and leave it "flat" or undistorted. It will then bend, warp, stretch, and skew the other images and place them alongside the initial image to create a finished layout. What's nice about the Perspective layout is that the first image remains largely undistorted. The disadvantage is that the resulting panorama will probably require a lot of cropping (see Figure 21.4)

- **Cylindrical** layout maps individual images to the inside of a cylinder, which is then unwrapped. Cylindrical layout greatly reduces the "bow tie" distortion that you'll see with Perspective layout, and it is ideal for extremely wide panoramas.

- **Spherical** tells Photomerge to map source images to the inside of a sphere. This option is best for 360° panoramas, but occasionally offers good results with panoramas that don't cover a full circle.

- **Collage** does just what you might think: images are overlapped, collage style, and are rotated or scaled, if necessary, to create good overlap. However, after layout, the images are not blended together, as with the other layouts, so seams might be visible.

- **Reposition** is like Collage, but images are not scaled or rotated. Photomerge simply overlaps them to the best of its ability. As with Collage, no blending is performed.

Those last two options allow you to create more traditional "David Hockney" type photo collages. They're great for times when blended stitches aren't working because your exposure was off, and so seams are visible. Sure, you won't end up with a seamless, perfect image, but you still might get a very usable result.

Other Photomerge Options

Beneath the Source area of the Photomerge dialog box, you'll find a few additional options.

- **Blend Images Together** uses a number of complex processes to reduce seams and create a more seamless panorama. If you turn this option off, Photomerge will still try to eliminate seams, but will use a less sophisticated algorithm. Turning this option off might be a better choice if you want to manually retouch your seams, something we'll discuss in the next section. For the most part, the only time you'd uncheck this is if you've got difficult source images that aren't blending, and you need to take matters into your own hands.

- **Vignette Removal** does just what it says—removes vignettes from source images before stitching, which can greatly reduce the threat of visible seams.

- **Geometric Distortion Correction** corrects barrel, pincushion, and fisheye distortion. Like Vignette Removal, this can help reduce the visibility of seams, and is particularly useful when working with wide-angle lenses.

Correcting Stitched Panoramas

When Photomerge is done stitching your source images, a final panoramic document should be open. Take a look at the Layers palette, and you should see a separate layer for each source image, each with a Layer Mask (see Figure 21.5).

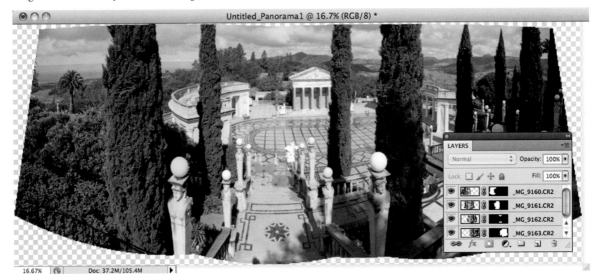

Figure 21.5 Once Photomerge has finished stitching, it will open the final, layered document. Because the document is unflattened, you can manually edit the merging of the different source images.

If you worked through the Layer Mask tutorials earlier, you should have a pretty good idea of what is going on. Photoshop has aligned and stacked all of your source images, and created Layer Masks to control which parts of the image are visible and which are masked out to reveal underlying layers.

If the stitch has worked well, then you shouldn't see any seams. But if seams are visible, you can try to minimize them by manually editing the Layer Masks. Use the Brush tools, Smudge and Smear, to move or refine the seams.

Before you spend too much time meticulously hand-correcting seams, though, try to assess why the seams are visible. Is it because your exposure wasn't even across your frames? Is it because there was vignetting on the edge of a frame? If it was the latter, make sure that Vignette Removal was turned on in the Photomerge dialog box. If it was the former, then you might be able to adjust the exposure in your original source images. If you can make the exposures more equal, then you might get a better stitch.

Cropping and Filling

All panoramas will need to be cropped. There's simply no way to stitch a panorama without creating distortions that result in a nonrectangular final image. Ultimately, you may end up making your Photomerge layout choice based on which method requires the least cropping.

There are no tricks to cropping a panoramic image. Because of their wide field of view, you most likely won't be cropping a panoramic image to a standard frame size, so be sure that your crop tool is not set to perform any constraining of aspect ratio.

Cropping a panorama can be frustrating, depending on how much distortion has occurred in your final panorama. An image that is wildly distorted, such as the Perspective example in Figure 21.4, requires such a dramatic crop, that you might lose image details that you like (see Figure 21.6).

Figure 21.6

Because of the distortion in this image, we have to perform a dramatic crop—one that cuts out a fair amount of the sidewalk, a pillar, and other details.

Obviously, in Figure 21.6, I could switch to a layout that yielded a more rectangular image, but if it's critical that the center of the image remains undistorted, this may not be an option.

Fortunately, in Photoshop CS5 and later, you have another option, Content Aware Fill. While Content Aware Fill can't fill the empty parts of an image like the one in Figure 21.6, it can often do an astonishing job of filling in the corners

Content Aware Fill is great because it's so easy to use. The fixes in Figure 21.7 took under a minute! However, there will be times when Content Aware Fill can't fill the empty spaces in your cropped panorama. Or you might be using an image editor that doesn't have such a feature. For these times, you can often fill empty areas with the Rubber Stamp (Clone) tool. Skies, especially, are often fillable with some creative cloning. When choosing a crop, you'll want to consider how much of an image you can realistically fill and repair.

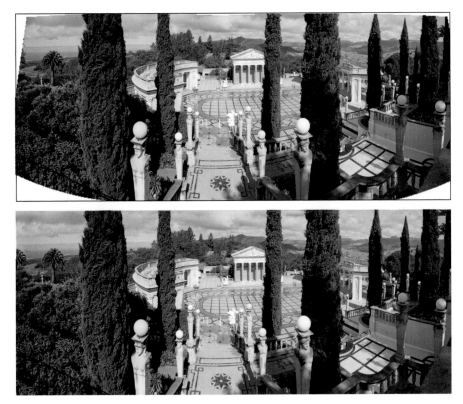

Figure 21.7

The upper image shows my initial crop, which left my image with some empty corners. The lower image shows what Content Aware Fill came up with when I selected the corners and filled them.

Retouching

Panoramas often need the same types of retouching that "normal" images do. You might have dust spots, lens flares, and other items that you want to remove. Because you don't know which ones might make it into the final panorama (one might fall on a seam and be hidden, for example), there's no reason to bother retouching your source images. Perform your merge and then retouch the finished panorama.

Similarly, color and tone correction should be performed on your final image. If you exposed your source images properly, then you won't want to alter their exposure until after you've stitched, lest you do something that will create an uneven exposure from one image to another.

Stitching Raw Images

As you've seen, raw images offer a number of advantages over nonraw. The capability to alter white balance and recover overexposed highlights can be a real life-saver, especially with panoramic images, where you're often shooting in situations that can confuse white balance, and where it's easy to overexpose some parts of your image.

When you pass a raw file to the Photomerge feature, it first processes the raw files and then merges the results. For the conversion, it uses whatever settings are currently stored for the file. If you haven't made any adjustments to the file, then it uses the standard, stock conversion—the same one you'd see if you opened the image in Camera Raw.

So, if you want to perform highlight recovery or white balance adjustments, you need to do those to the original source images, before you merge. Remember, after you merge, you'll no longer be dealing with a raw file, and you will be unable to perform these edits.

To ensure that you alter each image identically:

- Open the source raw files in Camera Raw.
- Click the Select All button.
- Click the Synchronize button to bring up the Synchronize dialog box.
- Click OK to accept the default settings.

Now any adjustments will be made to all the images.

Again, if you exposed the images properly when you shot, you shouldn't need to do too much to the exposure. Make your white balance adjustments and do enough highlight recovery to get the overexposed bits back to where they should be.

When you're finished, you can either open the images and activate Photomerge from within Photoshop, or click Done to close the files; then launch Photomerge from within Bridge. In either case, your settings will be stored in sidecar XMP files. Photomerge will process the images according to the settings you just defined.

Speeding Up Stitching

Panoramic stitching is a computationally intensive process, and it can sometimes take a while. However, there are some things you can do to speed up the process. Obviously, buying a faster computer will speed up all of your Photoshop operations, as will adding more RAM.

But considering image size can also make a difference. If you're shooting 20 megapixel images and then stitching them together, you're possibly ending up with huge final panoramas—panoramas that are much bigger than you'll ever actually print. So you can speed up your stitching operation by first resizing your images. Creating copies at 50% of the original size will give you source files that will merge much more quickly than giant originals and still yield a panoramic result with plenty of size.

If you're working with raw files, open the original files in Camera Raw and click the Workflow Options link at the bottom of the Camera Raw dialog box. Here, you can specify a smaller-than-original size. Also, if you normally set Camera Raw to output 16-bit files, you can consider switching Depth to 8-bit. If you're not planning on performing a lot of edits on the final panorama, then you may not need the extra bit depth. After configuring these options, click Done to save them, and you'll be ready to stitch.

Stitching Vertical Panoramas

As you saw in Figure 12.24, panoramic shooting is not just for shooting really wide fields of view. You can also use the technique for shooting really tall things. You'll tilt up and down while shooting, rather than panning left and right.

When it comes time to stitch these images, first rotate them 90° and then pass the rotated results to Photomerge. Your resulting panorama will be lying on its side, but you can easily rotate it back to vertical.

Merging High-Dynamic Range (HDR) Images

In Chapter 12, you learned how you can shoot the same image multiple times, with varying exposure, to capture an image with much more dynamic range than what your camera can capture in a single shot. Of course, as with panoramas, shooting these frames is simply the first part of the process. When you get home, you need to process them into a finished HDR shot (see Figure 21.8).

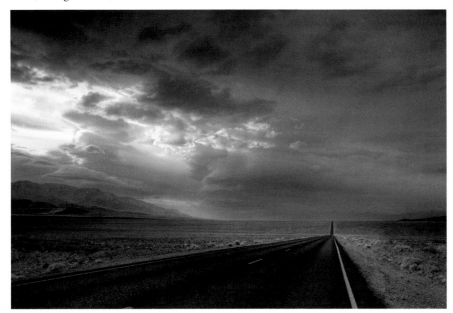

Figure 21.8

This image was merged from three identical shots, each captured with a separate exposure. This is an example of the type of work you can get from an HDR process.

Photoshop includes a built-in HDR merging feature called *HDR Pro*. It can take care of aligning your source images, to ensure they're registered properly, and then will build them into a single, finished HDR image.

HDR shooting offers some of the same organizational challenges as panoramic shooting, so you might want to employ some of the same organizational strategies discussed earlier in the panorama section. Make sure your images stay sequentially named and consider stacking HDR sets.

What HDR Merging Does

As mentioned in Chapter 12, there's no actual way to expand the dynamic range of a camera, monitor, or a piece of paper. But, if you've shot multiple frames with different exposures, you can use HDR merging software to compress the wide dynamic range captured by your multiple exposures to fit into the limited dynamic range of your chosen output media.

It does this through a process called *tone mapping*. Super bright tones are dulled to the level of the brightest tone that your piece of paper, or monitor, can display. Similarly, super dark tones might be brightened up to reveal more detail than just pure black shadows. In the midtones, lots of subtle variations might be made, as dark and light shades are remapped to different tonal values to bring out more details.

You've already seen how brightening an image can reveal more details in shadow areas or how darkening an image can reveal more highlight detail. This is what happens with tone mapping, but it happens at tiny, localized amounts that vary throughout your image. What's more, because you start with multiple images exposed in different ways, the tone mapping process doesn't have to rely on brightening or darkening existing tones. Instead, when the tone mapping algorithm needs a brighter tone, it can go to the image with a brighter exposure and copy that tone from there.

You've seen how brightening a dark image can often make it noisier. Because tone mapping routines can pull brighter tones from another image, rather than having to brighten dark tones and risk exaggerating noise, HDR images are often free of noise. However, they sometimes have their own set of troublesome artifacts.

Launching HDR Merge from Bridge

As with panoramic stitching, you can easily launch into an HDR merge process by selecting the images you want to merge in Bridge and then activating Photoshop CS5's HDR feature.

To start an HDR merge in Bridge:

- Select the images that you want to merge. If you don't know how to select multiple images, check out the tutorials in Chapter 13. If you've already grouped the images into a stack, open the stack and select all of the images within.
- Choose Tools > Photoshop > Merge to HDR Pro.

Next you'll configure the HDR Pro dialog box, as discussed later.

Launching HDR Merge from Photoshop

If you don't use Bridge as your workflow tool, then you'll need to launch the HDR merge feature from within Photoshop.

To start an HDR merge from Photoshop:

- Choose File > Automate > Merge to HDR Pro.
- The Merge to HDR Pro dialog box will open. This simple box lets you select the files that you want to merge.
- Add files. If your source files are already open in Photoshop—and they're the only files that are open—then you can simply click the Add Open Files button to add those image to the merge. Alternately, you can select individual files or a folder full of files.
- Click OK when you've selected your merge files.

Now the actual merge will begin.

Configuring Merge to HDR Pro

After you've selected the files you want to merge, either from Bridge or from the initial Merge to HDR dialog box, the actual merge will begin. Photoshop will open your source images, copy them each into their own layer in a single document, and then align the layers. Finally, it will present the Merge to HDR Pro dialog box (see Figure 21.9).

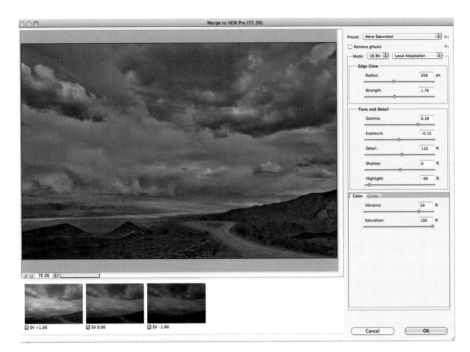

Figure 21.9

Photoshop CS5's Merge to HDR Pro dialog box gives you a fairly thorough set of controls for configuring your HDR merges.

The large preview display can be zoomed and panned, just like the previews in most Photoshop dialog boxes. Beneath the preview display, you'll see a thumbnail strip of source images. You can turn these images on and off to expand or limit the dynamic range in the image. In general, you probably won't find a huge effect from deactivating images.

At first, the preview image may look a little flat or unimpressive—not the HDR extravaganza that you were hoping for. Don't give up; different images can need radically different settings to pull correct detail into every part of the tonal range.

At the top of the HDR Merge Pro window is a Presets pop-up menu. Working through the presets is a great way to zero in on the type of look that you might want. If a preset doesn't get your image exactly the way you want it, it might still be a good starting point. For after you've chosen a preset, you can refine it using Merge to HDR Pro's other controls.

- **Remove Ghosts.** One of the tricky parts about HDR shooting is that you have to take multiple frames to generate source material. If something in your image moves between frames—a walking person, a blowing tree, etc.—then this can create trouble when it comes time to merge. Since there are multiple copies of the moving object, in different places in each picture, strange ghosting affects can appear. Remove Ghosts does a very good job of removing these artifacts.

- **Mode.** You can choose the bit-depth of the final HDR image—8, 16, or 32. Unless you have a specialized application, such as video compositing or 3D modeling, there's no need to ever choose 32-bit. In fact, your monitor can't display the full dynamic range of a 32-bit image. Sixteen bit is the best way to go, as you'll be able to make adjustments without concern for certain types of artifacting, and you can always convert to 8-bit later.

- **Local Adaptation.** Next to the Mode menu is a pop-up menu that defaults to Local Adaptation. If you open this up, you'll see some other HDR conversion algorithms, which each bring up their own set of controls. These are older methods that rarely yield good results, and are difficult to control, so you'll probably never need to change this setting.

- **Edge Glow.** These controls are somewhat akin to sharpening. They exaggerate edges by putting slight halos of tone around them. Fortunately, they're subtle tools, so while they can add a nice level of detail to your image, you usually don't have to worry about them introducing ugly artifacts.

- **Tone and Detail.** These tonal controls should already be familiar to you, as we've worked with similar controls in other places in Photoshop. The advantage of these adjustments is that they have such a large amount of source data to work with—the combined dynamic range of your multiple exposures. Note that, unlike other Photoshop controls, these sliders don't have a live update. To see their effects, you have to let go of the mouse. This is simply because Photoshop has to do so much calculation to render a change to one of these sliders. In general, it's better to do as much editing as you can with these sliders before moving on to Photoshop. Because of the large pool of data that the HDR merge feature has to work with, you can get cleaner adjustments than what you might get in Photoshop.

- **Color and Curve.** The Color tab gives you a Saturation and Vibrance slider, while the Curve tab provides a standard tone curve. Note that the curve in the Merge to HDR dialog box is very "fine." Even a slight adjustment can yield big results.

When you're done adjusting, click the OK button, and Photoshop will process your final image and open it in a new window. Your original source images will no longer be open, and the final image will be flattened. At this point, your image has not been saved. From here, you can perform additional adjustments if you couldn't get things precisely how you wanted them using the Merge to HDR Pro controls.

Other HDR Tools

Photoshop is not the only program that offers HDR merging. Stand-alone HDR merging packages offer more features and sometimes a finer degree of control. Perhaps the most popular of these is HDRsoft's Photomatix. At the time of this writing, nik Software has just released HDR Efex Pro, which also looks very promising. If you're serious about HDR imagery, then you'll want to look closely at these packages. Photoshop's HDR merge is capable, but limited in its controls and effects.

Aesthetic Considerations

High Dynamic Range Imaging is a fantastic tool, and one of the great photo breakthroughs of the last few years. However, as with any tool or effect, it needs to be used thoughtfully. A little HDR can go a long way, and it's not hard to turn an otherwise nice image into a garish monstrosity.

Traditionally, the photographic vocabulary is built from light and shadow, and we've explored this idea in some detail in these pages. Knowing when to let an area plunge into shadow or when to overexpose a highlight—these are all parts of your imaging vocabulary, and they are essential skills for creating images that lead the viewer's eye through your composition.

One of the great pitfalls about HDR images is that everything in them can be perfectly exposed and easily visible. While you might think "Great, I want everything in my image to be easily visible," the fact is that's not always true. When everything is equally visible, nothing stands out, and images can look dull and flat (see Figure 21.10).

Figure 21.10

While this image has some dramatic textures in it, overall it's very flat. Your eye doesn't quite know how to make its way through the scene. Compare this to the image in Figure 21.8, which has similar subject matter, but isn't so flat and evenly exposed.

Early HDR merging programs were, well, early. It was a new technology, and the processing techniques weren't as sophisticated and refined as they are now. Consequently, early HDR images had a very particular look, which is now known as "that HDR look" (see Figure 21.11). Unfortunately "that HDR look" has become something of an aesthetic. People intentionally aim for the effect not, I think, because it looks good, but because "that's what HDR is supposed to look like."

Figure 21.11

While this image may look like a typical HDR shot, I can't recommend that you aim for this effect. Garish and overwrought, it's an image that says "HDR!" more than it says anything else.

Here's a tip for applying any type of effect, be it HDR, a Photoshop filter, a dramatic color or tone adjustment, retouching, or whatever. If the effect you apply upstages the content of your image, then it's not a well-applied effect. In other words, if people look at your image and say "Wow, look at that HDR" rather than "Wow, look at that scene/whatever," then you have not created a successful image. A good edit is seamless, subtle, and serves to help deliver impact, not to be impactful itself.

Because the HDR process has such a distinctive look and can easily wreck your image, it's important to keep that concept in mind when performing your HDR merges.

HDR Panoramas

There's no reason you can't combine both of the techniques shown in this chapter to create HDR panoramic shots. The process is pretty simple, as long as you keep track of what you're doing along the way.

To shoot your HDR panorama, plan out your pan ahead of time, just as you would with a regular panorama, but when you shoot your first frame, shoot a bracketed set, just as you would with a regular HDR shot. Then pan your camera and shoot your next bracketed set, and so on.

The trickiest thing about HDR panoramas is to stay organized during postproduction. Collect all of your source images and group them into sets for HDR processing. Perform an HDR merge on each individual set, being careful to use precisely the same settings for each merge. Save each merged image as a TIFF or Photoshop document.

Once all your merging is done, use your panoramic stitching software of choice to merge the HDR merges into a single panorama (see Figure 21.12).

Figure 21.12 This panorama is composed of three different HDR sets. I merged the HDR files, stitched the output into a final panorama, and then adjusted and edited that panorama in Photoshop.

22

OUTPUT

Taking Your Images to Print or Electronic Output

You can perform a lot of tweaking, correcting, adjusting, and editing of your images, but none of it does any good if you can't get your results out into the world for other people to see. In general, output falls into two categories: printed output and electronic output for posting on the Web, emailing, giving to a client, or for sending to a photo printing service.

Earlier, we listed output as the last step in your workflow. Obviously, you have to have your image adjusted and edited to your liking before you worry about letting it loose in the world. However, like editing, your output process has its own workflow considerations. You'll need to get your image sized appropriately, possibly sharpened, and then output according to your specific output needs. Finally, you'll probably want to save your new resized, sharpened, ready-for-output version so you can output it again later, and to preserve your original full-resolution version.

In Photoshop (and many other image editors), you'll need to perform these steps in the order just described. You'll resize first because resizing can affect sharpness. Only after your image is your desired output size do you need to consider additional sharpening actions.

If you're using Lightroom, Aperture, or iPhoto, you won't necessarily need to perform separate resizing steps. These programs handle resizing on their own when you choose an output method. However, both Lightroom and Aperture *do* provide sharpening that performs the same types of tricks we'll discuss here.

One advantage to nondestructive editors like Lightroom, Aperture, and Nikon Capture NX is that their resizing and sharpening operations are also nondestructive, so you can always undo or change them later.

We're going to look at these operations in the typical order you'll perform them.

Resizing

Your camera probably captures far more pixels than you need for typical output. Unless you have a very old camera, or have configured your camera to shoot at a low pixel count, if you're exporting for the Web or email, or printing out a 4" × 6" print, you'll need to reduce the pixel count of your image. If your camera yields images with a very high pixel count—8 megapixels or higher—you might even need to resize when printing out to 8" × 10." Similarly, if you're delivering images to a client for use in a publication, they may have specific size and resolution requirements.

If you're printing at very, very large sizes, you might need to *enlarge* your image. In either case, understanding the nature of image sizing is an important first step in your output workflow.

Resolution

Although your camera may capture millions of pixels, it doesn't necessarily create files that are configured with a resolution that is appropriate for your intended output. In imaging terms, resolution is simply the measure of how many pixels fit into a given space. For example, if your image has a resolution of 72 pixels per inch (ppi), the pixels in the image are sized and spaced so that 72 of them lined up alongside each other cover a distance of one inch.

Resolution is a term that is usually misused. People speak of a camera having "6-megapixel resolution," but a camera doesn't actually *have* a specific resolution, unless you want to talk about the pixel density on the camera's sensor itself. A camera produces a certain number of pixels—we call this *pixel dimensions* or *pixel count.* How you choose to space those pixels is up to you, and we refer to that amount as *resolution.*

The resolution of an image file is simply a tag that is stored in the header information of the file. You can create two copies of the same image file and set one to 72 ppi and the other to 300 ppi, but the size of the file *will not change!* Both files will contain the same number of pixels; they will simply be tagged so that the pixels are spaced closer together or farther apart.

Different programs will choose to use this resolution setting or not. For example, a presentation program like Microsoft PowerPoint or Apple Keynote doesn't care about resolution, so it ignores the setting. These programs are only concerned with pixel dimensions, and they usually display one image pixel per screen pixel (unless you shrink the image within the application, so you can fit more image area on-screen). The average computer screen has a resolution somewhere between 72 and 96 ppi, so many digital cameras output files at 72 pixels per inch. At 72 ppi, an image from a four- or five-megapixel camera will have an area of several square feet. That is, if you line up those four or five million pixels so that 72 of them take up one inch, then your image will end up being several feet long.

When viewing on-screen in your image editor, this huge size isn't a problem because the computer can zoom in and out of the image to fit it onto your screen. For printing, though, this is far too large an area to fit on a typical printer, and 72 ppi is too low a resolution to yield good quality.

If your goal is to post the image to a Web site, then resolution is completely irrelevant—the only thing you care about is pixel count. A monitor has a fixed resolution. That is, the number of pixels that cover one inch is always the same. So the only thing you need to concern yourself with is how many pixels there are in total.

PPI Versus DPI

Pixels (short for *picture elements*) are the colored dots that appear on your computer screen. It's very important to understand that, when speaking of printing from your computer, there is a difference between the pixels on your screen—which are measured in pixels per inch—and the dots of ink your printer creates, which are measured in dots per inch. We'll be discussing this in more detail later. For now, take note that we're measuring our images in pixels per inch or ppi.

When you resize an image, you will have to decide whether you want to change the number of pixels in the image (to change its pixel dimensions), and whether you want to change the resolution setting of the file.

Resizing an Image

Most image editing applications let you resize an image in two ways: by changing how closely the pixels are spaced or by changing the total number of pixels. In other words, by changing the resolution or by changing the pixel count. When you change resolution, the overall pixel count doesn't change. When you change the pixel count, you'll either have to throw out some original pixels or make up some additional ones.

Let's say that you have a 10-megapixel digital camera that outputs an image with dimensions of 3648 × 2736 pixels and a resolution of 72 ppi. That is, if you line up 72 of your image's pixels side by side, you will cover one inch of space. At this resolution, 3648 × 2736 pixels will take up 72" × 38". Obviously, this is too big to fit on a piece of office paper.

If you want to print this image on an 8" × 10" piece of paper, while preserving its original resolution, you could tell your computer to throw out enough pixels so it only has 8" × 10" worth of pixels at 72 ppi. It would then discard every third pixel or so, to reduce the pixel dimensions of the image from 3648 × 2736 pixels to 576 × 720 pixels (see Figure 22.1). This process of changing the amount of data in the image is called resampling (or, more specifically, downsampling), because you are taking a sample of pixels from your original image to create a new, smaller image.

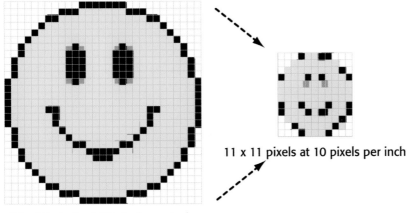

11 x 11 pixels at 10 pixels per inch

29 x 29 pixels at 10 pixels per inch

Figure 22.1

To resize an image down to a smaller size with the same resolution, you have to throw out some pixels (or resample) to fit your image into the smaller size.

The problem is that 72 ppi is too low a resolution to get a good print. After you've spent all that money for all those millions of pixels, the last thing you want to do is to throw a bunch of them out. Rather than resampling your image from 20" × 30" down to 8" × 10", it's better to change the resolution of your image so the dots are closer together, allowing you to cram more of them onto a page.

Imagine the same 72" × 38" image printed on a sheet of rubber graph paper. If you wanted to shrink this image to 8" × 10", you could simply squeeze down the sheet of paper. You would not throw out any pixels, but now your pixels would be much smaller and more of them would fit into the same space. That is, the resolution of your image—the number of pixels per inch—would have increased. This is what happens when you resize your image without resampling (see Figure 22.2).

Resampling can also be used to scale up images, but, just as downsampling requires your computer to throw away data, upsampling requires your computer to make up data.

For example, if you have an image that is 4" × 6" at 200 ppi, and you want to enlarge it to 8" × 10" at 200 ppi, you'll need to resample it upward, which will force the computer to generate new pixels. This process is called *interpolation*, and most applications offer a variety of interpolation techniques. Photoshop, for example, offers five interpolation methods: nearest neighbor, bilinear, bicubic, bicubic smoother, and bicubic sharper. When sampling up, it's best to use bicubic smoother, while bicubic sharper is best for sampling down. If your image editor doesn't offer these choices, bicubic is fine. Also, different vendors have their own implementation of bicubic resampling, so even if your image editor of choice doesn't offer separate bicubic sharper and bicubic smoother, it might have a bicubic algorithm that has this functionality built-in.

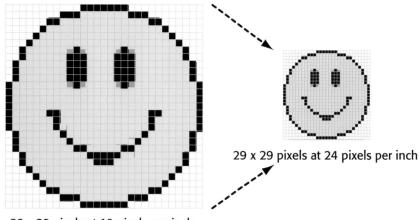

29 x 29 pixels at 24 pixels per inch

Figure 22.2

If you don't resample an image when you resize, all its pixels are kept, but they're squeezed closer together, resulting in a smaller, higher-resolution image composed of smaller pixels.

29 x 29 pixels at 10 pixels per inch

If you have a 4" × 6" image with a resolution of 200 dpi and you scale it up to 8" × 10" *without* resampling, you're effectively stretching the image. Its pixels get larger, and fewer of them fit into the same space—that is, the resolution goes down as the image gets larger. This is what happens when you resize up without resampling.

Most of the time, when you scale up, you'll want to resize without resampling to prevent the computer from making up new data. However, a printer requires a certain number of pixels to be able to make a sharp print at a given size. If your camera did not produce a big enough image to start with, you might not be able to achieve the size you want with the resolution you need unless you resample.

Tutorial Understanding Resolution

In addition to providing controls for resizing your images, Photoshop's Image Size dialog box provides a great tool for understanding the relationship between pixel dimensions, resolution, and image size. In this tutorial, we're going to take a quick look at this feature, and hopefully arrive at a better understanding of resolution, size, and resampling.

STEP 1: OPEN THE IMAGE

In Photoshop, open the `flower.jpg` image, located in the Chapter 22 section of the companion Web site at *www.completedigitalphotography.com/CDP6*. This image was shot with a Canon G2, a four-megapixel digital point-and-shoot camera.

STEP 2: OPEN THE IMAGE SIZE DIALOG BOX

From the Image menu, select Image Size (or Image > Resize > Image Size if you're using Elements). (See Figure 22.3.) For the purpose of this step, make sure the Resample Image checkbox is unchecked. Take a moment to familiarize yourself with the contents of this dialog box. In the Pixel Dimensions section, you can see the actual pixel dimensions of the image—in this case, 2160 × 1440—and the total size of the image, 8.9MB. Note that right now, these pixel values are *not* editable.

The Document Size section of the dialog box shows the resolution of the image in pixels per inch and the resulting print size in inches.

STEP 3: RESIZE THE IMAGE WITHOUT RESAMPLING

Notice that width, height, and resolution are linked by a thick, black line. This indicates that you cannot change one of these values without changing the others. For example, if we enter 10 in the Width field Photoshop will automatically calculate a new height of 6.667" at 216 pixels per inch (see Figure 22.4).

Photoshop has automatically adjusted the height to preserve the aspect ratio of the image and has calculated a new, lower resolution. Because Resample Image is *not* checked, Photoshop is not allowed to add or remove any data, so the only way it can fit the image into our requested size is to lower the resolution—that is, space the pixels farther apart.

When Resample Image is unchecked—when Photoshop is not allowed to add or remove data—it is as if your image is on a giant rubber sheet that can be stretched and compressed. As it gets compressed, resolution goes up because the pixels get pushed closer together. As it stretches, resolution goes down because the pixels get pulled farther apart.

STEP 4: RESIZE WITH RESAMPLING

As you'll learn later, the optimum image resolution for printing on most ink-jet printers is 240 pixels per inch. Enter 240 into the Resolution field. At that resolution, Photoshop calculates an image size of 9" × 6" for our image. Suppose, though, that you want to print the image at 3" × 5". Enter 5 into the width field and press Tab. Photoshop calculates a new height of 3.3" and a resolution of 432.

This resolution is too high for our printer, but if you enter 240 in the Resolution field, your print size will change back. This image simply has too much data to print 3" × 5" at 240 pixels per inch.

Click the Resample Image checkbox. Note that the Width and Height fields in the Pixel Dimensions area are now editable. With Resample Image checked, it is now possible to change the number of pixels in the image. Note, too, that Resolution is no longer linked to Width and Height. You're now allowed to change the resolution independently of the width and height, because it is now possible for Photoshop to throw out data if it needs to.

Figure 22.3

The Photoshop Image Size dialog box shows the actual pixel dimensions of an image and the print size at the current resolution.

Figure 22.4

After entering 10 in the Width field, Photoshop automatically calculates a new height and resolution, as indicated by the linking bars next to the pop-up menus.

With your Document Size width still at 5" × 3.3", change your resolution to 240 (see Figure 22.5).

Figure 22.5

With the Resample Image checkbox selected, resolution is no longer tied to print size because Photoshop is free to add or remove pixels. This lets you change resolution independently of print size.

Note that several things have happened. First, the pixel dimensions dropped from 2160 × 1440 to 1200 × 800. Our file has gone from 8.9MB to 2.75MB. More importantly, our print size did not change. We now have the width, height, and resolution we want.

Note, too, that we changed the Resample Image pop-up menu to Bicubic Sharper, since this is the best mode to use when resampling down.

When using the Image Size dialog box, pay attention to which fields are editable and which are linked. This will give you a better understanding of how pixel dimensions, print size, and resolution are all interrelated.

Printing with More Pixels Than You Need

If the optimum resolution for your printer is 240, what happens if your document has a higher resolution at your target print size? For the most part, nothing, in terms of image quality. But your document will be larger than it needs to be, and might take longer to print. In addition, it might require more aggressive sharpening. In general, it's just easier to work with an image that's been scaled properly for your target size. As long as you don't overwrite your original image, you can always return to your original, full-pixel-count version.

Scaling Styles

In Photoshop, Styles are special predefined image editing effects that add drop shadows, embossing, and other effects to a graphic element. Styles are targeted more toward graphic designers than photographers, so we haven't looked at them in this book. If you check the Scale Styles checkbox in the Image Size dialog box, then any styles that you've used will get scaled properly. For our uses, it won't matter if this box is checked or not.

When Should You Resample?

You should resample your image any time you have an image with more pixel data than you need for your intended output (downsampling) or not enough pixel data for your intended output (upsampling).

Downsampling

If you're outputting for the Web or email, you will definitely have to resample, unless you shot your images at a small size (640 × 480, for example). Similarly, if you're delivering electronic

files for print and your camera produces more pixel data than your printer needs, you'll need to downsample. If you're printing to your own desktop printer, you might also have to down-sample if your image has more pixels than you need for your desired print size. If you're prepar-ing images for use in a video, or for a DVD menu, or another electronic application, you'll almost certainly need to downsample.

Downsampling your image data is a fairly pain-free process. In fact, downsampling tends to improve sharpness and contrast in your image.

The Photoshop bicubic sharper interpolation algorithm does a very good job of downsam-pling. If you're using an earlier version of Photoshop, then the regular Bicubic method is also a good choice.

Upsampling

As you learned earlier, many digital cameras use interpolation to increase the resolution of their images. As explained, these interpolation schemes often degrade the quality of an image by introducing artifacts. Simply put, calculating new image data is a tricky, difficult thing to do. When it's done poorly, aliasing artifacts, loss of sharpness, and other image problems can appear. The same holds true when upsampling an image using an image editor.

The most basic rule of thumb for upsampling is that you want to do as little of it as possible. So you'll want to think very carefully about the precise print size and resolution you need, and upsam-ple to exactly those pixel dimensions. Any more, and you'll run the risk of increased artifacts.

We'll discuss print size and resolution choice in the "Printing" section, later in this chapter.

As with downsampling, in more recent versions of Photoshop, you have several different algo-rithm choices you can use when upsampling. While bicubic interpolation can work very well, bicubic smoother will usually yield results with fewer artifacts.

When resampling with bicubic interpolation, it's best not to make any single resizing step greater than 10 percent. If you need to enlarge by *more* than 10 percent, use multiple 10 per-cent steps. This is not a concern when using bicubic smoother—with this algorithm, you can perform a single resizing step of any kind.

There are several products on the market designed specifically for enlarging images for print. Alien Skin's Blow Up and OnOne Software's Perfect Resize (formerly Genuine Fractals) are two Photoshop plug-ins that use proprietary algorithms for making enlargements. While these products sound great in theory, in practice, you'll usually see little difference between them and Photoshop's bicubic smoother interpolation. In fact, in some instances, you'll find you get *better* results with Photoshop, even when performing very large enlargements.

Saving a Resized Version

If you're resampling your image in Photoshop, either up or down, you'll want to perform a Save As to create a separate, resized version. Since downsampling throws out data, and upsampling creates new, possibly soft pixels, it's important to preserve a copy of your original file. By doing a Save As either before or after you perform your resizing, you'll create a second version of your document with your new sizing. You can return to your original full-size version at any time.

Your image editor can actually sharpen an image far beyond what looks realistic, so it's important to pay attention when sharpening.

When you use a USM filter, start with a high Amount setting—300 to 400 percent—and a small Threshold. Then try to find a Radius that produces minimal halos (see Figure 22.8). Sharpening is a subjective process, so find a level of halo that suits you. However, be sure to consider your entire image.

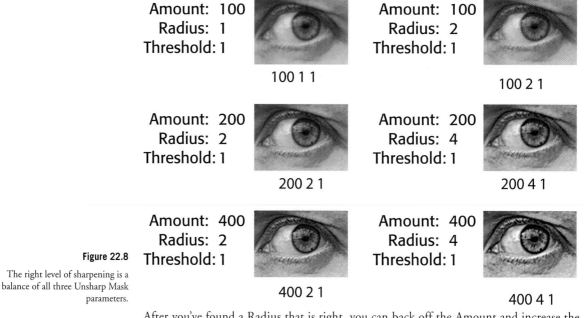

Amount: 100
Radius: 1
Threshold: 1

100 1 1

Amount: 100
Radius: 2
Threshold: 1

100 2 1

Amount: 200
Radius: 2
Threshold: 1

200 2 1

Amount: 200
Radius: 4
Threshold: 1

200 4 1

Amount: 400
Radius: 2
Threshold: 1

400 2 1

Amount: 400
Radius: 4
Threshold: 1

400 4 1

Figure 22.8

The right level of sharpening is a balance of all three Unsharp Mask parameters.

After you've found a Radius that is right, you can back off the Amount and increase the Threshold. Your goal is to use these two sliders to apply your desired radius to the appropriate amount of edge detail in your image.

Always Sharpen at 100 Percent

Be sure that you're looking at your image at 100 percent, or 1:1, when sharpening. If you've zoomed out from your image, your image editor is already downsampling its screen image, which will serve to render the image sharper. Consequently, accurate sharpening may not be visible.

Not All Sharpness Is Created Equal

Note that some subjects can withstand more sharpening than others. Foliage and small, very detailed background elements, as well as skin tones, usually don't stand up to a good deal of sharpening, whereas simple shapes with well-defined edges do. If these types of objects are mixed together, you might be better served by selectively applying different amounts of sharpening to different parts of your image.

Based on the techniques you've learned so far, there are a number of ways you can selectively apply sharpening. You can, for example, create selections using selection tools. Or, because sharpening is an effect you want to apply to edges, you can use the luminance masking technique we

learned earlier to build a mask from the image's edge detail and then apply sharpening through that mask. For the next tutorial, though, we're going to apply sharpening by painting.

Selective Sharpening

Figure 22.9 shows an original, unsharpened image that was pulled directly from a Canon digital SLR. Like most digital SLRs, Canon's do not apply much sharpening to an image, leaving you in complete control of the sharpening process. After all, you can't remove sharpening once it's there, so it's often better for a camera to err on the side of too soft, since you can always sharpen later.

Figure 22.9

This image was taken with a Canon SLR. By default, most SLRs apply very little sharpening. Here we want to sharpen some areas but not others.

Because this image was shot with a shallow depth of field, there's really no reason to apply any sharpening to the background. There's no edge detail there anyway, so sharpening would only serve to exaggerate any noise or artifacts that might be lurking in the image. The woman's face, on the other hand, could definitely use some sharpening. However, her face doesn't need equal sharpening all over.

Eyes are the most important part of any portrait, so we want to sharpen them quite a bit. Skin tones, however, can suffer from sharpening, because sharpening intensifies pores and wrinkles, so we'd like to apply less sharpening to those areas.

Fortunately, applying sharpening selectively is pretty easy, using some techniques you've already learned. For a selective sharpening tutorial, download the `Selective Sharpening.pdf` located in the Chapter 22 section of the companion Web site.

Don't Get Too Hung Up on Sharpening

As with any edit, bear in mind that it's the *content* of your image that matters. Some of the most famous photographers in the world shot images that were, by today's standards, very soft. But because they were composed and exposed well, the images remain evocative and effective.

Smart Sharpening in Photoshop

Photoshop CS2 and later include a variant of the standard Unsharp Mask filter called *Smart Sharpen*. Smart Sharpen does the same thing that Unsharp Mask does—finds edges and lightens and darkens the pixels on either side to make the edge more pronounced—but adds a few additional controls (see Figure 22.10).

Figure 22.10

Photoshop CS2 and later provide a Smart Sharpen filter, which performs an Unsharp Mask operation, but provides more control and allows for more subtle, controlled effects.

- **Remove** defines exactly which blurring algorithm is used to create the "unsharp" copy of your image that is used internally by the filter. Gaussian Blur yields the same type of sharpening as Unsharp Mask. Lens Blur will provide finer detail sharpening and possibly yield fewer halos. Motion Blur (and the accompanying Angle parameter) can yield better sharpening, depending on the image. Experiment to determine which algorithm is best for your image.

In the Advanced section of the dialog box, you'll find some additional parameters.

- **Fade Amount** adjusts the amount of sharpening that is applied to highlights and shadows.

- **Tonal Width** controls the range of shadow and highlight tones that are affected by the filter.

- **Radius** controls the size of the area that is analyzed to determine if a pixel is a shadow or highlight.

In general, when you use Smart Sharpen, you'll use the same methodology and need to keep an eye out for the same types of artifacts, as when you use Unsharp Mask. You'll probably find that Smart Sharpen does a better job of constraining its sharpening effects to edges. This makes it especially useful for sharpening portraits.

Web and Email Output

Web output is very simple. Unfortunately, this is partly because there are no color management controls for the Web. Since there's nothing you can do but post your images and hope your viewers are using decent monitors, you don't need to spend time trying to tweak your final image to look good on a particular monitor or paper type.

Your main concern when you prepare an image for the Web (or for email) is file size. You probably already know what it's like to wait for a large image to download, either from the Web or from your mail server. Don't inflict the same data glut on other people by posting or emailing really large files. Obviously, if you and your recipient have high-speed connections, you can probably get away with creating larger files. Be aware, however, that the mail servers

provided by many Internet service providers put a limit on the maximum size of an email attachment. If you absolutely *have* to email a large image to someone, consider segmenting it by using a file-compression utility.

Fortunately, images for the Web tend to be very small. You can safely assume that most users have a screen that's 800–1000 pixels wide. Of course, some users will have much larger screens, and if you know your intended recipient does, then you can send a larger image. In general, most Web and email images clock in around 300 to 600 pixels wide. Save a copy of your image (be careful not to recompress it) and resize it to an appropriate pixel size.

The two most common graphics file formats on the Web are GIF and JPEG. For photos, JPEG is really the only format you need to use. Fortunately, Photoshop offers an excellent Save for Web and Devices command (under the File menu) that lets you experiment with different JPEG compression ratios and compare the effects of different compression settings side by side (see Figure 22.11).

Figure 22.11

The Photoshop Save for Web and Devices command makes it simple to try different JPEG settings to balance size and quality.

In the Save for Web dialog box, you can select different compression types and play with different settings to see how image quality is affected. You can even view two- and four-up comparisons, so that you can see different compression settings side-by-side.

Save for Web also includes a set of Image Size controls, which let you resize the image upon output, and give you the option to convert to the sRGB color space, which we'll discuss later.

If you're sending your images to post on another person's Web site, consider sending an uncompressed image. That person may have his or her own size and compression requirements, and so will want to perform custom resizing and compression. If you send an uncompressed file, he'll be able to compress it to custom specifications without introducing further image degradation.

If you'd like to have your own photo Web site but don't have access to any Web space, consider using a photo-sharing Web site, such as Flickr. Flickr is a clever combination of photo sharing and social networking, which means a greater number of people are likely to see your

images. Many online printing services (which we'll look at in the "Printing" section) include photo-sharing features that allow you to post images for other people to see. They can even order their own prints.

While there's no standard color management system for the Web, there is a color space many Web browser makers try to respect and optimize for. Before outputting, if you convert your images to sRGB, there's a good chance your results will be a little more predictable and consistent from browser to browser. In Photoshop, you can convert to sRGB by choosing Edit > Assign Profile and then selecting the sRGB profile in the resulting dialog box. As mentioned earlier, you can also convert to sRGB from directly within the Save for Web dialog box.

If you already have a Web site, or if your Internet service provider includes Web serving in your account, you can create your own online photo gallery using the Photoshop CS and Photoshop Elements Web Photo Gallery feature. In Photoshop CS, click File > Automate > Web Photo Gallery. In Elements 2, click File > Create Web Photo Gallery.

The Web Photo Gallery plug-in has been removed from Photoshop CS4 because a similar function has been added to Bridge, as you'll see in the next section. If you're really attached to the Photo Gallery (or Contact Sheet II), you can download it from this site: *www.adobe.com/support/downloads/detail.jsp?ftpID=4047.*

In Photoshop CS4 and later, you can create Web galleries from within Bridge, by clicking on the Output tab at the top of the window. The Output tab lets you export PDF contact sheets or Web galleries. Click on either option at the top of the Output palette.

You'll find a number of prebuilt templates and controls for customizing and altering the template designs. Both options will construct their results using the images in the folder you're currently browsing (see Figure 22.12).

Figure 22.12

Bridge's Output tab provides a simple, powerful facility for creating Web galleries from a folder full of images.

Aperture and Lightroom also provide automatic Web gallery features that make it simple to output a selection of images as an easily navigable Web album. These programs (as well as Apple iPhoto) also provide custom Export plug-ins for automatically outputting images to photo-sharing services such as Flickr.

If you're using Aperture, Lightroom, or iPhoto, and you need to output files for use on the Web (without creating a full-blown Web gallery), you'll simply use those programs' Export facilities to create JPEG images at a smaller size. All three apps allow you to choose an output size at the time of export. Aperture, Lightroom, and iPhoto also provide special email functions that automatically create a small, email-ready image and then automatically attach this to an email in your chosen email client.

Don't Forget Your Copyright

Before posting your images to the Web, use your image editor to fill in the Copyright IPTC metadata field to include your name, and the copyright year. For example "Copyright © 2011 by Joe Kodak." This information will stay in the file even if people download a copy of it from your Web gallery. They can change it using their own metadata editor, but willfully changing a piece of copyright metadata can be construed as copyright violation, so ensuring a good copyright tag can afford a good amount of protection.

Outputting Electronic Files

While Web and email outputs are, technically, electronic files, there will be other times when you need to output full-res electronic files. Maybe you need to deliver images for printing to an electronic printing service, or simply create a file that someone else can edit. In any case, there are a few things to consider.

- **Outputting for delivery to a printing service.** If you plan to do your printing through an online service, camera store, or drug store, you'll need to output in a specific way. We'll discuss this in detail when we cover these services in the printing section, later in this chapter.

- **Outputting for delivery to a designer or printer.** If you're producing images that will be used by a graphic designer or printer, you'll need to check with them to find out exactly what their specifications are. They will probably need an image sized to very specific pixel dimensions and with a very specific resolution. They might also need an image that has been converted to CMYK (something you cannot do in Photoshop Elements, Aperture, Lightroom, or iPhoto), and they'll probably have specific file format requirements. Finally, they might also have specific color space requirements. They should be able to provide you with detailed instructions on exactly how to save the file, and can probably do any necessary CMYK conversions for you, although they may charge a fee for this service. You'll also want to find out what file format they expect for delivery. In many cases, a high-quality JPEG file will be fine, although some printers will insist on an uncompressed format such as TIFF, PSD, or possibly EPS.

- **Outputting for delivery to a retoucher or photographer.** Many photographers prefer to work with a professional retoucher, rather than perform retouching and editing on their own. After all, if someone else is handling your retouching, you'll have more time for shooting. There might be other times when you simply need to deliver an editable file for someone else because he or she needs a copy for his or her own use. In these instances, you'll want to deliver a full-res file, possibly with any layers you've created, and usually at the highest possible bit depth. So, if you've been shooting raw, you'll want to deliver a 16-bit file, while JPEG images will have to be sent at 8 bits. If possible, you'll want to send it in an uncompressed format such as TIFF or PSD.

Photoshop's Image Processor

Photoshop CS2 and later include a handy feature that makes it easy to convert batches of files from one format to another. If you choose File > Scripts > Image Processor, you'll be presented with the Image Processor dialog box, which lets you select a folder full of images, a destination location, and then checkboxes to select the file format of your output files (see Figure 22.13).

Figure 22.13

The Photoshop Image Processor lets you easily batch process entire folders full of images into different file formats.

In addition, you can opt to resize your files at the time of output, and you can even output in JPEG, PSD, and TIFF files simultaneously. Finally, using the Preferences section at the bottom of the window, you can choose an Action to run on the processed images (an action you've defined in the Actions palette), and a Copyright tag to embed in the file's IPTC info.

Note, too, that you can launch the Image Processor from within Bridge. Say there are some images that you want to resize and save as JPEGs for uploading to a Web site. Select the images in Bridge and then choose Tools > Photoshop > Image Processor. Configure the Image Processor dialog box accordingly, and your new files will be created.

If you need to convert many images to TIFF or JPEG very quickly, the Image Processor is an easy way to do so.

Bridge CS5 Export Tab

With Bridge CS5, Adobe added a new Export tab, which gives you a simple way of exporting images for online services, as well as for saving out new formats and sizes to your local drive.

The Export tab is modular, meaning Adobe can easily add support for new services later. However, the original release of CS5 did not include a working Export tab. The tab's there; you just won't see any controls in it. By default, the Export tab is located in the same pane as the Filter and Collections tab. If your Export tab doesn't look like the one in Figure 22.14, then you need to update your copy of Bridge. Choose Help > Updates and follow the instructions to get the latest version.

From the menu in the upper-right corner of the Export tab, you can choose to manage the currently installed modules. This allows you to deactivate modules you're not currently using, update installed modules, and automatically download new modules from the Adobe site.

To export images using the Export tab:

Figure 22.14

Bridge CS5's Export panel contains simple tools for exporting images to common online services and for exporting files in different formats to your local drive. If your Export panel doesn't look like this, update your copy to the latest Bridge CS5.

- Select the images you want to Export in Bridge.

- Double-click on the appropriate service in the Export tab

- A dialog box will appear, which allows you to configure the setting necessary to access your chosen service.

- Configure the login preferences accordingly and press Save to save your configuration.

Once configured, you'll be able to export your images to that service simply by clicking on the service in the Export panel.

The Save To Hard Drive option saves the currently selected images to the folder of your choice as a JPEG file, and offers you the option to resize images, add a metadata template, rename the file, and more. It's very much like the Image Processor that you saw earlier, but it works inside of Bridge, and has a slightly more streamlined interface. What's more, it can process any raw files that you may have, giving you a simple way to output JPEG files from your raw images.

Choosing a Printer

With the pixel counts of cameras climbing ever higher and prices continuing to drop, it's not hard to see that digital camera technology is constantly improving by leaps and bounds. But desktop printing technology has been making equally impressive advancement as evidenced by the fact that you can now buy a printer that delivers photo-lab-quality prints for under $100. For years, longevity and durability of prints was the Achilles' heel of desktop printing, but new pigment ink formulations have addressed this problem, and desktop ink-jets are now capable of producing prints that are *more* durable than traditional film printing processes.

Many new users are quick to point out that although the printers are cheap, ink cartridges are very expensive, and therefore, digital printing is a rip-off. This may be true when compared to having your film processed at your local Walmart, but you need to remember that you get what you pay for. Odds are, you'll get better-looking prints from your desktop printer than you'll ever get from a cheapo photo lab.

If you tend to want prints of most of the pictures you shoot, a desktop printer will be more expensive per print than if you print using a printing service. If this sounds like you, you will want to use a photo printing service for the bulk of your images and think of your desktop printer as a replacement for the custom photo lab you would go to for those times when you want enlargements, special prints, or precise control over color. Or you might think of it as a replacement for a color darkroom you'd normally have to keep in a closet or bathroom. When viewed this way, you'll see that desktop printing is much cheaper than using a custom lab, and definitely cheaper than the equipment and materials required for a wet darkroom.

What you may find is that the ideal printing solution is a combination of mail-order printing for your everyday prints and a desktop printer for larger prints or for times when you want to tweak and adjust the color of a print.

We'll discuss both technologies in this chapter. Fortunately, all the work you've done in the preceding pages should leave you well prepared for a discussion of printing. Most of the color theory you learned when you were working with your camera will apply to your printer as well. This section begins with a discussion of the issues and questions you'll face when you buy a printer. Following that, you'll learn more about how to adjust and prepare your images for printing.

Ink-Jet Printers

The best photo-printing solution is a color ink-jet printer. Ink-jets work by shooting tiny (*really* tiny—most ink-jets use a drop that is only a few picoliters) drops of ink out of a nozzle. As with any color-printing technology, different colored drops are combined to create full-color images.

Ink-jet printers have a number of advantages over other printing technologies. They have larger color gamuts, better sharpness, produce prints that are more durable, and provide much greater media flexibility than any other printing technology. With the right paper, a good ink-jet printer can create an image that's indistinguishable from a photographic print.

Ink-jet printers are typically far cheaper to buy than any other type of printer, although their cost per print can be expensive—up to $2 per page for a photo-quality 8" × 10" print. However, because of their ability to handle different media, you can also create lower-quality, less-expensive prints by using cheaper paper.

You might already have an ink-jet printer that you use for printing letters and other "office" type documents. The typical office ink-jet printer has four ink colors: cyan, magenta, yellow, and black. Just as your camera and computer create other colors by combining the red, green, and blue primary colors of light, your ink-jet printer combines its four primaries to create all other colors.

An office printer is suitable for printing text at reasonable speeds and will do a capable job of printing color photos. (HP even makes a *three*-color printer that uses cyan, magenta, and yellow inks, and then mixes these together to create black.)

A serious photo printer, though, uses more colors of ink. At the bottom end, a photo printer will have at least six colors, while a more sophisticated one might have as many as 13. For example, six-color photo printers usually add extra light cyan and light magenta cartridges to the four primaries, which allow the printer to reduce the visible printer dots that can appear in highlight areas and make it possible to create smoother color transitions and gradients. The extra colors also help improve fade resistance. Some primary colors fade faster than others, so by mixing colors from different, sturdier primaries, the printer can produce prints with better fade resistance.

Seven-color printers use those same six colors, but usually add an additional black cartridge specifically for printing on glossy paper. Several vendors make eight-color printers, but choose different mixes to achieve different results. For example, some printers use the same six colors as a six-color ink-jet and add red and green ink to yield prints with better reds and greens. Other printers start with the usual six-color mix and add two lighter shades of gray to produce truly neutral gray tones.

There are even more complex ink systems, but they're all designed to do the same thing: expand the gamut and improve *neutrality*—the capability to print a grayscale image without a color cast.

Additional inks are also employed to help reduce metameric shift, a property of some inks that can cause them to appear different in different types of light. A print that suffers from bad metameric shift might appear fine in bright daylight, but have a greenish cast under tungsten light. Metameric shift (sometimes referred to, incorrectly, as *metamerism*) is usually caused by a slight color cast in the black ink of a printer. To combat metameric shift, many printers mix a primary color with the black ink.

Ultimately, you don't need to concern yourself with the specifics of your printer's color mix. You simply want to find the printer that produces the best output. However, paying attention to the color mix in a printer can give you a good idea of what qualities to look for in a print.

With the jump from an office printer to a quality photo printer, you'll use almost twice as much ink per print. A printer that uses eight, nine, or more inks will suck up more ink per print than a six-color printer, but not substantially more.

Buy One of Each

In the end, you're probably going to find that you need both an office printer and a photo printer. An office printer is not good enough to print quality photos, *and* a photo printer is not cost effective when printing text.

To learn more about how to choose an ink-jet printer, and what separates one type from another, check out the Ink-jet Printer Buyer's Guide PDF, located in the Chapter 23 section of the companion Web site.

Media Selection

You can stick any old paper in your printer (as long as it's not a dye-sub printer), including the normal 20-pound copier paper typically used for office correspondence. However, paper choice can have a huge bearing on the appearance of your final image.

Glossy, or "luster" papers, for example, will deeply saturate colors, but exhibit weaker blacks than a matte paper. Weaker blacks will mean a cost of overall contrast ratio and shadow detail. Matte papers, meanwhile, will be able to display a greater color range, but at the cost of deeply saturated colors. Which choice is right depends on the image you're printing, what type of look you're going for, and how you will display the image. So, if a particular image is dependent on supersaturated colors, you'll want to go with a glossier paper, while an image with a very broad tonal range and lots of fine detail will need a matte-finish paper. If an image is going to be displayed under glass, you may find that the paper finish is less relevant because the glass obscures a lot of gloss and adds an apparent finish of its own.

Finally, you may make your decision purely on cost. Some papers are much cheaper than others. If you simply need to get some sample images to someone, or want to print out some snapshots, you might be best served by an inexpensive matte-finish paper.

In general, you'll want to experiment with your paper selections to find out what works best for your intended output. Be certain to read your printer's manual before you shove an experimental piece of paper through your printer. Most printers have thickness limits, and many printers—particularly archival-quality printers—can be damaged if you use media that wasn't specifically designed for the printer. Some types of handmade papers can produce lots of dust and particulate matter that can be hard on a print head, resulting in clogs and frequent cleanings.

Ink Choice

In general, you should always buy ink made and certified by your printer manufacturer. There might cheaper, third-party inks available for specialized printing applications, such as high-quality grayscale printing, and these often work just fine. However, be aware that it is possible for your printer head to be damaged by noncertified inks. More important, though, to get accurate color, your printer driver needs to know that the ink formulations in your printer will mix and blend in a particular way. If you use a third-party ink, there's no guarantee that they will have mixed their ink correctly, and you'll rarely have any idea of the archival qualities of third-party inks.

Printing

In an ideal world, once you have finished correcting and adjusting your images, you would simply click the print button and out of your printer would pop a print that looked exactly like it did on-screen. In the real world, printing is a bit more involved than that.

Earlier, we discussed the processes of resizing and sharpening. What we *didn't* discuss, though, was how to determine an appropriate resolution when resizing. You want to be sure you're using all the pixels in your image to your maximum advantage. Therefore, choosing a resolution is your first major decision when preparing to print.

Choosing a Resolution

Before you can resize an image (as discussed earlier), you need to know the resolution that is best for your printer. Different printing technologies have different resolution requirements, so calculating optimal resolution differs from printer type to printer type.

If you've ever looked at a black-and-white newspaper photo up close, you've seen how dot patterns of varying size can be used to represent different shades of gray (see Figure 22.15). This type of image is called a *halftone* and traditionally was created by rephotographing a picture through a mesh screen.

The color photos in this book are printed using a similar process. To create a color halftone, four halftones are created, one each for cyan, magenta, yellow, and black. When layered on top of each other, these four halftones yield a full-color image.

All color printing processes use variations on this practice of combining groups of primary colored dots to create other colors. Nowadays, halftones are usually created digitally by scanning an image into a computer (if it didn't start out as a digital image in the first place) and then letting the computer create a halftone. In the old days, you created a halftone by photographing an image through a screen.

Figure 22.15

Like all of the images in this book, this figure is a halftone. In a black-and-white halftone, patterns of differently sized black dots are combined to create the appearance of various shades of gray.

Your computer monitor works differently. A CRT monitor has three electron guns that light up three different colors of phosphor—red, green, and blue. An LCD monitor uses light sources with the same three colors. Liquid crystals sit in front of the light sources and act as shutters, which can be opened by varying amounts to blend and mix the three component colors.

In other words, there is not a one-to-one correspondence between a pixel on your screen and a dot printed on paper. While a pixel on your screen is made up of three component light sources, your printer might have to print a combination of 50 different cyan, magenta, yellow, and black dots to reproduce that one purple dot from your monitor. Although your printer may claim to have 1400 dots per inch of resolution, those are 1400 *printer dots*, not 1400 pixels. It might take a whole lot of printer dots to reproduce one pixel from your image. Choosing a resolution, then, is dependent on how much information your printer needs to do its job.

Choosing a Resolution for an Ink-Jet Printer

All ink-jet printers have a native resolution, measured in pixels per inch (ppi). If you send an image to the printer at some other resolution, then the printer will up- or downsample that image to the printer's native resolution before printing. So, for example, if your printer has a native resolution of 300 ppi, and you send it an image with a resolution of 600 ppi, at your desired output size, the printer will automatically downsample the image to that same size, at 300 ppi. In Photoshop, this is the same thing as resizing the image with Resample Image checked in the Image Size dialog box.

There are two potential problems that occur when the printer does this. First, if your printer's interpolation software is not as good as what's included in your image editor, then it's possible that you might see some image degradation when the printer performs this resizing.

More importantly, if you've sharpened your image and the printer resamples it, the result could have either too much or too little sharpening. For both of these reasons, it's best to resample the image yourself to the printer's native resolution before printing.

Unfortunately, printer vendors are not diligent about publishing native resolutions, so it can be difficult to determine what the native resolution for a particular printer might be. In general, Epson printers typically have a native resolution of 360 ppi, while Canon and HP printers typically have a native resolution of 300 ppi.

Printer Profiles

No matter what type of printer you're printing on, or what program you're printing from, to get the best output from your printer, you need to have a good printer profile. Earlier, you learned about monitor profiles and went through the process of calibrating and profiling your monitor. Just as you need to have an ICC profile for your monitor, you also need to have an ICC profile for your printer. More specifically, you need one for the particular type of paper you're going to print with in your particular type of printer.

Good profiles are essential for consistency from monitor to paper and to ensure the best possible output from your printer. When you installed your printer software, a collection of profiles should have been installed for each paper type your printer company sells. There may even be several profiles for each paper: some profiles are for specific viewing conditions (daylight, tungsten, etc.) or printer settings.

Unfortunately, not all vendor-supplied printer profiles are reliable. One reason is that some printers are easier to control with profiles than others. For example, some higher-end printers include sensors that carefully monitor ink flow through the print head to determine exactly how much ink is being delivered to the paper. Some printers are carefully calibrated as soon as they leave the assembly line. On the flip side, less-expensive printers often vary significantly from one unit to the next, meaning a generic, vendor-supplied profile may be of little use.

When you use a paper sold by someone other than the company that makes your printer, you'll need to make or find a profile for it. Many third-party paper vendors provide free profiles for download. Crane has an extensive profile collection, as do Hahnemühle and Ilford. Finally, you can often find free profiles on the Web simply by searching.

If you're not getting good output with vendor-supplied profiles, or if you're using a paper you can't find a profile for, it's time for a custom job. Several services, such as Inkjetart.com, make custom profiles for around $25. Simply download the supplied profile target, print it out on your printer, and mail it back. The company then sends you a standard color profile. When printing the target, be sure to set your printer settings to the ones you typically use and turn off the printer's built-in correction.

While $25 is cheap, you may find that as you change ink cartridges, your profile becomes less accurate. Continually regenerating a profile can become expensive. If you regularly create paper profiles, you may want to invest in your own profiling hardware. A paper-profiling system consists of a hardware/software combination that measures a sample output by your printer and generates a profile. To create a profile, you first print test target images, which are color swatches that come with the paper profiling system. Then you measure these targets with the included hardware. The XRite Pulse Color Elite is one such system. It ships in various configurations that can include a monitor calibrator as well.

However, paper-profiling systems are not cheap. Expect to spend at least $600 for an entry-level system. Such a system can pay for itself in saved ink and paper costs if you regularly use third-party papers, but if you only occasionally need to make a profile, it's probably not worth it.

If you're having trouble getting good prints from your printer, the solution may be nothing more than upgrading to a better profile, so you'll want to look into profile options as a first attempt at a solution.

On the Mac OS, you install printer profiles in the Library > ColorSync > Profiles folder. On Windows, install your printer profiles in WINDOWS\system32\spool\drivers\color. You might need to relaunch your image editing application to see the new profiles.

If you don't have a profile for the specific paper you're using, you might be able to get away with a similar one that's already in your driver. For example, if you have an HP printer that includes a profile for an HP semi-gloss paper, you might find that it works okay when printing on an Epson semi-gloss paper. It still won't be as good as a dedicated profile, but it might be good enough to get you started, and as you gain more experience with the paper, you may learn how to compensate for inaccuracies between the monitor and paper.

Soft Proofing

Some image editing programs such as Adobe Photoshop CS, and later, Nikon Capture NX and Apple's Aperture, let you view a photo in a special soft-proofing mode, which uses a color-management system and installed profiles to simulate on-screen what a print will look like when output to a specified printer.

We'll be using Photoshop for these examples, but similar options exist in Aperture and Capture NX. If you're using a different editor that provides soft proofing, its controls and options should be similar to Photoshop.

To generate a soft proof, have your most recent monitor profile active. Your profiling package should have installed it for you. If it's been more than a month since you profiled the monitor, do it again. It's best to profile your monitor at least once a month—more often if it's an older monitor.

If all of your profiles are in place, then you're ready to create a soft proof. Check out the Soft Proofing.pdf, located in the Chapter 22 section of the companion Web site for a detailed tutorial.

 Printing from Photoshop

After you've soft proofed, you'll be ready to print your image. Soft proofing might also reveal tonal adjustments and color shifts that need to be made, and we'll discuss how to handle that shortly. First, let's see how a color-managed printing process works in Photoshop. This tutorial assumes that you have an image you want to print open in Photoshop, and you have a printer installed and connected.

STEP 1: OPEN THE PRINT DIALOG BOX
If you're using Photoshop CS4 or later choose File > Print (with some earlier CS versions, you'll choose Print with Preview). Photoshop will show you a thumbnail view of your chosen paper size, with your image positioned as it will appear when printed (see Figure 22.16).

Figure 22.16

The print dialog box in
Photoshop CS4, and later,
provides all the controls you need
to run a color-managed print
process. In earlier versions of the
Photoshop Creative Suite, you'll
get the same types of controls
from the Print with Preview
dialog box.

You can use the Page Setup button to change the current paper size and orientation, and then
use the Position and Scaling controls to change how your image will be positioned and sized
on the page. We're assuming you've already resized your image to your desired print size and
resolution. If you haven't, you can use the Scaled Print Size controls to tell Photoshop to resize
the image now. You'll have no control over interpolation method, whether the image is resam-
pled, or of final sharpening, so this is not the best resizing option.

STEP 2: TELL PHOTOSHOP TO TAKE CONTROL OF THE COLOR

When you print, you can have Photoshop manage the color, or you can let the printer man-
age the color. We want Photoshop to manage the color so it can generate the same colors for
our print that it came up with for our soft proof. If we let the printer manage the colors, there's
no guarantee it will make the same color decisions.

In Photoshop CS4 and later, change the Color Handling pop-up menu to Photoshop
Manages Color.

In Photoshop CS and CS2, click the More Options button (if it's not already clicked) and
then change the Color Handling pop-up menu to Let Photoshop Determine Colors.

STEP 3: SET THE RENDERING INTENT

As we learned when we generated our soft proof, rendering intent is simply the method
Photoshop uses to cram the large color space your camera captures into the smaller space pro-
vided by your paper. You want to set the Print dialog to use the same rendering intent you
chose when you soft proofed. In our soft proofing example, we used Relative Colorimetric,
so set the Rendering Intent pop-up menu to Relative Colorimetric.

STEP 4: CHOOSE A PAPER PROFILE

Now set the Printer Profile pop-up menu to the same profile you chose when you soft proofed.
This will be the paper profile you selected in step 2 of the previous tutorial.

STEP 5: BLACK POINT COMPENSATION

If you chose Black Point Compensation when you configured Proof Setup, you need to activate it in the Print dialog. As you'll recall, we chose to enable Black Point Compensation, so check it now (see Figure 22.17).

Figure 22.17

Photoshop's Print dialog should now look something like this.

STEP 6: PRINT

Now, click the Print button. Photoshop will display your operating system's normal Print dialog box. From here, you can select the printer you want to print to (if you have more than one) and configure the printer driver's controls.

You'll need to tell the printer what type of paper you're printing on. This allows the printer to position the print head an appropriate distance from the paper, depending on how thick the paper is.

Finally, find the control in the printer driver that turns *off* color management. This may sound counterintuitive, but there's a very simple reason. Most printer drivers have their own color-management routines that try to correct an image's color for printing. However, you're asking Photoshop to take care of managing color, so you don't want the printer driver to be involved as well. If both systems mess with the color in your image, things get very unpredictable.

The method for turning off color management varies from printer to printer. For example, in most Epson printers, you'll find a Color Management option in the Printer dialog, which looks something like the controls shown in Figure 22.18.

Different printers will have different mechanisms for disabling printer color correction. This is an essential step when printing using Photoshop's color management. Consult your printer manual if you can't find the color management control.

Figure 22.18

It is essential that you disable your printer's built-in color management, using the Printer Driver dialog.

Click the Print button, and your image should print. Compare the printed page to the soft proof on your screen. If you have a good-quality monitor, printer, and profiles, the print should match the screen fairly well. You'll probably see that the blacks and overall contrast range are a little different. The monitor image is probably a little more saturated because of the nature of a self-illuminated display, but the overall hues should be fairly close. ◄¶

Improving Your Print

Throughout this book, I have repeatedly issued the disclaimer that color management is not a magic bullet. Your final print will never exactly match the image that appears on your screen because your monitor is simply a very different technology from a printed page. However, soft proofing can allow you to get your prints and screen to a pretty close match, and so reduce the number of test prints required to get a good print.

If you're sorely disappointed with the results of your print, there are a few things you can do to improve your output quality.

Change Your Rendering Intent

As you just learned, when you soft proof and print, you must select a rendering intent; that is, you tell the printer how to map "illegal" (out-of-gamut) colors to the color space of your printer—and, more specifically, to the color space of your paper.

In the last two tutorials, you selected Relative Colorimetric as your rendering intent because it's a good, general-purpose intent. It maps the white in your image to the white of your paper profile, so the whites in the print are represented by the white of the paper, not by ink. The Relative Colorimetric rendering intent doesn't touch any other color that falls within the gamut of your ink and paper. Illegal colors are mapped to the nearest in-gamut color. If you're a stickler for color accuracy, you'll probably prefer Relative Colorimetric.

As you've learned, while your digital camera must be white-balanced to reproduce color accurately, your eyes have the amazing ability to adjust automatically so that white tones always look truly white (or nearly so). Your eyes are also far more sensitive to contrast and the relationships between colors than to absolute hues. With this in mind, the Perceptual intent tries to compress all the colors in your image to fit within the color gamut of your paper, while preserving the relationships between those colors. If your image has many out-of-gamut colors, Perceptual intent creates a nice-looking image, although your colors may not be especially accurate.

You'll use the Relative Colorimetric and Perceptual rendering intents the most. If your image doesn't have out-of-gamut colors, you probably won't find much difference between the two. On a few images, you may find that one intent yields more "pop" than another—your images will look brighter and punchier. You can usually see this difference when soft proofing, so let soft proofs be your guide to which rendering intent to use. In Photoshop's Customize Proof Condition dialog box, you can select the rendering intent you'll ultimately print with, and see on-screen how it will affect your image. When you find the intent you like best, take note of it and select that same intent when you print.

Photoshop has two more rendering intents. Saturation produces as much saturation as possible and is intended for illustrations and business graphics. Absolute Colorimetric is similar to Relative Colorimetric in that it clips illegal colors. However, it doesn't remap the whites in an image. If the whites in a picture have a slight cast, a printer will print the whites with that cast, rather than leave them as paper white. In other words, Absolute Colorimetric never alters any legal colors in your image.

Many people say that you should never use Absolute Colorimetric for photo printing. However, on images with a large dynamic range, you might find that Absolute Colorimetric is actually the best choice. It sometimes provides a brightness that is missing from other intents. However, when Absolute Colorimetric is wrong for your image, it tends to be wrong in a very ugly way. You'll blow out an image's highlights or cause dark shadows to turn splotchy and weird. Pay close attention to these areas when soft proofing to determine if it's the right intent.

Perceptual and Relative Colorimetric also include the option of Black Point Compensation. In most cases, activating this feature is good, but again you should preview it in your soft proofs to be sure. Take note of your final choice because you'll need to select this as your intent in the Print with Preview dialog.

Finally, there's another option for improving the quality of your prints, which is to ignore Photoshop's color management altogether and let your printer handle your color. Depending on your printer, this may actually produce the best results. You'll see how to do this in the next section.

Soft Proofing in Other Programs

Both Apple Aperture and Nikon Capture NX provide soft-proofing tools that are very similar to Photoshop's, and you should be able to find your way easily through their controls based on what you've learned in the last two tutorials. Both programs have simpler interfaces to their soft-proofing and print features than does Photoshop. As noted earlier, Aperture only provides a single rendering intent, Relative Colorimetric. Both programs provide options for selecting a paper profile and black point compensation.

Printing with Driver Color

In our previous printing example, we let Photoshop calculate the color values sent to the printer. In the Photoshop Print dialog box, you chose Let Photoshop Determine Colors in the Options panel and then turned off Printer Color Management in the printer's driver dialog box. This left Photoshop in charge of all color calculations.

Now we're going to look at another way to print: choose Let Printer Handle Colors from the Color Handling menu of the Photoshop Print dialog box (or the Print with Preview dialog box if you're using CS or CS2). Leave Color Management turned on in your printer's driver dialog, and all color calculations will be performed by your printer. It's helpful to try this alternate method because you may find that your printer's included driver yields better results than Photoshop-managed color.

If I had suggested such a notion a few years ago, angry mobs of color geeks and printing nerds would have pelted me with empty ink cartridges. However, nowadays, printer vendors are engineering very good drivers that can often outperform Photoshop's built-in color handling.

This is especially true for black-and-white output on some printers. Some printers from both Epson and HP yield substantially better black-and-white output if you use the driver's built-in grayscale modes, rather than letting Photoshop determine colors.

With color images, when you let the printer driver control color, you might notice improvements in everything from overall cast, highlight or shadow detail, certain color ranges, and even continuous tone.

Now the bad news: Printer driver color has nothing to do with Photoshop's soft-proofing feature. In other words, there's no reason to bother with soft proofing in any soft-proof-enabled application if you're going to print with driver color. So you may find that there's less of a match between your screen and printer when using driver color. On the other hand, on some images, you might find a better match.

This points out another weakness of driver color: You might find that some images print better with Photoshop-controlled color, while others print better with printer driver-controlled color.

Also, your printer driver may not allow you to add new paper types, meaning that you won't be able to buy a third-party paper and install profiles for it.

So, does this mean you need to use even more ink and paper by printing every image using both methods? Probably not. You'll need to experiment a little, but what you'll likely find is that the differences between Photoshop and printer-generated color are very slight, and you can easily alter one to look like the other. With a little initial trial and error, you might also come to understand which types of images work better with one method than another.

Correcting Your Images

After enabling soft proofing or printing a test print, you can now think about correcting your image to fix any tone or color problems you found in your initial test print.

In Photoshop, the easiest way to make corrections is via Adjustment Layers. Since your corrections will be specific to the type of paper you're printing on, you can create separate Adjustment Layers for each paper type and activate them as needed. In addition, with the masks built-in to Photoshop's Adjustment Layers, you can constrain adjustments to particular areas in an image.

Many color problems will be the result of your image editor remapping out-of-gamut colors to fit them into the target color space. You can solve some color problems simply by bringing these colors back to legal. Choose View > Gamut Warning, and Photoshop will display out-of-gamut colors as gray pixels. (You can use this feature with Soft Proofing on or off.)

In most cases, you can bring illegal colors back into gamut by using a Hue/Saturation Adjustment Layer. Simply lower the Saturation level, and the gray gamut warning pixels disappear.

If you're using an editing system that supports multiple versions—like Apple Aperture, Nikon Capture NX, or Adobe Lightroom—you can create multiple versions tailored for printing on different paper types

Tweak Your Viewing Conditions

The quality of your monitor and printer profiles has a huge bearing on how well your printed page will match your screen. However, your viewing conditions can also have a pronounced impact on how you perceive color and contrast consistency from display to print.

When you build a monitor profile using a monitor calibrator, you tell the calibration software some of the details of the ambient lighting situation in your room. The ideal room has a fairly low level of ambient light, with no bright lights or colors in your field of view.

To make the most accurate assessment of your printer's output, view images under the ambient lighting conditions specified by your paper profile. For most paper profiles, this means daylight or artificial lighting that has the same color temperature as daylight. (Some vendors create multiple profiles for each paper, each tuned for different viewing conditions.)

If your print-viewing lighting is less than ideal, you'll want to consider getting some D50 lighting. D50 lights shine at 5000°K and are good matches for daylight.

If you happen to have a lot of cash lying around, you might want to spend it on a viewing station, such as a GTI Graphic Technology Professional Desktop Viewer. GTI makes all types of well-constructed viewing stations, from large stand-up units to collapsible, portable stations, and you can learn more about them at *www.graphiclite.com*.

A less-expensive option is the Ott-Lite, a 5300°K lamp that sits on your desk. You can order one for about $60 from Lumenet, and you can find details at *www.lumenlight.com*.

The cheapest D50 lighting option is to build your own. SoLux manufactures D50 lamps that start at $6.95 each. You'll need your own fixtures, which are easy to find at any hardware store. Check out *www.usalight.com* for a full assortment of SoLux lamps.

Web-Based Printing

A number of Web sites offer photo-printing services. After you upload your images to these sites, they will print the images and mail them back to you. These services typically use pictographic processes—traditional chemical-based printing processes that expose a piece of photographic paper using a laser or LED device.

The advantage to these services is that they're very simple to use. The downside is that you have to wait for your prints, and you don't know what sort of color and tonal corrections the service will make to your images. In other words, what you see on your screen may not be close to what you get in your prints. Typically, a particular printing service will be consistent about the type of adjustments they make to their images. Once you've figured out a particular service's idiosyncrasies, you can adjust your images accordingly before you submit them.

Pay close attention to a service's cropping guidelines. Some services will blow up your image to fill an entire print. If your original was a different aspect ratio than the final print, your image will be cropped. Most services allow the option of blowing up to full print size or padding the image to preserve your original aspect ratio.

Most services also provide photo-sharing facilities, which allow you to create one or more online photo albums. You can send the address of these albums to other people who can view your images and, if they want, order prints. Posting images to a Web site is convenient because you only have to upload your pictures and then send out a link. You'll have no concerns as to whether a particular recipient can receive large amounts of data through email. Photo sharing and printing can also save you the hassle of preparing prints for a bunch of people, because they can simply order their own.

Finally, some services offer much more than simple paper printing. Coffee mugs, T-shirts, banners, cakes, and cookies can all be adorned with your photographs.

In general, these services expect images in an sRGB color space. If you were shooting with your camera set to Adobe RGB (which you should be), you'll need to tag the images as sRGB before you upload them. In Photoshop, you use the Edit > Assign Profile command to assign a new color space.

These services also expect images to be delivered as JPEGs, and many will have specific size and resolution requirements. Consult each service's guidelines for more details.

Conclusion

While we've worked on both ends of the arts and craft spectrum, and you've practiced some very specific techniques, and learned to ask some very particular questions, the best thing you can do to improve as a photographer is to get out and take pictures! Your skill with both your camera and image editor will greatly improve as you practice, and you will begin to notice images where you possibly didn't before. Take your camera with you wherever you go and don't hesitate to fire away.

If you're shopping for a camera, either for the first time, or because you want to upgrade, then you'll want to download Chapter 23, "Choosing a Digital Camera," from the companion Web site.

If you would like more video tutorials, check out my photo courses on Lynda.com. And finally, *www.completedigitalphotography.com* offers up more articles, camera reviews, image galleries—and even free software.

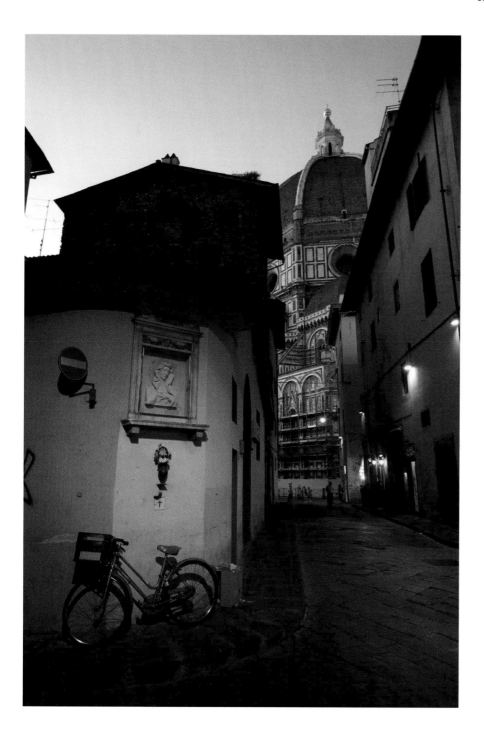

INDEX

NUMBERS

1/3rd rule, 274
24-bit images, 396
2/3rds rule, 274
35mm, equivalency, 42–43
8-bit images, 396

A

abstraction, photography as, 200–202
accepting edits, 400
accessing color channels, 396
activating menus, 46
Adams, Ansel, 194
Add button, 479
adding
 black, 74
 hue/saturation adjustment layers, 474
 levels adjustments, 470
 metadata, 315
 midpoints, 403
 points, 388–389
 storage, 70–76
 warmth, 404
Adelson, Edward H., 7
A-DEP mode, 275
adjusting
 black, 373, 384, 430
 black-and-white, 493
 Black-and-White Adjustment Layer, 495–496
 brightness, 477
 colorimetric adjustment, 103
 contrast, 429
 cropping, 350
 edges, 449–450
 exposure, 169–171, 428
 focus, 19
 f-stops, 112
 image processing parameters, 50–51
 levels, 468
 masking, 442–489
 midpoints, 380–381
 perspective, 360
 raw files, 412
 real-world images, 376–381
 saturation, 406–407
 skies, 474

 Targeted Adjustment tool, 481–482
 tones, 345, 526
 trees, 475, 494
 vibrance, 408
 white balance, 414
 white points, 374–375, 402–403
Adjustment Brush, selecting, 477–478
adjustment layers, 462–472
Adobe. *See also* Photoshop
 Bridge, 78
 Bridge CS5, 83
 Digital Negative, 420
 Photo Downloader, 90
 Photoshop, 69, 77, 79
 Photoshop CS4, 289
 Photoshop Elements, 80
advanced masking, 484–489
afternoon light, 198
Alien Skin Exposure, 501
aligning
 layers, 511
 views, 362
alpha channels, 455
analog images, 95
analyzing
 adjustment layers, 466–467
 histograms, 376–377
 images, 413
angles, shooting from different, 29
Aperture, 69, 77, 84–85, 419, 501, 520
 converting grayscale, 498
 copying edits, 439
 highlights and shadows, 433, 520
 Priority mode, 282
 Saturation control, 499
apertures, 20, 111–114
 effect on depth of field, 115–116
 balance, 117–118
 bracketing, 274
 shallow depth of field, 208
 sizing, 113
 sweet spots, 117
Apple Aperture. *See* Aperture
Apple iPhoto, 85, 90–91
applications. *See also* software
 browsing, 77–79
 cataloguing, 77–79
 editing, 79–82

 Image Capture, 91
 raw file conversion, 418–420
 Vertus Fluid Mask, 449
 workflow, 77, 82–85
applied editing techniques, 520–529
applying
 Adobe Photo Downloader, 90
 collections, 338
 keywords, 335
 scene modes, 24–27
Arbus, Diane, 194
archiving, 314, 318–319
areas
 desaturating, 366, 452
 filling, 528
 painting, 453
 repainting, 366
arranging views, 362
arrays, color filters, 101
art and craft, combining, 230–231
artifacts, 186
aspect ratios, 51, 52
attachments, special panorama, 285
audience, knowing, 203
Auto-Align Layers command, 511
autobracketing, 184–185, 291. *See also* bracketing
autochrome, 99
Auto Correction, 358
autofocus
 continuous, 131
 face detection, 131
 limitations of, 126
 low light in, 131
 Program mode, 124–126
autofocus-assist lamps, 125
Autofocus modes, 45, 56–57, 126–136
Auto ISO settings, 158
Auto Levels, 382–383
Auto mode, 11–31, 15–20, 121
autostacking in Bridge, 331
auto white balance, 138
availability of features, 27
available light, controlling, 233–236
averaging, center-weighted, 162
avoiding white balance, 141

B

backgrounds, 29
 composition, 219–221
 depth of field, 115–116
 fading, 459, 461
 fill flash, 243
 shallow depth of field, 208–211
backlighting, 30–31, 162
backups, 66, 71–72, 314, 318–319
 original versions, 491
 software, 72
balance
 apertures, 117–118
 composition, 212–215
 lighting, 140
 white, 129, 292. *See also* white
 balance
banding, preventing, 282
bar charts. *See* histograms
barrel distortion, correcting, 356–358
basic controls, 43
batches
 Camera Raw, 439–441
 processing, 257
 renaming, 338–340
batteries, 15
 maintenance, 57–58
 portable hard drives, 65
Bayer Patterns, 101
Bell Labs, 97
Best Shot Selection feature (Nikon),
 288
BeyondRaid, 72
bit depth, 95
black
 adding, 74
 adjusting, 430
 CMYK. *See* CMYK (cyan, magenta,
 yellow, and black)
 filling masks with, 472
 light meters, 165
 seeing black as black, 391–393
black-and-white, 100–101. *See also*
 grayscale
 adjusting, 493
 Camera Raw, 500–501
 converting, 490–505
 low-contrast images, 503–505
 plug-ins, 501–502
 shooting, 261–265
 sliders, 493

Black-and-White Adjustment Layer,
 495–496
Black-and-White command, 492–496
black points
 adjusting, 373, 384
 configuring, 377–379, 386
 settings, 399
blank discs, 66
Blending mode, 513–515
blending panoramas, 277
blooming artifacts, 102
blurring, 20
 effect of shutter speed choice, 115
 shallow depth of field, 208
bodies
 cameras, 13
 spraying compressed air on, 61
Boyle, Willard, 97
bracketing, 183–185
 apertures, 274
 autobracketing, 291
 focus, 274
 white balance, 141
brain, transmitting color to, 5–7
breathing, 156
Bridge, 78
 autostacking in, 331
 commands, 340
 configuring, 320
 copying edits, 439
 HDR merge, 546
 launching, 320
 Mini Bridge, 341
 navigating, 321
 panels, 323
 rating images, 326–328
 raw files, 420–421
 slideshows in, 332
 stitching, 538–539
 subfolders, 322
 thumbnails, 322
 tutorials, 320–325
 viewing images, 322–323
 workflow, 322
Bridge CS5, 83
brightness, 20, 50–51, 391. *See also*
 lighting
 adjusting, 477
 black-and-white, 494
 exposure, 166
 fill flash, 243–244
 ISO changes in, 158

 Manual mode, 175
 modifying, 47
 tones, 545
broad lighting, 237
browsing applications, 77–79
brushes, 516–519. *See also* tools
 Adjustment Brush, 477–478
 basic operations of, 447–448
 Healing Brush, 518–519, 530
 sizing, 365
 Spot Healing, 364
buffers, Drive mode, 146
building
 masking, 471
 shots, 203–211
built-in flashes, 237. *See also* flashes
built-in histograms, 176–183
Bulb mode, 112, 150
bundled raw converters, 419
burning, nondestructive dodge and
 burn, 530
burn tools, 82
Burst mode, 287
bust of images, shooting, 145. *See also*
 Drive mode
buying
 cameras, 38
 filters, 308
B+W filters, 266

C

cables, 66, 71
calculating
 depth of field, 274
 exposure, 165, 175
 focus, 129
 handheld shooting shutter speed,
 154–159
calibrating
 monitors, 75–76
 white balance, 105, 136–144
Calumet Photo, 234
Camera Bits Photo Mechanic, 78
Camera Calibration tab, 436
Camera Raw
 adjustments in, 433
 batch processing, 439–441
 black-and-white conversion,
 500–501
 copying edits in, 438
 editing in, 412–415
 Graduated Filter tool, 480–482

raw files, 420–421
Saturation control, 499
selective edits in, 476–482
toolbars, 412
cameras, 6, 11–31
buying, 38
CILCs, 14–15
configuring, 48–53
holding and controlling, 32–67
images, 68–93. *See also* images
infrared photography, 268
panoramas, 278–279
parts, 38–48
pinhole, 33
point-and-shoot, 11–13
positioning, 204
raw shooting, 258–259
resetting, 19
SLR, 11, 13–14
software that shipped with, 81
types of, 11–15
use of for better composition, 230
water damage to, 61–63
Cancel mode, 238
Canon auto mode, 16
Canto Cumulus, 78
capacity of media cards, 64
capturing
image data, 186
vistas, 283
care and maintenance, 57–64
carrying lenses, 61
Cartier-Bresson, Henri, 194
casts, correcting color, 397–401
cataloging, 77–79, 315, 319
CCDs (change-coupled devices), 34,
97, 98, 126
center-point focusing, 128
center-weighted averaging, 162
change-coupled devices. *See* CCDs
Channel Mixer, 498
channels, 100
alpha, 455
colors, 395
grayscale, 485
Green, 525
Lightness, 485
Luminance, 488
mixing, 498–499
Red, 524
charts. *See* histograms
chromatic aberrations, correcting,
361–363

chrominance noise, 157
CILCs (compact interchangeable lens
cameras), 14–15, 37
Circle tool, 445
Circular Marquees tool, 444
clarity, 433
cleaning, 57–64
lenses, 58–59
portraits, 529
sensors, 59–60
clear filters, 310
clipping, 181, 414. *See also* histograms
Clone tool, 517
cloning
tools, 82
video, 518–519
close shots. *See* macro photography
Close-up mode, 25
close-ups, 28
CMOS (Complementary Metal Oxide
Semiconductor), 34, 97
CMYK (cyan, magenta, yellow, and
black), 74, 100
cold weather, 63
Collage option (Photomerge), 540
collaging, 285–286
collapsible reflectors, 236
collections, 335–338
Collections (Bridge CS5), 83
color-based selection tools, 448–449
colorimetric adjustment, 103
Color Range command, 448
colors
backing up original versions, 491
channels, 395
components of, 498
converting, 74
converting space, 103
correcting, 346, 394–409
curves, 395–405
filter arrays, 101
highlight recovery, 429–431
interpolating, 101–102
Lab, 100
levels, 395–405
models, 100
temperature, 138
theory, 74, 99–100
transmitting to the brain, 5–7
Color tab, 548
ColorVision Spyder, 75
commands
Auto-Align Layers, 511

Black-and-White, 492–496
Bridge, 340
Color Range, 448
Duplicate Layer, 510
Undo, 366–367
commonality of cameras, 33
CompactFlash, 64, 86
compact interchangeable lens cameras.
See CILCs
comparing images, 324–325, 431
compatibility
of files, 257
raw converter, 86
compensation
bracketing, 184
exposure, 169–170
external flashes, 245
Priority modes, 174
Complementary Metal Oxide
Semiconductor. *See* CMOS
components
of cameras, 38–48
of colors, 498
of SLR cameras, 14
compositing, 509–512, 514
composition, 16
backgrounds, 219–221
balance, 212–215
black-and-white, 264
developing skills, 191–192
foregrounds, 219–221
geometry, 216–218
HDR (high-dynamic range)
imaging, 289
with light and dark, 221–223
mixing and matching, 219
performance shots, 295–296
repetition, 216
rule of thirds, 215
tips for better, 224–229
compressed air, spraying on bodies, 61
compressing
images, 48–49
JPEG images, 105–106
computers, 65
selecting, 69–72
transferring images to, 87–89
concerts, shooting, 291–296
configuring
adjustment layers, 465–466
black points, 377–379, 386
Bridge, 320
cameras, 48–53

Crop tool, 351
dates, 48
filters, 357
Gradient tools, 470
Macintosh computers, 91
merge to HDR Pro, 546–548
Photomerge, 539–540
raw shooting, 258–259
storage, 49
time, 48
white balance, 136–144
white points, 379–380, 387
connections, 66, 71
consistency of colors, 74
Content-Aware Fill, 526–528
continuous autofocus, 131
continuous flash shots, 147
Continuous mode, 287
continuous self-timers, 148
continuous shooting. *See* Drive mode
contrast, 50–51, 391
adjusting, 429
black-and-white, 494
detection systems, 124
diffusers, 234
evaluating, 179–183
low-contrast images, 503–505
reduction, 522
controlling
cameras, 32–67
lighting, 232–249
controls
basic, 43
bracketing, 184
Curves tool, 384
exposure, 111–114, 169–170
external flashes, 245
Levels, 372–381
lighting, 114–119
manual focus, 133
playback, 46–48
remote, 149–152, 270
Saturation, 499
shooting, 45
tones, 548
zooming, 43
converting
black and white, 490–505. *See also*
black-and-white
colors, 74, 103
grayscale, 346, 491
to luminance, 499
raw files, 77, 86, 411, 418–420

copying
editing, 438–439
images, 413
pixels, 518
copyrights, 292, 333
correcting, 314, 318
Auto Correction, 358
barrel distortion, 356–358
chromatic aberrations, 361–363
colors, 6, 346, 394–409
exposure, 171
focal length, 206
gammas, 103–104
geometric distortion, 345, 355–358
highlights, 520–523
Lens Correction Filter, 356
perspective, 359–361
pincushion distortion, 356–358
shadows, 520–523
stitched panoramas, 541–54
tone, 370–393
tools, 77
vignetting, 362
white balance, 144, 400, 426,
523–526
coverage, 31
craft, combining art and, 230–231
creating complex masks tutorial,
457–461
criteria, filtering, 330
cropping, 42, 345, 348–353
images, 360
joints, 31
nondestructive editing, 414
sensors, 43
Crop tool, configuring, 351
cubes, 7
cursors, modifying, 518
curves
colors, 395–405
editing, 390
gamma, 104
histograms, 348, 385
keyboard shortcuts, 405
Curves tool, 382, 383–391
customizing, 53
cyan, 74. *See also* CMYK
cylindrical layout maps (Photomerge),
540

D
darkness, 7–8, 20, 494. *See also*
brightness
data loss, troubleshooting, 381–382
dates, configuring, 48
DCIM folders, 92
delays, self-timers, 148
deleting
figures, 512
images, 47, 48, 328
layers, 508
paint strokes, 479
demosaicing, 101
depth, bits, 95
depth of field, 113, 211
aperture selections, 115–116
calculating, 274
extreme, 273–275
focal length, 275
landscape photography, 271
macro photography, 288–289
point-and-shoot cameras, 209, 274
shallow, 208–211, 288
tilt-and-shift lenses, 275–276
desaturating
areas, 366, 452
images, 499
deselecting images, 336
design
point-and-shoot cameras, 34–35
SLR (single lens reflex) cameras,
36–37
destructive editing, 462
Detail tab, 434–435
developing composition skills, 191–192
diffusers, 234
digital cameras, 6. *See also* cameras
digital negatives, 255–256
digital zoom, 40–41. *See also* zooming
digitizing, 95
diopter wheels, 19
displays. *See also* monitors
images, 23–24
shutter speed, 21–22
status, 44
distance, 135
focal length, 204–207. *See also* focal
length
hyperfocal, 273
distortion
geometric, 206–207
perspective, 345
portraits, 206–207

D-Lighting slider (Nikon Capture NX), 433
dodge tools, 82, 530
dragging. *See also* moving
 images, 349–350
 within images, 493
drawing, 195, 517
Drive mode, 45, 145–152, 184
dropping cameras, 15
Duplicate Layer command, 510
dust, 60, 345, 363–365
dynamic ranges, 7, 9

E

early morning light, 198
Edge Glow, 548
edges
 adjusting, 449-450
 defining straight, 354
editing, 186, 314, 318
 accepting, 400
 adjustments, 479
 applications, 79–82
 applied techniques, 520–529
 in Camera Raw, 412–415
 chromatic aberrations, 361–363
 copying, 438–439
 correcting geometric distortion, 355–358
 cropping, 348–353
 curves, 390
 Curves tool, 383–391
 destructive, 462
 dust removal, 363–365
 Green channels, 525
 histograms, 347–348
 images, 70
 masking, 459–460
 Nik Viveza, 489
 nondestructive, 81, 257, 411, 462
 order of, 345–347
 perspective, 359–361
 raw files, 252–257, 410–441
 red eye, 365–366
 selective edits in Camera Raw, 476–482
 skies, 488
 spot removal, 363–365
 straightening, 353–355
 white balance, 252

effects
 filters, 310
 of shutter speed choice, 115
 special, 346
Effects tab, 435
elbow positions, holding cameras, 54–55
electronic viewfinders, 37, 168
Elements (Photoshop), 318
elements, pictures, 95
equipment
 panoramas, 278–279
 use of for better composition, 230
equivalency, 35mm, 42–43
Erase button, 479

erasing. *See also* removing
 red eye, 365–366
 spots, 365
Erwitt, Elliot, 194
Essentials view, 329
evaluating
 contrast, 179–183
 focus, 135–136
 images, 413
 white balance, 140
Evaluative meters, 162
Evans, Walker, 194
events, shooting, 296–297
Exchangeable Image File. *See* EXIF
exercises, seeing, 192–196
EXIF (Exchangeable Image File), 183
ExpoDiscs, 142
exposure, 20, 108–121, 160–189
 adjusting, 169–171, 428
 black-and-white, 265
 bracketing, 184
 calculating, 165, 175
 compensation, 169–170
 controls, 111–114, 169–170
 correcting, 171
 external flashes, 245
 extreme depth of field, 273–275
 flashes, 239
 infrared photography, 268–269
 ISO, 119–120
 JPEG images, 158
 light meters, 161–168, 171–176
 locking, 129, 163–164, 173
 long exposure noise reduction, 305
 overexposure, 109–111, 166–168
 panoramas, 281–282
 Priority modes, 174

 settings, 182–183
 sound of, 155
 stops, 109, 169–170
 strategies, 189, 293–295
 underexposure, 109–111, 166–168
Exposure slider, 426
extensions for point-and-shoot cameras, 311
Extensis Portfolio, 78
external flashes, 244–249
external hard drives, 70
extra pixels, 102
extreme depth of field, 273–275
Eyedropper tool, 366
eyes, 4–5

F

face detection, 131, 136
fading backgrounds, 459, 461
Favorites, creating, 325
features, 27, 51–53
feet positions, holding cameras, 54–55
field of view, 17
figures
 deleting, 512
 painting, 467–468
files. *See also* images
 formatting, 50, 421
 managing, 92, 319
 raw, 50, 51, 251–252, 252–257. *See also* raw files
 readability of, 257
 renaming, 92
 TIFF, 50
 XMP, 417
Fill mode, 238
fills
 flash, 243–244, 521
 light, 431–433
 masks with black, 472
fills frames, 27
film negatives, 3
Filter panel, 329
filters, 308–311
 clear, 310
 color arrays, 101
 configuring, 357
 images, 329–330
 infrared photography, 265–269
 keywords, 335
 Lens Correction Filter, 356
 non-ratings, 330

red-eye removal, 365
stacks, 331
UV, 59, 310
finding subjects, 196–203
FireWire cables, 71
fish-eye lenses, 283
flare, 272
flashes, 46, 237–240
continuous flash shots, 147
exposure, 239
external, 244–249
fill flash, 243–244, 521
low light, 240–243
Manual mode, 249
modes, 238–240
point-and-shoot cameras, 12
ranges, 31
removing, 247–248
shooting at night, 302–305
Slow Sync mode, 248
SLR cameras, 13
white balance, 240
flattening images, 515
flesh tones, 139
flow charts, 315. *See also* workflow
focal length, 17, 204–207
depth of field, 209, 275
macro, 287
multipliers, 42–43
shallow depth of field, 208
focal planes, 33, 42
focus
adjusting, 19
apertures, 113
bracketing, 274
calculating, 129
center-point, 128
depth of field, 115–116. *See also* depth of field
evaluating, 135–136
infrared photography, 267
locking, 129–130, 132
low light, 303
macro, 287–288
manual, 133–135
modes, 135
points, 18, 126–128
Program mode, 124
rules, 136
tracking, 132
focus-assist lamps, 46, 125
folders. *See also* files
collections, 336

DCIM, 92
hierarchies, 319
foregrounds
composition, 219–221
fill flash, 243
optimizing, 472
painting, 468
forensics, images, 342, 368
formatting
adjustment layers, 464
black-and-white. *See* black-and-white
collections, 336
cropping, 350
Favorites, 325
files, 50, 421
gradients, 480–481
keywords, 334–335
layers, 508
masking, 451
sepia, 497
foveas, 4
fractional ISO numbers, 159
fractional stops, 120
frames, filling, 27
framing
images, 200
shots, 39
front-heavy cameras on tripods, 270
f-stops, 8, 109, 112
full-frame
equivalency, 42
sensors, 43
full resolution, 49
full-screen mode, 325
full wide, shooting, 114
Function buttons, 45

G

gammas, correcting, 103–104
Gamma sliders, 375, 387–388
gamuts, 100
geometric distortion, 206–207, 355–358
geometry
composition, 216–218
correcting, 345
glasses-free, shooting, 19
GPUs (graphics processing units), 69
gradated masks, creating, 460
gradients, creating, 480–481
Gradient tools, 347, 461, 470
Graduated Filter tool, 480–482

graduated neutral density filters, 310
graphics processing units. *See* GPUs
gray
metering, 164
shooting with gray cards, 401
white balance, 423–425
grayscale, 100–101, 263–264
alpha channels, 456
channel isolation, 485
converting, 346, 491
histograms, 178
modes, 265
ramps, 186
refining, 502–503
Green channel, 525
gripping cameras, 53

H

hair, masking, 455
halfway, pressing shutter buttons, 17
handheld shooting shutter speed, calculating, 154–159
hard drives
external, 70
portable battery-powered, 65
HDR (high-dynamic range) images, 289–291
merging, 545–550
panoramas, 550–551
HDR Pro (Photoshop), 545
heads, tripods, 281. *See also* tripods
Healing Brush, 518–519, 530
Helicon Focus, 289
hiding selections, 452
hierarchies of folders, 319
high compression, 49
high-dynamic range. *See* HDR
high ISO low-light shooting, 240–241
Highlight Clipping Warning, 414
highlights
colors, 429–431
correcting, 520–523
histograms, 181
overexposing, 167
recovery, 253–254, 415, 426–429
histograms, 46, 140, 371
analyzing, 376–377
color curves, 402
contrast, 179–183
curves, 385
editing, 347–348
in-camera, 176–183

modifying, 377, 524
three-channel, 182
History palette, 366–367
holding
cameras, 32–67
lenses, 33
horizontal panoramas, 284
hosting batch processing, 440–441
hot shoes, 14, 46. *See also* flashes
hot weather, 63–64
Hoya filters, 266
HSL/Grayscale tab, 435
hue, 405–407, 473–476. *See also*
saturation
hyperfocal distance, 273

I

**ICC (International Color
Consortium),** 75
icons, 43
Image Capture, 91
images
analog, 95
applications, 79–82
building shots, 203–211
capturing data, 186
comparing, 324–325, 431
compressing, 48–49
copying, 413, 438–439
cropping, 348–353, 360
deleting, 47, 328
depth of field, 115–116. *See also*
depth of field
desaturating, 499
deselecting, 336
dragging within, 493
edges, 449–450
editing, 70
evaluating, 413
film. *See* film
filters, 329–330
flattening, 515
forensics, 342, 368
framing, 200
grayscale, 502–503. *See also* grayscale
HDR (high-dynamic range),
289–291, 545–550
histograms, 176–183
importing, 86–92
JPEG, 49, 50
jumping, 46
learning from other, 194

locking, 47
low contrast, 503–505
managing, 92
moving, 319
navigating, 323–324
neutralizing, 401
one-bit, 95
opening in Photoshop, 340
original version backups, 491
panoramas, 276–286
playing back, 23–24
processing, 50–51, 105, 187–188
raster, 107
ratings, 326–328
recovering deleted images, 48
renaming, 92
retouching, 526–528
reviewing, 46, 147
saving, 367–368
selecting, 326–328
sensors, 34, 94–107
sepia, 497
sizing, 48–49
soft, 20
sorting, 332
stabilization, 40–41
stacking, 330–331
storage, 49, 70–76
straightening, 353–355, 413
thumbnails, 77. *See also* thumbnails
transferring, 68–93
turning data into, 103–106
viewing, 322–323
implementing RAID, 72
importing, 314, 316
images, 86–92
multi-card, 87
in-camera histograms, 176–183
infinity, focus at, 273
infrared photography, 265–269
exposure, 268–269
focus, 267
inks, 74. *See also* printing
interfaces
Curves tool, 384
Photoshop, 488
International Color Consortium. *See*
ICC
**International Press Telegraph
Committee.** *See* IPTC
International Standards Organization.
See ISO
interpolating colors, 101–102

intervalometers, 150
inverting selections, 452
iPads, 66
iPhoto, 77, 85, 90–91, 419
**IPTC (International Press Telegraph
Committee) metadata,** 332–334
irises, 4
**ISO (International Standards
Organization),** 20, 119–120, 292
Auto ISO settings, 158
fractional ISO numbers, 159
high ISO low-light shooting,
240–241
modifying, 155–158
isolating
grayscale channels, 485
subjects, 288

J

**Japan Electronic Industry
Development Association,** 183
joints, cropping, 31
JPEG images, 49, 50
black-and-white images, 265
compatibility of, 257
compressing, 105–106
correcting white balance, 523–526
exposure, 158
saving, 105–106
saving raw files as, 421
white balance, 400
jumping images, 46

K

Kelvin, 138
keyboard shortcuts
curves, 405
selecting rulers from, 354
keywords, 314, 316–317, 334–335
applying, 335
filters, 335
formatting, 334–335
kit lenses, 41
Kodak
filters, 266
Velvia, 501

L

Lab colors, 100
lag, shutters, 136
Landscape mode, 25, 187

landscapes
 panoramas, 278–279
 photography, 271–276
 shooting, 2–3
Lange, Dorothea, 194
laptop computers, 65
Lasso tool, 444, 527
launching Bridge, 320
layers, 507–515
 adjustment, 462–472
 aligning, 511
 Black-and-White Adjustment Layer,
 495–496
 deleting, 508
 dodging and burning, 530
 formatting, 508
 masking, 469–472, 511
 moving, 508
 one-click masking, 483–484
 opacity, 513–515
Layers palette (Photoshop), 464, 508
LCD screens, 12, 21–22, 44. See also
 viewfinders
 modifying brightness, 47
 using as viewfinders, 168
leading subjects, 28
leaving Playback mode, 24
length, focal, 17, 204–207
Lens Correction Filter, 356, 435
lenses, 38–43
 carrying, 61
 cleaning, 58–59
 extreme depth of field, 273–275
 eyes, 4
 fish-eye, 283
 focal length, 17
 holding, 33
 kit, 41
 point-and-shoot cameras, 12, 39
 shades, 272
 SLR cameras, 13, 41–42
 stabilization, 39–40
 stopping down, 114
 telephoto, 17
 tilt-and-shift, 275–276
 wide-angle, 283
 zooming, 39, 40–41
leveling tripods, 270
levels
 adjusting, 468
 colors, 395–405
 tone, 372–381

Levels Adjustment Layers, 465
Levels tool, 382
light and dark, composition with,
 221–223
light-collecting capabilities,
 optimizing, 102
lighting, 4, 7–8, 20, 232–249
 autofocus, 131
 backlighting, 30–31
 balance, 140
 broad, 237
 controls, 114–119
 diffusers, 234
 exposure, 109–111. See also
 exposure
 fill light, 431–433
 flashes, 237–240. See also flashes
 ISO changes in, 158
 Manual mode, 175
 narrow, 237
 non-changing light, 22
 painting, 519
 reflectors, 235
 shooting at night, 302–305
 tungsten, 6
 white balance, 136–144. See also
 white balance
light meters, 161–168, 164–166
 exposure, 171–176
 Manual mode, 174–175
 Priority modes, 173–174
Lightness channel, viewing, 485
Lightroom, 77, 83–84, 419, 501
 copying edits, 439
 Saturation control, 499
limitations
 of autofocus, 126
 of raw files, 257–258
 of selection tools, 457
 of using LCD screens as view-
 finders, 168
loading masks, 458, 487
Local Adaptation, 547
locking
 exposure, 129, 163–164, 173
 focus, 129–130, 132
 images, 47
 mirrors, 270
long exposure noise reduction, 305
looking versus seeing, 191–192
loupe tool, 325
low compression, 49
low-contrast images, 503–505

low light. See also lighting
 autofocus in, 131
 flashes, 240–243
 high ISO low-light shooting,
 240–241
 shooting at night, 302–305
Lumière brothers, 99
luminance, 164
 converting to, 499
 noise, 157, 531
Luminance channel, 488

M
Macintosh computers, transferring
 images to, 90–91
macro photography, 286–289
magenta, 74. See also CMYK
Magic Wand tool, 446
magnification, 17
magnifying glass tool, 362
maintenance, 57–64
 batteries, 57–58
 cleaning, 58–59
 water damage to cameras, 61–63
managing
 files, 92, 319
 image transfers, 91
 workflow applications, 258
manual focus, 128, 133–135
manual image transfers, 92
Manual mode
 flashes, 249
 light meters, 174–175
manual override with program shift,
 152–153
manual white balance, 139–140,
 422–423
mapping tones, 545
masking, 442–489
 adjusting, 485
 adjustment layers, 462–472
 advanced, 484–489
 building, 471
 complex masks tutorial, 457–461
 creating, 451
 editing, 459–460
 layers, 469–472, 511
 loading, 458, 487
 naming, 457
 Nik Viveza, 489
 one-click layer, 483–484
 painting, 467, 479

refining, 472, 485

saving, 455–457, 489

selective edits in Camera Raw, 476–482

targeted hue/saturation, 473–476

tools, 444–461

Masks palette, 482–484

Matrix meters, 162, 464

Maxwell, James Clerk, 99

measurements

f-stops, 113. *See also* f-stops

luminance, 164

white balance, 139

media cards, 15, 64–66, 86, 87

megapixels, 48

memory, 70, 515

menus, navigating, 46

merging HDR (high-dynamic range) images, 545–550

metadata, 77

adding, 315

forensics, 342

IPTC (International Press Telegraph Committee), 332–334

tagging, 314, 316–317

metering, 17, 45, 129, 207

electronic viewfinders, 168

light meters, 161–168, 171–176. *See also* light meters

Matrix meters, 464

partial, 163

spot, 163

Metering modes, 162

Micro Four Thirds, 15

Microsoft Expression Media 2, 78

middle gray, 164. *See also* gray

midpoints

adding, 403

adjusting, 380–381

Mini Bridge, 341

mirror chambers, 36, 37

mirroring, 72

mirror lockups, 270

mixing

channels, 498–499

and matching, 219, 223–224

models, colors, 100

modes

A-DEP, 275

Aperture Priority, 282

auto, 11–31, 15–20, 121

Autofocus, 45, 56–57, 126–136

Blending, 513–515

Bulb, 112, 150

Burst, 287

Cancel, 238

Close-up, 25

Continuous, 287

Drive, 45, 145–152, 184

Fill, 238

flashes, 238–240

focus, 135

full-screen, 325

grayscale, 265

HDR (high-dynamic range) images, 547

Landscape, 25, 187

Macro, 286–289

Manual, 174–175, 249

Metering, 162

Night Portrait, 25–26

panoramic, 43

Playback, 23–24

Portrait, 25, 187

Priority, 173–174

Program, 123–159. *See also* Program mode

QuickMask, 446

Raw, 144

Red-Eye Reduction, 238

Sand and Snow, 25, 187

Scene, 24–27, 187

selecting, 43

Shooting, 204

Single Frame, 147

Single-Shot, 146

Slow Sync, 241–243, 248

Transfer, 513–515

modifying

brightness, 47, 477

cursors, 518

edges, 449–450

exposure, 169–171

Gamma sliders, 387–388

histograms, 377, 524

image processing parameters, 50–51

ISO (International Standards Organization), 155–158

levels, 468

manual white balance, 140

masking, 442–489. *See also* masking

ratings, 329

vibrance, 408

white balance, 414

monitors, 73–76

calibrating, 75–76

preparing, 73–74

profiling, 75–76

Monochrome Mixer adjustments, 498

monopods, 271

mounts, tripods, 279. *See also* tripods

movies, cloning, 518–519

moving

images, 319, 349–350

layers, 508

light sources, 235

views, 362

muddy terrain, shooting in, 270

multi-card importing, 87

multiple images, shooting, 289

multiplication factor, 42

multipliers, focal length, 42–43

Multisegment meters, 162

N

naming

collections, 336

masking, 457

templates, 333

narrative, 227–228

narrow lighting, 237

navigating

Bridge, 321

images, 323–324

menus, 46

Photoshop, 488

raw files, 412

nearsightedness, 113

neck positions, holding cameras, 54–55

negatives

digital, 255–256

film, 3

neutral density filters, 309–310

neutralizing images, 401

New button, 479

Nicad technology, 57

night, shooting at, 302–305

Night Portrait mode, 25–26

Nikon Capture NX, 80, 419

copying edits, 439

D-Lighting slider, 433

Saturation control, 499

Nik Software Silver Efex Pro, 502

Nik Viveza, 489

nodal points, 281

noise, 156, 531

chrominance, 157

correcting, 318

ISO and, 120
long exposure noise reduction, 305
luminance, 157
reduction, 105, 346
non-changing light, 22
nondestructive dodge and burn, 530
nondestructive editing, 81, 257, 462
cropping, 414
raw files, 411, 416–417
nondestructive shadows/highlights,
523
non-ratings, filtering, 330
notebook computers, 66
not seeing any images, 57
numbers, fractional ISO, 159

O

objects, smart objects (Photoshop),
533
offline volumes, collections, 337
offloading, 66
one-bit images, 95
one-click layer masking, 483–484
one stops, 8
online printing, 74
opacity, 513–515
opening images, 340, 349
optical viewfinders, 12
optic nerves, 4
optimizing
foregrounds, 472
light-collecting capabilities, 102
monitor calibration, 76
snapshot shooting, 27–31
options
Manual mode, 175
panoramas, 281
Photomerge, 540
self-timers, 148
order of editing tasks, 345–347
organizing, 314, 316. *See also* managing
original version backups, 491
outdoor shooting, fill flash, 243
output, 314, 318, 346
overexposure, 20, 109–111, 166–168,
175, 179. *See also* exposure
overlapping images, 280. *See also*
panoramas
overlays, viewfinders, 53
oversharpening, 51

P

paint brushes, 82
painting
areas, 453
figures, 467–468
foregrounds, 468
light, 519
masking, 467, 479
shadows, 519
panels, Bridge, 323
panning, 279–281
panoramas
collaging, 285–286
HDR (high-dynamic range) images,
550–551
modes, 43
shooting, 276–286
stitching, 537–540
stitching software, 86
parameters, image processing, 50–51
parity, 72
partial metering, 163
parts, cameras, 38–48
passive autofocus systems, 124. *See
also* autofocus
patterns, Bayer Patterns, 101
PC adapters, 66
pentamirrors, 37
pentaprisms, 37
perceptual adjustments, 431
performance
GPUs (graphics processing units), 69
RAM (random access memory), 70
shooting, 291–296
peripheral vision, 5
permissions, 292
perspective
correcting, 359–361
distortion, 345
Photomerge, 540
pet-eye, removing, 365
phase difference, 126
Photo Downloader, 90
photographers, learning from other,
194
Photomerge, configuring, 539–540
Photoshop, 69, 77, 79
Black-and-White command,
492–496
Channel Mixer, 498
Content-Aware Fill, 526–528
correcting chromatic aberrations,
361–363

Elements, 80, 318, 498, 501
HDR merge, 546
HDR Pro, 545
interfaces, 488
Layers palette, 508
Lightroom, 83–84
opening images in, 340
QuickMask mode, 446
raw files, 420–421
smart objects, 533
stitching, 539
units, 353
versions, 465
photosites, 98, 99, 101, 102
pick images, selecting, 314, 317–318
Picture Controls (Nikon), 18
pictures, 95. *See also* images
Picture Styles (Canon), 188
pinhole cameras, 33
pixels, 95, 96, 107
configuring image size, 48
copying, 518
extra, 102
plane, focal, 33, 42
playback controls, 46–48
playing back images, 23–24
plug-ins
black-and-white, 501–502
masking, 449
Nik Viveza, 489
skin, 530
point-and-shoot cameras, 11–13
center-point focusing, 128
characteristics of, 33–38
depth of field, 209, 274
design, 34–35
extensions for, 311
lenses, 39
manual focus, 133
scene modes, 26
points
adding, 388–389
focus, 126–128
polarizers, 308
pop-up flashes, 46. *See also* flashes
portable battery-powered hard drives,
65
Portrait mode, 25, 187, 278–279
portraits
cleaning, 529
depth of field, 115–116
distortion, 206–207
shooting, 136

positioning. *See also* composition
 cameras, 204
 lighting, 236. *See also* lighting
 views, 362
posterization, 186, 255, 399, 425–426
postprocessing technology, 289
postproduction, 313–319
power
 external flashes, 244
 switches, 15, 43
practice shots, 20, 192–196
prefocusing, 136
preparing monitors, 73–74
presets, white balance, 138
Presets tab, 434
pressing shutter buttons, 17–19
pressure-sensitive tablets, 82
preventing banding, 282
previewing depth of field, 211
primary colors, 5. *See also* colors
printing, online, 74
Priority modes, light meters, 173–174
processing, 34
 batch, 257
 black and white, 261–265
 Camera Raw, batch, 439–441
 film, 3
 images, 50–51, 105, 187–188
 postprocessing technology, 289
product photography, 307–308
profiling monitors, 75–76
Program mode, 123–159
 autofocus, 124–126
 focus, 124
 manual override, 152–153
 white balance, 136–144
Program Shift feature, 152–153, 170

Q

Quarter Tones feature, 389
QuickMask mode, 446
Quick Selection tool, 446, 451

R

RAID (redundant array of independent disks), 72
RAM (random access memory), 70, 515
ramps, 348
random access memory. *See* RAM
ranges
 dynamic, 7, 9
 external flash, 244

flashes, 31
HDR (high-dynamic range) images,
 289–291, 545–550
raster images, 107
rates, sampling, 34
ratings, 319
 images, 326–328
 modifying, 329
ratios
 aspect, 51, 52
 signal-to-noise, 102
raw files, 50, 51, 251–252
 adjusting, 412
 black-and-white images, 265
 converting, 77, 86, 411, 418–420
 copying edits, 438–439
 editing, 252–257, 410–441
 highlights, 433. *See also* highlights
 limitations of, 257–258
 navigating, 412
 nondestructive editing, 411,
 416–417
 saving, 421
 settings, 412–415
 stitching, 543
 tabs, 433–438
 white balance, 422–426
 workflow, 316, 417–418, 420–421
 zooming, 412
Raw mode, 144
raw shooting, 250–259
readability of files, 257
readers, media cards, 86
reading shutter speed, 21–22
real-world images, adjusting, 376–381
reciprocity, 118–119, 119–120
recording exposure settings, 182–183
recovery
 deleted images, 48
 highlights, 253–254, 415, 426–429
Recovery slider, 426, 477
Rectangular Marquee tool, 445
Rectangular tool, 444
recycle times, 244
red, green, and blue. *See* RGB
Red channel, 524
red eye, 365–366
Red-Eye Reduction mode, 238, 244
reduction
 contrast, 522
 long exposure noise, 305
 noise, 105, 346

redundant array of independent disks.
 See RAID
Refine Edge tutorial, 450–455
refining
 grayscale images, 502–503
 masking, 472, 485
reflections, light meters, 164
reflectors, 235, 236
reframing, 129
remote controls, 149–152, 270
Remove Distortion slider, 355
Remove Ghosts, 547
removing. *See also* deleting
 barrel distortion, 357
 dust, 345, 363–365
 flashes, 247–248
 red eye, 365–366
 spots, 345, 363–365
renaming, 314
 batches, 338–340
 files, 92
repainting areas, 366
repetition of composition, 216
Reposition option (Photomerge), 540
resetting cameras, 19
resolution, 49, 95
retinas, 4
retouching, 346, 526–528
reverting to previous versions, 351
reviewing images, 46, 147
RGB (red, green, and blue), 5, 99
 channels, 395, 396
 demosaicing, 102
rods, 5
rotation controls, tripods, 281. *See also*
 tripods
rubber stamps, 82
Rubber Stamp tool, 517
rulers, selecting, 354
Ruler tool, 354
rules
 1/3rd, 274
 2/3rds, 274
 composition, 212
 focus, 136
 rule of thirds, 215
 Sunny 16, 175

S

sampling rates, 34
Sand and Snow mode, 25, 187
saturation, 405–407, 433, 473–476

Saturation control, 499
Saturation slider, 424
saving, 66
 collections, 338
 images, 70–76, 367–368
 JPEG images, 105–106
 masking, 455–457, 489
 raw files, 421
 reverting to previous versions, 351
Scene modes, 24–27, 187
screens, 21–22, 44
 images, 23–24
 LCD, 12
 modifying brightness, 47
SD (SecureDigital), 64, 86
SDHC cards, 64
SecureDigital (SD), 64
seeing
 exercises, 192–196
 looking versus, 191–192
selecting
 Adjustment Brush, 477–478
 computers, 69–72
 filling, 528
 images, 326–328
 modes, 43
 rulers, 354
selection tools, 444–449, 457
selective edits in Camera Raw, 476–482
self-timers, 147–149, 270
sensors, 4
 cleaning, 59–60
 CMOS (Complementary Metal
 Oxide Semiconductor), 99
 cropped, 43
 full-frame, 43
 images, 34, 94–107
 infrared photography, 266
 stabilization, 40
sepia, toning, 497
Servo Tracking, 132
settings. *See also* configuring
 Auto ISO, 158
 auto mode, 15–16
 black points, 399
 date and time, 48
 exposure, 182–183
 image size and compression, 48–49
 raw files, 412–415
 for shooting concerts, 292–293
 white points, 398
shades, lenses, 272

shadows
 correcting, 520–523
 exposure, 166
 external flashes, 244
 histograms, 178
 painting, 519
shallow depth of field, 208–211, 288
shapes, histograms, 181
sharpness, 50–51, 105, 273, 346
Shield (Adobe), 350
shift
 manual override with program,
 152–153
 white balance, 140
shooting
 in auto mode, 15–20
 black and white, 261–265
 concerts and performances, 291–296
 controls, 45
 from different angles, 28
 in Drive mode, 146–147
 events, 296–297
 with external flashes, 245–246
 framing, 39
 framing shots, 16
 full wide, 114
 glasses-free, 19
 with gray cards, 401
 HDR (high-dynamic range)
 imaging, 289–291
 high ISO low-light, 240–241
 infrared photography, 265–269
 ISO (International Standards
 Organization), 156
 landscapes, 2–3
 macro photography, 286–289
 modes, 112
 multiple images, 289
 at night, 302–305
 panoramas, 276–286
 portraits, 136
 practice shots, 20
 product photography, 307–308
 raw, 250–259
 shallow depth of field, 208–211
 sports, 297–299
 stabilization, 269–271
 street shots, 299–302
 tethered, 151–152, 308
 vacation, 306–307
 wildlife, 132
Shooting mode, 204

shutters, 111–114
 buttons, 17–19, 43
 flashes, 248
 lag, 136
 Manual mode, 175
 speed, 20–23, 115
 stabilization, 154
signal-to-noise ratios, 102
silver halide, 3
simplicity, shooting with, 229
Single Frame mode, 147
single lens reflex. *See* SLR
Single-Shot mode, 146
sizing, 346
 apertures, 113
 brushes, 365
 filters, 308
 images, 48–49
sketching, 195
skies
 adjusting, 474
 editing, 488
skills, 9, 196–203
skin, plug-ins, 530
skylight filters, 59
slave controls, external flashes, 245
sleep, 53
sliders
 black-and-white, 493
 D-Lighting, 433
 Exposure, 426
 Fill Light, 432
 Gamma, 375
 Levels, 372–381
 Recovery, 426, 477
 Remove Distortion, 355
 Saturation, 424
 Temperature, 424
 vibrance, 408
slideshows in Bridge, 332
slow shutter speeds, 115
Slow Sync mode, 241–243, 248
SLR (single lens reflex) cameras, 11,
 13–14
 auto mode, 16
 center-point focusing, 128
 characteristics of, 33–38
 depth of field, 209
 design, 36–37
 lenses, 41–42
 manual focus, 133
Smart Collections, creating, 337–338
smart objects (Photoshop), 533

Smart Radius tutorial, 450–455
Smith, George, 97
snapshot shooting, 11–31, 27–31
softening, 117
soft images, 20
software, 76–86
 backups, 72
 panoramas, 277
 raw file conversion, 418–420
 support, 258
 that shipped with camera, 81
 Vertus Fluid Mask, 449
Solio, 57
sorting images, 332
sound, 51, 155
space, converting colors, 103
special effects, 346
special mask tools, 449
special panorama attachments, 285
speed
 definition of, 120
 Drive mode, 146
 flashes, 248
 Manual mode, 175
 shutters, 20–23, 111–114, 115
 speeding up stitching, 544
 stabilization, 154
Spherical option (Photomerge), 540
split toning, 501
Split Toning tab, 435
sports, shooting, 297–299
spot focus, 128
Spot Healing Brush tool, 364
spot metering, 163
spots, removing, 345, 363–365
stabilization
 lenses, 39–40
 sensors, 40
 shooting, 269–271
 shutters, 154
stacking images, 330–331
stamps, 516–519
starting Bridge, 320
status, 20–23, 44
step-up ring, 308
Stieglitz, Alfred, 194
stitching, 285
 Bridge, 538–539
 correcting, 541–54
 panoramas, 537–540
 Photoshop, 539
 raw files, 543
 workflow, 538

stopping down lenses, 114
stops
 exposure, 109, 169–170
 fractional, 120
 f-stops. *See* f-stops
 stabilization, 154
storage
 images, 49, 70–76
 raw files, 257
 troubleshooting, 66
straightening, 345
 images, 353–355, 413
 Lens Correction filter, 358
Strand, Paul, 194
strategies, exposure, 189, 293–295
street shots, shooting, 299–302
String Substitution, 339–340
striping, 72
strokes, painting, 479
Styles, 498
subfolders, Bridge, 322
subjects
 composition, 225–227. *See also*
 composition
 depth of field, 115–116. *See also*
 depth of field
 fill flash, 243
 finding, 196–203
 isolation of, 288
 leading, 28
 types of, 203
Sunny 16 rule, 175
support, software, 258
Sutton, Thomas, 99
sweet spots, apertures, 117
switches, 15, 43
swiveling external flashes, 245

T

tablets, 66, 517
tabs, raw files, 433–438
tagging metadata, 314, 316–317
Targeted Adjustment tool, 481–482
targeted hue/saturation, 473–476
telephoto lenses, 17
temperature, colors, 138
Temperature slider, 424
templates, metadata, 332–334
tethered shooting, 151–152, 308
theory, colors, 74, 99–100
third-party remote controls, 150–151
three-channel histograms, 182

through-the-lens. *See* TTL viewfinders
thumbnails, 77, 322
TIFF files, 50, 257
tilt-and-shift lenses, 275–276
tilting external flashes, 245
time, configuring, 48
timers, self-timers, 147–149, 270
tips. *See also* optimizing; options
 for better composition, 224–229
 monitor calibration, 76
 white balance, 141–144
tone, 165. *See also* luminance
 correcting, 370–393
 Curves tool, 383–391
 levels, 372–381
Tone Curve tab, 434
tones
 adjusting, 345, 526
 black-and-white, 494
 controls, 548
 mapping, 545
 sepia, 497
 split toning, 501
 vibrance, 408
toolbars, Camera Raw, 412
tools. *See also* applications
 brushes, 447–448. *See also* brushes
 burn, 82
 Camera Raw, 412–415
 Circle, 445
 Circular Marquees, 444
 Clone, 517
 cloning, 82
 color-based selection, 448–449
 correcting, 77
 Crop, 351
 Curves, 382, 383–391
 dodge, 82, 530
 Eyedropper, 366
 Gradient, 347, 461, 470
 Graduated Filter, 480–482
 HDR (high-dynamic range) images,
 548
 Lasso, 444, 527
 Levels, 382
 loupe, 325
 Magic Wand, 446
 magnifying glass, 362
 masking, 444–461
 Quick Selection, 446, 451
 Rectangular, 444
 Rectangular Marquee, 445
 red-eye removal, 365

Rubber Stamp, 517
Ruler, 354
selection, 444–449
special mask, 449
Spot Healing Brush, 364
spot removal, 365
Targeted Adjustment, 481–482
tracking focus, 132
Transfer mode, 513–515
transferring images, 68–93
transmitting colors to the brain, 5–7
trees, adjusting, 475, 494
tripods, 269–271
effect of slow shutter speeds, 115
panoramic shooting, 279
troubleshooting
care and maintenance, 57–64
data loss, 381–382
exposure, 171
metering, 162
not seeing any images, 57
storage, 66
unreadable media cards, 87
water damage to cameras, 61–63
white balance, 141–144
TTL (through-the-lens) viewfinders,
37, 124
external flashes, 244
filters, 310
tungsten lighting, 6
turning data into images, 103–106
tutorials
adjusting real-world images, 376–381
adjusting saturation, 406–407
adjustment layers, 463–469
advanced masking, 484–489
Black-and-White command,
492–496
Bridge, 320–325
Bridge rating images, 326–328
Bridge starting, 320–325
chromatic aberrations, 361–363
cloning video, 518–519
collections, 336–338
compositing, 509–512
correcting color casts, 397–401
correcting color with curves,
401–405
correcting geometric distortion,
355–358
correcting tone with curves, 386–390
correcting white balance, 523–526
creating complex masks, 457–461

cropping images, 348–353
dust removal, 363–365
filtering images, 329–330
Graduated Filter tool, 480–482
IPTC (International Press Telegraph
Committee) metadata, 332–334
layer masking, 469–472
Levels input sliders, 373–376
masking hair, 455
overview of, 347
painting light and shadow, 519
perspective, 359–361
recovering overexposed highlights,
427–429, 430–431
Refine Edge, 450–455
retouching, 526–528
selective edits in Camera Raw,
476–482
Smart Radius, 450–455
spot removal, 363–365
stacking images, 330–331
straightening images, 353–355
targeted hue/saturation, 473–476
types
of cameras, 11–15
of diffusers, 234
of filters, 308–310
of lenses, 38–43
of subjects, 203

U

**UDMA (Ultra Direct Memory
Access),** 64, 86
ultraviolet filters, 308
underexposure, 20, 109–111,
166–168, 185
underwater photography, 305–306
Undo command, 366–367
units, Photoshop, 353
unreadable media cards, 87
upgrading applications, 85
USB (universal serial bus), 71
UV filters, 59, 310

V

vacation shooting, 306–307
versions
original backups, 491
Photoshop, 465
reverting to previous, 351
vertical panoramas, 284, 544
Vertus Fluid Mask, 449

vibrance, 408, 433
video, cloning, 518–519
view, field of, 17
viewfinders
adjusting focus, 19
CILCs, 15
electronic, 37
overlays, 53
point-and-shoot cameras, 12
SLR cameras, 13
TTL (through-the-lens), 37
using LCD screens as, 168
viewing
images, 322–323
Lightness channel, 485
metadata, 334
monitors, 73–76
views, arranging, 362
vignetting, 362, 531–533
virtual reality (VR) movies, 277, 281
vision, 4–5
vistas
capturing, 283
collaging, 285

W

Wacom
Bamboo Pen, 82
Graphire, 517
warmth, adding, 404
water, damage to cameras, 61–63
weather sealing, 63
weddings, shooting, 296–297
weight hooks, 270
wheels, diopter, 19
WhiBal cards, 143
white, 165, 236. *See also* black-and-
white; grayscale
white balance, 105, 129, 204, 292
auto, 138
avoiding, 141
bracketing, 141
correcting, 426, 523–526
editing, 252
evaluating, 140
filters, 310
flashes, 240
JPEG images, 400
manual, 139–140, 422–423
modifying, 414
posterization, 255, 425–426
presets, 138

Program mode, 136–144
raw files, 422–426
shift, 140
tips, 141–144
white cards, 139
white points
adjusting, 374–375, 402–403
configuring, 379–380, 387
settings, 398
wide-angle lenses, 283
wildlife, shooting, 132
wind, effect on tripods, 270
Windows 7 computers, transferring images to, 89–90
Windows XP/Vista computers, transferring images to, 87–89
wireless remote controls, 149, 151
workflow, 312–343
applications, 77, 82–85
approaches to, 319–331
Bridge, 322

chromatic aberrations, 361–363
correcting geometric distortion, 355–358
cropping, 348–353
dust removal, 363–365
editing, 345. *See also* editing
histograms, 347–348
managing, 258
perspective, 359–361
postproduction, 313–319
raw files, 316, 417–418, 420–421
spot removal, 363–365
stitching, 538
straightening, 353–355
Workflow Options tab, 436–438
Wratten 87 exposures, 266

X

XMP files, 417

Y

yellow, 74. *See also* CMYK

Z

zones, focus, 126–128
Zone System, 265
zooming, 16, 56
apertures, 114
controls, 43
external flashes, 244
lenses, 39, 40–41
macro, 287–288
raw files, 412
remote controls, 149